LANGUAGES OF TRAUMA

History, Memory, and Media

Languages of Trauma

History, Memory, and Media

EDITED BY PETER LEESE, JULIA BARBARA KÖHNE,
AND JASON CROUTHAMEL

UNIVERSITY OF TORONTO PRESS
Toronto Buffalo London

ISBN 978-1-4875-0896-8 (cloth) ISBN 978-1-4875-3941-2 (EPUB)
 ISBN 978-1-4875-3940-5 (PDF)

Library and Archives Canada Cataloguing in Publication

Title: Languages of trauma : history, memory, and media / edited by Peter
 Leese, Julia Barbara Köhne, and Jason Crouthamel.
Names: Leese, Peter, editor. | Köhne, Julia, editor. | Crouthamel, Jason, editor.
Description: Includes index.
Identifiers: Canadiana (print) 2020041612X | Canadiana (ebook) 20210091924 |
 ISBN 9781487508968 (hardcover) | ISBN 9781487539412 (EPUB) |
 ISBN 9781487539405 (PDF)
Subjects: LCSH: Psychic trauma in literature. | LCSH: Psychic trauma in the
 theatre. | LCSH: Psychic trauma in motion pictures. | LCSH: Psychic trauma
 in music. | LCSH: Psychic trauma and mass media. | LCSH: Memory in art. |
 LCSH: Memory in literature. | LCSH: Memory in motion pictures. |
 LCSH: War films – History and criticism. | LCSH: War in literature.
Classification: LCC NX650.M46 L36 2021 | DDC 700/.453 – dc23

University of Toronto Press acknowledges the financial assistance to its
publishing program of the Canada Council for the Arts and the Ontario Arts
Council, an agency of the Government of Ontario.

Canada Council Conseil des Arts
for the Arts du Canada

ONTARIO ARTS COUNCIL
CONSEIL DES ARTS DE L'ONTARIO
an Ontario government agency
un organisme du gouvernement de l'Ontario

Funded by the Financé par le
Government gouvernement
of Canada du Canada

Dedicated to our inspiring colleague Thomas Elsaesser

Contents

Illustrations

Acknowledgments

The essays in this collection are the result of ongoing conversations between members of an interdisciplinary group of scholars who have gathered for varied conferences, workshops, and panels since first meeting in Vienna at the 2011 "The First World War in a Gender Context – Topics and Perspectives" conference, followed by a conference in Copenhagen in 2013, "AfterShock: Post-traumatic Cultures since the Great War." Two other conference meetings led to the current collection. First, in November 2016 Julia Barbara Köhne (Humboldt University in Berlin) and Jason Crouthamel (Grand Valley State University, Michigan) organized a conference titled "Languages of Trauma: Body/Psyche, Historiography, Traumatology, Visual Media" at Humboldt University in Berlin. After this meeting we decided to incorporate more contributors and expand on the initial themes of the volume. This led to a second, follow-up event: four panels of papers on varied aspects of trauma and memory, organized by Peter Leese (University of Copenhagen), as a part of the December 2017 Memory Studies Association second conference, held in Copenhagen, Denmark.

Our thanks go to all of the contributors at these events: without the lively, collegial, and engaging discussions that have informed our thinking, this collection would not exist. Additionally, a number of colleagues have been strongly supportive, including Joanna Bourke, Graham Dawson, Susan Derwin, Iro Filippaki, Anne Freese, Maria Fritsche, Pumla Gobodo-Madikizela, Dagmar Herzog, Ville Kivimäki, Ulrich Koch, Michelle Meinhart, Mark Micale, Raya Morag, Bill Niven, Mike Roper, Robin May Schott, Barbara Törnquist-Plewa, and Jay Winter. We thank Michael Huner for language expertise, Max Coolidge Crouthamel for his technical support, and Stephen Shapiro at University of Toronto Press for his open-mindedness, kindness, and patience. We would also like to thank Terry Teskey for her editing expertise.

Individually we are also grateful to our various departments for providing the intellectual support and financial aid that have made our discussions, and this collection, possible. This includes support from the Deutsche Forschungsgemeinschaft (DFG) for the 2016 Berlin conference "Languages of Trauma," as well as the Department of English, Germanic and Romance Studies, University of Copenhagen. We are grateful to the Center for Scholarly and Creative Excellence and the College of Liberal Arts and Science, and in particular Dean Fred Antczak, at Grand Valley State University in Michigan, which made several of our conferences and workshops possible.

Finally, this volume is dedicated to the memory of our colleague Thomas Elsaesser, who passed away during the completion of the manuscript. We would like to express our gratitude towards Silvia Vega-Llona (The New School), who generously gave us approval to proceed with the publication of Thomas's article in this volume. His exceptional intellect, creativity, and collegiality will be sorely missed in our scholarly community.

LANGUAGES OF TRAUMA

History, Memory, and Media

Introduction: Languages of Trauma

PETER LEESE, JULIA BARBARA KÖHNE, AND JASON CROUTHAMEL

Trauma initiates an inner imaging, a disjointed process of creating images that are sometimes clearly remembered, sometimes subtly obscured. These images resist logic, explanation, or dissolution. Such traumatic recollection or intrusion is not static. It is a dynamic, malleable, mediated expression of the rememberer's present. In some cases, trauma causes silence, or a void,[1] but if it is beyond representation, how can we speak of its different languages? There is a distinction between trauma's representational problems, which are connected to its inherent, intrapsychic tendency to disguise itself, and its striving for articulation. Both might even happen simultaneously. The parts of the traumatic content that are seeking articulation take on the shape of a myriad of languages (in all media formats). Thus, seeming "unrepresentability" is actually followed by a vivid productivity of languages that appear in all kinds of representational forms. As Robert Dale notes, quoting Polina Barskova in his essay in this volume on Red Army veterans and representations of traumatic memories, "historical trauma leads not only to silence – unrepresentability – but also to a creative quest for a changed discourse and the emergence of a new poetics."[2] To more fully understand the representation of traumatic imagining, we must investigate its cultural and historical particulars, circumstances of family, community, and politics – a complex, volatile range of moods, emotions, and mediated forms.[3] This volume traces the distinct cultural languages in which individual and collective forms of trauma are expressed in diverse variations – be it a body or psyche showing signs or symptoms, or literature, photography, theatre plays, or cinematic images. These media forms transform and allegorize the past of the traumatized, and might themselves re-enact, re-animate, or activate traumatizing situations.

The essays in this volume collectively follow the view that traumatic memory never leads entirely to silence.[4] Rather, psychic traces of

negative, violent events are embroiled in a struggle towards meaning and coherence, which is at times hopeless, or even takes place in a state of muteness. The difficulties of hearing are often due not to a difficulty of representation, but instead of audibility, translation, recognition, and acknowledgment. This collection listens for varied idioms and dialects of trauma-in-articulation and considers some of the collaborations and contradictions that result. *Languages of Trauma* explores how traumatic memory strives to be articulated. How are traumatic memories narrated, or transformed into media? What different forms of language are used to recall, process, and define trauma across time? How can scholars in different fields uncover these elusive 'languages of trauma'? How do historical and cultural contexts as well as different media (oral articulations, writing, stage performance, art practice, film, comics, music, and other narrations) mirror, construct, or challenge subjective traumatic memories?

The unifying argument of this collection is that traumatic memories are frequently beyond the sphere of medical or state intervention. The prerequisite conditions for such treatment (including relevant medical practice, adequate institutional framework, political and financial means to take responsibility, positive cultural expectation) are in many cases absent. Moving beyond medicalized definitions of trauma, one might encounter subjects who often use broader, culturally richer, and polyvalent registers to express the complexity of their fluctuating subjective states. If trauma is too overwhelming and its clinically defined version too blunt a category to express these emotional histories, it is equally unlikely that direct references would be made to fear, hatred, resilience, shame, or rage. The identification and exploration of these and related emotions is nevertheless central to how subjects 'diagnose' their traumatic memories, not in a single, straightforward statement but often in a longer, continuing, and complex process. Consequently, the success or failure of this 'processing' – for example acknowledgment, coping procedures, successive retelling, stage re-enactment, collective activity such as singing – also takes place informally as social and imaginative expression.

The languages through which trauma is articulated or conveyed are diverse and are expressed in at least three categories. The first of these, which is the most familiar, registers as a medicalized, clinical, and institutionalized reading of trauma. Medical classifications, pension records, official documentation and letters, patient records, and clinical reports on individuals or groups fall within this category. The language of the clinic and its associated bureaucratic apparatus, often connected to the state, matters greatly, as it has the power to change lives through its moral, financial, and social effects. It helps grant or deny a legitimate

diagnosis, a pension, acceptance or rejection within a community. This perspective has been the most widely explored, particularly in historical scholarship, because it reveals how medics, institutions, and bureaucracies understood their task, and what kinds of categories and interactions took place. Such sources also obliquely register the ways in which carriers of traumatic memory were represented, and how they represented themselves. While medical, therapeutic, and bureaucratic professionals produced languages of trauma that changed both immediate circumstances and distant interpretations, doctors and policy-makers were and still are also interpreters of the symptoms endured by victims who live with the fluctuating effects of traumatic recollection first hand.

The second category of traumatic memory representation incorporates a wide range of personal encounters with trauma and a variety of uses of language. In the immediate aftermath of troubling events or circumstances, possibly at many months' or years' distance, there are instances of non-articulation, incoherence, and dialects expressed – besides bodily and mental expressions as functional or conversion symptoms – for example through writing culture. It is a widespread, non-institutional use of language in relation to trauma, which can have strong prophylactic and recuperative functions.[5] Likewise writing, or singing for that matter, can be understood through its social, emotional, and sense-making functions – via letters, diaries, poetry, hybrid fiction-memoirs as well as ephemeral fragments of text – to have a somewhat stabilizing, reparative effect on mental health. What matters in these individual, self-directed processes is the 'thinking through' of difficult events: the capture of ongoing mental processes in an externalized form. While facilitators are not necessary, there are also interesting instances of collaborative accounts that to some extent speak 'on behalf of.'

Third, there are those outside the professional sphere of medical or therapeutic expertise who do not necessarily have 'direct' experience of trauma but may be connected to it indirectly via relatives or community or through the wider conditioning of a particular cultural and social inheritance. Alison Landsberg calls subjective imprints "prosthetic memories" that would be disseminated by the mass media and culture – radio, film, television, or the internet: "Prosthetic memories are adopted as the result of a person's experience with a mass cultural technology of memory that dramatizes or recreates a history he or she did not live."[6] Such representations are widely present in popular culture as well as in varied aspects of the arts and imaginative expression, for example through film. Film expresses different aesthetics and points of view in relation to traumatic memory, each of which is constituted via audio-visual, dramaturgical, investigative, and commercial considerations. Whereas a letter,

play, or group performance has a relatively personalized and local production process, film culture is entangled with an industrialized production process – in the technologies required to record and edit it that make its final form, as well as in the ways it is advertised, distributed, and commercialized. Any given film's relation to traumatic memory is in this respect masked to a higher degree (whereas traumatic memory itself already serves as a mask covering up the original traumatizing situation, or sequential traumatization). Writing, film, and theatre all highlight the constructed nature of trauma representations, which can incorporate individual direct expression or highly commercialized and conventionalized cyphers.

To address these different but often intertwined modes of trauma language, this volume places in proximity a variety of disciplinary approaches to foster debate, to suggest the possibilities of cross-disciplinary investigation, and to provoke new insights. This approach is needed because prevailing (psychoanalytical or psychotraumatological) definitions of "trauma" can best be understood according to the particular cultural and historical conditions within which they exist. Such definitions need to be revised, refined, and adjusted when transferred to other sociocultural contexts. *Languages of Trauma* is exceptional because it explores what this means in practice by scrutinizing varied historical moments from the First World War onwards, and particular cultural contexts from across Europe, the United States, Asia, and Africa – striving to help decolonize the traditional Western-centred history of trauma, dissolving it into multifaceted transnational histories of trauma cultures.[7]

Trauma Theory: New Directions

Reflecting on the longer arc of trauma scholarship and the place of this collection within its development, we understand the particular mix of subjects and themes selected for *Languages of Trauma* as a strategic, critical intervention. As editors we wanted to choose and develop a group of contributions that amount to a 'collection' in the strong sense: a coherent, concentrated, and sustained effort to explore a focused but vital set of themes. These themes relate to the position of individuals and communities as they live with the aftermath of traumatizing events, who demonstrate both vulnerability and resilience as they attempt across the remainder of their lives to come to terms with psychic wounds referring to a traumatic past. We have also sought out contributions that reflect on the wider position of trauma representations as they are manifested in the public sphere, and especially in popular culture. Varied

psychological, psychoanalytic, literary, sociological, anthropological, and historical perspectives have expanded and questioned the nature of traumatic expression since the 1990s, as have trauma theory debates. In our view, the trauma concept has become one of the defining preoccupations of our time, but to make further progress in defining its past and present, a more collaborative, interdisciplinary, and transcultural exploration is now required.[8] This calls for an investigation into the cultural constitution and limits of trauma concepts with substantially greater contributions from outside the Anglo-American academy. To this end our collection deliberately cuts across disciplinary boundaries and cultures, since past and present manifestations of trauma can only be understood by combining these complementary perspectives.

Languages of Trauma is not a general amalgamation of perspectives – there is a particular agenda that we seek to address through the combination of essays. In our view, the wider discussions around trauma theory, trauma discourse, and historical traumas have paid too little explicit attention to the perspective of the traumatized. This goes beyond the requirement to explore traumatic environments, survival strategies, or hospital regimes – the starting point, for example, in much of the historical research. Rather, and especially in the first half of the collection, we seek a radical reorientation of perspective. This begins from the life course of those who recall traumatic events or relive them via psychic repercussions. Such an approach equally pays close attention to the expressive resources and procedures of post-traumatic adaptation, and it situates the individual at the centre of the research question within a located set of social, cultural, and political conditions.

While the social history of medicine and related contemporary perspectives are represented in *Languages of Trauma*, and while this and many other aspects deserve much greater and more systematic attention, as editors we are also concerned here with the opposite end of the spectrum, namely artistic interventions that have social, communal, and therapeutic significance. For this reason, Part 1 gives special attention to individuals and small groups, and in Part 2 we consider how public performance and community engagement has achieved new ways to define, address, and find release from the traumatic past. These expressions are outside the normal sphere of therapeutic definition, beyond the institutional confines of medical, military, or political establishments, and stress organic, community-based resilience-making processes. It is our contention that these essays document ways of coping with traumatic stress that long predate (or transcend) contemporary definitions beginning with *DSM-III* (1980), where post-traumatic stress disorder (PTSD)

was first defined. Likewise, there are earlier parallels to the codependent notion of resilience, as it has been newly defined in the 1990s and 2000s. These social contextualizations of the traumatic past cannot be a substitute for clinical expertise in the present, but they do point to the strength of organic, collective approaches to trauma, and to other ways of coping (or their failure) that exist outside the present-day PTSD-oriented therapeutics.

Parts 3 and 4 of *Languages of Trauma*, by contrast, deal with related aspects of what we might refer to as the 'trauma boom.' This last phrase relates to Jay Winter's notion of a "memory boom," and the two movements run in surprisingly close parallel from the later nineteenth into the early twenty-first century.[9] One aspect of the memory boom in its later manifestations is the rise of visual cultures and representations, and the many ways in which individual testimony, subjectivity, and creative processing accompany the rise of new digital media technologies. If we understand the trauma boom, and particularly the concept of traumatic memory, as a subcategory within the wider rise of interest in memory, there are two effects that demand special attention. First, thirty years on from the rise of present-day interest in trauma, we find the concept continuously popularized, trivialized, and proselytized across social media, entertainment industries, and, for example, celebrity memoirs. In many respects it is, as Thomas Elsaesser put it in his chapter for this collection, "the new normal." In our selection of essays on this theme, we attempt to address some of the questions this new set of conditions raises, not least because the trauma concept is often left unexamined, and the ways in which the term is used remain highly variable and vaguely defined. Second, popular cultural representations of trauma have proliferated. Readings of how trauma is currently conceptualized and employed are readily acceptable in the medium of cinema. The conjunction of moving image and psychological disruption is not new, but in *Languages of Trauma* film offers an especially visible insight, and the opportunity for a closer case study, into the creative interpretation, exploitation, and community engagement with trauma in diverse fiction and semi-fictional accounts.

One of the fascinating outcomes of trauma studies is the positive way in which it has already brought varied disciplinary approaches into play, enabling research into difficult social but also environmental circumstances as well as their diverse and often harmful psychological and physiological consequences. The relevance of trauma as a concept is unlikely to diminish. If anything, it is likely to increase. This is all the more reason to critically examine its manifestations and preconceptions, and to consider its workings also in light of our own emerging environmental crisis, as E. Ann Kaplan points out in the Coda to this volume.

Historiographical and Contemporary Contexts

Our purpose in conceptualizing and editing this volume has been to advance the conversation in trauma studies on how to uncover and analyse historical and contemporary aspects of trauma that tend to be tabooed or neglected. This project originated in discontent with the current fractured state of debate on both historical and contemporary aspects of trauma studies, and the often contradictory notions of trauma across the human, social, and natural sciences. Despite this fragmentation in the field, there is a common dilemma that scholars from a variety of disciplines and approaches have recognized: the subjective and culturally diversified languages through which trauma is expressed have largely eluded scholars, who are still struggling with finding methodologies for studying the more complex and sometimes seemingly incomprehensible modes of representation, narration, and remembrance.

Mark Micale, a leading expert in the history of mental trauma, has observed that trauma studies has moved past medical diagnosis and state treatment of soldiers in the First and Second World Wars (the 'first wave' of historical trauma studies).[10] This 'first wave' that focused on medical authorities and state conceptions of trauma was initiated by historians and scholars of the history of psychiatry[11] and defined by the groundbreaking collected volume co-edited by Mark Micale and Paul Lerner, *Traumatic Pasts: History, Psychiatry and Trauma in the Modern Age, 1870–1930.*[12] Micale and Lerner argued that trauma is a central experience in the social and cultural history of modern Western societies. Their volume focused primarily on how medical representatives constructed, diagnosed, and treated trauma, demonstrating that beyond just being event based, trauma was also an act of personal and collective remembering.[13] This work influenced an explosion of scholarship focusing on psychiatric constructions of trauma, including 'shell shock' and 'war hysteria,' and their effects on politics, welfare, gender roles, and memory, in the wake of the twentieth century's seminal trauma, the First World War.[14]

The 'second wave' of trauma studies expanded the frame of reference beyond combat experience. The focus shifted to new populations, sources, and types of traumatization, including economic deprivation, sexual violence, and dislocation experienced by women and children.[15] Scholars examined 'vicarious' and 'secondary trauma' and the chain reaction of symptoms, memories, and experiences that affected subsequent generations, with innovative approaches to the long-term impact of the Holocaust influencing new research.[16] This second wave placed trauma into the larger context of the history of emotions, which allowed

scholars to analyse traumatic experiences and accompanying emotional responses more subjectively, outside of strictly medical and state paradigms of definition and categorization.[17] This new approach also inspired innovative methods for evaluating ego-documents and symbiotic emotional relationships between men and women traumatized by mass violence, perhaps most notably in Michael Roper's essential work *The Secret Battle: Emotional Survival in the Great War*.[18]

The goal of our volume is to define and spearhead a 'third wave' of trauma studies, which uncovers previously unexplored languages for describing traumatic injuries, moving beyond PTSD and other medicalized frameworks for defining mental trauma. In Cathy Caruth's new 2016 afterword to her influential work *Unclaimed Experience: Trauma, Narrative, and History*, she calls on scholars to develop more innovative ways to uncover individual traumatic memories, and to expand attention beyond collective constructions of trauma reflected in medical and political spheres.[19] In *Languages of Trauma*, we seek to illuminate these subjective sites where individuals narrate trauma dynamics in diverse ways. Building on Caruth's thesis about the centrality of written language in understanding how trauma is culturally constructed, we aim to break new ground by exploring beyond literature but also in film, art, theatre, music, comics, letters, and diaries where individuals subjectively refer to and process traumatic memories. We are also influenced by Jay Winter's recent *War Beyond Words: Languages of Remembrance from the Great War to the Present*, where he argues that memory construction is diverse, subjective, and mediated through varied social and cultural contexts. He calls on historians to be particularly sensitive to the different languages in which memory is mediated.[20] Our project builds on a central question identified by Winter: What different forms of language are used to remember, process, and describe trauma? At the same time, our volume is distinct because it uncovers forms of language not identified by the historian, which reveal 'hidden' or taboo sites of traumatic memory and memory-building.

Identifying subjective narratives of trauma poses considerable challenges, and theorists have pointed out that the term 'trauma' itself, while expressive for diverse experiences with violence, is often vaguely used and ultimately elusive.[21] The concept of 'cultural trauma,' or 'collective trauma' in particular, has come under fire as a misleading and imprecise category of analysis that conflates complex individual encounters with trauma, which indeed is subject to changing social and cultural forces, and distorts representations of the traumatized and their psychological experiences.[22] Thus it is not surprising that several scholars have shied away from defining 'trauma' and what it means to be traumatized. At the

same time, theorists have tried to open up dialogue across disciplines to interrogate how trauma can be described, and how we can listen to narratives through which it is processed, remembered, and medialized.[23]

New approaches to ego documents have enabled us to uncover these subjective spaces. Letters and diaries reveal how trauma was often processed informally and in private. Outside psychiatric clinics and asylums, traumatized individuals worked through their haunting memories, flashbacks, and intrusions, and writing became a form of self-therapy. In the case of published memoirs and war novels, private memories entered cultural spaces. This did not necessarily mean these texts shaped collective memories; rather they placed individual traumas, as Jeffrey C. Alexander suggests, out in the open where they could be socially mediated and influence societal constructions of traumatic memory.[24] In this volume, we expand the scope of privately transmitted memories and go beyond written narratives to also examine narratives of trauma in art, theatre, and film. The subjectivities of these trauma narratives are often difficult to decipher. Though they enter into cultural spaces and play with the latter through performance and staging, the ways in which these narratives are perceived and reviewed are myriad, and elude categorization, collective reception, or even shared language.

Audiovisual Representations of Trauma: New Approaches

The languages of trauma in diverse audiovisual media, including film, feature films, documentaries, animés, cartoons, art house films, theatre, music, and performance art, also present significant challenges to scholars. This is due to the frequent medial transfer between, first, cultural representations of the past, which are, for example, poured into filmic or theatrical recreations of trauma and violence histories; second, the ever-changing trauma theory landscape; and third, memory politics and national identity constructions.[25] Trauma movies in particular come from a variety of national and representational contexts, as well as different decades of the twentieth and twenty-first centuries aiming to depict historical traumas and traumatic memories with regard to content, narration, and aesthetics.[26] In order to communicate and imitate shocking events from the past or present and their traumatic expressions within psyches and bodies, they 'invent' complex artificial languages.[27] The latter echo invisible elements of the traumatized inner self as well as visible outer symptoms, thus contributing to the widening of the spectrum of collective imaginary.

As indicated above, in many cases 'trauma' causes a gap between the traumatizing event and memory processing, which interferes with direct

and adequate forms of representation and communication, resulting in a communicational and representational vacuum. However, this very specific form of 'absence,' or systemic void, creates a whole variety of secondary imagery like nightmares, intrusions, delusions, daydreams, hallucinations, and other spectres embedded within a particular kind of time structure including latency, deferred action, and repetition. Interestingly, the traumatic time structure resembles the specific timeline and narrative strategies of film on multiple levels, as Thomas Elsaesser and others have pointed out.[28] Films that deal with traumas develop certain narrative techniques and aesthetics while attempting to translate psychological forms of injury, irritation, suffering, and pain (which can also affect the body in the form of, for example, conversion, psychosomatics, or "negative performativity")[29] into filmic language.[30] Several of the essays in this volume decode filmic trauma languages by borrowing from the vocabulary of classical trauma theory, or by thinking of innovative forms of describing moving trauma imagery.

Film can be highlighted as an audiovisual medium that produces a surplus of symbols via its unique ways of representing, analysing, and interpreting 'traumas': including filmic means as "backstory wound," flashbacks/cutbacks, close-ups, split screen, slow motion, blurred optic, or fade to black. This surplus can also provide phantasmal imaginaries of healing that function as "cultural patches" (see E.M. Hunter's notion of "healing scripts"), and which attempt to close unhealed traumatic wounds on a cultural level, influencing the social body and its perceptions of traumatic memory cultures.

In the analyses of trauma film cultures, cross-national perspectives[31] need to stand side by side, while particular film nations that have shaped discourse, such as the rich Israeli-Palestinian cinema, can be emphasized.[32] After a decades-long concentration on victims' trauma, in the last few years a new field of trauma film studies developed that focused on the difficult question of 'perpetrator trauma.' Film scholar Raya Morag has been a leading expert in this research area as she detected the Israeli cinema to be among the first to extensively turn to the perpetrator side, acknowledging its quasi-traumatic imprints. In fact, the question of perpetrator trauma is not a new one, as it has been part of psychological trauma discourse for decades. The latter concentrated on "traumatic restagings" (*"traumatische Reinszenierungen,"* Franziska Lamott), "perpetrator introjections" (*"Täterintrojekte,"* Mathias Hirsch), or perpetrator-victim inversions, which already had been theorized by Sigmund Freud ("The Aetiology of Hysteria," 1896), Sandor Ferenczi, and Anna Freud ("identification with the aggressor," in *The Ego and the Mechanisms of Defense*) in the 1930s.[33] Also, more recent positions claim to

not want to neglect the perpetrator side just to feel morally on the safe and just side. Saira Mohamed embraces 'perpetrator trauma' as an analytical tool in the realms of international criminal law and human rights, which enables a search for unconventional solutions in the context of genocides and mass atrocities and consequently strive for truth and reconciliation.[34] Mohamed demands that we disconnect 'trauma' from the victim category, and states that it could also be experienced by perpetrators, whom she thinks should not be perceived as "wild monsters" or "inhuman demons," but whom she generally accords "humanity" and "ordinariness." This volume will discuss these complex and ambivalent questions by giving space to analyses of film cultures dealing with this delicate issue.

Other forms of audiovisual media dealing with trauma require new approaches to understand how they challenge audiences with complex symbols and modes of representation. Music, theatre performance, and visual arts provide unique, subjective spaces for trauma survivors to represent and recreate impressions, emotions, and experiences. Recent work by scholars like Michelle Meinhart reveal how music, for example, was used by families to express the trauma of loss in the wake of the First World War.[35] While these performances interact with broader narratives of trauma inflicted by war, genocide, and migration, they offer a glimpse into layers of individual identity construction, shifting the focus from collective memory to more subjective constructions. As theorist Miriam Haughton argues, "Staging performances addressing and exploring instances of trauma, including the historical, the testimonial, as well as the functional and mythical, publicly centralizes and illuminates these spaces and experiences of darkness."[36] Performance, whether through art, music, or theatre, gives audiences an insight into the process by which individuals 'work through' traumatic memories, a process that otherwise occurs in fragmented and elusive private spaces.

In non-Western contexts, which are addressed in several chapters here, performances that emphasize the subjectivity of trauma survivors are particularly valuable because they confront the cultural and political power that has often concealed or repressed cultures and individuals. In the case of the Dialita choir in Indonesia, which is the subject of Dyah Pitaloka and Hans Pols's chapter in this volume, music gives voice to individuals who are often marginalized and stigmatized, and unable to process their experiences and memories through prevailing systems of mental health. Performance thus allows the building of social relationships and communication between otherwise isolated groups, enabling the construction of shared identities and solidarity.[37] These are the extremely personal spaces where the 'archives' of memories are transmitted

between generations, requiring artists to engage localized cultures and families, and to move beyond familiar narratives into hidden languages and landscapes of memory. Thus, music and theatre performance bridge public and private encounters with trauma, connecting individual struggles with trauma to collective experiences in unique ways.

Organization of the Volume

Part 1: Words and Images

The first section of *Languages of Trauma* focuses on major historical moments from the twentieth and twenty-first centuries and incorporates studies of writing by individuals attempting to represent their own traumatic memories, as well as studies of medical and media representation. If they are considered as a whole, what immediately becomes apparent in these five essays is the elusiveness of any single traumatic event and the importance of later circumstances in shaping subsequent recollections. Just as no two moments of traumatic experience are identical, so too there is a breadth of reaction and interpretation, a range of imaginative procedures that continually rework understanding of trauma. Reconstructing the particularities of circumstance and interpreting representations of subjectivity are critical to such readings.

Bridget Keown's study of private writings by British and Irish nurses in the First World War highlights the devaluation and neglect of women's experiences, and attempts to theorize different emotional constellations constituted according to individual temperament, but also to the position of women within the existing social and power structures of the early twentieth century. Letters, diaries, and unpublished memoirs here provide a counter-archive with accompanying distinctive narrative forms. The fluctuation of subjective states relates to changes in the medical profession, the extraordinary character of First World War experience, and the emphatically gendered, relational expectations wartime imposed on both women and men. In conditions of unprecedented self-sacrifice there was clearly a resilience-building and therapeutic role to private writing, and simultaneously severe difficulty with any attempt at coherent meaning-making. While physical danger was common to all participants and some civilians during the war, the danger of sexualized and gendered forms of violence was a stronger theme for women.

Jason Crouthamel's research into the uses of religious language by German soldiers maps the complex fluctuating dynamics of trauma representation across the course of the First World War. Like Keown, Crouthamel investigates diaries and letters to track the language of faith

as it enabled resilience, coping strategies, and the processing of trauma. Expressions of faith became a cultural resource deployed early on in the war by church and state to promote nationalist, state-sanctioned narratives of war engagement and persistence. However, state rhetoric failed in the face of first-hand experience. Under stress, faith language was reworked into hybrid combinations of traditional faith and individual interpretation as soldiers struggled to piece together meaning in the chaotic environment of total war. The language of religion as it was used by German soldiers during the First World War simultaneously expresses existential crisis and psychological stress. Even if they moved away from Judeo-Christian belief systems, the persistence of faith language enabled processing and agency as individuals tried to exert some control or influence over traumatic experiences.

Body language reveals another dimension of how victims of total war narrated trauma. In Ville Kivimäki's account of wounds, wounding, and the traumatic body among Finnish soldiers of the Second World War, he views psychological shock and pain as an act of "unmaking." Following Elaine Scarry, Kivimäki considers medical practice as an attempt to remake meaning through its associated rituals and artefacts. Both brain chemistry and culture constitute a particular version of traumatic memory. The most common symptoms were those closely associated with the First World War: brain concussion-like, sensory and motor dysfunctions, somatic responses, various inexplicable palpitations, most of all epilepsy-like seizures. Kivimäki's conclusion is that wound-inducing treatments – insulin coma or electroconvulsive therapy – constituted an assault on the inarticulacy of psychic injury. In the absence of conventional spoken or written sense-making procedures, traumatic memory expressed itself physically through the body of its carrier or rememberer.

Like both Keown and Kivimäki, Robert Dale reads source material, in this case the memoirs of Red Army veterans, for the culturally conditioned ways in which it attempts to make sense of traumatic experience. Dale's study reads Aleksandr Sobolev's *Efim Segal* (2006) as the fictionalized memoir of a Red Army veteran to suggest traumatic memory was present in late Soviet culture but continually pushed to the margins. The particularities of cultural conditioning matter greatly here, as there has been extensive attention to professional discourse and scientific categorizations or, for example, political terror. Yet there is far less attention, present or past, to individual volition, patient experience, or life beyond the consulting room. Investigating the social and cultural histories of late socialism, Dale suggests, makes it possible to access therapeutic spaces for the processing of trauma. Such cultural responses were not necessarily public or permanent. He concludes that the absence of identifiable

collective traumatic memory does not nullify the significance of the many individual cases.

To conclude this section, Jennifer Bliss analyses a popular form of contemporary media, the graphic novel, to explore chaotic, disjointed representations of subjective memory. Focusing on Art Spiegelman's *In the Shadow of No Towers* (2004), Bliss illuminates intricate connections between personal trauma and collective trauma. Though Spiegelman, who also grapples with the legacy of his better-known work *Maus* (1986), portrays his graphic novel as an attempt to process his reaction to the 9/11 terrorism attack, Bliss argues that the text actually reveals the author's deeply conflicted oscillations between individual and collective experiences and memories, a conflict that is mediated through competing, often clashing and oppositional, images. *No Towers* is distinct because it resists transforming trauma into a narrative, and instead embraces multiple languages that reinforce a non-linear, fragmented way of thinking. As Bliss demonstrates, reading this chaotic narrative is extremely difficult, underlining the inaccessibility of subjective memories that even the subject struggles to process.

Part 2: Music, Theatre, and Visual Arts

The second section moves from individual and often intensely private or personal expressions of traumatic memory to more collaborative and public work that is nevertheless unregistered by clinic or state bureaucracy. Such forms of traumatic memory may be developed as community initiatives by those who have a strong, often publicly unacknowledged sense of difficult pasts. For example, memory may be related to a major event that has been systematically repressed, such as the mass killings in 1965–6 Indonesia, or to an intimate family story of displacement and forced migration. Outside facilitators, artists for example, may have a critical role here that enables communal discussion, collaboration in the production of a performance or other text. Such initiatives can also be the result of grass-roots activism and self-help.

Dyah Pitaloka and Hans Pols's essay describes this approach through the case study of the Dialita choir in Jakarta and activities of the Teater Tamara. They focus on activism among a group who were stigmatized and unable to officially describe their violent experiences in the mass killings of 1965–6 until after the death of Suharto in May 1998. Noting the lack of attention to initiatives by groups of traumatized people who are not reliant on mental health professionals or on psychological and psychiatric theories, Pitaloka and Pols stress the importance of the "culture-centred approach." Health and illness are in this view "continuously negotiated

by cultural communities." The authors also highlight a common theme throughout this collection, namely the need for more serious attention to the voices and opinions of survivors. Performances by the choir and theatre have wider functions: the making of dialogic space and social identity, the forging of affective, emotional alliances between the performance groups and their audiences, and education of and discussion with young audiences whose only understanding of the massacres is through state propaganda. Audiences and performers co-construct emotions and alternative narratives of the past collaboratively through an artistic community.

Building on the theme of traumatic memory transmitted across generations, Katrina Bugaj considers history and the difficulties of knowing the past, and the record of how varied pasts and present concerns coalesce into a theatrical performance. In choosing a diaristic, highly personal communicative form, Bugaj invites readers to engage with the subjectivity of 'bad events' and to reflect on the form of our knowledge production. As a researcher of migration narratives and memories, and as a practitioner in the performing arts, the author brings together disparate concerns, including an interest in her Polish grandmother's time in a German displaced persons camp after the Second World War. The resulting essay is at once analytic and very personal. It may be read as an enactment of traumatic memory not because its author was traumatized, but because it expresses the processes of continual memory renewal, the procedures whereby a 'difficult past' is continually renegotiated in relation to the requirements and preoccupations of the present. Similar to Pitaloka and Pols, Bugaj draws on Sara Ahmed's concept of "encounters," which she understands as both performative and archival, personal and structural.

Emily Mendelsohn documents further theatrical encounters with traumatic memory, questioning how global south and north constitute a set of power relations that are reproduced in the understanding and attention paid to, for example, the Rwandan genocide. Mendelsohn's position lies between community initiatives such as the Dialita choir and the research/performance-based work of a 'conversational community' of artists, cultural and community workers in the United States, Uganda, and Rwanda, and in particular productions of work by Deborah Asiimwe, Erik Ehn, and Doreen Baingana. The author's claim is that the playwrights are engaged variously in efforts to illuminate and move beyond the traumatic legacies of colonialism by their use of contemporary ritual, oral storytelling, and performance. Political power relations are important to bring to mind here, as the contexts for performance include a theatre production connected to a United Nations refugee settlement in

Uganda, and the prolonged United States support for the dictatorship regimes of the Democratic Republic of Congo.

Maj Hasager also details two of her recent community engagements, this time from the perspective of a visual artist. She explores the 'inherited' recollection of eleven pre-1948 home villages among younger Palestinians using both photographs and texts. She also documents through a collaborative film the intersection of two pasts connected to the migration and current location of a Filipino community in Italy. As with Mendelsohn and Bugaj, she develops collaborative 'thinking together' methodologies on site. This gradual development of relationships and knowledge leads eventually to the production of relevant artefacts. Hasager's anthropological and socio-historical approach also stresses the ways in which visual arts articulate local, community-based ways of knowing.

Part 3: Normalizations of Trauma

In the third section of *Languages of Trauma*, scholars in philosophy, psychology, film studies, and literature explore how the concept of trauma has acquired different meanings in popular culture and media. This section explores questions related to the historical and contemporary uses of trauma to consider historical developments of the concept and its uses in contemporary mass culture. How has trauma been decontextualized, especially in popular discourse, and given different meanings by culture industries and audiences? How can scholars reconstruct these different meanings and trauma languages?

Providing an overview of the myriad trauma discourses that have emerged since the late nineteenth century, Ulrich Koch investigates different meanings attached to the notion of 'trauma,' especially in popular narratives. He contends that whether scholars shy away from or try to deconstruct various trauma discourses, they inevitably have to ask the fundamental question: what does it mean to be traumatized? Koch argues that the medical sciences and humanities have largely disagreed on this question, debating whether trauma is an exceptional, but universal category of analysis or a construct whose nature is contested. He argues for a reconciliation between the sciences and humanities, calling on both to acknowledge the limitations in their definitions of trauma, and the need to recognize that trauma is a lived experience that can be narrated through many languages, which require different disciplinary methods in order to elucidate its individual meanings.

One example of why it is important for scholars to be sensitive to different meanings of trauma, and the particularities of experience and

context, can be found in Thomas Elsaesser's essay. Reflecting on a question first posed by Sigmund Freud and Walter Benjamin, Elsaesser asks whether or not trauma could under certain circumstances be considered a 'solution' rather than a 'problem.' He finds in the dark comedy *Nurse Betty* (dir. Neil LaBute, 2000), and other examples from popular cinema, a lens through which audiences can perceive symptoms of trauma as potentially empowering or healing, allowing an individual to function and adapt to the chaos unleashed by a traumatic event. If popular culture can define 'being traumatized' as the "new normal," and this resonates with audiences and reflects broader cultural trends, theorists must perhaps reconsider whether trauma could conceivably be conceptualized as a positive experience as well.

Marzena Sokołowska-Paryż approaches constructions and perceptions of trauma in popular entertainment from a different perspective. She examines the powerful ways in which post-war cinema, specifically the war film genre, has misrepresented traumatic experience and the traumatized, in particular victims of sexual violence. What is the overall effect cinematic representations of rape have on audiences? Sokołowska-Paryż argues that popular war films, which are compromised by ideologically driven conceptions of gender and nationalism, have given audiences ethically and historically distorted representations of rape. Using a variety of case studies, she demonstrates that the cinematic language used by filmmakers to depict sexual trauma has been inadequate, and historical context and reasons for why and how rape occurs in war have been insufficiently addressed. Ultimately, the representational strategies and visual languages used to depict the trauma of rape have reinforced and encouraged a pornographic male gaze rather than critical analysis of the trauma of rape.

Part 4: Representations in Film

While the previous section highlights some of the ways in which cinema reinforces cultural assumptions about trauma, if it is distorted, normalized, or sanitized, Part 4 turns the focus on ways in which films challenge, disorient, or disrupt cultural assumptions about individual and collective trauma. Scholars in this section analyse the ways in which subjective traumas of individuals are translated into film languages and projected onto the screen and, in the course of this, influence the shaping of collective memories. This last section of the volume also addresses one of the more difficult emerging topics in trauma studies – the question of what some scholars address as 'perpetrator trauma,' that is, symptoms found in perpetrators that to some extent seem to match the symptomatological signs

of "post-traumatic stress injuries." Looking at symptoms in perpetrators that, regarding their intrapsychic dynamic and somatic display, in some ways resemble victims' trauma symptoms, the two final chapters in the volume demonstrate the importance of cinematic language in revealing, representing, and contesting this complex category from different perspectives.

Adam Lowenstein explores cinema's potential for reflecting 'collective trauma' and 'individual trauma,' defined by Cathy Caruth as violent, publicly recognized mass events versus subjective, less historically recognized forms of trauma.[38] Lowenstein focuses on the influential work of George A. Romero to examine distinctions between individual and collective trauma. Romero's *Night of the Living Dead* (1968) famously illuminated US experiences with collective trauma in the wake of mass atrocities in the 1960s, especially the Vietnam War. However, Lowenstein turns his attention to Romero's lesser-known film *Martin* (1978), which presents something altogether unexpected for the horror genre. It reveals how the vocabulary of horror cinema, with its graphic depictions of violence and gore, can also uncover and articulate individual trauma. *Martin* disrupts what we expect from the horror film genre, pushing audiences to see how subjective traumas are integrated into collective trauma, as the film's main character experiences an individual crisis that is melded into US-America's collective traumas in the wake of Vietnam and the Civil Rights movement.

Film offers a unique language for representing symptoms and psychosomatic imprints of trauma. Julia Barbara Köhne and Raya Morag explore this language for articulating trauma by examining, from complementary perspectives, depictions of 'perpetrator trauma,' or what Köhne calls "post-atrocity perpetrator symptoms." Köhne's chapter sketches the essay film *The Act of Killing* (2012) as a communicator of knowledge about post-atrocity perpetrator symptoms as well as the perpetrators' practice of theatrically re-enacting past extreme violence on camera. Thus, it resonates with neuropsychiatric, psychotraumatological, and therapeutic concepts, challenging the boundaries of conventional forms of 'historical consciousness.' Köhne focuses on the experimental and dissident film's portrayal of male perpetrators who participated in the historiographically long-neglected 1965–6 Indonesian genocide who have not been punished for their deeds and are glorified as cult figures to this day. The analysis of *The Act of Killing* shows how the perpetrators immerse themselves in their past as mass murderers commissioned by the government and army, proudly re-narrating their deadly acts. Köhne explores which narration techniques, dramaturgical strategies, and aesthetic means *The Act of Killing* plays out to open up new avenues towards a

complex memory of the Indonesian massacres. How do the levels of individual and collective memories intersect in the film diegesis and beyond?

Raya Morag argues that film studies experts must recognize that in the warfare of the twenty-first century, a new, almost indecipherable set of paradigms have emerged from the unprecedented targeting of civilians as a key military strategy. The major shift that has taken place is from the "victim trauma paradigm" to the "perpetrator trauma paradigm," the latter being fraught with problems of representation and meaning. Morag affirms the notion of 'perpetrator trauma,' taking into account the level of serious (traumatic) effects deriving from the ethical self-injury a violent deed sets into motion. While trauma theorists may struggle to acknowledge these paradigms, Morag shows that post-Iraq (and Afghanistan) War American documentary cinema (2006–16) is uniquely poised to open up ways of seeing the effects of twenty-first-century violence and the differentiation between victim and perpetrator trauma, giving us the opportunity to critically analyse the ideological and psychological complexities posed by these two types of trauma.

Since one of the aims of this volume is to explore new directions, methods, and paradigms for reading trauma, we asked E. Ann Kaplan, whose path-breaking work shaped much of the scholarship here, to reflect on the future of the field. Kaplan makes the case that we are currently facing a particularly urgent challenge that requires us to re-evaluate how trauma is processed, narrated, and remembered. That challenge is climate trauma, which involves new languages for pain and thus the ability to listen to the processes in which individuals express that pain. Humans are increasingly dealing with a world that requires greater versatility to cope with chronic violence and dislocation caused by dwindling resources and collapsing infrastructures. Just as humans need to adapt to new conditions to survive, Kaplan suggests, so do scholars need to readjust and rethink how they describe and listen to those who are traumatized by this changing world.

NOTES

1 Michael Elm, Kobi Kabalek, and Julia B. Köhne, eds., *The Horrors of Trauma in Cinema: Violence, Void, Visualization* (Newcastle upon Tyne: Cambridge Scholars Publishing, 2014), esp. 1–29.

2 Dale quotes from Polina Barskova, *Besieged Leningrad: Aesthetic Responses to Urban Disaster* (Dekalb: Northern Illinois University Press, 2017), 5. On ways in which historians confront silence and traumatic memory, see Jay Winter, "Thinking about Silence," in *Shadows of War: A Social History of Silence*

in the Twentieth Century, ed. Efrat Ben-Ze'ev, Ruth Ginio, and Jay Winter (Cambridge: Cambridge University Press, 2010), 3–31.

3 Graham Dawson, "The Meaning of 'Moving On': From Trauma to the History of Emotions and Memory of Emotions in 'Post-Conflict' Northern Ireland," *Irish University Review* 47, no. 1 (2017): 82–102.

4 For a discussion of the theoretical history of the term "traumatic memory," which addresses senso-motoric elements and sensory (intrusive) imprints that can be triggered, as dominant over ordinary, conscious, cognitive, constructive, linear forms of remembrance, see Bessel A. van der Kolk, "Trauma and Memory," *Psychiatry and Clinical Neurosciences* 52, no. S1 (1998), https://onlinelibrary.wiley.com/doi/full/10.1046/j.1440-1819.1998.0520s5S97.x.

5 Shafquat Towheed, Francesca Benatti, and Edmund G.C. King, "Readers and Reading in the First World War," *The Yearbook in English Studies* 45 (2015): 239–61; Debbie McCullis, "Bibliotherapy: Historical and Research Perspectives," *Journal of Poetry Therapy* 25, no. 1 (2012): 23–38; Jesse Miller, "Medicines of the Soul: Reparative Reading and the History of Bibliotherapy," *Mosaic: An Interdisciplinary Critical Journal* 51, no. 2 (June 2018): 17–34.

6 Alison Landsberg, *Prosthetic Memory: The Transformation of American Remembrance in the Age of Mass Culture* (New York: Columbia University Press, 2004), 28.

7 Michael Rothberg, "Decolonizing Trauma Studies: A Response," *Studies in the Novel* 40, no. 1/2 (Spring & Summer 2008), 224–34.

8 See, for example, Peter Leese and Ville Kivimäki, eds., *Trauma, Experience and Narrative: World War Two and After in Northern, Central and Eastern Europe* (London: Palgrave Macmillan, forthcoming); Mark Micale and Hans Pols, eds., *Traumatic Pasts: Asian Perspectives* (New York: Berghahn, forthcoming).

9 Jay Winter, *Remembering War: The Great War between Memory and History in the 20th Century* (New Haven: Yale University Press, 2006), 17–51.

10 Mark S. Micale, "Beyond the Western Front: Studying the Trauma of War in Northern and East Central Europe," keynote address given at the conference "Aftershocks: War-Related Trauma in Northern, Eastern, and Central Europe," University of Tampere, Finland, 25 October 2018.

11 See Peter Riedesser and Axel Verderber, *Aufrüstung der Seelen: Militärpsychiatrie und Militärpsychologie in Deutschland und Amerika* (Freiburg im Breisgau: Dreisam, 1985); George L. Mosse, "Shell Shock as a Social Disease," *Journal of Contemporary History* 35, no. 1 (2000): 101–8; Annette Becker, "Guerre Totale et Troubles Mentaux," *Annales : Histoire, Sciences Sociales* 55, no. 1 (January–February 2000), 135–51.

12 Mark S. Micale and Paul Lerner, eds., *Traumatic Pasts: History, Psychiatry and Trauma in the Modern Age, 1870–1930* (Cambridge: Cambridge University Press, 2001).

13 Mark S. Micale and Paul Lerner, "Trauma, Psychiatry, and History: A Conceptual and Historiographical Introduction," in ibid., 1–28.

14 For a few examples of scholarship included in this wave of trauma studies: Peter Leese, *Shell Shock: Traumatic Neurosis and the British Soldiers of the First World War* (New York: Palgrave Macmillan, 2002); Paul Lerner, *Hysterical Men: History, Psychiatry and the Politics of Trauma in Germany, 1890–1930* (Ithaca: Cornell University Press, 2003); Hans-Georg Hofer, *Nervenschwäche und Krieg. Modernitätskritik und Krisenbewältigung in der österreichischen Psychiatrie, 1880–1920* (Vienna: Böhlau, 2004); Edgar Jones and Simon Wessely, *Shell Shock to PTSD: Military Psychiatry from 1900 to the Gulf War* (Abingdon: Psychology Press, 2006); Jason Crouthamel, *The Great War and German Memory* (Liverpool: Liverpool University Press, 2009); Julia B. Köhne, *Kriegshysteriker: Strategische Bilder und mediale Techniken militärpsychiatrischen Wissens, 1914–1920* (Husum: Matthiesen, 2009); Stephanie Neuner, *Politik und Psychiatrie: Die staatliche Versorgung psychisch Kriegsbeschädigter in Deutschland, 1920–1939* (Göttingen: Vandenhoeck & Ruprecht, 2011); Fiona Reid, *Broken Men: Shell Shock, Treatment and Recovery in Britain, 1914–1930* (London: Bloomsbury, 2011); Livia Prüll and Philipp Rauh, eds., *Krieg und medikale Kultur: Patientenschicksale und ärztliches Handeln in der Zeit der Weltkriege 1914–1945* (Göttingen: Wallstein, 2014).

15 For a necessarily short list of this work, see, for example: John K. Roth, "Equality Neutrality, Particularity: Perspectives on Women and the Holocaust," in *Experience and Expression: Women, the Nazis and the Holocaust*, ed. Elizabeth Baer and Myrna Goldenberg (Detroit: Wayne State University Press, 2003); Suzanne Evans, *Mothers of Heroes, Mothers of Martyrs: World War I and the Politics of Grief* (Montreal/Kingston: McGill-Queen's University Press, 2007); Erika A. Kuhlman, *Of Little Comfort: War Widows, Fallen Soldiers and the Remaking of the Nation after the Great War* (New York: New York University Press, 2012); Michael Roper, "Subjectivities in the Aftermath: Children of Disabled Soldiers in Britain after the Great War," in *Psychological Trauma and the Legacies of the First World War*, ed. Jason Crouthamel and Peter Leese (New York: Palgrave Macmillan, 2016), 165–91; Lisa Pine, "Testimonies of Trauma: Surviving Auschwitz-Birkenau," in *Traumatic Memories of the Second World War and After*, ed. Peter Leese and Jason Crouthamel (New York: Palgrave Macmillan, 2016), 69–93.

16 Most influential here is Ruth Leys, *From Guilt to Shame: Auschwitz and After* (Princeton: Princeton University Press, 2009); see also, for example, Dora Apels, *Memory Effects: The Holocaust and the Art of Secondary Witnessing* (New Brunswick: Rutgers University Press, 2002).

17 For theoretical approaches to the history of emotions and its relation to trauma studies, see, for example, Joanna Bourke, "Fear and Anxiety: Writing about Emotion in Modern History," *History Workshop Journal* 55,

no. 1 (2003): 111–33; Ute Frevert, *Emotions in History: Lost and Found* (Budapest: Central European Press, 2011); Ruth Leys, *The Ascent of the Affect: Genealogy and Critique* (Chicago: University of Chicago Press, 2017).

18 Michael Roper, *The Secret Battle: Emotional Survival in the Great War* (Manchester: Manchester University Press, 2009). The challenges of reading ego-documents to uncover emotional responses to trauma have also been explored by Alexander Watson, *Enduring the Great War: Combat, Morale and Collapse in the German and British Armies, 1914–1918* (Cambridge: Cambridge University Press, 2008); Benjamin Ziemann, *Violence and the German Soldier in the Great War: Killing, Dying, Surviving* (London: Bloomsbury, 2017); Sophie Delaporte, "Making Trauma Visible," in *Traumatic Memories of the Second World War and After*, ed. Peter Leese and Jason Crouthamel (New York: Palgrave Macmillan, 2016), 23–46.

19 Cathy Caruth, *Unclaimed Experience: Trauma, Narrative, and History* (Baltimore: Johns Hopkins University Press, 1996; rev. ed. 2016).

20 Jay Winter, *War Beyond Words: Languages of Remembrance from the Great War to the Present* (Cambridge: Cambridge University Press, 2017).

21 Chris Brewin, *Posttraumatic Stress Disorder: Malady or Myth?* (New Haven: Yale University Press, 2003).

22 One of the leading critics of 'cultural trauma' as a category of analysis is Wulf Kansteiner; see his "Genealogy of a Category Mistake: A Critical Intellectual History of the Cultural Trauma Metaphor," *Rethinking History* 8, no. 2 (2004): 193–221; see also Kansteiner's "Testing the Limits of Trauma: The Long-Term Psychological Effects of the Holocaust on Individuals and Collectives," *History of the Human Sciences* 17, no. 2 (2004): 97–123. On constructions of 'cultural trauma' as a process of diverse, often conflicting social narratives 'making meaning,' see Jeffrey C. Alexander, Ron Eyerman, Bernard Giesen, Neil J. Smelser, and Piotr Sztompka, *Cultural Trauma and Collective Identity* (Berkeley: University of California Press, 2004).

23 See, for example, the interdisciplinary interviews in Cathy Caruth, *Listening to Trauma: Conversations with Leaders in the Theory and Treatment of Catastrophic Experience* (Baltimore: Johns Hopkins University Press, 2014).

24 Jeffrey C. Alexander, *Trauma: A Social Theory* (Cambridge: Polity, 2012), 11. See also Alexander's "Toward a Theory of Cultural Trauma," in *Cultural Trauma and Collective Identity*, ed. Jeffrey C. Alexander, Ron Eyerman, Bernhard Giesen, Neil J. Smelser, and Piotr Sztompka (Berkeley: University of California Press, 2004), 1–30.

25 Julia Barbara Köhne, ed., *Trauma und Film: Inszenierungen eines Nicht-Repräsentierbaren* (Berlin: Kadmos, 2012).

26 For the canonical work on trauma, history, and film, see Linnie Blake, *The Wounds of Nations: Horror Cinema, Historical Trauma and National Identity*

(Manchester: Manchester University Press, 2008); See also Marcia Landy, *The Historical Film: History and Memory in Media* (New Brunswick: Rutgers University Press, 1985); Vivian Sobchack, *The Persistence of History: Cinema, Television, and the Modern Event* (London: Routledge, 1997); E. Ann Kaplan, *Trauma Culture: The Politics of Terror and Loss in Media and Literature* (New Brunswick: Rutgers University Press, 2005); Raya Morag, *Defeated Masculinity: Post-Traumatic Cinema in the Aftermath of War* (Bruxelles: Peter Lang, 2009).

27 Adam Lowenstein, *Shocking Representation: Historical Trauma, National Cinema, and the Modern Horror Film* (New York: Columbia University Press, 2005).

28 See Thomas Elsaesser, *Terror und Trauma: Zur Gewalt des Vergangenen in der BRD* (Berlin: Kadmos, 2006); Elsaesser, *Melodrama and Trauma: Modes of Cultural Memory in the American Cinema* (London: Taylor & Francis, 2006).

29 Thomas Elsaesser, "Postmodernism as Mourning Work," *Screen* 42, no. 2 (2001): 193–201.

30 Vera Apfelthaler und Julia B. Köhne, eds., *Gendered Memories: Transgressions in German and Israeli Film and Theater* (Vienna: Turia+Kant 2007); Frank Stern, Julia B. Köhne, Karin Moser, Thomas Ballhausen, and Barbara Eichinger, eds., *Filmische Gedächtnisse: Geschichte – Archiv – Riss* (Vienna: Mandelbaum, 2007).

31 E. Ann Kaplan and Ban Wang, *Trauma and Cinema: Cross-Cultural Explorations* (Hong Kong: Hong Kong University Press, 2004).

32 Nurith Gertz and George Khleifi, *Palestinian Cinema: Landscape, Trauma and Memory* (Edinburgh: Edinburgh University Press, 2005); Raz Yosef and Boaz Hagin, *Deeper than Oblivion: Trauma and Memory in Israeli Cinema* (London: Bloomsbury Academic, 2013); Raya Morag, *Waltzing with Bashir: Perpetrator Trauma and Cinema* (London: I.B. Tauris, 2013).

33 Franziska Lamott, "Traumatische Reinszenierungen: Über den Zusammenhang von Gewalterfahrung und Gewalttätigkeit von Frauen," *Recht & Psychiatrie* 2 (2000): 56–62; Mathias Hirsch, "Täter und Opfer sexueller Gewalt in einer therapeutischen Gruppe – über umwandelnde Gegen- und Kreuzidentifikationen," *Gruppenpsychotherapeutische Gruppendynamik* 39 (2003): 169–86; Sandor Ferenczi, "Confusion of the Tongues between the Adults and the Child (The Language of Tenderness and of Passion)," *International Journal of Psychoanalysis* 30 (1949): 225–30; Anna Freud, *The Ego and the Mechanisms of Defense* (London: Karnac Books, 1992 [1936]).

34 For an affirmation of the term 'perpetrator trauma,' see, for example, Saira Mohamed's 2015 "Of Monsters and Men: Perpetrator Trauma and Mass Atrocity," Berkeley Law Scholarship Repository, 115 Colum. L. Rev. 1157.

35 Michelle Meinhart, "Memory, Music, and Private Mourning in an English Country House during the First World War: Lady Alda Hoare's Musical

Shrine to a Lost Son," *Journal of Musicological Research* 31, nos. 1–3 (March 2014): 39–95.

36 Miriam Haughton, *Staging Trauma: Bodies in Shadow* (New York: Palgrave Macmillan, 2018), 208.

37 This phenomenon is explored by Judith Hamera in "Performance, Performativity, and Cultural Poiesis in Practices of Everyday Life," in *The Sage Handbook of Performance Studies*, ed. D. Soyini Madison and Judith Hamera (Thousand Oaks: Sage, 2006), 50–1.

38 See Caruth, *Listening to Trauma*, 332.

PART ONE

Words and Images

1 "A Perfect Hell of a Night which We Can Never Forget": Narratives of Trauma in the Private Writings of British and Irish Nurses in the First World War

BRIDGET E. KEOWN

In March 1917, Voluntary Aid Detachment member Gertrude Pigott of Dublin was serving at 29 General Hospital in Salonika when the hospital sustained its second air raid in a week. According to the matron of the hospital, "in the next tent to where she was on duty a bomb was dropped, completely wrecking the tent and causing several casualties [...] The one Miss Pigott was on was perforated [...] all over."[1] Upon her return to Dublin in 1919, Miss Pigott reported to her doctor that she was suffering from "nervousness, waking with a start, pain about her heart" and ongoing tremours, conditions that only increased over time.[2] By 1925, she was completely unable to work due to tremours in her hands, as well as "weakness, inability to take any exertion," and "bad sleep."[3] When she applied for a pension for her condition (which also included complications from rheumatic fever, which she contracted while working in Reading Hospital in 1916), the Pension Board noted that it was "satisfied that this nurse suffered from the effects of several 'Air Raids' and that her claim for Neurasthenia is established."[4] However, because she remained on duty in Salonika and did not report any symptoms until after her discharge, the board also noted that it "did not feel justified in recommending entitlement on account of Neurasthenia," because "there is no evidence that she sustained any serious shock."[5] Her claims for both "neurasthenia" and "rheumatism" were subsequently rejected.

The 'shell-shocked soldier' remains one of the most enduring images of the First World War. Indeed, over the course of the twentieth century, the idea of shell-shock has, in many ways, "transcended the experience of the individual soldier" and become a symbol of, and metaphor for, the suffering of victims of war overall.[6] However, even as the concept of war trauma evolved over time, few scholars have extended this metaphor to include victims of war who were not male combatants. This chapter extends the study of trauma by considering women nurses' descriptions

of war, the sources of trauma and emotional stress they identified in their personal writings, and how they subsequently narrated these experiences of trauma in their private diaries.

The First World War exposed "the poverty of old medical categories" previously used to define physical and emotional shock.[7] Wartime necessity forced medical professionals to focus on the patients and the conditions that posed an immediate threat to their nation's victory at the front. Faced with increasing numbers of shocked and traumatized men in need of medical care, doctors had little choice but to work quickly, in poor and uncontrolled conditions that did little to advance either medical knowledge or overall patient care.[8] The result was a multitude of competing and often contradictory theories of trauma and psychological shock that relied on pre-war assumptions and theories regarding patients' identities, including gender, sex, class, heredity, mental disposition, emotionality, and behaviour, especially if they proved useful in returning bodies to the front. In addition, the needs of the nation at war limited the kind of patient around whom doctors developed theories, diagnoses, and frameworks for care. These patients, as Geroulanos and Meyer point out, "were male, mostly white, relatively young, comparatively fit … Indeed, it would be difficult to overstate the intensity with which the young male body became the model of patienthood and the criterion for treatment."[9] Medicine generally excluded categories perceived as secondary to the war effort, including women, from emerging theories of shock and trauma. Consequently, these trauma victims faced unique struggles in attempting to access care, understanding, or compensation for their suffering. Additionally, the designation of women as "volunteers" rather than "veterans" made it even more difficult for women's claims of suffering to be recognized.[10] Although some women, specifically battlefield nurses, proved able to navigate the bureaucratic, linguistic, and diagnostic labyrinth required to obtain care and compensation, shell shock and related diagnoses remained gendered conditions, focused on men, and, more specifically, white, English middle- and upper-class men, negating the suffering of women such as Gertrude Pigott, whose narratives did not conform to these biased constructions.[11] In the post-war period, the restoration of the patriarchal gender order, especially amongst combatant nations, premised the experiences and suffering of combatant men in the public discourse as well as medical and military publications.[12]

This process obscured, and continues to obscure, detailed discussion and recognition of women's war trauma in their own time as well as in the historiography of the First World War. When nurses are discussed in the context of war trauma, it is often to focus on their role as witnesses

to their patients' physical and emotional suffering. Many studies fail to look beyond nurses' reactions to patients, thus reinforcing women's secondary importance to the allegedly "real" story of the war: namely, that of men in the trenches.[13] As Ana Carden-Coyne observes, because "men overcoming their disabilities is portrayed as the triumph of the individual supported by military medicine[,] the role of women is silenced from a gendered understanding from the impact of war."[14] This essay reorients the study of war trauma, and builds on the work of Christa Hämmerle, in its attempts to understand what "nurses' war accounts tell us ... about the traumatization they developed ... [and] aspects of dis/integration or silencing of what they had had to witness and suffer during war."[15] In so doing, this essay, first, challenges traditional constructions of male-centred and gendered diagnoses of war trauma, which prevented many women's suffering from being recognized during their lifetimes. Second, it utilizes several sources of trauma that British and Irish women identified in their writings. These include feelings of helplessness, fear of physical harm from air raids and other enemy action, and fear of attacks from the soldiers in their care or with whom they worked. While by no means an exhaustive list of sources of trauma, these examples provide an opportunity to consider women's lived experiences of war and a context in which to consider how women attempted, both successfully and unsuccessfully, to integrate these experiences of industrialized warfare, relationships with patients, and personal emotional responses into a coherent autobiographical narrative.

The experience of the First World War permanently changed the nursing profession, as well as the individual women who served, by challenging previous notions of gender performance, authority, and emotionality. Nurses, both those trained professionally and those who volunteered during the war, developed new skills, mastered new techniques, and, generally, coped with circumstances, sights, and experiences for which no peacetime training could prepare them. The constant demands of caretaking, especially in wartime, further added to women's strain. As Debbie Palmer has observed, "just as mothers cannot go off duty or report in sick because of a cold, so nurses were expected to show the same level of self-sacrifice even when work conditions threatened their health."[16] Though their relationships, especially with other nurses, provided a source of resiliency, women often used their diaries and letters to trusted friends or family to express the emotions that they could not otherwise disclose.[17] These sources provide a rich field of analysis to help analyse the emotional experiences of women nurses during the First World War.

Placing women's narratives of trauma at the centre of a study provides several critical insights into the history of the First World War, as well as

the language of historical trauma. First, it continues the study of trauma outside of traditional medical and political narratives within which women's accounts are so often interpreted. Considering subjective narratives of trauma provides greater insight into the lived reality of war, as opposed to later attempts at memory-building. Second, this study subverts the patriarchal construction of health, emotions, and history that sidelines women's narratives and experiences of war. All too often, historical studies portray women's experiences, health, and history as niche and circumscribed and, consequently, do little to challenge or subvert the power structures inherent in the society they study or in which they are produced. In Britain and Ireland, women were denied access to the same language of suffering as combatant veterans in large part because of their gender and the stereotypes and assumptions made about their positionality to war and the wider world, as well as their supposed inherent emotional instability. Consequently, their traumatic experiences, and the languages and forms they used to describe them, are not an established part of the historical discourse of war trauma. The narratives I consider place emphasis on women's emotions as rational and valid reactions to their environment and interactions. They also insist on the veracity of women's memories and testimony of harm from patriarchal systems of war and interpersonal violence, regardless of the ways in which male authorities may interpret those narratives and resultant symptoms of trauma. The structuring of their stories, which can range from unlinked phrases and exclamations to long, coherent narratives, demonstrates not only the experiences of trauma that women endured, but also the practices identified by Potter and Acton by which women managed to "make meaning out of their experiences and, alongside the possibility of breakdown, indicate remarkable resilience and the ability to endure, challenging any attempt to understand this experience in terms of an either/or narrative."[18]

Helplessness

The extreme suffering of war held emotional complications for nurses, especially when their knowledge and training proved no match for the wounds they witnessed in the course of their service. These wounds often exceeded the nurses' capacity to provide care and effective healing, leading to often overwhelming feelings of horror and helplessness. The changing nature of the patient-nurse relationship over the course of the war, and the close and often difficult circumstances of their interactions, forged bonds between women and their patients that could make men's suffering (and the inability to alleviate that suffering)

particularly troubling. As Christine Hallett explains, during the First World War, nurses "were among the first to realize [...] the extent of the destruction that could be wreaked by industrial warfare; the fragility of the human body and mind in the face of its chaos."[19] Women frequently noted that such realizations, coupled with the inability to address patients' suffering adequately, remained unforgettable aspects of their wartime service.

These memories of suffering often proved emotionally overwhelming. Additionally, nurses specifically described feeling the "taint of collusion," as a result of their assigned task of healing men to return them to the dangers of war.[20] Mary Borden, volunteer nurse and author of the modernist war memoir *The Forbidden Zone*, described women's implication in the men's injuries by noting, "Just as you send your clothes to the laundry and mend them when they come back, so we send our men to the trenches and mend them when they come back again."[21] The irony of their position, at once healing and empathizing with their patient and yet facilitating their return to danger and potential harm, affected how women described and interpreted their gendered identity as caretakers and healers. Vera Brittain's memoirs provide a further example of how survivor guilt could affect a nurse's self-identity. In describing her postwar breakdown, Brittain related her belief that her face revealed "the signs of some sinister and peculiar change. A dark shadow seemed to lie across my chin; I was beginning to grow a beard, like a witch?"[22] As a result of this vision, Brittain lamented, "Why couldn't I have died in the War with the others?"[23] Like Borden, Brittain's reaction to her survival manifests in her self-understanding as a gendered body. This focus on attractiveness and beauty will figure in other discussions of trauma discussed below.

The diary of Hilda Mary Wells provides another example of a nurse's description of helplessness, one that shows the ways in which nurses established themselves within the context of the war, as a comrade to their patients. Wells received her training at the London Hospital School of Nursing, and was working at a military hospital in Antwerp in October 1914. In her diary, she described the exhausting process of evacuating patients in advance of the German invasion of the city, and her subsequent journey in a motor bus to the comparative safety of Ghent. While she noted her shock at the destruction wrought on the city by German bombardment, she was chiefly concerned with the suffering of her patients, and her own helplessness in mitigating their pain:

> The sufferings of our own wounded inside those awfully jolty buses are beyond words to describe – one poor man died – after about 3 hours of

our journey – and he had to lie for the remainder of the way until we got to Ghent – He was taken out at the first hospital there – It took 14 hours – we arrived just as it was beginning to get light about 4.45 in the morning – a perfect hell of a night which we can never forget.[24]

In subsequent descriptions of this harrowing journey, Wells's narration devolves into a series of short bursts of recollection, each of which recalls the many agonies she and her patients endured, including "Man with stump – with bedsore – held stump in his two hands all the way. Fearfully painful. Bus driver with broken leg which hadn't been set – screamed aloud at intervals when he could bear it no longer."[25] Such vivid sensory details, related out of a narrative context, are indicative of psychological trauma caused as much by Wells's personal feelings of horror, fear, and helplessness as – via identification and empathy – by the sight of wounded men.[26] In these descriptions, women serve not only as a mirror to men's suffering but as full participants, thinking, feeling, and reacting subjectively as well as sympathetically.

Another example of the stress nurses felt in the face of the patients' suffering can be found in the diary of Florence Elizabeth Ford, who trained at Guy's Hospital before the war and was assigned to convert the Belgian Convent of Les Soeurs de Notre Dame de Namur into a surgical hospital in the early months of the war. Confident in her own abilities, Ford noted just after her arrival that "I think we shall be able to cope with any difficulty except trephining."[27] However, by November she was forced to confront the realities of war:

Frightful rush [....] A very brave man died – he walked two miles with despatches after receiving a fatal injury – he knew he would die so Lady Dorothy promised to write his wife – he wished to tell her he considered it an honor to die for Belgium as she had done so much for France – he ought to have a V[ictoria] C[ross] – he was conscious until about half-an-hour before he died when we gave him morphine; really such awful things one sees and hears are included to rack one's nerves.[28]

Nurse Ford was confronted with suffering so great that there was no option but to provide enough morphine to allow the patient to die without pain. In assisting this soldier to compose his final letter, Nurse Ford, like many other professional nurses in similar positions, entered into a close, frequently familial relationship with patients in order "to provide comfort while at the same time avoiding the possible dangers of crossing emotional and relational boundaries."[29] While these relationships provided support and resiliency for both nurse and patient during their

interactions, they also caused a great deal of anguish when these relationships ended as a result of the patient's death.

Nurses' training prepared them to care for soldiers of their own army and allies, as well as enemy combatants. However, refugees and non-combatants also sought aide at military hospitals. Such occurrences flew in the face of many women's training, and often caused surprise and feelings of horror. Nurse Wells notes on 8 November 1914, after taking a tour of the trenches around the Ypres battlefield, that "we meant to have got close to the Yser to see the German corpses floating but there were so many shells bursting and shrapnel screaming overhead that they didn't think it was safe."[30] In this passage, her mental preparation is fortified by seeing soldiers wounded as a result of the war, and her understanding of the Germans as the vanquished enemy. Civilian patients, on the other hand, repeatedly caused her significant and noteworthy concern and discomfort. On 8 December, she wrote, "[l]ots of happenings today [....] Crowds of refugees lodging at our Hospital on straw from Ypres – Little boy age 10 – wounded by bursting shrapnel [*sic*] at Ypres had leg amputated – went into theatre and had quite a shock to see child on table."[31] Throughout the diary, she notes in detail the sights of helpless suffering, especially of children and mothers, never, as it would appear from the available sources, becoming used to the sight of injured civilians, or to the pain that they endured.

Dorothy Minnie Newman, a sanitary inspector assigned to the Stobart Field Hospital near the Balkan Front, expressed similar distress at the sight of wounded and suffering civilians. Newman took part in the mass retreat from Serbia in 1915, and during this period, she recounted the treatment of soldiers with professional detachment in her diary, noting the types and locations of wounds and her own ability to treat these injuries effectively. For example, she described in early November 1915:

> We were sitting by the roadside, playing bridge, when suddenly three bullock carts of wounded came up. I had to get into the carts to dress them, as they were too bad to move. The wounds were full of dirt and shrapnel, and one was shot through the liver, lungs, stomach and arm. Another was wounded in the lungs and the legs, and had the toes off both feet. We finished about 5 o'clock, and I went to see the sunset with the French doctors. It was glorious tonight, and well worth while the climb we made to see it.[32]

In cases where her professional skills helped her to treat her soldier patients, Newman ably described the injuries she observed in a straightforward, chronological manner. These events appear to be a part of her routine, easily recalled and just as easily relegated to the past. Her

recollections of this day are tempered by the remembered views of a sunset with work colleagues. However, there were also events that disrupted this chronology, typically sights of civilian or animal suffering to which Newman reacted with revulsion. For example, she recounted the graphic death of three horses that were "killed by a bomb yesterday, and … were thrown into the valley, where the horrible wild dogs are eating them up."[33] Newman, like many other veterans, used descriptors like "horrible" in an attempt to come to terms with the indescribable, and the unrelenting feelings of disgust that such memories evoked. Despite her desire to turn away from such sights, the smell of the horse carcasses and the sight of their dismemberment lingered in her mind, forcing her to attempt to record and thereby to overcome them.

Similarly, at the end of November, Newman described her experiences of retreat, and the encounters with human suffering and death that she could neither alleviate nor forget. On 25 November, she noted that "[t]here was a snow blizzard blowing strongly against us, and the corpses along the road were ghastly. Among them was a mother, dead with her dead baby in her arms."[34] Her use of descriptors in this reference, specifically the word "ghastly," indicates how such sights of civilian suffering and death disrupted the pattern of Newman's days, and challenged her descriptive abilities in a way that her descriptions of soldiers' injuries did not. That night, as she tried to sleep in a motor car for shelter, she noted, "It was very cold, and we thought of the horror we have seen to-day – five convicts in chains, shot through the head and lying dead in the snow, to say nothing of the corpses innumerable."[35] The next morning, she noted that "[i]t was a bitterly cold night, which I passed in having nightmares."[36] These notes about recurring thoughts and unrelenting nightmares attest to the disruption they caused and the lingering guilt and distress she felt over her own inability to help those who died in pain and fear.

As Potter and Acton observe, medical professionals who served during the First World War "had little or no precedent for articulating their experiences," or any kind of tradition or training that could provide "means of negotiating the emotional and physical impact of their experience."[37] For volunteer and professional nurses alike, their training provided a strong bulwark to the challenging sights and memories of war. However, the extraordinary injuries and extreme suffering they witnessed, compounded by the lack of control they felt during such events, challenged women's feelings of control, as well as their own professional self-identity within the context of war. In such cases, women often turned to their diaries to attempt to record and contextualize their memories, providing personal insight into the deeply emotionally troubling experiences of their wartime service.

Issues of Military Action

Among the clearest explanations for post-war trauma symptoms in nurses' pension files, exemplified in Nurse Pigott's account at the beginning of this chapter, is the fear and stress caused by threats to their physical safety and well-being as a result of military action. While the vast majority of British nurses died as the result of contagious diseases, specifically pneumonia and influenza, rather than from wounds, the threat of death and physical injury was an omnipresent source of concern.[38] Women wrote about their fear of enemy action, including air raids, long-range guns, and artillery fire, all of which were frequently directed at or near hospitals and medical areas. In the event of enemy action, nurses often described feeling an obligation to keep their own fear in check, while also preserving the safety of their patients. As trained nurse Mary E.C. Love noted in an unpublished post-war memoir, "the habit of the British Military Service is to 'Carry on as Usual' whenever possible under all circumstances. All fuss and excitement was reduced to a minimum and we were not encouraged to dwell on the 'danger of the night.'"[39] Yet despite nurses' devotion to duty, they still struggled to cope with feelings of extreme fear, for both their own safety and the well-being of their patients. Nurse Love described the emergency procedures taken at her hospital in Etaples, and the reactions of some of her fellow nurses, when German air raids became frequent late in the war:

> The second time the Bosch [German soldiers] appeared, the nurses and personnel who were off duty and all patients who were able to walk were ordered to go into the hills behind the hospitals. It must have been an unusual sight to see us scattered on the slopes in the moonlight, taking shelter where the ground afforded it and staying out in the open until early dawn. [...] At that time we had no underground bomb-proof shelters and during several succeeding raids all the day nurses were ordered into a large empty ward where we folded cots flat on the floor and lay prone on them. The young nurses of the Volunteer Aid Detachment, who might have been expected to lack the self-control of the graduate sisters, behaved exceedingly well, and although our limbs shook at each detonation and someone would occasionally cry out, there was no case of hysteria or cowardice.[40]

As conditions in the hospital deteriorated, patients and nurses had no choice but to spend the night in trenches dug outside the hospital as a makeshift shelter. In addition to the unsanitary conditions of these trenches, the smells and heat generated by so many bodies in such a small space were overwhelming. Nurse Love recalled "fainting one night

in the heat and stuffiness of the underground chamber and being laid on the ground and revived by a friendly Canadian doctor."[41]

In addition to the emotional challenges, air raids often proved physically exhausting for nurses, who cared for wounded patients and, in extreme cases, resorted to carrying them to safety. Eva M. Smith, a trained nurse who served with the Joint War Committee of the British Red Cross and the Order of St John in France for the duration of the war, described the increased workload that nurses faced when air raids were imminent:

> [...] we had early morning evacuations and if Fritz was knocking around we could not show a light. Every man had to have breakfast, his wound dressed, his clothes – pyjamas, pants, shirt, sweater, cap, muffler, socks and if winter, gloves all to be put on. Then if he had a splint, that had to be tied firmly to the stretcher.[42]

On several occasions, multiple evacuation orders came in a single day, creating an enormous amount of work and stress for staff. Smith herself described such a day as one "never to be forgotten." She continued:

> Started with an evacuation at 8 A.M. Take in at 9 A.M. Evacuation again at 12. Another take in at 3 and another evacuation at 4. The men were coming before the leaving ones were out of the beds. Serious dressings to be done and careful fixings of splints to do before they left.[43]

In the event that poor weather prevented evacuations, or in cases where patients were too ill or injured to be moved, Smith described how "we put mattresses over the patient to keep bits of falling shrapnel from hitting him."[44]

The amount of emotional strength required to remain calm and professional during night-time aerial attacks took a considerable toll on nurses' psyches. Dorothy Newman, working in Serbia, recounted an experience of aerial attacks, emphasizing the constant emotional strain, as well as the physical hardships she and her comrades endured as a result:

> We are settled in a field about a mile out of Racha, where we have put up the hospital tent [....] Three aeroplanes passed over us, two French and a German, the latter dropping bombs, and a captive balloon is over us all the time. The guns are so near us that we can gather shrapnel, and they have never ceased for a moment [....] As I am writing this the German plane suddenly came down, recovered itself within forty feet from the earth, and flew away. At half past six order came that we were to be ready to retreat at any minute. We packed everything up, had dinner, and awaited orders to

move [....] Suddenly a large convoy of wounded appeared, and as we were packed up there were no dressings ready. We had to unpack with the Germans within a few kilometers of us, and after much excitement we managed to make the men remain and help us [.... T]here were so many that we were at our wit's end to know how to evacuate them.[45]

The threat of enemy action provided an obvious source of stress for Newman and her colleagues, but the professional obligations of tending to a large number of wounded cases (at least until they managed to convince other members of their convoy to stay behind and assist) significantly compounded the stress that is evident in her description. Such was the case for many nurses who balanced personal fears, physical danger, and responsibility for their patients, which proved, unsurprisingly, extremely exhausting. As a result, such incidents formed a critically important, and unavoidably memorable, part of their war experiences and narratives.

Threat of Physical Attack

In addition to recounting the stress and fear brought about by working in life-threatening conditions, nurses also wrote about the threat posed by the men with whom they lived and for whom they cared. Analysing this aspect of their service as a source of stress and trauma challenges the traditional maternal or sororal depictions of the nurse-patient relationship. Histories of the First World War frequently portray nurses holding a position of power over injured soldiers, or note "the true spirit of friendship that could exist between them and their patients."[46] Such readings should not exclude the very real threat that soldiers could pose to nurses' physical safety, or the resulting fear women recorded during their service. Even in an injured and physically weakened or mentally overwrought state, soldiers proved capable of overpowering nurses, as Hilda Wells detailed at length in her diary:

There was a bad head case – He appeared perfectly quiet when I went on duty, just lying log-like, but for precaution, as head cases often try to get out of bed, I put the one empty bed up against his bed to keep him more securely in. Half-way through the night when I was busy at the other end of the ward with a bad haemorrhage I saw this man up on all fours & crawling across to the other bed – I went across to him and gently tried to persuade him back into his own bed – But he got violent immediately struck me a blow full in the face & then sprang out of bed & all my force was as nothing against his collosal [sic] strength & I was absolutely powerless – Then I tried to hold on to him so that he didn't escape or do something desperate to

the other patients – But he got me by the throat – one hand in front & the other at the nape of my neck & literally tried to strangle the life out of me!

I've never had a worse moment in my life – never more nearly dead – or rather thought I was!

I screamed & screamed & [...] I strained to get near the open window to yell "help" as I'd heard a chauffeur out in the garden with his ambulance car only a few minutes before – But no help came and nobody heard – the utter helplessness of it was awful – Then suddenly the door opened & Miss Barron came in quite by accident to borrow something – The man loosened his hold & fell exhausted on to the bed. How my head swam & ached for hours afterward – but I had to go on just the same with all the other patients bad & needing treatment & attention as tho' nothing had happened.[47]

The shift in this entry from Wells's usual straightforward tone and grammatically correct sentence structure to disjointed phrasing and run-on sentences is noteworthy. The multiple ampersands and dashes break the flow of narrative into short visions and bursts of action, verbally reminiscent of a traumatic flashback. Her emphasis throughout this passage is on the overwhelming strength of the soldier and on her own powerlessness. She does not relate the physical pain, but rather the isolation she felt, both on her rounds and during the terrifying attack. In the aftermath of this event, Wells realized she had no choice but to continue her rounds. Forced to repress their fear of physical harm and the potential violence of the men around them, nurses like Wells used their diaries as emotional outlets in order to carry on with their duties.

Other recorded cases of attacks against nurses by soldiers show that violence was not only the result of delirium, but also was carried out intentionally. Much has been written about the "brutalization" of soldiers in the aftermath of the First World War, though these studies focus more on issues of public violence, such as post-war riots, public brawling, and political rhetoric.[48] However, feminist scholars also note the personal, sexual, and gendered forms of violence this brutalization took in interpersonal relationships and domestic sites.[49] Susan Kingsley Kent, for example, states that "front soldiers returned home in a violent frame of mind" that manifested in "innumerable accounts of sexual attacks upon women."[50] Nurses' personal writings also reveal the ongoing nature of these threats in descriptions of the sexual and physical threat both allied and enemy soldiers posed during the war. For example, Eva Smith noted in her diary how she and her fellow nurses often slept outside when not on duty in order to escape the stress of the hospital. However, in September 1917, she and her friend Agnes Boys learned that the

dangers they feared in the hospital could not be avoided by sheltering outside of it:

> Matron had a nasty shock. We were awakened in the middle of the night by her shouts for help. She had wakened up suddenly feeling somebody was in her tent, her lamp which she always kept alight was out. She put out her hand to feel for some matches but someone caught hold of it saying, "Don't strike a light and do not shout." She promptly yelled for help and the person dashed away. Boys and I were sleeping in the woods just behind her tent (we always did all through the summer). After that night we had a guard round the Camp. Matron never slept by herself afterwards and we were stopped from sleeping in the woods, much to our sorrow. It was such a treat to get away from the cubicles, where one was never quiet, never got away from the sound of voices and one could never talk without being overheard.[51]

As Smith's diary shows, these attacks themselves were deeply troubling, to the extent that the hospital matron did not sleep alone for the rest of their service together. Additionally, the realization of the unstable power dynamics at play in the hospital, and the constant threat the women faced there, clearly felt jarring as well. Nursing probationer Elsie Fenwick echoed these sentiments in her own diary while she was working at a Belgian Red Cross hospital where a nurse was attacked in the middle of the night by a soldier:

> She was in a villa close to ours and alone in a room. A soldier climbed up the balcony, got in, knocked her down because she screamed, and tried to gag her. Luckily the nurses next door heard [the screaming] and got into the room. He hid under the bed and was caught! The poor nurse is the ugliest in the hospital, and is suffering from terrible shock! I think the man will get several years as he is going to be tried by court martial. What dangers we go through, and Aline and I have lived for weeks in a night villa all alone, not even a caretaker living in it.[52]

Although unrelated to the topic at hand, there is a wealth of commentary to be made on Fenwick's observation that the nurse who was attacked "is the ugliest in the hospital," and how militant patriarchy induces women to measure their worth by men's desire, even if it is unwanted. Fenwick describes the incident as a shocking, almost scandalous bit of exciting news that has effectively ended, as a result of the soldier's arrest and potential court martial. However, her final sentence, regarding the danger she and her fellow nurses faced, shows that this attack was

personal to her, despite her attempts to separate herself from its victim by referencing the latter's ugliness. Her bravado breaks down with the realization that the threat of future personal violence could never be mitigated completely.

Conclusion

The study of war trauma has historically relied on diagnoses and documents based around the experiences of combatant men. Military and medical officials developed their understanding and treatment of war trauma in order to return soldiers and officers to the front, and later debates over pensions focused on the need to compensate male breadwinners as a method of stabilizing society in the wake of war's many social upheavals. As a result, the study of war trauma remains predominately focused on the emotions and experiences of soldiers. These analyses repeatedly cast women as secondary characters, as caretakers and witnesses to trauma rather than as feeling, thinking historical agents in their own right. However, by acknowledging the gendered dimensions of trauma-related reports, it is possible to overcome them. One method is to utilize different, subjective, and personal sources, such as their diaries, letters, and private memoirs, to expose the sources of fear that women felt during war service, and the ways in which they managed the feelings such experiences provoked. They also show the processes by which women sought to integrate traumatic events into an autobiographical narrative that allowed them to regain a sense of control over their experiences and reactions.

I have attempted to challenge the historiography that treats the "generic man as the human norm" by looking at the experiences of traumatized women that continue to be overlooked as the result of a focus on combatant men's wartime psychological conditions, and by emphasizing a few specific sources of trauma that women faced in the course of their unique war service, from personal feelings of helplessness and lack of professional control to the threats posed by air raids and the soldiers in their care.[53] In so doing, I hope to have shown these women as fully independent and equal participants, who suffered harm not only by exposure to the violence of war, but via the patriarchal and social structures in which they operated. Because many women did not maintain or preserve their diaries after the war, it is difficult to trace the long-term effects of their experiences on their psyche. However, this analysis of women's narratives and their subsequent reactions has placed them in the centre of a study of war and emotions, allowing a more complete view of women nurses' lived, emotional, and psychological experiences of the First World War, and providing a framework for further study.

NOTES

1 National Archives Kew, Ministry of Pensions and Successors: Selected First World War Pensions Award Files, nursing member Gertrude Lucy Pigott, PIN 26/20203.

2 Ibid.

3 Ibid.

4 Ibid.

5 Ibid.

6 Peter Leese, *Shell Shock: Traumatic Neurosis and the British Soldiers of the First World War* (New York: Palgrave MacMillan, 2014), 180.

7 Stefanos Geroulanos and Todd Meyers, *The Human Body in the Age of Catastrophe: Brittleness, Integration, Science, and the Great War* (Chicago: University of Chicago Press, 2018), 67.

8 Fiona Reid, *Medicine in First World War Europe: Soldiers, Medics, Pacifists* (London: Bloomsbury Academic, 2017), 7.

9 Geroulanos and Meyer, *The Human Body*, 81.

10 See TNA, PIN 15/956, War Pensions Records, note dated 10 May 1920.

11 I am conscious of June Purvis's observation that in attempting to illuminate women's experiences in the past, historians may forget about the experiences of other marginalized groups. Thus, it is important to acknowledge that women were only one group out of many who were excluded from the narrative of trauma and the study of shell shock as a result of their national, ethnic, linguistic, religious, economic, or sexual identity. See Purvis, "Doing Feminist Women's History: Researching the Lives of Women in the Suffragette Movement in Edwardian England," in *Women's History: Britain, 1850–1945*, ed. Purvis (London: Routledge, 2000), 166–89.

12 Silke Fehlemann and Nils Löffelbein, "Gender, Memory and the Great War: The Politics of War Victimhood in Interwar Germany," in *Psychological Trauma and the Legacies of the First World War*, ed. Jason Crouthamel and Peter Leese (New York: Palgrave Macmillan, 2017), 156.

13 For more information on women's emotional responses to nurses and examples of compassion fatigue, see Christine Hallett, "Portrayals of Suffering: Perceptions of Trauma in the Writings of First World War Nurses and Volunteers," *Canadian Bulletin of Medical History* 27, no. 1 (Spring 2010): 65–84. Also see Cheryl Tatano Beck, "Secondary Traumatic Stress in Nurses: A Systemic Review," *Psychiatric Nursing* 25, no. 1 (2011): 1–10.

14 Ana Carden-Coyne, "Gendering the Politics of War Wounds since 1914," in *Gender and Conflict Since 1914*, ed. Ana Carden-Coyne (New York: Palgrave Macmillan, 2012), 90.

15 Christa Hämmerle, "'Mentally broken, physically a wreck …': Violence in War Accounts of Nurses in Austro-Hungarian Service," in *Gender and the First*

World War, ed. Christa Hämmerle, Oswald Überegger, and Birgitta Bader Zaar (New York: Palgrave Macmillan, 2014), 102.

16 Debbie Palmer, *Who Cared for the Carers? A History of the Occupational Health of Nurses, 1880–1948* (Manchester: Manchester University Press, 2014), 80–1.

17 Bridget E. Keown, "'I Think I Was More Pleased to See Her than Any One 'cos She's So Fine': Nurses' Friendships, Trauma, and Resiliency during the First World War," *Family and Community History* 21, no. 3 (2019), https://www.tandfonline.com/doi/abs/10.1080/14631180.2018.1555955.

18 Jane Potter and Carol Acton, *Working in a World of Hurt: Trauma and Resilience in the Narratives of Medical Personnel in Warzones* (Manchester: Manchester University Press, 2015), 33.

19 Christine Hallett, *Containing Trauma: Nursing Work in the First World War* (Manchester: Manchester University Press, 2010), 161.

20 Ruth Leys, *From Guilt to Shame: Auschwitz and After* (Princeton: Princeton University Press, 2007), 5.

21 Mary Borden, *The Forbidden Zone* (London: Hesperus , 2008), 79.

22 Quoted in Sandra M. Gilbert and Susan Gubar, *No Man's Land: The Place of the Woman Writer in the Twentieth Century*, vol. 2: *Sexchanges* (New Haven: Yale University Press, 1989), 320.

23 Ibid.

24 Royal London Hospital Archives, Papers of Hilda Wells SRN, RLH/PP/HWE/1.

25 Ibid.

26 For more on sensory descriptions as an indication of trauma, see Maria Crespo and Violeta Fernandez-Lansac, "Memory and Narrative of Traumatic Events: A Literature Review," *Psychological Trauma Theory Research Practice and Policy* 8, no. 2 (2016): 149–56.

27 Imperial War Museum, Private Papers of Miss F.E. Ford, Document 17247; trephining is the process of drilling into the skull in order to relieve pressure of the brain. Nurse Ford later developed a makeshift trephine using a spatula.

28 Ibid.

29 See Hallett, *Containing Trauma*, 177–8.

30 Royal London Hospital Archives, PP/HWE/1.

31 Royal London Hospital Archives, PP/HWE/1.

32 Wellcome Library, typescript "Diary of a Trekker in Serbia, covering service with Mrs St Clair Stobart's hospital at Kragujevatz and with the Field Hospital on the retreat," GC/165/1.

33 Ibid.

34 Ibid.

35 Ibid.

36 Ibid.

37 Potter and Acton, *Working in a World of Hurt*, 32–3.

38 British Red Cross, "VAD Casualties during the First World War," redcross. org.uk/WWI, accessed 25 February 2020, https://vad.redcross.org.uk /~/media/BritishRedCross/Documents/Who%20we%20are/History %20and%20archives/VAD%20casualties%20during%20the%20First %20World%20War.pdf.

39 Wellcome Library, Mary E.C. Love, "Through shadows and sunshine, 1914– 1918," GC/258/4: Box 1.

40 Ibid.

41 Wellcome Library and Archives, GC/258/4: Box 1.

42 Imperial War Museum, Private Papers of Miss E.M. Smith, Documents, 16098.

43 Ibid.

44 Ibid.

45 Wellcome Library, typescript "Diary of a Trekker in Serbia, covering service with Mrs St Clair Stobart's hospital at Kragujevatz and with the Field Hospital on the retreat," GC/165/1.

46 Quoted in Hallett, Containing Trauma, 177.

47 Royal London Hospital Archives, PP/HWE/1.

48 For examples, see Robert Gerwarth, The Vanquished: Why the First World War Failed to End (London: Allen Lane, 2016); Jon Lawrence, "Forging a Peaceable Kingdom: War, Violence, and Fear of Brutalization in Post–First World War Britain," Journal of Modern History 75, no. 3 (2003): 557–89; Benjamin Ziemann, Violence and the German Soldier in the Great War: Killing, Dying, Surviving (London: Bloomsbury, 2017).

49 Judith Lewis Herman, Trauma and Recovery: From Domestic Abuse to Political Terror (London: Pandora, 2001); E. Kuhlman, Reconstructing Patriarchy after the Great War: Women, Gender, and Postwar Reconciliation between Nations (New York: Palgrave Macmillan, 2008); Elizabeth Nelson, "Victims of War: The First World War, Returned Soldiers, and Understanding of Domestic Violence in Australia," Journal of Women's History 19, no. 4 (2007), 83–106.

50 Susan Kingsley Kent, Making Peace: The Reconstruction of Gender in Interwar Britain (Princeton: Princeton University Press, 1993), 97–8.

51 Imperial War Museum, Private Papers of Miss E.M. Smith, Documents, 16098.

52 Quoted in Anne Powell, Women in the War Zone: Hospital Service in the First World War (Stroud, UK: History Press, 2016), 135.

53 Harry Brod, "Introduction: Themes and Theses," in The Making of Masculinities: The New Men's Studies, ed. Harry Brod (Boston: Unwin Hyman, 1987), 2.

2 Religious Language in German Soldiers' Narratives of Traumatic Violence, 1914–1918

JASON CROUTHAMEL

Traumatic experiences are often processed through subjective language and concepts that are elusive and sometimes do not easily match diagnostic categories of psychological injury. One of the most intimate, and difficult to uncover, prisms through which trauma can be processed is religious belief. Diaries and letters produced by soldiers and civilians shattered by total war are remarkable for the frequency with which religious language was used to narrate psychological trauma.[1] Focusing on German soldiers but also some civilians who witnessed the First World War, this chapter explores the following interrelated questions: How were the traumatic emotional effects of violence processed through the language of religious faith? In turn, how did religious language shape narratives about traumatic stress?

In 1914–1918, religious faith was weaponized by military and religious leaders as a way to mobilize minds for war. German military and religious authorities conflated faith in God with faith in the nation, as ideals of loyalty, redemption, and sacrifice were merged together, fusing nationalist and religious rhetoric. Religious belief was also held up as an ideal way for men and women to 'hold through' or 'persevere.' Popular media – including postcards, newspaper articles, and journals – utilized this language to promote the idea that 'holding through' could be accomplished through belief in God.[2] Rhetoric about faith in God as a means for coping with stress was also ubiquitous in letters and diaries of ordinary men and women. Soldiers and civilians often expressed their emotions through the lens of religious faith, relying on their psychological and cultural toolkit of traditional rituals and belief systems to endure the stress of total war.[3] This was particularly the case in the early months after the 'spirit of 1914,' when rhetoric found in ego-documents often mirrored prevailing traditional ideals about faith in God and 'holding through.' However, as the war dragged on, religious language used to

cope with psychological trauma became much more complex. Beyond just providing a language for perseverance, religious faith became a framework through which individuals processed trauma, described psychological escape from violence, and narrated experiences of psychological rebirth or spiritual renewal.[4]

The central argument of this chapter is that ordinary Germans integrated the language of nerves with the language of religion in a complex, overlapping framework of thinking in which they applied familiar cultural concepts to combat the psychological crisis triggered by modern war. Religious language reveals how men developed psychological strategies to transcend victimhood and exert agency over their chaotic environment. In exerting this agency, many gradually became critical of religious and military authorities whose call for faith in God to 'hold through' sounded increasingly naive to soldiers fighting in the trenches. The language soldiers used suggests that many detached from traditional structures and discovered subjective interpretations of the psychological effects of the war experience. Perhaps most interestingly, some front soldiers employed language that was a hybrid of Christian imagery and more individualized beliefs drawn from their environment and experiences, which allowed them to achieve some sense of psychological homeostasis in the wake of trauma.

The focus of this chapter is on the history of religion and trauma 'from below.' However, letters and diaries that provide a glimpse into the spiritual and religious universe of ordinary men and women prove challenging, as backgrounds and beliefs fall across a broad spectrum. The responses of Protestant, Catholic, and Jewish soldiers and civilians to traumatic violence are myriad, and one must be sensitive to this wide range of beliefs and language. In addition to inherent challenges involved with interpreting the subjective world of religious belief, there are also significant problems and potential limitations in analyzing letters and diaries by soldiers and civilians.[5] Most letters available in archives were written by officers and non-commissioned officers from middle- and lower-middle-class backgrounds. Thus historians cannot over-generalize about the degree to which letters available in archives represent the experiences of a socially diverse mass army.[6]

Religious belief is extremely difficult to reconstruct. Language used to formulate narratives and memories of trauma is diverse and mediated through varied social and cultural contexts, requiring historians to be sensitive to the different languages in which narratives are constructed.[7] Further, language, along with symbols and images, is the primary portal into the psychological landscape of historical subjects, but the degree to which language reflects religious thinking is limited.[8] Tension

between language, belief, and practice has been recognized by gender historians,[9] and in the case of religion, the problem is exacerbated when even historical subjects admit that language falls short in encapsulating their traumatic experiences. Nevertheless, letters and diaries provide an extraordinary glimpse into how ordinary people experienced and narrated trauma. These were often written under artillery and machine gun fire, and they provide a raw glimpse into the often complex and contradictory immediate emotional reactions to traumatic violence and the impact of stress on soldiers' religious beliefs.[10]

This chapter is influenced by recent historiography that moves analysis beyond religious institutions, military chaplains, and home front morality organizations,[11] shifting focus instead to how ordinary men and women used religious language to cope with trauma. This direction has been spearheaded by historians Alexander Watson and Benjamin Ziemann, who explored religious faith as a key site for analysing how men coped with stress. They emphasize that many soldiers continued to rely on religious beliefs and rituals, even when the power of religious authorities eroded.[12] Ziemann also highlights diverse emotional responses to traumatic violence, and the tensions between the act of killing and religious beliefs.[13] While their methods influence my approach, I aim to also consider how religious language was employed to process and narrate traumatic experiences after a traumatic event. I want to explore not only contradictions and tensions between traditional religious beliefs and wartime experiences, but also how men constructed subjective belief systems out of the unique trench environment in order to cope with and process trauma. Thus one of my goals here is to move beyond the prevailing historiographical debate over whether the war reinforced or eroded religious beliefs,[14] and to illuminate the more nuanced, subjective ways in which the war experience shaped religious beliefs and language.

Finally, it is important to consider both the context of pre-war religious ideals through which ordinary men and women processed trauma, as well the ways in which the war experience altered those pre-war assumptions. Joanna Bourke illuminates pre-war Christian concepts about pain, and the ways in which Christian authorities instilled in the preceding generation the idea that suffering was a reminder of sin that enabled individuals to achieve spiritual renewal, a central tenet of Christian theology.[15] This perception of pain as a source of spiritual renewal or revitalization profoundly shaped the responses of ordinary soldiers and civilians to trauma. At the same time, individual narratives of trauma also reveal the degree to which violence shattered pre-existing belief systems, and thus also spiritual identities. Recent innovative scholarship on trauma can help illuminate how the war transformed individuals on a physical

and spiritual level. In a study of neurophysiological responses to trauma in the First World War, historian Stefanos Geroulanos and anthropologist Todd Meyers argue that "individuality – and indeed, individuals' very corporeality, their wholeness – was almost certainly collapsing."[16] This can also be applied to analysis of religious belief and psychological trauma, where the individual sense of self, the whole spiritual identity and belief system of soldiers, became fragmented and disintegrated. Traumatized men and women struggled with language to describe these feelings of spiritual disintegration.

"God's Hand": Fatalism, God's Will, and Emotional Support between Combat and Home Fronts

Fatalism, the notion that one's destiny was in the hands of a supernatural power beyond one's control, was one of the most common ways men and women processed stress. In their letters and diaries, this fatalistic language was rarely based on cynicism or negativity, but often described in positive terms. Men and women imagined God as a kind of companion or protector who interceded and bore the responsibility for life or death.

Fatalism was a key element of the front soldier's psychological arsenal for coping with trauma. This can be seen in the case of infantryman Ambrosius S., who wrote to his fiancée Elisabeth B. in April 1915 about a "terrifying battle" in which his battalion suffered "over 1,000 casualties." After a funeral for one of his comrades, Ambrosius reflected on God's omniscience:

> In today's funeral sermon our brave fallen comrades were remembered. Our hut looks very neglected. God willing, it will not be turned into a pile of rubble and we'll be spared. Lord, your will, not mine, will make it happen. He alone knows what is best for me [....] Let us thank our dear God that I am still alive. Shared joy is doubled joy, shared suffering is half suffering.[17]

Invigorated by sermons given at the funeral for his fallen comrades, he imagined God as a figure who could help him "share suffering," enabling Ambrosius S. to yield control over his fate. Faith thus also provided a sense of common community, a way to envisage connections between comrades and otherwise remote civilians.

Fatalism helped families endure the strain of mobilization and separation. Shortly after he arrived in France in September 1914, Anton K., who volunteered for a Bavarian infantry regiment, received an anxious letter from his sick wife worrying about who would finish harvesting the crops on their farm, and whether her husband would return. He called

on her to trust God's will: "From your letter I can tell that you are not well. Be content and do not complain. Here we are still ten times worse [....] The suffering caused by the war cannot be described. If it is God's will to do so, I will return home. And if it is not [...] then it has been decided by our Lord God (*Herrgott*). Do the field work any way you think it would be best."[18] Anton K.'s admonishment to relinquish control to God and "not complain" also hinted at growing tensions between men and women, and a widening gap between home and combat fronts. In this case, the husband used God to mediate and maintain influence and control over his wife.[19]

Letters home reveal how fatalism and reliance on 'God's hand' became a common mechanism for coping with fears of death and staving off psychological breakdown, especially as the war bogged down into stalemate and massive human losses. For example, Hans S., a printer who volunteered shortly after the outbreak of the war, wrote in 1915 from the Eastern Front to his wife Ida about fighting off depression. He tried to counterbalance despair with his belief that God was in control: "Here at the front one goes crazy from the gloomy hours and the death of his companions. I try not to let hope disappear with another final goodbye [....] The decision is indeed in the highest hand. Whatever he wishes, it is good."[20] Hans S.'s faith in "God's hand" remained constant over the course of the war. He wrote to his parents in August 1918 that whatever his fate, it was entirely in God's control: "I have had a particular experience that is worth noting: under heavy fire everyone became pious, and I myself had the strange feeling [*das eigentümliche Gefühl*] of being in God's hands."[21] Exhausted by war, Hans S. seemed to find comfort in his fatalism. He assured his parents that he was able to survive the strain as the "strange feeling" of God's control swept over him.

The language used in letters suggested that it was soothing for many men to capitulate to God as an all-powerful being who determined their fate. As historian Alexander Watson argues, religious faith gave men in a chaotic world a sense of order and agency.[22] Catholic front soldier Eduard F. wrote to his priest in December 1914 that in an environment in which he had completely lost a sense of control, belief in God provided a semblance of calm:

Unfortunately, I was wounded and was completely ripped away from my effective circle of control [*aus meinem Wirkungskreise herausgerissen*]. But you have to submit to God's will. He will do everything for the best. This shows how the Catholic religion is so sublime and beautiful.[23]

Eduard F.'s expression of admiration for Catholicism specifically is interesting, as he suggested that this particular faith system was ideally suited for alleviating front-line stress.[24] Submission to God's will, he intimated, counterbalanced his anxiety that he had become helpless and ineffective after he was wounded. For many front-line soldiers, faith in God was a mechanism for not only coping with but also articulating and processing psychological trauma.

Nerves and God's Will: Psychological Health and Religious Belief

Trauma was often couched in language about nerves and nervous disorders. The 'language of nerves' was widely used by medical and military authorities, as well as front soldiers themselves, to describe their psychological condition. Soldiers' nerves were a site of management and control, as doctors often characterized the war as a 'battle of nerves,' and expressed their commitment to prevent the psychological breakdown of soldiers stressed by modern war. Men who broke down with a diverse range of symptoms of mental trauma were categorized as 'war neurotics' or 'war hysterics,' which stigmatized them as allegedly deficient in masculine character and unable to survive the test of combat.[25]

A discourse on 'nerves' also pervaded front soldiers' letters and diaries. However, in their ego-documents, soldiers' language for coping with nervous tension departed from the medical framework used by psychiatrists to diagnose and treat the psychological trauma. Terms like 'war neurosis' and 'war hysteria' were rare in letters home. More common was a language in which men framed their nervous stress in terms of comfort from God. For example, in a correspondence with his pregnant wife Dorle in November 1914, Friedrich B. described the horrifying experience of enduring British artillery fire at the First Battle of Ypres. In contrast to some men who concealed their emotions and sterilized the psychological terror of war in their letters home, he intimated to his wife his feelings of terror:

> We are all so war-weary, our bodies and nerves are so tense because of the constant stress and being in a permanent state of danger. Right now, I just want to sit down on your bed, take your dear hand in mine and tell you about my recent experiences [....] I'm not ashamed to admit that right now tears are streaming down my face.[26]

As he continued his letter, he described the stress caused by the bombardment in religious terms. He wrote about seeking "salvation" from

the nerve-wracking artillery fire and his belief that God's hand determined his survival:

> Suddenly enemy bombs began to rain down on the village [....] Every moment we were being struck and there was no salvation. So we sat three hours in the most fearful nervous tension [*Nervenspannung*] like chickens under the hawk circling over them until we did not even notice it had become dark [....] I look back – the field is sown with dead and wounded. The English have been well targeted, death has kept a rich harvest. And I'm unhurt! That's no coincidence, that's the will of God, who was with me.[27]

Friedrich B.'s hope for divine intervention calmed his nerves and saved him from psychological collapse. He admitted that some of his comrades succumbed to nervous breakdown, but prayer helped him imagine an escape from the nightmare of war:

> God grant that Ypres, the main position of the British, can be taken without us. Our lieutenant, who leads the company, has suffered a nervous breakdown. A non-commissioned officer spent the day constantly crying – that's the reaction to all this. Hopefully we will have some rest for a while now. [...] Now, Dorle, we want to hope for the best, our collective prayers will be heard by God and we will celebrate by a tree in our little Biedermeier room.[28]

As he saw comrades break down, Friedrich B. relied on religious faith as a bulwark against mental disintegration. He was killed a few weeks after writing that letter.

As men transformed from idealistic volunteers to brutalized veterans, religious language was an essential framework they used to process traumatic experiences. This can be seen in the case of Wilhelm W.'s diary, which tracks his evolution of experiences. Before entering the trenches, his writing was filled with clichés about 'heroic sacrifice,' which was often conflated with Christian ideals of martyrdom and redemption. But once he experienced the horrifying reality of front-line violence, he became almost entirely focused on the task of survival. Under artillery fire, W. imagined God as a means of psychological escape, rather than a backbone of idealized courage, which saved him from nervous breakdown:

> Each time four shots from the battery: close in succession they hit. Boom! A piercing scream! A bomb hit the trench: six are dead, torn to pieces. Our medical officer breaks down at the sight. Men with stronger nerves have taken the bodies away at night. You have to have strong nerves under the shell fire [....] Shoom, boom! Crash! It's as if hell's been unleashed [....]

God, God in heaven, if it must be, then give me short death [....] Oh, the mutilations [*Verstümmelungen*]! And then I imagine peace comes over me and beautiful images from other days pass by.[29]

Here the language of nerves permeates Wilhelm W.'s description of stress under artillery fire. He eases his own psychological pain by calling on God to release him from this stress through a quick death, and he comforts himself by imagining home and his life before the war. Thus he conceives of God as an antidote to nervous collapse – not because God can give him the ability to remain courageous in battle, but because God has the power to remove him from his hellish experience. W. finally escaped combat when he was wounded, and he ultimately survived the war.

The act of praying reassured men that they might be able to overcome the stress placed on their nerves. For example, Berthold B., a twenty-year-old from Baden-Württemberg, wrote to his parents in October 1914 that he "would thank God" when he was finally relieved from the "miserable nest" of his trench, where he and comrades suffered from hunger and diarrhea. Several weeks later, Berthold B. wrote to his pastor, and he explained in greater detail how his belief in God helped ease the stress of life at the front. He wrote that once he returned to the front lines, he was pinned down under days of shell-fire. "We were all trembling as the result of co-lossal nervous strain [*Nervenanstrengung*]," he told his pastor, "until I read your dear little leaflet and a part of your booklet, and during the night I slept more calmly than ever before at the front." Berthold B. wrote that he found solace because the pastor's words reminded him that while "man is an unspeakably mean and miserable creature," God provided a feeling of "stability." Even if humans destroyed the world, B. concluded, God would still impose "a divine justice [that] will give our weapons the ability to achieve final victory." Berthold B.'s narrative operates on different levels. His language mixes rhetoric that was familiar in prevailing propaganda coming from religious elites about God intervening to deliver the nation to victory. Further, he saw God as a provider of "divine justice" and order. At the same time, he contemplated a more subjective personal interpretation of God as a force who eased his nerves and shielded him against trauma.[30] In one of his last letters he described his fears to his parents and told them that he hoped to survive with God's help. He was killed on 31 January 1915.

Nerves and Faith under Fire: Coping with Uncertainty

For many, the collapse of nerves paralleled a crisis of faith. As men and women reached a breaking point of nervous collapse, their traditional belief systems and rituals also began to deteriorate. Ego documents

reveal how difficult it was for men and women to describe the erosion of their religious beliefs. Further, the language they used to narrate their psychological experiences and their faith varied depending on their audiences, and whether they were writing for loved ones at home, for comrades, or in their diaries.

Men and women experienced tremendous emotional turmoil when they began to fear their faith in God was ineffective. For example, Wilhelm S. called on his family to join him in asking God for protection, and he assured his wife Lisette and three daughters that they could maintain courage through their belief in God. Volunteering in 1914 at thirty-nine years old, Wilhelm S. was older than most of his comrades. A plumber and proud member of the Social Democratic Party who distributed SPD newspapers to other soldiers on the Eastern Front, he was critical of what he saw as the unfair treatment of front soldiers, who faced danger, starvation, and neglect, but he saw his survival, and the end of the war, as in God's hands.[31] Imagining his whole family praying for an end to the war was essential: "If you feel strong enough, I want to write you the full truth. Was twice in battle, but God had his protective arm over us. Just pray diligently (to comfort you, I'll do it for you too)."[32] However, only a few weeks later, he expressed worry that believing in God was inadequate:

> Just 50–60 km ahead of us, a big decisive battle is under way. We hear the thunder of our heavy guns here. [...] You just have to hope for the best that you do not lose courage and trust in God. It makes you wonder, it makes you think, that in times of need one recognizes God. But this is not the case and I think you have already realized that for quite a while. This is how it's been for some time, but I have not mentioned it. Don't give my letters to anyone else.[33]

Wilhelm S.'s confessional tone, and his worry about his wife sharing his letters, reveal a dramatic change from his earlier calls for family prayer and keeping the faith. He suggested to his wife that they were both struggling with the same fear and unable to find a way to discuss it.

The familiar rhetoric about God being in control no longer provided Wilhelm S. comfort. On Christmas day, he wrote to his wife that while he still believed that his fate was in God's hands, he was overcome with despair that over a year had passed and God had not intervened to stop the war.[34] Wilhelm S. felt ashamed of his anguish and sense of doubt. His sense of order began to crumble when he could not reconcile God's silence. He confided in his wife that he was on the verge of emotional collapse: "My love, forgive my weakness. As I write this letter here, tears

have started to flood [....] I have confidence that I have a good wife and children at home, who pray for me, and when I imagine this, then I regain courage and the future does not look so bleak. But sometimes the thoughts come and overwhelm me."[35] His embarrassment about being "weak" reflected masculine expectations that men maintain emotional self-control.[36] Belief in God was a cornerstone of masculinity, but once the former started to break down, so did Wilhelm S.'s veneer of manhood and emotional control. Wounded in 1916, he survived the war to be reunited with his family.

In reconstructing the emotional lives of soldiers and civilians through their letters and diaries, it is important to consider how individuals wrote to different audiences. In their letters to loved ones, men and women put up a veneer of stoicism. But they also revealed, often in a personal diary or when they wrote to another confidante, that they were experiencing emotional turmoil. This can be seen in the example of Antonia Helming, a middle-class Catholic matriarch from the Rhineland who encouraged her five sons to volunteer at the outbreak of the war. She was proud of her sons' patriotism, and encouraged them to maintain their courage when they wrote home about the stress of life at the front. But inwardly, she worried intensely about their physical and psychological survival. Religious faith was the principle language through which she and her sons articulated their fear and nervous stress. In October 1915, her son Hans wrote to her about how frightened he was under fire, but reassured her that his faith in God prepared him for death. He wrote:

On the eve of departure [for the front], I went to confession and received the same evening holy communion. So I was ready to fight and, if God wanted, to die [....] Repeated counterattacks by the French were bloodily repulsed. I want to keep silent about details. It is too terrible. I have to tell myself that I have nerves like twine [*Nerven wie Bindfäden haben*].[37]

The tension in her son's language is interesting. He intimates the horror of life at the front, but at the same time holds back, telling her that the "details" are too gruesome to describe. He also suggests that he must tell himself that his nerves are strong, but his phrasing hints that he suspected this was not actually true.

Antonia Helming transcribed her son's letter into her diary, where she also divulged her own emotional pain. Hans's diligence in taking communion and expressing faith in God reassured her, and she noted in her diary entries that this faith was essential to ensuring not just her son's salvation, but also his psychological strength. She wrote in her diary

that, as it was for her boys, taking the sacraments· was the most effective cure for her frayed nerves:

> All Saints Day. I received the holy Sacraments. It's the best consolation for a heart full of worries [*sorgenvolles Herz*]. I have recommended all my dear deceased and also my soldiers to the dear God [...]. My heart focuses on my dear, dear children. God bless their life paths.[38]

In the case of Antonia Helming and her sons, religious rituals enabled them to form a kind of symbiosis between the home front and combat front. Even if they were unable to convey entirely their traumatic experiences, they connected through shared religious faith to soothe their fragile nerves.

Perhaps most interesting about Antonia Helming's letter exchange with her sons is that while they used a 'language of nerves' to describe their stress, they explicitly expressed scepticism about psychiatry. For example, her son Hermann wrote about a Dr. Abbé who asked soldiers if they needed time on leave to recover from stress. Nobody volunteered that they had problems, Hermann wrote, because of the stigmatization when doctors singled them out and suggested they were weak. His comrades wanted to show they could "endure their post until the body or spirit can no longer permit it."[39] But he also suggested that this was just posturing. In reality, he admitted that men were concealing the fact they were on the verge of a nervous breakdown. He told his mother that life at the front was too stressful, and she should not let his younger brother go to war: "Do not let Otto on any account even think about volunteering. The young guys appear to physically cope well with the strain [*halten zwar körperlich die Strapazen gut aus*], but their nervous system is actually in a state of collapse [*ihr Nervensystem bricht zusammen*]."[40] Though he admitted that men were suffering from psychological breakdown, Hermann was critical of the doctors, because they got offended if men did not maintain an image of steel nerves. His mother assured him in a letter that faith in God was more reliable than doctors. She tried to console him with earnest promises that faith in God would keep him intact, and that the impending Christmas would bring all her children to her table where she could help them heal. However, after the Christmas reunion, she expressed in her diary fear that it might be their last.[41] Indeed, Hans was killed in late 1917.

Women on the home front were often consumed with anxiety about whether their sons, husbands, and fathers maintained their faith. In particular, they worried that in moments of isolation and suffering, and even death, their loved ones would feel abandoned by God or would lose their

faith. This anxiety about losing faith was on the mind of a nurse at a field hospital who wrote to the mother of a soldier she saw die of wounds in October 1914. The nurse, who signed her name only as Gisela, could not bear that a "mother's heart" would not know her son's last thoughts at his death. According to Nurse Gisela, the son scribbled a few lines of poetry just before he died. She pried the poem out of his hand when he passed away, and sent it to the mother. The poem, a dream-like and confusing stream of consciousness that the nurse said was produced in a "feverish delirium," suggested that the young man was tormented with guilt from the act of killing. In contrast to most religious crises expressed in ego documents, where men saw themselves as victims, this individual experienced a crisis over feeling like a perpetrator. As he ruminated on his role as an instrument of violence, he broke down with the realization that his actions caused others pain: "Great God, this is a terrible crisis [*schwere Not*]! / I used to kill every fly / But now I think about it: they are suffering." The young soldier signed his poem, "A tired infantryman [*Landskne-cht*]." Perhaps fearful of how a mother would take the delirious last lines written by a tormented son, Nurse Gisela tried to provide some comfort:

> Dear poor mother, he was so tired, your son; the artist whom the war had made an infantryman [*Landsknecht*] and who with noble enthusiasm gave his life for his fatherland. He died as an artist: steel struck him from the clouds. One piece [of steel] that hovered above him ultimately caused his death. God gave you a falcon of mourning to comfort you and lift you up.[42]

The nurse tried to counterbalance the son's last descent into crisis with reassuring images of a compassionate God, "noble" sacrifice for the fatherland, and a fateful death over which no one has any control. Portraying God as caring and present, Nurse Gisela offered some hope that the mother could cling to as she imagined her son's death.

Describing the Indescribable: Spiritual 'Rebirth' and Subjective Belief Systems

The war created what Benjamin Ziemann describes as a "laboratory of violence," which yielded diverse, complex psychological responses to killing and survival.[43] It was also a laboratory for religious belief. The language employed by men to cope with violence reflected their compulsion to experiment with new belief systems to explain the inexplicable. Christian-infused language about spiritual renewal and salvation enabled some men to reconfigure despair and isolation into a positive experience. This Christian tendency to turn suffering into something

meaningful and spiritually invigorating was a familiar element in early modern and nineteenth-century approaches to physical pain as a path to redemption and spiritual renewal.[44] However, sources also reveal how men turn away from a strictly Christian framework of thinking. In many of these cases, front soldiers described how they were transformed by front-line experiences. This triggered a search for spiritual revitalization or modification of beliefs, often through subjective thinking, to restore their psychological balance, especially after a period of individual stress and cultural distortion, an evolutionary process that has been analysed by anthropologist Anthony Wallace in his classic work on how individuals and societies modify beliefs and rituals to construct "a more satisfying culture," especially in the wake of trauma.[45]

This language about spiritual renewal can be found in the case of Theodor K., a businessman from Stuttgart who volunteered shortly after the outbreak of the war. Compared to other men in 1914, Theodor K. did not anticipate the war was going to be an "adventure," or a revitalizing nationalistic experience, and he reassured his wife that he would not go "blindly" into battle seeking an iron cross.[46] Instead, he saw the war as a test of his Christian faith, which gave him a sense of resilience against stress: "But as long as the war lasts, my duty and my place is here, and I hope and wish that I may persevere to the utmost. The worst thing that can happen to me is that I lose my good courage, but today I still give praise to God."[47] More than just perseverance, Theodor K.'s faith also gave him hope for spiritual rejuvenation, which he described in a letter to his wife just before Christmas 1914:

> But even now I do not want to complain as this time should become a time of moral regeneration for me if I survive it. It should at the very least be my preparation and purification for life in the judgment of God, which we hope for as Christians. I am thus in good spirits and cheerful about the dangers that threaten me.[48]

This language of spiritual "regeneration" offers a glimpse into how Theodor K. found meaning in pain and suffering. In the midst of trauma and destruction, he imagined himself as undergoing a process of moral and spiritual transformation, transcending the material world.

The concept of rebirth or rejuvenation was often expressed through the prism of Christian ideology, but the traumatic experience of the front also caused men to experiment with different kinds of images and language to articulate the spiritual impact of the war. Front soldiers used language that employed a hybrid of Christian imagery and more subjective beliefs drawn from their war experience. In the indescribable world

of the trenches, men had to generate an original language to narrate the bizarre conditions that surrounded them. Reading narratives in which men mixed traditional religious icons with images that were particular to their wartime environment reveals the process by which individuals constructed religious and spiritual beliefs.

Contemporary psychologists recognized the linkages between traumatic experiences and elaborate belief systems, whether orthodox, traditional beliefs, popular or 'superstitious' beliefs, or subjectively constructed beliefs, as useful psychological defense mechanisms. One of the most interesting psychologists who theorized on front soldiers' emotional responses to war, including the psychological significance of religious beliefs, is Paul Plaut. Plaut was not a professional psychologist, but rather a non-commissioned officer (*Unteroffizier*) with combat experience, who was enlisted by psychologists William Stern and Otto Lipmann at the Institute for Applied Psychology at Potsdam to administer and later analyse a 1914/15 questionnaire to front veterans, who were asked about their experiences in the trenches, attitudes towards the enemy, perceptions of danger, sexual life, and religiosity.[49] In 1920, Plaut published the results in the essay "The Psychography of the Warrior" ("Psychographie des Kriegers"). Analysing the questionnaires, and drawing from his own combat experience, Plaut considered the war experience to be quasi-sacred, not in the context of patriotic and nationalistic conceptions of heroism, but, in his eyes, because the act of killing took on a sacrosanct character in the imaginations of front soldiers, who were psychologically transformed as a result of committing the ultimate taboo.[50]

Plaut, raised in a Jewish household himself, characterized the pre-war Christian world view of front soldiers as an essential part of their responses to mass death, shaping their language for describing sacrifice, suffering, and concepts of eternity.[51] However, he was not so focused on how men processed trauma through pre-war traditional beliefs. Ultimately, he considered it almost impossible to objectively assess the religious convictions of front soldiers, especially their systematic or formal religious beliefs, as he considered their religiosity in the face of extreme violence too complex and elusive.[52] Instead, he was interested in their more unorthodox attitudes, and how men constructed new, subjective beliefs, which helped them make sense of the particular environment of the trenches. These sparks of feeling, so difficult to describe, fascinated him:

> Much more valuable are the singular phenomena and expressions of simple soldiers, who generally do not like to talk about religion and religiosity, because in the immediacy with which they face things, they recognize the absurdity that lies in an ecclesiastical-inspired enthusiasm for war. They

calculate the level of their religious conscience according to the magnitude of the danger and the result that they can draw from it.[53]

Men in combat, Plaut argued, thus had a very practical approach to religious beliefs, which were valued based on their usefulness in coping with danger. Church leaders who asserted that men become more religious as a result of combat, he insisted, were deluding themselves with a self-serving assumption. Instead, "the world view [*Weltanschauung*] [of soldiers] has become something deeper, certainly not Church-focused [*unkirchlicher*]."[54]

Thus rather than analyse orthodox belief systems, it would be more useful, Plaut argued, to approach men's beliefs as a constellation of various 'superstitions' (in German, *Aberglaube*, or 'alternative beliefs'), which he defined as any beliefs or rituals that gave men a sense of hope and self-preservation.[55] The triggers between stress and spirituality fascinated Plaut, and he quoted psychologist Albert Hellwig to emphasize the linkages between supernatural beliefs and trauma:

> The powerful blow to the nerves [*nervöse Erschütterungen*] [...] creates an extremely favorable mood for superstition [....] It produces primordial thoughts and gives those who are in deep distress a firm belief that they are under supernatural protection, thereby giving them the firm faith in which they will survive despair and transcend pettiness![56]

Plaut argued that a wide array of protective devices, including "lucky clovers, lucky pens, blessed coins, amulets," had the same psychological function as crucifixes, consecrated saint medals, Bible passages sewn into the hem of clothing, and the like. Any coincidence of a soldier surviving while carrying one of these devices was cited as proof of its efficacy, reinforcing soldiers' psychological dependence on such mechanisms for personal insurance.[57] Plaut cited interviews and letters with front soldiers, including the following from a student he corresponded with, who described superstition as a haven within which someone could insulate themselves from trauma: "Whoever has a bit of fantasy imagination maybe also possesses a bit of nervousness (*Nervosität*) and probably also cocoons himself with some superstition."[58]

Unprecedented violence and the collision between machines and humans took on a surreal and supernatural quality that required more than superstitious beliefs to explain. The war experience needed a new, or hybridized, language to represent it, and new belief systems to endure it. Front-line violence was so profound that some even considered the war experience, and the apparent miracle of survival itself, to be an object of

worship. This can be seen perhaps most famously in the post-war writings of Ernst Jünger, who was obsessed with the "inner experience" of war. Rather than just surviving, or becoming desensitized to violence, Jünger worshipped violence and extolled the ability of the "new man" to endure the strains of the front experience. In his post-war memoir *Copse 125*, he developed a metaphorical language that mixed different religious traditions to reflect on how men may have replaced the old gods with the worship of war:

> Hence man has no choice but to become a bit of nature, subjected to its inscrutable decrees and used as a thing of blood and sinew, tooth and claw. Tomorrow, perhaps, men of two civilized countries will meet in battle on this strip of land; and the proof that it must happen is that it does. For otherwise we should have stopped it long ago, as we have stopped sacrificing to Wotan, torturing on the rack, burning witches, or grasping red-hot iron to invoke the decision of God [....] The blood shall circle in [the land] fresh and earthy as the sap of a wooden spring and beat with as manly a pulse as in the veins of our forefathers who made a saint of the Messiah. Rather than be weak and timorous, let us be hard and merciless on ourselves and on others.[59]

Here Jünger mingles pagan and Judeo-Christian history and beliefs to make his case that war is a kind of eternal experience that men desire. Echoing Christian rhetoric, he saw the war as transformative, but not because its brutalizing effects would remind men of their sinful nature and cause them to repent within a Christian framework of thinking. Instead, Jünger argued that war strengthened men's psyches and spurred them to rediscover their true nature as "hard and merciless" warriors.

Jünger's post-war writings were a self-conscious attempt to reconstruct himself as a superhuman figure who transcended the brutality of the trenches. As historian Benjamin Ziemann has observed, Jünger's post-war reflections were a stylized literary treatment of the psychological effects of war, which were in contrast to his more reserved wartime diaries that focused on everyday mechanisms of survival.[60] Nevertheless, his hybridization of traditional Judeo-Christian imagery and pagan metaphors can be found in other veterans' accounts, especially in post-war memoirs. Rudolf Stark, for example, a fighter pilot who published in the last year of the Weimar Republic an edited version of his wartime diary, utilized pagan imagery to describe the traumatic effects of war. Biographical background, in particular his political orientation, is obscure. But Stark's 1932-published memoir is interesting for its descriptions of redemption from death, notions of transcendence beyond

the material world, and a sense of spiritual belonging in the war. In his preface, he wrote:

> But Death lost his terrors for us, because he became commonplace and natural. Our fear of Death vanished because we learnt to despise him [....] And we loved those combats above all else. Because we loved them whole-heartedly, the war became a thing of beauty for us. A set of values was created for us, and we knew nothing else save war. Therefore we found a home in the war.[61]

Though his themes, especially his ability to conquer death, often resonated with Christian ideas, his narrative rarely employed Judeo-Christian language. Instead of God, Stark found meaning, belonging, and redemption in the war experience itself, which became an all-consuming addiction, a kind of new god to be celebrated.

Stark utilized a subjectively constructed language to describe the "religion of war," and the values it taught him. At the same time, in contrast to Jünger's Nietzschean perspective, Stark also focused on the sense of loneliness and vulnerability that he felt at the front, in particular at the loss of comrades. In these instances, he relied on pagan imagery, especially Nordic mythology, to find emotional comfort. For example, when the famous fighter pilot Manfred von Richthofen, whom many worshipped as a kind of invulnerable hero, was shot down in April 1918, Stark put his grief in these terms:

> Richthofen dead! [...] A gloomy silence broods over all [...]
> Oh God of Battles, you can often let men die happy deaths!
> Clouds bank up – huge white pillars.
> Two ravens, birds of Odin, fly aloft and vanish in the high, blue vault.[62]

Trying to come to terms with the capricious "God of Battles," Stark evoked images of the Norse supreme god sending his raven messengers, and men hoping for a "happy death" to release them from mortal suffering.

Such stylized writing and imagery found in post-war memoirs was of course less prevalent in wartime letters and diaries. Nevertheless, narratives written at the front often mingled familiar religious beliefs with subjectively constructed images that provided comfort against traumatic experiences. An example of this can be found in the case of Karl Außerhofer, who wrote about how he conjured images of his dead friends as protectors, fusing Christian notions of spiritual intercession with his immediate experiences in the trenches. Außerhofer was a Catholic farmer from Tyrol who fought as an infantryman in the

Austrian army. His diary reveals an interesting evolution of beliefs. At the beginning of the war, he emphasized the importance of Catholic ritual and belief in God as an all-powerful protector. He described in his diary the experience of going to mass, and how he felt bolstered by attending church services with other men. He also believed the war was God's will designed to test men's faith, and he was optimistic that his piety would give him courage.[63]

However, after several months of combat, Außerhofer succumbed to despair at the intense violence and the loss of close friends. His language for describing traumatic experiences had changed by 1915–16. It became more subjective and shaped by the universe of the trenches rather than his Christian background. One of the effects of being surrounded by mass death is that he imagined his dead friends were still with him, guarding him against bullets and shells. He recounted in his diary how his friends intervened from heaven to protect him from enemy fire:

> It roared all night with cannons and explosions. I dreamed that a 42er [artillery shell] has exploded in an Italian camp and as I woke up, I realized I shit my pants [....] Today I got word from home that my [friend] Fritz had died, and this causes me much pain. When I was home last he ran everywhere after me like a puppy dog. He was already a little sickly then, but now he can look down from heaven and protect me from the enemy bullets as my guardian angel. I already have three such angels above that pray for me to come home healthy.[64]

Außerhofer found psychological strength by imagining that his dead friends could shield him from harm. As the war dragged on, he continued to express these kinds of beliefs, writing diary entries about how his dead comrades intervened on his behalf.[65] By the middle of the war, while he comforted himself with these images of "guardian angels" that meshed with Christian imagery, he stopped explicitly referring to Catholic rituals or worship services, which had taken such a prominent place in his diary in the first months of fighting. Außerhofer survived the war, gained German citizenship in 1935, and lived until 1965.

Many continued to find emotional courage in their belief in a Judeo-Christian God, but their beliefs became more individualized as they grew disillusioned with religious institutions, which felt increasingly remote and inconsequential. As men processed traumatic experiences, they also bypassed the institutional framework for traditional religious beliefs. While Christian leaders tried to encourage them by promising God would protect them and give them courage, some began to develop more personal relationships with God, and they interpreted God's will

through their particular lens of the trench experience. Moving away from the 'spirit of 1914' and prevailing masculine notions of sacrifice and emotional strength for God and the nation, some men gradually perceived God as understanding and compassionate if they did not possess strong nerves. Meanwhile, they resented pastors and priests behind the lines who pressured them to remain tough. This can be seen in the case of Hans F., whose diary is in the federal archive in Freiburg. His file unfortunately does not provide any biographical background, but his diary entry on All Souls' Day (2 November) 1915 reveals his emotions about pervasive death, and his belief that God would forgive him for breaking down:

> All Souls' Day mood! But my mood is not shaped by thoughts of the dead, the fallen comrades – no, it is despair, which is aroused by the most horrific conditions that surround us [....] After an hour we are soaked. Our feet have become cold, everything is stuck to dirt. Well, I think our Lord will forgive us if we lose patience in such an hour – [they say], "You have come here as a battering ram, you are destined to defy the enemy here in the most vulnerable place and to impose the same respect as you would in yours [....] Show your trust in God worthily."[66]

At the end of this entry, he sardonically quotes the chaplains who call on him to show an iron will out of respect for God. Here he distinguishes those official pronouncements from his belief in a God who sympathizes with traumatized men who cannot 'hold through.' He decided that God would be empathetic with front fighters and forgive them if they were not courageous. As religious and military elites tried to weaponize religious faith, men who bore the brunt of front-line violence resented their claim to ownership of faith in God.

Hans F. felt more than just disillusionment with inhumane Christian leaders. The psychological stress of front-line violence caused him to also question whether there really was a God. In 1916 he wrote:

> How often do you ask yourself: is it possible that there is still a Lord God [*Herrgott*]? Won't Germany see that life cannot continue this way? We've reached that point here already. Potatoes have gone out, bread and meat portions are getting smaller. [...] When one hears the comrades longing for a crust of bread, the last remnant of love for the fatherland disappears.[67]

At the beginning of the war, love for the fatherland was often equated with love of God, conflating religious faith and nationalism. However, once that belief in the nation eroded, so did belief in God. When authority figures could no longer provide the physical sustenance (food)

or emotional comfort (God) needed to survive, men fell into isolation and cynicism.

Conclusion

Men and women who relied on God to endure trauma occupied a fragile psychological zone. They saw themselves as victims of not only traumatic violence, but also an increasingly incomprehensible world where God's will had become obscure. Belief in God gave individuals a mechanism for resilience, as faith allowed them to relinquish a sense of control in a chaotic environment. At the same time, faith in God also left them psychologically vulnerable: when they faced unimaginable violence, they struggled to explain pain and suffering, as trauma often shattered their belief in an ordered world. Why would an all-powerful, benevolent God allow such unimaginable suffering?

The language used by front soldiers in ego documents to answer that question suggests a dramatic shift from hegemonic structures of thinking to more subjective interpretations of God. Many ordinary men and women employed traditional religious language, but the rhetoric about sacrifice and redemption that dominated at the outbreak of the war evolved into religious language that focused primarily on physical and psychological survival. Further, after witnessing slaughter on a mind-numbing scale, they modified the language of 'holding through,' and suppressing personal pain that permeated 1914 discourse. Many began to instead construct God as a figure who was empathetic with their personal experiences of psychological trauma. Their language suggested the construction of a broad spectrum of images and ideas that reflected their environment, including a hybrid of belief systems, fusing Christian imagery and more subjectively constructed supernatural assumptions. The breakdown in beliefs that adhered to orthodox ideologies also seemed to parallel the collapse of faith in the establishment, whether represented by religious, political, or military authorities. Though this broad spectrum of beliefs is a challenge for historians to reconstruct, letters and diaries reveal that religious language was a crucial prism through which individuals processed the trauma of total war.

NOTES

1 Jay Winter called for greater attention to religious faith as a coping mechanism in "The Language of Shell Shock," keynote presentation at the conference "Aftershock: Post-traumatic Cultures since the Great War," University of Copenhagen, 22 May 2013.

2 This is not unique to Germany in the First World War. For comparative contexts see, for example, Michael Snape, *God and Uncle Sam: Religion and America's Armed Forces in World War II* (Martlesham, UK: Boydell, 2015); Ron E. Hassner, *Religion on the Battlefield* (Ithaca: Cornell University Press, 2016).

3 A debate over whether the war eroded or reinforced religious faith in the First World War is the focus of much of the historiography, including Patrick J. Houlihan, *Catholicism and the Great War: Religion and Everyday Life in German and Austria-Hungary, 1914–22* (Cambridge: Cambridge University Press, 2015); Jonathan H. Ebel, *Faith in the Fight: Religion and the American Soldier in the Great War* (Princeton: Princeton University Press, 2010); Michael Snape, *God and the British Soldier: Religion and the British Army in the First and Second World Wars* (New York: Routledge, 2005).

4 Psychologists have spearheaded studies on the appeal of religion's promise of salvation and redemption. See, for example, Martin Riesebrodt, *The Promise of Salvation: A Theory of Religion* (Chicago: University of Chicago Press, 2010). Psychologists have also argued that beyond the framework of religion, humans have a tendency to turn trauma into a transformative or revitalizing experience. See, for example, Ursula Wirtz, *Trauma and Beyond: The Mystery of Transformation* (New Orleans: Spring Journal Books, 2014), 83.

5 For an overview of different approaches to and problems with analysis of letters and diaries, see Bernd Ulrich, *Die Augenzeugen: Deutsche Feldpostbriefe in Kriegs- und Nachkriegszeit, 1914–1933* (Essen: Klartext, 1997), 12–36.

6 See Benjamin Ziemann, *War Experiences in Rural Germany, 1914–1923* (Oxford: Berg, 2007; first published in 1997 as *Front und Heimat: Ländliche Kriegserfahrungen im südlichen Bayern, 1914–1923* by Klartext Verlag, Essen).

7 This has been stressed by Jay Winter, *War beyond Words: Languages of Remembrance from the Great War to the Present* (Cambridge: Cambridge University Press, 2017).

8 For an insightful analysis of semantics and diverse language in British and German soldiers' letters, see Aribert Reimann, *Der grosse Krieg der Sprachen: Untersuchungen zur historischen Semantik in Deutschland und England zur Zeit des ersten Weltkriegs* (Essen: Klartext, 2000).

9 See Kathleen Canning, *Gender History in Practice: Historical Perspectives on Bodies, Class and Citizenship* (Ithaca: Cornell University Press, 2006), 101–20.

10 The complexity inherent in ego-documents, and the diverse discourse employed by men to process trauma, are expertly analysed by Benjamin Ziemann in *Violence and the German Soldier in the Great War: Killing, Dying, Surviving* (London: Bloomsbury, 2017), 19–20.

11 Historiography on religion and the First World War that focuses on religious authorities includes Philip Jenkins, *The Great and Holy War: How World War I Became a Religious Crusade* (New York: Harper One, 2015); Edward Madigan, *Faith Under Fire: Anglican Army Chaplains and the Great War*

(London: Palgrave Macmillan, 2011); Annette Becker, *War and Faith: The Religious Imagination in France, 1914–1930* (New York: Berg, 1998).

12 Alexander Watson, *Enduring the Great War: Combat, Morale and Collapse in the German and British Armies, 1914–1918* (Cambridge: Cambridge University Press, 2008); Benjamin Ziemann, *Violence and the German Soldier in the Great War*, 37.

13 Ziemann, *Violence and the German Soldier*; see especially analysis of soldiers' narratives on pp. 43–9.

14 This is the central question posed by Patrick J. Houlihan in *Catholicism and the Great War*, 9–10.

15 Joanna Bourke, *The Story of Pain: From Prayer to Painkillers* (Oxford: Oxford University Press, 2014), 122.

16 Stefanos Geroulanos and Todd Meyers, *The Human Body in the Age of Catastrophe: Brittleness, Integration, Science and the Great War* (Chicago: University of Chicago Press, 2018), 316–17.

17 Ambrosius S., letter to Elisabeth B., Lenkirch, 2 April 1915, in *"Solange die Welt steht, ist soviel Blut nicht geflossen": Feldpostbriefe badischer Soldaten aus dem Ersten Weltkrieg 1914–1918*, ed. Landesverein Badische Heimat e.V. and Landesverband Baden-Württemberg im Volksbund Deutsche Kriegsgräberfürsorge e.V. (Freiburg: Rombach, 2014), 128–9. Translations of primary sources are by the author.

18 Anton K., letter to his wife, 26 September 1914, from Chateau-Salines, MsG2/4563, Bundesarchiv-Militärarchiv Freiburg (henceforth BArch-MA).

19 Jason Crouthamel, *An Intimate History of the Front: Masculinity, Sexuality and German Soldiers in the First World War* (New York: Palgrave Macmillan, 2014), chap. 3.

20 Hans S., letter to Ida, Bazancow, 17 March 1915, Hans S. file, Bd. 1, Württembergische Landesbibliothek, Stuttgart, Feldpostbriefe, Sondersammlung "Zeit der Weltkriege" (henceforth WLS/SZdW).

21 Hans S., letter to his parents, 3 August 1918, Hans S. file, vol. 2, WLS/SZdW.

22 Watson, *Enduring the Great War*, 92–100.

23 Eduard F., letter to an unnamed priest, 10 December 1914, in *"Solange die Welt steht,"* 90–1.

24 Historian Patrick J. Houlihan also argued that Catholic rituals and belief systems were particularly reassuring to front-line soldiers. See Houlihan's *Catholicism and the Great War*, 1–2.

25 On the diagnosis of "war neurosis," see Paul Lerner, *Hysterical Men: History, Psychiatry and the Politics of Trauma in Germany, 1890–1930* (Ithaca: Cornell University Press, 2003); on post-war stigmatization of "war hysterics," see Jason Crouthamel, *The Great War and German Memory: Society, Politics and Psychological Trauma, 1914–1945* (Liverpool: Liverpool University Press, 2009), chap. 3.

26 Friedrich B., letter to his wife, 2 November 1914, MSG 2/4739, BArch-MA.

27 Ibid.

28 Ibid.

29 Wilhelm W., undated diary entry, in *Kasseler Soldaten im Ersten Weltkrieg: Tagebücher und Feldpostbriefe*, ed. Bettina Dodenhoeft (Kassel: Scribeo, 2014), 51–2.

30 Berthold B., letter to his parents, 28 October 1914, from Stadtarchiv Bietigheim-Bissingen (StaBB), published in Christa Lieb, *Zwischen Heimat und Front: Feldpost: Die Kriegsjahre 1914–1918 in Bietigheim, Bissingen, Metterzimmern und Untermberg*, Schriftenreihe des Archivs der Stadt Bietigheim-Bissingen, Band 8 (Stuttgart: Frechdruck, 2009), 37.

31 Wilhelm S., letter to his wife and daughters, 15 November 1914, Alexandrowo, in *Feldpostbriefe von Mörfeldern und Walldorfern aus dem Ersten Weltkrieg 1914–1918*, eds. Cornelia Rühlig, Katja Englert, and Dagmar Sesche (Offenbach: Berthold Druck, 2014), 21.

32 Wilhelm S., letter to his wife, 18 November 1914, in Rühlig, Englert, and Sesche, *Feldpostbriefe von Mörfeldern und Walldorfern*, 22.

33 Wilhelm S., letter to his wife and daughters, 11 December 1914, Njescawy, in Rühlig, Englert, and Sesche, *Feldpostbriefe von Mörfeldern und Walldorfern*, 24.

34 Wilhelm S., letter to his wife, 31 December 1914, Ostwehr, in Rühlig, Englert, and Sesche, *Feldpostbriefe von Mörfeldern und Walldorfern*, 26.

35 Ibid.

36 On tensions over masculine ideals in imperial Germany, see, for example, Thomas Kühne, "Comradeship: Gender Confusion and the Gender Order in the German Military, 1918–1945," in *Home/Front: The Military, War and Gender in Twentieth-Century Germany*, ed. Karen Hagemann and Stefanie Schüler-Springorum (Oxford: Berg, 2002), 233–54.

37 Antonia Helming, diary entry, 18 October 1915, which transcribes a 15 October 1915 letter from her son Hans, sent from the front, in Antonia Helming, *"Mutters Kriegstagebuch": Die Aufzeichnungen der Antonia Helming, 1914–1922*, ed. Stephanie Fredewess-Wenstrup (Münster: Waxmann, 2005), 96.

38 Antonia Helming, diary entry, 1 November 1915, in Helming, *"Mutters Kriegstagebuch,"* 99.

39 Hermann, letter sent on 14 November 1915, transcribed by Antonia Helming into her diary, 21 November 1915, in Helming, *"Mutters Kriegstagebuch,"* 103.

40 Ibid.

41 Antonia H., diary entry, 26 December 1915, in Helming, *"Mutters Kriegstagebuch,"* 109–10.

42 Nurse Gisela, letter, 5 October 1914, im Lazarett, to Frau Kauer (mother of soldier tended by Gisela), in *1914: Briefe und Feldpostbriefe vom Beginn des Ersten Weltkriegs*, ed. Horst Schöttler (Hamburg: Severus, 2014), 111.

43 Ziemann, *Violence and the German Soldier*, 10–11. Joanna Bourke also analyses this tension, especially men's complex responses to killing, including

enjoyment. See Bourke's *An Intimate History of Killing* (New York: Basic Books, 2000).

44 Bourke, *The Story of Pain*, 122.

45 See Anthony Wallace, "Revitalization Movements," in *American Anthropologist*, 58, 1956, 265-266.

46 Theodor K., letter to his wife, 17 December 1914, Band 372, WLS/SZdW.

47 Theodor K., letter to his wife, 12 December 1914, Band 372, WLS/SZdW.

48 Theodor K., letter to his wife, 17 December 1914, Band 372, WLS/SZdW.

49 For an expert analysis of Plaut's background and the significance of his work, see Julia Barbara Köhne, "Paper Psyches: On the Psychography of the Front Soldier According to Paul Plaut," in *Beyond Inclusion and Exclusion: Jewish Experiences of the First World War in Central Europe*, ed. Jason Crouthamel, Michael Geheran, Tim Grady, and Julia Barbara Köhne (Oxford: Berghahn Books, 2018), 317–61.

50 Köhne, "Paper Psyches," 344–6.

51 Ibid., 346.

52 Paul Plaut, "Psychographie des Kriegers," in *Beihefte zur Zeitschrift für angewandte Psychologie* 21, ed. William Stern and Otto Lipmann (Leipzig, 1920), 73.

53 Ibid., 74.

54 Ibid., 77.

55 Ibid.

56 Ibid., 78.

57 Ibid., 78.

58 Ibid., 79.

59 Ernst Jünger, *Copse 125: A Chronicle from the Trench Warfare of 1918* (New York: Howard Fertig, 2003), 56–7; originally published as *Das Wäldchen 125* (1925).

60 An excellent overview of Jünger's approach to writing about killing and surviving can be found in Ziemann, *Violence and the German Soldier*, 60–6.

61 Rudolf Stark, *Wings of War: An Airman's Diary of the Last Year of World War One*, trans. Claud W. Sykes (London: Greenhill Books, 1933), preface; originally published as *Die Jagdstaffel unsere Heimat: Ein Flieger-Tagebuch aus dem letzten Kriegsjahr* (Leipzig: Verlag von K.F. Koehler, 1932).

62 Ibid., 46.

63 Karl Außerhofer, diary entry, 18 September 1914, in *Karl Außerhofer: Das Kriegstagebuch eines Soldaten im Ersten Weltkrieg*, ed. Sigrid Wisthaler (Innsbruck: Innsbruck University Press, 2010), 91.

64 Karl Außerhofer, diary entry, 3 August 1915, in Wisthaler, *Karl Außerhofer*, 103.

65 See, for example, Karl Außerhofer's diary entries for 27 August 1915 and 4 August 1916, in Wisthaler, *Karl Außerhofer*, 131 and 161 respectively.

66 Hans F., diary entry, 2 November 1915, MsG 2/2735, BArch-MA.

67 Hans F., diary entry, 16 March 1916, MsG 2/2735, BArch-MA.

3 Languages of the Wound: Finnish Soldiers' Bodies as Sites of Shock during the Second World War

VILLE KIVIMÄKI

From the beginning of the Finnish-Soviet war of 1941–44, Private Eino K. served in a rifle platoon in a distant northern front sector, where the front line consisted of sparse strongholds in a primeval wilderness. The platoon ran patrols between the pickets and in no-man's-land, which required calm nerves and good physical health. In the summer of 1942, after his first year of service, Eino K. started to suffer from a sore throat, hoarse voice, and worsening shortness of breath. He had to visit the army physician several times, and while in the field hospital in January 1943, he felt strange cramp-like "tugs" in his limbs. Soon afterwards he had an unexplainable seizure, in which his arms, legs, and facial muscles became rigid, followed by a ten-minute body tremor. As no physical causes were found, Eino K. was transferred to the psychiatric unit of the 32nd Military Hospital in Oulu, northern Finland, with a preliminary diagnosis of "psychoneurosis." Coming from an ordinary family, having passed his elementary school without problems, and with "normal intelligence" and "stable appearance," Eino K. was embarrassed by the suspicion that he had a psychological illness, yet he could give no explanation for his fragile condition. He was diagnosed with *"reactio psychogenea hysteriformis"* and sent to serve in the separate fortification companies for nervous convalescents. Eino K. returned to the 32nd Military Hospital in April 1944 for a new medical evaluation; this time his diagnosis changed to *"constitutio psychopathica."*[1]

Eino K.'s psychological condition and symptoms bear little resemblance to the contemporary psychiatric understanding of war trauma, dominated by the post-traumatic stress disorder (PTSD) paradigm, which emphasizes the psychological consequences of traumatic experience: persistent re-experiencing and/or avoidance behaviour, emotional numbing, and increased arousal. Instead, Eino K.'s case is similar to the many and diverse "hysterical" bodily seizures, spasms, and dysfunctions

recorded especially in the First World War and in earlier conflicts.[2] Soldiers also developed unexplainable physical symptoms, for example, in the German and Soviet armies of the Second World War, where military medicine had taken a negative stand against psychological complaints and "weaknesses." In such circumstances, soldiers' bodies seemed to offer a more acceptable outlet for expressing stress and shock.[3] It seems that if the surrounding culture was ignorant, deaf, or hostile to psychological verbalizations of anxiety, distress, and fear, then bodies started to demonstrate the prohibited language of mental anguish.[4]

This chapter discusses Finnish soldiers' somatic symptoms of trauma during the Second World War and the physicality of countermeasures employed against them at the military hospitals' psychiatric units. My aim is to study both the soldiers' shocking experiences and their treatments in military psychiatry as a corporeal phenomenon, whereby the bodies were the medium for communicating the wound and for attempts at healing (and suppressing) it as well. How did soldiers, who had no concept of war trauma available to them, show symptoms of trauma on their bodies? I want to challenge a too-straightforward explanation of so-called conversion disorders, according to which the earlier, bodily symptoms of stress and shock would present a kind of primitive, uninformed predecessor to our present-day understanding of trauma and PTSD. By looking at Finnish soldiers' bodies in 1939–45, I study how their manifold expressions of anguish rose both from a culturally specific background and from a historically specific war experience. I aim to show that the soldiers' bodily symptoms were not simply a misspoken language of trauma – before the evolution of modern psychiatry would provide the correct words for the traumatic experience. They were rather a language in its own right, a resource of meaning to express the horrors of war. To study traumatic experiences in the context of modern industrialized warfare with all its corporeality, bodies need to be taken seriously and it is necessary to see trauma as manifesting in bodies and minds alike, in their inextricable totality.[5]

During the Second World War, Finland was involved in three different conflicts: first in the so-called Winter War against the Soviet aggression in 1939–40, then in the so-called Continuation War as a 'brother-in-arms' of Nazi Germany against the Soviet Union in 1941–44, and finally in the Lapland War against the German troops in northern Finland in 1944–45. In these three wars, around 96,000 Finns lost their lives, out of a population of circa 3.7 million. Finland was never occupied during the Second World War and, compared to the rest of Europe, the Finns experienced rather conventional warfare, in which nearly all fatalities were members of the Finnish armed forces. Consequently, almost all persons hospitalized

for war-related psychiatric disorders were also servicemen. Altogether around 18,000 Finnish soldiers ended up in psychiatric care during the war years. This translates to roughly 2–2.5 per cent of all the men serving in the Finnish Army during the Second World War.[6] The figure includes common peacetime mental illnesses such as schizophrenia; yet the overwhelming majority of the cases were disorders that would nowadays be considered war-related psychological or psychosomatic injuries.

The single most important sources for this chapter are the psychiatric patient files from the Finnish military hospitals' psychiatric units in 1939–45. In order to collect a cluster sample of psychiatric patient files for my doctoral dissertation, I chose five military hospitals with psychiatric units in 1941 and five in 1944. All the chosen hospitals had major psychiatric units, and they were thus representative of a large body of soldier-patients and of mainstream Finnish military psychiatry. A random sample of psychiatric patients was then taken from each hospital: altogether 369 patients, 161 of them for 1941 and 208 for 1944. The sample contained some small groups of patients who fell outside the scope of the study or whose patient files were insufficient to be used in this research. These patients were eliminated from the analysis, which then produced a sample of 315 patient files. To cover the Winter War, the data were later supplemented by a representative sample of psychiatric patient files from a single military hospital in 1939–40 (see note 15). Besides the statistical sample, I have also studied a large number of unsystematically chosen patient files. All in all, the work here is based on the reading of over 550 military psychiatric patient files from 1939–45.[7] Furthermore, I have made use of the wartime archives of the Finnish Army medical services as well as the military psychiatrists' published articles and some other published sources in which the soldiers' bodily experiences of stress and trauma have been discussed.

A New Type of Wound

Despite the short Civil War in 1918 – fought mainly between two amateur militias – the Finnish experience of the First World War was limited. News reports depicting the novelties of warfare were published, of course, and roughly 2,500 Finns fought as volunteers or professional soldiers on the Eastern Front, in both the Russian and the German armies. These numbers were, nevertheless, relatively modest, and none of these soldiers ever experienced the conditions of the Western Front in 1914–18. In the 1930s, psychiatrist Martti Kaila published three academic articles on the German lessons in treating "traumatic neurosis,"[8] and some of the famous novels of the Great War, such as Erich Maria Remarque's *All*

Quiet on the Western Front (1929), were translated into Finnish. It is safe to say, however, that the horrors of the First World War had largely escaped the Finnish cultural imagination and medical profession alike. There is rarely if ever a totally blank slate for any historical phenomenon; yet the Finnish discourse on "war neurosis," "shell shock," or "trauma" was very thin before the Second World War.

Consequently, as the Red Army crossed the country's border on 30 November 1939, Finnish soldiers, medical officers, and civilians came into contact with a new disorder, a large-scale emergence of acute war-related mental breakdowns. The most destructive experience of modern warfare was the massive artillery barrages, which closely resembled the drumfire on the Western Front in 1914–18. Authors K.A. Järventaus and Erkki Palolampi had both experienced some of the most violent battles of the Winter War in Kollaa and Summa, where the Red Army used its material superiority to break through the Finnish defences for weeks and months in a row. Järventaus and Palolampi published their experiences immediately after the war in 1940 and gave two similar descriptions for this novel experience of "shell shock" or, if translated literally, "shell terror" (in Finnish *kranaattikauhu*):

Shell terror is one of the most difficult problems at the front lines, because it spreads easily. If there is an opportunity to observe the men during a constant artillery barrage, the symptoms are easy to spot. A soldier thus afflicted should be relieved as soon as symptoms appear. A man's eyes start glazing unnaturally and the sides of the mouth turn downwards in an unnatural way. As a whole, his expression reflects inexplicable horror. And when the next shell explodes, the man loses it completely. He drops into the bottom of the trench, tries to protect himself in childish postures and repeats the names of his loved ones in a pitiful, childish, complaining voice. And what is the most curious: his whole body seems to shrink, shrivel to an unnaturally small size ...[9]

The men's nerves were extremely strained – thousands of fiery hammers banged in their brains during the deadly drumfire. Minds are apt to shake when casualties increase, men die and get wounded, dugouts collapse, and the stations are turned into raw earth pockmarked by craters. The ones who wait in the dim dugouts have a questioning look in their eyes, the faces of others twitch nervously, the restless hands grip the equipment, words come hard, and many pray in silence. [...] One man laughs monotonously, another weeps hysterical tears.[10]

From the early days of the Winter War, the Finnish front-line soldiers began to use a colloquial term, "shaken up" (*tärähtänyt*), for those of

their fellows who had lost their nerve or sanity in war.[11] Besides being associated with jolting, trembling, or vibrating, the term is closely related to being struck forcefully. In the post-war dictionary of Finnish military slang, *tärähtää* (to get shaken up) and *tärähtänyt* (a shaken-up person) are introduced as wartime concepts.[12] Nevertheless, it is possible that the word had been used in a somewhat similar fashion before the Second World War. In some areas of Finland a dialectal derivative (*olla täreissänsä*) to the root word *täristä* (to shake) had had an association to "being excited"; and in the dictionary of Helsinki city slang, the use of *tärähtänyt* to mean "crazy" is dated broadly to "1920s–1960s."[13]

Yet *tärähtää* gained new corporeal content in its front-line usage. Like the English term "shell shock," which was born out of the mentally devastating experiences caused by the unforeseen artillery firepower first encountered in the winter of 1914–15,[14] being shaken up had a strong bodily connotation referring to concussions. In the psychiatric patient files of the Winter War, the victims of artillery barrages and shell explosions exhibited mainly physical symptoms, without suffering from any objective physical injuries. Typically, after surviving a bombardment, a soldier experienced a fit of uncontrollable trembling affecting his limbs, head, or his whole body. He was often assailed by feelings of enormous feebleness and exhaustion, which made his body collapse into a totally limp state. Their condition resembled those suffering from brain concussions: the shaken-up soldiers showed confusion, disorientation, temporary unconsciousness, and loss of memory; they also suffered from palpitations, headaches, shortness of breath, and nausea. Sometimes the shock was accompanied by different sensory and motor dysfunctions (see Image 3.1). After the incident, the soldiers started to have violent nightmares or could not sleep at all. They had delusions related to the event, most often the constant tumult of shelling in their ears. Haunted especially by the sight of their fellow-soldiers being torn apart in explosions, these men were heavily downhearted and easily disturbed, irritated, and tearful.[15]

Among the military psychiatric patients, the consequences of being shaken up were so enduring and severe that they disabled the soldiers altogether. But other combat soldiers recognized the same fear and stress, which had made some of their mates collapse completely. Symptomatically, two slang words for the front-line positions and sentry dugouts were the "trembling pit" (*vapisemiskuoppa*) and the "nerve pit" (*hermokuoppa*).[16] Keeping one's fear in check under heavy bombardment required a great effort of will. When the artillery caught soldiers unguarded, everyone could temporarily get shaken up. Front-line medical officer Johannes Heilala witnessed at least twice how a sudden lone shell explosion woke up a tent full of sleeping soldiers: "Many of the men

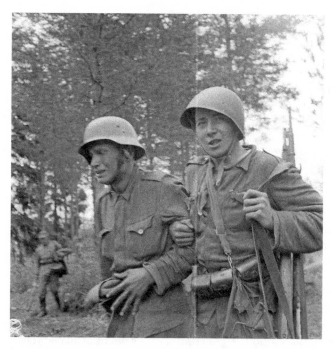

Image 3.1. "A soldier's equilibrium has been shaken by a shell explosion," reads the original caption from July 1944. Mentally wounded soldiers exhibited strong bodily symptoms similar to this man's manifestations, and they were often thought to suffer from physical concussions. Source: Finnish Wartime Photograph Archive, SA Photo no. 155 977.

trembled from head to toe. They suffered from strong tremors I have not seen in any other situations."[17] Usually such symptoms were short lived, as in Heilala's cases too. When possible, the army tried to rotate troops between front-line service and rest behind the lines, and soldiers were granted short home leaves on a regular basis, to provide the troops with sufficient relief from front-line stress.

The terror caused by artillery was not at all irrational: artillery was the most lethal weapon on the Finnish-Soviet front lines of the Second World War.[18] The more intensive the fighting, the more concentrated the shelling, and especially in the defensive battles of the Winter War and again in the summer of 1944, the Soviet artillery dominated the battlefield. In a statistic based on a single Finnish infantry regiment taking part in the heaviest combat in June–July 1944, as high as 79 per cent of casualties were caused by artillery fire.[19]

It is worth noting that the Finnish genesis of "war neurosis" in the Second World War followed roughly the same lines as the same phenomenon on the Western Front in 1914–15. First, there was the moment of shock, most importantly inflicted by the massive concentrations of indirect fire never before experienced at the same scale and strength as on the Western Front from the end of 1914 onwards and, in the Finnish case, in the trenches of the Winter War in 1939–40. All in all, the symptoms found in shaken Finnish soldiers were remarkably similar to those of the "shell-shocked" soldiers of the First World War,[20] although this phenomenon was practically unknown to Finns of 1939–45. As Leo van Bergen has noted, the list of causes for soldiers' mental breakdowns in 1914–18 is endless, but artillery fire was, by far, the most common instigator.[21] After the term "shell shock" was introduced in the British Army and public discourse in 1914–15, it quickly spread to soldiers' everyday use. Many of the officers and military psychiatrists tried to forbid the use of the term as harmful for the army, but this proved to be impossible: "shell shock" had become a commonplace notion, because it managed to encapsulate so vividly and dramatically the front-line soldiers' experience of what it meant to be under drumfire. Furthermore, "shell shock" seemed to denote a genuine, physical war wound caused by external factors, thus alleviating the morally laden connotations of cowardice and insanity.[22]

The Finnish concept of *tärähtänyt* shares much the same qualities, although it seems that it is not quite as neutral and physical as the English "shell shock." In Finnish soldiers' usage, the term had some dismissive and even pejorative associations. Unlike being shocked by a shell, the "shaken-up"' men were somewhat "derailed" from what was normal; a soldier was not really wounded, but "only" shaken up; a shaken-up person bordered on being a bit "loony." At the front lines, everyone feared being shocked, and everyone occasionally was, but becoming a "shaken-up" man seems to have meant a more or less irreversible crack in one's cohesive fibre, which other soldiers managed to hold intact. Calling the shocked soldiers "shaken-up" was not without pity and understanding, but it was also an exclusionary term, separating men who were broken from the rest.

Just as the symptoms of shell shock had initially led some of the medical officers of the First World War to suspect a somatic basis for the disorder, Finnish medical officers working close to the front lines and unfamiliar with the emerging tenets of military psychiatry also tended to expect hidden physical causes. Besides the obvious cases of mental breakdown, the soldiers arriving at the field dressing stations appealed to a variety of different somatic problems such as chest and stomach pains, dizziness, headache, nausea, and so on. In the primitive conditions of the field,

these kinds of ailments were usually impossible to objectify in any precise way other than by soldiers' self-reporting. It is probable that many of the cases were psychosomatic in nature, caused by the intense stress, fear, and exhaustion at the front lines. Many of the psychiatric casualties were initially treated as brain concussions.[23] Finally, in November 1941, the Finnish Army High Command had to issue rare diagnostic instructions to all the field hospitals to be more careful in diagnosing concussions: many of the psychological disorders had come to be labelled with this condition, although there was no physical head injury to be observed.[24] Still later, the medical officers recorded unexplainable nervous system failures, which caused headache, palpitations, and circulatory disorders. Such cases as Eino K.'s, described at the beginning of this chapter, come close to the so-called "soldier's heart" syndrome, which was one of the early medical attempts in the nineteenth century to diagnose soldiers' strange psychosomatic conditions.[25]

Bodies as the Language of Agony

In the summer of 1944, Private Aarne P. served in an infantry regiment that was hastily transferred to reinforce the shattering Finnish defences under the Soviet offensive. The regiment took part in the fighting in which the spearhead of the Soviet assault was finally halted. In these battles, both sides used unprecedented quantities of heavy artillery fire. According to his comrades, Aarne P. had earlier been a reliable and brisk soldier. Now, brought to a field hospital, he was in a state of complete confusion, only repeating the words as he gasped for breath with his hands seized up: "They shoot, they shoot." Evacuated to the psychiatric unit of the 59th Military Hospital, he was still shaking but able to talk in a whispering voice about how he had experienced a Soviet artillery barrage and lost all his senses – that was the only thing he could remember. Aarne P. was afraid of all loud noises and kept "seeing Russians in his eyes." He was given six electroconvulsive treatments (ECT), and his condition was improving, but in September, after the Finnish-Soviet armistice, some nearby gunshots precipitated a confused state during which he shouted and talked about an angel that he saw. In an awestruck tone he asked for permission to visit his parents. At the time of the general demobilization in November 1944, Aarne P. was sent home from the hospital with the diagnosis *reactio psychogenea*.[26]

Often the psychiatric patient files do not contain any utterances by the patients themselves, but Aarne P.'s few words here allow us a glimpse into his experience. What we might see there is the moment of violence: the shell explosion, or probably a barrage of explosions, showering his

dugout, the sound and quake of which broke one's senses. Although Aarne P.'s memory was otherwise gone, this experience would not fade from his mind. It was coupled with the image of Red Army soldiers, and indeed the artillery barrages at the front were usually followed by infantry assaults. The exact nature of the angel hallucination is impossible to reconstruct. Yet drawing from the Christian tradition in Finnish culture, we could expect the angel to point towards an experience of dying – or an experience of being miraculously saved by heavenly protection. In either case, Aarne P. still felt himself to be in the immediate vicinity of death, even if he was now safe in a Western Finnish military hospital and the war against the Soviet Union had already ended. He was trapped in the moment that would not go away: the moment of his wounding in the artillery fire, although his body remained physically unscathed.

By looking at the sample of 315 military psychiatric patient files from 1941 and 1944, we can get an overall view of the Finnish soldier-patients' symptomatology during the war years. The sample covers three distinctive phases of war: the Finnish offensive (June–December 1941), the last stage of the quiet stationary war period (January–May 1944), and the Soviet offensive (summer 1944). The aim here is not to observe the similarities and differences between these three periods, but rather to look at the symptoms in their entirety. For this purpose, Table 3.1 collects all the symptoms recorded in the patient files, divided into four groups according to their type, a method not aiming at medical precision[27] but serving as an instrument in grasping the general expressions of soldiers' psychological ordeals:

The compilation provided in Table 3.1, as well as the details of Aarne P.'s case demonstrated above, would allow for a discussion of the many post-traumatic features in the patients' symptoms – at a time when there was no understanding of "post-trauma" in Finnish psychiatry. My focus, however, lies elsewhere. In my view the most striking thing in the collection of symptoms is their acute corporeality: altogether 77 per cent of the patients experienced some psycho-physical symptoms. It seems evident that the present-day concept of PTSD, with its strong emphasis on the psychological, is not sufficient to understand the somatic nature of these experiences. We can get a better view of the question of corporeality by looking at the frequencies of individual psycho-physical symptoms in Table 3.2.

As we can see, different kinds of tremor appeared in 45.3 per cent of all the psychiatric soldier-patients. Unfortunately, this is a broad category. Because the patient files do not usually allow the scaling of symptoms by their gravity, the tremor here can mean anything from shivering hands to shaking bodies. Headaches, dizziness, nausea, palpitation, chest pains, stomach problems, and respiratory arrest form another diverse group of somatic ailments, most of which are based on the patients' subjective feelings rather than objectively diagnosable findings. But even concrete

Table 3.1. Grouped Symptoms in the Psychiatric Patient Files: Frequencies in %

	Among all (N = 315)	June–Dec 1941 (N = 132)	Jan–May 1944 (N = 100)	Summer 1944 (N = 83)
1. Distress and depression symptoms	87.1	83.6	88.0	91.7
2. Psycho-physical symptoms	77.4	76.1	76.0	81.0
3. Dissociative symptoms	51.9	55.2	41.0	59.5
4. Social symptoms	31.8	23.1	43.0	32.1

Source: FNA, the sample of patient files from the Finnish military hospitals' psychiatric units in 1941 and 1944.

Table 3.2. Psycho-Physical Symptoms in the Psychiatric Patient Files: Frequencies in %

	Among all (N = 315)	June–Dec 1941 (N = 132)	Jan–May 1944 (N = 100)	Summer 1944 (N = 83)
1. Tremor	45.3	45.5	41.0	50.0
2. Headache	35.5	30.6	37.0	41.7
3. Dizziness, nausea	28.0	30.6	21.0	32.1
4. Palpitation, chest pains	19.2	17.9	22.0	17.9
5. Limbic dysfunctions	13.5	11.9	11.0	19.0
6. Stomach problems	11.0	11.2	10.0	11.9
7. Respiratory arrest	7.9	5.2	11.0	8.3
8. Fainting, insensibility	7.5	5.2	11.0	7.1
9. Body seizures	5.7	3.0	9.0	6.0
10. Bedwetting	2.5	2.2	4.0	1.2
11. Blindness or deafness w/o physical cause	1.3	2.2	0.0	1.2

Source: FNA, the sample of patient files from the Finnish military hospitals' psychiatric units in 1941 and 1944.

and severe symptoms – limbic dysfunctions, fits of fainting or temporary insensibility, and body seizures, where the patient's body convulsed or became completely paralysed – manifested in 13.5 per cent, 7.5 per cent, and 5.7 per cent of all the cases, respectively. All the psycho-physical symptoms here were seen as having no objective physical cause, so the list does not include recognizable war wounds and symptoms of somatic

illnesses. At the extreme end we have the few cases of "hysterical" blindness or deafness, thus also without any physical injury.

It is important to note that such lists are based on the psychiatrists' attempts to classify their patients' symptoms, whereas the patients themselves rarely felt their disorders in such clear-cut fashion. Different symptoms combined to create an endless variety of unique individual conditions, from which the doctors tried to deduce their uncertain and imprecise diagnoses. What this clinical labelling and itemization misses, in my view, is the physicality of the patients' condition in its total: the shock was experienced limitlessly in the whole body.

If we view the psychiatric soldier-patients' bodily symptoms as a kind of discourse on agony, we might recognize at least two cultural sources from which the bodies draw their language. First, even though there was no discourse on "trauma" available to the soldiers, the turn of the twentieth century saw a keen interest in various, almost epidemic "neuroses" and "neurasthenia" among the Finnish population, allegedly brought on by the new modern life. This was a popular phenomenon that was not limited to a small circle of medical professionals: ordinary Finns started to observe their nerves for signs of fragility and exhaustion.[28] It is crucial to understand that "neurosis" here was understood as a real somatic ailment, as a disorder of the nervous system.[29] Thus, many of the symptoms in Table 3.2 could be seen as the commonplace symptoms of a nervous breakdown manifesting in bodies. In order not to be considered "psychopaths," "lunatics," or "malingerers," the soldiers at the edge of their mental and physical endurance appealed to their failing nerves – with a connotation of a genuine organic ailment – rather than to their psychological problems.[30] The etymological root of the Finnish word *hermo* (nerve) is a word that means a tough strand or twig, typically of willow. Before its medical adaptation, *hermo* had been used to mean strength, vigour, tenacity, and integrity. Old words for the lack of such "nerve" (*hervoton, herpaantua, herppo*) have connoted weakness and limpness – someone lacking resilient fibre.[31] It is almost eerie to see how the broken appearances of the Finnish "war neurotics" of the Second World War mirrored these age-old meanings as a somatic condition.

Second, it is worth noting how the patients' most severe physical symptoms closely resemble epileptic seizures. Epilepsy, or colloquially in Finnish the "sprawling illness" (*kaatumatauti*), was a well-recognized illness at the time. Like "neurosis," it was a kind of border case between somatic and psychic disorders. Some of the soldier-patients in the military hospitals had epileptic relatives whose seizures they had witnessed – yet the military psychiatrists could not diagnose any genuine epilepsy in their patients. It could be that in such cases mental breakdown could

take the form of symptoms resembling epilepsy: not in any simulative manner, but as a true manifestation of personal emergency and agony.[32]

Yet as intriguing as they are, I consider such symptom genealogies insufficient for properly understanding the essence of bodily symptoms. They seem too scholarly to grasp the experiential reality of front-line conditions, as if the traumatized soldiers would have "cited" their symptoms from earlier "literature." The missing component is the most obvious one: the extreme physicality of front-line violence itself. We have already discussed the shattering effects of artillery fire, and among the many aspects of modern warfare, the experience of terrorizing helplessness and immobility under drumfire seems, indeed, to have been the most forceful and traumatic.[33] But the battlefield was full of other horrendous sensations: the tearing sound of machine guns, the howling of dive-bombers, the breathtaking airbursts from explosions, the mechanic rattling of tank tracks, and even the bayonet thrusts in close combat. All of them revealed the naked vulnerability of human tissue. Over three quarters of the psychiatric soldier-patients had served in the front lines either immediately before being hospitalized or at some earlier stage of their military service. Thus the great majority of them had experienced the same physical ordeals as those of their fellows, whose bodies were pierced, crushed, stabbed, cut, burnt, torn, and mutilated – the only difference is that the soldier-patients were missing actual wounds as evidence of this experience. So even if their bodies were objectively unscathed, they *felt* themselves wounded by the violent circumstances at the front. The power of this traumatic experience manifested in the tangible corporeality of their symptoms, impossible to be simply "simulated" in any reasonable meaning of that word.[34]

I am not claiming a straightforward causality here, suggesting that the experience of drumfire would have simply necessitated a set of "drumfire-like" symptoms, although such a direct link is visible in a multitude of "shaken-up" soldiers. Various psycho-physical symptoms naturally existed already before the war, and during the war they could be experienced by soldiers who had not served at the front. Instead, I argue that modern industrialized war was a corporeal experience to the extreme, characterized by the physical aggression directed to vulnerable bodies. It was a massive attack on the physical integrity of human bodies. As an imagined threat, this experience was also intense outside the combat zone. Already the fear and stress caused by the proximity of violence were deeply-felt bodily sensations. Eino K.'s case above is a good example of how the bodies expressed this experience of being under continuous physical threat. The location of trauma in bodies was further reinforced by the nature of military medicine, which focused its attention on acute

somatic wounds and ailments. Bodies were thus the site for experiencing shock and vulnerability and for seeking medical attention to this injury. But they also proved to be the site for a renewed assault on the shocked soldiers in medical care.

Psychiatric Assault on the Body

As elsewhere, the diagnostic categories and policies of Finnish military psychiatry were a rather confusing field. Suffice it to say here that Hermann Oppenheim's famous First World War theory of traumatic neurosis, according to which soldiers' symptoms were caused by microscopic physical damage to the nervous system by shell explosions, thus making "war neurosis" similar to any other physical war wound, [35] was also known to Finnish psychiatrists. In early stages of the war, it even gained some support from Dr. Lauri Saarnio, who led an important military psychiatric unit during the Winter War. [36] But just as in Germany after 1916,[37] the tenets of Oppenheim's theory were refuted in Finland during the Second World War; Finnish psychiatrists did not recognize their patients' psychological or psycho-physical disorders as proper war wounds. Under conditions of extreme stress and exhaustion, temporary psychological symptoms could appear even in "normal" soldiers. But if the symptoms were severe and did not disappear quickly by themselves, the medical officers contested their war-related nature and located the real reason for the disorders in soldiers' mental constitution, inheritance, pre-existing weaknesses and attitudes, and other personal qualities and flaws. Because of the lack of psychological and psychoanalytic perspectives on "war trauma," soldiers' long-lasting symptoms were not seen as a problem of "traumatic memory" or as caused by the extreme front-line experiences.[38]

Notwithstanding the diagnostics, I will focus here on the shock treatments (or the "physical treatments," as they were often called) employed at the Finnish military psychiatric units. By coincidence, the phenomenon of war-related psychological injuries emerged when psychiatric treatment practices were in the midst of a radical change. The introduction of shock treatments from the mid-1930s onwards was expected to revolutionize civil psychiatry at large. Previously, despite psychiatrists' efforts, psychotic patients rarely recovered and mental asylums had remained places of isolation from society rather than places of recovery. Consequently, the psychiatric profession warmly welcomed shock treatments by insulin, Cardiazol (also known as Pentazol or Metrazol), and electricity as enabling true therapeutic progress. Finnish civilian psychiatrists began using these new treatments at the end of the 1930s and, when called to service during the war, applied them in military psychiatry as well.[39] By

looking at these peculiar and violent therapies, I aim to supplement the findings on the physicality of "mental wounds" by the physicality of their treatment. The paradox here is that while Finnish military psychiatrists dismissed their patients' psycho-physical symptoms as not presenting any real, somatic war injury, they employed physical treatments to counter these injuries, which they regarded as psychopathological in nature.

We can find detailed descriptions of implementation of shock treatments in German psychiatrist Anton von Braunmühl's handbook *Insulinshock und Heilkrampf in der Psychiatrie*, to which Finnish military psychiatrists referred as their guide.[40] The first of the treatments was insulin coma therapy, invented by Austrian psychiatrist Manfred Sakel in 1933–34 and introduced in Finland from 1936 onwards.[41] Here, the patient was given an insulin injection, which caused him to sweat, salivate, and begin to feel sleepy and limp. Additional insulin injections were given so that the actual "shock" began at the fourth hour. Tension in muscles grew and could finally lead to convulsions and strong spasms. If a full coma was induced, the patient completely lost consciousness. He was then tube-fed liquid sugar, which made him regain consciousness. The treatment was occasionally followed by an aftershock, and thus it was important to let the patient rest, and to continue to monitor his condition for the rest of the day. The minimum treatment time in civilian psychiatry was considered to be around two to three months with about thirty to forty "full shocks" (i.e., full-scale comas), but in difficult cases treatment could continue for up to half a year.[42] Yet in military use, there was rarely a chance for such an extensive course.

The second treatment, Cardiazol, was developed by Hungarian neuropathologist Ladislaus von Meduna (born László Meduna), and employed in Finnish mental asylums from 1937 onwards.[43] Von Braunmühl disliked the treatment because of its violence,[44] but nevertheless gave a detailed description of its application. The patient was to lie in bed with a cloth between his teeth to avoid biting his tongue. A dose of the circulatory drug Cardiazol was injected into a vein. Unlike insulin, Cardiazol launched a reaction in five to ten seconds after injection. First, the patient lost his speech, started to stare, and became dizzy. He could feel himself losing consciousness and see either blackness or red flames in his eyes; sometimes he hallucinated. At the start of the seizure, the patient shouted, expressed terror, and moved restlessly; often he tried to climb out of the bed. As he entered the actual convulsion, the patient's breathing stalled with a scream or sigh, his limbs cramped, and the whole body curved involuntarily. In the final stage, breathing returned, but the patient moved restlessly, sweated heavily, moaned, and expressed pain. Sometimes the patient immediately fell asleep. All this lasted only thirty

to sixty seconds. Two to three treatments were to be given in a week; if no recovery was observed, the course was halted after twenty to thirty full-scale seizures, but such extensive treatments were rare in Finnish military hospitals' psychiatric units.[45]

The third shock method was electroconvulsive therapy (ECT), which was pioneered by Italian psychiatrist Ugo Cerletti and first tested with a human patient in April 1938. The first ECT devices arrived in Finland in 1941, and during the war years more devices were acquired.[46] The application of ECT was relatively simple. The exact methods may have varied, but according to von Braunmühl, the patient was to lie on one side in a fetal position with a cloth in his mouth (see Image 3.2). Two electrodes wired to the device were pushed firmly against the temples. The current had to be strong enough to cause the patient to lose consciousness and then have a full epileptic seizure; otherwise, the patient could experience a "lightning strike" sensation while awake. Yet too strong a shock could be dangerous. After the shock had been initiated via electricity, a latency period lasted from one or two seconds to almost a minute. Typical for the actual convulsion were the flection and abduction of the patient's legs, reflexive movements, and then a rigorous stiffening of the body followed by cramps. The course of the ECT treatment was the same as with Cardiazol: two to three shocks per week with the treatment to be halted if twenty to thirty full seizures did not bring about any recovery.[47] ECT must be distinguished from the "electroshocks," or "active therapies," already used in military psychiatry during the First World War, the so-called "Kaufmann cure" and "faradization." The latter were electrocutions used as a form of punishment and torture, with no real medical purpose.[48]

A fourth method of shock treatment combined insulin coma either with Cardiazol or with ECT. Psychiatrist Ilmari Kalpa tested this so-called block method with civilian patients at the Pitkäniemi hospital in 1940. He noted very positive results when the patient entering coma was given reduced doses of Cardiazol, which did not cause full convulsions. Thus the method did not elicit such terror as pure Cardiazol treatment did, and it caused fewer physical complications. Furthermore, it could be applied every day in contrast to two to three days a week. The results seemed positive, but during the coming war years the method was restricted due to insulin shortages. Some patients at the psychiatric unit of the 10th Military Hospital in Pitkäniemi were treated with the block method, but I have not been able to establish whether the method was used elsewhere.[49]

The exact frequency with which shock treatments were employed at Finnish military hospitals' psychiatric units is difficult to determine.

Abb. 36

Lagerung des Kranken zur Krampfbehandlung. Die mobilen Elektroden werden manuell an die Schläfen des Patienten gedrückt.

Image 3.2. Renewed shock: medical instructions to apply electroconvulsive therapy in psychiatrist Anton von Braunmühl's manual. Source: Anton von Braunmühl, *Insulinshock und Heilkrampf in der Psychiatrie: Ein Leitfaden für die Praxis*, 1938, 2nd rev. ed. (Stuttgart: Wissenschaftliche Verlagsgesellschaft M.B.H, 1947), p. 147.

According to Sven E. Donner, at the time the leading Finnish military psychiatrist and the army's inspector of psychiatric units, they were used "extensively."[50] Based on the above-mentioned sample of patient files, I have estimated that at least every sixth patient was given some version of shock treatment. This would translate to about three thousand soldiers in 1939–45.[51] The psychiatrists would have preferred to use the treatments much more widely, but this was impossible because of the lack of time, personnel, and material resources.

Wounding the Patient

Throughout Finnish military psychiatrists' writings, and in accordance with the enthusiasm for shock therapies in peacetime psychiatry, the results gained with the new methods were seen to be astonishingly positive. In the most comprehensive report, published by psychiatrist Oscar Parland in 1946, altogether sixty-six psychiatric soldier-patients diagnosed as *reactio psychogenea* or *reactio psychogenea hysteriformis* were studied in 1944 at the psychiatric unit of the 10th Military Hospital. The selected cases had often been treated unsuccessfully for long periods at other hospitals, and

they were characterized by strong bodily symptoms: forty of the patients had paralytic symptoms, and the rest suffered from tremors, spasms, deafness, blindness, pains, or disturbances of equilibrium. In 54 per cent of the cases the patients were treated only with Cardiazol or ECT. The block method of combining Cardiazol or ECT with insulin coma was used in six cases, and a further six cases were treated only with insulin.[52]

The shock treatments were combined with strong "suggestion therapy" to overcome the patients' bodily symptoms. According to Parland, the mobility of paralysed limbs increased after each treatment, blind eyes started to see, and tremors disappeared. The reported results of the treatments were, indeed, striking: only four of the sixty-six patients did not show any improvement, seventeen recovered to some degree, eighteen considerably, and twenty-seven patients recovered completely and were as a result symptomless. Physicians reported that Cardiazol and ECT were especially effective, whereas insulin treatment seemed to be least suited to treat such somatic symptoms. Parland concluded that the patients' bodily symptoms were not consciously produced – in his eyes, the soldiers truly had not known before how to get rid of their highly disturbing symptoms. Even if they lacked the required willpower to battle the symptoms, or wished to retain them to avoid being sent to the front, this was not the decisive factor.[53] The exact process through which the shock treatments gained their curing power remained unknown, but to Parland it seemed most plausible that it had to do with the convulsions' effects on the physical nervous system.[54]

Here, it is necessary to state the obvious: the Finnish wartime psychiatrists' criteria for recovery were very different from those of today. Recovery did not mean achieving mental harmony, happiness, or health in any contemporary sense; nor were the psychiatrists trying to "heal traumas," but understood their task differently. Recovery amounted to a process of behaving in an organized and rational manner, and of regaining the willingness to serve. It was roughly equivalent to regaining one's fitness to work productively and to according the collective war effort primacy over one's personal hardships and needs. In the case of strong psycho-physical symptoms, as in Parland's study group, the disappearance of these symptoms was enough to be considered a recovery.

It may well be that Finnish military psychiatrists' enthusiasm for these seemingly scientific and medico-technical therapies had a positive placebo effect on patients who suffered greatly from their symptoms and wished to be truly healed.[55] But it is even more important to point out the shock treatments' coercive character. As the descriptions above show, these were intrusive and violent treatments, which seem excessively rough to a contemporary observer. The disciplinary element of

the Cardiazol and often also of ECT is undeniable, and the deliberate employment of Cardiazol as a deterrent was not foreign to Finnish military psychiatrists. In a 1943 discussion, psychiatrist Sven E. Donner stated that, especially in "hysterical" cases, the terror of Cardiazol could actually have the key "therapeutic" effect of the drug.[56] It is tragic to see how the soldiers, who were utterly shocked by their war experiences, were again literally shocked by Cardiazol, electric convulsions, and insulin coma to make them "flee back to health."[57]

Descriptions of the patients' experiences of shock treatments are scarce and scattered. It is thus important to recognize the limitations of what can be known about these subjective experiences and not to reduce their human variety to a single explanation. The remaining accounts are documented by the physicians, not by the patients themselves. With these limitation in mind, the few available documentations point towards an experience of wounding. In patient files the descriptions of shock treatments' curative effects create an impression of a symbolic death (the coma caused by insulin; falling into a darkness in Cardiazol and ECT), followed by a revival or rebirth. Already in 1938, Sven E. Donner explained the patients' "peculiar experiences" to his medical colleagues: the injection of Cardiazol caused an "uncanny" sensation, which could grow to a terrorizing "feeling of annihilation" (*Vernichtungsgefühl*). One patient described it as a total darkness surrounding him, until an expanding spot of light then brightened everything. Another patient experienced the recovery brought about through the shocks as "climbing up from a grave" and being relieved from loneliness and isolation.[58] There are close analogies here to being wounded at the front, encountering death, and then surviving a nearly fatal hit. Quite characteristically, describing the different methods at the Finnish military psychiatric units, Donner called the shock treatments "the most important *weapons* in our arsenal."[59] Seen in this way, the institutions of psychiatric care were also a continuation of the actual battleground, where the soldiers' bodies were still under attack. Through the violent shocks and convulsions, the patients' feeling of being wounded was retroactively provided with the act of injury, which attached the subjective experience of woundedness to a concrete bodily sensation of pain and shock. This was a form of coercion, but it was also a way of forming a link between the patient's feeling of injury and the same bodily matter on which the original injury was experienced.

To be clear, the psychiatric soldier-patients were not in need of being wounded in order to be cured – and the shock treatments did not heal the patients in any contemporary sense of the word, so that the trauma of war had been "repaired" by a physical intervention. Yet the patients' bodies acted as a medium both for the appearance of soldiers' agony in the

form of psycho-physical symptoms and for the psychiatric intervention. On this material platform, the psychological element of war trauma was bypassed both by the patients and their doctors; in this way, the trauma of war was experienced and treated in physical terms. This is not meant to justify these violent methods in any way, but to understand and bring together the corporeality of the "shaken-up" soldiers' experience and symptoms with the physicality of the treatments they received – a link that remains inexplicable if we look at the issue of "war trauma" only as a primarily psychological phenomenon. The shock treatments were not the only way to cause the wound at the military psychiatric wards. Almost every tenth patient was recorded as having suicidal tendencies or committing self-injury. Here, soldiers' shock and depression manifested in an assault against their own body.

Conclusions: Bodies in the Culture of Artillery Fire

As Elaine Scarry notes in her classic work *The Body in Pain*, the corporeality of pain resists objectification in language. As a shattering sensation it remains inexpressible and confined to bodies that suffer it. Yet while the experience of pain tends to deconstruct language, "to unmake the world," it is simultaneously surrounded by practices, meanings, rituals, and artefacts of creation – the body in pain is also a source of culture that "makes the world."[60]

We can recognize a similar dualism of "making" and "unmaking" in the experiences of shock at the Finnish-Soviet front lines of the Second World War. First, in the midst of horrendous assault on the soldiers' bodies and minds, there was the experience of profound injury, even if physical wounds were absent. As we have seen, the soldiers' bodies would turn into mute signifiers of the experience, which they could not verbalize. Besides the strong corporeality, a common feature here is the soldiers' speechlessness, terseness, or fragmentation of expression: it is as if words proved inadequate for the intensity of the assault. Likewise, the high frequency of different forms of dissociation can be seen as demonstrating a violent rupture in one's subjective relationship to the surrounding reality; too mentally devastating to be encountered as such, the world around turned unreal and scattered, or was completely wiped out from memory.[61]

Thus, we can see these broken soldiers as epitomes of "unmaking the world." At the same time, though, in this state of powerlessness, the bodies remained the last resort of agency to communicate the experience of woundedness. The seeming uncontrollability of their symptoms mirrored the chaotic and random nature of violence they had experienced; and the seizing, trembling, and convulsing bodies signified a continued existence

under artillery fire, even when lying in a hospital hundreds of kilometres away from the actual battle. In fact, these struggling bodies seem to be a more precise and direct language to mediate traumatic experience than any possible verbalization. The psychiatric patients lacked the ability to find protective distance from intimate violence, something that words and discourses might have provided. Meanwhile their fellow-soldiers at the front lines, who managed to retain their resilience, developed a term to describe the experience of wounding without physical wounds – and just like "shell shock," being "shaken up" did this by emphasizing the corporeality of the thundering drumfire and the shattering fear it caused.

Conducting a statistical analysis of "war syndrome" symptoms in the British Army in six different conflicts, from the Victorian campaigns in the latter half of the nineteenth century to the Gulf War of 1991, Edgar Jones and Simon Wessely demonstrated cultural variations in the different symptoms of what would nowadays be broadly called "war trauma." Symptoms grouped under the "debility syndrome" were typical for the earliest conflicts; "somatic syndrome" was most common in the First World War; and "neuropsychiatric syndrome" became the dominant group of symptoms during and after the Second World War. Interestingly, though, Jones and Wessely also observed a considerable overlap in the symptoms of different wars from the 1850s to the 1990s: despite the historically changing emphases on the most manifest syndromes, a diverse totality of symptoms kept appearing in all the studied conflicts. Consequently, conversion disorders with physical symptoms, that is, the rough equivalent of earlier "hysteria," have not completely disappeared, although they have now been overshadowed in medical research by the canonic PTSD paradigm. All this led Jones and Wessely to conclude that both the expressions and the medical diagnostics of "war trauma" are culturally influenced and that too narrow a focus on PTSD as the final truth has limited our understanding of the issue:

> Our findings imply that the pathology of war syndromes is not static. Culture, along with advances in treatments, the discovery of new diseases, new diagnostic tools and the changing nature of warfare, plays a significant role in shaping patterns of symptoms. There is no single way for human beings to respond to the terrifying events of war. We suggest that war syndromes are one more phase in the continually evolving picture of man's reaction to adversity.[62]

The historically specific experience of trench warfare and artillery fire gave the psychological and psychosomatic injuries of the world wars a particular content that was different, for instance, from the burdens of the

Napoleonic campaigns or the Vietnam War. Besides the horrors of genocide, the first half of the European twentieth century was the era of death and mutilation pouring down from the sky, in the form of shells, shrapnel, or aerial bombs. For the soldiers on the Western Front in 1914–18 as well as for Finnish soldiers in 1939–45, we could call this a "culture of artillery fire," which reduced the soldiers to passive victims of faceless aggression. Despite the parallels of soldiering, this is a different experience than fighting in the Vietnamese jungle in the 1960s and 1970s, which has been the paradigmatic war experience behind the development of PTSD.

Thus, the traumas of 1939–45 also manifested in different ways than the psychological problems among, for instance, American Vietnam veterans. I have attempted to show how shock and violence materialized in Finnish soldiers' bodies. It may seem strange that trauma and its treatments were so strongly a bodily matter, but given the psycho-physical quality of soldiers' symptoms, it was consistent that bodies were the proper site of psychiatric interventions. In the militarized context of wartime medicine, where the psychiatrists were arming themselves with "weapons," the new shock methods with insulin, Cardiazol, and ECT were well suited for the purpose of "fighting" the neurosis. Indeed, although these treatments were not invented during the war, their brutally straightforward character – and the readiness to apply them without ethical hesitation – may have had to do with the general atmosphere of the European interwar period that preferred radical and violent solutions.

ACKNOWLEDGMENTS

The chapter is based on my doctoral dissertation *Battled Nerves: Finnish Soldiers' War Experience, Trauma, and Military Psychiatry, 1941–44* (Åbo Akademi University, 2013). I am grateful to Hannu Tervaharju for English translations of quotations and to the Academy of Finland for financing this research, as well as to the VITRI Center for the Transdisciplinary Research of Violence, Trauma and Justice at Charles University, Prague, where I stayed as a visiting fellow in November–December 2018 while working on the chapter.

NOTES

1 Finnish National Archives (FNA), 32nd Military Hospital (MH), 13 January 1943, folder 171, patient file 1571/IV (a renewed inspection made at the 32nd MH in April 1944). All the patients' names have been changed. At the

FNA, the files are stored at the patient archive of each respective military hospital. In footnotes, the date is the day of arrival at the hospital, followed by the number of the folder in the given military hospital's patient archive.

2 Eric T. Dean, Jr., *Shook Over Hell: Post-Traumatic Stress, Vietnam, and the Civil War* (Cambridge, MA: Harvard University Press, 1999), 117–20; Paul Lerner, *Hysterical Men: War, Psychiatry, and the Politics of Trauma in Germany, 1890–1930* (Ithica: Cornell University Press, 2003), 61–3, passim; Eric J. Leed, *No Man's Land: Combat and Identity in World War I* (Cambridge: Cambridge University Press, 1979), 163–4.

3 Ruth Kloocke, Heinz-Peter Schmiedebach, and Stefan Priebe, "Psychological Injury in the Two World Wars: Changing Concepts and Terms in German Psychiatry," *History of Psychiatry* 16 (2005): 1, 46; Ben Shephard, *A War of Nerves: Soldiers and Psychiatrists 1914–1994* (London: Pimlico, 2002), 302–9; Catherine Merridale, *Ivan's War: The Red Army 1939–45* (London: Faber & Faber, 2005), 232–4; Svenja Goltermann, *Die Gesellschaft der Überlebenden: Deutsche Kriegsheimkehrer und ihre Gewalterfahrungen im Zweiten Weltkrieg* (Munich: DVA, 2009), 183–4.

4 See Joanna Bourke, *Dismembering the Male: Men's Bodies, Britain and the Great War* (London: Reaktion, 1996), 76, 81, 107–23; Joseph Pugliese, "The Gendered Figuring of the Dysfunctional Serviceman in the Discourses of Military Psychiatry," in *Gender and War: Australians at War in the Twentieth Century*, ed. Joy Damousi and Marilyn Lake (Cambridge: Cambridge University Press, 1995), 162–77.

5 See Stefanos Geroulanos and Todd Meyers, *The Human Body in the Age of Catastrophe: Brittleness, Integration, Science, and the Great War* (Chicago: University of Chicago Press, 2018).

6 Matti Ponteva, *Psykiatriset sairaudet Suomen puolustusvoimissa vv. 1941–1944*, Annales medicinae militaris Fenniae 52:2a (Helsinki: Suomen lääkintäupseeriliitto, 1977), 86; Paavali Alivirta, "Om krigets inverkan på uppkomsten av sinnessjukdomar," *Psykisk Hygien – Tidskrift för Social-Psykiatri*, nos. 1–4 (1940): 28.

7 For further details, see Ville Kivimäki, "Battled Nerves: Finnish Soldiers' War Experience, Trauma, and Military Psychiatry, 1941–44" (Ph.D. diss., Åbo Akademi University, 2013), 84–5, 479–85.

8 Martti Kaila, "Psykogeenisten oireiden merkityksestä korvauskysymyksissä," *Duodecim* 46 (1930): 601–14; Kaila, "Die traumatische Neurose und ihre Abhängigkeit vom Zeitgeist," *Acta Psychiatrica et Neurologica* 13 (1938): 419–30; Kaila, "Traumaattisen neuroosin psykopatologiasta," *Duodecim* 55 (1939): 337–66.

9 K.A. Järventaus, *Summan savut – Muistelmaromaani Suomen sodasta 1939–1940: Mukanaolleen omakohtaisia havaintoja ja kokemuksia* (Porvoo: WSOY, 1940), 146.

10 Erkki Palolampi, *Kollaa kestää: Kertomuksia Kollaanjoen rintamalta* (Porvoo: WSOY, 1940), 244–5.

11 For the first printed occurrence of the term, see ibid., 77–8. Still today –
 and without any war-related connotations – this Finnish word can be collo-
 quially used to refer to someone considered "crazy" or "freakish."

12 Simo Hämäläinen, *Suomalainen sotilasslangi*, Vol. 1: *Sanasto* (Helsinki: SKS,
 1963), 259.

13 *Suomen kielen etymologinen sanakirja*, Lexica Societatis Fenno-Ugricae 12:5,
 ed. Erkki Itkonen, Aulis J. Joki, and Reino Peltola (Helsinki: Suomalais-ugri-
 lainen seura, 1975), 1481; Heikki Paunonen and Marjatta Paunonen,
 Tsennaaks stadii, bonjaaks slangii: Stadin slangin suursanakirja, 6th ed.
 (Docendo: Jyväskylä, 2017), 1243.

14 Peter Leese, *Shell Shock: Traumatic Neurosis and the British Soldiers of the First
 World War* (Basingstoke: Palgrave Macmillan, 2002), 1.

15 This overall view is based on the study of patient files from the 43rd Military
 Hospital's psychiatric unit in 1939–40 (situated at the FNA). This was the
 most important psychiatric unit during the Winter War due to its size and
 vicinity to the front lines; see also Pirita Reinikainen, "43. Sotasairaalassa
 hoidetut puolustusvoimien psykiatriset potilaat ylimääräisten harjoitusten ja
 talvisodan aikana" (master's thesis, University of Joensuu, 2010).

16 Hämäläinen, *Suomalainen sotilasslangi*, 27, 310.

17 Johannes Heilala, *Eldanka: Rintamalääkärinä Vienan sotateillä* (Helsinki: Alea,
 1982), 66; see also 56.

18 FNA, Military Medical Central Archives (Lääkintäkeskusarkisto), Hb 1 (60),
 undated statistic on different types of wounds 1941–44 (N = 10,000).

19 Ibid., undated statistic on the types of wounds in Infantry Regiment 49 in
 June–July 1944 (N = 1,041).

20 See Edgar Jones, Nicola T. Fear, and Simon Wessely, "Shell Shock and Mild
 Traumatic Brain Injury: A Historical Review," *American Journal of Psychiatry*
 164 (2007): 11, 1641.

21 Leo van Bergen, *Before My Helpless Sight: Suffering, Dying and Military Medicine
 on the Western Front, 1914–1918* (Farnham: Ashgate, 2009), 234–5, 247–8.

22 Leese, *Shell Shock*, 36–9, 51–67; see also Fiona Reid, *Broken Men: Shell Shock,
 Treatment and Recovery in Britain 1914–30* (London: Continuum, 2010).

23 FNA, T 20942/F31–F32, Army High Command, Medical Department (PM
 Lääk.os.), physicians' experiences from the Winter War (F31: M. Strigeff
 and L. Bergroth; F32: A.A. Kallio, A.E. Hanén, and Medical Captain
 Seppänen).

24 FNA, T 2554/5, Army High Command, Services Department (PM Huolto 1),
 Services Order No. 22/41, Major General A.F. Airo, 12 November 1941. The
 army general services orders very rarely intervened in medical diagnostics.

25 Sven E. Donner, "Psykiatrinen diagnostiikka ja terminologia sodan
 kokemusten valossa," *Sotilaslääketieteellinen Aikakauslehti* 21 (1946): 3, 66;
 on "soldier's heart" see Edgar Jones and Simon Wessely, *Shell Shock to PTSD:*

Military Psychiatry from 1900 to the Gulf War (Hove: Psychology Press, 2005), 39–44, 193–4.

26 FNA, 59th MH, 19 August 1944, folder 81, patient file 1047.

27 The first group, distress and depression symptoms, includes suicidal tendencies, self-injuring, uncontrollable fear or terror, general nervousness and/or irritation, tearfulness, sleeplessness, tiredness, restless sleep, depression, and depressive reticence. The second, psycho-physical symptoms, includes blindness or deafness without physical cause, body seizures, limbic dysfunctions, fainting, insensibility, headache, palpitation, chest pains, stomach problems, dizziness, nausea, respiratory arrest, tremor, and bedwetting. Third, dissociative symptoms include serious delusions, serious apathy, stupor, hallucinations, mild or momentary delusions, memory loss, disorientation, and general confusion. Fourth, social symptoms include violent behaviour, anti-social disobedience, shyness, general social problems, and general disregard. I am thankful to MD Raimo K.R. Salokangas, professor emeritus of psychiatry at the University of Turku, for his kind help in outlining the categories of different symptoms. I am, of course, solely responsible for any shortcomings in this account.

28 Minna Uimonen, *Hermostumisen aikakausi: Neuroosit 1800- ja 1900-lukujen vaihteen suomalaisessa lääketieteessä* [The age of nervousness: The neuroses in Finnish medicine at the turn of the twentieth century] (Helsinki: SHS, 1999), passim; Anssi Halmesvirta, *Vaivojensa vangit: Kansa kysyi, lääkärit vastasivat – historiallinen vuoropuhelu 1889–1916* [The captives of their ailments: People asked, physicians answered – A historical dialogue, 1889–1916] (Jyväskylä: Atena, 1998), 247–78. For the wider Western context of neurasthenia at the turn of the century, see Marijke Gijswijt-Hofstra and Roy Porter, eds., *Cultures of Neurasthenia: From Beard to the First World War* (Amsterdam: Rodopi, 2001); also Petteri Pietikäinen, *Neurosis and Modernity: The Age of Nervousness in Sweden* (Leiden: Brill, 2007).

29 Cf. Edward Shorter, *A History of Psychiatry: From the Era of the Asylum to the Age of Prozac* (New York: Wiley, 1997), chap. 4.

30 See Konrad von Bagh, "Über unsere Diagnostik der Neurosen im Lichte der Kriegserfahrungen," *Annales Medicinae Internae Fenniae* 35 (1946): 254.

31 *Suomen kielen etymologinen sanakirja*, Lexica Societatis Fenno-Ugricae 12:1, ed. Y.H. Toivonen (Helsinki: Suomalais-ugrilainen seura, 1955), 70; *Suomen sanojen alkuperä: Etymologinen sanakirja*, Vol. 1 (Helsinki: SKS, 1992), 158.

32 For example, FNA, 32nd MH, 28 October 1941, folder 263, patient file 500; 43rd MH, 2 June 1944, folder 29, patient file 30011; 59th MH, 11 February 1944, folder 67, patient file 457. Cf. van Bergen, *Before My Helpless Sight*, 233.

33 In Outi Ampuja's study on the sounds of war as remembered by elderly Finnish war veterans in the 2000s, a helpless cry of a wounded soldier was the single most horrifying sound of war, but it was followed by the

terrifying noise of artillery barrages, which left lasting imprints on veterans' memories. Outi Ampuja, "Ääni ja melu modernissa sodankäynnissä," in *Sodan ekologia: Nykyaikaisen sodankäynnin ympäristöhistoriaa*, ed. Simo Laakkonen and Timo Vuorisalo (Helsinki: SKS, 2007), 313–14, 321–3, 329–32.

34 For an interesting discussion on the impossibility of drawing a hermetic line between psychological and physical war wounds, see Jones, Fear, and Wessely, "Shell Shock," 1644.

35 Lerner, *Hysterical Men*, 62–7, 229–37; Kloocke, Schmiedebach, and Priebe, "Psychological Injury," 50–1; Goltermann, *Gesellschaft der Überlebenden*, 168–9; Shephard, *War of Nerves*, 97–104.

36 Lauri Saarnio, "Sotaneurooseista," *Duodecim* 56 (1940): 228–54.

37 Lerner, *Hysterical Men*, 74–85, 243–4; Kloocke, Schmiedebach, and Priebe, "Psychological Injury," 51–3; Goltermann, *Gesellschaft der Überlebenden*, 170–3; Heinz Schott and Rainer Tölle, *Geschichte der Psychiatrie: Krankheitslehren, Irrwege, Behandlungsformen* (Munich: C.H. Beck, 2006), 375–6; Babette Quinkert, Philipp Rauh, and Ulrike Winkler, "Einleitung," in *Krieg und Psychiatrie 1914–1950*, ed. Quinkert, Rauh, and Winkler (Göttingen: Wallstein, 2010), 16–19.

38 For a much longer discussion on this, see Kivimäki, *Battled Nerves*, chap. 4. For the slow acceptance of environmental and situational causes for war-related mental breakdowns, see Simon Wessely, "Twentieth-Century Theories on Combat Motivation and Breakdown," *Journal of Contemporary History* 41 (2006): 2, 269–73.

39 Kalle Achté, *150 vuotta psykiatriaa: Lapinlahden sairaalan historia 1841–1991* (Klaukkala: Recallmed, 1991), 111–12; Ilmari Kalpa, "Šokkikäsittelyn vaikutuksesta mielisairaalan toimintaan," *Duodecim* 63 (1947): 623.

40 Anton von Braunmühl, *Insulinshock und Heilkrampf in der Psychiatrie: Ein Leitfaden für die Praxis*, 1938, 2nd rev. ed. (Stuttgart: Wissenschaftliche Verlagsgesellschaft M.B.H, 1947); cf. Ilmari Kalpa, "Maanis-depressiiviseen mielisairauteen kuuluvien depressiotilojen cardiazolikäsittelystä," *Duodecim* 56 (1940): 488; Martti Paloheimo, "Pitkäaikaisesta insuliinihoidosta eräissä kroonisissa jakomielitautitapauksissa," *Duodecim* 61 (1945): 811.

41 Edward Shorter and David Healy, *Shock Therapy: A History of Electroconvulsive Treatment in Mental Illness* (New Brunswick: Rutgers University Press, 2007), 11–21, 51–3; see also Schott and Tölle, *Geschichte der Psychiatrie*, 473–4; FNA, Finnish National Board of Health (Lääkintöhallitus) V, Ebg:1–13, mental asylums' annual reports, 1936–39; and Johan Runeberg, "Erfahrungen mit Insulinbehandlung am Krankenhaus zu Pitkäniemi," 571–81, and Aarne Soininen, "Über Resultate der Insulinschockbehandlung bei Schizophrenie und 'schizophrenieähnlichen' Psychosen," with a discussion, 591–617, both in *Acta Psychiatrica et Neurologica* 13 (1938).

42 Von Braunmühl, *Insulinshock und Heilkrampf*, 43–102, 179–82; also Paloheimo, "Pitkäaikaisesta insuliinihoidosta," 810–21.

43 Shorter and Healy, *Shock Therapy*, 21–30, 60–66; Paloheimo, "Pitkäaikaisesta insuliinihoidosta," 812; FNA, Finnish National Board of Health V, Ebg:1–13, mental asylums' annual reports, 1937–39.

44 Shorter and Healy, *Shock Therapy*, 61.

45 Von Braunmühl, *Insulinshock und Heilkrampf*, 125–36, 182; see also Kalpa, "Maanis-depressiiviseen mielisairauteen," 483–90.

46 Shorter and Healy, *Shock Therapy*, 31–48, 66–73; Kaija Vuorio, *Niuva*, Vol. 1: *Niuvanniemen sairaala 1885–1952* (Kuopio: Niuvanniemen sairaala, 2010), 113, 151; FNA, Finnish National Board of Health V, Ebg:1–13, mental asylums' annual reports, 1941–44.

47 Von Braunmühl, *Insulinshock und Heilkrampf*, 142–61, 182.

48 See, e.g., van Bergen, *Before My Helpless Sight*, 382–91.

49 Kalpa, "Maanis-depressiiviseen mielisairauteen," 483–4, 488–9; Oscar Parland, "Shock Therapy for Soldiers Suffering from Psycho-Somatic Disturbances during the War," *Acta Psychiatrica et Neurologica*, Supplement 47 (1946): 513.

50 FNA, Sven E. Donner's Collection, Folder 3, discussion synopsis on C.A. Borgström's presentation at the meeting of the Finnish Medical Society, 8 April 1943.

51 Kivimäki, *Battled Nerves*, 370–2.

52 Parland, "Shock Therapy," 511–13, 516–20.

53 To demonstrate this point, Parland told of a "debilitated" patient, whose two fingers were paralysed. The man was returned to the front to serve in a machine gun squad, and he used these two paralysed fingers as a useful "hook" when pulling the heavy weapon. As the man was hospitalized again for a cerebral contusion, he tried unsuccessfully to dissimulate the paralysis in fear of the shock treatments. But after one Cardiazol shock, the paralysis disappeared completely; ibid., 522.

54 Ibid., 521–3.

55 Cf. Kalle Achté, *Optimistisen psykiatrin muistelmat* (Porvoo: WSOY, 1999), 106.

56 FNA, Sven E. Donner's Collection, Folder 3, discussion synopsis on C.A. Borgström's presentation at the meeting of the Finnish Medical Society, 8 April 1943; cf. von Braunmühl, *Insulinshock und Heilkrampf*, 136.

57 The German concepts "*die Flucht in die Krankheit*" (the flight to illness) and its opposite "*die Flucht in die Gesundheit*" (the flight to health) were actually used by Finnish military psychiatrist Konrad von Bagh, when he described the effects of "disciplinary gymnastics" and other rigid measures in treating "war neurotics"; von Bagh, "Reaktiivisten sielusyntyisten häiriötilojen käsittelystä ja ehkäisemisestä joukko-osastossa," *Sotilaslääketieteellinen Aikakauslehti* 20 (1945): 2, 82–3.

58 FNA, Sven E. Donner's Collection, Folder 3, discussion synopsis on the Cardiazol treatment for schizophrenia at the meeting of the Finnish Medical Society, 8 December 1938; see also Kalpa, "Maanis-depressiiviseen

mielisairauteen," 484; FNA, Finnish National Board of Health V, Ebg:10, Siilinjärvi mental asylum, annual report 1938.

59 Sven E. Donner, "Experiences of War Psychiatry from Finland's Second War 1941–1944," *Acta Psychiatrica et Neurologica*, Suppl. 47 (1946): 498, my emphasis.

60 Elaine Scarry, *The Body in Pain: The Making and Unmaking of the World* (Oxford: Oxford University Press, 1985), 3–6, 19–20.

61 Cf. Chris R. Brewin, *Posttraumatic Stress Disorder: Malady or Myth?* (New Haven: Yale University Press, 2003), 52–4, 119–24.

62 Jones and Wessely, *Shell Shock to PTSD*, 199–208.

4 *Efim Segal, Shell-Shocked Sergeant*: Red Army Veterans and the Expression and Representation of Trauma Memories

ROBERT DALE

May 31, 1944, the last day of spring, was Sergeant Efim Segal's final day of armed service. The previous day, at the hospital where he had been treated, a medical commission labelled Efim unfit for front-line service, demobilizing him for war work in his hometown of Moscow. In the fresh air and warmth of a glorious late spring day, Efim "felt himself to be the happiest, richest man on the earth. Behind [him] was the hell of the front, hundreds of days and nights of a mad cat-and-mouse game to the death... An implausible reality, delirious dreams."[1] He was discharged with the uniform he was wearing, two pairs of underwear, a lightweight towel, a loaf of bread, a blue enamel mug shot through in two places and kept as a relic of war, and a very uncertain future. At the age of twenty-eight, having been seriously wounded and concussed twice, he was now categorized as a war invalid. "Since he hated ostentatious patriotism, he did not request to go back to the front lines."[2] Having fulfilled his military duty with a clear conscience, he felt that he had earned the right to a peaceful civilian life. Yet there was much about the civilian world that was unfamiliar and disorientating. During his years of front-line service, and lengthy periods of hospitalization, he had grown unaccustomed to everyday sights and routines. It now seemed deeply disquieting that the trams were still running, children played on the streets, and men and women went about their business out of uniform, whilst the war raged beyond Soviet borders. Despite all his optimism for the future, Efim Segal was about to discover that readjusting to civilian life after the distressing and traumatic experiences of industrialized warfare was far from straightforward. Although he had survived the carnage of the front lines, his war was far from over.

This is how readers of Aleksandr Sobolev's autobiographical novel *Efim Segal, kontuzhenyi serzhant* (Efim Segal, Shell-Shocked Sergeant) are introduced to the work's eponymous hero. This little-known piece was

penned in two parts, the first entitled "The Recovery of Sight" (*Prozrenie*), written between May 1974 and November 1975, and a shorter second part, "Wedding Travels," completed between December 1975 and October 1977. It was published posthumously in 1999, thirteen years after its author's death. The novel tells the story of Efim Segal's difficult transition to civilian life and documents the social and psychological problems faced by demobilized veterans, especially the war-disabled. It confronts themes, most notably the persistence of war-related trauma and the pervasive anti-Semitism of Stalin's final years, that were difficult to explore in late Soviet literature, public culture, and political debate. Such candid, direct, and sustained descriptions of trauma written at the height of the heroic cult of the war are rare; a sensibility to these issues amongst veterans themselves was even rarer. In these respects, and others, this is an unusual work that is neither celebrated as a literary classic nor appreciated as a historical document. The novel, as its copyright page indicates, was published by a small independent publishing house, in a print run of just a thousand copies. It was not reviewed by the major literary journals at the time, and has not subsequently attracted comment. While *Efim Segal* has not entirely disappeared without trace, it has barely made a ripple in artistic or academic circles within or beyond Russian borders. Few European or North American research libraries hold a copy.[3] Mordechai Altshuler has quoted this novel as evidence of anti-Semitic prejudice within the ranks of the wartime Red Army.[4] But the value of this text as evidence of war's traumatizing effects has escaped literary scholars and social and cultural historians. Despite its limited impact, uncertain reception, and questionable literary merit, *Efim Segal, kontuzhenyi serzhant* is an important repository of traumatic memories, which offers tantalizing insights into how some veterans processed their trauma.

This chapter takes this document as a starting point for re-examining the traumatic experiences of the Red Army's psychiatric casualties and reassessing how Soviet veterans made sense of their war trauma long after the war ended. It focuses on two main texts: the published form of the novel, and Tatiana Soboleva's biography and recollections of her husband, published in 2006. Although the latter's explicit goal of cementing Sobolev's literary legacy, and its uncritical attitude to a beloved husband, are problematic, it nevertheless contains important information about his career and family life.[5] Taken together, these sources allow for a detailed reconstruction of the connection between Aleksandr Sobolev's experiences, both during and after the war, and his representation of them in fiction later in life. The intention here is to move away from researching trauma primarily through the lens of psychiatric and medical discourses, as reflected in scientific research, patient case histories, and

the files of psychiatric institutions, in favour of examining the languages of trauma employed by veterans themselves, and more widely in Soviet society. Military and civilian psychiatric records, at least in the Soviet case, remain productive research areas for trauma scholars. However, professionalized psychiatric vocabularies, which were themselves highly contested, and the array of specialized treatments they described, were detached from the languages used by traumatized former soldiers. Veterans understood their experiences, symptoms, and treatments differently from how leading researchers described them on the pages of psychiatric journals. This chapter, then, returns to Soviet cultural sources, such as life-writing, fiction, films, and other representations of war-related trauma, with the aim of bringing us closer to the experiences of veterans themselves. It combines approaches from historical trauma studies, social and cultural history, and literary studies to bring us closer to the story of post-war transition and the traumatic aftermath of war in veterans' own words. It is particularly influenced by Vera Dunham's pioneering literary research, which succeeded in opening new perspectives on late Stalinist society and culture through a subtle and creative reading of the poetry and prose of the period.[6] This chapter asks what languages former soldiers, and wider society, employed to discuss trauma, and how Soviet veterans made sense of their own trauma. It argues that although psychiatric wards and outpatient clinics were important in treating trauma's most severe manifestations, trauma was also worked through informally in cultural spaces. It was through writing that Sobolev made sense of his traumatic memories; writing became a therapeutic activity. Although *Efim Segal, kontuzhenyi serzhant* is an unusual text written by an atypical author, it nevertheless serves as a useful prompt for reconsidering how Red Army veterans framed their trauma.

What follows is structured around four main sections. The chapter begins by briefly sketching the contours of Sobolev's biography, focusing on his wartime military service, post-war life, and literary career. The aim is to demonstrate the close correspondence between Sobolev's life and that of his fictional alter ego Efim Segal, thereby demonstrating how deeply informed the novel was by personal experience. A second section examines the state of the historiography of Soviet war-related trauma, especially in relation to war veterans. According to the current scholarship traumatic wartime memories, which ran counter to official narratives, were quickly repressed. Indeed, in Stalinism's political, social, and cultural ecosystem, and the hyper-masculine world of the Soviet military, expressing psychological and psychiatric damage was taboo. However, the existence of texts like *Efim Segal, kontuzhenyi serzhant* and other overlooked sources suggests that late Soviet society had a more nuanced

and complicated relationship with trauma than often acknowledged. Although the Soviet state and wider society found it difficult to situate their traumatic emotions, experiences, and memories within the official Soviet lexicon, many veterans attempted to express trauma, albeit opaquely. The third and main section of the chapter focuses on the languages in which war-related trauma and post-war psychiatric breakdown are explored in *Efim Segal*. Here the words and ideas of one atypical, and potentially unreliable, witness are contextualized by analysing them in the light of other evidence and the wider secondary literature. This section, in particular, advances the argument that cultural representations of trauma became a means of constructing coherence, in this instance on paper, amidst disorderly and confusing experiences and mental states. Finally, the chapter reflects on how a wider appreciation and rereading of cultural sources might reveal more about how languages of trauma were constructed in wider societal consciousness. Building on insights derived from Sobolev's novel, the last section highlights a range of other cultural products, many of them better known, which in their own way made efforts to represent traumatic experience.

Aleksandr Sobolev – A Life on the Page

Isaak Vladimirovich Sobolev was born 18 August 1915 in the small village of Polonnoe, in Volynskaia gubernia, in what is now modern-day Ukraine. He was the youngest child of a poor Jewish family, whose impoverishment was no doubt exacerbated by the scourges of war, revolution, and civil war, which formed the backdrop to his childhood.[7] These were not the only tragedies that affected the young man. His mother died when he was aged fifteen and was replaced by a stepmother indecently quickly. Isaak left home soon after to begin a new life in Moscow. His father, according to Tatiana Soboleva's recollections, attempted neither to dissuade him nor prevent his departure. Having furnished Isaak with thirty roubles for the journey and to establish himself in Moscow, his father considered his parental responsibilities discharged. "In the young traveller's wicker basket lay two pairs of patched underwear and an exercise book containing his first poems."[8] Sobolova gives no indication as to whether this move was connected to the economic dislocation caused by collectivization, which was then ravaging the Ukrainian countryside. She highlights instead Sobolev's early affinity for writing, stressing that Isaac began composing poems at the age of seven. This serves her goal of establishing her husband's literary reputation as a great but neglected poet. Isaac's trajectory was similar to that of a significant group of young Soviet Jewish men from southern Russia and Ukraine who made their

way to Moscow, in the early years of Soviet power, with the hope of beginning cultural careers. Many of these, like Isaak, would subsequently change their names, and assert new identities within Soviet society.[9]

Isaak arrived in Moscow in 1930 at a moment of economic hardship and political instability, as Stalinism consolidated its hold over the party, state, and wider society both in the capital and nationally. As an unwelcome guest of his older sister's family, and as a burdensome extra mouth to feed, he quickly abandoned these remaining family ties and registered at a factory training school, where he trained and qualified as a metal worker.[10] This was not a direct route to a literary career, but it provided Isaak with an independent income and plenty of opportunities to write for factory wall-newspapers (locally produced periodicals written and edited by worker correspondents and pasted on the walls of public spaces), and volunteer articles for the local press.[11] By the mid-1930s Sobolev, under his assumed name Aleksandr, was building a career in print, and even managing to get occasional poems published. This modest journalistic and literary career was interrupted in 1942 when Sobolev was mobilized into the ranks of the Red Army, where he would remain until his demobilization due to physical and psychological wounds in the spring of 1944. The details of Sobolev's front-line career do not appear to have been preserved, but armed service, as many combatants discovered, had a profound impact on their future lives. It was, according to Soboleva, "in the course of front line everyday experiences, rather than as the result of an individual emotional shock, that the notion of the war as a perverted and repulsive state of mankind, which led to the self-destruction of millions, arose, formed and strengthened in him."[12] Front-line service, it is argued, hardened and brutalized veterans,[13] but in many instances it was as likely to inspire pacifism or anti-war conviction.

Sobolev was demobilized aged twenty-eight in Moscow in May 1944. Arriving in a city where he had no family network to fall back on, he was quickly remobilized into war production, and he began a post-war trajectory that mirrored that of his fictional alter ego. Both were classified as invalids of the Great Patriotic War, described as having been concussed (*kontuzhenyi*), a word commonly translated as "shell-shocked," and they experienced traumatic reactions to their wartime experiences. Sobolev found work in Moscow aviation engine factory No. 45, either in the instrument or casting workshops. Here Soboleva's accounts differ, which is itself a possible indication of the blurred lines between Sobolev and his central protagonist.[14] Segal also worked in the instrument workshop of a factory in the war industries. In 1944, a year before the war would end, acute labour shortages meant that disabled veterans were in high demand in the industrial economy, and enjoyed better job prospects

Image 4.1. Aleksandr Sobolev before his demobilization in 1944. Source: Tat'iana Soboleva, "*V opale chestnyi iudeĭ*" (Moscow: Paralleli, 2006).

than they would once able-bodied veterans flooded home during mass demobilization beginning in mid-July 1945.[15] Segal, like Sobolev, aspired to become a poet, and quickly moved from the shop floor to working on the factory newspaper, although both later found themselves pushed aside through a mixture of anti-Semitism and employment practices that privileged returning able-bodied veterans. Sobolev and his fictionalized self both experienced war-related trauma, the severity of which fluctuated, both spent time in psychiatric institutions in the years after their demobilization. The lives of Sobolev and Segal in their key features and general texture mirrored each other. There can be little doubt that *Efim Segal, kontuzhenyi serzhant* was a deeply autobiographical text, in which Sobolev sought to represent his life story, and process his war-related trauma.[16] As such it deserves to be recognized as a key source in the cultural representation of Soviet war trauma.

Sobolev has an alternative claim to recognition as a significant figure in the expression and representation of Soviet trauma. His most celebrated poem, *Bukhenval'dskii nabat* (The tocsin of Buchenwald), became one of the most famous of all Soviet anti-war and anti-fascist poems, although it was not always attributed to him. Whilst listening to the radio in the summer of 1958, Sobolev heard a report about the construction of a memorial complex at Buchenwald. This site, designed by the sculptor Fritz Cremer (1906–93), was the largest and most significant Holocaust memorial of the time, the centrepiece of which was a 160-foot bell tower.[17] The radio report made a profound emotional impression on Sobolev.

Within two hours he had written the first draft of the poem, the central motif of which was the sonorous tolling of the memorial tower's liberty bell.[18] The poem was published in *Trud*, the All-Union Trade Union newspaper, in September 1958, the same month as the dedication of the Buchenwald memorial complex, after being initially rejected by *Pravda*, the Communist Party's national newspaper.[19] The poem only found widespread resonance once it was set to music by the Soviet Georgian composer Vano Muradeli (1908–70). The song, according to Tatiana Soboleva, became "an inalienable part of the spiritual life of our people between the 1960s and 1980s." The state-run Melodiia record label pressed around nine million copies of it. Schools and amateur dramatic clubs in Leningrad even performed a ballet based upon it.[20] Although both Sobolev and Muradeli were nominated for a Lenin prize in 1962, in later years the music and lyrics of the song were routinely attributed to just Muradeli. Despite Sobolev's important contribution to the anti-fascist canon and the framing of the violence and trauma of the Second World War, a collection of his poetry was only published in 1985, a year before his death. He remained a little-known poet on the margins of the Soviet literary world, pushed aside, in part, by official anti-Semitism.[21] While it would be an exaggeration to present his literary exclusion as a secondary trauma, it rankled and added to a sense of detachment from post-war society, a key theme of *Efim Segal.*

Soviet War Trauma: Historiography and Representation

Compared to the rich and expanding historiography of war-related trauma in other theatres and national contexts, remarkably little had been written about the traumatic aftermath of the Second World War as experienced by Red Army veterans. Given the brutal nature of combat, and the scale of death and suffering on the Eastern Front, this might seem anomalous.[22] In part, it reflects the official position of the Soviet party-state that Soviet social, economic, and political structures minimized soldiers' psychological and psychiatric breakdown. According to a chapter written by Viktor Petrovich Osipov, the director of Leningrad's Military Medical Academy, published in 1941, soldiers and armies with higher political and class consciousness were better equipped to resist the biological, emotional, and nervous threats of war.[23] Although the existence of traumatic reactions in the Red Army was never denied outright, a myth that "Russians were genuinely immune to the neuroses of the 'soft' west" took firm hold in late Soviet society and continues to gain traction in post-Soviet Russia.[24] Yet the relative absence of public discussion about war trauma amongst veterans also reflects the reality

that the Soviet Union had its own social, cultural, and scientific frame-
works for processing traumatic experiences. The Soviet case serves as an
important reminder that trauma is culturally conditioned rather than a
universal phenomenon. Indeed, it bears out the trauma theorist Jeffrey
Alexander's argument that, "trauma is not something naturally exist-
ing, it is something constructed by society."[25] As he goes on to explain,
"[t]rauma is a socially mediated attribution," rather than the product
of inherently traumatic events.[26] Across time and space different socie-
ties have responded to trauma in their own ways, drawing upon various
diagnoses and languages to describe a wide array of specific traumatic
symptoms produced by extreme stress. Well before the surge of interest
in war trauma experienced on the Western front during the First World
War, late imperial Russia had begun to form its own notions of battle-
field trauma, which in-turn informed Soviet psychiatric practice.[27] Soviet
psychiatrists were well-informed about past thinking about wartime
psychiatric breakdown even when it was ideologically unacceptable.[28] Yet
by 1941, individual and collective responses to trauma had been recal-
ibrated by the experience of waves of war, revolution, civil war, famine,
and political violence. Soviet collectivism, it was argued, helped protect
its citizens from the aftershocks of extreme violence, and helped foster
resilience. Having lived through a long sequence of crises Soviet citizens
developed different attitudes to fear, suffering, pain, and mental anguish
that reshaped notions of trauma.[29] Somatic explanations for trauma
were favoured ahead of psychological ones, inspired by Pavlovian rather
than Freudian approaches to the mind; treatment was based on rest and
better nutrition rather than psychoanalysis. In a society reeling from the
material and social devastation of war, medicine and psychiatry provided
only one mechanism for confronting trauma. Individuals internalized
the pain, families offered support, and the bottle provided solace.

Nevertheless, researchers have carefully documented the existence of
war-related trauma amongst individual soldiers and civilians damaged
by wartime experiences. While Soviet society avoided collective cultural
trauma, traumatized individuals remained a social and cultural real-
ity, which left traces throughout the historical record. Historians have
deployed several approaches to writing the history of trauma in a society
that was at best sceptical about, and at worst openly hostile to, the idea
of trauma. Several scholars, myself included, have scoured the archives
of psychiatric research institutes and their scientific journals for an un-
derstanding of how the psychiatric profession conceived, diagnosed, and
treated trauma during and after the war.[30] Paul Wanke, for example, has
surveyed published research produced by Russian and Soviet military psy-
chiatrists from the Russo-Japanese War to the end of the Great Patriotic

War, providing insights into how the wartime identification and treatment of psychiatric casualties was supposed to operate.[31] On the basis of a wider range of evidence, including archival materials, Benjamin Zajicek has reconstructed the theoretical underpinnings of the Stalin-era psychiatric profession and how in practice the psychiatric consequences of war were confronted and treated.[32] Others have deployed similar approaches to explore the starvation-related mental conditions researched by psychiatrists in besieged Leningrad.[33] Research papers in learned journals, mediated as they were through professional discourses often reveal more about scientific categories and priorities than the experiences of psychiatric casualties. Such sources run the risk of stripping patients of their agency, making them appear passive objects of academic interest rather than individuals with complex lives beyond the consulting room. Social histories of traumatized groups and communities have expanded the focus beyond the front lines, bringing the trauma experienced by civilian women and children into sharper perspective.[34]

This approach offers the opportunity to reveal something of the lived experience of trauma, and how the traumatized intersected with their families, workplaces, and wider communities. The archival traces left by traumatized veterans, however, are often fragmentary, difficult to connect to specific wartime experiences, and frequently relate trauma through the bureaucratese of state institutions rather than in individuals' own words. Finally, cultural historians have begun to examine how traumatic aspects of the Stalinist past, as well as traumatized individuals, were represented on the page and screen, and how these texts were received by wider audiences. As Elena Baraban eloquently demonstrates, there is much to learn from reinterpreting well-known texts from the official Soviet canon in light of trauma theory.[35] This approach has proved productive but has tended to privilege exploring the traumatic aftermath of political terror ahead of the legacy of industrialized warfare.[36]

Cultural theorists of trauma have stressed that trauma often lies beyond recovery, comprehension, assimilation, and representation.[37] This holds true, to a certain extent, in the Soviet case. As Catherine Merridale writes, "Trauma, in the Red Army, was virtually invisible. [...S]hock, and the distress of all that the men witnessed at the front, was virtually taboo."[38] Indeed, war's damaging psychological effects have often been rejected more widely.[39] Red Army veterans, of course, were not unique in finding it difficult to give voice to the less heroic side of battle. Ex-servicemen have often maintained that civilians, who lacked first-hand experience of combat, could not possibly understand war's traumatic and de-stabilizing effects. They have frequently kept their experiences to themselves for fear of being stigmatized or misunderstood, or a desire to protect loved-ones

from direct knowledge of war's horrors.[40] Highly authoritarian societies, like the Soviet Union, had their own particular social, cultural, and political barriers to expressing trauma, but were not entirely unique.

Traumatic experiences were never far below the surface of post-war Soviet society, and broke through more regularly than often assumed. The deeper scholars delve into the social and cultural history of late socialism the more visible these traumatic aftermaths become. Sometimes references to trauma were opaque, amounting to little more than a nudge and a wink, but in others they were more direct and meaningful. Survivors of the Leningrad siege, especially members of the literary and cultural intelligentsia, for example, were frequently compelled to explore traumatic memories of mass death, extreme suffering, and urban destruction through creative cultural processes. As Polina Barskova argues, "historical trauma leads not only to silence – unrepresentability – but also to a creative quest for a changed discourse and the emergence of a new poetics."[41] During and after the siege, cultural responses to death and destruction became important means of processing trauma. Reading historical fiction and writing diaries could provide a 'protective capsule' or therapeutic space in which to confront trauma.[42] Although Leningrad was a special case, both in terms of the scale of the traumas experienced by blockade survivors, and the importance of cultural expression to local identities, literary and artistic activity provided a means of confronting trauma beyond the northern capital. The literary front was itself a key battleground in mobilizing and motivating Soviet soldiers to fight and keep fighting. The writing of journalists, authors, and poets like Ilya Ehrenburg, Vasili Grossman, and Aleksandr Tvarovskii gained a popular following, offering a mixture of entertainment, propaganda, and comfort to beleaguered soldiers. The war also created its fair share of writers, and even its own genre: "lieutenant prose" or "trench fiction." Writers like Victor Nekrasov, Vasil Bykov, and Viktor Astasf'ev, to name but three, carved out a literary niche by attempting to describe the horrors of front-line experience.[43] For these former soldiers, writing could become a means to deal with "the war within."[44] In order to represent traumatic experiences, new languages and rhetorical devices, as well as a sense of detachment, were sometimes necessary. "To represent the Siege," as Polina Barskova writes, "the representer had to create some kind of distance, a psychological buffer between his or her subjectivity and the site of the pain."[45] *Efim Segal* shared many features of socialist realist literature, particularly a positive hero determined to uphold core Soviet values, but it sought new ways to express and represent trauma. Its focus on Segal's emotions, his fractured nightmares and flashbacks, and periods of hospitalization, offered a different aesthetic. Instead of hints

and allusions to trauma, which the knowing reader was left to interpret, the language and imagery of the novel were more direct and visceral than Soviet fiction usually permitted. The gap between Sobolev's experiences and that of his alter ego, however, were often paper thin.

Efim Segal and the Languages of Trauma

Although Efim Segal was returning to his hometown, Moscow and its inhabitants seemed much changed by the war. He had lost his family and home, after the death of his parents following their evacuation to the Urals in October 1941. He no longer recognized much of the city, or indeed the morality of its inhabitants. People were exhausted from grueling labour, and gaunt from their inadequate rations. The behaviour of officials and bureaucrats who appeared to be sitting the war out in the rear was confusing and disorientating. This sense of alienation, especially towards men who appeared to have avoided the front, was particularly common among returning veterans.[46] This was no doubt aggravated by the regression in the life-cycle that medical discharge or demobilization represented.[47] Segal found himself back on the shop floor, on the bottom rung of employment, living in the sparse surroundings of a workshop converted into a dormitory. These were difficult circumstances for any veteran, but especially challenging for somebody so severely shaken by their wartime experiences.

Sobolev's writing is notable not just for its descriptions of post-war disorientation, but also the openness and candour with which it confronts psychological trauma. The languages employed to describe mental breakdown in *Efim Segal* are interesting for what they reveal about how veterans might have understood and spoken about trauma. Arriving at a redistribution point run by the Moscow City Military Registration Office a fellow soldier askes Segal why he had been discharged from hospital, the ensuing dialogue is telling. He replies that he had been "a little bit shell-shocked (*kontuzilo malost'*)," to which the soldier fires back, "They don't discharge (men) from the army with trifles."[48] When asked later, "Why he had been discarded from the army?" by a senior inspector at his new workplace, Segal reluctantly replies, "Shell-shock (*Kontuzii*), wounds."[49] The word *kontuziia*, used to mean trauma in these exchanges and throughout the novel, requires a brief word of explanation and analysis. This label, usually translated as shell-shock, literally referred to a concussion or contusion; in other words, physical damage to the brain and nervous system caused by rapid changes in air pressure from shelling. The term, sometimes rendered as *voennaia kontuziia* (military contusion) or *vozdushnaia kontuziia* (air contusion), dominated the psychiatric

discourse surrounding battlefield trauma from the Russo-Japanese War onwards. Professional psychiatric consensus on the meaning of this vocabulary, as well as the aetiology and symptoms of trauma, was far from universal. The emotional, behavioural, and psychological symptoms that the term described changed over time. Segal's use of the term, however, demonstrates how far this language had penetrated beyond the medical profession. Despite the taboos surrounding trauma and the reluctance of men to identify themselves as 'damaged goods,' Sobolev's characters readily used this language, and understand something by it. What precisely these languages of trauma meant to Sobolev, and potentially other traumatized veterans, becomes clearer in a series of episodes connected to Segal's war trauma.

The most obvious manifestation of trauma in the novel is a series of vivid nightmares that force Segal to re-experience the horrors of front line combat. Walking around Moscow soon after his arrival, Segal finds himself in the Izmailovo Park, a large wooded suburban park which had been a popular place of rest and relaxation away from the bustle of the city. The park is described as, "deserted, quiet, very quiet, as in a real forest," the peace broken occasionally by the sound of the trams that ran through it. Soothed by these surroundings Segal sits down on a park bench, closes his eyes to think, and nods off. The deafening quiet is broken by the rumbling drone of an approaching low-flying aircraft, and he is suddenly transported back at the front in the previous July; gathered around him are thousands of soldiers, their tanks and other military equipment as the division waits to cross a river. Suddenly, "tens of bombs are simultaneously plunging, with a howl and a whistle, to the shore and into the river, exploding, a crash, flinging up columns of earth, dust and water."[50] He fears for his life amidst this carnage, but is powerless to escape. "Tightly screwing up his eyes, having covered his head with both hands,/ Efim lays neither alive nor dead facedown in a shallow dip – symbolic cover, unable to protect him from neither bullets, bombs, nor a direct hit."[51] The details of the aftermath of this deeply traumatizing moment, bodies frozen into unbelievable poses, blood spatters, the groans of the injured, are seared deeply into Segal's memory, and brought to life in nightmares. It is measure of the severity of his trauma that these nightmares intruded on such peaceful surroundings. Yet, when Segal awakes his thoughts turn not to his condition, but to survivor's guilt. As Sobolev expresses it, "War and peace. Peace and war. A fatal sequence replacing one with the other century after century, thought Efim. Here in these minutes, thanks to fate and God he has been preserved during war, while he sits in the fairy-tale silence of the wooded park, his comrade-*frontoviki* wage an intense battle (*tiazhelye boi*), death cuts down

people without relent, shells tear (people) to pieces, the sky is full of smoke and fire." Far away from the front it is hard for Segal to escape the knowledge of the war's horrors. At a moment when he might have rejoiced in his personal safety, Segal is preoccupied with dark thoughts: "Peace and war, war and peace – until complete self-extermination, is this how it has to be whilst humanity inhabits the earth?!"[52]

Nightmares continue to plague Segal throughout the novel. In the close proximity of an over-crowded dormitory, these traumatic symptoms could not be kept from other people. Indeed, his roommates cursed him for interrupting their sleep.[53] During the day Segal worked incessantly, but became increasingly exhausted by the workplace regime. By noon his eyes were shutting, his arms and legs heavy, his whole body drowsy, his head clouded in fog. This was by no means unusual, industrial workers as late as 1944, as Donald Filtzer has so skilfully demonstrated, were often weakened and exhausted by the cumulative effect of physically demanding labour and inadequate rations.[54] Yet for traumatized veterans, these working conditions were even more challenging. At the end of a twelve-hour shift, Efim Segal returned to his dormitory, ate a meal of black bread, drank a mug of unsweetened tea and laid down to sleep. But he was unable to gain much rest. "In his sleep he saw long nightmares: that he had fallen into German captivity and that they were torturing him, that shell shrapnel pierced his abdomen, and other terrible things to think about." It was impossible to get much rest in these circumstances. "He flung himself about his sheets, cried out in a frightening inhuman howl …," becoming increasing run-down by the lack of sleep.[55] Segal's neighbours, frustrated by the "concerts (he) gives at night," might have understood that he was damaged by war, but were largely unsympathetic. The curses they shout are perhaps a telling indication of social attitudes to the traumatized.[56] Embarrassed by this situation and keen to avoid a repetition, Efim covers his head with a blanket, and is unable to sleep: "In the morning, he is jaded, as if he was slaving away (at work) all night, with difficulty he dragged himself to the factory."[57] This cumulative exhaustion appears to have exacerbated Segal's other symptoms, adding growing irritability to painful headaches. Sometimes after these nightmares he is crippled by headaches that could only be soothed by laying his head in his hands.[58] After attending a funeral Segal is unable to go back to work, his head "began to hurt to breaking point in the temples, until there was ringing in (his) ears."[59] Back in his dormitory he sits on his bed, "wrapping his head in his hands, rocking, trying to drive out the pain with monotonous movement, to deaden the mental suffering."[60] These descriptions of trauma, taken together, present a remarkable picture of how trauma was experienced beyond the clinic and in everyday post-war spaces.

Segal is initially keen to avoid contact with doctors after his wartime medical experience, fearing that he might end up back in a hospital bed. Yet, this is precisely what happens, albeit in more dramatic circumstances than he might have imagined. One Sunday morning he goes to purchase bread, but once at the bakery discovers that his ration card has been stolen from his shirt pocket. After several days he finally visits the ration card office, "hunger dragging him by the collar," in the hope of obtaining a replacement card. Here Segal encounters a bureaucrat with whom he has previously clashed, deeply dislikes, and against whom he holds a grudge. Segal's suspicions about this callous and slippery official are confirmed when he is accused of first trying to obtain a second ration, and then of having illegally sold his card. This provokes an angry and violent reaction: "Oh you bastard! Rear-line Rat! – (Efim) said through clenched teeth, he grabbed from (the official's) desk a heavy marble paperweight and ... he did not remember any further."[61] This was more than an instance of "assertive Ivan" banging his fist on the desk and arguing with uncaring bureaucrats.[62] Aggression, irritability, and a tendency to lose one's temper are behaviours often associated with trauma. Efim created more than a scandal. We later learn that he struck the official in the face with the paperweight. Because he was carrying documents identifying himself as a war invalid and a certificate about his shell-shock the police admitted Efim to a psychiatric hospital.[63] Even allowing for these circumstances, Efim was exceptionally fortunate not to find himself in police custody. Where war invalids committed violent crimes in real life, trauma was rarely considered an adequate defence.[64]

The descriptions of Efim Segal's hospitalization and psychiatric treatment are highly unusual. Psychiatric institutions and treatment were not unfamiliar subjects in late Soviet prose and poetry, but they were more commonly encountered in the context of punitive psychiatry forced upon dissidents.[65] However, in this instance institutional psychiatric care is presented as a therapeutic space, in which Segal begins to take steps towards post-war readjustment and recovery. Segal's doctor is presented as a caring and diligent professional, who is recalled with affection, and referred to throughout by his name and patronymic - Boris Naumovich. His treatment is not presented as particularly invasive. He receives an injection from a nurse, which sends him into a deep sleep, which was most probably a form of insulin shock therapy.[66] Awaking from this lengthy sleep, "it is as if a hand had waved away his head ache," he feels renewed strength, and a returning appetite. Over the course of his treatment he continues to receive injections, to take medicine, to recuperate with rest and better nutrition, and to spend time talking with Boris Naumovich. These discussions with a doctor may have served dramatic purposes, but

they also reveal something about the circumstances of Segal's wartime traumatization and earlier treatment. His initial instance of *kontuziia* was considered relatively mild, and after twenty-eight days in a military hospital he was passed fit. At this point, "he still felt unwell, frequent headaches exhausted him, suddenly his vision would darken, he still had an appetite." His military doctor, "an attentive and polite woman," nevertheless declared, "In the conditions of our hospital it is not possible to treat you."[67] Segal is not convinced by the efficacy of his medical treatment, but accepts it to avoid offending Boris Naumovich. It is clear by the time Segal is discharged that he had not fully recovered, but he was leaving the hospital stronger and better equipped to deal with the post-war world. Nevertheless, Boris Naumovich asks Segal to promise, "henceforth to not kick against the pricks (*vpred' ne lezt' na rozhon*)," a reference to avoiding taking on the unscrupulous officials that Segal so detested.[68]

Traumatic symptoms remained part of Segal's life throughout the novel. Yet over time he begins to find his place in post-war society, the turning point comes once he returns to journalism, writing for his factory's wall newspaper. Just as Sobolev found solace in writing, so does his fictionalized version of himself. It is through the written word that Segal's fortunes begin to improve. Through grassroots journalism he becomes both a man of words and a man of his word, a point that is captured in the published novel's cover image (see Image 4.2). He uses his voice in print, rather than his fists, to skewer the pretensions of corrupt officials and to correct burning injustices. He continues to be motivated by his frustration that while soldiers traumatized at the front were branded as "crazy" (*choknutyi*) or deserters, officials shirking their patriotic duty attracted little opprobrium.[69] By following up on letters sent to the editorial office of the newspaper, he attempts to address many of the social problems faced by individuals whose lives continued to be disrupted by the war and its aftermath. In one notable instance, he successfully lobbies on behalf of a war widow and her family for them to be relocated from a damp and dilapidated early 1930s barrack to more modern and spacious accommodation.[70] Resolving the injustices highlighted in these "signals from below," which in passing reveal much about the texture of life and work in post-war Moscow, drives the plot throughout the rest of the novel.[71] In this regard, Efim Segal has much in common with other literary positive heroes who sought to hold unscrupulous or stale bureaucrats to account, such as Dimitri Lopatkin, the central protagonist of Vladimir Dudintsev's *Not by Bread Alone*.[72] Despite the passages dealing with official anti-Semitism and the abuses of Stalin-era politics, Aleksandr Sobolev's novel was in many ways a rather conventional Soviet text.

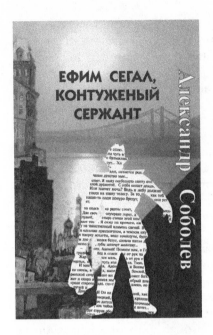

Image 4.2. The cover of *Efim Segal,
kontuzhenyi serzhant.*

Trauma Texts – Widening the Field

The pages of *Efim Segal, Shell-Shocked Sergeant* were part of its author's
attempts to work through his own war-related trauma. In its sustained
use of the language of trauma the text gives a valuable indication of
how veterans and wider society framed the psychological and psychi-
atric aftermath of war, and as such it deserves to be read as a trauma
text. The existence of this striking example of autobiographical writing,
which openly described and represented psychologically damaged vet-
erans, indicates that the silence around trauma was never complete. If
war trauma found expression in this novel, then other texts and cultural
products might also be reinterpreted in light of trauma theory. By focus-
ing attention on languages of trauma in their diverse forms it might be
possible to gain fresh insights into how wider Soviet society made sense
of traumatic experiences. Although severely traumatized veterans were
rarely represented in fiction, psychologically and emotionally damaged
ex-servicemen appeared more frequently than one might anticipate.
The feelings of disorientation and confusion that characterized Efim
Segal's initial return were a recurring theme in post-war fiction. Viktor
Nekrasov, a front line veteran who built a distinguished literary career,
explored the difficulties of adjusting to civilian life in a novel published

in 1955.[73] The first part of Iurii Bondarev's novel *Tishina* deals with a young veteran's difficulties reintegrating into civilian life, including the intrusion of traumatic wartime memories and feelings of resentment to those who appear to have shirked military service.[74] Andrei Platonov's 1946 short story *The Return* focuses on the challenge of reintegrating into the dynamics of family life after years of separation.[75] These texts demonstrated far greater emotional subtlety than late Stalinist socialist realist fiction, which tended to present veterans as one-dimensional exemplary heroes.[76] These texts, of course, were part of the literary landscape in which Aleksandr Sobolev wrote, and may have informed his thinking.

Languages of trauma can also be discerned beyond written texts. Many of the novels that confronted demobilization and the experiences of returning veterans were remade for the cinema screen during the Khrushchev era-thaw. Cinematic representations of disturbed soldiers or traumatized veterans did appear. The word *kontuziia* and the vernacular vocabulary of trauma may not have been spoken on screen, but the more naturalistic style of Thaw cinema enabled trauma to be expressed visually through bodies, movements, and gestures.[77] Elena Baraban's re-reading of Sergei Bondarchuk's 1959 film *Fate of a Man*, an adaptation of a 1956 short story by Mikhail Sholokhov, demonstrates the scope for interpreting post-war films as "testimonies of trauma." She lists a number of late Soviet war-films ripe for reinterpretation, including Andrei Tarkovsky's *Ivan's Childhood* (1962) and Elem Klimov's harrowing *Come and See* (1985).[78] Less stylized films also attempted to represent trauma. *The Cranes are Flying*, Mikhail Kalatozov's highly acclaimed 1957 film, contains a scene in which the film's heroine attempts to calm a wounded soldier. His head and arms are wrapped in bandages, and he is in the grip of an emotional breakdown after having learned that he has been jilted. The hero of Grigory Chukhrai's 1959 *Ballad of a Soldier* comes to the assistance of a depressed and dejected war invalid fearful of returning to his wife.[79] The actor who played this character, Evgenii Urbanskii, would later play the lead role in another of Chukhrai's films, *Chistoe Nebo* (1961), which explored the emotional turmoil of a former Prisoner of War.[80] The expression of trauma in visual form was not restricted to film. Photographers also attempted to frame trauma. Dmitri Baltermants's famous photograph "Grief," for example, taken in early 1942, depicts Kerch residents encountering the corpses left by German atrocities, and attempts to capture their anguish.[81] Psychologically damaged veterans may not have been the direct subject of the graphic arts, but issues of loss and bereavement often featured on canvas. The holes left in families by the death of men at the front were often represented in subtle ways, but nonetheless spoke to Soviet viewers.[82] Re-examining these representations of trauma,

and further research to uncover others, would help widen understandings of the languages of trauma deployed beyond the psychiatric profession.

Conclusion

Aleksandr Sobolev's novel *Efim Segal, Shell-Shocked Sergeant* serves as a prompt for re-examining Soviet war-related trauma. The text offers a valuable insight into the languages of trauma as expressed by veterans themselves, and an opportunity to examine veterans' psychiatric disturbances from a viewpoint other than a professional medical gaze. It reveals that despite the prevailing social attitudes to mental illness and psychiatric disturbances, some veterans sought to explore their trauma through the process of writing. Sobolev's writing was unusual in its explicit focus on war trauma, but its very existence opens a discussion on the limits of expressing trauma. Far from being unrepresentable, trauma found broader expression in literature and a wider Soviet culture. Sobolov's fiction also helps to illustrate why instances of individual trauma, which were abundant, did not evolve into a wider sense of collective cultural trauma. As Jeffrey Alexander suggests, it was often through literature that traumatic memories appeared in the open.[83] Although there were accounts that could be read as trauma texts, none of these found a mass audience, nor did they receive widespread resonance. There was no Soviet equivalent, for example, of Pat Barker's Regeneration Trilogy, which brought shell shock and war neuroses to the forefront of public consciousness in the United Kingdom.[84] *Efim Segal*, then, helps illustrate how and why no, "compelling, public available narratives of collective suffering" emerged in the Soviet Union. It was not that Soviet writers did not write through trauma, but that their words did not find wider traction. It was not simply that Soviet collective identities minimized individual trauma, although this may have been the case, but that accounts of trauma that might have facilitated a wider discussion remained on the margins of the literary landscape. The languages of trauma that undoubtedly circulated in late Soviet society never attained the status of a publicly sanctioned discourse.

NOTES

1 Aleksandr Sobolev, *Efim Segal, kontuzhenyi serzhant* (Moscow: Izdatel'skii dom PIK, 1999), 7.
2 Ibid.
3 According to WorldCat only seven copies of the novel are stored in libraries beyond Russia (at the National Library of Israel, the New York Public

Library, Princeton University Library, the University of North Carolina at Chapel Hill, the University of Illinois at Urbana Champaign, and Stanford University Library), accessed 21 February 2020, http://www.worldcat.org /oclc/46889713.

4 Mordechai Altshuler, "Jewish Combatants of the Red Army Confront the Holocaust," in *Soviet Jews in World War II: Fighting, Witnessing, Remembering*, ed. Harriet Murav and Gennady Estraikh (Boston: Academic Press, 2014), 29.

5 Tat'iana Soboleva, "*V opale chestnyi iudei*" (Moscow: Paralleli, 2006).

6 Vera S. Dunham, *In Stalin's Time: Middleclass Values in Soviet Fiction*, enlarged and updated ed. (Durham: Duke University Press, 1990 [1976]).

7 Soboleva, "*V opale chestnyi iudei*," 7, Photographs of his headstone give his date of birth as 6 November 1915: accessed 21 February 2020, http://po.m -necropol.ru/sobolev-aldr.html.

8 Ibid., 9.

9 For an analysis of the role young Jewish men played in establishing Soviet photography, see David Shneer, *Through Soviet Jewish Eyes: Photography, War and the Holocaust* (New Brunswick: Rutgers University Press, 2011), 1–30.

10 Tat'iana Soboleva, "Govoriat, chto ia schastlivyi," in Aleksandr Sobolev, *Bukhenval'dskii nabat: Stroiki-Arestanty* (Moscow: EKA, 1996), 7–8.

11 On the opportunities for citizen journalism, see Matthew Lenoe, *Closer to the Masses: Stalinist Culture, Social Revolution, and Soviet Newspapers* (Cambridge, MA: Harvard University Press, 2004), 103–244.

12 Soboleva, "*V opale chestnyi iudei*," 15.

13 See George L. Mosse, *Fallen Soldiers: Reshaping the Memory of the World Wars* (Oxford: Oxford University Press, 1990), 159–81; Joanna Bourke, *An Intimate History of Killing: Face-to-Face Killing in Twentieth-Century Warfare* (London: Granta, 2000).

14 Soboleva, "Govoriat, chto ia schastlivyi," 8; Soboleva, "*V opale chestnyi iudei*," 16.

15 Robert Dale, *Demobilized Veterans in Late Stalinist Leningrad: Soldiers to Civilians* (London: Bloomsbury, 2015), 114.

16 Soboleva, "*V opale chestnyi iudei*," 220.

17 Harold Marcuse, "Holocaust Memorials: The Emergence of a Genre," *American Historical Review* 115, no. 1 (2010): 75; James E. Young, *The Texture of Memory: Holocaust Memorials and Meaning* (New Haven: Yale University Press, 1993), 72–9.

18 Soboleva, "*V opale chestnyi iudei*," 60–1.

19 Ibid., 62–5; Marcuse, "Holocaust Memorials," 75. The memorial complex was dedicated on 14 September 1958.

20 Soboleva, "*V opale chestnyi iudei*," 69.

21 Aleksandr Sobolev, *Bukhenval'dskii nabat: Stikhotvoreniia* (Moscow: Sovremennik, 1985).

22 On the nature of this conflict, see Mark Edele and Michael Geyer, "States of Exception: The Nazi Soviet War as a System of Violence, 1939–1945," in

Beyond Totalitarianism: Stalinism and Nazism Compared, ed. Sheila Fitzpatrick and Michael Geyer (Cambridge: Cambridge University Press, 2009).

23 V.P. Osipov, "Osnovy raspoznavaniia psikhozov i psikhoticheskikh sostoianii v praktike voennogo vracha," in *Voprosy psikhiatricheskoi praktiki voennogo vremeni*, ed. V.P. Osipov (Leningrad: Narkomzdrav SSSR, 1941), 6.

24 Catherine Merridale, "The Collective Mind: Trauma and Shell-Shock in Twentieth-Century Russia," *Journal of Contemporary History* 35, no. 1 (2000): 47.

25 Jeffrey C. Alexander, "Toward a Theory of Cultural Trauma," in *Cultural Trauma and Collective Identity*, ed. Jeffrey C. Alexander, Ron Eyerman, Bernhard Giesen, Neil J. Smelser, and Piotr Sztompka (Berkeley: University of California Press, 2004), 2; Jeffrey C. Alexander, *Trauma: A Social Theory* (Cambridge: Polity, 2012), 7.

26 Alexander, "Toward a Theory of Cultural Trauma," 8; Alexander, *Trauma*, 13.

27 Laura L. Phillips, "Gendered Dis/ability: Perspectives from the Treatment of Psychiatric Casualties in Russia's Early Twentieth-Century Wars," *Social History of Medicine* 20, no. 2 (2007): 333–50; Jan Plamper, "Fear: Soldiers and Emotion in Early Twentieth-Century Russian Military Psychology," *Slavic Review* 68, no. 2 (2009): 259–83; Merridale, "The Collective Mind," 40–1.

28 For example, S.V. Gol'man, "Nevrozy voennogo vremeni (Po materilam imperialisticheskoi voiny 1914–1918 gg.)," in *Psikhozy i psikhonevrozy voiny*, ed. V.P. Osipova (Leningrad: Gosudarstvennoe izdatel'stvo biologichekoi meditsinskoi literatury, 1934), 34–66; S.A. Preobrazhenskii, "Voennaia psikhatriia v period pervoi mirovoi voiny," *Voenno-meditsinskii zhurnal*, no. 9 (September 1946): 41–3.

29 Merridale, "The Collective Mind." On this continuum of crisis, see Peter Holquist, *Making War, Forging Revolution: Russia's Continuum of Crisis, 1914–1921* (Cambridge, MA: Harvard University Press, 2002).

30 Robert Dale, "'No Longer Normal': Traumatized Red Army Veterans in Post-War Leningrad," in *Traumatic Memories of the Second World War and After*, ed. Peter Leese and Jason Crouthamel (New York: Palgrave Macmillan, 2016), 119–41; Albert R. Gilgen, *Soviet and American Psychology during World War II* (Westport: Greenwood, 1997); R. Gabriel, *Soviet Military Psychiatry: The Theory and Practice of Coping with Battle Stress* (Westport: Greenwood, 1986).

31 Paul Wanke, *Russian/Soviet Military Psychiatry, 1904–1945* (London: Routledge, 2005).

32 Benjamin Zajicek, "Scientific Psychiatry in Stalin's Soviet Union: The Politics of Modern Medicine and the Struggle to Define 'Pavlovian' Psychiatry, 1939–1953" (Ph.D. diss., University of Chicago, 2009), 168–227.

33 Pavel Vasilyev, "Alimentary and Pellagra Psychoses in Besieged Leningrad," in *Food and War in Twentieth Century Europe*, ed. Ina Zweiniger-Bargielowska, Rachel Duffett, and Alain Drouard (Farnham: Ashgate, 2011), 111–21;

Alexis Peri, *The War Within: Diaries From the Siege of Leningrad* (Cambridge, MA: Harvard University Press, 2017), 191–8.

34 Lisa A. Kirschenbaum, "The Meaning of Resilience: Soviet Children in World War II," *Journal of Interdisciplinary History* 47, no. 4 (2017): 521–35; Julie K. deGraffenried, *Sacrificing Childhood: Children and the Soviet State in the Great Patriotic War* (Lawrence: University Press of Kansas, 2014), 24–7, 35–6; Catriona Kelly, *Children's World: Growing Up in Russia 1809–1991* (New Haven: Yale University Press, 2007), 242–54.

35 Elena Baraban, "'The Fate of a Man' by Sergei Bondarchuk and the Soviet Cinema of Trauma," *Slavic and East European Journal* 51, no. 3 (2007): 514–34.

36 See Polly Jones, "Breaking the Silence: Iurii Bondarev's *Quietness* between the 'Sincerity' and 'Civic Emotion' of the Thaw," in *Interpreting Emotion in Russia and Eastern Europe*, ed. Mark D. Steinberg and Valeria Sobol (Dekalb: Northern Illinois University Press, 2011), 152–76; Polly Jones, "Memories of Terror or Terrorizing Memories? Terror, Trauma and Survival in Soviet Culture of the Thaw," *Slavonic and East European Review* 86, no. 2 (2008): 346–71.

37 Cathy Caruth, ed., *Trauma: Exploration in Memory* (Baltimore: Johns Hopkins University Press, 1995); Caruth, *Unclaimed Experience: Trauma, Narrative and History* (Baltimore: Johns Hopkins University Press, 1996); Ruth Leys, *Trauma: A Genealogy* (Chicago: University of Chicago Press, 2000).

38 Catherine Merridale, *Ivan's War: The Red Army 1939–45* (London: Faber & Faber, 2005), 15.

39 Catherine Merridale, *Night of Stone: Death and Memory in Russia* (London: Granta, 2000), 18–21.

40 See Michael Roper, *The Secret Battle: Emotional Survival in the Great War* (Manchester: Manchester University Press, 2009), 276–306; Alistair Thomson, *Anzac Memories: Living with the Legend* (Oxford: Oxford University Press, 1994), 109–12, 168–9.

41 Polina Barskova, *Besieged Leningrad: Aesthetic Responses to Urban Disaster* (Dekalb: Northern Illinois University Press, 2017), 5.

42 Barskova, *Besieged Leningrad*, 133–96, 154–5; Peri, *The War Within*, 201–33.

43 Viktor Terras, "The Twentieth Century: The Era of Socialist Realism, 1925–53," in *The Cambridge History of Russian Literature*, ed. Charles Moser (Cambridge: Cambridge University Press, 1992), 506–8; Andrew Kahn, Mark Lipovetsky, Stephanie Sandler, and Irina Reyfman, *A History of Russian Literature* (Oxford: Oxford University Press, 2018), 727; Zina J. Gimpelevich, *Vasil Bykaŭ: His Life and Works* (Montreal/Kingston: McGill-Queen's University Press, 2005); Katherine Hodgson, *Written with the Bayonet: Soviet Poetry of World War Two* (Liverpool: Liverpool University Press, 1996); Rina Lapidus, *Young Jewish Poets Who Fell as Soviet Soldiers in the Second World War* (Abingdon: Routledge, 2014).

44 Peri, *The War Within*.

45 Barskova, *Besieged Leningrad*, 16.

46 Robert Dale, "Rats and Resentment: The Demobilization of the Red Army in Postwar Leningrad (1945–1950)," *Journal of Contemporary History* 45, no. 1 (2010): 113–33.

47 Mark Edele, "Soviet Veterans as an Entitlement Group, 1945–1955," *Slavic Review* 65, no. 1 (2006): 113.

48 Sobolev, *Efim Segal*, 9.

49 Ibid., 20.

50 Ibid., 17.

51 Ibid., 17–18.

52 Ibid., 18.

53 Ibid., 79.

54 Donald Filtzer, "Starvation Mortality in Soviet Home-Front Industrial Regions during World War II," in *Hunger and War: Food Provisioning in the Soviet Union during World War II*, ed. Wendy Z. Goldman and Donald Filtzer (Bloomington: Indiana University Press, 2015), 313.

55 Sobolev, *Efim Segal*, 20.

56 Ibid., 79.

57 Ibid., 21.

58 Ibid., 79.

59 Ibid., 261.

60 Ibid., 262.

61 Ibid., 22.

62 Amir Weiner, "Saving Private Ivan: From What, Why, and How?" *Kritika: Explorations in Russian and Eurasian History* 1, no. 2 (2000): 317–20.

63 Sobolev, *Efim Segal*, 23–4.

64 Dale, *Demobilized Veterans*, 151.

65 Rebecca Reich, *State of Madness: Psychiatry, Literature, and Dissent after Stalin* (DeKalb: Northern Illinois University Press, 2018).

66 Sobolev, *Efim Segal*, 22. On these forms of treatment, see Benjamin Zajicek, "Insulin Coma Therapy and the Construction of Therapeutic Effectiveness in Stalin's Soviet Union, 1936–1953," in *Psychiatry in Communist Europe*, ed. Matt Savelli and Sarah Marks (Houndmills: Palgrave Macmillan, 2015), 50–72.

67 Sobolev, *Efim Segal*, 34.

68 Ibid., 36.

69 Ibid., 26–7.

70 Ibid., 223–37.

71 On the culture of letter writing from below, see Sheila Fitzpatrick, "Signals from Below: Soviet Letters of Denunciation of the 1930s," *Journal of Modern History* 68, no. 4 (1996): 831–66; Fitzpatrick, "Supplicants and Citizens:

Public Letter-Writing in Soviet Russia in the 1930s," *Slavic Review* 55, no. 1 (1996): 78–105.

72 Vladimir Dudintsev, *Not by Bread Alone*, trans. Edith Bone (London: Hutchinson, 1957); Denis Kozlov, "Naming the Social Evil: The Readers of *Novyi mir* and Vladimir Dudintsev's *Not by Bread Alone*, 1956–59 and Beyond," in *The Dilemmas of De-Stalinization: Negotiating Cultural and Social Change in the Khrushchev Era*, ed. Polly Jones (London: Routledge, 2006), 80–98; Kathleen E. Smith, *Moscow 1956: The Silenced Spring* (Cambridge, MA: Harvard University Press, 2017), 256–79, 319–24.

73 Viktor Nekrasov, *V rodnom gorode* (Moscow: Molodaia gvardiia, 1955).

74 Yury Vasil'evich Bondarev, *Silence: A Novel of Post-War Russia*, trans. Elisaveta Fen (London: Chapman & Hall, 1965); Jones, "Memories of Terror or Terrorizing Memories?," 155.

75 Andrei Platonov, *The Return and Other Stories* (London: Harvill, 1999).

76 For example, Semen Petrovich Babayevsky, *Cavalier of the Golden Star*, trans. Ruth Kisch (London: Lawrence & Wishart, 1956).

77 On the cinema of the Thaw, see Josephine Woll, *Real Images: Soviet Cinema and the Thaw* (London: I.B. Tauris, 2000).

78 Baraban, "'Fate of a Man,'" 515. On Soviet war films, see Denise J. Youngblood, *Russian War Films: On the Cinema Front, 1914–2005* (Lawrence: University Press of Kansas, 2007).

79 Grigorii Chukhrai, dir., *Ballad of a Soldier* (Mosfilm, 1959). On Chukhrai's own war experience see his *Moia voina* (Moscow: Algoritm, 2001).

80 Grigorii Chukhrai, dir., *Clear Skies* (Mosfilm, 1961).

81 Shneer, *Through Soviet Jewish Eyes*, 100–8; David Shneer, "Picturing Grief: Soviet Holocaust Photography at the Intersection of History and Memory," *American Historical Review* 115, no. 1 (2010): 28–52.

82 Claire E. McCallum, "The Return: Postwar Masculinity and the Domestic Space in Stalinist Visual Culture, 1945–53," *Russian Review* 74, no. 1 (2015): 117–43.

83 Alexander, *Trauma*, 11.

84 Peter Leese, *Shell Shock: Traumatic Neurosis and British Soldiers of the First World War* (Basingstoke: Palgrave Macmillan, 2002), 173–5; Dan Todman, *The Great War: Myth and Memory* (London: Hambledon Continuum, 2005), 146–7, 174–7; Tracy Loughran, "Shell Shock, Trauma, and the First World War: The Making of a Diagnosis and Its Histories," *Journal of the History of Medicine and Allied Sciences* 67, no. 1 (2010): 97; Michèle Barrett, "Pat Barker's 'Regeneration' Trilogy and the Freudianization of Shell Shock," *Contemporary Literature* 53, no. 2 (2012): 237–60.

5 The Falling Man: Resisting and Resistant Visual Media in Art Spiegelman's *In the Shadow of No Towers* (2004)

JENNIFER ANDERSON BLISS

In the Shadow of No Towers I (2004), an oversized and unconventional work of comics, centres on Art Spiegelman's experiences with and reaction to the terrorist attacks on the World Trade Center in New York on 11 September 2001.[1] The memoir illustrates the intricate, often disavowed, bonds between instances of personal trauma and public disaster, and shows Spiegelman's deeply conflicted and complex position between individual and collective experience negotiated through competing mediated images. *No Towers* draws together the trauma of Spiegelman's experience during 9/11 with that of the Shoah, working within and against the legacy of his earlier magnum opus, *Maus*, a comics memoir of his father's experiences in the ghettoes in Poland and the Nazi concentration camps during the Second World War.[2] In so doing, the text demonstrates the complicated network of trauma and memory within the multiple layers of visual representation in the text. *No Towers* is a work that defies convention in form and in content; the language of trauma here is the very language of comics, found at the intersections of the visible and invisible, the speakable and the unspeakable. In manipulating this medium, Spiegelman opens the possibilities for the representation of what was once considered "unrepresentable"[3] – that is, the representation of trauma in visual media.

The visual elements of *No Towers* both create and resist the transformation of trauma into narrative through the use of many different visual styles and references in a non-linear framework. Rather than pursue a conventional or linear narrative, Spiegelman writes in his preface to the memoir, "The Sky Is Falling," that he created *No Towers* as a way to "sort out the fragments of what I'd experienced from the media images that threatened to engulf what I actually saw."[4] Thus the text lingers in its own fragmentation, as the pieces of Spiegelman's memories rub against the "Master Narrative" of terror that emerged following the attacks – a

narrative created with and through a variety, even an overabundance, of images. *No Towers* presents the ways in which those "engulfing" media images inform Spiegelman's reactions to and understanding of the events of 9/11. Moreover, he situates these experiences in relation to his father's experiences of the Shoah, forcing a comparison – though not necessarily an equation – between the two situations, and between direct experience and what Marianne Hirsch calls the "postmemory" of experience.[5]

Much of the scholarship on *No Towers* focuses on these relationships between image, time, and trauma. In one of the first scholarly works on *No Towers*, Hillary Chute examines the relationship between trauma and temporality in the memoir, arguing that Spiegelman blurs the distinction between past and present in order to reflect his own lived experience of trauma and its comparison to the postmemory of the Shoah.[6] Following Chute, critics like Katalin Orbán[7] and Richard Glejzer[8] have explored the connections between the visual rendering of trauma and the fragmentary nature of memory, emphasizing the reliance on visibility and images in Spiegelman's work. This chapter follows and builds on such work, focusing on the significance of the hypermediated public images as central to Spiegelman's conceptualization of the traumatic event as a blend of the visible, the mediated, and the imagined. In its reliance on public images to render his personal experience into narrative form, *No Towers* also concretizes the ever-shifting intersections between the public and the private spheres of experience.

The overarching problem in *No Towers* lies in the convergence of multiple traumatic moments and experiences, which results in a complicated visual and textual narrative whose very physicality makes for an unconventional reading experience in terms of materiality, narrative, and subject matter. The physical act of reading Spiegelman's text is in itself a departure from an ordinary reading experience. The book measures the same as a tabloid newspaper spread, with the images and story filling both sides of the spread; unlike a newspaper, however, this book has thick cardstock pages, or plates.[9] Each plate is oriented so that the spine of the book runs horizontally, rather than vertically, again shifting the standard reading approach from one of right-to-left page turning to bottom-to-top. Reading *No Towers* requires space, patience, and adaptability.

This unorthodox presentation is a physical corollary to the thematic interventions of Spiegelman's work. *No Towers* brings together multiple traumatic elements into a single, if not cohesive, work: Holocaust postmemory; Spiegelman's immediate (as in, unmediated) lived traumatic experience of 9/11; the secondary pain of the US government's co-opting of the attacks for its own agenda; the tertiary suffering of the hypermediation of the attacks through the overabundance of imagery

played out in television, newspapers, films, billboards, and the like; and ultimately, the challenging act of creating comics out of this event. The visual and the traumatic are thus intimately bound up with one another, as Spiegelman navigates both media images and his own visions and artistic creations, weaving them into a patchwork medley of visible fragments.

Sorting the Fragments of Memory and Narrative

In "The Sky Is Falling," Spiegelman writes that in the aftermath of 9/11, "I was slowly sorting through my grief and putting it into boxes."[10] He frequently refers to the act of creating *No Towers* as an artistic response to his experiences, his trauma, and his political ire. Thus the act of "putting [his grief] into boxes" works as a metaphor not only for processing his own memories but also for creating comics, where the panels are like boxes containing the narrative of those memories. These "boxes," however, do little to make conventional narrative sense of the 9/11 terrorist attacks or of Spiegelman's own trauma; the ten plates that make up the text display a kind of frantic choppiness, a fragmentation of both image and memory.

This fragmentation and lack of linearity creates an almost tangible experience of temporal suspension and confusion on the page for the reader. The non-linear experience of time echoes many descriptions of acute trauma as "an event that [...] is experienced too soon, too unexpectedly, to be fully known and is therefore not available to consciousness until it imposes itself again, repeatedly, in the nightmares and repetitive actions of the survivor."[11] That is, a psychoanalytic reading of trauma claims a traumatic event to be one that resides outside of the regular experience of linear time. The traumatic event causes an acute wound whose vastness or intensity causes the victim to move in multiple temporal directions at once, unable to fully process the event in the present as it occurs, but drawn back to it as an involuntary recurrence beyond that moment.

Time thus figures as a central axis in the conceptualization of trauma as a psychological wound, and Spiegelman's narrative of his experiences during 9/11 continues this tradition and centralizes time as a major aspect of his work. The first series of panels across the top of the first plate, under the heading "The New Normal," depict three people watching a television. In the first panel, a calendar behind them reads "Sept 10" and the family lolls on the couch listlessly, expressions blank. In the second panel, the calendar reads "Sept 11" and the family stares at the TV screen, hyperbolic shock and disbelief on their faces, with their hair standing on end. The final panel in this sequence includes the family,

with hair still remaining standing on end, returning to their earlier cat-
atonic states in the exact same lethargic poses from the first panel. In
this final panel, the calendar has been replaced with an American flag,
whose white stripes are tinted bluish from the television screen's glow.
This off-coloured flag becomes its own panel, half hidden by yet another
panel depicting the orange "glowing bones" of the second tower, which
permeate the text.

While this blue-tinted image is undoubtedly a reference to the ubiq-
uitous presence of the American flag after 9/11, it has also quite liter-
ally replaced time (the calendar) in this panel. That is, in a "post-9/11"
world – a world whose very verbal designation marks a temporal and con-
ceptual break with a "pre-9/11" world – time seems to cease to progress
linearly. Instead, the world of the text – Spiegelman's world – is now
suspended in a kind of timelessness, where uncritical patriotism and hy-
permediated images reside alongside the trauma of the terrorist attacks.

Spiegelman's response to this timelessness, to his traumatic experi-
ences, is both to resist the co-option of 9/11 images by insisting on his
own memories and their distinctly visual nature, and to overemphasize
the fragmentary nature of these images. Doing so leads to a major dis-
ruption of a more traditionally linear reading experience. Chute notes
that "the publication of 'No Towers' as a serial comic strip, appearing in
print at irregular intervals, reflects the traumatic temporality Spiegelman
experienced after 9/11, in which a normative, ongoing sense of time
stopped or shattered; he feels that these pages represent what he calls "a
slow-motion diary of the end of the world.'"[12]

The digitally created image of the North Tower as it disintegrates ap-
pears in a series of five panels falling along the right-hand side of the first
plate of the text, but also appear in two panels on the lower left of the
plate. The captions' extensive use of ellipses and em dashes lends even
more confusion – to which elliptical phrase does a given caption belong:
the phrase following, or the phrase to the right?

In terms of appearance, there are at least six different visual styles
employed on this single plate: Spiegelman's 'standard' contemporary
cartoon style in the first panels; the nineteenth-century cartoon style of a
series labelled "etymological vaudeville"; the digitally altered and overly
pixilated image of the Twin Towers, drawn to mimic a television screen;
the orange-coloured, digitally created image of the North Tower collaps-
ing; the horror-movie-poster-inspired, brightly coloured central panel
below the fold of the page depicting a crowd running in panic; and
finally, the superimposed photograph of a shoe inside that lower middle
panel. This mismatch of artistic styles, coupled with the non-linear and
non sequitur page layout, echoes Spiegelman's experience of trauma

as a kind of psychic shock and unmooring. The disjointed stylistic approach is also his attempt to navigate visuality in the aftermath of the event's oversaturation of images.

The fragmented narrative of *No Towers* is not limited to the visual, however; it finds a textual equivalent in the shifting use of perspective. The second plate and most of the following plates switch between first and third person, as if the only way for Spiegelman to narrate the actual events of 9/11 is to distance himself from them through pronouns. For example, the third plate alternates between third- and first-person narrative, as rows of panels alternate between depictions of Art Spiegelman and his wife, Françoise Mouly, trying to find their daughter Nadja at her high school at the foot of the towers, and Art as a *Maus* mouse speaking to the reader while smoking and reflecting on the poor air quality and negative health conditions in New York City following the attacks. Running the length of the plate lie two columns bordering these two narrative arcs: the left column is the orange tower, grainy and pixilated; the right is an oversized cigarette, equally grainy; from both images rises a plume of orange smoke.

The third-person narrative series of this plate follows Art and Françoise as they arrive at Nadja's school: "They were the only parents allowed inside. Hysteria has its uses ..." (plate 3). The captions' insistence on the third person throughout this narrative and visual arc reflect Spiegelman's distance from his memories, his need to retell the story of what he saw and did on 9/11 as if it occurred to someone else. Just as Art and Françoise are the exception among a crowd of parents, "the only parents allowed inside" and separated into some other space, so too does Spiegelman's reaction to 9/11 separate him from himself. Paradoxically, this distance actually brings the text and the images closer together, as the reader always sees the avatars of Art (whether in human or mouse form) as visual objects, rather than from a first-person perspective. As Gillian Whitlock writes, "For Spiegelman, dissonance and estrangement [...] are vital to the work of representing traumatic memory in the comics."[13] In this way the reader and the author mimic one another's positions as outsiders looking in on one man's memories.

Even slightly more conventional looking plates, like plate 10, disrupt standard reading patterns. Starting as a reader of English usually would, in the upper left, the reader then moves from left to right through the first set of panels in the first column. The thick black line indicating the end of the column might indicate that the reader at this point should move to the next set of panels in the first column. The artwork in the next column, however, carries with it the same motifs – the same figure of Spiegelman holding his patriotic alarm clock – as in the first set of

panels in the first column. Is the reader therefore supposed to jump across the gap between the columns and read the first set of panels in the second column? Or, as stated before, should the reader instead move from the first set of panels in the first column to the second set of panels in that same column? Either approach might actually work for the first few sets of panels, until it eventually becomes apparent that the two columns actually contain two different narratives, and therefore each column is to be read separately.

The ambiguity and confusion here stem from Spiegelman's revisions and manipulations of the traditional ways that comics function. As Scott McCloud illustrates, the gaps between panels indicate usually that something in the narrative has happened – something the reader cannot see or read – between the first and second panel. Continuity in artwork and in text helps lead the reader to make certain conclusions about what has happened in the lacunae or the gutters between panels.[14] This process of navigating the black spaces of the gutters is what McCloud calls "closure." In this instance, however, continuity in artwork does *not* indicate continuity in narrative; in a way the text resists the very act of both graphic and narrative closure.

No Towers intentionally disrupts conventional comics form as an expression of Spiegelman's experiences. In fact, many of the panels do not actually have a traditional gutter of blank white space. Instead they appear on a background image, as in plate two – the shadows cast from the towers at the top right of the page fill in the spaces between panels across the rest of the page. Thus the spaces between panels, the necessary gaps in narrative, do not exist. The text attempts to fill in (or even overfill) the blanks, so to speak, with earlier images and shadows. One might even read the use of the towers' shadows as background as a kind of attempt to force the reader in a particular direction, towards a particular image of simultaneous disaster and absence. The shadow extends from the upper right of the page to the lower left, working against the direction of the progression of panels, disrupting the conventional reading experience of comics. Moreover, these shadows end in the recurrent image of the North Tower's "glowing bones." That the shadow of the towers fills the spaces between images reflects the apparent omnipresence of the towers in Art's post-9/11 life. On this page, the towers' shadows fill the empty space between panels, the gap between narrative moments. There is no escaping the Twin Towers or their destruction; even in the moments that should be empty (the gutters), the towers are present, breaking through, interrupting the story, casting their shadow.

This manipulation of traditional comics narrative devices emphasizes again the fractured character of Spiegelman's personal narrative of

trauma, as well as his rejection of the use of a traditional narrative to look at these events. In her article "Collateral Damage," Hirsch maintains that "[c]omics highlight both the individual frames and the space between them, calling attention to the compulsion to transcend the frame in the act of seeing. They thus startlingly reveal the limited, obstructed vision that characterizes a historical moment ruled by trauma and censorship."[15] The traumatized narrator cannot help but relate his story in a disjointed fashion; likewise, the comics creator shapes the structure of his text to reflect this "limited, obstructed vision" caused by the traumatic moment. Spiegelman simultaneously resists and embraces this "compulsion to transcend the frame" by disrupting the narrative flow of the pages, and by disfiguring, expanding, filling in, or otherwise shifting the spaces of the gutters.

The fourth plate, for example, contains practically no room for closure, no visual pause between panels, since the gutters are filled with the Lichtenstein-esque oversized newsprint pixels that form an image of one of the "Tower Twins," Spiegelman's parody of nineteenth-century newspaper cartoons. This pixilated background represents both the towers themselves and their overabundant media presence haunting the page and the narrative, making it impossible to escape the presence of the towers at any moment, even between the narrative moments.

At other moments the text renders itself semi-invisible as it covers its own panels, indicating both Spiegelman's insistence on a story that cannot (or should not) fully be told, and his troubled relationship with the comics medium itself. For example, as he and Françoise wait for Nadja in the school, "they couldn't see the maelstrom outside, but they could hear the guard's radio," which reports in Spanish on the attack on the Pentagon of that morning: "*un aeroplano acaba de estrellarse en el Pentágono!*" (plate 3). In the following panel the guard translates the radio's transmission ("They saying a plane just bomb into the Pentagon"), but a *Mars Attacks* bubblegum card covers up whatever image might have been accompanying this translation.

Art and Françoise's responses to the guard are unclear and, perhaps more significantly, invisible and silenced: one of them, presumably Art, 'speaks' an exclamation point in a speech balloon, while the other (Françoise) 'thinks' "Nadja?" in a thought balloon. These two image-texts *symbolize* real-life responses but do not *signify* them. They indicate to the reader that the two characters respond in some non-verbal way to the news of the Pentagon attacks, but they relegate that knowledge to the realm of the unseen and unarticulated. Mirroring the distance between Art and the attacks on Washington, this series of panels distances the reader from Art.

The *Mars Attacks* card depicts "Washington in Flames" and under attack from an alien flying saucer. Spiegelman explains, "When I was Nadja's age, in 1962, I loved those *Mars Attacks* cards published by TOPPS GUM, INC. Funny how things turn out. I worked for Topps for 20 years, from the time I finished high school till Nadja was born" (plate 3). Spiegelman's career as an artist and the terror attack on Washington come to a visual convergence here, through the bubblegum card covering up the avatars of Art and Françoise. Spiegelman visualizes the attack on Washington as a cartoon-y, alien event, despite his first-hand experience of the attack on New York, and thus he uses this card as the replacement for his own reaction to and understanding of the attack on the Pentagon.

In the panels following, Spiegelman muses, "He figured the Martians had invaded, that Paris was burning and Moscow was vaporized [...]. It was hard for puny human brains to assimilate genuinely new information ... and it remains just as hard now, these many months later ..." (plate 3). This last panel contains the principal's announcement coming from the intercom: "Due to today's unusual conditions, absolutely no students will be allowed outside for lunch" (plate 3). The disconnect between the principal's announcement and the events of the day parallels the disconnect between Spiegelman's understanding of the attack on Washington and that event. In both cases, moreover, Spiegelman relies on comics and cartoons to visualize the events, but in both cases these visualizations fall short of representation: the intercom and the bubblegum card act as intermediaries of the dissonance of that day's events.

Another 'external' image covers a panel on this lower half of the third plate. This image hides both the caption and the image of the underlying panel, creating a sense that the reader is missing an entire section of the narrative. The mouse-Spiegelman in the final row of the plate holds a protest sign that extends up into the preceding panels. It reads "NYC to Kids: Don't Breathe!" and features an image of two young children from the 1940s or 1950s wearing massive black gas masks. This poster, which Art designed for a protest at the school after 9/11, appears as if it is layered over or covering the panel beneath it, allowing just a corner of a caption and a piece of the loudspeaker to show. In this instance, the emphasis is not on the attacks themselves interrupting and disrupting narrative and vision, as above, but rather on Spiegelman's own need for artistic and political expression. The poster, he explains, was not used at the air-quality protest at the school, because "some parents protested my poster for being too shrill" (plate 3). In this instance, Spiegelman's own creation gets in the way of his narrative, covering up a panel, keeping the reader at a distance, echoing the way that Spiegelman's outspoken political views are met with reluctance in the public arena after 9/11.

No Towers thus illustrates the complicated ways in which personal narrative and memory work with and against one another, drawing the reader and the narrator together while simultaneously insisting on their distance from both the text and one another.

Memory and Image Construction

Comics critic Douglas Wolk describes *No Towers* as "a god-awful mess": "Its ten tabloid-sized pages pastiche the iconography and style of early-twentieth-century comic strips as a response to the fall of the World Trade Center, but Spiegelman's drawing is overworked and overcomputerized, and there's no sense of drive or closure to it – it just kind of ends after a while."[16] Part of the disjointedness so disliked by Wolk comes from Spiegelman's attempt to reject the images of 9/11 that pervade the mainstream media and are appropriated by the government and the media to serve their own purposes. As Spiegelman writes in the introduction, "I had anticipated that the shadows of the towers might fade while I was slowly sorting through my grief and putting it into boxes. I hadn't anticipated that the hijackings of September 11 would themselves be hijacked by the Bush cabal that reduced it all to a recruitment poster." Though Spiegelman's own views are on the left of the political spectrum, his disavowal of the government's treatment of the attacks in their aftermath seems to go beyond party affiliation. The memoir is strewn with references to the disgust Art feels at the glorified nationalism and commercialism he encounters in the months following 9/11. Spiegelman's resistance to the "Bush cabal" becomes in turn a resistance to the dominant representation of the terrorist attacks in the American news media.

Hirsch endorses Spiegelman's view of the widespread photographs – Spiegelman's "recruitment posters" – from 9/11, writing: "In the work of cultural memory, their [the photographs'] multiplicity may be overwhelming, and thus the archive of atrocity photos is quickly limited to just a few emblematic images repeated over and over. In their iconicity and repetition, they may lose their power to wound."[17] Those well-known images of 9/11 – the burning World Trade Center towers with smoke billowing from their sides – have begun to lose their power, according to both Hirsch and Spiegelman, due to their prevalence in the mainstream media and in most other representations of the attacks since.

Spiegelman therefore tries to actively work against such images in his work; his trauma will not allow him to accept the proliferated images and the desensitization they provoke. His insistence on other, more marginal images also tries to place emphasis on the person rather than the public sphere. Moreover, this insistence indicates Spiegelman's attempts

to distance himself from the Bush administration and its appropriation of those images for its own political agenda. Instead, Spiegelman creates and obsesses over a new, invented image – the disintegrating orange tower – that stands for his personal experience at Ground Zero. He writes: "The pivotal image from my 9/11 morning – one that didn't get photographed or videotaped into public memory but still remains burned onto the inside of my eyelids several years later – was the image of the looming North Tower's glowing bones just before it vaporized."[18] That this particular representation of the Twin Towers was not captured by photography or video camera reinforces the unique nature of this image for Spiegelman. It is what *he* claims to have seen, personally, not what was presented to him through the media, and his explicit, adamant claim to this image serves, at least superficially, to reclaim 9/11 not as a mythic national disaster, but as local and personal.

The repetition of the image of the glowing orange tower indicates the ways in which this image continues to haunt Spiegelman. It is a marker of that which he cannot escape and yet cannot fully express. That the tower is present on each page is a kind of repetition that serves to further emphasize Spiegelman's trauma. Furthermore, in insisting upon this image, Spiegelman also insists upon the moment of trauma itself, on the instant "the world ended" rather than on whatever happened before or after the attacks (plate 1). In fact, Spiegelman himself defines his own trauma: "I insist the sky is falling, they roll their eyes and tell me it's only my Post-Traumatic Stress Disorder ... That's when Time stands still at the moment of trauma ... which strikes me as a totally reasonable response to current events!" (plate 2). The representation of the orange tower indicates precisely "Time stand[ing] still at the moment of trauma"; it freezes one instant – literally mid-eruption – and repeats it, so that the instant becomes fixed and replicated, rather than a fluid movement forward in time. In addition, as Karen Espiritu writes, "the 'obsessive' labor involved in creating a graphic novel parallels the harrowing interminability not only of grief itself, but also of attempting to 'master' or understand – though never completely – a particularly traumatic experience."[19] In obsessively recreating this image, Spiegelman is attempting to work through his trauma, but the repetition of the image also indicates the "interminability" of such work.

Spiegelman's creation of this orange tower speaks to the visual nature of memory in this text; he relies on the use of some images to resist the co-option of other images. The imagined orange "glowing bones" of the tower come to stand for Spiegelman's personal traumatic memory, his own experiences, to which he clings desperately in the face of the mainstream media barrage and the US government's co-option of the disaster

for its own political ends. The image of the disintegrating tower that so disturbs Spiegelman also haunts his work; one can find the digital representation of the tower's glowing bones in each of the ten plates that comprise *No Towers*. In emphasizing this image – one not captured by camera, nor appropriated by mainstream media – Spiegelman actively rejects the now-iconic images of the terrorist attacks of 9/11. Whether or not this tower *actually* disintegrated in the manner Spiegelman depicts is a moot point, as Orbán argues: "the issue is not whether the visual representation of the subject can be appropriate and authentic at all, but rather whether there can be a visual alternative to the infinitely light and repeatable mediatized images, imitating overly familiar film scenes and intimating presence as a convention of genre."[20]

For Spiegelman, the "alternative to the infinitely light and repeatable mediatized images" is the image he creates of the orange tower; he "came close to capturing the vision of disintegration digitally on [his] computer."[21] The orange tower is thus admittedly a construct, without the presumed authority of a recorded or documented image, like those proliferated in the mainstream media. Instead the image is intensely personal, one that reflects Spiegelman's position in relation to the collapse of the Twin Towers, his own traumatic experience. Although this image is not one that was ever recorded, its invention in Spiegelman's work acts as his resistance to the oversaturation of 9/11 images in the media in the wake of the attacks. As such, the image of the orange tower is itself an image of the slipperiness of traumatic memory. Although it is not based in empirical or objective reality, the image of the orange tower is based in Art's lived experience, his individual, traumatized interpretation of this historic moment.

Media Images and Mediated Terror

Despite Spiegelman's obsession with his own created image of the "glowing bones" of the tower, the profuse media images that he tries to resist also appear throughout the text. Plate 10, for example, is organized into two different columns of panels. These columns are outlined in black; one has a spire extending up into the white border of the page. A proportionally small plane flies between them, just entering the black border of the right-hand column. The layout of the page here very deliberately corresponds to the Twin Towers, and the inclusion of the small plane echoes those very images against which Spiegelman acts. In spite of his insistence otherwise, Spiegelman is haunted not only by the image of the disintegrating orange tower, but by those now-iconic media images that, to quote Hirsch again, "[in their] repetition, they may lose their power to wound."[22]

Early in the work Spiegelman describes his reaction to the now-iconic media images of the burning towers:

> Those crumbling towers burned their way into every brain, but I live on the outskirts of Ground Zero and first saw it all live – unmediated. Maybe it's just a question of scale. Even on a large TV, the towers aren't much bigger than, say Dan Rather's head Logos, on the other hand, look *enormous* on television; it's a medium almost as well suited as comics for dealing in abstractions. (plate 1)

Spiegelman thus argues that the images of the Twin Towers have become smaller, less impressive, and less powerful through their overexposure on television (they are now the same size as Dan Rather's head). Moreover, most people in the United States and elsewhere experienced the 9/11 attacks through these mediated images. "Mediated" here has a double sense: the images reach us indirectly, through the television, newspapers, or the Internet; and they are images appropriated by the media (the mainstream media, at least). In the first panel in this series, Spiegelman presents a pixilated image of the Twin Towers billowing smoke (see plate 1), as if to reinforce this double mediation of images like this.

Using these hypermediated images might also be one way for Spiegelman again to claim to be moving past his trauma in the very act of creating these comics, as he maintains in the introduction. After all, as Patrick Bray shows, the media images of 9/11 also freeze and repeat the trauma of that day:

> These mass-distributed images, broadcast the world over at the speed of light, managed to shock and awe while the only information they transmitted was the continual disappearance of the Twin Towers. The towers were hit, fell, and reappeared in an eternal return The image of the Twin Towers as icons of world capitalism were never more present than after their physical destruction.[23]

It is little wonder that Spiegelman might explicitly define his own work in opposition to these images of both disaster and the conservative capitalist world view he attacks so vigorously.

Indeed, as Bray says, the orange tower that Spiegelman insists on in his personal traumatic vision of 9/11 is also the "overworked and overcomputerized" creation so disliked by Wolk:

> [The tower] calls attention to itself as visually different from the surrounding hand-drawn comics. At the same time, within the image itself, its own

status as representation of lived memory is undermined by the exaggerated size of its pixels, which guarantee the readability of the image's technical origin. The fleeting memory of the moment just before the collapse of the north tower, a memory threatened by the devastating force of media images, can only be represented by an image that exposes the danger of vision machines. The computerized illustration offers a vision of disintegration (of the tower and of memory), which itself disintegrates into pixels.[24]

Thus both the mass media images and the personal images offer a doubled disintegration of the towers: once as the moment of the attack fixed in time, and once through the pixilation of the images themselves, indicating a disintegration (and dis-integration) of those images as representations of the event. In this way, the tension between the public and personal images of the disaster becomes blurred, causing the individual and collective experiences of 9/11 to come into contact with one another.

Perhaps the most problematic of these overmediated images occurs on the sixth plate, in a panel that runs the entire length of the plate. This panel depicts a muted version of the North Tower, reminiscent of the repetitive orange tower thanks to its similar structure and pixelated texture. The tower appears brown instead of orange, set against a slate grey background. As the reader moves down this panel, we see Art's avatar tumbling along its length, as if he is falling out of the tower. Spiegelman here conflates memory with a kind of haunting, drawing parallels between his own personal experiences and the images he did *not* see: "He is haunted now by the images he *didn't* witness ... images of people tumbling to the streets below ... especially one man (according to a neighbor) who executed a graceful Olympic dive as his last living act" (plate 6).

The "Falling Man" image is perhaps one of the most controversial images coming from the days immediately following 9/11. One image in particular, taken by Associated Press photographer Richard Drew, juxtaposes a man who looks almost vertically suspended in air against the vertical lines of one of the towers behind him. According to Tom Junod's 2003 article in *Esquire* magazine, this photograph appeared in numerous newspapers around the country on one day, and never appeared again, due mostly to public outrage: "In the most photographed and videotaped day in the history of the world, the images of people jumping were the only images that became, by consensus, taboo – the only images from which Americans were proud to avert their eyes."[25] Spiegelman's inclusion of himself as the Falling Man points to an anxiety over co-opting this image and, simultaneously, *becoming* this image. Even the muted brown of Spiegelman's tower mimics the colouring of Drew's photograph. That is, in a link between "falling man" and "sky is falling" – the title of his

introductory essay and a line he repeats throughout the ten plates of *No Towers*, Spiegelman worries about his own work becoming *like* those very images he despises and by which he finds himself trapped.

Moreover, his own memory of the orange bones of the North Tower is here muted – both literally, in the colour palette, and figuratively, in its position as background – and layered underneath the haunting image of what Spiegelman never saw himself. One of the central crises of the text is not the exclusive encroachment of horrifying yet overabundant, desensitizing images, but the battle for memory itself, its visibility in tension with the imagined but invisible – paradoxically rendered visible in Spiegelman's own work – narratives of catastrophe. Indeed, the image of the "Falling Man," particularly Drew's photograph, actually attests to the mutability of images, their fallibility, their constructedness – that is, the ways in which they undermine themselves in the confrontation between fixity and fluidity.

Post-*Maus*, Postmemory

No Towers situates Spiegelman's individual experiences among larger public and collective experiences not only of the same event, but also of the transgenerational trauma of the Holocaust. The mouse icon from *Maus*, the autobiographical comics masterpiece of Holocaust postmemory for which Spiegelman is best known, appears in six of the ten plates that comprise this work. The *Maus* icon's presence indicates both the convergence of Spiegelman's Holocaust postmemory with his primary experience of 9/11, and *Maus*'s enduring legacy and even inescapability. The mouse imagery first appears as early as the second plate, not coincidentally alongside a brief shift from first- to third-person narration in the captions, where Spiegelman muses, "Equally terrorized by al-Qaeda and by his own government Our Hero looks over some ancient comics pages instead of working. He dozes off and relives his ringside seat to that day's disaster yet again, trying to figure what he actually saw ..." (plate 2). Art, wearing a mouse mask, sits slumped over a table, with a comics sheet dangling from his hand, as caricatures of a terrorist and an American politician (looking somewhat like George Bush, with a dash of Ronald Reagan) leer over him from either side. The *Maus* reference brings this moment into a complicated network of perceived victimization, as the lethargic and passive Art looks as if he has given up under the doubled weight of this "equal terrorism," the convergence of two historical traumas (the Holocaust and 9/11), and the doubled legacy of *Maus* and early comics.

Alongside this first image of the artist-as-mouse is a vertical series of panels, in which Spiegelman openly wonders about "issues of

self-representation" as he looks in a mirror, and which culminates in the figure of the smoking Art-mouse from *Maus*: "I was clean-shaven before Sept. 11. I grew a beard while Afghans were shaving theirs off. But after some 'bad reviews' I shaved it off again. Issues of self-representation have left me slack-jawed!" (plate 2). As Art shifts from bare-faced to bearded then back to clean shaven and ultimately to mouse, the text reveals the repeated intrusion of the Holocaust in Spiegelman's contemporary moment. Unable to decide how to represent himself both within and without the text, Spiegelman ultimately falls back on the mouse – an avatar and uneasy metaphor of the victim.

Using the *Maus* iconography creates a kind of transgenerational victimhood in which Art's own trauma comes into contact with the legacy of his father's trauma, and with the "postmemorial," intergenerational trauma of living under the Holocaust's shadow as the child of a survivor. That is, individual experiences – Spiegelman's experiences – rub up against and try to find their places within a larger social and historical network. Yet the particular influence of the Holocaust on this narrative points to the problematic notion that the Holocaust is often considered the trauma par excellence of the twentieth and early twenty-first centuries, the standard against which other catastrophes are measured. However, Spiegelman's references to the Holocaust are less in terms of defining 9/11 in relation to the concentration camps themselves – though he does perform that connection to a certain extent – and more in terms of navigating the interstices of individual, familial, and social networks of trauma and catastrophe that converge in this particular image.

One way this conflation between the historical and the individual occurs is through the motif of the cigarette. In well over half the panels in which Spiegelman appears, he is smoking a cigarette, and this addiction takes a central role in the third plate, in which the smoke from the cigarette is linked with both Auschwitz and Manhattan. On that page, a cigarette runs the entire length of the right side of the plate, and mirrors the orange tower running the length of the left side. At the top of both of these images, orange smoke curls from the objects (cigarette and tower). Thus a visual equation is made between the public attacks and the individual addiction (though choice) of the narrator. This equation is furthered near the end of the page, when Spiegelman laments the New York air quality: "I'm not even sure I'll live long enough for cigarettes to kill me," he states fatalistically as the smoke from his cigarette fills the panel (plate 3).

Near the top of the page, Spiegelman appears in *Maus* form, saying "I remember my father trying to describe what the smoke in Auschwitz smelled like …. The closest he got was telling me it was 'indescribable.'"

Spiegelman then 'pauses' for a panel to smoke his cigarette, and then looks out to the reader in the following panel, saying, "That's exactly what the air in Lower Manhattan smelled like after Sept. 11!" (plate 3). The Holocaust and 9/11 are brought together in extra-textual sensory ways at this moment in *No Towers*, as Orbán notes, with the smell of the air during both catastrophes mingling in the cigarette-smoke-filled air above Art's head.[26]

This caption also pulls the Holocaust and 9/11 into the same zone of contact precisely through their *unrepresentability*; it is not that the smoke from the camps and the smoke from the Towers smell alike, but that they are both "indescribable," outside of representation and language. Visually, moreover, these panels bring together multiple points in the past, as the *Maus*-mouse pulls both the Holocaust and Spiegelman's earlier work into the present, while filling the panels with the smoke from his cigarette. With the smoke and ash of 9/11 mingling with the smoke of Auschwitz and the smoke of Spiegelman's cigarettes, the text seems to imply that Spiegelman is in fact inhaling the ashen remnants of historical moments themselves – and that any one of those moments or choices might prove fatal.

Interwoven with this troubled navigation of traumas is a meditation on Spiegelman's "issue of self-representation" in terms of representing himself as more than the creator of *Maus* – which is in and of itself a definition in terms of *Maus*. Spiegelman's self-representation and his conflation of the personal with the historical are not a "working through" of trauma itself so much as a labour of reclaiming that trauma as *both* personal and historical. Kristiaan Versluys calls *No Towers* "a narrative that serves to reintroduce trauma into a new network of signification without normalizing or naturalizing the event,"[27] an apt description that might include collective and individual aspects. This network, however, is tightly bound to Spiegelman's position vis-à-vis the medium of comics and its potential for reproducing those very mechanisms against which he struggles.

Conclusion

In the opening series of panels in the second plate, Spiegelman's avatar addresses the reader directly as he laments his "Post-Traumatic Stress Disorder" while an eagle wearing an Uncle Sam hat hangs from Art's neck. The first panel in this series is a standard, flat panel, but the following panels appear to shift or rotate, revealing a three-dimensional aspect. Eventually the panels themselves form an image of the Twin Towers, complete with fire streaming from the top of the North Tower in a visual echo of the iconic, overly circulated images of the disaster in the media.

More significantly, however, the transformation of the actual panels of the narrative into the towers creates a sense in which the act of creating comics, for Spiegelman, is linked with and a product of disaster; creating comics and narrating the experience of this event actually fixes the moment of trauma as such. Moreover, as apparently three-dimensional objects and not flat two-dimensional panels, the shifting frames appear to physically contain Spiegelman inside both the comic and the tower. Just as he feels trapped by 9/11, and by its co-option by the Bush administration, so does it seem that comics themselves trap Spiegelman.

That comics as a medium here visually ensnares Spiegelman echoes his inability to escape the artistic and historical legacy of *Maus* – that is, not only the legacy of the Holocaust as postmemory, but also the legacy of a groundbreaking, Pulitzer-winning work, and the legacy of a medium so frequently sensational and sensorial. As the panels on plate 2 shift from panels to towers, Spiegelman displays his discomfort with the idea that this form is becoming as overdone as the media images he tries to resist. There is thus a twofold concern with the possible disaster of creative response and with artistic creation out of disaster.

The text itself is a conflation of public and private, despite Spiegelman's continued verbal claims that he rejects the public and dominant narrative of 9/11. The inescapable comparisons with *Maus* and the very fact of the text's initial serial publication in international presses attest to Spiegelman's involvement – reticent or not – in the public arena. While clinging almost desperately to his personal vision and experiences, Spiegelman's text nonetheless demands he situate those experiences in conversation with the larger national and historical framework of the catastrophe. *No Towers* itself thus presents comics as a means of survival in a world that demands both personal and public responses. Mixing text and image, presence and absence, it is the perfect medium for also expressing the tensions between subject positions. In the introduction, Spiegelman writes that "the unstated epiphany that underlies all the pages is only implied: I made a vow that morning to return to making comix full-time despite the fact that comix can be so damn labor intensive that one has to assume that one will live forever to make them."[28] While the frames of the comics do appear to trap Spiegelman, this is a trap consciously chosen as a means to reclaim his experiences and as a way of remaining in the in-between space. The very act of creating *No Towers* therefore becomes an act of surviving trauma, of both "sorting out" and remaining fragmented, of remaining invisible and simultaneously of rendering visible. Spiegelman's manipulation of the comics medium in unconventional ways – his filling in of gutters, the newspaper-sized cardboard pages, the blend of visual styles, and the reliance on many kinds of

media images – emphasizes the centrality of visual media to the understanding and representations of historical and personal trauma.

NOTES

1 Art Spiegelman, *In the Shadow of No Towers* (New York: Viking, 2004).

2 Art Spiegelman, *Maus, A Survivor's Tale: My Father Bleeds History* (New York: Pantheon, 1986); Spiegelman, *Maus, A Survivor's Tale: And Here My Troubles Began* (New York: Pantheon, 1991).

3 Cathy Caruth, *Unclaimed Experience: Trauma, Narrative, and History* (Baltimore: Johns Hopkins University Press, 1996).

4 Art Spiegelman, "The Sky Is Falling," preface to Spiegelman, *In The Shadow of No Towers*.

5 Marianne Hirsch, *Family Frames: Photography, Narrative, and Postmemory* (Cambridge, MA: Harvard University Press, 1996).

6 Hillary Chute, "Temporality and Seriality in Spiegelman's *In the Shadow of No Towers*," *American Periodicals* 17, no. 2 (2007): 228–44, http://www.jstor.org/stable/20770987.

7 Katalin Orbán, "Trauma and Visuality: Art Spiegelman's *Maus* and *In the Shadow of No Towers*," *Representations* 97, no. 1 (2007): 57–89, https://doi.org/10.1525/rep.2007.97.1.57.

8 Richard Glejzer, "Witnessing 9/11: Art Spiegelman and the Persistence of Trauma," in *Literature after 9/11*, ed. Ann Keniston and Jeanne Follansbee Quinn (New York: Routledge, 2008), 99–122.

9 I refer to 'plates' rather than 'pages' throughout because the text's pagination refers to the two-page plate rather than to the individual page; each plate was originally published individually before being collected as a single volume.

10 Spiegelman, "The Sky Is Falling."

11 Caruth, *Unclaimed Experience*, 4.

12 Chute, "Temporality," 230.

13 Gillian Whitlock, "Autographics: The Seeing 'I' of Comics," *Modern Fiction Studies* 52, no. 4 (Winter 2006): 977, https://doi.org/10.1353/mfs.2007.0013.

14 Scott McCloud, *Understanding Comics* (New York: Harper Collins, 1993), 94–8.

15 Marianne Hirsch, "Editor's Column: Collateral Damage," *PMLA* 119, no. 5 (October 2004): 1213, https://doi.org/10.1632/003081204X17798.

16 Douglas Wolk, *Reading Comics: How Graphic Novels Work and What They Mean* (Cambridge, MA: Da Capo Press, 2007), 346.

17 Hirsch, "Collateral Damage," 1212.

18 Spiegelman, "The Sky is Falling."

19 Karen Espiritu, "'Putting Grief into Boxes': Trauma and the Crisis of Democracy in Art Spiegelman's *In the Shadow of No Towers*," in *Review of*

Education, Pedagogy, and Cultural Studies 28, no. 2 (2006): 182, https://doi .org/10.1080/10714410600739905.

20 Orbán, "Trauma and Visuality," 72–3.

21 Spiegelman, "The Sky Is Falling."

22 Hirsch, "Collateral Damage," 1212.

23 Patrick Bray, "Aesthetics in the Shadow of No Towers: Reading Virilio in the Twenty-First Century," *Yale French Studies* 114 (2008): 4, https://www.jstor.org /stable/20479414.

24 Bray, "Aesthetics," 15.

25 Tom Junod, "The Falling Man," *Esquire*, 1 September 2003, https://classic .esquire.com/article/2003/9/1/the-falling-man.

26 Orbán, "Trauma and Visuality," 58.

27 Kristiaan Versluys, "Art Spiegelman's In the Shadow of No Towers: 9/11 and the Representation of Trauma," *MFS: Modern Fiction Studies* 52, no. 4 (2006): 980, http://doi.org/10.1353/mfs.2007.0011.

28 Spiegelman, "The Sky Is Falling."

PART TWO

Music, Theatre, and Visual Arts

6 Performing Songs and Staging Theatre Performances: Working through the Trauma of the 1965/66 Indonesian Mass Killings

DYAH PITALOKA AND HANS POLS

In the aftermath of an attempted military coup in Jakarta on the night of 30 September 1965, more than half a million people were killed in widespread army-orchestrated massacres while a further million communists, communist sympathisers, and supporters of left-wing causes were sent to prisons and detained under testing circumstances and, at times, tortured.[1] Survivors, their descendants, and family members and descendants of those who perished suffered decades of social marginalization, discrimination, and harassment as 'marked' individuals. In the meantime, Suharto, who took power after the 1965/66 massacres and established a military dictatorship, continuously vilified the Indonesian Communist Party (Partai Komunis Indonesia – PKI) and its members through propaganda and pervasive attempts to rewrite history.[2] Only after his fall in May 1998 did a small number of survivors start to speak up, albeit in a very modest way. Since then, several of them have undertaken attempts to work through their trauma and gain recognition for their suffering. Some focused on political activism, hoping that the Indonesian government and armed forces would acknowledge their involvement in the 1965/66 massacres and, ideally, apologize. Others formed groups concentrating on artistic activity, irrespective of what might happen in the political arena.

In this chapter, we follow the activities of the Jakarta-based Dialita choir (= abbreviation of _Di atas lima puluh tahun_; "above fifty years old") and the Teater Tamara (= abbreviation of _Tak pantang menyerah_; "never give up"), which is organized by Kipper (_kiprah perempuan_; "women's action"), a Yogyakarta-based theatre group. Members of both groups are survivors of the anti-communist repression of the Suharto regime. They aim to give artistic expression to their past suffering and, at the same time, embody voices of hope. We explore the voices of these survivors, their initiatives to articulate their trauma, both within their groups

and publicly, as well as their attempts to work through it. Singing and the power of music as mechanisms for resilience have been widely discussed among scholars, who have argued that singing and music had improved general well-being and quality of life for communities such as Aboriginal and Torres Strait Islanders in Australia,[3] displaced children in Colombia,[4] and asylum seekers in Australia.[5] Largely missing from the discursive spaces devoted to trauma, recognition, and healing are initiatives by groups of traumatized people who develop participatory activities that do not rely on the assistance of mental health professionals and on psychological or psychiatric theories concerning the 'nature' of trauma. The voices and opinions of survivors who initiate and take part in activities addressing their shared trauma and developing ways to work through those traumas have not always been foregrounded. By applying a culture-centred approach (CCA), our study views the narratives survivors articulate together and the collective trauma healing processes they design as the main entry point in understanding the 'nature' of the trauma suffered by these groups.

Listening to Survivors' Voices: The Culture-Centred Approach

Although the Indonesia massacres of 1965/66 are among the largest that took place after the Second World War – the number of people killed is roughly equal to that in Rwanda in 1994 – the Indonesian events have thus far received little international attention. The alleged coup and subsequent massacres have been carefully crafted and presented to younger generations by emphasizing the destructive role of the PKI in the coup of 30 September 1965 and the heroic efforts of the Indonesian armed forces to neutralize the threat it posed to the future of the nation. Not surprisingly, this dominant narrative consists of highly virulent anti-communism propaganda.[6] Fear and hatred of communism inspired gravely discriminatory actions towards alleged communists and ex-prisoners as well as their families and descendants:[7] they were unable to join the civil service, were excluded from university study and many forms of employment, and suffered continuous harassment. Many of them remained social 'pariahs' for decades.

Silence – an uneasiness and discontent produced by trauma – often occurs during conversations with survivors. In his research on political taboos in Croatia, Nebojša Blanuša wrote that a "taboo is imposed by the ruling class as an unquestionable way of public thinking and speaking that includes silencing any critical examination of the past."[8] In this context, problematic memories and awkward traces from the past are potentially disruptive and fear inducing; because they potentially destabilize

social balance and harmony, they are forbidden and are repressed.[9] For decades, public discussion about the mass killings, the regime's violence as well as its enduring effects, has been successfully suppressed by the state. Labelled as the 'cruel masterminds' behind the purported 1965 coup attempt, individuals accused of being communists or communist sympathisers had no right to claim that they suffered from trauma caused by what the government views as its victorious acts in "crushing communism" – acts it justified as a victory of the Indonesian people and their self-sacrificing army.[10]

After Suharto was forced to resign in 1998, it became possible to have a closer look at the 1965/66 massacres and their impact, and ascertain the extent to which the memories of these events continued to affect the lives of both victims and perpetrators. For the victims, their families, and descendants, memories of traumatizing events might be adaptive for group survival, as they prompt a search for meaning and the construction of transgenerational collective selves and identities. For the perpetrators, on the contrary, acknowledging their participation in the mass killing, and acknowledging the traumatic memories of the survivors, poses a threat to their collective identity and the identity of the Indonesian nation.[11] As a result, perpetrators at times address past atrocities by "denying history, minimizing culpability for wrongdoing, transforming the memory of the event, closing the door on history, or accepting responsibility."[12] The Indonesian government had hoped that the traumatic memories of the survivors would never surface. For more than fifty years the personal narratives of those survivors, who often were living restricted and marginalized lives, were unrecognized, unmentioned, and relegated to the realm of silence.

The culture-centred approach (CCA), as developed by Mohan J. Dutta, assumes that notions and meanings related to health and disease, and decisions affecting both, are continuously negotiated in cultural communities.[13] Analysis of cultural contexts can therefore offer significant theoretical insights concerning health and the management of ill health and disease. Engaging in dialogues with participants in these cultural communities results in locally valid articulations related to a complex web of meanings within which health is understood and co-constructed. These local understandings of health and disease often challenge the generally linear assumptions underlying dominant Western models of health communication.[14] In the culture-centred approach, health is not viewed merely as universal and located within a biomedical model; instead, it is made meaningful within the logics of culture and understood through the lived experiences of members of cultural communities.[15] Local understandings of issues related to health and disease are co-constructed

through dialogue among community members and researchers; this process precedes any intervention that might subsequently be undertaken.

Locating itself in contexts of marginalization, the culture-centred approach interrogates the mainstream biomedical knowledge production and turns the lens onto alternative ways of articulating knowledge about health and disease. Taking the culture-centred approach, researchers focus on the implicit web of meanings shared by members of specific cultural groups, foregrounding their agency instead of viewing them merely as recipients of neutral and objective advice.[16] This is accomplished through deconstructing taken-for-granted assumptions in mainstream knowledge venues and subsequently co-constructing discursive spaces that create openings for dialogic engagements and bottom-up articulations of meanings and experiences. Culture is seen as dynamic; it continually transforms itself as values and beliefs are passed on from one generation to the next. Listening to the cultural meanings of health disrupts the monolithic logic of health that informs the biomedical model, thus opening up discursive spaces to explore alternative ways of knowing and multiple epistemologies that often coexist as cultural members navigate the realms of health, illness, healing, and curing. This act of listening helped the authors, and in particular the first author, who belongs to the younger Indonesian generation, to identify how well we retell such stories.

In this chapter, we apply the culture-centred approach, which has mainly been deployed in exploring meanings of health and disease in culturally diverse communities, to investigate the way in which trauma, suffering, and healing are understood by survivors of the Indonesian massacres of 1965 and 1966. We focus in particular on two communities engaged in artistic activities – singing and performing – because their shared trauma has motivated them to initiative such activities. Instead of taking psychological, psychiatric, or literary theories of trauma as our starting point and investigating the extent to which the ideas and activities of both artistic groups can be analysed and explained by applying them, we aim to explore the meanings of trauma, survival, and healing that are, both implicitly and explicitly, central to these ideas and activities through long-term dialogue and discussion with the members of both groups.

Performing Resilience

The concept of historical trauma, pioneered by Maria Yellow Horse Brave Heart and Lemyra M. DeBruyn, maintains that the symptoms many Native Americans are experiencing (e.g., depression, substance abuse, diabetes, dysfunctional parenting, unemployment) are related to historical loss. They are the result of the cross-generational transmission of trauma

from historical losses (e.g., the loss of population, land, and culture).[17] Some research suggests that narrative writing and articulating personal stories are beneficial in helping Native Americans to recover from these traumatic events.[18] The Indonesian choir and theatre group we consider reflect spontaneous ways in which individuals and everyday communities engage in healing activities. Through mutual support and sharing of narratives of suffering and loss as well as hope with other members of the community, everybody contributes to the collective process of healing.

Stigmatized, socially isolated, and officially denied recognition of trauma, survivors of the Indonesia 1965/66 mass killings had been excluded from communicative spaces, including spaces to stage performances. The members of the Dialita choir and the Tamara theatre are ageing, and they currently struggle to reclaim access to these spaces and share their stories. Sundari, a member of the Dialita choir, describes that struggle as follows:

> Honestly, there is no such thing as a 'safe place' for us. We must stay alert. When people hear about 1965 or the PKI, they will instantly turn their head away from us. This is a struggle, for us [...] to at least introduce our stories to the younger generation. In this country, individual stories from the 1965 survivors were silenced.[19]

For the survivors, "PKI" and "1965" are identity markers that (re)create interpersonal and non-personal relationships as well as social meanings amongst themselves, and between their communities and society. Scholars have suggested that using arts-based approaches, such as poetry, songs, and theatre, helps co-produce knowledge within underserved and marginalized communities.[20]

Dini, a member of Kipper, describes the everyday challenges of being a survivor: "If you see poor people out there, then we are the underprivileged. We are the lowest of everybody [...] in everything. Dignity is the only thing we have left [...] that [conviction] has made me stronger." For the members of the Dialita choir and Tamara theatre, their respective groups provide spaces where they are able to seek support while, at the same time, providing support to others. The ability to support others, according to Wati, a member of the Dialita choir, constitutes a source of energy and motivation. Ratih says of Kipper meetings: "We have nowhere to go. Apart from my hair salon, the theatre is my source of hope. I can meet my friends and rehearse for our performance, I can channel my singing hobby [...] but most importantly, I'm happy." Similarly, Tinuk, who loves dancing and singing and used to work as a *keroncong* (traditional Javanese ballad) singer and traditional Javanese

theatrical performer, speaks about her involvement in the Kipper theatre group as "*obat sehat dan awet muda*" (a long-lasting youth and health medicine). Although a car accident in 2011 forced her to walk using a crutch, Tinuk still shows incredible energy and spirit.

For all participants, their theatre group and choir have become spaces where they can find hope and strength. "Many of our friends doubt that songs can initiate change: 'Reconciliation through song? It's lack of seriousness! If you want change, we must march through the street!' but I believe that ... no matter how small the change we make, it means something. We choose song, because we believe that if young people want to come to our performances, it means they're willing to listen [...] and if they're willing to listen, they may want to work together with us to create a better world for the next generation of Indonesians." Even though their artistic activities are not direct political interventions, the members of the Dialita choir hope that these activities will have enduring consequences. Fauzia, for example, discusses her concerns and struggles to create "cultural reconciliation" through songs – an approach that to some of her fellow 1965 survivors displays a "lack of commitment" and is "*lembek*" (soft). Tickets to their performances (Image 6.1) have always sold out, which illustrates anarchist Emma Goldman's argument (as paraphrased by James Thompson) that "art is understood to have a role in the present, as a protective force with an 'in spite of' quality that enables people to tolerate suffering, not so that they become immune to it, but so that they have the energy to continue to resist."[21] In a similar vein, Tati explains:

> Singing about joy and hope creates hope in others. We don't want to talk about blood, torture, or sufferings – well, nobody wants to hear about that, especially young people. We want people to see and recognize our strength, *semangat* [spirit; energy], and positivity. Like this song [she starts humming]: "*Bersama terbitnya matahari pagi*" [together with the morning sunrise], "*mekar mewah, mekarlah melati*" [roses and jasmine opulently blooming].

The song she hummed, "Salam Harapan" (Greetings of hope) was written inside Bukit Duri prison and, together with "Tetap Senyum Menjelang Fajar" (Keep smiling before dawn), was meant as a gift to fellow prisoners who celebrated their birthday. These two songs display hope amidst the distress and hardship that these women suffered as political prisoners. A sense of resilience and perseverance that dominates the lyrics offers alternative narratives to suffering and healing. "Sad, but stories behind the song [...] celebrating humble birthdays with friends inside the prison brings back happy memories [...] of love, support, and attention," Tati adds.

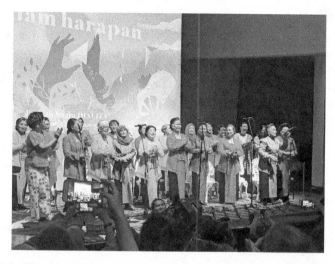

Image 6.1. The Dialita Choir at the concert celebrating the release of their CD *Salam Harapan*, at the Goethe-Institut Jakarta, 31 January 2019. Photo by Hans Pols.

Members of the Dialita choir and Teater Tamara use performance spaces as platforms to express their personal views, present their stories of struggle, survival, resilience, and hope, and promote their campaign for recognition.[22] Sri, a member of the Dialita choir, provided a long response about the importance of the choir to her:

A long time ago, when we formed this choir, we had no agenda. We just wanted to meet new friends. As time went by, we found comfort in each other and were able to share our stories [....] [To me, it meant that] we're not alone, that we share the same fears, the same past, the same struggles. We became a family. As we grew bigger, we realized that we needed to reach out to those who were less fortunate than us, especially elderly survivors. We visited their houses, brought small gifts, and sometimes we sang for them. I didn't realize that singing would bring such happiness and joy to all of us. We once were so frustrated with everything, knowing that the 1965 case is not going anywhere. It is stuck. Failed. Today, Dialita has grown bigger and we keep on singing. We continue to meet new friends, including young people outside the 1965 [circle] who are starting to accept us. Their acceptance means a lot to us. We feel accepted as human beings. For me personally, Dialita is and will always be a movement [...] to share a message of peace and love.

Tanti, who wrote several songs when she was detained at Bukit Duri prison, stated: "It is important to share our songs publicly, especially with the younger generations. These songs have been silenced for too long and for me, rewriting the lyrics and trying to find notes gives me energy to keep moving. We don't have much time. It's the only way we can create a better place for the next generation."

Adapting traditional Javanese theatrical performance styles in their plays, Teater Tamara Yogyakarta invites their audience to physically experience the sound and voices they create as an expression of loss, happiness, anger, love, and hope. In one of their plays, entitled *Temu Rindu* (reunion), each performer, who was also a performer and/or artist during the 1960s, had an opportunity to display their talents and claim their right to resilience. From *nembang* (a set of traditional Javanese singing skills) to *klothekan* (playing rhythmic patterns),[23] and from poetry reading to dancing, *Temu Rindu* combines various elements of everyday life into an inviting performance.

The murky and dark side of suffering reveals a story of family happiness that was forcibly shattered by acts of atrocity. However, Teater Tamara incorporates joyful music in its plays to introduce the audience to and engage them in the troupe's sense of resilience and strength (Image 6.2). Sri, a Teater Tamara member, stated:

> We don't want people to see us merely as a bunch of people who brag and complain about our lives. We want people to see our talent, our capability [...] our ability to survive, to thrive.

While the audience weeps, they also dance with joy, allowing the stories to fill their space and engage with them in a dialogue about what happened to too many families, young children, and friends after the 1965 tragedy.

For these survivors, acceptance and engagement are sources of resilience. Performing songs and staging theatre performances means engaging in a dialogue with their audiences. Scholars have argued that the importance of dialogue is evident in a number of areas of communication enquiry into democratic practices, such as managing difference and promoting social participation and social change.[24] Until recently, resilience has been viewed as the ability of individuals to recover from adversity.[25] However, in this context, we observed that both Dialita's and Teater Tamara's performances offer open invitations to their audiences to become entangled in the narratives of the survivors. Jati, a member of Teater Tamara, explains: "We get help from these young people. These are university students who voluntarily help us with this performance.

Image 6.2. Teater Tamara performance, 30 November 2018, Yogyakarta. "Plantungan" is the name of a prison for female political prisoners near Semarang. Photo by Dyah Pitaloka.

Mongkok atiku (I feel grateful and proud)." Artistic performance thereby becomes a way of collectively building resilience.

Voluntary support, according to Ning, a member of the Dialita choir, shows young people's acceptance and support for their struggle:

> *Alhamdullilah* [thank God], we gained support from these young people. Dialita spreads the message of peace and hope, so I believe that we don't walk alone. This is a collective effort. The involvement of young musicians in this album [Dialita's first CD] and the friendly requests for collaboration that we have received from young singers and artists are amazing.

The launch of Dialita's first CD, *Dunia Milik Kita* (The world is ours),[26] transformed and dissolved the state-prescribed identity and ongoing discrimination that stigmatized survivors and their descendants. The use of the word '*kita*' (we/us) offered an entry into a new world, a world without discrimination. One of the young people who sat next to the first author during Dialita's performance in December 2018 whispered that she never thought she would attend an event involving 1965 survivors: "This one is different. The songs and the women, it's as if like … like … watching my mom singing."

In this context, resilience is manifested in the ability of the performance to alter prejudice amongst members of the audience. The choir

and the theatre serve as resources for the survivors to cope with, and to neutralize, stigmatization.[27] In addition, for the audience members, the performances "mark a structural transformation that allows them to expose, to experience, to appreciate, and to engage bodily with different voices about 1965."[28] Artistic performances thereby become spaces of interaction between survivors and audience, which enables both groups to listen to each other's voices. In this context, resilience should be perceived as the capacity of both to recognize and interrogate the inequities that have framed relationships between those accused of communist sympathies and those who had previously perceived themselves as "clean" and untainted.[29]

Tati, one of the members of the Dialita choir, describes how the involvement of young musicians and singers in the launch of Dialita's CDs (the second one was launched on 31 January 2019) represented a collective force. To her, this force has become her motivation that encourages her and her group to continue to sing:

> I am overwhelmed by the response and the support that they [the young people] give us. These young people have no connection to 1965, and this is *important*. To me, it means they are willing to learn and walk with us. Kelik, Endang, Bonita, Tika [young musicians and singers who have collaborated with Dialita]: they put their musical touch and arrangements in our songs and they're more interesting now! Dialita has expanded into a larger family.

Similar experiences occur during the performances of Teater Tamara. The involvement of young volunteers in preparing the venue, the stage, the costumes, the music and documentation, and taking part in the performance, indicates the ability of theatre to create communicative spaces for communal activity and acknowledgment.[30] Performance as communicative space facilitates building social networks and establishing social relationships that, together, create what Judith Hamera describes as a social force or "cultural poiesis," as establishing a communication infrastructure that makes identity, solidarity, and memory shareable.[31]

The Co-production of Knowledge

In our research, we emphasize the centrality of dialogue to realize social change. In his writing, Simon Frith recounts the essence of music because it "articulates and offers the immediate experience of collective identity."[32] Music and theatre both create dialogical spaces where audiences are captured and drawn into "affective and emotional alliances."[33]

At a Humanity Concert featuring Dialita in December 2018, the first author noted:

> The girl sitting next to me said to her friend: "This beautiful love song was written inside prison?!? I can't imagine that! They're under tremendous pressure!" Note to myself, this song, "Red Rose," has a cheerful melody and, yes, is very romantic, but I wonder if it's due to the singer's interpretation and arrangement?

"Red Rose" is a song about two young people who had to give up their love because of the political situation. Observing how the song was performed by two people – Yati, the original female character in the song, and Kelik, one of the most talented young Indonesian singers today – in two different musical arrangements, clarified the message that these women survivors were trying to convey. "Red Rose" was written by Tati, Yati's close friend, who spent fourteen years with her in Bukit Duri prison.[34] The song relates the story of Yati and the young man she fell in love with. Unfortunately, they were unable to see each other let alone go on dates, since they were both imprisoned. The lyrics are as follows:

> Mawar merah yang indah kupetik (I pick a beautiful red rose)
> Dari tangkainya, untukmu adik (from its stem, for you, my sister)
> Kuserahkan padamu (I give it to you)
> dengan sepenuh kasihku (with all my heart)
> Sebagai jalinan cinta kasih (as proof of my love)
>
> Senja sejuk, angin sepoi basah (cool sunset, cold wet breeze)
> Semerbak mewanginya mawar merah (the fragrance of the red rose)
> Jadilah kau mawar saksiku sumpah setia (let the rose be the witness of my vow)
> Cinta serta kasihku kepadanya (my love to her)
>
> Esok lusa kau aku akan berpisah (the day after tomorrow, we will be apart)
> Usahlah engkau resah (don't be worried)
> Malam akan sirna, pagi pasti datang (night will fade, morning will come)
> Hari esok kita kan cemerlang (our future will be bright)

In a romantic and melodious swing arrangement, Kelik sang the song and invited audience members to sing and dance with him. The rhythm mesmerized the audiences, allowing them to experience the emotion between Yati and her lover. Kelik closed his performance by handing Yati a beautiful red rose.

It was interesting to observe how Kelik's performance contrasted with Yati's. With sad tones and tears, Yati, who will always cry whenever she talks about the song, describes "Red Rose" as more than just a love song. Actually, it was never meant to be a love song at all:

> I am happy that *Mas* [big brother] Kelik came up with a beautiful arrange-ment. It's fun and cheerful. You know, young people wouldn't want to hear sad and scary stories, especially about '65. They enjoy the melody because it's about love [speaking in a lower tone], young people. The truth is, we're just two young people who were forced to live in prison without knowing our mistakes. We didn't know when we would be out of prison […] and so, we had to let go of our feelings. Everything was so uncertain.

Kelik's interpretation of Yati's story and his involvement in the process of creating a new arrangement reflects a partnership among the members of the choir in defining both problems and solutions, and thereby in generating knowledge about 1965.[35] For Yati and other participants in this study, it is important to speak the language that young Indonesians understand and use. Studies found that, in a performance context, theatre is able to change opinions, create change, and empower both survivors and the audience, even on controversial topics.[36]

In her seminal work *The Cultural Politics of Emotion*, Sara Ahmed argued that experiencing emotion allows audience members to co-construct alternative narratives.[37] When a group of young traditional musicians and dancers shared the stage with the survivor-members of Teater Tamara, or when young singers and musicians sing together with the members of the Dialita choir, both performers and audiences are engaged in a process of transforming dominant narratives that work through othering. During these performances, "*ex-tapol*" ("*tapol*" is an abbreviation for "*tahanan politik*" or political prisoner) and "PKI" – those who are 'not us' and therefore imperil what is ours – become co-producers of alternative narratives that allow each individual to experience and adopt what Ahmed describes as "the you" into their narratives.

Through song and theatrical performance, survivors share stories of individual suffering that had been concealed from public view for decades. Yani, one of the members of Kipper, related:

> Nobody knows about the struggle and suffering that a kid must bear after their families were torn apart. They missed lots of birthdays, they missed the presence of their parents when they were sick, when they were being bullied or scolded at school. It was hard. For me, even when I missed my father so much, I could not whisper his name.

These experiential realities were hidden from the general public, repressed through a master narrative enforced by the New Order government. Younger generations have never witnessed any reality than the one enforced by the repressive and silencing tactics of the New Order, evident in history books and the 1984 state-sponsored movie *The Treachery of G30S/PKI*.[38] This is why, according to Fauzia, a member of Dialita, it is crucial for survivors to engage in dialogue with the younger generation. Fauzia and her friends from Dialita agree that articulating their experiences will help young people to emotionally engage with survivors and participate in meaningful dialogues. Themes such as love, friendship, determination, joy, and hope were selected by the members of the Dialita choir to optimize chances of dialogue and exchange. Through a long process, the members of the choir have worked, and are still working, to revisit and rewrite the memories they have shared with friends and families during those rough years – memories that, according to Sri, had helped them survive.

Love connects audiences with the stories of children, parents, and couples who were forcibly removed and detained during the annihilation of those accused of communist sympathies in the course of the 1965/66 massacres. One of the songs, for example, tells a story of a girl who was only fourteen years old when she was forced to live in prison without knowing why. Missing her mother, this young girl became the composer of the song "*Ibu*" (Mother), which builds a strong emotional attachment with the audience. This shared emotion creates personal connections between the audience and the motherly figures of the Dialita women – as if they were their own mothers. The act of listening that emerged during the performance opened up a discursive and resistive space for articulating new ways of thinking about 1965, increasing public awareness of the structural and systemic discrimination suffered by the victims and survivors.

This study suggests entry points for understanding the meanings of healing for 1965 survivors by listening to their voices, which may otherwise be marginalized or, at times, completely silenced. Through theatrical performance and singing, the community of survivors interrogate the meanings of health and healing. Choir and theatre serve multiple purposes for participants. They help survivors to negotiate the tension that comes with the struggle to participate in everyday life amidst stigma. Activities such as concerts, performances in various places, monthly (and sometimes weekly) practice, and rehearsals provide more complete and fulfilling lives. And apart from keeping participants busy, performing in front of audiences encourages a sense of personal worth and dignity, provides personal satisfaction, and promotes well-being.

Conclusion: Surviving, Healing, Thriving

In this chapter, we have sought to trace the strategies for dealing with trauma and realizing healing developed by two Indonesian communities of women survivors, focusing in particular on the survivors of the Indonesian mass killings in 1965 and 1966. We have explored the ways in which two artistic communities, the Dialita choir in Jakarta and the Kipper theatre group in Yogyakarta, employ artistic performance as a way of working through the trauma they suffered as survivors of these events. For these communities of survivors, healing consists in creating communicative spaces and engaging in dialogues with younger Indonesians. For the members of both groups, resilience is not defined as merely the ability of individuals to deal with past suffering and to cope with life's current challenges.[39] The members of both groups view resilience not as a personal attribute or an aspired outcome to be attained after therapeutic or other effort, but as a continuous process of challenging, disrupting, and interrogating power imbalances and injustice. They seek to open up spaces in which dialogue, discussion, and negotiation can take place, in particular where none previously existed. In those spaces, they aim to shape alternative futures both for themselves and for their main audience – the younger generation of Indonesians. For them, creating such spaces is the main source of inspiration and health.

Because both choir and theatre serve as networks of support for the community of survivors, whether they are performers or audience members, their performances assist survivors by creating spaces in which trauma can be articulated and heard. Through singing and performing, the members of the Dialita choir co-construct their specific individual experiences of suffering and healing by inviting younger generations in a dialogue about resilience and hope. The choir and the audience thereby co-construct alternative narratives about 1965, which alleviate trauma and become a source of hope and healing. For the members of Teater Tamara, theatrical performance constitutes a source of support and empowerment. By revisiting memories and sharing stories of suffering, they honour their history. By articulating pain, sorrow, and struggle, they situate various meanings of healing within their local contexts. The theatre performance, which combines acting, music, and singing, restores survivors' sense of pride and identity, and thereby creates a communicative space where members of the community of survivors no longer see themselves as victims, but primarily as survivors.

Notable in the initiatives of both choir and theatre group is that trauma and recovery are not primarily viewed as the outcome of individualized therapeutic processes. It is through the formation and the

activities of their artistic communities that trauma is transformed into hope and resilience and healing takes place. The narration of trauma does not occur in the abstract dialogue space of the therapeutic encounter. The dialogue between performers and audience is central for the process of healing. This dialogue arises between younger Indonesians who have not personally experienced the traumas of 1965 but grew up in a dictatorship based on the eradication of communist sympathisers, their continuous demonization in mass propaganda, and the silencing of memories of genocide, trauma, and marginalization.

This study shows that stage performances provide opportunities for survivors to form and present a different perception of their characters. Colourful *kebaya* (traditional Javanese dress), decorative elements, and music arrangements connect the audience with choir and theatre performers – whose talents and gifts shine through with each song and theme they present. Through songs and theatrical performance, 1965 survivors create alternative meanings to suffering and healing, challenging and disrupting structural inequities, injustice, and stigma that have debilitated them as humans. Seeking collective healing of their traumatic pasts, the women survivors' stories reflect and challenge larger social discourses of resilience and healing. Choir and theatrical performance are used by these women survivors to claim dignity and to initiate change. For these women, a better world for the younger generation of Indonesians is a world where one's dignity and capability as humans can be recognized and appreciated by others.

NOTES

1 Douglas Anton Kammen and Katherine E. McGregor, eds., *The Contours of Mass Violence in Indonesia, 1965–1968* (Singapore: National University of Singapore Press, 2012); Jess Melvin, *The Army and the Indonesian Genocide: Mechanics of Mass Murder* (New York: Routledge, 2018); Katharine McGregor, Jess Melvin, and Annie Pohlman, eds., *The Indonesian Genocide of 1965: Causes, Dynamics and Legacies* (Basingstoke: Palgrave Macmillan, 2018); Geoffrey Robinson, *The Killing Season: A History of the Indonesian Massacres, 1965–66* (Princeton: Princeton University Press, 2018).
2 Katherine E. McGregor, *History in Uniform: Military Ideology and the Construction of Indonesia's Past* (Singapore: National University of Singapore Press, 2007).
3 Jing Sun and Nocholas Buys, "Using Community Singing as a Culturally Appropriate Approach to Prevent Depression in Aboriginal and Torres Strait Islander Australians," *Journal of Alternative Medicine Research* 5, no. 2 (2013): 111–17, accessed 29 February 2020, https://www.researchgate.net

/publication/321903809_Using_community_singing_as_a_culturally
_appropriate_approach_to_promote_wellbeing_in_people_with_depression.

4 Gloria P. Zapata Restropo and David J. Hargreaves, "Musical Identities, Re-
silience, and Wellbeing: The Effects of Music on Displaced Children in Co-
lombia," in *Handbook of Musical Identities*, ed. Raymond MacDonald, David
J. Hargreaves, and Dorothy Miell (Oxford: Oxford University Press, 2017),
736–50.

5 Caroline Lenette, Donna Weston, Patricia Wise, Naomi Sunderland, and
Helen Bristed,. "Where Words Fail, Music Speaks: The Impact of Participa-
tory Music on the Mental Health and Wellbeing of Asylum Seekers," *Arts &
Health* 8, no. 2 (2015): 1–15.

6 See, for example, I. Wayan Badrika, *Sejarah Untuk SMA Kelas XI* (Jakarta:
Penerbit Erlangga, 2006).

7 Robert Cribb, "Political Genocides in Post-Colonial Asia," in *The Oxford
Handbook of Genocide Studies*, ed. Donald Bloxham and A. Dirk Moses (New
York: Oxford University Press, 2010), 445–65; Mary S. Zurbuchen, "His-
tory, Memory, and the '1965 Incident' in Indonesia," *Asian Survey* 42, no. 4
(2002): 564–81.

8 Nebojša Blanuša, "Trauma and Taboo: Forbidden Political Questions in
Croatia," *Croatian Political Science Review* 54 (2017): 171.

9 Antoon van den Braembussche, "The Silenced Past: On the Nature of His-
torical Taboos," in *Świat Historii: Prace Z Metodologii Historii I Historii Historio-
grafi I Dedykowane Jerzemu Topolskiemu Z Okazji Siedemdziesięciolecia Urodzin*, ed.
Wojciecha Wrzoska and Jerzy Topolski (Poznań: Inst. Historii UAM, 1998),
97–111.

10 Martijn Eickhoff, Gerry van Klinken, and Geoffrey Robinson, "1965 Today:
Living with the Indonesian Massacres," *Journal of Genocide Research* 19, no. 4
(2017): 449.

11 Gilad Hirschberger, "Collective Trauma and the Social Construction of
Meaning," *Frontiers in Psychology* 9, no. 1441 (2018): 1441; Braembussche,
"The Silenced Past."

12 Hirschberger, "Collective Trauma," 1441.

13 Mohan J. Dutta, *Communicating Health: A Culture-Centered Approach* (Cam-
bridge: Polity Press, 2008); Dutta-Bergman, "Poverty, Structural Barriers and
Health: A Santali Narrative of Health Communication," *Qualitative Health
Research* 14 (2004): 1–16; Dutta-Bergman, "The Unheard Voices of Santalis:
Communicating About Health from the Margins of India," *Communication
Theory* 14 (2004): 237–63; Deborah Lupton, "Toward the Development of
a Critical Health Communication Praxis," *Health Communication* 6 (1994):
55–67.

14 Dutta, *Communicating Health*.

15 Lupton, "Toward a Critical Health Communication Praxis."

16 Dutta, *Communicating Health*; Mohan J. Dutta and Ambar Basu, "Health among Men in Rural Bengal: Exploring Meanings through a Culture-Centered Approach," *Qualitative Health Research* 17 (2007): 38–48.

17 Maria Yellow Horse Brave Heart and Lemyra M. DeBruyn, "The American Indian Holocaust: Healing Historical Unresolved Grief," *American Indian and Alaska Native Mental Health Research* 8 (1998): 60–82.

18 Jennifer Lunden, "Salvage, Salvation, Salve: Writing That Heals," *Creative Nonfiction*, no. 48 (2013), 64–7; Anne M. Krantz and James W. Pennebaker, "Expressive Dance, Writing, Trauma, and Health: When Words Have a Body," in *Whole Person Healthcare, Vol. 3: The Arts and Health*, ed. I.A. Serlin, J. Sonke-Henderson, R. Brandman, and J. Graham-Pole (Westport: Praeger, 2007), 201–29.

19 All interview fragments derive from interviews conducted by the first author, Dyah Pitaloka, over the last five years. They were translated into English by the first author.

20 Mary Gergen and Kip Jones, "Editorial: A Conversation About Performative Social Science," *FQS: Forum Qualitative Social Research / Sozialforschung* 9, no. 2 (2008): Art 43; Kip Jones, "A Biographic Researcher in Pursuit of an Aesthetic: The Use of Arts-Based (Re)Presentations in 'Performative' Dissemination of Life Stories," *Qualitative Sociology Review* 2, no. 1 (2006): 66–85.

21 James Thompson, *Performance Affects: Applied Theatre and the End of Effect* (Basingstoke: Palgrave Macmillan, 2009), 2.

22 Fazila Bhimji, "Collaborations and Performative Agency in Refugee Theater in Germany," *Journal of Immigrant & Refugee Studies* 14, no. 1 (2016): 83–103; Melvin Delgado, *Music, Song, Dance, and Theatre: Broadway Meets Social Justice Youth Community Practice* (New York: Oxford University Press, 2017).

23 *Klothekan* means "playing rhythmic patterns freely, or improvising by listening to each other and responding to other players, resulting in a musical composition"; accessed 29 February 2020, https://www.andfestival.org.uk /blog/hive-conversation-ikbal-simamora-lubys-tony-maryana/.

24 Larissa A. Grunig, James E. Grunig, and David M. Dozier, *Excellent Public Relations and Effective Organizations: A Study of Communication Management in Three Countries* (Mahwah: Lawrence Erlbaum Associates, 2002); William K. Rawlins, *The Compass of Friendship: Narratives, Identities, and Dialogues* (Los Angeles: Sage, 2000); Julia T. Wood, "Foreword: Entering into Dialogue," in *Dialogue: Theorizing Difference in Communication Studies*, ed. Rob Anderson, Leslie A. Baxter, and Kenneth N. Cissna (Thousand Oaks: Sage, 2004), xv–xxiii; and Heather M. Zoller, "'A Place You Haven't Visited Before': Creating the Conditions for Community Dialogue," *Southern Communication Journal* 65 (2000): 191–207.

25 Elizabeth Buikstra, Helen Ross, Christine A. King, Peter G. Baker, Desley Hegney, Kathryn McLachlan, and Cath Rogers-Clark, "The Components of Resilience: Perceptions of an Australian Rural Community," *Journal of*

Community Psychology 38 (2010): 975–91; Norman Garmezy, "Reflection and Vulnerability to Adverse Developmental Outcomes Associated with Poverty," *American Behavior Scientist* 34, no. 4 (1991): 416–30; Margaret O'Dougherty-Wright, Ann S. Master, and Jan J. Hubbard, "Long-Term Effects of Massive Trauma: Developmental and Psychobiological Perspectives," in *Rochester Symposium on Developmental Psychopathology*, ed. D. Cicchetti and S.L. Toth (Rochester: University of Rochester Press, 1997), 181–225.

26 The word 'we' in Indonesian can be translated into either '*kami*' or '*kita*.' '*Kami*' excludes listeners (the person or persons one is talking to), whereas '*kita*' includes listeners in the activity or condition. By using the latter in the title of their album, Dialita includes both the choir and listeners, that is, the public at large.

27 Leanne S. Son Hing, "Responses to Stigmatization: The Moderating Role of Primary and Secondary Appraisals," *Dubois Review* 9, no. 1 (2012): 149–68.

28 Dyah Pitaloka and Mohan J. Dutta, "From Victims to Survivors: The Healing Journey of the Dialita Choir," *Jakarta Post*, 27 September 2016.

29 Dyah Pitaloka and Mohan J. Dutta, "Embodied Memories and Spaces of Healing: Culturally-Centering Voices of the Survivors of 1965 Indonesian Mass Killings," in *Communicating for Social Change Meaning, Power, and Resistance*, ed. Mohan Jyotti Dutta and Dazzelyn Baltazar Zapatta (Singapore: Palgrave Macmillan, 2019), 233–58.

30 Mohan J. Dutta, "A Culture-Centered Approach to Listening: Voices of Social Change," *International Journal of Listening* 28, no. 2 (2014): 67–81.

31 Judith Hamera, "Performance, Performativity, and Cultural Poiesis in Practices of Everyday Life," in *The Sage Handbook of Performance Studies*, ed. D. Soyini Madison and Judith Hamera (Thousand Oaks: Sage, 2006), 50–1.

32 Simon Frith, "Music and Identity," in *Questions of Cultural Identity*, ed. Stuart Hall and Paul Du Gay (Thousand Oaks: Sage, 1996), 108–27.

33 Simon Frith, *Performing Rites: On the Value of Popular Music* (Oxford: Oxford University Press, 1996), 273.

34 Bukit Duri Penitentiary was a women's prison located in Kampung Melayu, Jakarta, where some political prisoners were imprisoned between 1965 and 1979.

35 Mohan J. Dutta, et al., *Culture-Centered Method: The Nuts and Bolts of Co-creating Communication Infrastructures of Listening in Communities* (Singapore: CARE – Center for Culture-Centered Approach to Research and Evaluation, National University of Singapore, 2016).

36 Augusto Boal, *Theatre of the Oppressed* (New York: Theatre Communications, 1985); Gaurav Desai, "Theater as Praxis: Discursive Strategies in African Popular Theater," *African Studies Review* 33, no. 1 (1990): 65–92; Robert J. Landy and David T. Montgomery, *Theatre for Change: Education, Social Action, and Therapy* (Basingstoke: Palgrave Macmillan, 2012).

37 Sarah Ahmed, *The Cultural Politics of Emotion*, 2nd ed. (Manchester: Manchester University Press, 2014).

38 Nindyo Sasongko, "Epistemic Ignorance and the Indonesian Killings of 1965–1966: Righting the Wrongs of the Past and the Role of Faith Community," *Political Theology* 20 (2019): 280–95; Ann Laura Stoler, "On the Uses and Abuses of the Past in Indonesia: Beyond the Mass Killings of 1965," *Asian Survey* 42, no. 4 (2002): 642–50; Zurbuchen, "History, Memory."

39 Susan L. Cutter. L. Barnes, M. Berry, C. Burton, E. Evans, E. Tate, and J. Webb. *Community and Regional Resilience: Perspectives from Hazards, Disasters, and Emergency Management*, CARRI Research Report 1 (Columbia: Hazards and Vulnerability Research Institute, 2008); C. Folke, "Resilience: The Emergence of a Perspective for Social-Ecological Systems Analyses," *Global Environmental Change* 16, no. 3 (2006): 253–67; Brian H. Walker and David Salt, *Resilience Practice: Building Capacity to Absorb Disturbance and Maintain Function* (Washington, DC: Island Press, 2012).

7 *Some Things Are Difficult to Say,* Re-membered

KATRINA BUGAJ

In 1955, my mother's family emigrated from a displaced persons camp in Hildesheim, Germany, to Buffalo, New York. They were Polish refugees. For most of my life, that was where my family's history began – on a boat journey to the United States, where my five-year-old mother tried Coca Cola for the first time and my grandmother suffered from extreme seasickness. For the majority of my life, our family story contained painfully few details. There was an unspoken rule that we did not talk about the past. There were no outside relatives to ask, no family photos to reference. Just silence.

In 2008, I saw Quarantine Theatre's production of *Susan and Darren* at the Dublin Fringe Festival. The performance was created and performed by real-life mother and son Susan and Darren Pritchard. He was a professional performer (a dancer), she was not. They wrote and created their performance with artists from Quarantine Theatre, based in Manchester. The performance blended theatre, dance, direct address, autobiographical storytelling, and participation. Set within a theatrical frame, the performance staged memories from their lives, presented through dialogue and monologues spoken directly to (and sometimes with) the audience. The son, Darren, performed a dance he had choreographed and the rest of us got into the act, joining them both for a dance, some food, and a bit of a chat as the performance glided seamlessly into the liminal space of a participatory event. I still remember the moment when Susan recounted the story of the day her husband was murdered. Though I do not remember all of the details of her story, I remember the spot lighting, her glittering sequin dress, how her hands shook, and the authenticity of her presence. I was moved. Ever since that moment, I have found myself increasingly seeking out performances that blur the line between the autobiographical, the real, and the theatrical.

In 2009, I emigrated from Long Island, New York, to Copenhagen, Denmark, to build a life and home with my Danish husband, Troels. In 2015, I found myself pregnant with my first child. I also found myself struggling to communicate, growing quiet, and increasingly distraught over the negative rhetoric regarding immigrants living in Denmark, and the silences and holes within my own family history and identity. With the impending birth of my son, I felt an overwhelming need for a reckoning with the past (Image 7.1).

As a research-practitioner in the performing arts, I responded to my situation by embarking on a creation process. Gathering the fragmented personal stories, pieces of history, and a range of theories I had been engaging with, I entered the rehearsal studio determined to open pathways between hitherto unexplored combinations of autobiography and fiction, theory and practice. I wanted to create a productive space of encounter between all these various fragments. I felt compelled to make a performance. I did not want to wait, for funding or anything else. I needed to start immediately. To that end, I conscripted Troels, also a creator-performer in his own right, into the project. And we began the long (and frequently interrupted) process of gathering ideas, images, stories, and facts for our devising process, for the conceptual-concrete development of the unfolding piece. The result was a performance called *Some Things Are Difficult to Say,* which we performed at Teaterøen in Copenhagen as a part of the Copenhagen Stage Festival, in 2018.

The public performance of *Some Things Are Difficult to Say* intertwined personal and cultural memories with broader histories of transnational movements, traumas, and cross-currents, creating a "site of memory," as well as a site of remembering, "re-membering," and remembrance. I borrow the concept of "sites of memory" from the French historian Pierre Nora, who describes them as sites that involve the interplay of memory, remembering, and history where "memory crystallizes and secretes itself."[1] As a site within which memories have been given form and "secreted," *Some Things Are Difficult to Say* embodies knowledge of the interplay between these acts, or doings, of engaging with memory and remembering personal and historical pasts and traumas, often giving testimony through silence.

Michael White's concept of "re-membering," understood as "a process of reorganizing the events and persons that figure most prominently in our lives, much as we might reorganize the furniture in our homes to create new and more livable spaces," is also valuable when encountering the traces of process and performance left behind by *Some Things Are Difficult to Say.*[2] Remembering suggests that identity is shaped by a collective frame and narrative storytelling process of reordering one's experiences and memberships to communities.

Image 7.1. Troels Hagen Findsen and Katrina Bugaj, *Some Things Are Difficult to Say*. Performance material, personal archive.

With *Some Things Are Difficult to Say* I wanted to re-member my life story – a life and a story imbued with "postmemories."[3] I wanted to create a performance that could bear testimony to my grandmother's experience and to the silence surrounding certain historical events following the Second World War, namely, life in post-war displaced persons camps

and the treatment of Poland following the Tehran Conference. I also wanted to draw a link between the post–Second World War displaced persons camps (like the one my mother was born in) and the injustices happening today in Denmark, where there is an 'invisible' network of camps and detention centres for asylum seekers.[4] I started to consider how I might use my creative practice to present specificity in the face of the general and invisibility – to transform the personal into the political through a communal act of storytelling and imagination.

> Staging performances addressing and exploring instances of trauma, including the historical, the testimonial, as well as the functional and mythical, publicly centralizes and illuminates these spaces and experiences of darkness. If the unknowable, the unspeakable and the unrepresentable can be explored through the potentially utopian space and encounter of performance, then there is meaning and value to be generated.[5]

This essay is an attempt to continue the process I began with *Some Things Are Difficult to Say.* In it are the reflections of someone trained as a performer, director, and research-practitioner. These reflections are saturated with my experiences and memories as a creator-performer. They do not, however, depend on memory alone. Instead, my memories of creating and performing *Some Things Are Difficult to Say* have been supplemented with (and influenced by) photographs of the performance, interactions with the script, theory, notes, sketches, and conversations with my husband-collaborator as well as audience members. To borrow performance and postcolonial scholar Diana Taylor's terminology, the following reflections involve the interplay of the archive and the repertoire, where "the archive" refers to "enduring materials i.e. texts, documents, buildings, bones" and the repertoire is the "embodied practice/ knowledge i.e. spoken language, dance, sports, ritual."[6] Though the process and performance of *Some Things Are Difficult to Say* themselves were fleeting, perhaps the traces they left behind can extend their life and knowledge – as well as my journey, a journey deeply rooted in silence and the traumatic memories of my family that predated my own life (but have had a defining place within it nonetheless), and in a belief in the politics of experience and sharing life stories (where past and present, memory and imagination, interact in tangible ways) through public performance.

> Every place of violence and social suffering becomes, for a time, a place of silence. Deserted villages. Unmarked graves. Stunned survivors, whom words failed. Words are travesty, for words cannot bring back what has been lost. At such times, traumatic experiences tend to be salted away in the subjectivity, too painful and personal to be told. Gradually, however, the

passivity and silence in which the trauma endlessly recapitulates itself gives way to an impulse to rework one's experience and reclaim control over it. Events that seemed to occur adventitiously are subtly transformed into a story. Storytelling is an empowering act that helps move one from being the world's mere "matter" to an artificer of the world (Hobbes 1978, 19),[7] of experiencing oneself not as a creature of circumstance but as someone who has claim, some creative say, over how those circumstances may be grasped, borne, and even forgiven.[8]

Devising Process

Some Things Are Difficult to Say was devised by my husband Troels and myself based on a creative practice gained while attending L'école Internationale de Théâtre de Jacques Lecoq in Paris. This shared theatrical training is significant. These particular devising techniques take as their starting point the performers' bodies, their experiences, their imaginations, and what Lecoq articulated as a shared "search of truth, authenticity."[9] At the same time, Lecoq training explores highly theatricalized and physicalized styles of performance (mime, clown, buffoon, etc.). Thus, it provides a foundation rooted in creating original theatrical works from encounters between autobiography/self and theatricality, fact and fiction.

The inspiration for *Some Things Are Difficult to Say* came from several sources, the first being my own personal narrative, memories, and family history. The second source was feminist and postcolonial scholar Sarah Ahmed's concept of "encounters." As Ahmed states, encounters involve both "the domain of the particular – the face to face of this encounter – and the general – the framing of the encounter by broader relationships of power and antagonism."[10] As with autobiographical performances that draw on personal memories and cultural histories, Ahmed's encounters also involve a complex relationship between proximity and distance, the present and the past: "Encounters are meetings, then, which are not simply in the present: each encounter reopens past encounters."[11] Eventually, the concept of encounters became a guiding methodological framework for our process, performance, and this essay – as we thought through ways of providing productive platforms for fragments of theory and practice, the past and present, image, performance text, and personal reflections to meet. The third source was a visual and written record of my own 'dialogue' with a number of scholars and artists engaging with questions of identity, storytelling, trauma, and the relationship between the past and present. This archive was composed of scribbled notes, images, drawings, family photos, and quotes gathered during a

Image 7.2. Research and rehearsal notes, *Some Things Are Difficult to Say*. Personal archive.

research process for a paper investigating the personal narratives of immigrants and the intersection of fact and fiction in theatrical performances that take such accounts as their primary source (Image 7.2).

The devising process took place across three stages: improvised studio-based explorations of my own personal experiences and fragmented family history, with a particular focus on which stories had not been and were not being told – and why; improvisation and staged juxtapositions of materials, ideas, and bodies inspired by the concept of encounters; and finally, improvisation exploring the central role of language in the identity crisis that often results from immigration and traumatic experiences. Each of these stages of studio practice involved an iterative process of response (to tasks, materials, improvisations) – research – reflection – doing/improvisation – articulation – presentation (to invited audiences for feedback, as well as the eventual public performance of the work). The aim was to cultivate and foster a multilayered, open-ended process in which the personal, theoretical, research, and creative methodologies could interact and potentially produce surprising results.

As noted, Sara Ahmed's work with the concept of encounters permeated numerous aspects of our process. Aside from providing a working methodology, her work provided many of the quotes scribbled in my rehearsal notebook and posted on our rehearsal studio walls. World religion scholar and existential anthropologist Michael Jackson's work

regarding the transformative, and political, power of storytelling was also very present during our devising process. I have extracted some of the observations that came from Ahmed's book *Strange Encounters: Embodied Others in Post-Coloniality* (2000) and Jackson's *The Politics of Storytelling: Variations on a Theme by Hannah Arendt* (2013) that were stuck to the wall of our studio while we worked and interspersed them with my own reflections and memories of our devising process to try and create re-membered, and new, spaces of encounter.

The Rehearsal Studio

We began with a long-form improvisation during which my collaborator, Troels, asked me to tell my story. And to tell my family's story.

> [I]n telling a story with others one reclaims some sense of agency, recovers some sense of purpose, and comes to feel that the events that overwhelmed one from without may be brought within one's grasp.[12]

He asked me questions about my family. I had a stack of blank paper in my hand and each time I came to something that was difficult to say I was supposed to put a piece of paper on the floor. It became clear, during the improvisation, that there were three reasons something was difficult for me to say. First, if the answer required was taboo, or involved personal information about myself, or someone in my family, and it felt like a violation to say it aloud. Second, if I did not know the answer, because it had never been talked about, and therefore I simply could not say. Third, if I was unable to articulate the answer clearly enough in Danish. At the end of the improvisation, the floor was covered with papers and I had said very little aloud. We also tried to make lists of 'things that are difficult to say.' It proved challenging to make a list that did not come across as either too revealing (personally and on behalf of my grandmother), preachy, or banal.

Next, we tried to re-enact what we thought it might have been like for my family during and after the war. Through this work we were confronted with the limitations of theatrical representation, particularly given the scope and scale of our project. It became particularly obvious when we attempted to faithfully re-enact the traumatic experiences my grandmother and mother's family had experienced. We staged scenes based on the few fragments of stories I did know. This prompted self-reflection about what these scenes might 'do' to the others intertwined within my story – a reflection that has continued through this process as well. I also felt uncomfortable and questioned if the '"doing'

of those scenes was responsible, harmful, ethical. What was my responsibility to the others in my story/ethics and the creative work/aesthetics?

We also tried to imagine what my family had gone through. These imagined scenes seemed to do the opposite of what we intended, and the moments fell flat or felt too staged. Living within a global culture already saturated with stories of persecution during the Second World War, particularly stories that include or centre around Holocaust memories and testimonies, and faced with so much silence surrounding my grandparents' lived experiences during that time, we turned our attention to life after the war, a time my mother, who is still alive, lived through. During our research, these experiences seemed to be less visible, with so many WWII stories we came across ending with the end of the war itself. It felt important to insist on presenting the unacknowledged (or rarely acknowledged) history of life in a displaced persons camp, of the people stuck in a state of limbo, people who felt it was impossible to go back to Poland after the war, people whom, I imagined and thought I remembered hearing, felt betrayed by the way their country was handled by the Allies. We struggled to find ways of presenting or representing that historical moment, those people, my family and their emotions that did not feel clichéd or in support of already dominant narratives. It was challenging to tell the story of getting out of the displaced persons camp in a way that felt honest without making myself, or my family seem, ungrateful. It felt delicate and difficult.

> Stories are often cover stories, defences against danger and hurt. They downplay any disparity between the truth of one's own experience and the truths enshrined in the dominant narrative of the state, which expects gratitude from refugees, not grievances, conformity not criticism.[13]

As we continued with our work, it became clear that what moved us, and frightened me, was the impossibility of it all. The impossibility of ever fully capturing what it was like, or of filling the silence with anything more powerful than itself. We started to work with the idea of staging and performing silence. We began juxtaposing and layering the pieces of information, incomplete memories, and facts that we did have into my own personal journey. We mapped my family's history backwards. We started with me and my present location and experience of living in Denmark and worked backwards to see how far back we could go. I spoke to my mother and a couple of her sisters. I turned to the Internet in an attempt to find distant relatives and research my family linage. I wrote to Polish government agencies and contacted representatives from the national archives in Germany. I was able to find information about the

two generations before me. The incompleteness called attention to an interrupted, fragmented, 'unspeakable,' and unknowable family history. We began to look back further, this time to imagine connections: with people from the village of Bugaj in west-central Poland; to Slavic tribes; to the Polish Vikings; with our extinct close relative, the Hominini Lucy.

We also wanted to work with the difficulty I was having talking about my family's past, and communicating generally, as an immigrant in Denmark. We began to focus on using the silence instead of trying to talk over it, to think about hearing in a new way.

> To think of hearing as touch is to consider that being open to hearing might not be a matter of listening to the other's voice: what moves (between) subjects, and hence fails to move, might precisely be that which cannot be presented in the register of speech, or voicing.[14]

We placed silences in juxtaposition to gesture and 'authenticating' documents – such as my mother's birth certificate and a handful of photographs – in order to experiment with what might be moved between the stage and audience in doing so. While my best friend's family had always had bulging family albums going back decades, we did not have any photographs from my mother's childhood until she inherited a couple of albums during the late 1990s. I printed copies of the six photos I had acquired from my mother's childhood (restricting my search to the ten years before and after her family immigrated to the United States), and put them up on the wall while we worked. We tried to listen to the photographs. To pay attention to the quiet, quotidian, posed images. The expressions were curious. Who were these people? I wondered what was outside of the frame. I thought about how these images had remained with my grandmother for decades, about who might have seen them. Were they ever shared with anyone? I sought out conversations with my mother that I hoped would help me amplify the moments that the photographs seemed to incompletely elicit.

> Such encounters always conceal as much as they reveal: they involve trauma, scars, wounds, tears that are impossible to forget (they affect how we arrive or face each other, the encounter itself involves a form of remembering) or to present or to speak (they are not to be found in the mouth or on the skin of the one who is speaking or who remains silent).[15]

Since our process was unfunded, it was often interrupted. During one such interruption, I found myself working with a slide projector on another project. I started to think about the collective, ritualized

twentieth-century practice of the family slide show. A constitutive practice common during my mother's life, and my early childhood, used to remember and re-member family identity and history. A space I always imagined to be full of laughter, anecdotes, popcorn, and the hum of white noise. A space for the recounting and remaking of family identity. I started to think about what a slide show with very few photos might evoke. What stories could we tell? How? I brought a slide projector into the rehearsal studio for *Some Things Are Difficult to Say.* As we projected larger-than-life versions of the photographs of my family (sitting for a photo in a displaced persons camp, on the boat over to the United States, posing for an Easter family portrait) against the back wall, I started to be troubled with the work and to question: what drives someone to remain silent their entire life about such experiences? To never share these photos, even with their grandchildren? Would my grandmother give her consent for me to make her personal photos, and life, public? How was I using the images and to what end? I tried to look closer, I made the photos small, big, placed them in different contexts within the developing piece. I wondered: what are these photos saying?

> For in the encounter in which something might be said or heard, there are always other encounters, other speech acts, scars, traumas, that remain unspoken, unvoiced, or not fully spoken or voiced.[16]

Eventually, we selected one photo to use during the performance. We decided to emphasize the overall lack of archive and create an almost entirely blank family slide show. After a series of blank white light-squares and clicks, the Bugaj family Easter portrait appeared on the inside of a suitcase (Image 7.3).

As part of our work, we explored the notion of giving testimony and the idea of offering an elegy to my grandmother, to the people left in limbo at displaced persons camps for years after the war. We struggled with questions of: What should be told? Who could I/we speak for? What would we even say? How was all of this relevant to our community here in Denmark? We researched and investigated the connection between what people experienced after the Second World War in displaced persons camps and what appeared to be a political strategy to disappear the asylum seekers at places like the Sjælsmark Detention Centre in Denmark.

I started asking my mother about what she remembered about her childhood, life in Germany, or what she could recall being told about life there, and recording our conversations. I listened to faint descriptions of converted army barracks turned living spaces. I heard about a displaced persons camp that was part of the British Zone, located just

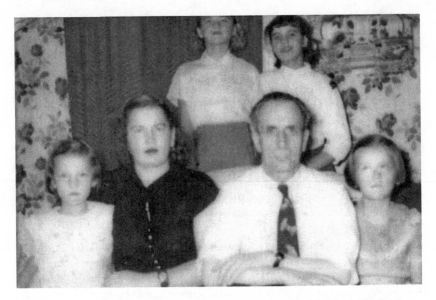

Image 7.3. The Bugajs, *Some Things Are Difficult to Say*. *Seated, left to right:* Barbara, Janina, Kazimesh, Henrika. *Standing, left to right:* Emily, Genevieve. Buffalo, NY, circa 1956. Performance material, personal archive.

outside of the city of Hildesheim, Germany, where mostly Polish refu-gees lived while trying to get somewhere else. Of how no one there was allowed to go to the city proper without written permission. My mother spoke of how sometimes all there was to eat was half a slice of bread for the entire day. How it took over seven years for my grandparents to find a way out in 1955. How they were being strong-armed to go back to what became communist Poland. How they were a problem for the Allies. So many details and feelings seemed to resonate with what people were describing about life at Sjælsmark and other detention centres; the dis-tancing, isolation, so many years waiting, people going about their daily lives in nearby cities. The unspeakable, unknowable experience of living through the war was also hinted at, with small details that suggested ex-periences of humiliation, violation, violence, and 'impossible' situations.

Those conversations were brought into the studio and devising pro-cess, along with statistics about the war and its aftermath. We selected some of her words and we made signs. We juxtaposed them with facts about post-war life for Polish refugees and the names of detention cen-tres in Denmark today. We told stories through written fragments, at times smashing together the beginning of one fact with the end of a sen-tence from my mother's stories. We started working with a microphone,

a standard convention of the confessional or testimony and a performative tool useful for focusing attention on the spoken word. It became clear, over time, that there was a tension in the room. There was a desire to stage silence, to respect the choices of my grandparents to stay silent, to protect them, to protect myself, and not share too many details of their/our lives. And there was a desire to scream it all out at the top of my lungs. To tell and tell and tell until all the words and secrets were out. We investigated whose stories should be told, and how, and what those stories might do. We experimented with what we might communicate with words, what could be shown, and how I could tell my story without actually saying anything? Out of this exploration arose the idea of working with a recorded voice.

> If she does not speak her resistance, then how can we hear it? How can we listen out for her? How can we listen carefully? Have I got too close? The narrative moves me forward. Everywhere there are broken bodies.[17]

Working with a recorded voice introduced a whole new dimension to this work, as well as the concept of performing silence. A recorded voice could speak perfect Danish. Being removed from me, she could say things I found uncomfortable to say aloud. Or things I simply could not pronounce. She could name personal and historical traumas. She could speak from the past, having already been recorded, already 'been there.' That could give her a position of authority. I could remember and manipulate her voice. I could skip over stories I did not want told, stage the metaphor, go back and replay something I wanted to repeat. I could break the machine she was speaking from, I could break her. I could align myself with her, or make the audience think that her voice was my own. And all the while, I could remain, for all intents and purposes, silent. We found a woman to record the performance text. A non-performer. Details and text that may have seemed banal became fragile, and authentic when framed by a recording device and amplified by the onstage speakers.

We staged a performance encounter where I sat and looked each audience member directly in the eye as 'my voice' told stories of how my mother used to hide under the kitchen table as a young girl in Buffalo. An extremely shy girl, she would sit and listen to adult stories told over vodka. I threw my own body onto the floor, arriving violently from a boat journey. We wanted physical movements to have consequences. I repeated the movement, starting as one woman and becoming a wash of broken bodies at the edge of the sea. We layered these movements with information about people moving, refugees moving, asylum seekers

migrating. We layered contemporary movements of people onto move-
ments of post-war refugees. I would enter these physical narratives and
fully believe them, like: at one point it became impossible for me to get
up off of the floor and I thought: "I want to get up, I need to, but my
body won't comply." The overall result was a performance composed of
pieces and layers, like a collage, that embodied the incoherent, incom-
plete affect of orphaned, traumatic experience and identity. Experiences
that became a part of me and my story, even though I could never really
know or represent them.

> I have been thinking about belonging and visibility. My own. My mother's.
> My grandmother's. Other daughters and mothers and grandmothers. I pres-
> ent my body as the central container of multiple layers of memory, as well as
> the primary site of identity making – with the past not just being reflected
> back, but reconstructed through oral recollection and bodily reenactment.
> My grandmother's trauma has imprinted on me. (Can I even name it as
> such, she never did ...) Or rather, the result, her silence. I remember once
> telling a friend that I felt so frustrated that there were some things I did not
> know, that she never told me, or at least my mom. He suggested, carefully,
> that maybe she was trying to protect us, me. I am trying to take that in. To
> create and transmit a new version of an individual and collective past and
> present. Is that coming across? Can silence be an act of testimony? A way
> to remember?[18]

Performance Notes

Lacking post-performance public documentation and interpretation, the
knowledge *Some Things Are Difficult to Say* embodies risks being lost to the
ephemeral nature of the repertoire. That said, some of this knowledge
will be lost. Performances disappear and writing about them is an act
of translation. How, then, do we engage with performances such as the
one described above in a way that can capture them beyond the text and
the images left behind? The following is an attempt to try and address
that question, to remember and re-member the performance. It aims to
write this work of the repertoire (the live performance) into the archive
without being overly reductive or trying to recreate or replace the live
performance as a thing in and of itself. It also aims to try and do so from
the inside, from a position of embodied experience and being there.

 The public performance of *Some Things Are Difficult to Say* at the
Copenhagen Stage Festival provided a community to bear witness to my
own processes of personal, narrative reordering and identity-making.
Re-membering (like remembering and its 'bedfellow' forgetting) was an

action and strategy used in the performance to create new possibilities within myself, for me to reckon with my lived and inherited past, and a pathway to membership within my foreign, Danish community and artistic community.

Using the authoritative 'I' of storytelling, all of the events retold and reworked in *Some Things Are Difficult to Say* gave testimony to the two-way interaction between the past and present, between memory and identity construction, and between myself and the audience. The performance, in which I was accompanied by my husband Troels, blended together physical gesture and dance, music, re-enactments, authentic objects, and testimony. At moments we used the explicitly theatrical, re-enacting memories we never experienced, imagined scenarios. Other times, we drew on the contextual 'realness' of lecture-performance and highlighted the auto/biographical claims of the piece, using our own names and sharing authenticating documents such as family photos. As a result, we presented a troubled space of in-between that deliberately and strategically moved away from the auto/biographical while simultaneously claiming it.

During the performance itself, the audience follows the title character, Katrina, who has literally lost her voice. In an effort to find it, with the help of her husband, Troels, she goes about mapping out her life. Their journey unfolds through a non-linear fragmented narrative, weaving together voice and gesture, stories and fragments from different periods, present day and the past. Katrina's journey becomes increasingly incoherent, incomplete, and made up of imagined and orphaned fragments of memory and history as she goes back and forth between present-day Denmark, France (where she met Troels), the United States (where she was born), a DP camp in Germany (where her mother was born), a farm in Poland (where grandmother was born), a detention centre in Denmark, and an incomplete set of remains in Africa (belonging to Lucy, the "African Eve" that, the performance suggests, was also migrating/moving at the moment she died). Trying to find herself, Katrina becomes an amalgamation of locations, temporalities, experiences, and women, namely herself, her mother, her grandmother, a woman sitting in a detention centre in Denmark, Lucy. The momentum and accumulation of stories eventually builds to the point where her voice can no longer hide (culminating during a moment of birth/rebirth) and she finally addresses the audience with her own imperfect Danish before stripping down to her underwear and running out of the room to jump into the water outside the performance space with Troels. Katrina's immersion in the water suggests a symbolic baptism as she claims her adopted country and language and the family history that has brought her to this place. It is also linked, through repetition of gestures earlier in the performance, to the ritual of baptism practised in her Catholic mother's family.

Rather than resolve everything by neatly suggesting an acceptance into her new community, the performance just moves on, transforms, and slowly dissolves into an informal and impromptu conversation with the audience members who have gathered by the water's edge.

Performance

Imagine the sound of a gentle breeze.
A man blowing softly into a microphone.
Close your eyes for a moment.
The sound builds, becomes a storm.
You're on a boat.
The floor boards are creaking.
The sea is raging.
In front of you is a woman.
She is on a boat.
She is on a journey.
She is looking out over the sea.
Her heart is beating fast.
A baby girl cries out.

På det sidste har jeg tænkt meget over hvordan jeg havnede her.
(pause recording)

Lately, I've been thinking a lot about how I got here.

We stand in an old annex building near the sea (Images 7.4 and 7.5). The water and boats visible in the distance. A small group of people. Most of you are sitting on sofas and arm chairs. I am standing when you arrive. Walking, actually, in place.

It all seems pretty straightforward. This is no black box. It is a type of anti-theatre performance aesthetic, conveyed through the narrative authority of direct address (recorded) storytelling. We are not pretending to be anything other than what we are.

The walls are off-white wooden panels, the wooden floor is painted red, there are a couple of windows and doors. We are bathed in natural lighting, and there are some found lamps. An original song is being played on an acoustic guitar by a man. He has a microphone. A recorded voice speaks, there is a confessional quality. You are looking at me. My wet hair. My clothes – sartorial choices made from my personal wardrobe (a scarf that belonged to my grandmother, a dress my mother gave me). There are big white signs with writing on them against the back wall. They will eventually splice story

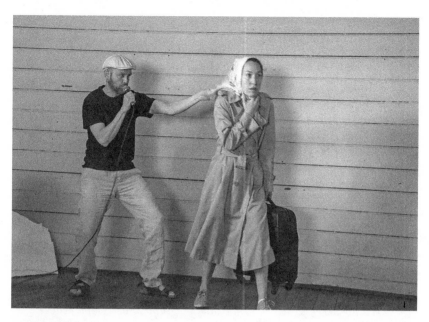

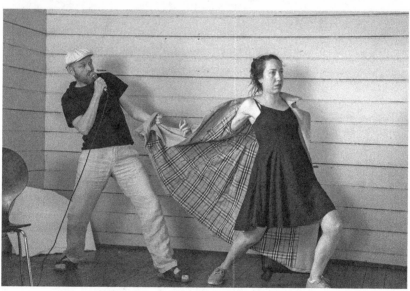

Images 7.4. and 7.5. Troels Hagen Findsen and Katrina Bugaj, *Some Things Are Difficult to Say*. Photos by Ole V. Wagner, © Out of Balanz.

fragments and time periods together: we can start a sentence with one memory (from my childhood) and end it with another (an imagined memory from my grandmother's life in a displaced persons camp). They will be nailed into the wall, thrown onto the floor. There is a suitcase in my hand. It is heavy. Inside there is a tea cup, M&M's, personal photographs, lots of dirt. The dirt is packed into see-through plastic bags. As they emerged from the suitcase, it becomes clear that each bag represents a location from the map of my life story. The story goes back and forth, through four generations and two continents. I am silent but the way we interact, the bags of dirt and I, speaks. I reveal Poland with care, gently opening the bag to expose three small potatoes inside (my grandmother and her parents on their farm before the war). Germany is dropped suddenly like a bomb. I stomp on it and the bag smashes open. Your body jolts. The United States is big and heavy. I rip it open, excitedly, and walk across it with a pair of children's shoes. Together, we imagine the first steps on the moon that fascinated my mother growing up, my mother's first steps on American soil as a child, and my son's first steps taken while visiting my mother over the previous summer.

Um...jeg mener, jeg er her, i Danmark, på grund af den mand derover.
Troels (live): *Hej.*
Ham mødte jeg da jeg studerede i Frankrig
(pause recording. We approach one another, from across the room. You are about to take my hand. Everyone is looking. We turn out to face them. We dance.)

Um ... I mean, I'm here, in Denmark, because of that man over there.
Troels (live): Hi.
Who I met while I was studying in France

Jeg kan ikke huske min mormor's stemme.
Hun talte ikke særlig meget.
Og når hun gjorde var det ofte på polsk, selvom hun godt kunne tale engelsk. Når jeg tænker på hende husker jeg de smukke tørklæder hun bar over sit hår, når hun var udenfor. Jeg husker hvordan hun drak te. Jeg kan huske hendes testel og hvordan hun drak sin te uden sukker. Jeg kan huske hun sad ned og drak sin te. Jeg kan huske at der altid var en skål med m&ms til os. Det havde et billede af paven på det. Jeg kan huske hun sad ned og drak te og jeg spiste m&m's og der var ingen af os der sagde noget.
(pause recording)

I can't remember my grandmother's voice.
She didn't speak very much.

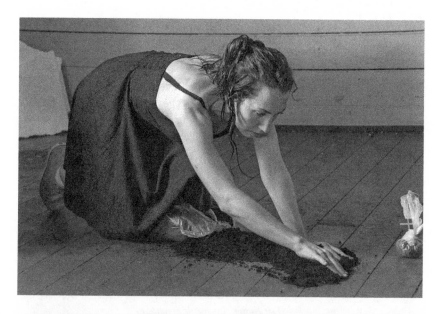

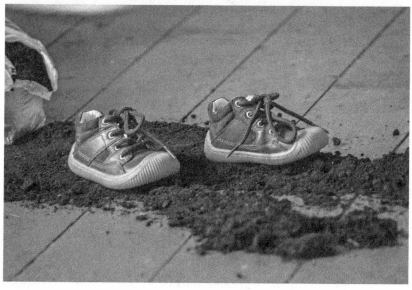

Images 7.6. and 7.7. *Some Things Are Difficult to Say.* Photos by Ole V. Wagner, © Out of Balanz.

And when she did it was usually in Polish, though she could speak English.
When I think of her I remember the beautiful scarves that she wore over her hair
when she was outside. I remember how she drank tea. I remember her tea set
and how she drank her tea without sugar. I remember her sitting, drinking tea.
I remember that there was always a littlebowl of M&M's for us. It had a picture
of the pope on it. I remember her sitting, drinking tea and me, eating M&M's
and no one really saying much.

Jeg er sky Genert,
ville nogle nok sige
Jeg er rædselslagen for
At hver gang jeg taler dansk
Siger folk: Hvad for noget?
I speak English. And I feel strong and confident.
Jeg elsker lyset når solen går ned over København på en sommerdag
Min søn har lys i øjnene
Der er altid modvind når man cykler
Frihed
Det ligger lige om hjørnet
Forpustet, svedig
Dagene er korte
Byen længes

I'm reserved.
Shy, some would say.
I'm terrified that
Every time I speak Danish
People say: What was that?
I speak English
And I feel strong and confident.
I love the light when the sun goes down over Copenhagen on a summer day
My son has light in his eyes
There is always headwind when you're bicycling.
Freedom.
It's just around the corner.
Breathless, sweaty.
The days are short.
The town is longing

Det er sådan det lyder i mit hoved når jeg taler dansk. Perfekt. Uden
accent eller fejl.
Flydende.

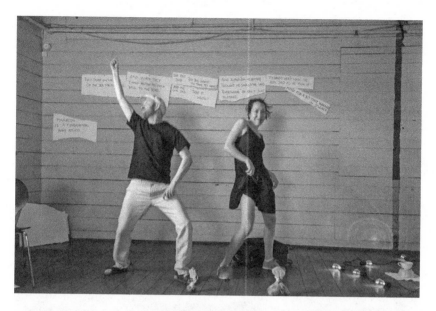

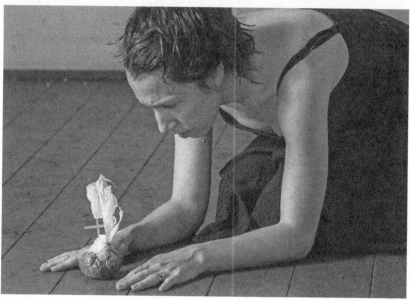

Images 7.8 and 7.9. Troels Hagen Findsen and Katrina Bugaj (top), Katrina Bugaj (bottom), *Some Things Are Difficult to Say*. Photos by Ole V. Wagner, © Out of Balanz.

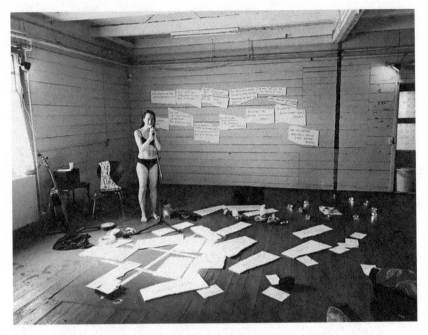

Image 7.10. Katrina Bugaj, *Some Things Are Difficult to Say*. Photos by Ole V. Wagner, © Out of Balanz.

Men i virkeligheden lyder det sådan her...
(stop recording)

Katrina: (live) *Rød grød med fløde.*
Når jeg taler med en Dansker og de finder ud af at jeg er fra New York, spørgerde mig, næsten altid – hvorfor er du her?

This is how it sounds in my head when I speak Danish. Perfect. Without any accent or mistakes.
Fluent.
But in reality, it sounds like this ...
(stop recording)

Katrina: (live) *Rød grød med fløde.*

When I speak with a Dane and they find out that I am from New York, they almost always ask me – why are you here?

The words and currency of one story encounter and smash into another.
It is hot.
The sun is shining.
We drink a cup of tea in silence.
Between 11 and 20 million people were displaced.
He takes off his clothes.
In 1948 they act, make an act, open up the borders
for 200,000 displaced persons.
I take off my clothes.
We,
you ... are among them finally
open the door
and the sun blinds us.
We laugh.
Run towards the sea.
Jump in.

Curtain Call

I was almost shaking when you walked in. (I wonder if you noticed?) Now, I am relieved. You are standing at the edge of the pier, clapping and smiling. You hang around. You want to talk. To share your stories about why you are here, your grandparents, your friend who is also an immigrant, things you find difficult to say. I climb out of the water and grab my towel. I listen. You continue to talk as I put on my clothes. "Danish is a difficult language," you say. "Your Danish is very good." I thank you. We walk back to the space. We shake hands. Sometimes you want to give me a hug. Our bodies touch. This time, out in the real world. You have a few more things to say. I squint in the sun. I listen. Smile. You say goodbye, slowly begin to walk away.

I walk back into the room. Everything is spread out in the open. I look at it and think, I still do not know what this piece looks like. I only know how it touches me when I perform. I have a suspicion that I have gotten closer to something, have reworked something, but I am not sure what yet. You leave and I begin to pick up the dirt. My fingernails are soiled again. I think about my grandmother. I can almost see her. I remember how she always loved to garden. How she would spend hours outside in her garden, alone. I wonder what she was thinking about.

I look at my husband cleaning up the signs scattered across the floor. The aftermath of what had developed from an intimate artistic dialogue with him, between us. I think about how we let big things move through our bodies, but a lot has remained unexpressed as we selected, staged, and moved what we could not say, or even really ever know.

It is over (for now) but I keep imagining more and more little frag-
ments, movements, silences to shape ... and share.

NOTES

1 Pierre Nora, "Between Memory and History: *Les Lieux de Mémoire,*" *Rep-
 resentations* 26 (1989): 7, http://doi.org/10.2307/2928520.
2 Michael Jackson, *The Politics of Storytelling: Variations on a Theme by Hannah
 Arendt* (Copenhagen: Museum Tusculanum Press, 2016) 26.
3 Marianne Hirsch, "The Generation of Postmemory," *Poetics Today* 1 (2008):
 106, https://doi.org/10.1215/03335372-2007-019.
4 The refugees.dk site is a valuable resource for articles and information on
 procedures, legislation, and statistics regarding seeking asylum in Denmark,
 as well as news stories and articles with a human story at the centre. Many of
 these articles reference isolation and a political will to keep asylum seekers
 at a distance from Danish society.
5 Miriam Haughton, *Staging Trauma: Bodies in Shadow, Contemporary Perfor-
 mance InterActions* (New York: Palgrave Macmillan, 2018), 208.
6 Diana Taylor, *The Archive and the Repertoire: Performing Cultural Memory in the
 Americas* (Durham: Duke University Press, 2003), 19.
7 [The reference is to Thomas Hobbes, *Leviathan, or the Matter, Forme, and
 Power of a Commonwealth Ecclesiastical or Civil,* ed. Michael Oakeshott (New
 York: Collier, 1978).]
8 Michael Jackson, *The Politics of Storytelling,* 140.
9 J. Lecoq, *The Moving Body: Teaching Creative Theatre* (New York: Routledge,
 2001), 136
10 Sara Ahmed, *Strange Encounters: Embodied Others in Post-Coloniality* (London:
 Routledge, 2000), 8.
11 Ibid.
12 Michael Jackson, *The Politics of Storytelling,* 53.
13 Michael Jackson, *The Politics of Storytelling,* 14.
14 Sara Ahmed, *Strange Encounters: Embodied Others in Post-Coloniality* (New York:
 Routledge, 2000), 156.
15 Ibid., 158.
16 Ibid., 156.
17 Sara Ahmed, *Strange Encounters,* 159
18 Katrina Bugaj and Troels Hagen, *Some Things Are Difficult to Say,* Copenha-
 gen Stage Festival, Teaterøen. Unpublished primary source. Performance
 script, process notes, and rehearsal journal, 2018.

8 Performing Memory in an Interdependent Body

EMILY MENDELSOHN

Between 2010 and 2014, I directed Ugandan playwright Deborah Asiimwe's *Cooking Oil* and American playwright Erik Ehn's *Maria Kizito* with an ensemble of artists from the United States and Uganda, and in the case of *Cooking Oil*, also Rwanda. Our productions dealt with the creation of historical memory by "implicated subjects" within communities whose members are not implicated in the same way. I am taking the notion "implicated subject" from Michael Rothberg's writing on memory formation from the position of persons who are not directly perpetrators of a trauma but derive benefit from it, or were complicit in its unfolding.[1] Asiimwe's *Cooking Oil* explored the impact of foreign aid on an allegorical "developing" village, and Ehn's *Maria Kizito* (Image 8.1) followed the prayer life of a real-life nun who participated in a massacre at her convent during the 1994 Tutsi genocide in Rwanda. Both *Cooking Oil* and *Maria Kizito*, as imagined in our productions, lived between fiction and document as they rehearsed acts of witness to traumas we did not live. Our formal explorations of embodied language, hybridity, and contemporary ritual became containers to consider ways genocidal ideology or systemic neglect played out in our personal and collective lives, and by extension to invite audiences into this consideration. Theatre presented a collaborative translation process, which ideally allowed audiences access to an analogue of traumatic experience and the power structures within which it is experienced.

More Life

In *Maria Kizito*'s epitaph, playwright Erik Ehn quotes Adrienne Rich: "I came for the wreck and not the story of the wreck."[2] Ehn's writing and moving through the world feel to me like a sweeping wind. His plays and his movement-building projects, like RAT, the international network

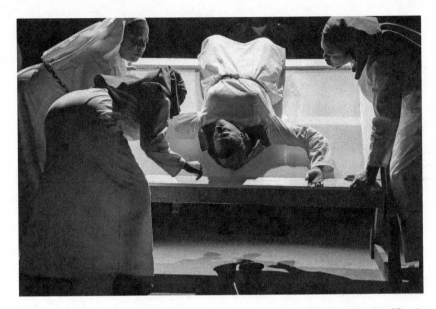

Image 8.1. Sherri Marina, Esther Tebandeke, Loren Fenton, and Monica Harris in Erik Ehn's *Maria Kizito*, design Jeff Becker, costumes Cybele Moon. Produced in collaboration with ArtSpot Productions, New Orleans, 2014. Photo: Elizabeth Brooks.

of alternative theatres that he co-founded, gather eclectic sources into an improbable, precarious, and vital assembly. He began travelling to Rwanda after sitting in on Sister Maria Kizito and Mother Superior Gertrude Mukangango's 2002 trial in Belgium to research a play that explored the nuns' prayer life, and how it illuminated his own Catholic practice and capacity for genocide. In Rwanda, he met scholar Jean Pierre Karegeye, and the two founded an annual two-week exchange program More Life in 2005. In this program, local and international students, faculty, and professional artists visited genocide memorials and met with survivors, scholars, artists, government, and cultural workers in Rwanda to study the history of the country and how theatre can participate in acts of recovery from genocide. In articulating the project's intention, Ehn states: "What theatre is in this context, how it can be an effective frame for testimony, for slow speech and for slow hearing, is entirely up for grabs. We are establishing an exchange program with Rwanda, because gigantic acts of creation are underway, acts of global significance."[3] In pursuit of reciprocity, Ehn and Karegeye also convened a conference at the California Institute of the Arts (CalArts), where Ehn served as

dean of the theater school. The travel and conference, part academic study, part artistic exchange, and part intentional community-building process, sparked what Ehn referred to as a "conversational community" of international artists and cultural workers invested in peacebuilding. This community centred stories and expertise emerging from post-genocide Rwanda, in dialogue with other sites and voices of conflict and conflict transformation. A practice of radical hospitality, influenced by his Catholic faith, runs through much of Ehn's work. The ethical claim, both in *Maria Kizito* and for the conversational community that grew out of it, was one of *being-with*, prior to understanding or narrative.[4] In a context of a majority white Western group travelling to Rwanda, this ethic recognized and worked to dismantle colonial ideas of "saving" or "delivering expertise."

More Life was a catalyst for festivals, plays, and artistic relationships, including our theatre lab. Asiimwe and I participated in More Life programs and collaborated as graduate students in Ehn's theatre department from 2006 to 2009. My directing background grows out of a downtown New York theatre scene, marked by accessing physical presence and heightened emotional states through embodied image and gesture, and also by deconstructing narrative and received signs to reveal something of the experience of experience. I had entered a graduate program to explore a form of storytelling that held in tension deconstruction's expansion of meaning, and the knitting together of meaning and experience found in narrative. I am interested in staging how we come to perceive (and to un-know) ourselves and our world as an embodied event. Asiimwe's writing immediately spoke to me. She has a striking capacity for empathy, and the dramatic event in her writing often centres on a moment of mutual witness. This resonates with the philosophy of Ubuntu, or "I am because we are," that Asiimwe has cited as an influence throughout our conversations. Scholar Pumla Gobodo-Madikizela, who has written extensively on Ubuntu and South Africa's Truth and Reconciliation process, describes Ubuntu as a visceral recognition of relationality, not only between individuals, but in the fabric of identity itself. This orientation creates conditions for an accountability that simultaneously holds the humanity of victims and perpetrators.[5] In keeping with this philosophy, Asiimwe's plays, rather than follow an individual's actions on an external, inert world, chart acts of world-making. Characters create and negotiate their stories as they go. They strive to arrive face to face with each other, and with the audience. In these emotional turns, which move as much by rhythm, image, and shared negotiation of framing as by plot, her dramaturgy reflects a "who" happens more than a "what" happens. Her writing invites an audience to practise seeing from a place of interdependence.

A 2010–11 Fulbright Fellowship and a Cultural Exchange Initiative grant from the Los Angeles Department of Cultural Affairs allowed me to accept Asiimwe's invitation to continue our collaboration by staging her play *Cooking Oil* in Uganda. That same year, Ehn started gathering artists for *Soulographie*, his seventeen-play series on twentieth-century genocides and American policy, and he asked the artists working on *Cooking Oil* to stage *Maria Kizito* for this series. Our process for both plays built on the tone and the networks begun in *More Life*. We wanted a theatre that connected to ways of knowing from the body – to *be-with* the wreck – without de-historicizing it. In this chapter, I will outline some main elements of our approach in the *Cooking Oil* production.

Cooking Oil: The Text

Throughout *Cooking Oil*, Asiimwe's protagonist, a teenager trying to carve a future from her village's precarious circumstances, asks: "Do you see me?" This in-text question implicates everyone listening: do you see *me* (in my specific becoming) as being *in relationship to you?* Asiimwe began the play while studying playwriting in the suburbs of Los Angeles as a corruption scandal involving tuberculosis, AIDS, and malaria Global Fund monies unfolded in Uganda. She was struck by discrepancies between narratives of Western "helping" and aid's more complicated realities. The play resonated with a moment of growing critique, like the one exemplified in Dambisa Moyo's *Dead Aid: Why Aid Is Not Working and How There Is Another Way for Africa*, that claimed the foreign aid industry served political and economic systems that perpetuated poverty through tied aid, funding sources unaccountable to leaders' constituents, and programs developed without regard to recipients' specific contexts.[6] Rather than advocate for particular policy change, *Cooking Oil* proposed a shift in discourse to face lives of those affected by extreme poverty.

In the play's inciting incident, the teenage protagonist Maria is killed crossing a border to sell cooking oil. Aid worker Ndeeba and Maria's mother Neeza, in the play's present, invoke bureaucratic and divine modalities for justice, respectively:

> *This prayer is not of thanksgiving for the cooking oil. It is to tell you that it was a blessing and a curse. I seek redress. I seek justice. I seek fairness.* / So that no one denies the truth. It all started when I was posted in this village. / *When her spirit is avenged ... /* When the commission of inquiry sees this[7]

The play unfolds in flashback over five "movements" or acts, presumably sharing in real time the events, recounted in Neeza's prayer and

Ndeeba's report, that led to Maria's death. Their story begins with a lo-
cal politician, Silver, who markets his village's poverty to receive interna-
tional food assistance. This food supports the village in a drought and,
through illegally selling the aid package's cooking oil to the struggling
villagers, funds Silver's ambitions for higher office. Silver offloads the
cooking oil business in neighbouring markets to his friend Bataka, whose
name means "everyman." This ordinary accomplice takes his daughter
Maria out of school to sell the cooking oil across a militarized border.
Unknown to her father, she sells in Silver's territory and pockets a per-
centage of her small sales to fund her ambitions for education.

We meet Silver and Maria in flashback, boasting about their day's
earnings to the audience:

> SILVER: Hard work! That is hard work! I reap from my hard work.
> MARIA: I have sowed hard work, but look at me!
> SILVER: Look at me!
> MARIA: Very bad!
> SILVER: The fruit of my hands!
> MARIA: I have worn this dress for the last one year!
> SILVER: Marks and Spencer is my trademark.
> MARIA: For how long will this poverty be?
> SILVER: People are poor because they are lazy!
> MARIA: Three thousand shillings in one day? Makes me somebody!
> SILVER: Three million shillings in just one day! I am not a nobody!
> MARIA: Today is my lucky day!
> SILVER: Today is my lucky day![8]

Silver and Maria work to survive inside of marginalizing systems, systems
that label them "nobody." Silver has successfully worked his way out of
personal poverty, and now desires power beyond his poor village. He
comes across as a relatable but undeniable villain. Maria, taken out of
school, is fighting to regain her ability to write her future even if it di-
minishes her ability to help her family survive. We root for her, even
as she knowingly participates in the same crimes. In pairing Maria and
Silver's differently scaled corruption, Asiimwe widens the lens to indict
the systems that create conditions in which corrupt choices feel like, and
perhaps are, the only options.

The rhythmic, call-and-response quality of address, common in
Asiimwe's writing, is influenced by Ekyevugo, the epic poetry she en-
countered growing up, where a performer energetically channels text
in concert with an audience. This direct address, not only of the fram-
ing characters Neeza and Ndeeba, but also of the play's flashbacks,

sets up a world where the membrane between past and present, self and other, shifts and blurs. Characters drift effortlessly between memory and present, dream and waking, scenes between characters and direct address to the audience. They enter each other's thoughts. As Asiimwe describes, "The story becomes a shared dream and/or reality, it becomes communally owned, the storyteller and listener become one, the space of separation gets blurred, together you 'see,' together you are 'seen.'"[9]

Following the impulse of this blur, audience and performers began the show sitting together in a circle. Rather than having a "stage" and an "audience" space, we began in a mutual ritualized space. Over the eighty-minute production, the performer playing Maria entered and occupied the centre of the circle, walked its circumference, then exited. This durational event worked in opposition to text and called attention to the act of seeing in the present of the performance event. Duration also aimed to estrange the work of seeing the performer and, by extension, the character she represented. The separation between storyteller and listener was actively blurred in this shared work of composing story and composing acts of seeing in the performance. This permeable border sought to trouble dichotomies of doomed victim/innocent saviour embedded in foreign aid narratives. The audience, along with the play's characters, were asked to see our shared complicity in normalizing global systems of inequality.

As tension mounts in the text's flashback, it becomes less clear whether characters are reckoning with a complicity realized in the past or in the present act of remembering (Image 8.2):

MARIA: On my graduation day. Do you see me, Ndeeba?

NDEEBA: I see you Maria.

MARIA: The university chancellor will call out my name …

NDEEBA: Ladies and gentlemen, I now call upon … Maria Kakazi Bataka!

(*Hand clapping is heard. Maria whispers something to Ndeeba.*)

NDEEBA: That's right! The best law student this academic year …

MARIA: I have to shake the chancellor's hand …

NDEEBA: I see you Maria …

MARIA: He wants me to give a speech …

NDEEBA: I see you Maria.

MARIA: I will first introduce my father to you.

NDEEBA: I think you should go home now!

MARIA: Father, I can't go home now, I have not even given my speech!

NDEEBA: I am your father now? I thought I was the college chancellor?

MARIA: Father, all these people turning up for my graduation ceremony![10]

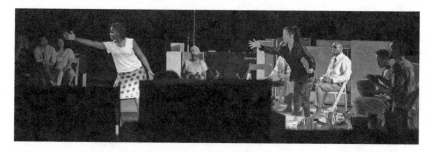

Image 8.2. Esther Tebandeke, Kaya Kagimu Mukasa, Sharon Wang, Renell White, Tonny Muwangala, Loren Fenton, and Sammy Kamanzi in Deborah Asiimwe's *Cooking Oil*, design Shannon Scrofano, costumes Stella Atal. Produced by Los Angeles Performance Practice with Center for New Performance, Atwater Crossing, Los Angeles, 2013. Photo: Andy Featherston.

Ndeeba, the righteous young aid worker from the city, tries to convince Maria to leave the illegal cooking oil business. The two negotiate a shared recognition of reality. Ndeeba's parents funded her education. Maria, whose parents do not have this option, fights to make visible to Ndeeba her dreams of entering discourses of power through education. In their framing language at the beginning and end of the play, Ndeeba and Neeza make a claim for vengeance for Maria's death. In asking Ndeeba to see her dreams, Maria speaks back not only to Ndeeba's efforts in flashback to take away her income, but also to this punitive justice claim. The call for recognition destabilizes, and we jump to a movement that largely takes place in Bataka's mind. This movement shifts its ground more often, and it is not clear whether we are watching Bataka in a forward-moving past where he wrestles with his conscience before Maria's death, or if we are following his mind in the play's present as he enacts a confrontation with Silver he wished he could have had in the past. In the movement's liminal time, he encounters Maria as ghost, not just as memory, and asks for forgiveness for his role in the circumstances of her death. The call to recognition has consequences, even as the play's final movement leaves us with Ndeeba choosing to take up Silver's seat following his arrest, and an implied continuation of cycles of corruption.

Cooking Oil: The Process

Our performance history demonstrates how imperial aesthetic traditions operate to obscure their own deconstruction and critique. In 2010, working with a team of performers, designers, and producers from Kampala

and Los Angeles, we staged a performance and dialogue series around *Cooking Oil* and its themes at Uganda's National Theatre. This production failed. The architecture of the British-built proscenium theatre created a visceral separation between audience and performance that did not serve the communal seeing-together at the heart of Asiimwe's text, and my direction failed to invite performers into the personal urgency of Asiimwe's and my mutual exploration.

This failure launched us into a new three-year development process for *Cooking Oil*, spanning Kigali, Kampala, and Los Angeles, and emphasizing the lab aspect of our work equally with its production. In 2011, actors Tonny Muwangala, Allen Kagusuru, and Sam Lutaaya, along with myself, travelled to Rwanda and partnered with artists affiliated with the women-run Ishyo Art Centre to workshop and present a reading of *Cooking Oil* at Centre x Centre, an arts and peacebuilding festival affiliated with More Life. This workshop aimed to drop language into the body. We used rhythm as an entry point into text, and the performers created repetitive gestures that got their bodies synched to the building of thought through rhythm. The actors playing Maria (Solange Umuhire and, later, Esther Tebandeke) and Silver (Tonny Muwangala) developed a counting gesture in their opening invocation that built momentum as the characters laid out their plans for the lives their money would support. After finding something in rhythm that felt alive to us, we would stop and try to name our experience, and what we knew about how we arrived at it. Slowly, we came to build a shared language for pointing at presence and shifts of energy.

As a praxis, our lab came to frame the colonial as a static relationship to form. Asiimwe and many of the Kampala-based actors in *Cooking Oil* trained at Makerere University's Music Dance and Drama department, where theatrical pedagogy leaned towards the literary. In dance and music performance, I saw performers working effortlessly from impulses in the body, but much of the theatre I witnessed felt like it was operating "from the neck up." Despite the legacy of professors like Rose Mbowa or Dr. Jessica Kaahwa, who encouraged students to imagine popular forms and uses of performance and to reclaim and repurpose theatre, theatre still seemed to many of the students that I met in 2011 to be an ahistoric Western form, without a body or response to specific cultural context. My work in rehearsals to facilitate connection with impulses in Asiimwe's text read (rightly) as an "American" style. The multiplicity of indigenous traditions in Uganda and Rwanda (in addition to difference between countries, Uganda's British-drawn borders enclosed over forty local languages spoken by peoples with specific histories and traditions), and members of our East African team's training derived from European

naturalism or classical guitar, further complicated a singular binary of "African"/"Western" aesthetic that neatly correlated to African/Western bodies. It is not hard to imagine a context where a theatrical form takes on a literal, one-to-one relationship to dominant and oppressive cultural expression, but in our already cross-pollinating community, messiness felt authentic.

Through acting exercises, actor-generated music and gesture, and rehearsal discussions, we attempted to cultivate relationships to form that connected impulses to our bodies and to cultural contexts that came out of both a history and an availability to change. Sometimes we generated our own language for our experience in acting exercises. Sometimes we would discuss a visual event in the play, for example, Neeza's prayer to release Maria's spirit, and name our different relationships to this event, and what it might look like on stage. In the Rwanda workshop, Neeza walked the circle with burning brush. In Los Angeles, this became cooking cassava, which she prepared throughout the play's performance. We tried both to work towards a shared language and exploration, especially around presence and ways of moving image through the body, and to embrace difference. Neeza could be cutting cassava within a scene with Maria where Maria was symbolically bathing herself in cooking oil that flowed from a wheelbarrow suspended above the centre of the performance circle. These actions, generated from different moments in our development process, together highlighted gendered bodies and bodily practices at stake in a scene about Maria's vulnerability to male authority, and also dramatized the difference between the characters' states of mind in the scene. Neeza was pragmatically focused on sustaining her family, and Maria, who had just accepted disturbingly seductive money from Silver, was absorbed in her fantasies of returning to school. We wove our multiple entry points into a world that served both Asiimwe's story and kept visible our varied relationships to the story and to creative practice. In this process, we came to see a decolonizing practice as one that encouraged physical, mutual presence, an exploration of forms that maintained curiosity about context and intention, and liveness: a continuous availability for transformation.

The hybridity in our lab's aesthetic was not neutral. It reflected acts of creative agency, and also histories of erasure. In a 2017 interview with journalist Andrew Kaggwa, Asiimwe echoes Gayatri Spivak's famous observation that the subaltern are tasked with forming selves-in-translation to appear in the realm of the public.[11] "There is no way we can talk about ourselves without talking about an 'ourselves that is based elsewhere,'" Asiimwe notes. "Even before we had been to the West we have had a relationship and a history with it. Thus, there is a need for stories

addressing this, always growing, relationship with the West."[12] In addressing this in-translation and in-process relationship with the West, *Cooking Oil* plunged us into double visions: Maria's and Silver's unequal corrupt businesses, Ndeeba's and Neeza's different addresses for justice. While Neeza often serves as moral compass of the play, *Cooking Oil* is less interested in a static authentic/inauthentic lens (both Ndeeba and Maria fight to show up in the landscapes of power in which Silver operates), and more concerned with the experience and consequences of living in double exposure. In a space where stories of suffering have market value, and where colonial and neocolonial imaginaries have created unequal control of resources and then etched (seemingly) fixed alterities and hierarchies into donor/recipient relationships, the systems in which suffering becomes visible can also be used to reinforce oppressive power structures. By refusing fixed perspective, centring contingent agencies, and moving language and thus listening into the body, *Cooking Oil's* formal and narrative liminality locates us between appearance and erasure, here and elsewhere, the systemic and the dearly human.

In engaging with this double vision, production designer Shannon Scrofano, costume designer Stella Atal, Asiimwe, and I wanted to interrupt tropes of local and global that cast Uganda as a culturally particular "local" translating itself for a universal American "global." I find resonance with ethnographer Anna Tsing's critique of this local/global alterity. Tsing argues that a colonial viewpoint fixes universal reason and reach to the West and a static, hermetically closed particular to the West's "Others." In truth, however, "all human cultures are shaped and transformed in long histories of regional-to-global networks of power, trade, and meaning."[13] In consequence, "endorsing local or indigenous knowledge as the counterpart to universalist expertise" is useful in acknowledging the reality of cultural difference and agency, but does not go far enough to challenge the categories of local/global themselves.[14] "The knowledge that makes a difference in changing the world," rather, "is knowledge that travels and mobilizes, shifting and creating new forces and agents of history in its path."[15] Tsing's global is this messy and unpredictable movement of knowledge and power across many (albeit unequally positioned) agents of history. Tsing argues for *friction*, "the awkward, unequal, unstable, and creative qualities of interconnection across difference" where cultures "are continually co-produced."[16]

Our stage design (Image 8.3) employed forms of knowledge, materials, and architectures that travelled and mobilized. In Los Angeles, designer Shannon Scrofano set in motion a process, which she described as a scenic script, for our local technical director and his crew to create a

periphery delineating our playing space within the larger Atwater warehouse:

> The scenic script originates from research surrounding refugee spaces in Africa and elsewhere, composite spaces built by owners from scavenged materials, portability, mutability, permeability, and the way that standardization is re-possessed and re-claimed in the functional service and aesthetic tendencies of its owners and users.[17]

The script provided open but specific guidelines to build a series of boxes created from salvaged materials to circle performer and audience. We wanted a process of assembly that performed a reclaiming and repossessing of our design plans, and also our production's history, that was specific to the materials and agencies of Los Angeles. Our audience and performance circle reflected the dramaturgical needs of the play, but also grew out of the accident of the round architecture of Ishyo Arts Centre's outdoor bar, where we held our 2011 reading. In our 2012 workshop in Kampala, we played with this circle spilling out of the art and social justice centre In Movement's rectangular tent, superimposing the production's past site on its current architecture. The impulse to respond to local materials and to engage the agencies of local collaborators also travelled through each iteration of development. We wanted the story of performance site, and its method of construction, to enact the creative friction present in recipient communities' encounters with standardized aid systems.

Shopping for costumes, Atal discovered a T-shirt at the market in Kampala, presumably part of a bulk shipment of once-donated clothes, and it immediately became Maria's costume. The white, feminine-cut shirt, emblazoned in English with "Country / This town doesn't sleep for 24 hours," grabbed us for the emblematic negative impact clothing donation has had on local economies; the way the slogan gathered associations for neoliberal exhaustion; and for its uncanny distance and familiarity.[18] What town is this? Is "Country" the town's name, a local establishment, a quality? Why this constant insomnia? What is the context behind this unsettling phrasing? In a small and playful way, the T-shirt asks us to meet in the act of making meaning with a sign not fully available to translation. This partial legibility is also present in the text around borders of cultural history, power, and trauma. In the final moments of *Cooking Oil*, Maria's spirit forgives her father and, turning to leave, pauses under her suspended wheelbarrow. She laments, "I was left with three litres only."[19] Unlike her father, she does not regret selling the village's cooking oil. She regrets that she did not succeed in escaping poverty. The play does not invite us into

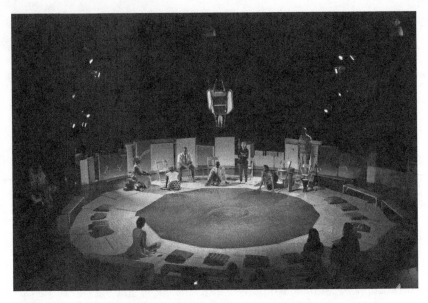

Image 8.3. Kaya Kagimu Mukasa, Esther Tebandeke, Renell White, Tonny Muwangala, Sharon Wang, and Loren Fenton in Deborah Asiimwe's *Cooking Oil*. Photo: Andy Featherston.

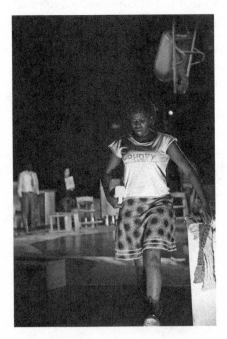

Image 8.4. Esther Tebandeke, Tonny Muwangala, and Sharon Wang in Deborah Asiimwe's *Cooking Oil*, Los Angeles, 2013. Photo: Andy Featherston.

an epiphany and transformation for her character. Maria has known the reality of her terrain all along. We hear the staccato percussion of gunfire as she crosses the border out of the playing space (Image 8.4), and out of the warehouse. Her release and moral reckoning (if any) is not for us. We remain with Ndeeba, who assumes Silver's empty seat of power as the cycle of corruption begins again. Ndeeba meets the audience's gaze and recognizes us as a faceless, staring figure looming over the play's world. The call to see face to face is not a right to access or legibility.

Some Closing Reflections

Our work exists within the systems we desire to critique. As part of our research for *Cooking Oil*, Asiimwe and I visited a refugee settlement in Uganda run by the government and UNHCR. We walked through a market where women selling cooking oil in glass soda bottles complained about the *mzungu* who had come to observe and not buy.[20] Folks shared that World Food Programme distributions did not last the month, and included grain that needed to be ground, meaning that some of this already insufficient grain had to be sold in order to grind the rest. They wondered if aid in Europe was more generous. When we asked if they had any questions about our theatre project, one man enquired why refugees could not receive money directly to buy their own food. The question rendered our knowledge as artists irrelevant. For those waiting in line every month, boundaries between global power and powerlessness are simple and stark. The remoteness of our (especially my) witness is real, as is our (differing) adjacency. The country of origin best represented in the settlement is the Democratic Republic of the Congo, whose stability has been affected by thirty years of United States–supported dictatorship, a Ugandan/Rwandan overthrow of this government, and the ongoing exploitation of the region's cobalt for cell phones or the laptop on which I write now. From within these systems, the *Cooking Oil* project invited collaborators and audiences to examine their complicity and also to rehearse a receptivity towards models of belonging and alterity that contributed to more just personal and political relationships.

NOTES

1 Michael Rothberg, "Multidirectional Memory and the Implicated Subject: On Sebald and Kentridge," in *Performing Memory in Art and Popular Culture,* ed. Liedeke Plate and Anneke Smelik (New York: Routledge, 2013).

2 The version of *Maria Kizito* that we staged is published in Erik Ehn, *Soulographie: Our Genocides* (New York: 53rd Street Press, 2012).

3 Erik Ehn, "A Space for Truth: Meditations on Theatre and the Rwandan Genocide," *American Theater Magazine* 24, no. 3 (March 2007), 34.

4 For more on *Maria Kizito* see Laura Edmondson, "Genocide Unbound: Erik Ehn, Rwanda, and an Aesthetics of Discomfort," *Theater Journal* 61, no. 1 (March, 2009): 65–83; and Emma Willis, "'The World Watched': Witnessing Genocide," in *Theatricality, Dark Tourism and Ethical Spectatorship* (London: Palgrave Macmillan, 1988).

5 Zara Houshmand, "Ubuntu and the Politics of Forgiveness," *Mind and Life Digital Dialogue*, 2019, accessed 8 March 2020, https://ubuntudialogue.org /ubuntu-and-the-politics-of-forgiveness/.

6 Dambisa Moyo, *Dead Aid: Why Aid Is Not Working and How There Is Another Way for Africa* (New York: Farrar, Straus and Giroux, 2009).

7 Deborah Asiimwe, *Cooking Oil*, rehearsal script, 69.

8 Deborah Asiimwe, *Cooking Oil*, rehearsal script, 6.

9 Emily Mendelsohn and Deborah Asiimwe, "Cooking Oil," in *Innovation in Five Acts*, ed. Caridad Svich (New York: Theatre Communications Group, 2015), 72.

10 Deborah Asiimwe, *Cooking Oil*, rehearsal script, 46.

11 Gayatri Spivak, "Can the Subaltern Speak?," in *Marxism and the Interpretation of Culture*, ed. Cary Nelson and Lawrence Grossberg (London: Macmillan, 1998).

12 Andrew Kaggwa, "Better Days for Ugandan Theatre: Interview with Asiimwe Deborah GKashugi," *Critical Stages* 15 (June 2017), accessed 20 February 2020, http://www.critical-stages.org/15/better-days-for-ugandan-theatre -interview-with-asiimwe-deborah-gkashugi/.

13 Anna Tsing, *Friction: An Ethnography of Global Connection* (Princeton: Princeton University Press, 2005), 3.

14 Ibid., 8.

15 Ibid.

16 Ibid., 4.

17 From "Cooking Oil Deck," Shannon Scrofano's design proposal created for Atwater production of *Cooking Oil* in Los Angeles, May–June 2013.

18 My thanks to Ajay Singh Chaudhary for identifying "exhaustion" as a defining experience of neoliberalism in his lectures "Revolutionary Subjects: What Is Mass Politics Today?" and "The Long Now: Ecology & Time after History," Brooklyn Public Library, 27 January 2018 and 3 February 2019.

19 Deborah Asiimwe, *Cooking Oil*, rehearsal script, 67.

20 Both Asiimwe and I have made monetary contributions to folks in the region affected by poverty and continued to contribute to marginalized economies during our work on *Cooking Oil*, but the challenge around the heart of our efforts is on point.

9 Memory and Trauma: Two Contemporary Art Projects

MAJ HASAGER

This essay takes its point of departure in two of my artistic projects: the first was developed in a Palestinian context between 2008 and 2010, and the second in an Italian context between 2012 and 2015. Both projects investigated the languages of memory and trauma through the looking glass of my artistic practice. My work as a visual artist and filmmaker centres on ideas and notions of power structures, identities, memories, construction of history, and subjective history. I have in particular dealt with stories narrated from a perspective of the displaced, the exiled, or stories from the periphery, and how "sites of trauma" – whether recognized as such or not – inform the past, present, and future. I explore the potentialities of bringing out alternative perspectives through ongoing encounters and exchanges with witnesses and protagonists of migration, displacement, conflict, and struggle.

During the past decade, I have used oral history interview techniques as a method for accumulating information relating to personal stories, witness accounts, sites, and historical or political matters. This approach allows the material to unfold itself through different voices and from different perspectives. Often these interviews lay the groundwork for the way I make use of narrative forms and fictional writing, namely as a tool to address personal stories in the context of sociopolitical matters. One of the concerns when making use of oral interview techniques is how memories, traumas, and the gaps in retelling can become voids and ruptures that can create new pathways when contextualized through an artist's practice. Another question that directly follows is: how can visual art contribute to shedding light on under-recognized perspectives in a way that moves beyond the retelling and reanimation of trauma and, in addition, still foster dialogue across generations, borders, and communities?

By revisiting the work *Memories of Imagined Places* (2010) in relation to the more recent work *We Will Meet in the Blind Spot* (2015), I attempt

to draw links between a "site of trauma" and the notion of inherited or embodied memory. When speaking of "sites of trauma" I draw upon the writings of philosopher Dylan Trigg, whose "use of the word 'ruins' designates location of memory, in which trauma took place and continues to be inextricably bound with that location in both an affective and evidential manner." In his article "The Place of Trauma: Memory, Hauntings, and the Temporality of Ruins," Trigg takes a point of departure in Claude Lanzmann's seminal nine-hour film *Shoah*[1] on the Holocaust from 1985,[2] specifically in a scene where the filmmaker and one of the witnesses to the genocide returned to the site of trauma – a plain field with few traces of the genocide that took place:

[T]he scene establishes a portal between the past and the present. The result of this opening is the sense of the ruin – in both its natural and built environment – becoming possessed by a past that cannot be reconstructed in a conventional narrative. Instead, the place of trauma vibrates with an indirect language, blocked from interpretation and displacing the certainty of self, memory and place. In the midst of this altered dreamscape, the terms 'place' and 'site' lose their comparative bearings. Whereas the term 'place' attests to the desire to orient ourselves in an environment, the resultant emergence of 'site' disrupts that desire, leading to a hybrid between the two dimensions. Between place and site, we are nonetheless in the center of a scene that serves to gather the past through rupturing a surrounding narrative.[3]

A more recent example of an artistic practice dealing with trauma and embodiment can be found in the American artist Jenny Yurshansky's 2019 work *Legacy of Loss*, in which a site of trauma has been transformed into a silenced heritage. In this work, she has looked into her family's history of displacement. Yurshansky's grandmother successfully fled a Nazi death squad in Moldova; her parents fled the USSR decades later. She was born in Italy en route to the United States, technically stateless at birth. She returned to Moldova with her reluctant mother, for the first time since her family fled the Soviet Union, in search of clarity about the family trauma.

Yurshansky's work consists of labour-demanding sculptures and mixed media installations and, through the act of replicating sites of trauma, explores a mute embodied heritage of trauma as well as piecing together fragments of a genealogy. She states: "This piece is part of a body of work that comes out of a lifelong attempt at reckoning with what it means to be a refugee. So much of our history is carried with us and yet, those traumas are only known because they are what is avoided, forgotten, or suppressed. My mother will never directly answer my questions about the past. It took hours of sitting together through silences, sharing the

frustrations and rewards of embroidering at this scale, for memories to bubble up and come to the surface."[4]

In this example, Yurshansky makes use of autobiographical material and the accessibility to a site of trauma, and so an inherited and embodied trauma is explored through complex visual layering and multiple threads in her work. But what kind of exploration is possible when a site of trauma is inaccessible for the traumatized subjects, for instance continuously occupied as in the case of the descendants of the 1948 Palestinian Exodus?

Memories of Imagined Places

The first of my artistic projects I discuss in this essay, the textual and photographic historiography *Memories of Imagined Places*, investigates the construction of contemporary space through architecture and its relation to a traumatic past as well as collective and inherited memory. In relation to inherited or embodied memory, I worked empirically through the act of intergenerational retelling and passing of events in the work. The focus of this project lies on Palestinian villages that existed before the foundation of the State of Israel in 1948. The Palestinian citizens that inhabited them – more than seven hundred thousand – fled or were deported during the Palestinian 1948 *Nakba*, as it is named today, which in Arabic literally means 'catastrophe.' *Memories of Imagined Places* came out of a long process of meetings and interviews with young Palestinians between seventeen and twenty-nine years of age, most of them third-generation refugees living in refugee camps in the West Bank, and investigates their inherited memories of the villages their grandparents were forced from in 1948. The interviews were transcribed and edited into short narratives, which accompany photographs of what remained of the Arab villages in 2009. The descriptions of these places relayed by the young Palestinians led me in search of eleven specific villages,[5] which had been erased and therefore do not appear on current maps. Most of the villages were completely excised from the landscape, or reinhabited under a political directive from the newly established State of Israel as a way to avoid claims to the right of return from Palestinian refugees. I travelled to the eleven destroyed villages to produce images of what remained of these places, which are now located in Israel and thus out of reach for the participating young Palestinians living in the West Bank in exile. Afterwards, I returned to share the photographs with them and to expand our conversations with the newly produced images and what they meant to them. For most of the participants, seeing the places as they were in 2009 filled them with great

sadness, which on many levels was expected by all involved. As Edward Said writes: "Exile is strangely compelling to think about but terrible to experience. It is the unhealable rift forced between a human being and a native place, between the self and its true home: its essential sadness can never be surmounted. And while it is true that literature and history contain heroic, romantic, glorious, even triumphant episodes in an exile's life, these are no more than efforts meant to overcome the crippling sorrow of estrangement."[6]

For the parents of some of the younger participants, the images provided a way of reconnecting to their heritage and allowed a glimpse of the past to manifest itself in the present, in spite of the current geopolitical situation. In this way, the work can be seen as reinvoking a sense of "*Jetztzeit*," a term coined by Walter Benjamin, describing when traditional history as written by the victors is ruptured and no "longer homogenous, empty time, but time filled by the presence of the now [*Jetztzeit*]."[7]

Memories of Imagined Places is a series of eleven photographs (54.5 x 84 cm each) accompanied by texts in Arabic and their translation into English (Image 9.1). When one looks at the series of photographs and texts, refugee issues are probably not the first things that spring to mind. The images depict clear blue skies, architectural remains, and open land – at first glance without any trace of trauma.

A key concern for me as an artist is to remove myself from the spectacle of a so-called conflict, to avoid the 'normalization' of an occupation including extreme violence against the former village inhabitants by naming it a 'conflict,' and to shift the focus to a more personal relationship with the people and the stories they generously share with me, which allows the work to develop over a long period of time as well as for questions to be raised over and over.

Time is also needed to allow for contemplation and silence, so that the works' textual elements can be likened to a game of telephone, passed on from one body and voice to the next, with all the gaps and losses that occur in the transfers. The inclusion of these aspects better reflects an inherited memory, with its shifts and slippages across time and space. The title of the work, *Memories of Imagined Places*, refers to the notion of inherited memory – in this case a sense of site and home is passed on through the generations of the displaced and exiled from the 1948 Palestinian Exodus, continuing to the present day, where teenagers fight for their right to return to places they have never been. One of the participants in the project completely rejected my photographs and insisted that I had been to the wrong village. Its present state was simply too far removed from his mental image of it – and the 1980s photographs of his grandfather's farm – for these two dimensions to be fused.

Image 9.1. Installation view of *Memories of Imagined Places* (2010), Overgaden –
Institute for Contemporary Art, Copenhagen. Photo: Anders Sune Berg.

While the American philosopher, writer, and political activist Susan
Sontag states that "there is no such thing as collective memory, but
rather collective instruction,"[8] it is clear that trauma and recollection
bleed through the generations when it comes to displacement and loss.
Sontag continues: "What is called collective memory is not a remember-
ing but a stipulating: that this is important, and this is the story about
how it happened, with the pictures that lock the story in our minds."[9]
But what are these images that keep glowing across generations – very
much like images of a lost homeland do? These images are not carved
in stone or stipulated; they are carried within the bodies and minds of
those who long for what is not yet returned. The lost origin or home-
land is at the core of this trauma, in conjunction with displacement and
exile. The experience of growing up in a refugee camp in the West Bank
under continuous occupation further strengthens the images of what
once existed as a site of origin. Shared through oral tradition and trans-
generational passing-on, the site now lives on as vivid images that belong
to multiple generations, for whom access to their heritage is blocked by
walls, fences, and military force.

When the passing of stories of loss happens while living under pre-
carious and traumatic conditions, such as in a refugee camp or as a

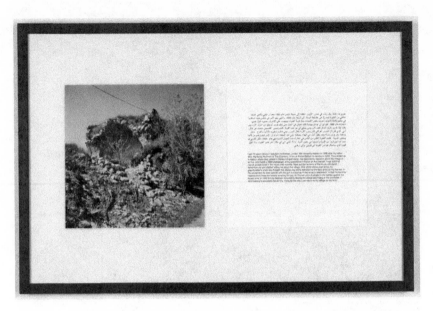

Image 9.2. *Memories of Imagined Places* (2010). The English translation of the text that accompanies the image reads: "I am 19 years old and I was born in Amman, Jordan. We moved to Nablus in 1995 after my father died. My family fled from al-Tira (Dandan), in the al-Ramla district, to Jericho in 1948. They ended up in Nablus where they settled in Balata refugee camp. I've done some research about the village of al-Tira, and found a 1986 photograph of my grandfather's house on the Internet. I was told that Jewish people lived in the house until recently. Now just the remains of the house still stand. I remember my grandfather telling me about the village. One of the stories was about my grandmother's uncle who thought the village was being liberated by the Iraqi army during the war. In his excitement he went outside with his gun to shoot up in the air as a celebration, in that moment he realized that it was the Israelis entering the city. Al-Tira lost a lot of people in the battles against the Israeli army in 1948, but my relatives survived by fleeing the village and hiding in the cornfields. I don't belong to anywhere but al-Tira. I long for the day I can return to my village, to my land." Photo: Anders Sune Berg.

stateless person without any acknowledgment of what was lost, it gives rise to the question of whether a re-narration of displacement and exile can become a form of cross-generational re-traumatization. To return to my initial question: how can visual art contribute to shedding light on under-recognized perspectives in a way that moves beyond the retelling and reanimation of trauma and, in addition, still foster dialogue across generations, borders, and communities? Some would argue that this is

no goal for visual art – that it should have no purpose in this sense – but my engagement in other people's lives and stories – the fact that my material has been generated through personal conversations – makes ethical demands on my use of that material. The development of such relationships and the exchange of ideas and stories often become a foundational element in the finished work, alongside the visual presentation. An important aspect in my artistic practice is to be able to bring back the findings to the people involved in the project – rather than to have an object to exhibit.

The Romanian curator and writer Alina Şerban describes how in a research-based art praxis, authorship changes from sovereign authorship to multiple authorships, and the focus ceases to be on producing new artifacts. She writes:

> [A research-based practice] also reflects the artist's desire to get to know the realities of the present through direct experience, to borrow something of the simplicity and openness of a pilgrim who humbly and curiously approaches the mysteries of everyday life. The transformation of the artwork into a document allows the artist-researcher to become aware of his or her own role in the societal space and to operate directly here, by suggesting new topics to be included for debate in the public agenda.[10]

We Will Meet in the Blind Spot

The project *We Will Meet in the Blind Spot* is an example of artistic research with multiple authorships and cross collaborations leading to the production of a document in the form of an art film.[11] The film was developed in an Italian context between 2012 and 2015. It takes its point of departure from the architecture in and around the area Esposizione Universale di Roma (EUR) in Rome. EUR was built during the fascist era and was meant to be the site of the World Exposition in 1942, in addition to being a celebration of the twenty-year jubilee of fascism in Italy. Additionally, the area was used to create a new narration of Italian national identity after the end of fascist rule, through feature films of the 1960s by, for example, Federico Fellini and Michelangelo Antonioni.[12] Under the banner of "the White City," EUR today is a mix of business district, iconic buildings (many of which are abandoned), and villas and apartments for the wealthy. But outside office hours, it seems to be a massive void. I was interested in using the district's architecture as a point of departure for a discussion on visibility and invisibility in an Italian and also broader European context, specifically in relation to notions of class, migration politics, and the hierarchies embedded both in the site itself and in the current discourse surrounding migration.

We Will Meet in the Blind Spot is constructed as a hybrid film, featuring the narrative of fiction with the voice-over of documentary. It is based on personal and previously untold stories from a group of migrants who are part of the Filipino community of the church Santi Pietro e Paolo in EUR. Curiously, the church is a scaled-down version of St. Peter's Basilica in Rome and was, according to myth, intended as Benito Mussolini's mausoleum. The film revolves around the Filipino community, their lives, and their invisibility within the architecture of EUR, due to living within a hierarchical society. The first waves of Filipino immigration in Italy date back to the 1970s, largely consisting of women, most of whom were employed as domestic workers. In the early 1990s, the flow of immigration increased significantly, leading to the passing of several amnesty laws in Italy (Sanatorie), which made it possible for illegal migrant workers to obtain a work-live permit.[13] Through my ongoing conversations with the strong Filipino community that meets every Sunday in the church, stories and voices were revealed. In the film, the focus is on leisure time, interests described by individual members of the community, and references to scenes from post-war Italian cinema.[14] When filming, we worked around the community's limited free time, with Sunday afternoon being the only time they could participate. This defined the frame for the film production, which was inserted between their work, community life, and church. This limited schedule formed an important premise of the film, recalling a passage from John Berger and Jean Mohr's 1975 book on migrant workers, *A Seventh Man*:

> The only present reality for the migrant is work and the fatigue which follows it. Leisure becomes alien to him because it forces him to remember how far away he is from everything that he still believes to be his real life. Beyond the present of work and his own exertion, the rest of his life is reduced to a series of fixed images relating to past and future, to his values and hopes. These images are the landmarks of his life, but they remain static; they do not develop.[15]

We Will Meet in the Blind Spot (see Image 9.3) emphasizes the protagonists' leisure time in an attempt to release some of the potential embedded traumas of the site, work, and contemporary life of a migrant worker – that is, to make a multifaceted life visible and not just confined to the sphere of labour. One of the first questions some members of the community asked when I proposed the project to them was "Why us?" The answer was, "Because of your unique relation to the site of EUR." Hardly any members of the Filipino community live in the district, but they still spend most of their time, both work and leisure, in EUR.

Image 9.3. Film still: *We Will Meet in the Blind Spot* (2015).

The Italian curator Silvia Litardi writes in her essay "Copenhagen, Rome, or Manila?," included in *Making Visible*, the companion publication to the film, that the Roman attitude towards the Filipino community is generally one of "civil inattention."[16] Here she uses an expression coined by the Canadian sociologist Erving Goffman to describe a lack of attention to or an unfocused perception of the 'Other,' who is basically ignored, seen as neither particularly interesting nor particularly dangerous.[17] For the film, I encouraged the community – which is already present in reality in EUR but often invisible in the cityscape on the basis of civil inattention – to claim the streets and inhabit the architecture. They become physical bodies mapping the space of what has been and still is deemed one of the most filmed locations in Italy. Making the group explicit and visible allows structures of class to be placed at the forefront. The camera floats with the movement of a person walking through the historical centre of EUR, and we move from exterior to interior and back again – ruptured by a voice-over as well as historical maps, both of which link the film to the documentary genre. It was very important for the community that we made a document but not a documentary, and so we made use of fictional formats in its production.

When I speak with migrant communities, who have left their home countries primarily for reasons of economic necessity within the last thirty years, I am interested in their relation to the present. In the description of what was (the past) and what will be (the future), the present, to the migrant,

seems like a long passage between mental states and dreams. This is some-thing that Berger and Mohr describe with great accuracy in *A Seventh Man*, which deals with the life of migrant workers in a European context. The book depicts the life of the migrant (leaving the place of origin, becoming a migrant worker, and returning to the origin) as an almost mythical pas-sage. It is through these descriptions of existing between states and tenses that Berger and Mohr's book unfolds the life of the migrant worker with poetic precision, and points to what *We Will Meet in the Blind Spot* is also concerned with: the loss of the present, which could also be read as trauma of displacement. This brings me back to Said's wording on "the unhealable rift forced between a human being and a native place," which connects to Berger and Mohr's reflection on trauma of displacement:

> The past acts as a wall which prevents the present entering the life's time; or, if it filters in, it is transformed immediately into terms of the past. Everything he sees reminds him of what he can no longer see; and what he is reminded of becomes the essential experience, not what he sees.[18]

Making Visible

The links and traces that occur in the dialogue between the two works *Memories of Imagined Places* and *We Will Meet in the Blind Spot* have taken me on a journey through the shifts and slippages of recollection, loss, and trauma – all contained in the stories and lives of the communities that have contributed to developing the collaborative works by sharing their experiences and engaging in an act of thinking together. Visual art can in its different formats offer a different language to illuminate trauma across generations and boundaries. Benjamin claims: "Language has unmistakably made plain that memory is not an instrument for exploring the past, but rather a medium. It is the medium of that which is experienced, just as the earth is the medium in which ancient cities lie buried. He who seeks to approach his own buried past must conduct himself like a man digging. Above all, he must not be afraid to return again and again to the same matter; to scatter it as one scatters earth, to turn it over as one turns over soil."[19]

What happens if we dig together and excavate the mundane, the non-spectacle, and then listen to the voids that create ruptures in the surface patterns? In both *Memories of Imagined Places* and *We Will Meet in the Blind Spot* the site of trauma is at stake. In the former, violent causes have sent the people into exile, and the continuous occupation makes it impossible to return to the lost homeland, while oppression keeps build-ing on the trauma.

In the latter, the site of trauma is divided between a traumatic history of location and the embodied trauma as a migrant. "The past and the future," in the words of Berger and Mohr, deprive the migrant of the present – and the collaborative effort of the making of the film *We Will Meet in the Blind Spot* is a way of documenting the stories of the community and reclaiming a present. In conclusion, a proposition of collaboration rather than one of participation is perhaps a way forward, when one reflects upon the potential languages of trauma from an artist's point of view. However, it is still daunting for many artists to inhabit the role of facilitator and to forgo an outcome in the shape of an artwork, in order to nurse a space for a dialogue that can potentially shed light on non-linear corners of the minds and souls.

I will end this essay with a piece of art writing from the publication *Making Visible*: a fictional letter that carves its way across time, space, and between bodies, only to arrive back at the place from which it departed. It was developed from some of my reflections on making *We Will Meet in the Blind Spot* and earlier works.

Dear I and A,[20]

I have been meaning to write to you both for a while, but mundane reasons have kept me from doing so. Not until the moment I shifted my location east did it become impossible to postpone this matter further. I believe you have never met, though you are both crossing paths perhaps on a weekly basis.

The area of Esposizione Universale di Roma was intended as a showcase during the World Expo in 1942, but the war changed both the attention of the fascist system and the grandiose plans to show the world that the future was filled with straight lines and efficiency. Today the area carries the name EUR, and as an integrated part of Rome it still functions as a perfect backdrop for different realities. I am still struggling with the pronunciation of EUR: it seems to be a rolling sound stuck in my throat.

For different reasons, you both have strong connections to this historical place, which was conceived to be a site without history by architects commissioned by Mussolini. Here the streets are grids and the white shades of rationalist architecture create sharp corners when the sun strikes the right angle. On Sundays there is hardly a person or car in sight when wandering the empty streets. Except at the famous Caffè Palombini, where you, A, are to be found, or the miniature version of Saint Peter's Basilica located on top of a hill in EUR – where you, I, are to be found together with the large Filipino community.

I am writing to you from Warsaw, and being in a post-totalitarian state of mind, in a city built rapidly on ruins after a damaging war, it all came back

with urgency. At dusk, whilst wandering the streets of the reconstructed old city of Warsaw – I don't know if you have been there, but it is right at the edge of where the Warsaw Ghetto was located in 1940–43 – the sound of some of your words came back to me: shadows, community, periphery, totality.

The past acts as a wall, which prevents the present from entering the life's time; or, if it filters in, it is transformed immediately into terms of the past. Everything she sees reminds her of what she can no longer see; and what she is reminded of becomes the essential experience, not what she sees.

A: You told me that you don't believe in the democratic system while we were walking around in the area of Esposizione Universale di Roma. You casually mentioned things were more straightforward in the times of a dictator, and that you appreciated efficiency. You looked content when you walked around the area where you were born.

I: You mentioned how for twenty-five years, since the time you migrated to Italy, you have spent every day working in EUR. You described how you arrived as a tourist in Italy and never left.

It was about the same time that the community began to hold ceremonies in the park near the lake without permission, and only much later that the church agreed to host your ceremonies.

Somehow both your Sunday activities make me think of the paths we create for ourselves and make me wonder if you would ever consider looking for each other in the different locations? Would it make sense at all? Being here in Warsaw somehow urges me to question the notions of past, present, and future tense, particularly in relation to my own perception.

The layering of history I am walking upon in the streets of the rise and fall of a totalitarian ideology.

How people insisted on having the cultural palace – a symbol of starvation and Stalinism – brought down after the fall of communism, to demolish the violence of its hated symbolic value, and how it still stands whilst hundreds of thousands are migrating from Poland in order to pursue another sort of independence, although many end up being stuck. The flow and ebb of people creating new paths for themselves while the outlines of the frontiers are being drawn harder and harder in order to prevent the appearance of these new paths. The first- and second-class compartments enforced in trains, etc., remind us of a difference – the one that is produced when you legitimately enter either of those compartments. There were no compartments when leaving the Warsaw Ghetto at the time when the World Expo of 1942 was intended to open and when dictators were in charge. So it made me wonder what you, A, meant when you said that you like the idea of a one-party system. Couldn't it be too efficient?

I: You said that Italian employees like the Filipinos better, since they are hardworking and honest, and you didn't mind going along with that perception. You simply want to be treated well – so your future could be secured. You reluctantly mentioned the future, which somehow had become the present and the past, while you were working away, and you had almost forgotten that you wanted to return to your origin.

This brought me to think of something, A, casually mentioned during our walk. That EUR in many ways represents a past stuck in a past; every attempt to change its architecture or its path fails. The place without history somehow has become the site of a contested fascist history – till this day very present as an ideology that seeps through Europe as a revival of something that should have been abandoned, but not forgotten. Instead, it was right there in front of us: a group of young neo-fascists right next to the statue of Mussolini that has been kept since the time of the utopian vision.

It may sound strange to bring up these issues, and it is hard to put into writing why I want the two of you to cross paths – at least through this letter.

Kind regards,

M

NOTES

1 The Holocaust has been known in Hebrew as the Shoah since the 1940s.
2 *Shoah* (France 1985), dir. Claude Lanzmann, Les Films Aleph.
3 Dylan Trigg, "The Place of Trauma: Memory, Hauntings, and the Temporality of Ruins," *Memory Studies* 2, no. 1 (2009): 87–101, https://doi.org/10.1177 /1750698008097397.
4 Jenny Yurshansky, "A Legacy of Loss (Shroud)," 2019, accessed 29 February 2020, http://www.jennyyurshansky.com/Jenny_Yurshansky/A_Legacy_of _Loss_Shroud.html.
5 The Palestinian villages that we visited and documented in 2009 were: al-Masmiyya al-Saghira (former Gaza district), al-Abbasiyya (former Jaffa district), Yazur (former Jaffa district), al-Jammasin al-Sharqi (former Jaffa district), al-Burj (former Ramla district), al-Qubab (former Ramla district), Qastina (former Gaza district), al-Tira (Ramla district), Bayt Dajan (former Jaffa district), Saknet Darwish (former Jaffa district), and Bayt Jibrin (Hebron district).
6 Edward W. Said, "Between Worlds," in *Reflections on Exile and Other Essays* (Cambridge, MA: Harvard University Press, 2002), 173.
7 Walter Benjamin, *Selected Writings 1938–1940*, vol. 4 (Cambridge, MA: Harvard University Press, 1996), 410.

8 Susan Sontag, *Regarding the Pain of Others* (New York: Farrar, Straus and Giroux, 2003), 67.

9 Ibid.

10 Alina Șerban, "The Way of an Artist: Rewriting Images, Remapping Narratives," in Maj Hasager, *Making Visible* (Malmö: Woodpecker Projects, 2015), 95–6.

11 The community – consisting of Jerry Arquisola, Maxima Garcia Banella, Cleto Banella, Ivy Castillo, Julie Garcia, Ramil Magsino, Lhyn Magsino, Cristy Porlucas Magsino, Arnel V. Magtibay, Bella Gonda Ortega, and Dante Ortega – was very clear that the film should not be a documentary, but rather a document mapping and tracing their migratory path.

12 Federico Fellini chose the setting of the EUR district for his films *La Dolce Vita* (Italy, 1960) and *Le Tentazioni del Dottor Antonio* (Italy, 1962). Michelangelo Antonioni filmed *L'Eclisse* (Italy, 1962) in the EUR district.

13 MAPID – Migrants' Associations and Philippine Institutions for Development (First year's activity), Italian Report, by Laura Zanfrini and Annavittoria Sarli, Quaderni Ismu 1/2009, accessed 29 February 2020, http://old.ismu.org/wp-content/uploads/2014/01/Mapid_pdf-intero_con-copertina.pdf.

14 One example could be the 1962 stylistic film *L'Eclisse* by Michelangelo Antonioni, where the still rather young site of the EUR is used as a backdrop for the uncanny relationship between a couple without any reference to the site's historical and complex origin.

15 John Berger and Jean Mohr, *A Seventh Man*, 2nd ed. (London: Verso, 2010 [1975]), 175.

16 Silvia Litardi, "Copenhagen, Rome, or Manila?" in Hasager, *Making Visible*.

17 Erving Goffman, *Behavior in Public Places: Notes on the Social Organization of Gatherings* (New York: Free Press, 1966), 83–8.

18 Berger and Mohr, *A Seventh Man*, 182.

19 Walter Benjamin, "Ibizan Sequence" [1932], in *Selected Writings, Vol. 2, Part 2 (1931–1934)*, ed. Marcus Paul Bullock, Michael William Jennings, Howard Eiland, and Gary Smith (Cambridge, MA: Belknap, 2005), 576.

20 "Dear I and A" was first published in *Woodpecker Letters #1* (Malmo: Woodpecker Projects, 2014).

PART THREE

Normalizations of Trauma

10 Between Social Criticism and Epistemological Critique: Critical Theory and the Normalization of Trauma

ULRICH KOCH

It is an often remarked but rarely reflected upon feature of the academic discourse on trauma that it is multidisciplinary, that the notion of trauma has emerged, sometimes matured, often only flared up in rather disparate discursive contexts.[1] Since the 1990s in particular, trauma has become both a prominent topic for scholars in the humanities and an extensively researched subject in the psychological and medical sciences. Scientific ideas about the consequences of psychological trauma have also gained prominence outside of academe and given rise to popular notions of victimhood and, its corollary, survivorship. Clearly, trauma speaks in many tongues and through numerous mediums. But what are we to make of the multitude of trauma languages and discourses that have evolved since the late nineteenth century, the proliferation of popular trauma narratives, the many meanings, political causes, scientific and scholarly aspirations that have become attached to the word 'trauma' over the years?

Scholars, who have remained sceptical of this surge in interest, have responded to the ubiquity of trauma by pointing out the vagueness of a concept deemed evocative yet ultimately elusive and contradictory.[2] Others, those committed to contributing to the various fields in which scholarly and scientific notions of trauma have struck roots, have often drawn on, in interdisciplinary fashion, the diverse, rich bodies of literatures that have emerged on their topic to illustrate or corroborate their own claims about the 'nature' of trauma.[3] In other words, as scholars either lament or embrace the multitude of trauma discourses they often do so to either critique or validate certain ideas about what it means to be traumatized.

This chapter is not concerned with arriving at conclusions about a presumed 'nature' of traumatic experience. Rather than clarifying how trauma *should* be understood, it aims to delineate the different theoretical

trajectories on which the trauma concept has been placed. I am interested in the conceptual tensions that arise as the category of trauma is deployed in different disciplinary and discursive contexts to advance diverging epistemic and political projects. To reconstruct the emergence of these tensions, I focus on how the closely related notions of trauma and shock were invoked by the eminent theorist of the Frankfurt School, the musicologist, sociologist, and philosopher Theodor W. Adorno. More specifically, this chapter places his usage of these terms in his sociological and aesthetic writings in their theoretical and historical contexts and contrasts them with more recent clinical conceptualizations of trauma.

By focusing on Adorno's writings, I not only want to elucidate an important strand that would feed into the theorization of trauma by post-structuralist literary scholars in the 1990s, most prominently and controversially by the literary critic Cathy Caruth.[4] Putting his different uses of the trauma and shock metaphors into their respective theoretical contexts also sheds light on the shifting ethical and epistemological stakes of how they have been invoked since by humanities scholars. As I show in the following section, what attracted Adorno and other critical theorists to the notion of psychological trauma was that it could be deployed to argue for the *damaging* effects of fragmented, discontinuous experience. Yet I argue that within their critical-epistemological projects, this notion of damage remained ambiguous since discontinuous experience is often seen as the 'norm' rather than the exception. Because critical theorists understood trauma in terms of a damaging yet ubiquitous mode of apperception, psychological trauma was from the start – and not just since the flourishing of cultural trauma studies in the 1990s – rendered as a universal experience. Contrasting this view with more recent clinical theorizing of psychological trauma in the second part of this essay, I argue that trauma's moral impetus, as well as the epistemology underpinning the study of traumatic stress, rest on the opposing assumption, namely that traumatic experiences are the exception rather than the norm. Traumatic events are damaging because they disrupt regularities, biological, social, and psychological norms; and they are deemed morally objectionable because such disruptions are frequently caused by acts of violence and are seen as avoidable.

A fundamental tension therefore exists between how, on the one hand, trauma has come to be understood in clinical and scientific contexts and, on the other hand, how it has been understood in some quarters of the humanities. I further contend, however, that a recognition of such tensions must not lead to intellectual defeatism. Becoming aware of the concept's limitations may yet help us to better delineate what gives the multitude of trauma discourses their cohesion, despite their apparent lack of coherence.

Also, given the impetus of the broader question raised here, a closer reading of Adorno's contributions will prove worthwhile, as the notion of trauma appeared in his work precisely at a moment where he probed the limits of integrative approaches in the social sciences. To begin to reflect upon the significance of the inconsistencies that arise from trauma having become, in the words of Susan Leigh Star, a "boundary object," then, there is no better place.[5]

"The Traumatic Is the Abstract"

It is important to note that, presently, fascination with psychological trauma not only cuts across the divide of the 'two cultures' separating the humanities from the natural sciences; it also straddles several disciplinary boundaries within the human sciences. Since the introduction of the diagnosis post-traumatic stress disorder (PTSD) in 1980, the study of traumatic stress has evolved into a prominent site for researching how harmful social conditions and environmental factors interact with psychological and physiological processes to produce a wide range of negative health outcomes. Biomedical, clinical, and social scientific methodologies are all harnessed to study the effects of trauma on an individual's body and mind. Over a relatively short period of time, in other words, the study of trauma-related disorders has become an exemplar of successful interdisciplinary enquiry in the medical and psychological sciences.

In the 1940s and 1950s, though, Adorno was intermittently compelled by the notion of trauma because of its marginal status within the social sciences. Although he would participate in interdisciplinary research projects himself, he first referred to traumatic experience in the context of a scathing critique of what he regarded as a naive synthesis of the psychological with the other social sciences. For Adorno, the Freudian "model of trauma" was noteworthy because it resisted its integration into a comprehensive social scientific approach that aims to combine psychoanalytical with sociological perspectives.[6] Who were the targets of his critiques, and what were the theoretical and societal developments to which he responded?

Adorno draws upon the notion of trauma in this sense in two, at first glance, seemingly disconnected debates. In a paper titled "Social Science and Sociological Tendencies in Psychoanalysis," presented to members of the San Francisco Psychoanalytic Society in 1946 – and later published in the German psychoanalytic periodical *Psyche* – he delivered a philosophical critique of the psychoanalytic teachings of recent fellow émigrés to the United States Karen Horney and his former colleague at the Institute for Social Research, Erich Fromm, denouncing their

revisionist tendencies. By incorporating social psychological and anthro-pological perspectives into her explanation of neurosis, by underscoring the importance of the social milieu, Adorno argued, Horney unwittingly yet effectively dispensed with what was left of psychoanalysis's critical impulses. His criticism of the social-scientifically informed approach propagated by Horney, Fromm, and other "revisionists" was first and foremost a critical response to how psychoanalysis had become popu-larized in the United States and, more broadly, the degree to which psy-chotherapeutic practices, of different derivations, were enthusiastically embraced by a number of professional groups as a social technology to help troubled individuals adjust to a rapidly transforming society. From this talk and a number of aphorisms contained in the *Minima Moralia*, his *Reflections from Damaged Life*, written around the same time, a picture emerges of a profound scepticism towards any form of psychotherapeu-tics that seek to alleviate human suffering without tending to the societal conditions that perpetuate it.[7]

The sombre undercurrent of his views may have been lost to his au-dience of psychoanalysts. However, Adorno's defence of Freudian drive theory was a welcomed philosophical intervention in a recurring debate within American psychoanalytic circles about what formed the knowl-edge base of psychoanalysis. Unlike in many European countries, in the United States psychoanalysis had successfully established itself as a medical specialty, restricting its practice to physicians. Orthodox or 'classical' Freudians maintained that psychoanalytic drive theory should not be jettisoned in favour of the approach propagated by the so-called neo-Freudians, who stressed the significance of social relations and influ-ences for the individuation process.[8]

The other context in which Adorno alluded to trauma was a crit-ical evaluation of attempts to develop a unified social theory, which he saw exemplified in the work of the sociologist Talcott Parsons. In his article "On the Relationship between Psychology and Sociology," published almost ten years later, soon after his return to Germany from exile, Adorno set his sights on Parsons's proposal to reconcile socio-psychoanalytical explanations of personality development with the sociological study of societal processes and institutions. In the post-war years, interdisciplinary research efforts in the social sciences, often draw-ing on psychoanalytic theorems, did indeed receive broad institutional support in the United States.[9] In fact, during and immediately after the war, Adorno himself had been involved – although only marginally – in what became one of the most widely known and commented upon pro-jects of this kind, a study undertaken by a group of researchers based in Berkeley, California, culminating in the publication of *The Authoritarian*

Personality, in 1950.[10] However, critics soon pointed to the work's methodological shortcomings and began questioning many of its underlying premises about both the nature of authoritarianism and how it relates to personality development.[11]

Adorno's criticism, articulated after his return to Germany and mainly as a response to Parsons, was more fundamental. He had concluded that erecting a theoretical edifice following the idealized image of a universal social science would ultimately lead to a glossing over, a forced "harmonization" of the irreconcilable differences between individual and society. Proposing a unifying social theory, he argued, allows the "fitting-together of man and the system" to be treated as the "norm."[12] Like other critics of Parsons, Adorno pointed out the theoretical limitations of his structural-functionalist approach. With its focus on social functioning, the possibility of social deviance and societal transformation eluded its theoretical grasp. In the same article, Adorno also rekindled his criticism of the psychoanalytic revisionists, depicting them, similar to Parsons, as primarily concerned with maintaining the social order by equating the "healthy" personality with the well-adjusted one. He deemed therapeutic practices that aim to reconcile oppressive social conditions with individual desires morally reprehensible, as they burden the individual with striking a balance between forces of unequal legitimacy.[13] Whereas many contemporary psychoanalysts, even those wedded to psychoanalytic orthodoxy, had begun to focus on how an individual's ego matures and adapts to its social environment, Adorno's emphatic individualism barred him from seeing in adjustment anything other than blind conformism. Again, he draws on Freud to provide readers with an approach that did not conceive of socialization as an undisturbed, continuous process.

In his 1946 San Francisco lecture, Adorno had alluded to what he regarded as the defining feature of Freud's "model of trauma":

> Ultimately, what prompts Freud to ascribe so much importance to separate occurrences [*Vorgänge*] during childhood is, although implicitly, the notion of damage. [...] Character is much more the effect of such shocks than of continuous experience [*Erfahrung*]. Its totality is a fiction: one could almost call it a system of scars, which are never fully, and only under great suffering, integrated.[14]

It is important to highlight, as did the intellectual historian Martin Jay, the conceptual difference, insinuated by Adorno, between continuous experience or *Erfahrung* and an isolated experience or *Erlebnis* that has not been placed in broader experiential contexts.[15] With this philosophical

distinction, Adorno emphasized structural qualities of traumatic experiences without delimiting their content. Trauma, then, is the mode of disjointed experience, which is also the medium of socialization in late capitalist societies.

In his article, several years later, he again juxtaposed the idea that "damages" are the primary medium of socialization against recent theorizing that seemed to be intent on constructing a conceptual "continuity between society and psyche."[16] However, he argued, echoing his earlier comments, that the postulate of a continuity between individual experience and its social determinants is dubious. For where theorists like Parsons claim continuity, a radical discontinuity is actually the norm. Those socialized in late capitalist societies are inevitably "unidentical with themselves, simultaneously social and psychological character, and, due to this fission, *a priori damaged*."[17] Because society demands of its members that they act against their own self-interests, the discontinuity extends *into* the individual, into the mental realm itself, as it were.

In the aftermath of a thoroughly relentless socialization process, little seemed to remain that Adorno would qualify as truly "psychological." Because individuals are made to act in accordance with societal demands that follow the blind logic of self-preservation, of instrumental reason, the scope of a psychological science becomes limited. The concept of the psychological, Adorno asserted, "finds its substance only in the opposition of the irrational to the rational as something exterior to psychology."[18] Adorno not only re-erects the breach between the individual and society *within* the individual, he also again imagines trauma to be what acts as a medium between what has been forced apart:

> Just as society insulates itself from psychology so does psychology cut itself off from society and becomes paltry. Under the pressures of society, the psychological layer only responds to the ever-same and deprives itself of the experience of the particular. *The traumatic is the abstract.* Therein, the unconscious resembles society, which conforms to the same abstract law, yet to whose existence it remains oblivious whilst serving as its glue.[19]

In his earlier talk, Adorno had still critiqued the neo-Freudians' tendency to explain their patients' neuroses with "social influences" and interpersonal conflicts while neglecting the significance of early childhood events when he had called upon the idea of trauma.[20] Now, he invoked the latter without even an indirect reference to specific experiences. The traumatic had indeed become the abstract.

The quoted statement should be understood against the backdrop of Adorno's perennial concern with the dialectics of the general and the

particular. Because the individual must struggle to place isolated experiences in broader contexts, to transform *Erlebnis* into *Erfahrung*, it also, retroactively, as it were, loses its ability to experience particulars – that which cannot be subsumed under concepts or dissolved through abstractions in other ways. The individual ultimately withdraws from any attempt to experience that which it cannot assimilate. The "psychological character" is forced into submission, so to speak, as the "sociological character" reigns supreme. For the sake of continuity, for society's normal functioning, unrestrained experience is sacrificed and the acts of enforcing that continuity, the daily routines that have become devoid of meaning, themselves become traumatic, only adding to the damage already suffered.

In these writings, Adorno thus imagined a vulnerable individual in opposition to a society intent on overpowering any vestiges of individuality. Against the backdrop of this rather bleak picture, traumatic experience is rendered as an experience that is both inevitable and universal in late capitalist society. Trauma is not necessarily a vital threat. Rather, 'traumatic' in this sense is the continuation of what must remain the same, the very production of normality through deprived experience.

This motif, that trauma is both the compulsory continuation of experience and the means or medium through which it is forced upon the individual, had already surfaced before in Adorno's writings. In an aphorism written in 1944, Adorno had reflected on the difficulty of forming wartime narratives; of recounting the sequence of events through which a war unfolds, – its strikes, campaigns, and counteroffences – but also of narrating the battle experiences themselves. Wartime narratives, he observed, initially consist of fragments that only later, with the passage of time, coalesce into a story. Due to the war, he wrote, "[l]ife has been transformed into a timeless sequence of shocks with holes, paralyzing intervals gaping between." Yet, he continued, nothing speaks more to the ill fate that awaits than the fact that the very possibility of a future is now at stake; since "every trauma, every unresolved [*unbewältigte*] shock of the returned is a ferment of coming destruction. – Karl Kraus was right to call his play 'The Last Days of Mankind.' What is happening today would have to be called 'After Doomsday.'"[21]

In this context, the description of a forced, seemingly timeless, sequence of shocks becomes more tangible as part of the author's lived experience (the foregoing aphoristic fragment takes on the perspective of someone learning about the war's atrocities through the coded language of newsreels). As the aphorism ends on a hyperbolic note, the true horror, it appears, is that the horrors are only bound to continue, although the cursory nature of this reference to war trauma, in this and

other contexts, is surely also owed to the fact that, beyond psychiatric and psychoanalytic circles, the category of trauma was not yet as regularly invoked in connection with war experiences as it is today. It is also important to note that in all of the writings thus far mentioned, Adorno does not describe the effects of trauma in terms of memory, even as he points out, as in the aforementioned aphorism, the challenges of *recounting* the experience of war. Again, it is the challenge of rendering a sequence of lived events as part of a cumulative, integrated experience (*Erfahrung*).

In the post-war years, Adorno would famously elaborate the claim that in light of the atrocities perpetrated by the Nazis, the very act of carrying on, of perpetuating the culture that had been the seedbed of catastrophe, has become questionable, if not horrific in itself. Because, in his 1966 book *Negative Dialectics*, he extended this line of thought to the damning, perhaps self-defeating conclusion that reasoning itself has become complicit in committing the atrocities that occurred during the Second World War, Adorno has been assigned a crucial place in the genealogy of the trauma discourse in the humanities.[22] "Our metaphysical faculty is paralyzed," he wrote in the book's last chapter, "because actual events have shattered the basis on which speculative thought could be reconciled with experience. [...] After Auschwitz there is no word tinged from on high, not even a theological one, that has any right unless it has undergone a transformation."[23]

Although Adorno does not make any references to trauma in this instance, his deliberations on the cultural and epistemological significance of the Holocaust would later prompt several authors to extend this line of thought through a theoretical idiom of trauma that was unique to the humanities – and, as will be shown later, somewhat out of touch with more recent trends in the clinical sciences. Philosophers such as Jean-François Lyotard or Giorgio Agamben,[24] for instance – drawing on psychoanalytic theorems about the disturbing temporality of traumatic memory – treated the theoretical and moral challenges Adorno had alluded to as problems of representation, stressing their implications for recounting the historical events of the Holocaust. The limitations of conventional historiography brought to the fore by the challenges of writing the history of the Nazi death camps, moreover, were soon identified in other historical and cultural contexts supposedly indicating a *crisis of representation* in the wake of trauma. Lyotard, for one, was generally concerned with the exclusion of that which eludes the "synthesis" of reasoning and representation, allegedly inherent to occidental thought. Subsuming a plurality under a given concept, for a representation to become identical with itself, he among others argued, requires the exclusion of its other. In his 1988 essay *Heidegger and "the Jews,"* Lyotard

employed the metaphor of a dual shock to illustrate the consequences of representational thought. The first, unregistered shock is the one of a primordial repression, lying at the root of all representation, which relentlessly returns as a second, affective shock, surfacing as anxiety.[25] Perhaps more true to Adorno's critical intentions, the philosopher and psychoanalyst Slavoj Žižek, building on the Lacanian notion of "the real," similarly theorized one year later in his book *The Sublime Object of Ideology* the existence of a "traumatic kernel" that resists symbolization, yet the symbolic order is structured around it.[26] The recurring theme in these and later writings, which articulated similar notions in other post-structuralist terms, is not only the difficulty of representing trauma, but also the idea that trauma somehow *resists* representation.

As I have attempted to show, the philosophical notion of trauma as a radical discontinuity was first introduced as one between different modes of apperception, isolated as opposed to integrated. It was only later that it was transformed into a breach between representational thought and that which eludes its grasp. Although Adorno's early references to trauma had been vague, through this transformation 'trauma' became still further removed from actual experiences. Whereas Adorno had never suggested that the traumas of childhood are epistemically intractable, the anti-representationalist stance by later authors was developed to show that historical events leading to trauma could no longer be regarded as knowable in the conventional, epistemologically naive sense of the term. Still, it remained at least *desirable* to acquire some form of knowledge about trauma. Postmodernism may have thrown into doubt the idea of universal truth, as it mounted arguments against the existence of unassailable knowledge; postmodern philosophy, however, is nevertheless intensely devoted to the ideal of *truthfulness*. Or to put it differently: although knowledge has fallen into dispute, the postmodern intellectual project is still committed to delineating and probing its boundaries. Thus, among theorists of "structural trauma" – to borrow Dominick LaCapra's phrase[27]– the mental wounds left by traumatization gain epistemological significance insofar as they, through their repetition, re-enactment, or silence, bear witness to the otherwise inaccessible, damaging event – and in Lyotard's case, also to a presupposed original injury, a primordial separation.

In the instances cited above, Adorno does not elevate trauma to this epistemological status. Nevertheless, the idea that suffering or, to put it in broader philosophical terms, the experience of negativity encloses other possibilities of understanding is anything but alien to Adorno's thinking. Hence, in the context of his aesthetic theory, he draws on a metaphorical language strikingly similar to the one in his sociological

writings to develop a line of argument, later extended by Lyotard, that identified art as a realm of culturally mediated experience where the non-identical becomes tangible.

Before outlining how pathogenic experience came to be conceived in psychological and medical discourses, I will therefore briefly turn to Adorno's aesthetic theory, both to better delineate the anthropological assumptions that underlie his figure of the "*a priori* damaged individual," and to demonstrate the inherent epistemological and moral ambiguities of the philosophical notion of a traumatizing radical discontinuity. To this end, a discussion of Walter Benjamin's usage of the shock metaphor will also prove useful.

Aesthetic Shocks

In his last major work, the posthumously published *Aesthetic Theory*, Adorno delivers a far-reaching philosophical reconstruction of modernist aesthetics. Modernist art, he argued, unrestrained by notions of beauty, deliberately creates dissonance and shatters harmony; and it is through such aesthetic shocks that the experience of particulars and non-identity is retained. "Scars of damage and disruption," he wrote in the introduction, "are the modern's seal of authenticity; by their means, art desperately negates the closed confines of the ever-same; explosion is one of its invariants."[28] Aesthetic shocks, in other words, resist tradition and, by extension, an oppressive societal praxis; and because the disruptive force of the shock contests the immediate gratification that comes with the appreciation of beauty it nurtures desire and, ultimately, hope: "For the sake of happiness; happiness is renounced. It is thus that desire survives art."[29] Or as Adorno would put it differently many pages later: "Art is the ever broken promise of happiness."[30] Mediated through works of art, aesthetic shocks may inflict damage on questionable ideals of harmony, yet they do not pose a vital threat to the spectator.

As Adorno's biographer and former student Rolf Wiggershaus pointed out, in his aesthetic theory Adorno retained the Marxist idea that the sublation of class antagonisms would ultimately unleash society's productive forces, including its technological capabilities. In his own critical theory of society, however, Adorno had all but abandoned such faith in technology.[31] In the *Dialectics of Enlightenment*, Adorno and Max Horkheimer famously argued that technological progress compulsively followed the narrow trajectory projected by instrumental reason, systematically precluding the pursuit of other ends besides self-preservation and the domination of nature. In the realm of art, Adorno does not presuppose the opposition between subjectivity and – in a broader sense – technology.

This chasm between Adorno's aesthetic theory and his sociological writings relates to a disanalogy of how he employs the shock metaphor in both contexts. As a medium of socialization, shock experiences are inadvertently damaging; in the context of his aesthetic theory, on the other hand, they are valued for their, as it were, therapeutic qualities. By breaking through the veil of the spectator's complacency, they reveal to him or her the fragility and deceptive character of cultural mediation.[32]

From this perspective, it is not surprising that Adorno, although he conceived of art as a technically mediated experience of the non-identical, remained opposed to the application of psychotherapeutic techniques – including clinical psychoanalysis, which, so he reckoned, "cannot avoid breaking what it sets free"[33] – to alleviate human suffering. His limiting perspective on technology, as being inextricably bound up with the dehumanizing tendencies of instrumental reason, becomes even more salient if Adorno's use of the shock metaphor is contrasted with Walter Benjamin's use of the same term, mainly in his essay "The Work of Art in the Age of Mechanical Reproduction," as well as in other works of the 1930s.

Benjamin's writings have, of course, become a much-revisited starting point for cultural theorists exploring the interconnections between ideas about modernity and trauma.[34] Benjamin perhaps most emphatically described how the experience of shocks has become a daily occurrence in the modern metropolis. Factory work, the accelerated pace of life in the city streets, gambling and other forms of mass enjoyment like cinema, he observed, all exposed bodies and minds of everyday citizens to shocks and to disconnected events, the experience of which had to remain fragmented. Also, Benjamin pointed to the potentially damaging consequences of such experiences.

In his essay on the modernist poetry of Charles Baudelaire, for instance, Benjamin distinguishes between the shock and its "traumatic effect"; and, taking up Freud's speculations in "Beyond the Pleasure Principle," he surmised that the perceptive apparatus protected itself against sudden jolts through heightened awareness – a "shock defense."[35] New artistic media such as film and photography as well as the modernist poetry of Baudelaire, he argued, by mimicking this fragmented experience, have the potential to *transform* perception: "By means of its technical structure," Benjamin wrote in his essay on the work of art in the age of mechanical reproduction, "the film has taken the physical shock effect out of the wrappers in which Dadaism had, as it were, kept it inside the moral shock effect." In a footnote, he adds:

The film is the art form that is in keeping with the increased threat to his life which modern man has to face. Man's need to expose himself to shock

effects is his adjustment to the dangers threatening him. The film corresponds to profound changes in the apperceptive apparatus – changes that are experienced on an individual scale by the man in the street in big-city traffic, on a historical scale by every present-day citizen.[36]

Even though Benjamin acknowledged the potentially damaging effects of this "habituation," he also pointed to its emancipatory potential. "Distraction [*Zerstreuung*]," the dispersion of attention, he argued, breaks with tradition and traditional ways of relating to works of art through "contemplation." Just as psychoanalysis opens the one undergoing analysis to the existence of his unconscious desires, so does film, by upsetting established patterns of perception, open viewers' eyes to the world of "unconscious optics," a layer of the visible world that previously had gone by unnoticed.[37]

In Benjamin's writings, thus, aesthetic shocks have quite different connotations. Taken together, his ideas remain more ambivalent than the ones later espoused by Adorno. By pointing out the viewer's "need" to expose himself or herself to "shock effects," Benjamin at once acknowledged and obfuscated the differences between the shock as a structural principle of works of art and threatening, potentially traumatizing shocks. His notion of the aesthetic shock, moreover, operates in the register of perception, explicitly grounded in bodily experience. In Adorno's aesthetic theory the shock functions as a disorienting blow and is conceived in more intellectualist terms, resembling the muted "moral shock," to take up Benjamin's metaphor.

For Benjamin, habituation did not amount to conformity, nor did it carry the mark of defeat. Whereas the shock of the "ever-same," which Adorno envisioned, was depriving, Benjamin was willing to entertain the possibility that isolated, dislodged experience may contain the seeds for its transcendence.[38] It was also Benjamin who first drew on the distinction between experience as *Erfahrung* and experience as *Erlebnis*, particularly in his essay "On Some Motifs in Baudelaire." He never considered the latter a regressed or decaying form of experience.[39]

Upon reading his essay, Adorno had indeed criticized Benjamin for directing his analysis towards the embodied experience of film reception, thereby supposedly adopting a quasi-behavioristic view of the spectator subject.[40] But it is Benjamin's refusal to disentangle the shock metaphor, his shifting back and forth between threatening shock experiences and the more benign blows delivered through new artistic mediums that reveals the historicity both of perception and of traumatic experience itself. He reminds his readers of the broader historical conditions that can lead to shock experiences and further raises the possibility that,

through a transformation of their "apperceptive apparatus," individuals would adapt to the disruptions in their sensory surroundings. If shocks are part of daily life and one can become inured to at least some of them, then what may function as a shock is likely to change.

Their contrary perspectives surely reflect underlying philosophical differences. However, it is important to acknowledge the historical fault line separating their vantage points. Published before the war, the writings in which Benjamin invokes the shock metaphor were conceived under the impression of the rapid cultural transformations and social turmoil that had become so palpable in Berlin during the interwar period. "Normality" or, to put it in terms he had used in his essay "The Storyteller," "shared experience" appeared tenuous to Benjamin because he believed it could no longer be attained.[41] But Benjamin did not survive to witness German reconstruction. In his *Aesthetic Theory* and *Negative Dialectics* especially, Adorno was concerned with questions of how the Holocaust *should* be remembered. Already in 1944, Adorno deemed the inclination to return to normality after the war, any attempt to somehow re-establish "culture" after millions of Jews had been murdered, "idiotic" – "Normality is death" was his verdict in the *Minima Moralia*.[42] During exile and after his subsequent return to Germany, Adorno had observed the efforts, mounted on many fronts, to create a stable post-war social order. From his perspective, then, so-called normality was not only precarious, it had ominously turned into its opposite: "the disease of the normal."[43]

Pathogenic Experience

Adorno's presupposition that the experience of trauma must remain impervious to the methods of a positivist social science had always lacked empirical support. The experience of massive psychiatric casualties during the Great War did not only draw the interest of psychiatrists and neurologists in many war-waging nations to those suffering from traumatic or war neuroses, as they were then often called. During the interwar years, the presumed traumatic origins of some neuroses also framed the decidedly interdisciplinary, experimental study of mental disorders in animal laboratories in the United States.[44] Within the evolving medical discourse on stress, traumatic events were seen as *extreme* events that exceeded an individual's capacity to adjust to exceptionally harsh environmental conditions.

The vision of the individual under stress, which further gained contours in the post-war era, differed markedly from Adorno's implicit anthropology of a vulnerable individual, bound to be damaged by the recurring events that constitute everyday life in late capitalist societies.

Yet by the 1960s and 1970s, proponents of the anti-psychiatry movement, other intellectuals, and political activists breathed new life into Adorno's claim that society itself was pathological.[45] This time, the idea drew wider circles and resonated among a number of social groups in the United States, among them protesters of the ongoing war in Vietnam. As social critics questioned psychiatric understandings of normality, the causes of psychopathologies, most prominently of schizophrenia but also of traumatic neuroses, were no longer primarily located within the individual but in his or her pathogenic social surroundings. Among clinicians, however, even the politically engaged ones, the idea that a sick society produces sick individuals did not fare well in the long run.

While the reasons for the decline of this kind of sociogenic explanation of mental illness are surely varied, that decline does reflect a profound change in the overall political climate, including a fracturing of political causes, which altogether became more grounded in the shared experiences of groups of individuals rather than being tied to the anticipated fate of society as a whole. Reflecting the political exigencies of identity politics, the notion of a pathological society was displaced by the idea that circumscribed pathogenic experiences took their toll on individuals and circumscribed communities. As social scientists, radical psychiatrists, and psychologists lost ground in the battle over how mental illness should be understood, a new consensus around the clinical notion of trauma evolved, namely that it represented an *abnormal* experience.

The debilitating effects of violent experiences had, of course, been well known and studied before the official recognition of PTSD. As mentioned, the psychiatric casualties observed during two world wars had been decisive in turning the attention of clinicians and researchers in a number of disciplines to the effects of harmful social conditions.[46] The clinical observations made during times of war proved impactful because the conclusions drawn from them seemed to be applicable to peacetime society. For instance, in a 1948 book written for the popular press, the psychiatrist William Menninger, who had worked for the Office of the Surgeon General during the war, argued that the soldiers' experiences undoubtedly differed from those struggling with social pressures at home: "But the effect on the personality is very much the same."[47] Similarly, in their now classic book *Men Under Stress*, published in 1945, the Chicago psychoanalysts and psychiatrists Roy Grinker and John Spiegel posit a continuity between the experience of combat and the stresses experienced during times of peace. The psychological mechanisms of stress, they argued, "apply to Everyman in his struggle to master his own environment," as "[u]nder sufficient stress any individual may show failure of adaptation."[48] Traumatic experiences, in short, were effectively

normalized. In the eyes of many psychiatrists they constituted excessive, extreme experiences rather than point to a different *class* of experiences, different not only in degree but also in kind.[49]

The same normalizing tendency could be observed in bordering disciplines. Already during the 1940s and 1950s, physiologists and neurologists had turned their attention to the enduring negative health effects of what was then called "life stress."[50] A decade later, the psychiatrists Thomas Holmes and Richard Rahe developed the influential Social Readjustment Rating Scale to study the effects of disruptive "life events" on overall health. The scale assigned a numerical value to events that required "a significant change in the life pattern of the individual" insofar as they constituted deviations – positive as well as negative – from "the existing steady state." Among the events included in the scale were marriage, death of a spouse, major changes in eating habits, and foreclosure on a mortgage or loan.[51] Typical of the post-war period and the burgeoning science of stress, Holmes and Rahe's work showed a concern with not just physiological homeostasis but also social stability.[52]

By the late 1970s, however, the negative health effects of major life events were increasingly called into question on empirical grounds, and stress researchers turned their attention to the cumulative impact of minor stresses – "daily hassles," as they were called. Particularly the work of the psychologist Richard Lazarus, who had co-developed the Daily Hassles and Uplifts Scale, would anchor the study of stress more firmly in the field of experimental psychology. Lazarus's transactional theory of stress emphasized the roles of the subjective assessments of external threats and personal coping styles. As a consequence, stress research became steadily less concerned with social and other "external" causes and more so with the role of the individual in mitigating the effects of potentially stressful situations.

In order to contextualize the growing clinical interest in trauma in the 1970s and the subsequent introduction of the PTSD diagnosis by the American Psychiatric Association in 1980, it is important to take into account these broader social and scientific developments. The influence that socially engaged therapists, especially those treating returning Vietnam War veterans, have had on the creation of this new diagnostic entity is well known, often celebrated as leading to a scientific breakthrough that was long overdue, and sometimes also viewed with suspicion as yet another triumph of politics over science in the field of psychiatry.[53] The urgency felt by clinicians, who struggled for the recognition of a condition they had observed in soldiers returning from Vietnam as well as in civilians, in victims of domestic abuse and other catastrophic experiences, becomes understandable in light of the

increasing marginalization of sociogenic explanations of mental suffering during the same period. After all, the third edition of the *Diagnostic and Statistical Manual of Mental Disorders* (*DSM-III*)[54] – psychiatry's 'bible,' in which PTSD was first codified – represented a significant shift away from the psychoanalytic orientation of previous manuals and towards the discipline's biomedicalization.[55]

Because of the individualistic focus that came with a reawakened biological psychiatry and the psychologization of stress, clinicians, who fought for the recognition of PTSD, maintained an ambivalent relationship to both. Not only had the focus of stress researchers begun to shift towards minor daily stressors and individual coping mechanisms; as a scientific construct, stress remained too indiscriminate and morally ambiguous. For instance, in the collected volume *The Trauma of War: Stress and Recovery in Viet Nam Veterans* from 1985, the psychologist Ghislaine Boulanger denounced the failure of earlier generations of stress researchers to acknowledge the fundamental difference between the experience of trauma and the more benign stresses experienced by many over the course of their lives:

> It seems almost illogical to argue that experiences such as beginning college or starting a new job [...] can be equated in type if not in magnitude with the experience of combat. But this is the argument being advanced by these authors. Indeed, carried to its illogical conclusion [...] this point of view denies the relevance of the trauma and does considerable disservice to those who have been exposed to life-threatening experiences.[56]

Boulanger, in other words, insisted on the existence of a discontinuity between mildly stressful experiences, surmountable life challenges, on the one hand, and traumatic stress, on the other. Upholding this difference is necessary for both methodological and moral reasons. If traumatic stress could be placed at the end of a continuum ranging from mild to severe forms of stress, the study of trauma did not necessarily warrant a separate field of study; and since individuals can mostly be expected to adapt to stress, conceiving of trauma as its most severe form would entail questions about the individual's role in also shaping these types of stress experiences. Questions concerning personal responsibility and, hence, the possibility that trauma victims might be blamed for not being able to cope, seemed not too far off. Indeed, prior to the introduction of the PTSD diagnosis, victim-blaming was the norm rather than the exception. For the most part of the twentieth century, psychiatrists had looked at a patient's weak constitution, his or her history prior to the traumatic event, or the allegedly perverse incentives of the pension system for what

ultimately *caused* the pathological reaction to trauma. Gaining status as victims had been a hard-fought win for patients and the therapists advocating on their behalf.[57]

Under the new paradigm, 'normal' individuals could also succumb to trauma.[58] For normal individuals to become vulnerable, however, the pathogenic experience had to be categorized as 'abnormal' and dissociated from 'normal' experience. Indeed, in 1987, the DSM defined trauma as an "event outside the range of usual human experience."[59] (In 1980, it had required that an event causes "significant symptoms of distress in almost anyone" to qualify as traumatic.)[60] Later definitions, however, were forced to change the defining criteria yet again, as epidemiological studies showed that traumatic stressors were altogether not that unusual, that is, were 'normal' in a statistical sense. Moreover, subsequent studies also showed that not all who experience trauma succumb to its effects. These empirical findings and, as the Harvard psychologist Richard McNally has termed it, the continuing "bracket creep" in the definition of trauma threaten to undermine the idea of a discontinuity between 'normal' and traumatic stressors. [61]

Most profoundly and lastingly, the unique characteristics that clinicians ascribed to memories stemming from traumatic events ensured that traumatic stress could be seen and treated as distinct from normal stress.[62] Yet the sciences of memory did not always prove to be a dependable resource, as researchers still debate the validity of so-called dual representation theories. Also, PTSD with a delayed onset, which was observed in many Vietnam veterans, who often only showed symptoms after they had returned home, has been found to be rather uncommon, with some researchers even doubting its existence.[63] After the scandals and controversies surrounding recovered memories in the 1990s, repressed memories of trauma are now rarely the focus of treatment in cases of PTSD. Traumatic memories may be incoherent, and victims may try to avoid them, as McNally summed up the state of research in his 2003 book *Remembering Trauma*, yet trauma can be and often is remembered.[64] Generally, with the advent of cognitive-behavioral therapies and the decline of psychoanalysis and other dynamic treatment approaches, the practice of delving deeply into the patient's past is becoming scarce. The methods and methodologies employed in the contemporary study of traumatic stress have furthermore weakened the link between the severity, the specific nature of the traumatic experience and its sequalae. The clinical case history still contained second-hand accounts of traumatic experiences, rendering the unique perspectives of those who had been traumatized and of those treating them epistemically significant. Details of the personal and social circumstances surrounding trauma

rarely emerge in a field that has come to rely more on aggregated and population-level data. And a recent epidemiological study found that events that do not qualify as traumatic nevertheless produced symptoms of PTSD, suggesting that "PTSD may be an aberrantly severe but nonspecific stress response syndrome."[65]

In her widely read 1992 book *Trauma and Recovery*, the Harvard psychiatrist Judith Herman thus remained sceptical of the advances made in the study of post-traumatic stress. The investigation and treatment of trauma, she argued, requires empathy, rather than the unbiased, uninvolved stance of the researcher. Without the broader political support of a social movement sympathetic to the victims' claims, she argued, "the possibility of authentic understanding is inevitably lost."[66]

Herman's anti-positivist instincts, however, are not always shared by grass-roots social activists, humanitarian aid advocates, and other members of civil society, who are more than willing to draw on the growing knowledge base about the health consequences of traumatic experiences furnished by epidemiology and clinical research to further their causes.[67] To turn public attention to social injustices and to argue for the right for compensation, the science of post-traumatic suffering has provided activists with new argumentative resources.

Drawing on stress research to support political causes does pose its own moral risks, however. To tie moral and political demands to scientific claims may unduly constrain what can be demanded and whose voices are heard. Some individuals' reactions to violence may differ from the syndromes conceived by diagnosticians; and not all social causes can be related to the experience of trauma or other types of personal damage. If victimhood is solely understood in terms of what can be scientifically described as a universal human reaction to traumatic stress, then "trauma effectively chooses its victims," as Didier Fassin and Richard Rechtman have succinctly put it.[68] Condemning social injustices on the grounds that they have caused post-traumatic stress cannot function as a substitute for political or moral deliberations that engage with the social conditions that produce them. Trauma, conceived as 'abnormal' experience, is easily identified as the culprit, whereas the sadly all-too-often 'normal' social conditions that lead to trauma and shape its experience are more difficult to grasp and assess.

Conclusion

Ironically, the concept of trauma, which Adorno once fathomed as irreconcilable with a scientistic outlook, has been enthusiastically embraced by the medical and psychological sciences. It is not altogether surprising

that the trauma concept has gained traction, even at a time when bio-medical explanations of mental suffering have become dominant. Be-cause traumatic stressors, in most cases, constitute identifiable events, which are uniformly perceived, they are easily tractable to quantitative research methods. While this positivist conception of trauma is clearly at odds with how the notion was invoked by Adorno in his epistemological critique of the human sciences, it is more easily reconciled with pro-gressivist ideas about the improvement of the human condition through informed collective action.

Both perspectives, I have attempted to show, rely on the notion of trauma as constituting a breach, a discontinuity. Epistemological critique sees in trauma a discontinuity of experience *as such*, however, while the clinical sciences have come to associate trauma with a break in con-tinuous, *normal* experience. This has led to numerous contradictions between what the term came to represent in the humanities and how it is used in the medical and psychological sciences. However, as the history retraced here also shows, both initially shared a social-critical impetus.

Yet social criticism can take on different forms. No longer is societal 'normality' (or its ideal) deemed traumatic, or in some other sense path-ogenic. Instead, when social critics point to human suffering caused by trauma today, they maintain that traumatic experiences are abnormal, an aberration, and that they could have been avoided. This corresponds to the scientific and many clinical approaches to traumatization, which rest on the conviction that one's environment is, in principle, controlla-ble and that human suffering can be remedied by technical means.

To be sure, there have been attempts to reconcile the critical-epis-temological perspective with the socio-critical one often espoused by clinicians. Herman's plea for "authentic understanding" carried by em-pathy and social activism can be read as such an attempt,[69] although it remains questionable whether Herman's clinical approach could be reconciled with, for example, Caruth's attempt to theorize trauma in terms of a simultaneous crisis of representation, truth, and temporal-ity. However, both argue that there exist privileged forms of knowing that may unearth a truth about trauma that is – inherently and often deliberately – obscured. Still, being a clinician, Herman not only envi-sioned the possibility of "authentic understanding" but also the possi-bility of recovery and healing, whereas many humanities scholars have rejected the possibility of coming to terms with one's traumatic past.[70] Thus, the spectre of integration, which had already been conjured by Adorno, also continues to haunt more recent theorizing of trauma in the humanities. Post-structuralist literary theorists have often maintained, as Anne Whitehead has written, an "anti-therapeutic stance."[71] Caruth, for

one, has argued that the "integration" of an elusive traumatic memory into narrative memory and representational knowledge inadvertently distorts its "truth" and weakens its impact.[72] Fortunately, victims who have been helped by their therapists will likely not regret no longer acting as a medium for a truth that can only be apprehended by academics trained in close reading but must remain elusive to themselves.

This radical commitment to being truthful – to the point where truth must be 'acted out' by another, a victim, to remain truthful – not only blinds itself to the fact that the trauma concept has co-evolved along conflicting trajectories; it must also ignore differences in how individuals react to trauma. The kind of trauma theory epitomized by Caruth has more recently been critiqued by a number of scholars, often historians who have shown the historical malleability of practices of remembering and expressions of suffering.[73]

Narrating trauma clearly poses its challenges. These challenges may be countless and are not always alike, however. The struggles victims may experience as they attempt to tell their stories and make them heard differ from the quite diverse set of representational challenges faced by literary scholars, historiographers, or traumatic stress researchers. Moreover, such difficulties, even if they are not always overcome, do not necessarily point to a crisis, nor to the impossibility of representation.

What does the discontinuity of experience that psychological trauma has come to represent to several disciplines for various purposes indicate if not a crisis of representation? The historical episodes discussed here underscore the centrality of moral concerns for both scientific and non-scientific understandings of trauma. Trauma has come to designate those circumstances that we, as compassionate listeners, are not willing to *accept* as 'normal.' But since a transgression of that which is 'normal' is not necessarily a *moral* transgression, we may find ourselves questioning the validity of trauma's moral plea. The boundary between 'normal' and 'abnormal' experience, in other words, not only delimits the morally unacceptable, but also designates whose suffering is justified. The perhaps never-ending struggle to define trauma, to limit the number of situations that can be deemed traumatic, is first and foremost an indication of the deep-rooted concern that the concept's moral authority could be undermined. But scientific knowledge alone cannot and should not determine which transgressions one is not willing to accept, nor what social remedies we should hope for.

Rather than theorize 'trauma' in ways that sever it from lived experience, scholars in the humanities should turn their attention to the many languages through which traumatic experiences become articulated and palpable. Because of the individualistic focus and socially decontextualizing methods of the contemporary study of traumatic stress, the

humanities have an important role to play alongside the social sciences when it comes to elucidating the social, cultural, and material conditions that give rise to trauma as well as shape its experience and societal consequences.

NOTES

1 An important exception is Roger Luckhurst's *The Trauma Question* (London: Routledge, 2008).
2 See, for example, Chris Brewin, *Posttraumatic Stress Disorder: Malady or Myth?* (New Haven: Yale University Press, 2003); Ruth Leys, *Trauma: A Genealogy* (Chicago: University of Chicago Press, 2000). One of the most outspoken critics of the theoretical trauma discourse in the humanities has been Wulf Kansteiner, "Genealogy of a Category Mistake: A Critical Intellectual History of the Cultural Trauma Metaphor," *Rethinking History* 8, no. 2 (2004): 193–221, https://doi.org/10.1080/13642520410001683905.
3 See, for example, the interdisciplinary dialogues in Cathy Caruth, *Listening to Trauma: Conversations with Leaders in the Theory and Treatment of Catastrophic Experience* (Baltimore: Johns Hopkins University Press, 2014).
4 Other intellectual traditions besides the Frankfurt School can be more easily tied to these recent developments through which trauma has become an important interpretative category in the humanities (see Luckhurst, *Trauma Question*, 5). However, Adorno's references to trauma in the context of his sociological writings have found little or no mention in existing genealogies of the once nascent field of 'trauma studies.' One notable exception is Harald Weilnböck, "Zur dissoziativen Intellektualität in der Nachkriegszeit: Historisch10-psychotraumatologische Überlegungen zu Metapher/ Metonymie und Assoziation/Dissoziation bei kritischen, neukonservativen und postmodernen Autoren," in *Verletzte Seelen: Möglichkeiten und Perspektiven einer historischen Traumaforschung*, ed. Günter H. Seidler and W.U. Eckart (Gießen: Psychosozial-Verlag, 2005), 125–203; see also my earlier attempt to explicate Adorno's understanding of trauma, on which the following sections are based, in Ulrich Koch, *Schockeffekte: Eine historische Epistemologie des Traumas* (Berlin: Diaphanes, 2014).
5 In sociology, "boundary objects" designate epistemic objects that prove to be useful for members of various disciplines and professions, often to varying ends, hence acquiring different meanings for different scientific communities; see Susan Leigh Star and James R. Griesemer, "Institutional Ecology, 'Translations' and Boundary Objects: Amateurs and Professionals in Berkeley's Museum of Vertebrate Zoology, 1907–39," *Social Studies of Science* 19, no. 3 (1989): 387–420.

6 Theodor W. Adorno, "Die revidierte Psychoanalyse," in *Gesammelte Schriften: Soziologische Schriften I* (Frankfurt am Main: Suhrkamp, 1990), 23, my translation.

7 See, for example, the aphorisms "Die Gesundheit zum Tode; Diesseits des Lustprinzips; Aufforderung zum Tanz; Ich ist Es; Immer davon reden, nie daran denken" in Theodor W. Adorno, *Gesammelte Schriften, Vol. 4: Minima Moralia* (Frankfurt am Main: Suhrkamp, 1997).

8 The psychoanalytic establishment of the post-war era, it must be noted, did not become known for harbouring social critical views and encouraging dissent among their clientele – quite the opposite. Also, many of the points raised by Adorno would be reiterated by Herbert Marcuse in a critical exchange he had with Erich Fromm in the 1950s, the so-called culturalism-revisionism debate, published in the Journal *Dissent*. See also Ulrich Koch, "'Cruel to Be Kind?' Professionalization, Politics and the Image of the Abstinent Psychoanalyst, c. 1940–80," *History of the Human Sciences* 30, no. 2 (2017): 88–106, https://doi.org/10.1177%2F0952695116687239.

9 See Jamie Cohen-Cole, *The Open Mind: Cold War Politics and the Sciences of Human Nature* (Chicago: University of Chicago Press, 2014).

10 Theodor W. Adorno, Else Frenkel-Brunswik, Daniel J. Levinson, and R. Nevitt Sanford, *The Authoritarian Personality* (New York: Harper, 1950).

11 Michael E. Staub, *Madness Is Civilization: When the Diagnosis Was Social, 1948–1980* (Chicago: University of Chicago Press, 2011), 28.

12 Theodor W. Adorno, "Zum Verhältnis von Soziologie und Psychologie," in *Gesammelte Schriften: Soziologische Schriften I* (Frankfurt am Main: Suhrkamp, 1990), 45, my translation.

13 Ibid., 65, my translation.

14 Adorno, "Revidierte Psychoanalyse," 23–4, my translation.

15 Martin Jay, *The Dialectical Imagination* (Berkeley: University of California Press, 1996 [1973]), 104.

16 Adorno, "Soziologie und Psychologie," 52, my translation.

17 Ibid., 65, my translation and emphasis.

18 Ibid., my translation.

19 Ibid., 61, my translation and emphasis.

20 See also Jay, *Dialectical Imagination*, 104.

21 Adorno, *Minima Moralia*, 60.

22 See Kansteiner, "Genealogy," as well as Luckhurst, *Trauma Question,* introduction.

23 Theodor W. Adorno, *Negative Dialectics* (London: Routledge, 1973), 362; quoted in Luckhurst, *Trauma Question*, 5.

24 See, e.g., Giorgio Agamben, *Remnants of Auschwitz* (New York: Zone Books, 1999); Jean-François Lyotard, *The Differend: Phrases in Dispute* (Manchester: Manchester University Press, 1988).

25 Jean-François Lyotard, *Heidegger and "The Jews"* (Minneapolis: University of Minnesota Press, 1990).

26 Slavoj Žižek, *The Sublime Object of Ideology* (London: Verso, 1989).

27 See Dominick LaCapra, *Writing History, Writing Trauma* (Baltimore: Johns Hopkins University Press, 2014).

28 Theodor W. Adorno, *Aesthetic Theory*, trans. Robert Hullot-Kenter (London: Athlone, 1997), 23.

29 Ibid., 13.

30 Ibid., 136.

31 Rolf Wiggershaus, *Theodor W. Adorno* (Munich: C.H. Beck, 2006), 127.

32 As Wulf Kansteiner has pointed out, Lyotard's theory of "the sublime" follows the same trajectory, since also he "seeks vestiges of authentic non-identity in the realm of aesthetics" ("Genealogy," 201).

33 Adorno, *Minima Moralia*, 73.

34 See, e.g., the contributions in Inka Mülder-Bach, ed., *Trauma und Modernität: Beiträge zum Zeitenbruch des Ersten Weltkrieges* (Vienna: Universitätsverlag, 2000); also, Ulrich Baer, "Modernism and Trauma," in *Modernism*, ed. Astradur Eysteinsson and Vivian Liska (Philadelphia: John Benjamins, 2007), 307–18.

35 Walter Benjamin, "Über einige Motive bei Baudelaire [1939]," in *Medienästhetische Schriften* (Frankfurt am Main: Suhrkamp), 39.

36 Walter Benjamin, "The Work of Art in the Age of Mechanical Reproduction," in *Illuminations*, ed. Hannah Arendt (New York: Schocken, 1969), 26.

37 Benjamin, "Mechanical Reproduction," 16.

38 Cf. Bernd Kiefer, "Aufmerksamkeit und Zerstreuung der Wahrnehmung mit/nach Walter Benjamin" in *Bildtheorie und Film*, ed. Thomas Koebner and Thomas Maeder (Munich: edition text+kritik, 2006), 221–38.

39 In his essay "The Storyteller," Benjamin warned of seeing in the decline of the cultural practice of storytelling, which draws from the well of a collective, communicable experience, a "symptom of decay." Benjamin, "Der Erzähler," in *Erzählen: Schriften zur Theorie der Narration und literarischen Prosa* (Frankfurt am Main: Suhrkamp, 2007), 103–28. On the distinction between *Erlebnis* and *Erfahrung* in Benjamin's writings see also Thomas Elsaesser, "Between *Erlebnis* and *Erfahrung*: Cinema Experience with Benjamin," *Paragraph* 32, no. 3 (2009): 292–312, https://doi.org/10.3366/E0264833409000625.

40 Theodor W. Adorno, *Walter Benjamin, Briefwechsel 1928–1940*, ed. Henri Lonitz (Frankfurt am Main: Suhrkamp, 1994), 193.

41 Benjamin, "Erzähler."

42 Adorno, *Minima Moralia*, 62.

43 Ibid., 66.

44 See Ulrich Koch, "The Uses of Trauma in Experiment: Traumatic Stress and the History of Experimental Neurosis, c. 1925–1975," *Science in Context* 32, no. 3 (2019): 327–351, https://doi.org/10.1017/S0269889719000279.

45 See Staub, *Madness Is Civilization*.

46 See also ibid., chap. 1.

47 William C. Menninger and Munro Leaf, *You and Psychiatry* (New York: Scribner's Sons, 1948), 135; quoted in Staub, *Madness Is Civilization*, 23.

48 Roy Grinker and John Spiegel, *Men Under Stress* (Philadelphia: Blakiston, 1945), ix.

49 My use of the term 'normalize' here is based on that of Jürgen Link, *Versuch über den Normalismus: Wie Normalität produziert wird* (Göttingen: Vandenhoeck & Ruprecht, 2009).

50 See Mark Jackson, *The Age of Stress: Science and the Search for Stability* (Oxford: Oxford University Press, 2013).

51 Thomas H. Holmes and Richard H. Rahe, "The Social Readjustment Rating Scale," *Journal of Psychosomatic Research* 11, no. 2 (1967): 217.

52 See Jackson, *The Age of Stress*.

53 See, for example, Wilbur J. Scott, "PTSD in DSM-III: A Case in the Politics of Diagnosis and Disease," *Social Problems* 37, no. 3 (1990): 294–310, https://doi.org/10.2307/800744; as well as Allan Young, *Harmony of Illusions: Inventing Post-Traumatic Stress Disorder* (Princeton: Princeton University Press, 1997). For the clinical and experimental groundwork that laid the foundation for the PTSD diagnosis see, among others, Robert J. Lifton, *Testimony on Oversight of Medical Care of Veterans Wounded in Vietnam. Hearings before the Subcommittee on Veterans' Affairs of the Committee on Labor and Public Welfare*, United States Senate (Washington, DC: US Government Printing Office, 1970), 491–510; Chaim F. Shatan, "The Grief of Soldiers: Vietnam Combat Veterans' Self-Help Movement," *American Journal of Orthopsychiatry* 43, no. 4 (1973): 640, https://doi.org/10.1111/j.1939-0025.1973.tb00834.x; Sarah A. Haley "When the Patient Reports Atrocities: Specific Treatment Considerations of the Vietnam Veteran," *Archives of General Psychiatry* 30, no. 2 (1974): 191–6; https://psycnet.apa.org/doi/10.1001/archpsyc.1974.01760080051008; Mardi J. Horowitz and George F. Solomon. "A Prediction of Delayed Stress Response Syndromes in Vietnam Veterans," *Journal of Social Issues* 31, no. 4 (1975): 67–80, https://doi.org/10.1111/j.1540-4560.1975.tb01012.x; Mardi J. Horowitz, Nancy Wilner, and Nancy Kaltreider, "Signs and Symptoms of Posttraumatic Stress Disorder," *Archives of General Psychiatry* 37, no. 1 (1980): 85–92, https://psycnet.apa.org/doi/10.1001/archpsyc.1980.01780140087010.

54 American Psychiatric Association, *Diagnostic and Statistical Manual of Mental Disorders*, 3rd ed. (Washington, DC: APA, 1980).

55 See also Hannah S. Decker, *The Making of DSM-III: A Diagnostic Manual's Conquest of American Psychiatry* (Oxford: Oxford University Press, 2013).

56 Ghislaine Boulanger, "Post-Traumatic Stress Disorder: An Old Problem with a New Name," in *The Trauma of War: Stress and Recovery in Viet Nam Veterans*, ed. Stephen M. Sonnenberg, A.S. Blank, and J.A. Talbott (Washington, DC: American Psychiatric Press, 1985), 18.

57 See Young, *Harmony of Illusions;* Paul Lerner, *Hysterical Men: War, Psychiatry and the Politics of Trauma in Germany, 1890–1930* (New York: Cornell University Press, 2003); Julia Barbara Köhne, *Kriegshysteriker: Strategische Bilder und mediale Techniken militärpsychiatrischen Wissens, 1914–1920* (Husum: Matthiesen, 2009); Stefanie Neuner, *Die staatliche Versorgung psychisch Kriegsbeschädigter nach dem Ersten Weltkrieg in Deutschland, 1920–1939* (Göttingen: Vandenhoeck & Ruprecht, 2011); Hans-Georg Hofer, Cay-Ruediger Pruell, and Wolfgang Eckhart, eds., *War Trauma and Medicine in Germany and Central Europe, 1914–1939* (Herbolzheim: Centaurus, 2011). For discussion of the moral questions raised here see Ulrich Koch, "Preparing for the Unthinkable? The Prevention of Posttraumatic Stress and the Limits of Positive Psychology," in *Developments in Neuroethics and Bioethics*, vol. 2., ed. Kelso Cratsley and Jennifer Radden (London: Elsevier Academic Press, 2019), 211–33.

58 See Edgar Jones and Simon Wessely, "A Paradigm Shift in the Conceptualization of Psychological Trauma in the 20th Century," *Journal of Anxiety Disorders* 21, no. 2 (2007): 164–75.

59 American Psychiatric Association, *Diagnostic and Statistical Manual of Mental Disorders*, 3rd rev. ed. (Washington, DC: APA, 1987), 247.

60 APA, *DSM-III*, 3rd ed., 238

61 Richard J. McNally, "Progress and Controversy in the Study of Posttraumatic Stress Disorder," *Annual Review of Psychology* 54, no. 1 (2003): 229–52, https://doi.org/10.1146/annurev.psych.54.101601.145112.

62 On the history of traumatic remembering see especially Young, *Harmony of Illusions;* Ian Hacking, "Memoro-politics, Trauma and the Soul," *History of the Human Sciences* 7, no. 2 (1994): 29–52, https://doi.org/10.1177 %2F095269519400700203; Hacking, *Rewriting the Soul: Multiple Personality and the Sciences of Memory* (Princeton: Princeton University Press, 1998); Leys, *Trauma.*

63 See, for example, Bernice Andrews, Chris R. Brewin, Rosanna Philpott, and Lorna Stewart, "Delayed-Onset Posttraumatic Stress Disorder: A Systematic Review of the Evidence," *American Journal of Psychiatry* 164, no. 9 (2007): 1319–26, https://doi.org/10.1176/appi.ajp.2007.06091491.

64 Richard J. McNally, *Remembering Trauma* (Cambridge, MA: Harvard University Press, 2005).

65 Andrea Roberts, Bruce Dohrenwend, Allison Aiello, Rosalind Wright, Andreas Maercker, Sandro Galea, and Karestan Koenen, "The Stressor Criterion for Posttraumatic Stress Disorder: Does It Matter?" *Journal of Clinical Psychiatry* 73, no. 2 (2012): 264, https://doi.org/10.4088/JCP.11m07054.

66 Judith Herman, *Trauma and Recovery* (New York: Basic Books, 1997), 240.

67 For illustrations of the different ways in which the concept has been appropriated by social movements and in humanitarian aid contexts, see Didier

Fassin and Richard Rechtman, *The Empire of Trauma: An Inquiry into the Condition of Victimhood* (Princeton: Princeton University Press, 2009).

68 Ibid., 282.

69 See also Caruth, *Listening to Trauma.*

70 Cf. Christa Schönfelder, *Wounds and Words: Childhood and Family Trauma in Romantic and Postmodern Fiction* (Bielefeld: Transcript, 2013), chap. 1.

71 Anne Whitehead, *Memory* (London: Routledge, 2009), 117.

72 Cathy Caruth, "Recapturing the Past: Introduction," in *Trauma: Explorations in Memory* (Baltimore: Johns Hopkins University Press, 1995), 153.

73 See, for example, Leys, *Trauma;* Jacques Rancière, "Über das Undarstellbare," in *Politik der Bilder* (Zurich: Diaphanes, 2005); 127–60, Jean-Luc Nancy, *Am Grund der Bilder* (Zurich: Diaphanes 2006); Kansteiner, "Genealogy."

11 The New Normal: Trauma as Successfully Failed Communication in *Nurse Betty* (2000)

THOMAS ELSAESSER

This chapter raises a question, first posed by Sigmund Freud,[1] but also by Walter Benjamin,[2] namely in what sense and under what conditions can trauma be the "solution," rather than the "problem"? It would have to be the solution to a problem not yet fully identified or, at the very least, in need of being redefined. Such a redefinition is my aim, asking whether there might be objective, historical circumstances that make being traumatized, that is, living with post-traumatic symptoms, 'the new normal,' so that the usual forms of therapy, such as acting out, working through, or narratively integrating the traumatic event, merely misrecognize the conditions under which trauma may now occur, and what might be its purpose for the organism thus affected (and not only 'afflicted'). Such a definition could lead to the surprising and thoroughly counter-intuitive possibility that trauma, rather than harm or hinder, may actually benefit the victim.

How do I arrive at entertaining such a possibility? The thought occurred to me after a second look at *Nurse Betty* (dir. Neil LaBute, USA/ GER 2000), a critically acclaimed and moderately successful Hollywood film starring Renée Zellweger and Morgan Freeman. As often as it was praised, it was also dismissed as lightweight and silly for either irresponsibly endorsing its airhead heroine's addiction to TV soap operas or cruelly mocking her naive if persistent credulity. The ambivalence is nicely caught in a caption review for the film: "what happens when a person decides that life is merely a state of mind? If you're Betty, a small-town waitress from Kansas, you refuse to believe that you can't be with the love of your life just because he doesn't really exist. After all, life is no excuse for not living."[3]

The ironic-sarcastic tone reflects the fact that in *Nurse Betty*, the consequences of trauma are strangely enabling and empowering. One hypothesis would be that trauma, in the form of a post-traumatic state of

mind, now functions as a 'black box.' That is, when invoked in contemporary media, such as on television shows, where it is frequently signalled by amnesia, it provides a 'missing link' in motivation (covering a gap in narrative logic, or a character's being written out of the series) without actually explaining anything. Similarly, when trauma appears in films as either background information (*Mystic River*, USA 2003; *The Silence of the Lambs*, USA 1991), in order to motivate a character's personality (the 1989 *Batman* franchise, to name one prominent example), or as the trigger for a character's actions (as in the case of *Nurse Betty*), it also can become a black box of a more general kind. For instance, it can point to a crisis in what we understand as personal experience, and by extension, 'trauma' connotes ambivalence regarding the sites, sources, and elements of personal identity. In this sense, the signifier 'trauma' highlights one of the roles that popular media – possibly substituting or supplementing religion – now tend to fulfil: to present personal experience and social reality as *meaningful*, which is to say, to narratively process everyday lives and extraordinary events, not so much as these occur or are reported in the news, but as lives and misfortune are depicted in the melodrama genres of soap opera and other television series, as enacted in talk shows, or as they furnish the subjects and topics for reality TV. In each genre, but also in mainstream cinema, including franchise and blockbuster films, such meaningfulness is increasingly both connoted (suggested or implied) and denoted (directly referenced) by a traumatic incident, which has to stand for an otherwise inaccessible source or unknown origin.

Needless to say, this work of black box meaning-making-without-making-sense in the popular media takes place against the background of the self-same personal and social reality being experienced as random, contingent, unpredictable, empty. Trauma, by contrast and by definition, is deemed to be significant: which is why it can be deployed as a special category of potentially momentous experience. As such, it brings with it some of the philosophical baggage that the term 'experience' has acquired over the course of the twentieth century, during what we usually refer to as 'modernity': in German *Lebensphilosophie*, in Walter Benjamin's distinction between *Erfahrung* and *Erlebnis*, but also in phenomenology, feminist film studies, the affective turn, and in the political-economic category of the 'experience economy.'[4] In several of these contexts, trauma would stand first and foremost for 'failed experience,' that is, non-integrated and non-assimilated experience, but – this will be part of my argument – the formal or aesthetic significance of this apparent 'failure' has not always been fully recognized or appreciated. For instance, the most visible external index of this potentially traumatic non-integration manifests itself in a feature much prized by audiences of

cable television in the 1980s and 1990s, and the hallmark of the high-end television output of streaming services, such as Netflix: the open-ended, addictive character of soaps and series, feeding on a repetition compulsion that always promises closure and always frustrates the desire for it.

In other words, it seems the occurrence of 'trauma' in the popular media is especially effective when highlighting the gap between media reality and an individual's lifeworld reality, insofar as trauma symbolizes different kinds of rupture, but 'fills' them negatively, by an absence that also serves as a punctuation mark. Such a notion of trauma as both an aspect of lived experience and an element in a formal semiotic system means that trauma translates a certain type of experience into a new meaning system whose key has been lost, has not yet been found, or at any rate is no longer or not yet accessible to the subject concerned.

In this sense, trauma does not necessarily have to refer to an actual event, such as the one that occurs in the story world of *Nurse Betty* and triggers the subsequent action: trauma could be something like a placeholder category in the reality discourse of the media, pointing to the inevitable failure of experience to be meaningful. It may be why 'trauma' can paradoxically acquire both the status of a cause and the force of an explanation. The logic would be that of the old joke of the drunk, who loses his house key on the way home and looks for it under the lamp post. Asked by a helpful policeman if he was sure to have lost it there, he answers, "Of course not – but here at least there is better light."[5] The joke aptly illustrates the efficacy of trauma as a placeholder (the lamp post), for a non-integrated experience or an unsuccessful mediation (the house key), by fusing two sites that are strictly separate: the site of origin ('losing') and the site of explanation ('finding'). Trauma, as constitutively non-integrated or failed experience, points backwards to a past event, but by the very fact of being non-integrated, also potentially cuts loose from this past, thereby freeing energies that are directed towards a differently meaningful future.

Given these considerations, I understand this chapter as also a contribution to the question of why the idea of trauma today seems to play such an important role in media studies and in the humanities: it offers a way out of an otherwise intractable dilemma of how the arts, humanities, and social sciences can still make sense of the contemporary world. Secondly, the fact that trauma has become such a popular topic also means that we now not only have one trauma theory, but even several, partly competing, trauma theories.[6] Thirdly, with the pervasiveness of the concept of trauma, we may have left behind a certain approach to 'working through' as applied to both life and literature. That is to say: could it be that the classic therapeutic or Aristotelian theories of drama

and narrative have given way to another model, which it would be wrong to describe as 'Brechtian,' but which works more like 'homeopathy' or as a pharmakon, with antibodies of the same substance fighting the debilitating effects of trauma? One of these antibodies is repetition, addiction or paratactic sequencing (as indicated above), while another one – the one that interests me here – is a special kind of non-integration and disconnect, which I call 'parapractic.' It manifests itself by way of 'successfully performed failure' (parapractic being the English translation of Freud's *Fehlleistung*, failed performance/ performed failure), which – in the case of *Nurse Betty* – tends to take the form of 'successfully failed communication.'

For a long time, the leading trauma theory has been the version made popular by Cathy Caruth in the 1990s, when she drew on Sigmund Freud's writings *Beyond the Pleasure Principle* (1920) and another meta-psychological study, *Moses and Monotheism* (1938). Partly inspired by Paul de Man's deconstructionist literary theory, Caruth, in *Unclaimed Experience: Trauma, Narrative and History* (1996), as well as in another collection edited by her entitled *Trauma: Explorations in Memory* (1998), deals with historical traumas, such as the Holocaust or Hiroshima, treating them as 'texts,' requiring a particular hermeneutics. Their afterlife is manifest in the many discourses on the crisis of representation and in the postmodern concept of history. In a century as fractured by moral catastrophes and political violence as the last one, the traditional historical categories of linearity, causality, and narrative telos must fail – a sentiment or argument we also find expressed in the writings of Hayden White and other philosophers of history such as Jean François Lyotard or Reinhart Koselleck.

Thus, the past no longer coheres or consolidates into history: the so-called after-history ("*posthistoire*"), according to which nothing new can happen anymore, is, following Caruth, better understood with the concept of trauma, which would then be something like 'failed history' – at once close to the "postmodern condition" and yet also quite different.[7] Confronting the problem of unrepresentability and the unspeakable in the testimonies of survivors, Caruth's theory of trauma seeks to develop a performative theory of language and hermeneutics, according to which it must be possible to arrive at a new concept of history that is taking hold whenever discourse seems to be cut off from the plane of reference.

If 'history' (as a past with consequences) only emerges when there is no predetermined course or goal, then history becomes history precisely at those points where reality manifests itself in the form of trauma: in the face of natural or human-made disasters and unexpected coincidences or improbable parallels in events, personal and social reality appears as 'text,' demanding to be 'read,' because manifesting the kind

of stylistic figures or tropes familiar from rhetoric: hyperbole, chiasmus, zeugma, non sequitur, paradox – and, I would add, parapraxis, the 'Freudian slip.' This would be the performative aspect of trauma, to which one might have to add the peculiar tense of 'deferred action' (also typical of trauma), that is, the apparent reversal of cause and effect, of 'before' and 'after,' and ultimately of latency, according to which the processes of transmission or transition are no longer straightforward but either abrupt or hidden, either sudden or protracted – also between the generations, the sexes, and in the asymmetrical power relations of a postcolonial world.

Caruth's model of trauma theory does not put the emphasis on repression ("return of the repressed") but on the body and language.[8] Arguing for the mutually conditioned and interdependent relationship of the (invisible) wound and the (inaudible) voice, Caruth not only gives the (female) voice a special meaning in the trauma theory. She also develops a theory of witnessing, which takes traumatic relationships into the intersubjective realm, including into the discussion of trauma the question of identification, over-identification, and transference.

A critique of Caruth's trauma theory has been offered by Susannah Radstone.[9] She cautions that the concept of trauma as a 'language of the body' should not be transferred too directly to historical and social reality, since the danger is for trauma to attain a kind of metaphorical universality, which is then applied literally to a person's life story. And it is true that trauma theory has become an important but double-edged weapon in the arsenal of identity politics and the so-called memory wars, where the invisibility of the wound can be invoked as the very sign of oppression, and the inaudibility of the voice as eloquent testimony to forcible silencing.[10]

Radstone's own trauma theory changes Caruth's psychoanalytically oriented hermeneutics in order to intervene strategically in the body-politics of (gendered) identity by assigning a central role to the concept of fantasy, less in the sense of orthodox Freudian theory, as for instance, in the problematic 'seduction fantasy' of sexual abuse by family authority figures, but by examining the place of fantasy in the mediation of social and historical experience. She develops a theory of the subject, and by extension, of the spectator-observer, not based on desire and its constitutive origin in 'lack' (the Freud-Lacanian route of castration anxiety), but centred on memory and its – politically undetermined yet patriarchal dominated – gaps, absences, and unmarked traces. In its most polemical form, this trauma theory would be a charter for victimhood and the politics of blame, in which various ethnic minorities, gender activists, or sexual preference groups stake claims and demand rights from society,

the state, or the privileged elite: sometimes in solidarity with each other, but on occasion also competing against each other.[11] Radstone analyses why there has been such a resurgence of victim-culture, relating it to the fact that authority and power structures have become increasingly ungraspable as well as to a corresponding inability to tolerate internal conflict or cognitive dissonance. My reading of *Nurse Betty* will reflect some of Radstone's concerns.

By reviving the concept of fantasy in connection with trauma theory Radstone is trying to redefine the theoretical and political ground about the status of fantasy, which was once thought of as the motor of political action – the May '68 slogan of *L'imagination au pouvoir* – but is now more often blamed as the engine that drives consumerism, without giving up referentiality (as does deconstruction, or when fantasy is opposed to reality). On her account, the scope of trauma theory extends well beyond grappling with the aftermath of historical traumata, which suggests that its emergence in the humanities is a symptom for which the reasons may have to be sought elsewhere than in war and genocide alone. The juncture of fantasy and trauma (as opposed to fantasy and desire), and the slippage between fantasy and reality, but also between recall, (false) memory, and amnesia do point to a fractured relation between an inner psychic reality and outer public reality. Media and cinematic representations are filling the gap, but as I am arguing, they do so in the mode of performative failure or 'failed experience,' as another word for trauma, which brings me back to *Nurse Betty*.

Nurse Betty – Which Story, Which Genre

To briefly recapitulate the action of *Nurse Betty*: Betty Sizemore (Renée Zellweger), a waitress at a diner in the small Kansas town of Fair Oaks, is married to the abusive and shifty second-hand car dealer Del (Aaron Eckhart), but spends much of her time both at home and at work watching the daily television soap opera *A Reason to Love*. One day, unobserved and undetected, Betty is witness to two men identifying themselves as Charlie (Morgan Freeman) and Wesley (Chris Rock) entering the house, tying up her husband, and torturing and then brutally killing him, in pursuit of a shipment of drugs he had failed to deliver and tried to double-cross them with. The shock of the violent murder is such that Betty immediately represses the memory of the incident. Convinced that she is in fact a hospital nurse who was engaged to Dr. David Ravell (Greg Kinnear), a fictional character in *A Reason to Love*, she decides to leave town and drive to California in order to reunite with her ex-fiancé, taking

her late husband's car, unaware of the stolen drugs hidden in the trunk. Throughout her trip she is being tailed by the two hit men trying to recover what they consider theirs. In Los Angeles, Betty becomes involved with the soap opera's production team, who believe she is an aspiring actress pitching herself 'in character' for a part on the series, while one of her husband's killers is convinced she is a calculating "cold-blooded bitch" who has knowingly absconded with the stolen drugs. After a series of eventful encounters and violent confrontations, which, among other things, confirm her aptitude as a nurse and eventually eliminate the hit men, Betty's memory is restored thanks to another shock. Having been a sensation with her traumatic delusion, she is hired by the production to play the part of a nurse, while using her earnings to continue her studies to become a trained nurse.

As this summary indicates, *Nurse Betty* is an unusual film, sustained by a wildly implausible premise. Yet in feel and some of its plot twists it is also symptomatic and almost prototypical for a certain genre-hybrid that has emerged since the turn of the century: It shows affinity with films variously labelled puzzle films or mind-game films, such as *Pulp Fiction* (dir. Quentin Tarantino, USA 1995), with which it shares both cartoonish violence and a loquacious pair of gangsters; *Memento* (dir. Christopher Nolan, USA 1999), with which it shares an amnesiac central protagonist; *The Truman Show* (dir. Peter Weir, USA 1998), with which it shares the confusion of reality and make-believe; and *EDtv* (dir. Ron Howard, USA 1999), with which it shares the celebrity-driven milieu of reality television. Other films that come to mind are *The Purple Rose of Cairo* (dir. Woody Allen, USA 1985), *Being John Malkovich* (dir. Spike Jonze, USA 1999), and even the real-life confidence trickster comedy-drama *Catch Me If You Can* (dir. Steven Spielberg, USA 2002), while one explicitly named cinematic subtext is *The Wizard of Oz* (dir. Victor Fleming, USA 1939), with Betty at one point referred to as "Dorothy," and a more in-joke reference is to the Coen Brothers' *Fargo* (USA 1996), when Charlie says, "I see Betty as a Midwestern Stoic type. Ice water in her veins. A clear thinker. Probably a Swede or a Finn." In other words, *Nurse Betty* heightens its hybridity as a neo-noir black romantic comedy to the point where the pile-up of genre clichés and stereotypes becomes a clever collision of seemingly incongruous plot situations and character traits.[12] The clash can easily be read as mirroring the heroine's own mental state of splintered and multiple identities, which she does not seem to register as fragmented: an effect that transmits itself to the spectator, for whom the generic confusion, too, gradually merges into a more or less seamless fusion of kaleidoscopic but somehow fitting moments and incidents.

The Traumatic Incident: Trigger or Retroactive Confirmation

Central to the idea that *Nurse Betty* is about trauma and its consequences is the extremely violent scene, taking place early on in a domestic setting, and acting as the trigger to produce in Betty a form of amnesia described as 'dissociative fugue.'[13] As the local doctor explains: "She's in a kind of shock. I see all the signs of a post-traumatic reaction with possible dissociative symptoms. [...] It's a type of altered state [...,] it allows a traumatized person to continue functioning." Thus, the film specifically identifies Betty as "traumatized," which differs from other examples already cited, where a traumatic experience is either gradually revealed (*Memento, The Truman Show*) or merely implied (*Forrest Gump*, USA 1994, with whose idiot savant protagonist *Nurse Betty* has in common the *Zelig*-like blending into whichever setting she finds herself in).

The key scene of the murder is carefully set up. Before the two hit men turn up at Del's second-hand car lot, they get their breakfast at the diner where Betty works. She elegantly serves them coffee and second-guesses their preferences: to the astonishment of Charlie, who admires the skill she shows when pouring the coffee without as much as taking her eyes off the television set.[14] Later on, when Del, accompanied by Charlie and Wesley, enters the house, nobody knows that Betty is home, engrossed as she is in her bedroom watching *A Reason to Love* on tape. The noise from the kitchen draws her attention, she "quickly snaps out the light and closes the door until it is open only a crack," and then watches as if through a peephole or camera obscura the grisly scene of Del being interrogated, tortured, and then scalped. When Del is finally shot in the head, Betty turns away, hitting the rewind button on her VCR to catch the soap opera scene she just missed.[15] Later, when the local sheriff and a reporter arrive at the scene to investigate the crime, Betty does not seem to be put out by what she has witnessed. She calmly packs a suitcase to spend the night at one of her friend's house. In her mind, she has already become the character of the nurse in *A Reason to Love,* and in the middle of the night, she leaves the friend's home, gets into Del's Buick LeSabre, and takes to the road. Whatever her trauma, she acts like a winner, not a victim.

If we therefore have to assume that *Nurse Betty* is neither the case history of a mentally disturbed or psychologically damaged individual nor a satire on the dangers of watching too much television, but a film that uses Betty's 'altered state' as a probe, or thought experiment, then what is it that is being probed, what is the experiment about, and what becomes apparent by telling the story through this oblique angle of trauma? To put it in the terms indicated at the outset: is it possible that

Betty's 'condition' – in its apparently post-traumatic manifestations of dissociation, fugue, fantasy, and disavowal – is *the solution* to a trauma that precedes her husband's brutal murder? In which case, what problems – or violent incidents – preceding her trauma do the actions that Betty's trauma triggers bring to the fore?

An answer might come in two variants, apart from the most obvious one, namely that her marriage to Del was so traumatic that the violent manner of his death was indeed a liberation. Another kind of violence that Betty's post-traumatic behaviour highlights would be that in order to cope with contemporary (media-saturated, non-integrated, incomprehensible, dystopian) 'reality,' the more fluid and flexible a person is in negotiating what is real and what is imagined, what is true and what is false, what is authentic and what is performance, the more 'successfully adapted' and effective an actor (also in the sense of possessing agency) s/he can be. Alternatively: in order to cope with everyday reality, its boredom and routine, but also its disappointments, its unexpected contingencies and sudden catastrophes, the modern subject, in order to survive, needs to develop a 'dysfunctional functioning' personality, and acquire what I will call a 'productive pathology,' such as being an amnesiac who is also a schizophrenic. Betty is just such a ('Sizemore' – larger than life) survivor, with her fantasy of being a character in a soap opera as her tactically productive pathology.

Thus, the surface meaning of *Nurse Betty* would be that here is a woman who manages to 'cope' with her drab suburban life by learning systematically to split herself into two modes of existence: the fantasy-identification with the love life of characters in a soap opera and a grim reality life (marriage to Del, life as a waitress in small-town Kansas).[16] However, the one sustains the other in a delicate but liveable balance. Once the soap has become Betty's primary reality, the marriage is just a bad dream: this would be the status quo ante at the beginning of the film. She still knows the difference between the two worlds, which she navigates by a kind of division-of-labour schizophrenia, depicted in the film by having Betty watch television also at the diner, her work place, where the other waitresses happily play along with her addiction to *A Reason to Love*, for instance, giving her a life-size cardboard cut-out of Dr. Ravell for her birthday. Del, by contrast, ignores her birthday, in fact has sex with his secretary on the office couch while Betty is working her shift at the diner. The film leaves no doubt that Betty's day-to-day reality with Del is traumatic precisely to the extent that it obliges her to be in denial about the sheer awfulness of her situation in life. Del not only cheats on Betty, he in turn berates her and takes her for granted, and in every possible way behaves as a monstrously detestable husband. The thought of wishing

him dead must have crossed her mind more than once.[17] Being the sweet person that Betty is, having to suppress this thought is already part of her parlous state of mind, so that having her wish come true most probably also enters into the traumatic aspects of her situation and condition.

Under these circumstances, disavowal becomes a 'successful' coping strategy, making Betty's being in denial neither a sign of naivety nor a form of self-deception. Rather, her traumatic non-witnessing of Del's murder is like a retroactive confirmation of a prior intention, so that the 'dissociative fugue' that Del's gruesome death triggers is merely acting on the decision she wished she had taken earlier: to leave Del and hit out to LA to start a new life, and finally to be the nurse her marriage to Del had prevented her from becoming. It is in this sense, too, that the trauma is not the problem, but the solution.

If 'being in denial' turns out to be a coping strategy, an asset, and a 'productive pathology,' what about Betty's blurring of the distinction between real and imagined? One answer is that such a blurring reflects the core dilemma of American domestic melodrama, where individuals – mostly – put unrealistic demands on themselves, of what their lives must be like in order to be the good wife, perfect mother, helpful neighbour of the "American Dream." The inevitable failure to live up to these demands may well generate, in the case of Betty, a compensatory split, which the traumatic incident did not cause but merely brought to a tipping point. It was her normal life that first created the 'disconnect' between different realms of experience, leaving them non-integrated, unassimilated, and unmediated – other than by being hypermediated in the form of her daily dose of soap opera.

Once Betty decides to pack up and go, she actually heals the traumatic rift, unifying herself around chasing the dream of romantic love. We can once more think of the lamp post/lost key effect. Romantic love (as the lamp post) would be the answer to a life whose meaning (the key) had been lost somewhere else – well before the hit men killed her husband – namely when she became the good wife and gave up on her personal ambition to become a nurse. In this sense, being able to transition between the real and the imagined is more a back-and-forth shuttle between reality and fiction, shown in the film not as the perilous slippage from the realm of truth to the land of make-believe, but rather as the ability to manage fluid identities and flexible performativities, as the situation demands, by effecting smooth transitions between actual and virtual, while, as it were, reaping the benefits that come from negotiating possibly equally valid ontological registers, in a world built on nothing more solid than the belief in self-perfection, while permeated by hypocrisy, lies, and fake news.

Fantasy Is on the Side of Reality

Disavowal as dissociation and flipping the actual and the virtual are in this context strategies that 'liberate' energies and enable actions that might otherwise be tethered by hesitation or paralysed by self-doubt and depression. It is the point where the category of fantasy can be usefully reintroduced, at first perhaps in the way that it is often understood: as one part of the dialectic between desire and fantasy, where desire projects one forward into unknown territory, while fantasy normalizes and thereby 'defangs' the dangerous side of desire. If "the fundamental role of fantasy [is] to provide relief from desire,"[18] then it does so for the subject in the mode of either neurosis or psychosis. While the neurotic seeks in fantasy "a substitute satisfaction for what she or he does not find in reality" (a common reading of Betty's addiction to *A Reason for Love*), the psychotic "confuses reality and fantasy and experiences them as equivalent"[19] (Betty's state subsequent to the murder). This, however, may be only one construction of the function of fantasy in Betty's case. As discussed above, there are several theories of fantasy in relation to trauma: for Cathy Caruth, trauma is unmediated, so that for the traumatized subject there is no room for 'fantasy' to intervene. For Susannah Radstone, fantasy is what 'covers' and mediates, and thus it helps to 'work through' trauma. For Slavoj Žižek fantasy is necessary for facing reality, but it is external to the subject: we are not free to choose our life-sustaining fantasies, they are the synthomes that make up the (irrational, unconscious, hard) core of our existence.

If we apply Radstone's interpretation of fantasy in relation to trauma to Betty and to the collective national fantasy usually referred to as "The American Dream," we can concur with Radstone that an event is experienced as traumatic when it "puncture[s] a fantasy that has previously sustained a sense of identity – national, as well as individual."[20] In the case of the United States, the dominant fantasy screen the culture had erected around itself was, according to Radstone, fantasies of "impregnability and invincibility," buttressed by macho posturing and "male narcissism."[21] These were shattered by 9/11, which is why it was cast by the culture as "traumatic."[22] Similarly, in the case of *Nurse Betty*, it may be that the (female-gendered) fantasies associated with the American Dream were being pierced by the brutal violation of Betty's home and domestic space, confronting her with ocular evidence of what she already knew: that her marriage was a sham. For as Radstone also points out, some traumatic events are "unimaginable" precisely because "they *had previously been* imagined,"[23] referring to the fall of the Twin Towers 'playing' like a Hollywood movie, while Betty, in the face of what she has just witnessed in her kitchen, presses the rewind button on her remote control.

If, on the other hand, we follow the psychoanalytic theories of fantasy, where it is tied up with a deadlock around the demand/desire of the (big) Other, then trauma has a different function. Desire is here equated with lack or the void, opened up not by striving after what one wants, but by not knowing what the Other wants (from me). As Todd McGowan argues: "in the place of the question of desire that results in a perpetually dissatisfied subject, fantasy offers the possibility of satisfaction, albeit on the level of the imaginary. Instead of suffering the perpetual uncertainty of desire, fantasy allows the subject to gain a measure of certainty" – and one might add: of agency and control.[24] Referring to a similar deadlock, Žižek explains the workings of ideology by way of fantasy, when he points out that fantasy is not the binary opposite of reality, but "must be placed on the side of reality,"[25] that is, it is the very means that allows us to function in reality, and not be overwhelmed or swallowed by it. Žižek calls this the fantasy frame of ideology, necessary as a "support" for reality (in the sense of empowering one to take meaningful action):

> Ideology is not a dreamlike illusion that we build to escape insupportable reality; in its basic dimension it is a fantasy construction which serves as a support for our "reality" itself: an "illusion" which structures our effective, real social relations [...]. The function of ideology is not to offer us a point of escape from our reality but to offer us the social reality itself as an escape from some traumatic, real kernel.[26]

Applied to *Nurse Betty* (and my reading of it), the heroine's 'psychotic' (rather than 'neurotic') response is in fact the more sensible and socially adept, not only insofar as this turns out to be a 'successful' strategy with respect to some of her life ambitions, but because it unifies the subject around a productive pathology. Also, Betty's 'psychotic' strategy illustrates another point, often made by critics when defending women's penchant for soap operas, namely the extent to which soap operas are not so much killing time or even filling time, as they provide eminently useful lessons in living under neoliberalism.

Learning from Soap Operas

In one of their quarrels that opens the film, Del dismissively but not without wit retorts to Betty: "[soap operas are] shows for people with no lives, watching other people's fake lives." For a fraction we might be tempted to agree with him, but since his remark occurs in an exchange about whether it is better for Betty to watch soaps, or watch him play tenpin bowling, which is supposed to involve superior 'skills,' we may

well switch sides. The argument, put forward by feminists and television scholars, is that soaps are not just comforters and palliatives, but actually train women for staying focused while dividing their attention, as well as train them in empathy and several other important social and nurturing skills.[27] While men may not appreciate the type of engagement, patience, and focus it takes to 'learn' from soaps, *Nurse Betty* vindicates these skills, not least when as the fake nurse she saves a real person's life.

I already mentioned the scene in the diner, where Betty's skills at multitasking are appreciated by her customers, especially by Charlie (which foreshadows his admiration and idealization of Betty's 'grace'). The point is that Betty may be spacey and dissociative, but the flip side of the coin is her precise attention to detail: she displays what one might call the new aptitudes of a labour force turned service personnel: distributed attention, and the efficient execution of seemingly unrelated activities, such as pouring coffee and anticipating the wishes of her customers while not taking her eyes off the television set.

Betty is, in this somewhat under-appreciative environment of the local diner, an example of the female multitasker, showing special skills around 'affective labour.' As a waitress, she displays a remarkable ability to successfully and simultaneously process diverse information from various sources. One of the demands of the new economy that was beginning to become dominant, at the time the film was released, was to be able to manage data and to work the post-Fordist social 'machine' not only of customer relations but of the service sector quite generally: from nursing and home care to education and child rearing. In their performative dimension, these types of affective labour bring the domestic sphere of the home, the institutional sphere of the hospital or school, and the make-believe world of the movie and television industries rather closer together, indicative of the degree to which television soaps and melodrama are embedded in but also are enabling a certain (wo)man-media-machine symbiosis, where the sincere and the simulated, the actual and the virtual merge and converge with the animated and the automated.

Feminist cultural studies has had a special interest in soap opera spectatorship, leading to intriguing empirical fieldwork about the viewing behaviour of daytime television audiences. It seems to confirm that viewers are fully aware of the fictional nature of what they are watching: they know the constraints of their own material situation, but are nonetheless willing to suspend this knowledge for the sake of heightened participation. They appropriate 'their' soaps as a way to assert the right to something of their own, to claim time for themselves, and to own their pleasure in transgressive fantasies.[28] Based on her analysis of fan letters, interviews, and conversations, Louise Spence has argued that the same

viewers who give advice to the characters and send them wedding presents as if they were real are also the ones who comment critically on a show's evolving narrative, suggest new plotlines, object to the quality of the acting, or complain about sloppy writing.[29]

Equally relevant here is some of the more theoretical work, which focuses on the affective side of the soap opera experience, which also brings us back to trauma. It was Tania Modleski who first argued that daytime television "plays a part in habituating women to distraction, interruption, and spasmodic toil"[30] – necessary for the women's work in the home, which requires dealing with several people of different ages and needs, coping with interpersonal conflicts and emotional problems, and functioning by distraction and not by concentrating their energies exclusively on any one task. Women, as Spence has observed, often perform chores while viewing television in a distracted mode.[31] She, too, points out that soap opera viewing enacts multiple interruptions, as each show follows numerous storylines that interrupt each other, commercial breaks interrupt with their own narratives (where mundane crises of housework are quickly resolved), and viewers might follow multiple soaps as well as other morning programs like quiz shows.[32] Modleski maintains that "the flow within soap operas as well as between soap operas and other programming units reinforces the very principle of interruptability crucial to the proper functioning of women in the home."[33] If such interruptability, along with repetition, the rewind, and distributed attention are properties (or symptoms) of television, trauma, and the neoliberal economy, then this would in itself not only constitute an apt rejoinder to Del's quip about "people with no lives, watching other people's fake lives," but also confirm the idea that the representation of trauma has become a kind of homeopathic medicine for some of the consequences of neoliberalism, by training 'resilience' to precariousness and teaching 'flexibility' in the face of discontinuity, interference, non-integration, and sudden change.[34]

Nurse Betty as the Mise-en-Abyme of Its Own Premise

The arguments from soap opera about affective labour at home and in the workplace, about interruptability as a practical feature of women's (and, one may now want to add, house husbands') daily lives and as a formal feature of television series – as well as the fluid transitions from one reality to another under the sign of performativity and participation – all have one feature in common: they establish a symbiotic, interactive, and self-referential relationship between the soaps and their spectators, between the work of fiction and the world it purports to

depict. This auto-reflexivity extends to the film itself and its eponymous heroine: Nurse Betty. One can speak of a mirroring relationship, but not in the sense of some version of realist reflection theory. Rather, what emerges is a system of feedback relays, where doublings and echo-effects build up and consolidate a free-floating but self-supporting structure of cross-references that amounts to a *mise-en-abyme*, where the film repeats its own premise (fusing into a back-and-forth actor, fictional character, social role, and fantasy figure) by enacting these reversals literally and metaphorically, and reproducing them as themes-and-variations.[35] The process plays out on several levels, and presents itself in the form of characters interacting across shared movie references, repeated scenes at identical locations, mistaken identities, or common obsessions across the differences of race, gender, occupation, and region.

For instance, throughout the film Betty encounters very diverse characters who are all familiar with the show *A Reason to Love*: a housewife and a (male) reporter from Betty's home town; Ellen, the waitress in an Arizona bar who tells Betty about the time she visited Rome (a visit that Betty will repeat and re-enact at the end of the film). While the waitress chose Rome to finally "be herself," in honour and memory of (and thus re-enacting) Audrey Hepburn in *Roman Holiday* (USA 1953), Betty when in Rome watches an Italian-dubbed *A Reason to Love* in a café, which keeps the waiter spellbound and multitasking in exactly the way she was glued to the screen in the diner at the beginning while pouring coffee. The show is also followed by Rosa, the sister of the woman whose son was rescued by Betty, and from whom Betty rents a room; likewise the (female) attorney that Rosa works for in Los Angeles, who gives Betty an invitation to the party where the cast of *A Reason to Love* are celebrating and thus enables her introduction to 'Dr. Ravell.' Even Wesley, a criminal whose life is certainly not short of excitement, makes a point of staying up to date with the series because he has a crush on 'Nurse Jasmine.' Towards the end of the film, Wesley and several other characters he is holding hostage come together in front of the television set in Rosa's apartment to watch a tape of the latest episode, in order to find out whether Jasmine really is a lesbian, a revelation that so upsets Wesley that the hostages manage to retrieve a gun and fatally wound him.

Similarly structured as a *mise-en-abyme* is Charlie's growing obsession with Betty, which comes to mirror Betty's with Dr. Ravell. The critic Roger Ebert was the first to comment on the parallels:

> *Nurse Betty* is about two dreamers in love with their fantasies. One is a Kansas housewife. The other is a professional criminal. The housewife is in love with a doctor on a television soap opera. The criminal is in love with the

housewife, whose husband he has killed. What is crucial is that both of these besotted romantics are invisible to the person they are in love with. [...] Under the influence of Betty's sweet smile in a photograph, he begins to idealize her and to see her as the bright angel of his lost hopes. [...] Once you understand that Charlie and Betty are versions of the same idealistic delusions, that their stories are linked as mirror images, you've got the key.[36]

Calling them 'besotted romantics' is one way to understand what takes place between Charlie and Betty when they encounter each other in Charlie's imagination at the edge of the Grand Canyon. It is a scene that doubles an earlier one, when Betty, on her way to Los Angeles, also stops at the South Rim lookout, and has a vision of Dr. Ravell greeting her with a bouquet of flowers.[37] The parallel is so explicit that it draws attention to itself, acting as the kind of structural support typical of Hollywood narratives, when scenes 'rhyme' or repeat themselves in variations.

But it also invites one to put the two fantasies in relation to each other, where the apparent similarity turns out to be asymmetrical and inverted. Once he is convinced that Betty has the drugs he is after, Charlie forms an image of her as the femme fatale from a 1940s film noir, cold-blooded and calculating in the mould of Barbara Stanwyck in *Double Indemnity* (dir. Billy Wilder, USA 1944). It is an image (and not a fantasy) built up from information that Charlie gathers piece by piece, more like a detective constructing the forensic profile of a suspect. This profile is confirmed for Charlie after he sees Betty's picture in the newspaper, in an article explaining that she is missing from home after having witnessed a murder. Remembering her deft service skills at the diner and remarking on her quick departure and deathly silence during the murder, when most women in a similar situation would have screamed, Charlie deduces that she must be "a cunning, ruthless woman." He questions another waitress at Betty's former workplace who shows him the photograph of Betty holding the life-sized cutout of Dr. Ravell: further proof to him that Betty had big plans for herself to move up in life.

But Charlie's is also an image formed and contaminated by the movies, and in the course of the film it undergoes a transformation into a fantasy: perhaps a less complicated, compensatory fantasy, of an old man regretting the errors of his past and wanting to make good with a pure angel of a woman. Having tracked down Betty's grandparents, Charlie sees another photograph of her, aged twelve and dressed as a ballerina, prompting him to comment on her grace, perfect posture, and impressive poise. And after he reads excerpts from the journal she kept as a child, the fantasy forms in his mind that casts Betty as his soulmate, sent his way to show him the path to salvation.[38] That path leads directly to

the vision he has of Betty at the Grand Canyon, leaning on the guardrail as he approaches and kisses her. Later on, during a phone conversation when trying to locate her in Los Angeles, we get a sense of how Charlie now thinks of her: "Betty Sizemore ... blonde hair, a great figure ... sort of a whole Doris Day thing going on. That's what I said – Doris Day. You could see her working at the U.N., or something. 'The U.N.' United Nations."

As in his mind Barbara Stanwyck gives way to Doris Day, and Betty the femme fatale turns 'wholesome,' Charlie, the hard-bitten criminal and cold-blooded killer loses his grip on reality: coming too close to his fantasy turns out to be fatal for him (in contrast to Betty, whose persistence in her fantasy ends up netting her respect and a career move from waitress to nurse to soap star). When Charlie and Betty finally meet at Rosa's apartment, amidst hostage taking, a shootout, and the storming of the building by the police, he finally realizes how wrong he has been about Betty.[39] Yet rather than kidnap or kill her and shoot his way out, he locks himself in the bathroom and puts a gun to his head. The fantasy literally kills him: taking his own life is the honourable thing to do for this professional, caught out by his imagined code of a Roman general falling on his sword.[40] But not before he has some sage advice: "I want you to listen to me, Betty. People don't lie when they're about to die. You don't need that doctor. You don't need that actor. You don't need any man. It's not the 1940s, honey. You don't need anybody. You've got yourself ... and that's more than most people can say."

Successfully Failed Communication

"You've got yourself" – the phrase is deeply ironic, especially when understood to echo what (moment before) Charlie reads to Betty from her own diary: "If who I am and who I hope to be should meet one day, I know they will be friends." Yet by the logic of what I am proposing, "you've got yourself" is not at all ironic, since it confirms that the two Bettys are indeed "friends," but only because they have been living on parallel but separate tracks for so long. Maintaining disavowal, shifting between real and imagined, and deploying 'fantasy' as reality sustaining rather than as reality denying are Betty's ways of owning herself, of possessing agency, and of being self-sufficient. Being and having yourself in the twenty-first century is to master strategies that a generation earlier would have been identified as 'post-traumatic.'

One of the reasons, however, why these post-traumatic pathologies work for Betty is that almost all her contacts with the world are based on creative misunderstandings or comic miscommunication. Once upon

a time, communication functioned because both speaker and listener adhered to a number of mutually agreed rules or 'felicity conditions.'[41] Now, in our post-truth age of 'fake news,' those rules may no longer apply, having been replaced by a generalized form of performativity: if a lie is performed often enough, and repeated by enough different speakers, it now has a good chance of becoming fact. In John Langshaw Austin's speech act theory, for instance, a performative utterance is neither true nor false, but can instead be deemed "felicitous" or "infelicitous" depending on the nature of the interpretation given: is it a declaration, a request, or a warning? One could argue that Betty's behaviour and utterances are in a similar but also different sense "performative," insofar as with her conviction that Dr. Ravell is real and that she was once engaged to him, she wills a reality into being, which – under conditions of the industrial production of fantasy that is the Hollywood of daily soaps – does indeed have the necessary traction of constituting a workable reality.

If successful communication is normally dependent upon speakers being sincere in their statements and commitments,[42] then Betty qualifies, since she is manifestly sincere and authentic in what she says. So how can one square this particular circle, where she is both sincere and delivering a performance, while neither naive nor delusional? Returning to my earlier point about the 'parapractic' nature of Betty's response, and remembering that 'parapractic' is the translation of Freud's *Fehlleistung*, failed performance/performed failure, one can speak of Betty's utterances or mode of verbal interaction as 'successfully failed communication.' It is one of the achievements of the script, and in no small measure due to Zellweger's acting skills, that the same statements and events can be understood in radically different ways, producing what could be called parapractic (i.e., unintentional) double entendres: post-classical versions of classical Hollywood's "structured ambiguity."[43]

Enchanted by her professionalism in staying in character, George begins to improvise along with her, performing a duet as if in a Mozart opera. Each side slips into the fantasy space of the other and assumes they know what the other wants, and, in this way, the two successfully conduct an entire conversation: they are indeed lovers – inebriated by being in love with their own projections. Betty's sincerity is productively misunderstood as method acting, and when George ("David Ravell") says: "God, I haven't felt like this since I was with Stella Adler in New York. You're so … real," Betty answers, slightly piqued: "You never mentioned a 'Stella' to me. [...] I would have remembered that name. The only Stella I ever knew was a parrot." "Real" for George is still a category within acting, while for Betty the mention of a woman's name stirs real

feelings of jealousy, comically – but also aptly – deflected by the reference to a parrot, the only bird that can act as an echo, repeating, mimicking, and ventriloquizing human communication. Conversely, when Rosa, her landlady, finds out that 'David,' Betty's "boyfriend," is Dr. Ravell from *A Reason to Love* and she confronts Betty with this fact, Betty thinks Rosa is merely jealous and forgives her, knowing that Rosa has had some bad luck with men in the past.

Nurse Betty is thus structured around a series of successfully 'failed' exchanges and improbably 'successful' encounters. Lines from the soap turn up in Betty's conversation, but also vice versa: an exchange between Betty and George is repeated in an episode of the show. If Betty successfully incorporates George, the actor, into her fantasy of ex-fiancé David, George too incorporates Betty into his own fantasy of trying to revive *A Reason to Love*, which has gone stale, by bringing Betty into the show. His exchange with the show's producer Lyla Branch hints at the dizzying depth of the mutual *mise-en-abyme*:

> GEORGE: It'll be like live television! Let's live on the edge a little. You and I can break the mould here!
> LYLA: I said I'll think about it.
> GEORGE: Fine, but promise me one thing. If we use Betty, I want to direct those episodes. She's my discovery.
> LYLA: Actually, she was my discovery ... just like you.

Soon Lyla will characterize Betty's story as "beyond belief" and therefore "perfect for us." Eventually, she orders George to fly to Oak Falls, Kansas, and get Betty to come back and join the cast. The reasons she has to bring Betty back are instructive, since they demonstrate why 'parapractic' double entendres and successfully failed communication are so useful: twice the film shows that when communication is direct (face to face, 'real'), the encounter ends in 'death.' I have already discussed Charlie's fatal face-to-face with Betty in Rosa's apartment; but Betty's face-to-face exchange with George is only slightly less devastating. When 'David' does in fact direct Betty, and finally realizes she was not 'in character' but had indeed not realized the Loma Vista Hospital was a set (where scenes require different takes), he treats her with brutal disdain. He so humiliates her in front of the cast, with words that directly echo Del's dismissiveness about "fake lives," that she not only walks out but suddenly remembers Del's murder: the protective fantasy collapses, although what appears is not truth, but its monstrous perversion: Žižek's "traumatic kernel" of the real.

Conclusion

My argument has been that many of the symptoms we generally identify as post-traumatic – disavowal as a coping strategy, blurring the distinction between 'real' and imagined, erecting a protective fantasy screen and adopting psychic mimicry, and ignoring the felicity conditions of normal conversation in favour of psychotic doublespeak – are in *Nurse Betty* at one level presented as, precisely, post-traumatic. However, the fact that they appear in what I called a 'black romantic comedy' should alert us to the possibility that these symptoms are treated in the film not only as reflexive and self-referential but, more importantly, as highly adaptive strategies of survival in a new epistemological and ontological environment, irrespective whether we call it 'post-modern,' 'post-truth,' or ... 'post-traumatic.' The adaptive part is the reverse side of the traumatic coin: 'in denial' as a successful tactic rather than a form of self-deception, fantasy as reality sustaining rather than as reality denying, psychotic double speak as successfully failed communication or 'parapractic double entendres,' while mental conditions such as amnesia, schizophrenia, autism, and bipolarity might turn adaptive when they are part of a 'productive pathology.' If the language of trauma is seen as not only 'pathological' but also as 'parapractic' and if some of its main features (dissociative fugue, schizo-splitting, etc.) can function as adaptive strategies, then perhaps we may not want to call it trauma, just as we may not want to continue to refer to 'attention deficit disorder' but value its symptoms as assets, for instance, as 'rapid reaction and redeployment capability.'[44]

My provocative suggestion that trauma is the solution rather than the problem might no longer seem quite so strange and counterfactual as when I announced it in my opening paragraph. The lesson to take from *Nurse Betty* (the film and the character) is indeed meant to be nurturing and healing: learn to live with contradictions, do not try to integrate, narrativize, or assimilate: *in the traumatic element immerse!*[45] Instead of seeking coherence and identity, open yourself up to the contingency of the world, while keeping your innate goodness and grace. Beware of deploying trauma as the black box for the loss of meaning in your life and for missing explanations – the 'victim's' way of retroactively attaining (negative) identity – but let trauma lead you to coping with the positive feedback that a world out of control has made into the new normal.[46] "Accommodate, aggravate, and accelerate your symptoms" might be the appropriate but also appropriately risky motto ...[47]

If *Nurse Betty* features a protagonist whose scary dedication to disavowing the difference between artifice and life is mistaken for method acting, it is perhaps no wonder that the old problems of realism and

reference in the arts are revived in the digital age, where the fake looks more 'real' than 'the real thing,' but where we have become so suspicious of authenticity and where the image worlds we inhabit are of such universal duplicity, that it is axiomatic that 'the real thing' must be fake.

As with films like *The Truman Show, Matrix* (USA 1999), or *Being John Malkovich*, the intriguing questions at the heart of *Nurse Betty* are philosophical: the (epistemological) problem of 'other minds' and the (ontological) problem of 'other worlds' – in the first case, what would it mean to 'know' what goes on in someone else's mind, and what proof do I have that others actually exist, and in the second, if the world I live in is merely someone else's fiction, where would the 'outside' be, from which I could ever see that I'm trapped 'inside,' if not inside someone else's inside?

Trauma as a topic in culture – understood as the non-integration of experience, as 'failed experience,' as the unexpected return of a violent incident, or the sudden opening up the void – would be the affective, subjective side of such radical philosophical scepticism. In this sense, trauma is the problem *and* the solution: a symptom of sensory overload (not least of 'too much' media-stimuli), it is the fever that purges, before it breaks. But post-traumatic symptoms are also adaptive responses to these forces of disorder and positive feedback loops, which is why I mentioned antibodies, homeopathy, and the pharmakon.

Watching soap operas, as depicted in *Nurse Betty*, is not just a primer for the "justified life of the housewife" or the escape fantasy for a traumatic or traumatized existence, but reveals itself as part of a survival kit for the "next society."[48] This next society is one where the majority, and especially housewives, will have to not just survive in a fully mediatized, high-tech environment, but navigate everyday life between creative flexibility and economic precariousness, between affective labour and boredom, between low-level anxiety and variable attention. To function, one needs to be 'flexible' and 'creative,' also towards yourself: among our skill set will be dissociation and numbness, amnesia and rapid reaction. If so, 'the new normal' is to be 'traumatized.' And popular entertainment, so my argument suggests, may be more attuned to this condition than high theory acknowledges. If Albert Camus said, "we must imagine Sisyphus a happy man," then perhaps *Nurse Betty* says, "we must imagine trauma a happy state of being."

NOTES

1 On Freud's notion of trauma as a way for an organism to cope with excessive stimuli, see my "Freud as Media Theorist: Mystic Writing-Pads and the Matter of Memory," *Screen* 50, no. 1 (2009): 100–13.

2 For Walter Benjamin, shock and trauma were the very indicators of
 'modernity.' See his "The Work of Art in the Age of Mechanical Reproduc-
 tion" (1935). I examine this aspect more closely in "Between Erlebnis and
 Erfahrung: Cinema Experience with Walter Benjamin," *Paragraph* 32, no. 3
 (2009): 292–312.
3 Advertisement for *Nurse Betty* in the *Billings Gazette*, 27 March 2017. The tag
 ends with: "Traumatized by a savage event, Betty enters into a fugue state
 that allows – even encourages – her to keep functioning in a kind of alter-
 nate reality."
4 See Elsaesser, "Between Erlebnis and Erfahrung."
5 The joke is often referred to as "the streetlight effect," https://en.wikipedia
 .org/wiki/Streetlight_effect and https://quoteinvestigator.com/2013/04/11
 /better-light/.
6 Among the most important interventions are: Cathy Caruth, *Unclaimed
 Experience* (Baltimore: Johns Hopkins University Press, 1996); Ruth Leys,
 Trauma: A Genealogy (Chicago: University of Chicago Press, 2000); Hal Foster,
 "Obscene, Abject, Traumatic," *October* 78 (Autumn 1996): 106–24; and Wulf
 Kansteiner, "Genealogy of a Category Mistake: A Critical Intellectual History
 of the Cultural Trauma Metaphor," *Rethinking History* 8, no. 2 (2004): 193–221.
7 The term '*posthistoire*' refers to a new phase in human culture, where the
 old world views no longer apply and new ones are not yet articulated or
 accepted. *Posthistoire* does not mean that nothing happens anymore, but
 that a certain historical momentum in the West (of both the bourgeoisie
 and the proletariat) has exhausted itself. But the concept of the *posthistoire*
 must be distinguished from that of postmodernism. A philosopher of post-
 modernism such as Jean-François Lyotard, when arguing the end of the
 grand narratives of progress, breaks with the Hegelian model of history as
 the self-realization of reason, while philosophers of the *posthistoire* such as
 Francis Fukuyama are more likely to appeal to Hegel and proclaim the 'ful-
 filment' of history.
8 Caruth, *Unclaimed Experience*, 3–4.
9 Susannah Radstone, "Introduction" and "Screening Trauma: Forrest Gump,
 Film and Memory," in *Memory and Methodology*, ed. Radstone (Oxford: Berg,
 2000), 1–22 and 79–107, as well as her introduction to "*Screen* Dossier on
 Trauma," *Screen* 42, no. 2 (Summer 2001): 188–93.
10 These reservations apply more whenever trauma theory enters the realm
 of activism and militancy, whereas Caruth initially formulated her theory
 mainly within the context of and in response to a series of crises in literary
 studies and feminist theory. See Thomas Elsaesser, "Trauma Theory: Post-
 modernism as Mourning Work," *Screen* 42, no. 2 (Summer 2001), 193–201.
11 See also Paul Antze and Michael Lambek, eds., *Tense Past: Cultural Essays in
 Trauma and Memory* (New York: Routledge, 1996).

12 One commentator called it "a virtual bran-tub of genres, from soap opera, road movie and crime drama to comic satire and romance." Christopher Bigsby, *Neil LaBute: Stage and Cinema*, Cambridge Studies in Modern Theatre (Cambridge: Cambridge University Press, 2007), 194.

13 "Dissociative fugue is a psychological state in which a person loses awareness of their identity or other important autobiographical information and also engages in some form of unexpected travel. [...] In addition to confusion about identity, people experiencing a dissociative fugue state may also develop a new identity." See *Psychology Today*, https://www.psychologytoday.com/intl/conditions/dissociative-fugue-psychogenic-fugue.

14 [CHARLIE]: Miss?
 Betty leans forward, grabs the coffee pot and moves in front of him. Without taking her eyes from the TV, she pours the java, which somehow lands in his cup without spilling a drop.
 [CHARLIE] (cont'd): Very impressive. That is very ... (turning to others) Did anybody see that?
 ...
 [CHARLIE] (cont'd): Thank you. Could I bother you for a little more ...?
 Before he can even finish, Betty is topping him off with milk.
 (*Nurse Betty*, Screenplay by John C. Richards and James Flamberg, story by John C. Richards, shooting script 3/9/1999 [henceforth cited as "script"], n.p., accessed 3 March 2020, http://www.dailyscript.com/scripts/nursebetty.html.)

15 Ibid.: "Betty points her remote at the dining room and clicks it, as if trying to make the image disappear. Finally, she gives up, slowly turning away from the carnage and aims at the TV. *A Reason to Love* pauses on the face of David Ravell and Betty sits in absolute silence."

16 "Kansas" in this context has become an overdetermined signifier, not just because of *The Wizard of Oz*, explicitly mentioned. It is also in the title of one of the key books analysing the right-wing lurch of Middle America: Thomas Frank, *What's the Matter with Kansas?* (New York: Henry Holt, 2004).

17 The town's law enforcer, Sheriff Ballard, when investigating Del's murder, actually raises the possibility that Betty herself might have ordered Del's assassination.
 Script: ROY: You said a woman couldn't have done it.
 BALLARD: A woman can write a check.
 ROY: So you're saying Betty Sizemore – our Betty Sizemore – who you were in swing choir with – has now hired somebody to scalp her husband in her own kitchen while she watched? You're amazing.
 BALLARD: It's just a theory ... just 'cause I'm thinking it don't mean I like it.

18 Todd McGowan, "Finding Ourselves on a Lost Highway: David Lynch's Lesson in Fantasy," *Cinema Journal* 39, no. 2 (2000): 54.

19 Ibid., 53.

20 Susannah Radstone, "The War of the Fathers," *Signs* 21, no. 1 (Autumn 2002): 468.

21 Ibid.

22 By contrast, there were voices that saw the attack as "America's chickens are coming home to roost," that is, that US policies in the Middle East had stoked the kind of anger and resentment that contributed to radicalizing Islam. The phrase originated with Malcolm X, referring to the Kennedy assassination, but was then applied to 9/11 by Obama's former pastor, the Reverend Jeremy Wright, in a sermon entitled "The Day of Jerusalem's Fall," delivered in Chicago on 16 September 2001. See the so-called Jeremia Wright Controversy, accessed 3 March 2020, https://en.wikipedia.org/wiki /Jeremiah_Wright_controversy.

23 Radstone, "The War of the Fathers," 469.

24 Todd McGowan, "Looking for the Gaze: Lacanian Film Theory and Its Vicissitudes," *Cinema Journal* 42, no. 3 (Spring, 2003): 36.

25 Slavoj Žižek, *The Sublime Object of Ideology* (London: Verso, 2008 [1989]), 44.

26 Ibid., 45.

27 The pioneering studies are Tania Modleski, *Loving with a Vengeance: Mass Produced Fantasies for Women* (New York: Routledge, 1982); and Louise Spence, *Watching Daytime Soap Operas: The Power of Pleasure* (Middletown: Wesleyan University Press, 2005).

28 Spence, *Watching Daytime Soap Operas*, 166.

29 Ibid., 156. Spence labels the popular image of soap opera fans as unable to distinguish between fiction and reality the "*Nurse Betty* syndrome."

30 Modleski, *Loving with a Vengeance*, 92.

31 Spence, *Watching Daytime Soap Operas*, 63.

32 Ibid.

33 Modleski, *Loving with a Vengeance*, 93.

34 Since a soap opera is never-ending, and there are no conclusions, it can sustain a sense of uncertain outcome, but also of endless possibilities. In this sense, too, it trains resilience. For a psychoanalytic take on melodrama and non-closure, see Joan Copjec, "More! From Melodrama to Magnitude," in *Endless Night: Cinema and Psychoanalysis, Parallel Histories*, ed. Janet Bergstrom (Berkeley: University of California Press, 1999), 249–72.

35 "Throughout, *Nurse Betty* plays this kind of juggling game. The central plot conceit of Betty's fugue […] is a latter-day take on amnesia, that reliable old standby of soap writers; and more than once, as we're about to chortle at some especially crass line of dialogue, it's revealed to be a quote from the soap-within-the-movie, *A Reason to Love*. Following soap-land's penchant for providing running updates for new viewers, the film's characters constantly define each other in neat encapsulations: Charlie talks of Betty as 'sort of a

wholesome Doris Day figure.'" Philip Kemp, "Nurse Betty," *Sight and Sound* 10, no. 10 (October 2000): 53.

36 Roger Ebert, *Nurse Betty*, movie review and film summary, 8 September 2000, https://www.rogerebert.com/reviews/nurse-betty-2000.

37 Script: "Betty walks to the rail and gazes out at the canyon. Turning her head slowly, as if expecting it, she sees DAVID RAVELL leaning on the rail about twenty feet away, clutching a bouquet of roses. Betty starts toward him ... he starts toward her ... A magic moment ... Shattered when a black sedan appears, inching its way along. She freezes. David vanishes, and ... An ELDERLY MAN helps his wife out of the car and snaps her picture in front of the canyon. Betty moves away."

38 Script: CHARLIE (reading from Betty's diary): When I grow up I'm going to become a nurse or a veterinarian. I always want to help people and value all life, be it animal, plant or mineral.

39 Script: BETTY: I'm not really who you think I am.
CHARLIE: No one is, honey.

40 Script: CHARLIE: Betty, I don't wanna shrivel up alone in some stinking prison. No way. I've got some professional pride. And I don't want anybody else to get the credit for taking me out. [...] When a Roman general knew a battle was lost, he'd throw himself on his sword.

41 The phrase was introduced by J.L. Austin. See Deirdre Wilson and Dan Sperber, *Relevance: Communication and Cognition* (Oxford: Wiley-Blackwell, 1985). The authors provide an updates summary, "Relevance Theory," *UCL Psychology and Language Sciences*, 2002, accessed 3 March 2020, https://www.phon.ucl.ac.uk/publications/WPL/02papers/wilson_sperber.pdf.

42 Jürgen Habermas, *On the Pragmatics of Communication* (Cambridge, MA: MIT Press, 2000), 82, 85.

43 On structured ambiguity, see Thomas Elsaesser, "James Cameron's *Avatar*: Access for All," *New Review of Film and Television Studies* 9, no. 3 (2011): 247–64.

44 "Thrilling utopian idea to just 'play on the keyboard of trauma,' embracing all the post-traumatic symptoms like delusions, dissociation, etc. What a world this would be ..." This comment was made in a review of a draft of this chapter by Julia B. Köhne on 29 August 2019.

45 A paraphrase of Stein's words in Joseph Conrad's *Lord Jim* (1899), chap. 20. The full passage reads: "A man that is born falls into a dream like a man who falls into the sea. If he tries to climb out into the air as inexperienced people endeavor to do, he drowns [....] The way is to the destructive element submit yourself, and with the exertions of your hands and feet in the water make the deep, deep sea keep you up [....] In the destructive element immerse." (Norton Critical Edition of *Lord Jim* [1996], 129).

46 Neil LaBute, who began as a playwright before becoming a director, did not write the screenplay of *Nurse Betty*. Asked why he made the film, he said:

"Was I trying to say anything with the film? Make a comment about the way reality and fantasy can so easily bend to our will, or bend us to its will? Point out that sometimes we have to go a little crazy to find ourselves? Probably." Cited in Bigsby, *Neil LaBute*, ix.

47 This motto is evidently a partly ironic nod towards the philosophical current known as "accelerationism."

48 The term originated from the management guru Peter Drucker, but in the sense I am using it here, I borrow it from the German sociologist Dirk Baecker's influential *Studien zur nächsten Gesellschaft* [Studies towards the next society] (Frankfurt am Main: Suhrkamp, 2007).

12 The Exploitation of Trauma: (Mis-)Representations of Rape Victims in the War Film

MARZENA SOKOŁOWSKA-PARYŻ

With the contemporary global reach of film via international cinema screenings, the DVD market, Netflix, or YouTube, one is justified in claiming the potential power of war films to construct a transnational "cultural imagination" of military conflicts, distant from either a temporal or geographical perspective: "[the] myriad representations of war [...] provide the common ground upon which a collective, shared sense of war is worked out, articulated, and sometimes contested," and "with time, this collected sense of war becomes a pattern of thought, a hardwired set of expectations and desires that constrain the very ways we think about war."[1] The war film should thus be acknowledged as undoubtedly one of the most influential genres in disseminating knowledge about historical instances of wartime rape. Considering the increasing number of war films tackling this subject matter across the past few decades, it is essential to scrutinize how effectively the trauma of rape victims has been conveyed by means of its filmic (i.e., fictional) representations.

The persuasiveness of war film derives from its ability to create an (illusory) proximity to historical events by conjuring an emotionally charged visual and auditory image of the "real," in the here and now: "film lets us see landscapes, hear sounds, witness strong emotions as they are expressed with body and face, or view physical conflict between individuals and groups"; thus it "can most directly render the look and feel of all sorts of historical particulars and situations."[2] Yet film is as much a narrative medium as it is a visual one, and it needs to 'tell' its individual story within the structural framework of a beginning, development, and a conclusive end, with plot being the most unrealistic of all the strategies underlying (fictional) narratives. In the case of a traumatic experience, if its truth resides in its being "seemingly without purpose, arbitrary, outside the framework of meaning," then its representation "[may not] be absorbed by the [addressee], whose framework of meaning remains essentially

intact."[3] In other words, the problem at the core of filmic representations of wartime rape is the overall effect – intentional or inadvertent – of *how* the traumatic experience is shown and *how* it is told within the construed plot. It is not always the case that war films about wartime rape actually serve the purpose of an empathetic understanding of actual historical cases of the traumatization of women during military conflicts.

One must bear in mind that whatever historical facts provided the initial inspiration, "[all] historical films are fictional," for "they have to reconstruct in a purely imaginary way the greater part of what they show, [and] combine actual events and completely fictitious individual episodes."[4] Hence, it is necessary to pose the question on the strengths and the limits of such imaginings/representations of physical and psychological suffering on screen, for, if such filmic fictions aim to construct a "cultural imagination" of the past in cognitive, affective, and ideological terms, one needs to be aware of "[the] matrix of competing pressures" at the heart of the medium, including "narrative considerations, [...] genre conventions, political and regulatory pressures."[5] The issue of war film's inherent "vulnerability to historical inaccuracies [...] and outright distortions"[6] is especially relevant in the context of the (mis-)representations of wartime rape victims. The official diagnosis of PTSD by the American Psychiatric Association in 1980 and its subsequent theoretical appropriations (Cathy Caruth, Shoshana Felman, Dori Laub, Dominick LaCapra)[7] established trauma as one of the most important psychological and social concepts of the twentieth century. This does not necessarily mean, however, that the representations of trauma in popular culture serve the purposes of knowledge, understanding, and empathy. War films in particular have proven to be all too prone to ethically problematic metaphorizations of rape due to their gender- or nation-related generically determined ideological agendas.

The problem resides, first and foremost, in the prerequisites of the specific genre of the war film, which, from its very beginnings, was combat oriented, that is, focusing specifically on soldier-protagonists, the assumption being that "the acts soldiers commit in battle are comprehensible only in a world defined by war."[8] Women-figures generally tended to appear in the background of the main (combat) action, cast in roles stereotypically subservient to the male characters: nurses (helping the soldier regain his fortitude) or lovers (performing a relief-from-war function). It was the interwar combat film that brought into being conventions of portraying the disillusioned soldier (*All Quiet on the Western Front*, dir. Lewis Milestone, 1930) and – in today's terminology – the traumatized soldier (*Westfront 1918*, dir. Georg Wilhelm Pabst, 1930), in an ethically charged opposition to the propagandist images of the just and thus

always-successful warrior-hero. Yet, significantly, there are no films about women-in-wartime to be seen today as canonical and thus convention creating. True enough, the history of Edith Cavell was adapted to film in 1916 (*Nurse Cavell*, dir. W.J. Lincoln), 1918 (*The Woman the Germans Shot*, dir. John G. Adolfi), 1928 (*Dawn*, dir. Herbert Wilcox), and 1939 (*Nurse Edith Cavell*, dir. Herbert Wilcox), yet these are now treated as no more than examples of cinematic propaganda, exploiting the execution of a British nurse to justify one's own nation's participation in war. The attempted rape in D.W. Griffith's *Hearts of the World* (1918) is likewise today considered merely a crude propaganda attempt rather than an insightful depiction of a traumatic experience, the film depicting the female character as a representative of a community that "endure[s] and prevail[s] due to their determination and strong moral fibre."[9]

In post-1945 war films, we encounter types of war rape victims whose torment at the hand of the perpetrators serves political/nationalist functions superseding considerations of why rape occurs so systematically in wartime, of the extent of the physical torment endured by the victim, and of the psychological and medical consequences for the woman if she manages to survive. I agree with Sarah Projansky that representations of rape may prove "themselves functional, generative, formative, strategic, performative, and real," for "[they] form a complex of cultural discourses central to the very structure of stories people tell about themselves and others."[10] It is also beyond question, however, that when "tales of violation [are translated] into nationally specific cultural symbologies and conclusive narratives,"[11] it is inevitable that "[films] may ultimately work at cross-purposes with their own goals, drawing on particular representational strategies in order to achieve antirape, antisexism, and antiracism goals but often reinscribing rape, sexism, and/or racism in the process."[12] There is yet another danger to be considered, namely the increasing number of war films taking up the subject matter of wartime rape. On the one hand, one may view this as a positive sign, considering that "despite the proliferation of the feminist movement specifically, and the victims' movement more generally, attention to wartime sexual violence was ill-considered until the 1990s."[13] On the other hand, "the frequent and ubiquitous representation of rape can serve to normalize the act in a way that makes sexual assault permissive, feeding an already ambivalent rape culture."[14] It is all the more urgent, therefore, to scrutinize contemporary and past filmic productions as to what extent the so-called visual and narrative language of film can show and tell wartime rape in terms of what Elaine Scarry has designated as pain's "inexpressibility," that is, "the events happening within the interior of [a] person's body [...] belonging to an invisible geography,"[15] and what Cathy Caruth

has stated to be trauma's "unrepresentability": "the transformation of the trauma into a narrative memory that allows the story to be verbalized and communicated, to be integrated into one's own, and others', knowledge of the past, may lose both the precision and the force that characterizes traumatic recall."[16]

There is another interpretative dimension to be considered with regard to the representations of wartime rape in film. There have been numerous groundbreaking academic studies on the (mis-)uses of representational strategies in documentaries, TV programs and series, and popular films revolving round the subject matter of rape. However, all concentrate primarily on the ways rape is depicted within peacetime socially determined environments (family, school, work) in relation to issues of medical and psychological care, community versus political support, legislation, the criminal justice system – Sarah Projansky's *Watching Rape: Film and Television in Postfeminist Culture* (2001), Tanya Horeck's *Public Rape: Representing Violation in Fiction and Film* (2004), Sabine Sielke's *Reading Rape: The Rhetoric of Sexual Violence in American Literature and Culture, 1790–1990* (2001), Lisa M. Cuklanz's *Rape on Prime Time: Television, Masculinity, and Sexual Violence* (1999), or Sorcha Gunne and Zoë Brigley Thompson's co-edited *Feminism, Literature and Rape Narratives: Violence and Violation* (2010). Concomitantly, studies on representations of rape/trauma also include the specific genres of the rape-revenge film (Alexandra Heller-Nicholas's *Rape-Revenge Films: A Critical Study*, 2011; Jacinda Read's *The New Avengers: Feminism, Femininity and the Rape-Revenge Cycle*, 2000; Claire Henry's *Revisionist Rape-Revenge*, 2014; Noah Berlatksy's *Fecund Horror: Slashers, Rape/Revenge, Women in Prison, Zombies and Other Exploitation Dreck*, 2016), the sexploitation film (Jack Hunter's *Sex, Death, Swastikas: Nazi Exploitation SSinema*, 2010; Mike Quarles's *Down and Dirty: Hollywood's Exploitation Filmmakers and Their Movies*, 2001), or horror films in a more general trauma-related context (Linnie Blake's *The Wounds of Nations: Horror Cinema, Historical Trauma and National Identity*, 2008). Academic studies on (specifically) wartime rape are, in turn, mostly historically oriented, offering explanations ranging from those based on the specific circumstances of a given military conflict, such as ethnic cleansing (Bosnia and Herzegovina) or tribal-related genocide (Rwanda), to those trying to find more universal mechanisms underlying sexual victimization of women in war: "in some situations rape was a cultural weapon or a matter of strategy; in others it was part of masculine military revenge against the enemy," and "practices such as gang rape acted as recreation and social bonding among combatants, or were treated as a necessary libidinous release following combat."[17] If, as Projansky writes, "the argumentative narration"

of documentary and filmic representations of rape "is based on 'transferring' an aspect of the experience of rape to the spectator in order to increase understanding and to fulfil an educational goal of informing the general public about rape,"[18] then one needs to ask to what degree war films can combine telling the truth of war with telling the truth of wartime rape in a manner that could convince the audience that rapes of women within the specific circumstances of different conflicts across historical time and geographical settings are relevant for an understanding of what rape is and what it entails in our contemporary here and now.

An edited volume such as Raphaëlle Branche's and Fabrice Virgili's *Rape in Wartime* (2012) aims to foreground the historical/geographical contexts of wartime rape during the Spanish Civil War, the Great War, the Second World War, the Greek Civil War, the Bangladesh War, the Israeli-Palestinian conflict, the Nigerian Civil War, and other African military conflicts. Branche and Virgili assert that their book "takes its inspiration from two trends in historical scholarship – the promotion of gender as a category of social analysis and a concern to explore multiple facets of wartime violence."[19] A war film cannot possibly cover such a transtemporal and transnational territory. Its thematic focus is unavoidably restricted to national concerns, and here two paths are available for the filmmaker: either "adherence to a dominant national interpretation of the past" or "a radical re-interpretation of [the] 'fateful events.'" Filmic representations of wartime rape tend to fall into the first category, the more so when sexual violation of women is written into a "rape of the nation" ideological schema, and thus they may well "result in a 'resurrection' of past antagonisms."[20] The greatest limitation of war films is, however, their predominant setting of the action in the past of a military conflict that appears to have no bearing on the problem of sexual abuse in the viewer's contemporary time. In other words, there is a tendency to view wartime rape and peacetime sexual victimization as "historically distant" in their reasons and repercussions, as it is argued that "peacetime rape tends to be experienced according to a dichotomy between the fantasies of the rapist, which are psychosocial and rarely acknowledged outside the act itself, and the social stigmatization of the victim, which is traditionally expressed in terms of the honour of the family, clan or community," whereas "in wartime, [...] through its collective dimension and the fear that it generates, rape is seen as a threat to society as a whole and, in this way, it helps to weld the community together through condemnation of the enemy."[21]

Film, as an integral component of the present-day "commodified mass culture," can make it "possible for people to take on, in a personal way, memories of events through which they did not actually live." Such

"prosthetic memories," as defined by Alison Landsberg, are "personally-felt public memories that result from the experience of a mediated representation of the past."[22] Though this can potentially allow "people who share little in the way of cultural or ethnic background [to possess] shared memories,"[23] it is also essential to consider "the ramifications of prosthetic memory for what constitutes history and the acquisition of historical knowledge."[24] And thus it is necessary to put filmic representations of rape under close scrutiny so as to see what kind of "prosthetic memories" they are effectively – or inadequately – constructing. It is, of course, important for viewers to understand the historically and ethnically specific conditionings of mass rape and gendercide, yet it must be made clear why the particular circumstances of wartime rape during a particular conflict are relevant in a transnational and transtemporal perspective. Such considerations are important, as it is not the case that "sexual violence is endemic in all conflicts or that there is no hope for ever ending this cruelty and suffering," since "not all conflicts contain sexual violence. For instance, regional conflicts between ethnic groups in Sri Lanka and Israel/Palestine have featured continuous and severe violence. However, incidents of sexual violence have been low in both conflicts."[25] This means that an understanding of what triggers mass rape or gendercide can potentially foster an awareness of those nationalist or ethno-political determinants that may – today – lead to the same type of conflict and outbreak of sexual violence as in the past. The elimination of such determinants may thus decrease the possibility of history repeating itself. This is, therefore, a matter of educating societies, for "the level of idealism within the group, and the need of the group for civilian support and/or international support and aid all seem to play a part in whether a military group discourages or utilizes sexual violence."[26]

The contemporary relevance of past instances of wartime rape, as well as the mechanisms underlying wartime and peacetime rape, are best foregrounded in *The Human Rights Watch Global Report on Women's Human Rights* (1995). The report is divided into what may be called 'historical' and the 'contemporary' sections; the former includes a synopsis of "rape as a weapon of war and a tool of political repression" in various national contexts, and is followed by an analysis of "sexual assault of refugee and displaced women," "abuses of women in custody," "trafficking of women and girls into forced prostitution and coerced marriage," "abuses against female workers," "domestic violence," and "reproduction, sexuality and human rights violations."[27] The report offers a comprehensive account of the victimization of women that is not restricted primarily to (wartime) rape, and therefore provides that crucial point of connection between the traumas of women, in the time of war and in the time of peace,

from a global perspective. War films tend to be subservient to their own national agendas and restricted by their format. Deconstructions of the genre are possible by means of generic hybridity or ideological reconfigurations. Yet it is hard to imagine a war film that could possibly embrace the spectrum of issues as set forth in the *Women's Human Rights Watch* document. Nevertheless, there is a need for a platform where the global scope of films on wartime and peacetime rape could be set together, for purposes of comparison and (re-)thinking of the past and present experiences and repercussions of sexually determined trauma within the context of the adequate/inadequate representational strategies adopted by filmmakers.

The contemporary relevance of films on wartime rape resides also in their production history. One needs to ask *why* this film appeared in this particular time, for taking up the subject matter of rape can be either the effect of challenging a hitherto repressed history (Max Färberböck's 2008 adaptation of Marta Hillers's 1953 memoir *Anonyma – Eine Frau in Berlin*), or an attempt at constructing a "screen memory" that "[provides] a greater level of 'comfort' than confrontation with more 'local' problems would allow"[28] (films about the Rape of Nanking would create such a "comforting" dichotomy of the victimized, and therefore moral, Chinese, versus the perpetrator, and therefore evil, Japanese, in contrast to "discomforting" and thus impossible – considering the regime's censorship – Chinese films about the 1989 Tiananmen Square Massacre).[29] If war films tend to perform primarily a combined cognitive and memorial function, it is their ideological meaning and affective impact – intended or unintentional – that "play a role in the acquisition of historical knowledge":[30] "[the] different forms of narration and the different forms of 'story-space' [...] have ramifications for the reader's [viewer's] position in relation to the unfolding narrative; in other words, the extent to which the reader is invited into that diegetic space – or held out of it – has ramifications for the reader's [viewer's] sense of connection to or intimacy with the past."[31]

Analyses of popular war films on rape must be seen, therefore, as serving an ethical goal by promoting a critical awareness of the morally ambiguous effects of the representational strategies adopted by filmmakers. In my research on the specific genre of the war film, I have so far concentrated on ideological exploitations of rape in the form of creating the depersonalized victim (Brian de Palma's *Casualties of War*, 1989; *Redacted*, 2007) and its metaphorical equivalents (Stanley Kubrick's *Full Metal Jacket*, 1987; Bruno Dumont's *Flandres*, 2006), the sacrificial victim (Janusz Morgenstein's TV series *Kolumbowie*, 1970; Reg Traviss's *Der Feind im Inneren*, 2006; Lu Chuan's *Nanjing! Nanjing!*, 2009), and the defiant

victim (Max Färberböck's *Anonyma – Eine Frau in Berlin*, 2008; Juanita Wilson's *As If I Am Not There*, 2010). The depersonalized victim lacks an individual and autonomous characterization in comparison to the full-scale psychological insight provided into the male soldier-protagonists. The process of metaphorization includes a gender-related transfer of significance from person to an entire nation that is presumed to have been raped. The sacrificial victim seems, initially, to constitute a challenge to the objectification of the female body in the war film, primarily because this type of rape victim has, at least, a more visible character-presence within the plot. The construction of the sacrificial victim requires that she is ultimately killed, yet her 'willingness' to be raped (however controversial this may sound) serves only as a signifier of a (defeated) (male) nation's victimhood, with a glimmer of hope that this sacrifice will not be in vain, promising the nation's ultimate restoration. The defiant victim, in turn, is conventionally always a survivor, depicted as psychologically strong enough to overcome the trauma she endured, and thus the character's symbolic meaning is more explicitly related to her gender than to her nation.[32]

Though films as "mass-mediated [prosthetic] memories are not premised on any claim of authenticity," they nevertheless should "[create] the conditions for ethical thinking precisely by encouraging people to feel connected to, while recognizing the alterity of, the 'other.'"[33] Is it not that case that viewers are more inclined to feel empathy for rape victims depicted on screen only on condition that "at the moment of trauma, the victim is rendered helpless by overwhelming force"?[34] Both the sacrificial victim and the defiant victim, by asserting their agency and subjectivity, challenge familiar patterns of representing women in the war film, and, furthermore, upset longstanding convictions about the necessary prerequisites for a female character to be seen as suffering from trauma. The same may be said of the ethically problematic constructions of raped female characters in cinematic productions that have made international news, such as the melodramatic victim in Angelina Jolie's *In the Land of Blood and Honey* and the sacrosanct victim in Anne Fontaine's *Les Innocentes*. *In the Land of Blood and Honey* (2011) was released a year after *As If I Am Not There*, and thus Wilson's film is an obvious point of comparison. What unites the two films is the showing of women held captive in what appear to be rape-camps where non-Serbian/Muslim women would be systematically gang-raped by Serbian soldiers during the Bosnian War (1992–95). Such camps have since come to be considered the hallmark of this conflict, as well as evidence that rape can be encouraged as a deliberate military strategy for the purposes of ethnic cleansing: "A raped [Muslim] woman was often viewed as defiled and faced expulsion

from her community. [...] In many camps, a woman was raped until a gynaecologist confirmed she was pregnant and would not be released until it was too late to abort [as] nationality [was seen] to be patrilineal, or based on the father's culture and ethnicity."[35]

It is "one of [film's] most direct forms of appeal to identification," Pierre Sorlin writes, "to pass from the general to the particular,"[36] and there is no better means for ensuring an affective involvement in a historically embedded plot than showing/telling a personal story centred on affable and thus also ethically acceptable protagonists. From the point of view of audience engagement, the decision to focus on the story of a young and idealistic teacher coming from Sarajevo to a small village (Wilson's Samira) or a loving sister and very talented painter (Jolie's Ajla) would appear to be the right one. However, such a choice meant adopting a very restricted perspective on a very complicated conflict: "it was in the Bosnian context that the term 'genocidal rape' was minted, stressing the centrality of sexual assaults of women." Yet "men and adolescent boys were also sexually assaulted and tortured on a large scale in detention facilities such as Omarska and Trnopolje."[37] Though it has been officially acknowledged that "rape by Bosnian Serb soldiers [had] been particularly systematic and widespread,"[38] it has also been underscored that "Bosnian Croat and Muslim forces [were] guilty of serious abuses of human rights and humanitarian law."[39] Wilson's and Jolie's films construct an image of "the psychopathic Serb," which all too ostentatiously "draw[s] [its] force from the demonization of [...] Serbia in the 1990s," as well as "the long-standing stereotypes of Balkanist irrationality."[40] In *In the Land of Blood and Honey*, the viewer is shown civilians shot for simply refusing to evacuate their homes, people shot randomly in the streets, female prisoners treated as live shields, starved men standing behind a fence with barbed wire (an obvious reference to the Holocaust), or men with bound hands standing over a pit and facing a firing squad.

Wilson's Samira is both the protagonist and focalizer – we see only what she sees. The consequence of a dominant single-protagonist focalization is that "the spectator, like Samira herself, does not know what happens to other women after they are led away (that not knowing is arguably more horrifying than graphic depiction). When they come back, the women do not talk about their brutalization but rather focus on caring for one another."[41] Samira's construction as the defiant victim must, therefore, be necessarily viewed through the prism of the trauma-inducing rape that is so blatantly rendered on screen – so as if to deliberately force the viewer to cringe. The purpose of the disturbingly voyeuristic rape scene, bordering on pornographic explicitness, was explained by the film director at the conference "International Cultural Responses to Wartime

Rape: Ethical Questions and Critical Challenges" at Maynooth University, Ireland (19–20 June 2017). During the Q&A session, following a screening of her film, Wilson emphasized that to understand the overbearing psychological consequences of rape, one must first understand (*see*) what the victim had to endure in terms of the sheer physical pain – as well as the degree of humiliation that was inflicted during the act. Her aim was, therefore, to achieve an "unsettled response to another's unsettlement, [which] disturbs disciplinary protocols of representation and raises problems bound up with one's implication in, or transreferential relation to, charged, value-related events and those caught up in them."[42] It ought to be underscored that Wilson took care that this particular scene provided justification for Samira's subsequent 'willing' choice to become the lover of the camp's commandant: "Her disembodiment in the moment of extreme trauma is, in a seeming jump cut, then transformed into a shot in which she stands in the background while the men urinate in the foreground. [...] The following shot [...] reveals that the men are urinating on Samira, and that the seeing figure in the background conveys Samira's experiencing the brutalization as an out-of-body event."[43] Thus, Samira's defiance – in terms of 'choosing' her rapist, if albeit only a symbolic act – signifies "the human attempt to reverse the de-objectifying work of pain by forcing pain itself into avenues of objectification [...] laden with practical and ethical consequence."[44]

In contrast, in *In the Land of Blood and Honey*, Jolie chose to depict wartime rape during the Bosnian conflict from the dual perspective of a female Bosnian-Muslim victim and a male Serbian perpetrator within "[an] all-seeing camera gaze [which] dissects the events from a cold distance that purports to reflect comprehensive understanding rather than a sense of traumatic immediacy."[45] The main problem of the film is, however, the construction of the female protagonist. In contrast to Wilson's Samira, Jolie's Ajla remains in an emotionally charged relationship with her captor. The opening scenes of *In the Land of Blood and Honey* introduce Ajla as she prepares for a date with Danijel, their meeting and dancing together indicating a budding love between a Muslim Bosnian and a Serb. The sudden explosion at the pub symbolizes the abruptness of the war that will shatter lives. There is a subsequent temporal shift in the plot line. Four months after the explosion at the bar, Ajla and her sister are awakened by Serbian soldiers who enter the block of flats where they live, forcing all the (Muslim) inhabitants to leave, then separating the men from the women. The men are shot and selected women are taken to a detention centre.

At the camp, the women have all their belongings taken away from them, and they are lined up facing the Serbian guards. A young woman

is brutally raped in front of the others: "the scene is, in one obvious respect, something of a didactic illustration of rape as an instrument of war, but it is also undeniably and rightly disturbing. It rattles the movie and you [the spectator] along with it, and it also introduces the idea that war is very much about the violent domination of women and not just about nation-states, ethnic conflicts, historical grudges, and men killing men."[46] Ajla is also 'selected' for rape, but Danijel notices her and saves her. In a somewhat sarcastic manner, one may say that it would be difficult not to notice her, considering the snow-white shirt and glaring yellowish sleeveless sweater she is wearing. Other questions immediately pose themselves. How plausible is it that of all the rape camps, Ajla finds herself in the one where her former love is the commander? And why, when given a chance to escape from the camp by Danijel himself, does she not do so?

Ajla is initially introduced in the film as a melodramatic victim, whom I define as a protagonist within a love-centred plot that is determined by a framework of conventional devices including "strong pathos," "heightened emotionality," "moral polarization," "nonclassical narrative mechanics," and "spectacular effects."[47] "Strong pathos" is defined "as a kind of visceral physical sensation triggered by the perception of moral injustice against an undeserving victim," yet it also "requires identification, which, by extension, leads to the notion that pity often (or always?) involves an element of self-pity."[48] The generic prerequisite of "heightened emotionality" demands "states of emotive urgency, tension, and tribulation," whereas "moral polarization" entails "a moral absolutism and transparency" in the construction of characters.[49] The "non-classical narrative mechanics" designate "a far greater tolerance, or indeed a preference for outrageous coincidence, implausibility, convoluted plotting, *deus ex machina* resolutions, and episodic strings of action that stuff too many events together to be able to be kept in line by a cause-and-effect chain of narrative progression";[50] and, finally, the "spectacular effects" dictum demands "an emphasis on action, violence, thrills, awesome sights, and spectacles of physical peril."[51] Of course, it is not unusual for a war film to integrate conventions of the melodramatic genre (Rowland V. Lee's 1927 *Barbed Wire*, or Howard Hughes's 1930 *Hell's Angels*), the obvious purpose of which is to cater to both male and female audiences.

Ajla's melodramatic visage is subsequently combined with that of the defiant and avenger rape-victim types within a plot that is as spectacular as it is highly improbable. One may argue that Jolie intended the love story to convey the senselessness of a conflict that tore a multi-ethnic nation apart, forcing former neighbours, friends, and lovers to become enemies. As Danijel tells Ajla, "I do not like the role of the murderer of

the people I know." And yet Ajla's characterization as a melodramatic victim must be considered ethically unacceptable for the primary reason that she simply does *not* appear as a traumatized woman – in either her behaviour or her appearance – to the viewer. When she is chosen by Danijel and taken to his room for the first time, there is, significantly, no sex. Rather, we witness an awkward reunion of former lovers-to-be. There is likewise no sex when Ajla is summoned for the second time, with Danijel confessing to her his moral misgivings about his duties as a soldier. During their third encounter, they indulge in a strange date-talk, asking each other about their interests and professions. There are only smiles and the holding of hands. It is only after Ajla is brutally mistreated during a dinner for the Serbian soldiers, with one guard stepping on her hand while she is trying to pick up broken plates, that her meeting with Danijel ends with sex, the act being a means of comforting her. The close-up of Ajla's face shows her to be at ease and happy. After they make love, Danijel tells her of a way she may escape, and yet she does not make the attempt, obviously preferring to stay with him and for him. Ajla will run away only when Danijel is posted elsewhere. This film was made more than two decades after the definition of rape trauma syndrome was introduced, a definition unambiguous in its implications: "RTS can only be induced through a *nonconsensual* sexual incident" (my emphasis).[52]

The Bosnian War was crucial in changing the manner of thinking about rape in wartime. What this war brought to attention was the patterns of sexual victimization beyond the hitherto assumed typical contexts of rape ("individual and gang rapes in conjunction with looting and intimidation of the target ethnic groups"), such as "rape in detention facilities or camps, involving women being picked out by soldiers, camp guards, paramilitaries and civilians for both individual and gang rapes, beatings and killings," "women detained for the purpose of rape and impregnation in detention facilities in order to carry out a policy of ethnic cleansing," "captivity of women in hotels and similar facilities for the purpose of providing sexual entertainment for the soldiers."[53] Though according to one review, "Jolie manages the tricky feat of creating a chaotically violent vision, in which the focus remains intently on those who, in many war movies, are often an afterthought: the women,"[54] one needs to ask about the type of female victim she conjured upon the screen. For not only does Ajla behave as if she were all too happy to be with her beloved in the detention camp, but she also looks impeccably beautiful in her consistently clean clothes. Her appearance marks her out from the other women, whose bodies are dirty and whose clothes are rag-like, an obvious visual signifier of their suffering and humiliation. Ajla as the melodramatic victim must raise objections, particularly

in light of the attempts to discredit actual rape victims during the trials of accused Serbian war criminals. Nicola Henry provides the telling example of the Foca trial, where "Witness 87 was recalled to rebut that she was a girlfriend of the accused [...]. Defence witnesses had testified to seeing Witness 87 with Kovač in several cafes around Foča during the summer of 1992, that she had been introduced as his 'girlfriend,' and the couple 'looked to be in love.'"[55] The victim was thus denied the status of victimhood because she was allegedly "having feelings" for the perpetrator.

Melodrama is characterized by an implausible plot the aim of which is to engage the viewer affectively by sensational twists and turns of action. The caesura in Jolie's film is marked by Ajla's successful escape and her reunion with her sister, from whom she learns about the death of her baby nephew (thrown out of the window by a Serbian soldier). A group of Bosnian Muslims are in hiding, and they think of ways they could get information about the plans of the Serbian army. Knowing of Danijel's feelings for Ajla, their plan is to get her 'captured' again so that she can act as a spy among the Serbs. At this point of the film, we see the transition of Ajla from a melodramatic victim to an avenger-version of the defiant victim. When she is again with Danijel as his 'captive,' it is no longer clear to what extent she loves or hates him, particularly when, in summer 1995, she hears on the radio about the discovery of mass graves of Muslim men and boys in Srebrenica, or when she is raped by one of Danijel's soldiers at the command of his father. As the end of the war is approaching, with NATO bombing Serbian positions, there is to be a meeting of the military command in a church, a fact that Danijel reveals to Ajla. Sheer luck saves Danijel, who leaves the church for a moment to have a smoke. It is then that the explosion occurs, killing his father and his comrades-in-arms. When he sees Ajla's sister behind the gates of the church, he knows he was betrayed by the woman he had loved and protected. This is the most stereotypical designation of a woman as an object of desire inevitably leading a man to his downfall, an almost biblical Eve-Adam pattern. Danijel returns to kill Ajla, and then gives himself over to the UN forces. This highly intricate plot, in which Ajla is first a lover and then a spy within circumstances of captivity, is a slap in the face of actual rape victims. So much work has been done by human rights activists and feminists to exceed hitherto accepted definitions of rape so as to account for the diverse sources of traumatization, also encompassing – significantly – "cases where women are free to go home at night or even to escape, [but] the conditions of warfare might nonetheless be so overwhelming and controlling as to render them little more than sex slaves" because they "may be forced to submit to serial rape in exchange for their safety or that of others or the means of survival. Even though

the women would not, strictly speaking, be prostitutes, they would be forced to engage in an exchange of sex for something of value for one or more men in a dominant position of power."[56] The key word to understanding what rape entails is 'coercion,' whatever form it takes. And if there is obviously no coercion in the case of Ajla, then there is no rape, and if there is no rape within the melodramatic framework of this film, then we can speak only of a simulacra of victimhood.

It is, however, the symbolism of Ajla's nakedness that renders her Muslim/female victim-status the most morally questionable, to say the least. It is not clear why Jolie would wish to eroticize the female body to such an extent, with the close-ups on Danijel and Ajla having sex, Danijel dancing with a fully naked Ajla, or Danijel binding Ajla so as to take her by force, a scene uncomfortably close to pornographic fantasies. Jolie's decision to undress her leading actress effectively excludes constructing the effect of physical and psychological traumatization. It should be added that the explicitness of the rape scene in Wilson's film is achieved without the audience seeing Samira fully naked, that is, prior to the rape. She is shown desperately trying to cover herself. It is worth mentioning here the role of Danijel's 'demonic' father, who is obsessed with Muslims, whom he regards a threat to the Serbian national identity. Yet when he tells his son to get rid of Ajla, warning him that she should not be trusted, he is right – for she will ultimately betray him. And the foreshadowing of her deceitful nature is inscribed precisely in her fully displayed nakedness. This is not to say that this was Jolie's intention; rather, the meanings of Ajla's naked body derive from the overall context of the uses/abuses of female nudity in the war film.

If male nudity in the war film has overt epistemological meanings pertaining to the ideological representations of war itself, be it in versions of the transformed body in initiation/de-initiation scenes or the liberated body, the defeated body, and the traumatized body in contexts of combat,[57] female nudity conveys a significance that has nothing to do with the military conflict itself – being predominantly a judgment on the morality of the woman. To put it bluntly, the more the woman is undressed, the more immoral she proves to be. In the conventional (combat-oriented) war film, female nudity is depicted primarily as the depraving body, whether in the form of illicit photos the soldiers share with each other (Jack Gold's *Aces High*, 1976; William Boyd's *The Trench*, 1999) or possessing naked women as 'trophies of war,' though this 'immoral' erotic fascination with the female body symbolically foreshadows the male defeat/death in war after the initial victories (Rauni Mollberg's *Tuntematon Sotilas*, 1985). If a female combatant appears in the war film, she is frequently undressed for the purposes of constructing an image of

the carnivalesque body (Hieronim Przybył's *Rzeczpospolita babska*, 1969) in order to ridicule "the transgression of gender boundaries," for "the institution of war was gendered as masculine both ideologically and pragmatically[;] the fact of uniform being a 'man's' might be taken for granted."[58] Most pertinent to Jolie's film is, however, the use of female nudity to signify the woman's ethical positioning in the film as the depraved body. In Jean-Paul Salomé's *Les femmes de l'ombre* (2008), for instance, only three out of the four female SOE (Special Operations Executive) agents sent to France on a mission to free a British geologist from the Gestapo are shown in partial or complete nudity: Jeanne, a former prostitute and convicted murderer; Suzy, the French lover of an SS officer; and Gaëlle, a seemingly innocent recruit who will break down during interrogation and betray her comrades. The undressing of these women in film denotes either their previous immorality (Jeanne and Suzy) or their subsequent moral degradation (Gaëlle). In contrast, the character of Louise, defined by her impeccable moral fibre and outstanding efficiency and courage as an SOE agent, is never shown in the nude – even during the scenes of torture by the Gestapo she is undressed only to her underwear. Further, one will not see an actress shown stripped naked when performing the role of Irena Sendlerowa, who saved hundreds of Jewish children from the Warsaw Ghetto (John Kent's *The Courageous Heart of Irena Sendler*, 2009). Hence, Ajla's nudity in Jolie's film is a readable code of her demoralization.

The construction of Ajla as an acquiescing lover and a defiant avenger defies "the standard dynamic of trauma [that] makes the traumatized subject the passive recipient of the traumatic event,"[59] and may lead to questioning of the traumatic nature of the experience of the Serbian rape camp itself. The symbolic meaning inherent in the visualization of female nakedness must likewise create an ethical and empathetic distance from this character, the more so as such an explicitly eroticized body visually negates "the force of the violated [traumatized] body as witness to the exercise of power [that] is carried over to the violated psyche, with its analogous but invisible scars."[60]

In turn, Anne Fontaine's *Les Innocentes* (2016) conjures a sacrosanct rape victim. Though said to have been inspired by fact, the film is marked by historical inaccuracies and a highly contrived plot that, altogether, must raise doubts as to how women's trauma is shown and told on screen in this particular case. The film is based on the true story of Madeleine Pauliac, a representative of the French Red Cross whose work in Poland was predominantly focused on finding and repatriating French POWS from a one-time war zone. In Fontaine's film, she is renamed as Mathilde Beaulieu, indicating that historical veracity was not the main aim of the

filmmakers. The setting of the action is stated at the beginning of the film to be "Poland, 1945," though in truth Pauliac encountered raped and pregnant nuns in Gdańsk (Danzig). Setting the film 'somewhere' in Poland immediately creates an interpretive framework within which the Soviet soldiers are the barbarian-rapists. The film's focus on nuns as victims of rape comes across as evidence of the Red Army's total lack of respect for the sphere of the sacred, assumed to be untouchable within so-called civilized societies. The Red Army soldiers are shown to come back to the convent when Mathilde is present – it is only her lie that there is a typhoid threat that saves the nuns from yet another wave of rape. Hence the image of the Red Army in this film is disturbingly similar to Nazi propaganda warnings against the "Asiatic horde," "backward and primitive," with "[their] sheer otherness [...] pronounced to emphasise that defeat would mean the end of civilisation."[61] Fontaine's film (deliberately?) overlooks the behaviour of Soviet troops as they entered territories perceived to be German even if within the borders of pre–Second World War Poland – as in the case of towns such as Poznań (Posen) or Gdańsk, where rape sprees occurred on a massive scale. In her analysis of the depiction of the Soviets in Färberböck's *Anonyma – Eine Frau in Berlin*, Petra Rau writes that "the Eastern Front is an unseen prequel to *Anonyma*, and the subtlety of the film lies in the fact that the audience – from the point of view of the civilian protagonist – gradually realise that the events on the screen unfold as a corollary of German fascism and genocidal warfare."[62] Though it is true that women in all so-called liberated territories were widely considered by the Red Army as 'spoils of war,' it is also a fact that the Soviets did not deliberately target nuns; rather, one may claim that the rape of the nuns in Gdańsk was more due to the fact that the soldiers viewed this city as German, and the rapes were driven more by a desire for revenge for the German army's war crimes within the USSR than for any other reason.

If historical veracity was not the main concern in the case of *Les Innocentes*, then what could possibly be the purpose of this film about raped nuns? Nuns cover their bodies, which need to remain in a state of innocence so that their bearers are worthy as 'the brides of Christ.' The sexual violation of their bodies is thus a violation of the sphere of the sacred. Rape is here a sacrilegious act of "bodycide":[63] a genocidal destruction of the pure female (Christian) body. To invade the sphere of the sacred – that is, to rape nuns – calls forth an overt ethical judgment on the conduct of Red Army soldiers, but what end does it serve as regards the representation of the sexual subjugation of women in wartime? It is within the context of this specific film that I propose the definition of the sacrosanct victim type so as to underscore how this cinematic exploitation

of the historical fact of raped nuns effectively blocks the possibility of an empathetic response on the part of the viewer. A sensationalist effect is (inadvertently?) created – nuns raped, nuns pregnant, nuns bearing children. These nun-characters face dilemmas that the vast majority of viewers will all too certainly be unable to identify with, namely, how to interpret 'God's will' in the face of the atrocity that befell them, or how to reconcile religious vocation with the maternal instinct.

There is a sequence of scenes that are an apparent attempt to create a common ground between the sacrosanct victim (the nuns) and the atheist Mathilde. The question is: how successful is it? The first scene within the sequence shows Mathilde trying to examine all the nuns who are pregnant. One of the nuns cringes when Mathilde tries to touch her. The viewer could interpret this instinctive repulsion as the traumatic repercussion of the rape itself, any attempt at physical intimacy – necessary in gynaecological treatment – causing a purely defensive reaction. However, Sister Maria explains to Mathilde what it means for a nun to be raped and what are the psychological consequences. Regardless of the physical violation of their bodies, the nuns must still abide by the rule of chastity. This means they cannot expose their bodies or accept being touched by another person, for this would be a sin. Mathilde obviously does not understand the nuns' refusal to be helped. The next scene shows Mathilde stopped by Red Army soldiers at a checkpoint as she is driving back to the Red Cross mission. The men force her out of the ambulance and attempt to rape her. She is saved by the soldiers' commanding officer, and returns to the convent where – significantly – she finds temporary solace in the prayers and hymns. It is from this point in the film that Mathilde and Sister Maria find a common ground. However, to claim that this film argues for the sanctity of the female body would be going too far.

Though Sister Maria tells Mathilde about her inability to forget the obviously traumatic experiences of the gang rapes, and many of the nun-characters are shown to be in a state of "extreme fear" or desperately trying to "control [their] observable reactions,"[64] the film appears less an insight into rape trauma syndrome and more a psychological study of vocation when challenged by the maternal instinct. This inner conflict takes its most dramatic turn when Sister Zofia, having had her own baby taken away from her, agrees to nurse the child of another nun. When she also loses this child, she commits suicide. Most of the nuns obviously desire to retain their children, and this will prove possible when Mathilde comes up with an idea that can save the nuns from social ostracism and political persecution by the new Polish regime: to establish an orphanage within the walls of the convent. From the beginning of the film, Mathilde is shown to be very attentive to the plight of the homeless children coming

to the French Red Cross mission. We see through her eyes the desperate means by which these children try to survive, begging for money or selling cigarettes. Before leaving Poland, she brings these children to the nunnery, asking that they be protected and cared for. And the nuns are all too happy to take them under their care, a decision that will also allow the nuns to remain the mothers they want to be. The 'happy ending' of the film thus poses a problem in terms of the meanings conveyed through the spring setting of the scene, exaggeratedly showing the nunnery-as-orphanage full of happy children running around amongst the fresh and blooming nature. When Mathilde first comes to help the nuns, it is winter, and the bleak seasonal scenery only enhances the alienating austerity of the nunnery, a place as cold and empty as the snow-covered fields. It appears a lifeless place – in a metaphorical sense, for the nuns have 'lost' their previous lives and are unable to find paths leading them out from their emotional deadlock. There is a highly visible contrast between the nunnery in winter, and the misery of its inhabitants, and the nunnery-as-orphanage in spring, with nuns playing with the children. Though it is difficult to believe that such a message was intended by the filmmakers, the concluding colourful images of bliss appear to indicate the 'beneficial' consequences of the rapes. However traumatizing their experience was, the nuns – due to motherhood – become simply more 'human,' no longer shut off from the outside world and entrapped within their religious rituals.

The character who sparked the greatest controversy is that of the mother superior. In a commentary on the film, provocatively entitled "I Will Not Go to the Cinema to See *Les Innocentes*," Małgorzata Borkowska, a Benedictine nun herself, writes that it is clear that the film is based on an existing stereotype of a "demonic abbess": "I know, for example, that a general image of the nunnery, shared by novelists (and screenplay authors), is that of a herd of sheep who completely succumb to the power of the wolf, a scary and soulless mother superior. The demonization of a mother superior is a fact, and nobody takes the trouble to explain where such wolves come from."[65] In the film, the mother superior, in order to safeguard what she understands as the respectability of the nuns – the more necessary in the wake of the changing political reality of post-WWII communist rule in Poland – disposes of the babies born of rape, telling their mothers that they were taken by families ready to nurse and raise them. In reality, she takes them to a crucifix erected at a small path leading through the fields. Considering it is winter, the babies left in a basket out in the open have no chance of survival. Of course, poetic justice demands that the villain be punished, and the mother superior – also a rape victim – is discovered to be in an advanced stage of syphilis. At the

end of the film, she is shown lying in bed, suffering from the physical pain and the spiritual torment she obviously deserves. Yet, as Borkowska writes, convents always had their clear-cut rules, even in wartime: "As regards the future of the victims, the rule is that if a nun is raped and gets pregnant, she is given a choice: she can raise the child herself, in which case her vows cease, or she can submit the child for adoption and return to the nunnery."[66]

Most importantly, Borkowska asks about the purpose of the film. For though it is a fact that there were instances of nuns being raped by Red Army soldiers, "why should somebody's pain be turned into a spectacle?"[67] The answer is that this is not just any woman's pain but a nun's, and thus it promises from the outset a shocking content. There is, she writes, always an aura of mystery surrounding closed convents: wouldn't one want to know what is going on behind those walls? And suddenly this great story falls into the hands of a French film director, "a bloody and graphic story about a group of nuns and novices who have been raped and give birth to their children in secret."[68] It is enough to look at the newspaper headlines following the release of *Les Innocentes* – "Forgotten Story of Polish Nuns Gang-Raped and Made Pregnant by Advancing Soviet Troops and Cared For by a French Female Doctor Revealed for the First Time in 70 Years,"[69] "French Film Looks at Soviet Barbarism against Polish Nuns in WWII"[70] – to note that the trauma of the rape victim was not at the forefront of reviewers' attention.

Conclusion: The Ethical Pitfalls of Filmic Representations of War-Rape Victims

My work on a typology of rape victims in the war film derives from my concern about the adequacy of the representational strategies adopted by various filmmakers to convey both the shades of individual traumas suffered in wartime and the diverse truths of why rapes occurred during specific military conflicts, for, as Dominick LaCapra notes, "there is something inappropriate about signifying practices – histories, films, or novels [that] in their very style or manner of address tend to overly objectify, smooth over, or obliterate the nature and impact of the traumatic events they treat."[71] Analysis of war films taking up the subject matter of wartime rape inevitably leads to the question of the (ethical) role of the viewer. Within the specific context of Holocaust testimonies, Dori Laub writes of the ethical responsibility of the listener who "comes to be participant and co-owner of the traumatic event" because "it is only in this way [...] that he can become the enabler of the testimony – the one who triggers its initiation as well as the guardian of its process and its

momentum."[72] One may claim that the 'perfect' film revolving around
the issue of trauma is one capable of both cognitively and affectively
engaging its audience. In the case of the war film genre, however, yet
another audience role is intended, that of the "memorial-witness," to
be understood in terms of convincing viewers that a historical event
is worth 'remembering.' And it is only when the audience can see the
relevance of a historical event for their national/social/ethnic/racial/
gender identities that they can become an "enabler" of the past for the
purposes of the present.

As regards filmic (as well as literary and other artistic) representations
of trauma, it can be argued that "the task is an impossible one" because
"no second-hand rendering of it is adequate" and "only the experience
of trauma has the traumatizing effect." Kali Tal adds, however, a point
that is particularly pertinent to the showing and telling of rape in the
historical (war) film: "the [victim] comes to represent the shattering of
our national myths, without being able to shatter [the audience's] indi-
vidual personal myths. And it is those personal myths that support and
uphold the most widely accepted national ones. No grand re-structuring
of national myth can be accomplished without a concurrent destruction
of the personal myths that [images] simply cannot reach."[73] Hence, the
audience may not be all that willing to *see* (i.e., understand) the connec-
tions between the past and present, if this would entail questioning one's
national identity. Too *see* (on screen) Serbs raping Bosnian Muslims, or
Red Army soldiers raping nuns, may prove a desired escape route from
troublesome questions about the complicity of one's own nation in the
sexual victimization of women, in wartime or in the present, for it is all too
easy to interpret ethically comfortable films as *not concerning us*, because
'we' are not the Serbs, Soviets, and so on, and it all happened elsewhere
and in the past, so why should we care? Hence, filmic representations
of rape-victim types are all-important: "Put more sharply and more con-
cretely, it is not only a question of whether the single image or frame can
stand for an entire event, but also whether, quite generally, the one can
stand for the many, [...] whether one human being can represent the
collective, [...] in a medium where the single image and the individual
voice have assumed a new power."[74]

Finally, one needs to ask about the reasons behind the post-1990s
proliferation of films about war rape. This may well be viewed as the
long-awaited interest in a hitherto marginalized subject matter – or as
an exploitation of a trendy topic. One must bear in mind that the more
overt the visualization of rape in film, the more likely it is to promote the
'pornographic gaze,' that is, an audience reaction that focuses on the
perverse pleasure of viewing an eroticized female body rather than on

the trauma that rape entails. Additionally, the more filmic rape depictions one sees, the more immune one becomes to the physical and psychological suffering rape involves. In the words of LaCapra, "there is a routinization of hyperbole or excess, and uncontrolled transference and acting-out," and consequently "the absolutization of trauma,"[75] which becomes more of a sublime event, invoking awe and fascination, rather than an empathetic understanding.

NOTES

1 Guy Westwell, *War Cinema: Hollywood on the Front Line* (London: Wallflower, 2006), 5.

2 Robert A. Rosenstone, "History in Images/History in Words," in *The History on Film Reader*, ed. Marnie Hughes-Warrington (London: Routledge, 2009), 35.

3 Kali Tal, *Worlds of Hurt: Reading the Literatures of Trauma* (Cambridge: Cambridge University Press, 1996), 121.

4 Pierre Sorlin, "The Film in History," in *The History on Film Reader*, ed. Marnie Hughes-Warrington (London: Routledge, 2009), 36.

5 Mike Chopra-Grant, *Cinema and History: The Telling of Stories* (London: Wallflower, 2008), 8.

6 Ibid.

7 See Susannah Radstone, "Trauma Theory: Contexts, Politics, Ethics," *Paragraph: A Journal of Modern Critical Theory* 30, no. 1 (2007): 9–29, http://dx.doi.org/10.3366/prg.2007.0015.

8 Tal, *Worlds of Hurt*, 128.

9 James Latham, "1918 Movies, Propaganda, and Entertainment," in *American Cinema of the 1910s: Themes and Variations*, ed. Charlie Kiel and Ben Singer (New Brunswick: Rutgers University Press, 2009), 210.

10 Sarah Projansky, *Watching Rape: Film and Television in Postfeminist Culture* (New York: New York University Press, 2001), 2, 3.

11 Sabine Sielke, *Reading Rape: The Rhetoric of Sexual Violence in American Literature and Culture, 1790–1990* (Princeton: Princeton University Press, 2002), 6.

12 Projansky, *Watching Rape*, 215.

13 Nicola Henry, *War and Rape: Law, Memory and Justice* (London: Routledge, 2011), 137.

14 Rachel S. Harris, *Warriors, Witches, Whores: Women in Israeli Cinema* (Detroit: Wayne State University Press, 2017), 189–90.

15 Elaine Scarry, *The Body in Pain: The Making and Unmaking of the World* (New York: Oxford University Press, 1985), 3.

16 Cathy Caruth, "Recapturing the Past: Introduction," in *Trauma: Explorations in Memory*, ed. Caruth (Baltimore: Johns Hopkins University Press, 1995), 153.

17 Shani D'Cruze, "Sexual Violence in History: A Contemporary Heritage?" in *Handbook on Sexual Violence*, ed. Jennifer M. Brown and Sandra L. Walklate (London: Routledge, 2012), 41.

18 Projansky, *Watching Rape*, 221.

19 Raphaëlle Branche, Isabelle Delpla, John Horne, Pieter Lagrou, Daniel Palmieri, and Fabrice Virgili, "Writing the History of Rape in Wartime," trans. Helen McPhail, in *Rape in Wartime*, ed. Raphaëlle Branche and Fabrice Virgili (New York: Palgrave Macmillan, 2012), 4.

20 Marzena Sokołowska-Paryż and Martin Löschnigg, "Introduction," in *The Enemy in Contemporary Film*, ed. Martin Löschnigg and Marzena Sokołowska-Paryż (Berlin: De Gruyter, 2018), 1.

21 Branche et al., "Writing the History of Rape," 9.

22 Alison Landsberg, *Engaging the Past: Mass Culture and the Production of Historical Knowledge* (New York: Columbia University Press, 2015), 3.

23 Alison Landsberg, *Prosthetic Memory: The Transformation of American Remembrance in the Age of Mass Culture* (New York: Columbia University Press, 2004), 9.

24 Landsberg, *Engaging the Past*, 3.

25 Kristen Zaleski, *Understanding and Treating Military Sexual Trauma*, 2nd ed. (New York: Springer, 2018), 12.

26 Ibid.

27 *The Human Rights Watch Global Report on Women's Human Rights* (New York: Human Rights Watch, 1995).

28 Michael Rothberg, *Multidirectional Memory: Remembering the Holocaust in the Age of Decolonization* (Stanford: Stanford University Press, 2009), 12.

29 It is worth noting that Lu Chuan, the director of *City of Life and Death* (2009), received death threats despite his film being about the Rape of Nanking. The anger of the government and the Chinese audience was due to the allegedly "too humane" portrayal of one Japanese soldier focalizing (and judging) the barbarous conduct of the Japanese Imperial Army, as well as the plight of "comfort women." See Howie Movshovitz, "The Horror of War in the 'City of Life and Death,'" https://www.npr.org/2011/06/21/137296321/the-horror-of-war-in-the-city-of-life-and-death.

30 Landsberg, *Engaging the Past*, 10.

31 Ibid., 12.

32 For an analysis of the depersonalized rape victim in the war film, see Marzena Sokołowska-Paryż, "The Narration and Visualization of Rape and the Inadvertent Subversion of the Anti-war Message in Brian De Palma's *Redacted* and *Casualties of War*," *War, Literature and the Arts* 24 (2012), accessed 16 February 2020, https://www.wlajournal.com/wlaarchive/24_1-2/SokolowskaParyz.pdf. For an analysis of the sacrificial and defiant rape victim in the war film, see Marzena Sokołowska-Paryż, "War Rape: Trauma and the Ethics of Representation," in *Traumatic Memories of the Second World*

 War and After, ed. Peter Leese and Jason Crouthamel (New York: Palgrave Macmillan, 2016).

33 Landsberg, *Prosthetic Memory*, 9.

34 Judith Herman, *Trauma and Recovery: The Aftermath of Violence – From Domestic Abuse to Political Terror* (New York: Basic Books, 1992), 33.

35 Zaleski, *Understanding and Treating Military Sexual Trauma*, 11.

36 Sorlin, "The Film in History," 16.

37 Adam Jones, *Genocide: A Comprehensive Introduction* (London: Routledge, 2011), 323–4.

38 *Human Rights Watch Global Report*, 10.

39 Ibid., 9.

40 Stephen Harper, "Bosnia beyond Good and Evil: (De)Constructing the Enemy in Western and Post-Yugoslav Films about the 1992–1995 War," in *The Enemy in Contemporary Film*, ed. Martin Löschnigg and Marzena Sokołowska-Paryż (Berlin: De Gruyter, 2018), 333, 341.

41 Dijana Jelača, "Gendered Visions in *As If I Am Not There and In the Land of Blood and Honey*: Female Precarity, the Humanitarian Gaze and the Politics of Situated Knowledge," *Jump Cut: A Review of Contemporary Media*, no. 57 (Fall 2016), accessed 16 February 2020, https://www.ejumpcut.org/archive/jc57.2016/-JelacaBosniaRape/index.html.

42 Dominick LaCapra, *History in Transit: Experience, Identity, Critical Theory* (Ithaca: Cornell University Press, 2004), 136.

43 Jelača, "Gendered Visions"

44 Scarry, *The Body in Pain*, 6.

45 Jelača, "Gendered Visions."

46 Manohla Dargis, "In a Fractured Society, Ethnic War Kindles Both Hatred and Desire," *New York Times*, 22 December 2011, http://www.nytimes.com/2011/12/23/movies/angelina-jolies-in-the-land-of-blood-and-honey-review.html?partner=rss&emc=rss.

47 Ben Singer, *Melodrama and Modernity* (New York: Columbia University Press, 2001), 7.

48 Ibid., 44.

49 Ibid., 45.

50 Ibid., 46.

51 Ibid., 48.

52 Jeffrey T. Waddle and Mark Parts, "Rape Trauma Syndrome: Interest of the Victim and Neutral Experts," *University of Chicago Legal Forum*, vol. 1989, article 18, 402, accessed 16 February 2020, http://chicagounbound.uchicago.edu/uclf/vol1989/iss1/18.

53 Henry, *War and Rape*, 65.

54 Dargis, "In a Fractured Society."

55 Henry, *War and Rape*, 86.

56 Women's Caucus for Gender Justice, "The International Criminal Court," accessed 16 February 2020, http://www.iccwomen.org/wigjdraft1/Archives /oldWCGJ/icc/iccpc/iccindex.html.

57 Marzena Sokołowska-Paryż, "The Naked Male Body in the War Film," *Journal of War and Culture* 5, no. 1 (2012), 22–4, 25–7, 27–8, 28–30.

58 Dora Apel, "'Heroes' and 'Whores': The Politics of Gender in Weimar Antiwar Imagery," *Art Bulletin* 79, no. 3 (1997): 376–7.

59 Ana Douglass and Thomas A. Vogler, "Introduction," in *Witness and Memory: The Discourses of Trauma*, ed. Ana Douglass and Thomas A. Vogler (New York: Psychology Press, 2003), 10.

60 Ibid., 12.

61 Petra Rau, "From 'Ivan' to Andreij: The Red Army in German Film and TV," in *The Enemy in Contemporary Film*, ed. Martin Löschnigg and Marzena Sokołowska-Paryż (Berlin: De Gruyter, 2018), 123–5.

62 Ibid., 133.

63 I am appropriating here the term "bodycide"/"*ciałobójstwo*," which appears in Wojciech Tochman's reportage on the Rwandan genocide, *Dzisiaj narysujemy śmierć* (Today we will draw death) (Wołowiec: Wydawnictwo Zarne, 2010), 53.

64 Waddle and Parts, "Rape Trauma Syndrome," 401.

65 Małgorzata Borkowska, "Nie pójdę do kina na 'Niewinne,'" trans. Marek Paryż, *Tygodnik Powszechny*, 9 March 2016, https://www.tygodnikpowszechny.pl /nie-pojde-do-kina-na-niewinne-32712.

66 Ibid.

67 Ibid.

68 Ibid.

69 Darren Boyle, "Forgotten Story of Polish Nuns Gang-Raped and Made Pregnant by Advancing Soviet Troops and Cared For by a French Female Doctor Revealed for the First Time in 70 Years," *MailOnline*, 2 October 2016, https://www.dailymail.co.uk/news/article-3818311/Forgotten-story-Polish -nuns-gang-raped-pregnant-advancing-Soviet-troops-cared-French-female -doctor-revealed-time-70-years.html.

70 Christine Niles, "French Film Looks at Soviet Barbarism against Polish Nuns in WWII," *Church Militant*, 10 February 2016, https://www.churchmilitant .com/news/article/french-film-looks-at-soviet-persecution-of-polish-nuns -in-wwii.

71 LaCapra, *History in Transit*, 136.

72 Dori Laub, "Bearing Witness of the Vicissitudes of Listening," in *Testimony: Crisis of Witnessing in Literature, Psychoanalysis, and History*, ed. Shoshana Felman and Dori Laub (New York: Routledge, 1992), 57–8.

73 Tal, *Worlds of Hurt*, 121.

74 Thomas Elsaesser, "One Train May Be Hiding Another: History, Memory, Identity, and the Visual Image," in *Topologies of Trauma: Essays on the Limit of Knowledge and Memory*, ed. Linda Belua and Petar Ramadanovic (New York: Other Press, 2002), 69.

75 Dominick LaCapra, *History and Memory after Auschwitz* (Ithaca: Cornell University Press, 1998), 111.

PART FOUR

Representations in Film

13 Translating Individual and Collective Trauma through Horror: The Case of George A. Romero's *Martin* (1978)

ADAM LOWENSTEIN

George A. Romero placed an indelible stamp on the horror genre's relation to historical trauma when he directed his debut feature, *Night of the Living Dead* (USA 1968). Romero's landmark horror film is now widely considered not only one of the most important independent American films ever produced, but a savage commentary on the trauma of the Vietnam War and the civil rights struggle.[1] War, riots, assassinations – these are all examples of what leading trauma studies theorist Cathy Caruth calls "collective trauma," characterized by distinct and often sudden, violent, publicly recognized mass events. *Night of the Living Dead* certainly captures collective trauma through its images of horror that evoke warfare, urban unrest, and lynchings. But a broader look at Romero's career beyond *Night of the Living Dead* and its five sequels, with an emphasis on his underrated psychological vampire film *Martin* (USA 1978) in particular, reveals a remarkable talent for articulating what Caruth calls "individual trauma" – slower, quieter, and/or more private, less historically recognized forms of trauma – and translating individual into collective trauma through a vocabulary of horror.[2]

In *Martin*, the gradual economic and social decline of Braddock, Pennsylvania, in the wake of its collapsing steel industry is central to the film's horror. The young, mentally ill Martin (played with haunting sensitivity by John Amplas), who believes himself to be a vampire, arrives in Braddock to find a community already vampirized economically. This form of social catastrophe is closer to Caruth's definition of individual trauma rather than collective trauma, so it fits less easily with previous studies of trauma and the horror film that have tended to focus on events rather than processes.[3] Romero's approach in *Martin* demonstrates a counter-intuitive relation between the horror film and trauma: one might suppose that a genre often perceived as being built on shock and spectacle would not be well suited to engage the subtleties of individual

trauma. *Martin* teaches us just the opposite, and alerts us to the significant but under-recognized role that individual trauma plays in Romero's cinema. Next to *Martin*, the quiet humiliations of aging in his "lost" film *The Amusement Park* (USA 1973), the struggle for agency when living with a physical disability in *Monkey Shines* (USA 1988), and the desolation of a marriage that cannot acknowledge female subjectivity in *Season of the Witch* (USA 1973) start to look more representative than anomalous. By remapping Romero's work in this way through a close analysis of *Martin*, this essay ultimately attempts to recast our assumptions about the horror film's relation to collective and individual trauma.

The language of trauma spoken by *Martin* is not the one we expect from the horror film, with its traditional investments in fantastic spectacle. Instead, it is a language that combines horror's fantastic vocabulary and documentary's realist vocabulary in ways that undermine our attempts to distinguish between the two modes. When Romero insists on interweaving the fantastic and the real along the axis of individual and collective trauma, he reveals how horror can speak about trauma in a manner that demands a new kind of vision from its viewers. This vision urges us to see catastrophe where we are accustomed to seeing only the mundane, and collective trauma where we routinely see only individual trauma. In *Martin*'s version of horror, the economic decline of Braddock is paired with trauma connected to the Vietnam War and immigration. The film moves between these coordinates to revisualize the distinctions that divide the fantastic from the real, as well as the individual from the collective.

Documentary and Fantastic Impulses

Romero himself was fond of referring to *Martin* as his personal favourite among all of his films. I think one of the reasons for this is that *Martin*, with stunning power and precision, balances the two creative drives that characterize all of Romero's work: the documentary impulse and the fantastic impulse. These two drives express themselves in all of his films to one degree or another, but it is in *Martin* that they harmonize most perfectly and are unmasked not as competing opponents but as interdependent partners.[4] When Romero's vision is at its sharpest, he shows us how documentary ways of seeing and fantastic ways of seeing can combine to reveal more truth about the world around us than either one on its own.

So is *Martin* a vampire movie? Yes, but not just because Martin kills his victims and drinks their blood. After all, he has no fangs, no coffin, no fear of mirrors, garlic, or crucifixes. This is a vampire film in a deeper, more disturbing, and more social sense, where it is Martin's surroundings that have been bled dry of economic and emotional vitality. When

he arrives from Indianapolis to live with his elderly cousin Cuda (Lincoln Maazel) in Braddock, a decaying rust belt town outside of Pittsburgh, he finds himself in a community that has already largely disintegrated. The collapse of the steel mills has wreaked havoc far beyond economic suffering – there is distrust between the older and younger generations, alienation between couples, and desperation among the poor echoed by listless depression among the rich.

Romero captures all of this with a documentarian's expert eye, so much so that Braddock emerges as a character every bit as vivid as the unforgettable Martin himself. In fact, Martin, in his own strange and sick way, may be closer to representing the "new blood" Braddock needs to revive itself than the vampire out to drain life from the town. Although Cuda curses Martin as "Nosferatu" and maintains that his inheritance of the "family shame" stems from "the old country" in an unnamed region of Eastern Europe, Martin is decidedly modern in both his outlook and his methods. He dismisses vampire lore as superstitious "magic," substitutes hypodermic needles for fangs, masters the use of electronic technologies (the automatic garage-door opener, the telephone), and even dabbles quite successfully in mass media exposure (his confessional calls to a late-night talk radio show). What's more, Martin works hard – not just as a delivery boy for Cuda's butcher shop and a handyman for Mrs. Santini (Elyane Nadeau), but as the closest thing to an amateur therapist that Braddock can muster. Martin speaks very little, but he *listens* carefully and empathically: to his cousin Christina (Christine Forrest) about her struggles with her unreliable boyfriend Arthur (Tom Savini) and undercutting grandfather Cuda; to the lonely housewife Mrs. Santini, who becomes Martin's lover; even to Cuda, whom he hears out to the best of his ability (going so far as to sit through most of an exorcism ritual that Cuda subjects him to) and tries to educate by showing him how he is not the old-world vampire Cuda imagines him to be.

Much of *Martin*'s most fantastic imagery is contained within a form then commonly associated with documentary realism and its connotations of reportage-oriented objectivity: black-and-white film.[5] *Martin* is a colour film, but switches to black and white for sequences that function as fantasy/memory flashpoints from Martin's subjective perspective. Much of this black-and-white imagery could sit comfortably with scenes from classic horror films – the torch-bearing townsfolk, the fair maiden, the stern priest. So when Romero merges the black-and-white look of documentary with the images of fantastic horror, he alerts us to how *Martin* continually challenges the distinctions we tend to draw between these two registers. Part of the shock of Martin's death at the end of the film – Cuda hammers a stake through his heart as punishment for a murder Martin

did not commit – is that what is supposed to be an image from a classic horror film has now erupted in the real world of Braddock. Romero presents this brutal killing in full colour, with no recourse to black and white. The result is devastating on several levels: not only has Martin's subjectivity been snuffed out, but our ability to separate the "fantastic" from the "real" has been destroyed as thoroughly as Martin's body.

The disintegration of distinctions between the fantastic and the real performed in *Martin* has important implications for our understanding of the relationship between individual and collective trauma. When Romero depicts the character of Martin through both horror genre imagery (in subjective yet documentary-coded black and white) and documentary realist iconography (in objective yet genre-coded colour), he frustrates our desire to explain Martin as purely the product of either fantasy or reality. Instead, what Romero suggests is that we need the fantastic to fully comprehend the real, just as we need the real to fully grasp the fantastic. This blind spot in our ways of seeing corresponds to our difficulty in recognizing the presence and impact of individual trauma when our conventional yardstick is collective trauma. If Martin is not quite a fantastic vampire, then perhaps Braddock becomes much more of a real community for having been metaphorically vampirized of its economic vitality. In other words, the difficulty of imagining and visualizing the slow process of traumatic economic decline in Braddock is remedied through the addition of Martin, with his potent mix of fantastic and real characteristics. Martin constantly reminds us how we are always missing something when we fall back on our habits of separating individual from collective trauma. No, an earthquake has not levelled Braddock, and yet something profoundly traumatic has transpired here, something that eludes words, as the film never explicitly refers to the steel industry's collapse; still, the implicit economic trauma attached to this collapse is powerfully present. Romero wants us to see that and feel that, to access the significance of individual trauma despite the absence of collective trauma's often authenticating imprint.

How *Martin* Begins

The opening sequence of *Martin* confronts us immediately with both the complexity and the horror embedded in Romero's mission to make individual trauma recognizable for his audience. While boarding a train from Indianapolis bound for Pittsburgh, Martin glimpses his next victim: a beautiful woman dressed fashionably in an Annie Hall–style suit, separate from the rest of the passengers in both her look and her manner. She is stand-offish, setting herself apart from the conductor and the passengers

in their friendly greetings of each other. Instead, she makes it clear to the conductor that she is travelling alone in her private sleeper car, and does not want to be disturbed when the train arrives in Pittsburgh because she is destined for New York. She tips him as a way of cutting short his attempt at conversation with her about "the Big Apple." So this woman is marked from the outset by signs of things that Martin does not possess: wealth, upper-class sophistication, the demeanour of a kind of New Yorker who does not believe that Pittsburgh is worth waking up for.

Martin, on the other hand, is marked in a completely different way. He is a young, awkward, quiet loner, carrying an army-style knapsack that contains what is revealed to be drug paraphernalia: needles, vials, razor blades. When he locks himself in the train's public bathroom and prepares a needle for injection, we are already beginning to form a profile of him: a drug addict, probably a Vietnam veteran who never quite made it back from the war, likely dangerous. This impression is solidified when Martin picks the lock to the woman's sleeper car and has a hallucinatory vision (filmed in black and white) of what he will find behind the door: the woman dressed in sexy negligee, holding her arms out to him invitingly. What he discovers instead is that the woman is in her bathroom flushing the toilet, her face covered in an unappealing mud mask (see Image 13.1). He injects her with the needle and wrestles with her, trying to calm her when she fights back and calls him, quite appropriately, a "freak rapist asshole." He attempts to reassure her that he only wants her to sleep, that he is "always very careful with the needles." Once she becomes unresponsive, he strips her and himself, arranges their bodies in an embrace, and then slits her wrist with a razor blade, drinking the blood that spurts out.

So our initial impressions of Martin as a traumatized, drug-addicted Vietnam veteran, complete with hallucinatory visions and a propensity for sexual and murderous violence, shifts with this revelation of his vampiric nature. The drugs are not for him, they are for her; they replace the Hollywood vampire's seductive stare. The razor blade doubles for the Hollywood vampire's fangs, as well as evidence after the fact for the woman's suicide (a scene that Martin carefully stages after the murder to cover his tracks). And Martin's hallucinatory vision, as we discover through later examples, is not a post-traumatic combat symptom but a subjective sense of history and/or fantasy regarding his life as a vampire.

When Romero mixes these signals surrounding our understanding of Martin – post-traumatic Vietnam veteran on the one hand, bloodsucking vampire on the other – he short-circuits our habits of perception on two levels. First, he activates but then refuses our desire to stereotype Martin in the registers of either realism (Vietnam veteran) or fantasy (vampire).

Image 13.1. Martin, hiding in the shadows, prepares to attack a woman on a train in George A. Romero's *Martin*. © 1978 New Amsterdam Entertainment. All Rights Reserved. Image courtesy of Richard P. Rubinstein.

Second, he visualizes the trauma of post-traumatic stress disorder and rape in ways that are so vividly matter-of-fact, so viscerally horrifying, that he creates a powerful cinematic argument for what was then a matter of controversy in the professional psychological community: the very existence of PTSD as a diagnosable disorder. When PTSD first entered the American Psychological Association's *Diagnostic and Statistical Manual of Mental Disorders* in 1980, it was largely due to a belated recognition of the painful experience of Vietnam veterans. In other words, the professional acceptance of PTSD as a diagnosis marks an important moment in the transformation of the Vietnam War from a buried, private, individual trauma to a recognized, public, collective trauma. Even today, rape still struggles to be understood as traumatic in ways beyond the personal and individual, as the recent #MeToo movement testifies. In the opening sequence of *Martin*, the Vietnam War and rape come together through shocking visuals that defy the viewer to dismiss these experiences as insufficiently traumatic. We are robbed of our habits of wishing away such disturbing images through dismissive rationalizations such as "that's just the actions of a crazy Vietnam vet" or "that's just the actions of an imaginary Count Dracula," or even "that's just the risk a woman runs when travelling alone." Instead, the real and the imaginary collide in ways that invite us to redraw the boundaries between individual and collective trauma.

Romero extends this redrawing of boundaries in the sequence that follows the opening on the train. Once Martin arrives in Pittsburgh, he is picked up by a stern new guardian, his elderly cousin Cuda. Dressed in an imposingly formal all-white suit and issuing terse commands in thickly

accented English that instantly conveys his distaste for and distrust of Martin, Cuda manages to make Martin seem more like a vulnerable child than a predatory threat. It is as if Martin shrinks in the presence of Cuda. But it is not Cuda alone who enacts this shrinkage of Martin. It is also Martin's exposure to the wide outside world rather than the confined quarters of the train. At first, this world is represented by Pittsburgh, with its tall, massive downtown buildings that turn Martin into a tiny figure by comparison, made smaller by Cuda distancing himself deliberately from him as he walks ahead of him, speaking to him only rarely, and even crossing himself at the sight of him. Cuda tells Martin they must board another train, this one headed to the town of Braddock just outside of Pittsburgh. This second short train ride effectively undoes the dread we experienced in the film's opening train sequence, as Martin drags his luggage inelegantly, nearly misses the train after stopping in the public bathroom, and sits silently next to the cigar-smoking Cuda as if he were a child in need of supervision. Martin the predator who speaks confidently to his prey during his attack has become Martin the child who can only observe silently and helplessly.

What Martin observes when he arrives in Braddock is primarily emptiness. The streets lack people despite the sunny daytime weather, barking dogs run loose without owners, and the only functioning business seems to be a junkyard where the abandoned hulks of cars are compacted. Even Cuda's neatly kept white Victorian house is empty. His granddaughter Christina, who lives with him, is not at home. What fills the house instead is evidence of the superstitions that Cuda holds onto as weapons against Martin's vampirism: crucifixes, garlic, mirrors. When Cuda addresses Martin as "Nosferatu," it triggers Martin's second series of black-and-white visions. These visions depict a younger-looking Martin subject to the religious rites of priests meant to cast out the vampire, while Martin retorts, "There isn't any magic, it's just a sickness." Back in the colour-film reality of Braddock, Martin repeats similar gestures with Cuda amidst similar objects, including a Virgin Mary statue. Martin demonstrates to Cuda that he has no fear of crucifixes, no allergy to garlic, and no invisibility in the mirror. When Martin finally speaks to a somewhat shaken Cuda, he insists that he is not Nosferatu at all, just Cuda's cousin Martin.

One significant detail in Martin's black-and-white vision that appears to have no direct analogue in the colour reality of Braddock is a hammer and wooden stake that one of the priests threatens Martin with. Since Romero cross-cuts so skilfully between the black-and-white and colour images, emphasizing graphic matching and matches on action between shots, the presence of the hammer and stake in black and white but

absence in colour becomes an important way of distinguishing between the two registers. The hammer and stake is synonymous with an ancient, perhaps even mythological old world milieu more commonly associated with classic horror films, not the American reality of the present. But by the end of the film, of course, the hammer and stake will indeed materialize in Braddock and facilitate Cuda's destruction of Martin. So Romero, from the very opening scenes of *Martin*, has already framed a relationship between the black-and-white and colour footage in his film that resists categorizations of subjective and objective, imaginary and real, even past and present.

A Vampire Documentarian

One result of Romero's framing of his film in this way is that he asks his audience to occupy a vampire documentarian's point of view on Braddock. Martin, after all, is like us: he is the stranger in the strange land of Braddock, trying to comprehend an alien environment where he must observe carefully to make sense of his new surroundings. The oxymoronic concept of a vampire documentarian becomes less puzzling when we see how carefully Romero positions us to experience Braddock in ways that are not simply the perceptions of a vampire alone nor a documentarian alone, but the two together simultaneously. The film's opening scenes have established our horror of Martin and our fear of his actions, but they have also aligned us with Martin's illness, vulnerability, and oppression. We know him better than Cuda or any of the other characters we will encounter in Braddock, and we will ultimately trust his perceptions more than any of them because he, like us, is a stranger here.

Just as Romero evokes Martin as a figurative Vietnam veteran (but not a literal one), so too does Martin's status as a stranger in Braddock present him as a figurative immigrant (but not a literal one). Immigration forms a bedrock layer of Braddock's history and a key to understanding its economic decline as traumatic. One of the landmarks of immigrant literature in the United States, Thomas Bell's *Out of this Furnace* (1941), is set in Braddock. Bell's semi-autobiographical novel offers a number of significant contexts for *Martin*, not least of which are the traumatic aspects buried within the immigration experience that resurface when the American dream turns sour. Bell chronicles an earlier wave of immigration to Braddock from "the old country" than Cuda's – for Bell, it is the Slovaks, beginning in the 1880s and continuing into the 1940s – but the structure is strikingly similar. *Out of this Furnace* spans three generations, like *Martin* (Cuda's generation, the generation of Martin and Christina's absent parents, and the generation of Martin and Christina

themselves), with an emphasis on how the traumatic transition from old world to new world crosses those generations. The originary trauma in *Out of this Furnace* are the conditions of immigration endured when the family leaves the European old country to work for American steel manufacturers in Braddock. Rather than highlighting the conventional narrative of immigration to America as the path to prosperity, Bell focuses on how the Slovaks suffered by being "exploited, ridiculed, and oppressed." The Slovak immigrants in *Out of this Furnace*, disparaged with the epithet "Hunkies," were looked down upon in their new country, despite how "the Slovaks with their blood and lives helped to build America."[6]

The vampiric bloodletting of *Martin* forms a bridge to the bloody toil of immigrant labour and its traumatic legacy in *Out of this Furnace*. Indeed, *Martin*'s black-and-white visions of "the old country" constantly remind us of how the past lives in the present, and how old world experiences and beliefs do not simply wash away with Americanization. This is especially true when the promises of Americanization turn out to ring hollow. If we perceive Martin as a figurative immigrant, then we can see how his figurative Americanization is incomplete. Not only does he have visions of the old country, but he believes himself to be a vampire who is over eighty years old. He is Americanized in the sense that he has left behind the "magic" that Cuda clings to concerning the old country's superstitious beliefs about how a vampire is supposed to act, but he still believes he is a vampire and seeks victims accordingly. In short, Martin is an embodied amalgam of unacknowledged trauma, of stories not told that shape Braddock as powerfully as anything we can see. These are the traumatic stories of immigration, the economic collapse of the steel mills, and the decline of the American Dream.

"A Protest against Something Unacceptable"

Cathy Caruth, in conversation with the psychologist Arthur S. Blank, Jr., an author of pioneering work on PTSD in Vietnam veterans, calls PTSD "a protest against something unacceptable."[7] Martin is a witness to Braddock's disintegration, and his traumatized and traumatizing vampirism can be seen as a protest against this disintegration. His vampirism, suspended between "the real" and "the unreal," tells the story of Braddock's decline in ways that make that story's trauma recognizable. Caruth claims that one important way in which individual trauma becomes collective is in the telling of an apparently private story to the public. Telling this private story in a manner that highlights its public dimensions shifts our understanding of individual trauma through "creating a collective public story that can be told and heard."[8] Blank offers a concrete

example of this process when he explains how the PTSD of one Vietnam veteran went from clinically uncategorized to categorically recognized in 1980. A traumatized veteran whose illness was never properly diagnosed or treated as Vietnam-related PTSD was able to receive government compensation, several years after his suicide, because his wife, working with Blank, was able to tell the story of his mental breakdown through the letters he sent home from Vietnam. His story, which Blank summarizes as describing "his mind falling apart under the impact of certain events," strikes Blank as evidence of how a private story (undiagnosed illness not officially linked to the collective trauma of the Vietnam War) becomes a public story (PTSD recognized officially as connected to the war).[9]

Of course, not every traumatized veteran has the benefit of detailed letters that can narrate their story after their death in ways that turn private, individual trauma into collective, public trauma. But film offers an especially powerful means of transforming private stories into public stories. The inherently collective dimensions of film in terms of both its production and reception suit the demands of converting individual trauma into collective trauma extremely well. In fact, high-profile war films such as *Coming Home* (dir. Hal Ashby, USA 1978) and *The Deer Hunter* (dir. Michael Cimino, USA 1978) had already thrust the private pain of Vietnam veterans into the public spotlight prior to 1980. *The Deer Hunter* in particular, with its Western Pennsylvania setting, steel mills, and Eastern European immigrant cultural milieu, is in some ways a secret sharer with *Martin*. But even though both films were released in the same year and contain some intriguing resemblances, *Martin* ultimately accomplishes what *The Deer Hunter* cannot: *Martin* reveals the systemic social complexity embedded within Vietnam trauma that eludes *The Deer Hunter* by, paradoxically, not referring explicitly to Vietnam at all. While *The Deer Hunter* goes to great lengths to deliver a "realistic" portrait of the Vietnam War that proves undeniably moving in its depictions of anguish on both the home front and the war front, it cannot escape the exclusivity of its realist investments. By making Vietnam so "real," *The Deer Hunter* also places Vietnam at a remove from the audience's concerns: as painful as this might be, we know how to process this. It is "real," and can be filed safely under that label.

But what is *Martin*? Is it "real"? Is it fantasy? Is it a private story? A public one? Romero's insistence on confronting us with these questions without providing immediately accessible answers enables us to channel *Martin*'s engagement with the wide spectrum of issues surrounding the Vietnam experience – including economic crisis and immigration histories – into translations of individual trauma as collective trauma. This work of translation occurs precisely because our conventional frameworks of "real"

and fantastic are not available to us. As soon as we attempt to label Martin as a vampire, or an immigrant, or a Vietnam veteran, we must face a conundrum of interpretation. Unlike *The Deer Hunter*, we do not know how to process what the film presents according to our routine habits of perception. We remain alive to the act of interpretation, so that we move beyond standard labels not only of Martin himself, but of Braddock as a whole. Braddock cannot be just another depressed rust belt town that we label unthinkingly, because we are seeing it through the eyes of Martin, a vampire documentarian. The impossibility of the category "vampire documentarian" is exactly what keeps *Martin* open to Vietnam, immigration, and economic decline as intermixed elements in the story of Braddock. This story is offered to viewers at first through the lens of what appears to be individual trauma, but becomes translated ultimately as collective trauma because Romero refuses to grant the story easy legibility at the level of individual trauma alone.

Martin as impossible individual – the vampire documentarian – becomes Martin as collective sign for the traumatic experience of Braddock. Romero tells this collective story of Braddock through Martin by making him not a native of the town, but the relay between all of the residents there that we come to know through his presence. For example, Mrs. Santini is a customer at Cuda's shop, but it is only through Martin's relationship with her that we are permitted to see and understand her depression and loneliness that eventually leads to her suicide. The same can be said for Christina. Even though she has lived with Cuda for quite some time, it is only through Martin that we witness her disappointment and desperation in her relationship with Arthur, whom she holds onto solely as a ticket out of Braddock. This is another way in which Martin comes to stand for Braddock – he stays, while Mrs. Santini (through suicide) and Christina (through moving) leave. It is striking that despite Cuda's insistent negativity towards him, Martin never attempts to flee Braddock. He even does his best to follow Cuda's rules about not taking victims from Braddock itself. The most elaborate sequence in the film depicting one of Martin's vampiric attacks, a home invasion gone awry when a woman's extramarital lover is unexpectedly present, takes place in Pittsburgh rather than in Braddock. So when Martin leaves Braddock, he always returns.

How *Martin* Ends

Martin's alignment with Braddock, his ability to graft his individual trauma onto Braddock's collective trauma, becomes most heightened at the end of the film. Shortly before his murder at the hands of Cuda, Martin joins Braddock's residents outdoors on a beautiful sunny day for

a town parade. Earlier in the film, Martin would complain about how bright sunlight bothers his eyes, but here he walks freely without sunglasses as a marching band passes by in a celebratory parade. He clearly enjoys the sound of the music and the rhythm of the marchers, even smiling and falling in alongside them as they make their way through Braddock's streets. This is one of the most hopeful moments in the film, especially since it comes on the heels of Martin's devastating discovery of his lover Mrs. Santini's dead body. We learn through Martin's conversation with the talk radio host, with whom he confides on the air as "The Count," that he has grown more self-aware and perhaps even more empathetic towards others in the wake of Mrs. Santini's suicide. Martin speaks of his powerlessness to control Mrs. Santini's actions, quite unlike the omnipotent vampires of the movies. "In real life, you can't get people to do what you want them to do," he explains.

Martin's apparent surrender of his illusions of control over others marks a significant departure from the fantasies that have animated all of his vampiric attacks, where the drugs he administers to his victims allow him to bend them quite literally to his will. Now that he has retreated from this desire to master others, it frees him to be with others in a different way. This is what we see when he joins the Braddock parade – he becomes part of the town, his individuality now merged with Braddock's collectivity. For a fleeting moment, he belongs. And in this moment of belonging, Martin's story and Braddock's story meld, converting the individual trauma expressed through vampirism into the collective trauma encompassing the Vietnam War, economic decline, and immigration.

This is why Martin's death, which occurs with shocking suddenness immediately after the town parade sequence, registers as such a deep loss. Cuda awakens Martin, asleep in his bedroom, by telling him he has heard about the death of Mrs. Santini. Cuda refuses to believe she committed suicide; he is convinced Martin killed her. "I warned you, Martin. Nobody in the town," says Cuda. "Your soul is damned." Cuda then hammers a stake into Martin's heart, the blood spewing out of his body and onto Cuda's clothes.

Romero then pairs two remarkable shots that mirror each other in equal but opposite ways to conjoin the individual, literal death of Martin with the collective, social death of Braddock. First, the camera zooms out slowly from Martin's lifeless face, streaked with blood, to reveal the full horror embodied by the stake implanted in his chest (see Image 13.2) – this is real death in all of its ghastly materiality, not a bloodless fantasy scene from a black-and-white Hollywood vampire movie, or even the dematerialized disappearance of the vampire as the sun rises in F.W. Murnau's *Nosferatu* (Germany 1922). After a cut, the camera zooms

Image 13.2. Martin's death in George A. Romero's *Martin*. © 1978 New Amsterdam Entertainment. All Rights Reserved. Image courtesy of Richard P. Rubinstein.

Image 13.3. The aftermath of Martin's death in George A. Romero's *Martin*. © 1978 New Amsterdam Entertainment. All Rights Reserved. Image courtesy of Richard P. Rubinstein.

in slowly from outside towards the frontal exterior of Cuda's house, where we know a horrific murder has just taken place – and yet the house betrays no signs of disorder, even as the camera draws closer and closer to it (see Image 13.3).

These two shots, united by the formal similarity of slow zooms but differentiated by camera movement outward that discloses death (first shot) and camera movement inward that conceals death (second shot), crystallize *Martin*'s aesthetics of trauma. We see Martin's individual trauma, captured so horrifically in the image of his body's destruction. We cannot

see Braddock's collective trauma, hidden behind the faceless exterior of Cuda's house. But since Martin has become part of Braddock, with his story of individual trauma now thoroughly imbricated with Braddock's collective trauma, we do see Braddock translated through Martin; the two trauma narratives become one. Romero establishes this union not only thematically, but cinematically. The spectatorship Romero invites is summarized in these two paired zooms: to see presence where only absence appears, to see the collective where we only see the individual, to see trauma where we only see the everyday.

The sequence continues over the film's end credits, showing us Cuda sprinkling seeds over a patch of newly dug soil in his backyard. As we realize that this is Martin's unmarked grave, the soundtrack reverberates with a cacophony of overlapping radio voices that repeat the question, "What happened to The Count?" While Cuda kisses a small white crucifix and buries it in the earth that he has just seeded, the chaotic din of voices quiets down to just one. It is a gentle, hesitant male voice, not Martin's but also not unlike Martin's. The voice says, "I think I know where The Count is. I have a friend who I think is The Count." Fade to black.

Conclusion

Martin is dead, the film is over, and yet Martin lives on. He has been incorporated as a voice from Braddock, a figure lodged within the town's imagination as well as our own. His story lives as a trauma narrative that enables us to see Braddock's story beyond the clichés. If "What happened to The Count?" is the spoken question that Romero leaves us with, then its unspoken corollary is "What happened to Braddock?" The experience of watching *Martin* teaches us how indivisible these questions really are, and how answering them requires that our habits of perception belonging to the documentary and the fantastic, the individual and the collective, the traumatic and the everyday must not remain neatly separated. They must contaminate each other, disturb each other, even contradict each other in order for us to see.

Once we understand *Martin* in this way, we can begin to recognize the full dimensions of the film's genesis and afterlife. Romero's commitment to blurring the borders between documentary realism and fantastic horror, right down to alternating between colour and black-and-white film, recalls the work of one of Romero's favourite directors: Michael Powell, and *Peeping Tom* (UK 1960) in particular. Powell spoke of his own shocking horror film as "a very tender film," and I think the same could be said of the equally shocking *Martin*.[10] Much of this tenderness comes from the fact, apparent in just about every frame, that *Martin* is a film made by a community about

the community. Nearly everyone involved with the production, filmed on a shoestring with a tiny crew on location in Braddock and Pittsburgh, does double and triple duty: special effects maestro Tom Savini also plays Arthur and performs stunts; cinematographer Michael Gornick provides the voice of the radio talk show host; sound technician Tony Buba, director of important documentaries about Braddock in his own right, has a small acting role, helped to scout locations, and granted access to his mother's home to play the crucial role of Cuda's house; producer Richard P. Rubinstein appears as the husband of one of Martin's victims; Romero himself not only writes, directs, and edits, but plays a young priest with a taste for good wine and an affection for *The Exorcist* (dir. William Friedkin, USA 1973).

In short, *Martin* is no work for hire about some faceless place. It is a labour of love that stands as an invaluable portrait of Braddock alongside the documentaries of Tony Buba (especially his seminal *Lightning over Braddock* [USA 1988] in which Romero makes a brief appearance as himself) and photographs of LaToya Ruby Frazier, who brilliantly brings to life an African American Braddock detectable only at the edges of Romero's vision in the film.[11] It is worth noting that in *Martin*'s pivotal town parade sequence, described earlier, many of the musicians in the marching band as well as most of the onlookers watching the parade are African American. These images hint at yet another layer in the story of Braddock that Romero leaves largely unexplored in *Martin*, but that will be taken up years later by Frazier. What Frazier chronicles so movingly in her work, drawn from her own experiences growing up in Braddock, is the African American specificity of Braddock's collective trauma, its connections to race alongside other forms of economic and social pain. Even if *Martin* does not pursue this story itself, it certainly opens the door to its telling.[12] Indeed, the film still has many stories to tell. Not least is the story of how Romero's cinematic project, too often simplified as a series of zombie films famed for their spectacular displays of graphic gore, encompasses the translation of individual into collective trauma.

NOTES

1 See, for example, Ben Hervey, *Night of the Living Dead* (New York: Palgrave Macmillan, 2008); Sumiko Higashi, "*Night of the Living Dead*: A Horror Film about the Horrors of the Vietnam Era," in *From Hanoi to Hollywood: The Vietnam War in American Film,* ed. Linda Dittmar and Gene Michaud (New Brunswick: Rutgers University Press, 1990), 175–88; Adam Lowenstein, *Shocking Representation: Historical Trauma, National Cinema, and the Modern Horror Film* (New York: Columbia University Press, 2005), 153–64.

2 Cathy Caruth, in conversation with Shoshana Felman, discusses how to "make an injustice that has previously seemed to occur on the individual level (even when it has involved millions of individuals) clearly recognizable as collective, public, or universal" through "creating a collective public story that can be told and heard." See Caruth, *Listening to Trauma: Conversations with Leaders in the Theory and Treatment of Catastrophic Experience* (Baltimore: Johns Hopkins University Press, 2014), 332. Caruth's emphasis on the process of translating individual into collective trauma through narrative and representation intersects, at least in part, with Jeffrey C. Alexander's social theory of cultural trauma, where he asserts that "trauma is a socially mediated attribution." See Alexander, *Trauma: A Social Theory* (Malden: Polity Press, 2012), 13. The work of both Caruth and Alexander influences my claims in this essay, as well as the long history of research in trauma studies that relates individual and collective trauma. This history can be detected at least implicitly in Sigmund Freud's work connected to the shell-shocked soldiers of the First World War in *Beyond the Pleasure Principle*, ed. and trans. James Strachey (New York: Norton, 1989 [1920]) and more explicitly in Kai Erikson, *Everything in Its Path: Destruction of Community in the Buffalo Creek Flood* (New York: Simon and Schuster, 1976).

3 My own *Shocking Representation* is largely organized, with the exception of its final chapter on David Cronenberg, around an understanding of historical trauma's relation to the horror film as a matter of discrete events rather than unfolding processes. In this sense, this essay builds outward from that book's final chapter and in conjunction with recent work in film and trauma studies that attempts to imagine new temporal frames for our understanding of trauma through cinema. See, for example, William Guynn, *Unspeakable Histories: Film and the Experience of Catastrophe* (New York: Columbia University Press, 2016); E. Ann Kaplan, *Climate Trauma: Foreseeing the Future in Dystopian Film and Fiction* (New Brunswick: Rutgers University Press, 2016); Bliss Cua Lim, *Translating Time: Cinema, the Fantastic, and Temporal Critique* (Durham: Duke University Press, 2009).

4 Although *Martin* has attracted very little critical attention, it is worth noting that several important critical accounts of the film all note its striking commitment to realism of one kind or another, but not its engagement with trauma. See Richard Lippe, "The Horror of *Martin*," in *The American Nightmare*, ed. Robin Wood and Richard Lippe (Toronto: Festival of Festivals, 1979), 87–90; Tony Williams, *The Cinema of George A. Romero: Knight of the Living Dead*, 2nd ed. (London: Wallflower, 2015), 80–9; Robin Wood, "Neglected Nightmares," in *Robin Wood on the Horror Film: Collected Essays and Reviews*, ed. Barry Keith Grant (Detroit: Wayne State University Press, 2018), 181–200. For valuable information on *Martin*'s production history, see

Paul R. Gagne, *The Zombies That Ate Pittsburgh: The Films of George A. Romero* (New York: Dodd, Mead, 1987), 71–81.

5 In fact, *Martin* began as Romero's first (and only) black-and-white film since *Night of the Living Dead*, but economic and marketability concerns necessitated a switch to colour as well as a significant shortening of the film's first cut. Since many commentators, including Romero himself, had noted the black-and-white look of *Night of the Living Dead* as part of the film's gritty power and kinship with contemporary news coverage, it is likely that the "objective" connotations of black-and-white film were important to *Martin*'s production. See Gagne, *The Zombies That Ate Pittsburgh*, 78–9.

6 David P. Demarest, Jr., afterword, in Thomas Bell, *Out of this Furnace* (Pittsburgh: University of Pittsburgh Press, 1976 [1941]), 418. Demarest, a literary scholar at Pittsburgh's Carnegie Mellon University, was responsible for rediscovering *Out of this Furnace* and bringing it back into print in 1976 – just around the time Romero was conceptualizing *Martin*.

7 Caruth, *Listening to Trauma*, 288.

8 Caruth, *Listening to Trauma*, 332.

9 Arthur S. Blank, Jr., quoted in Caruth, *Listening to Trauma*, 293.

10 See Lowenstein, *Shocking Representation*, 55–82.

11 See, for example, LaToya Ruby Frazier, *The Notion of Family* (New York: Aperture Foundation, 2014).

12 One film that walks through that door is *The Transfiguration* (dir. Michael O'Shea, USA 2017), a remarkable horror film featuring a young African American "vampire" imagined along lines very much indebted to *Martin*.

14 Aesthetic Displays of Perpetrators in *The Act of Killing* (2012): Post-atrocity Perpetrator Symptoms and Re-enactments of Violence

JULIA BARBARA KÖHNE

The essay film *The Act of Killing*[1] has made waves since its release in late summer 2012, within Indonesia and in its international reception.[2] US-American director Joshua Oppenheimer, in association with filmmaker Christine Cynn, collaborated on the film together with an Indonesian co-director and team, both kept anonymous for safety reasons. The film crew also included political activists and academic scholars. *The Act of Killing* straddles genres because, with some justification, the film could also be described as a reality-based horror movie that confronts the status quo of an "open secret."[3] The film, with more than seventy nominations, including an Academy Award nomination for Best Documentary Film in 2014, provides insight into the cultural imaginary of today's island nation of Indonesia regarding the official suppression of critical memory of the 1965–66 state-orchestrated mass killing of civilians.[4] In its experimental and challenging, open and free, regime-critical and self-reflexive form, the essay film[5] not only presents excerpts from an until now unwritten perpetrator story of mass murderers from northern Sumatra. It also provides an allegorical analysis of the violent past that lies outside the traditional and dominant historical discourse. Figuratively speaking, it creates a bridge on which past and present collide, and art, imagination, and interpretation of reality are mutually illuminated. Through this dynamic, a counter-history evolves to challenge the official Indonesian, biased historiography, which has long manipulated the historical perception of this period for purposes of suppression.

This chapter focuses on *The Act of Killing* as a catalyst for sociopolitical attention to a 'genocide' that had fallen into oblivion for decades. Its international film reception, as well as numerous insightful interviews with Oppenheimer, have progressively promoted a historiographic awareness of this forgotten 'genocide' in Indonesia, flanked by comparative genocide studies. The film acts as a communicator of knowledge

about mass murderers and their extremely complex psyches. In addition to intrapsychic dynamics, *The Act of Killing* highlights the perpetrators' conceited self-perceptions and their ambivalent levels of agency. The counterpart to the film, Oppenheimer's *The Look of Silence* (2014/15),[6] deals with the victims' rather than the perpetrators' perspective.

At the centre of the documentary narrative found in *The Act of Killing* are a handful of male mass murderers[7] who actively persecuted alleged opponents of the regime during the Indonesian massacre of 1965–66. These men conducted systematic ethnic-political purges, and detained large numbers for years as political prisoners in detention camps. They interrogated and accused the detained; tortured, killed, and raped victims; and expelled and suppressed the persecuted. The men participated in the mass murder and detention of about a million or more suspected 'communists,' extending over large parts of the archipelago.[8] The label 'communist' was applied to members of the Indonesian Communist Party (Partai Komunis Indonesia, PKI) as well as leftist sympathizers, trade unionists, artists, intellectuals, and ethnic Chinese and Abangan Javanese.[9] At that time, the PKI was blamed for having killed six high-ranking military generals on 30 September and 1 October 1965. Today historians consider this claim to be false, put forward to conceal the atrocities' real cause, which was linked to internal military conflicts.[10]

The goal of the military leaders, among them the future dictator General Suharto, and their paramilitary followers, including religious organizations, who gave orders, endorsed, or carried out the 'genocide' and ethnic cleansing, was to decimate the PKI and "annihilate the historical and social existence of this heterogeneous victim group."[11] Even decades later, the perpetrators remember their deeds in detail, proudly, and with pleasure, but at the same time they are haunted by memories of their violent acts. About forty-five years later, *The Act of Killing* portrays the political mass murderer Anwar Congo and some of his (former) companions – at the time the essay film was shot they were in their seventies – by providing a subtle cinematic psychographic profile of these men, who have lived in Medan since the mid-1960s. The psychological profile, which the film presents by means of various perpetrator re-enactments and plentiful close-ups of perpetrators' faces, includes the question of the moral and psycho-mental injury the perpetrators inflicted on themselves during the multiple killing operations. Instead of embarking on the conventional gesture of demonization, pathologization, criminalization, and dehumanization of perpetrators, Oppenheimer developed an innovative iconography of offenders, generated through filmic investigation. To achieve this, the filmmaker initiated an unusual partnership: in the mid-2000s, he provided the perpetrators the cinematic space to conduct

self-representation and self-questioning. The Oppenheimer team supplied them with film technology, film sets, make-up artists, wardrobe, and camera, while the perpetrators contributed the ideas, screenplay, direction, and acting. Without giving the resulting film a fixed direction, Oppenheimer hoped that it could illuminate the depths of human existence and seed insights that would contribute to a non-violent future.

Oppenheimer's cinematic investigation method neither judges its film characters nor explicitly evaluates their actions. Instead, it holds a mirror up to the audience, who belong to the human species just like the perpetrators. By making spectators look at the subjective perspective of perpetrators, who are depicted in an accessible and sometimes even likeable way, *The Act of Killing* creates unpleasant but instructive ways of identifying with individuals who, to the present day, deny their guilt for reasons of self-protection and preservation of power. For example, we can watch Anwar Congo a dozen times doing body care, discussing perfume aromas, combining sunglasses with his extravagant outfit, or using a denture to perfect his front row of teeth: "I know what looks good on me. I'm an artist." It's these intimate physical details that fuel spectator interest in the characters. These shared intimacies counterbalance the long passages where the film tracks the conditions in which violence and its cover-up unfolded. Violence committed by men is addressed here in a way that recognizes complexity, as it is not referred to as being 'natural inborn,' or otherwise essentialized and biologized. Rather, it appears as an (avoidable) result of a complex structure of specific sociopolitical, economic, ideological, and psycho-mental framework conditions. Instead of communicating extensive historical factual knowledge and archival imagery, *The Act of Killing* focuses on an in-depth study of past and potential conditions of brutal mass violence in order to make the mechanisms of this violence recognizable in other contexts.

The argument of this chapter is that *The Act of Killing* acts as a driving force for processes of reflection in which the mass murder of the 1960s is brought out into the open and its long-term legacy of discrimination, intimidation, and victim-stigmatizing can be criticized. This is a legacy that has reigned in Indonesia to this day in the form of extortion of protection money, corruption, and harassment of certain sections of the population with dissonant political opinions. It is a reign that was based for a long time on the silence of the victims, who still must live in the same neighbourhood as their perpetrators. They stay silent out of fear of further state-military repression, social exclusion, and hostility – Anwar sums up the perpetrators' way of seeing such people, who already were marginalized back then: "But if they didn't pay, we killed them. They can't have it both ways."[12] The essay film has an influence on the political

Image 14.1. One of Anwar's post-atrocity perpetrator symptoms is insomnia, *The Act of Killing* (2012). Image courtesy of Joshua Oppenheimer.

imaginary insofar as it uses cinematic narrative to rewrite mental images of violence and guilt, which actively shape the perception of genocidal history and post-genocidal presence that is still characterized by repression. It reveals that 'historical facts' are rarely purposeless, but rather a system of statements that are constantly reconfigured and often close to centres of power.

Besides the continuity of power, the film extensively refers to the psychosomatic manifestations that Anwar recounts to spectators, such as insomnia (Image 14.1), restlessness, repeated nightmares, and distanced affects, that seem to have disturbed his killer ego since the end of the massacres:

> I know that my nightmares were about what I did, killing people who did not want to die. I forced them to die. [...] I'm disturbed in my sleep. Maybe because when I strangled people with wire I watched them die. [...] If I fall asleep, that's exactly what catches up with me.

Through self-medication, drug abuse, alcoholism, and hedonistic dancing, Anwar attempted in the late 1960s to mask the symptoms and suppress the memory of his actions. The point here is to explain why it would not be adequate or effective to call the psychological symptoms that Anwar shows in the film 'perpetrator trauma.' I suggest instead the term 'post-atrocity perpetrator symptoms' in order to clearly

differentiate, both conceptually and linguistically, between post-deed psychological phenomena in a perpetrator and the trauma of victims.

Theoretical Background on Perpetrator-Victim Inversion

It is important to discuss in detail the practice of re-enactments of violence, including perpetrator-victim inversions, demonstrated in *The Act of Killing*. It is beneficial for perpetrators to deal with suppressed guilt and shame regarding their exceptionally violent and inhumane acts by oscillating between reliving the perpetrator role and performative imitation. By remembering past deeds via the 're-enactment time channels' for years, Anwar playfully empathizes with the victims, temporarily taking over parts of the victim position by means of 'cross-identification.' First, it becomes clear that the temporary cross-identifications open up new ways for Anwar to think about his past motivations for his killing actions and his torn self. Second, he can actively put himself in the situation of victims whom he has terrorized, in a gesture of catching up with the feelings of empathy and emotions he had suppressed in the acts of killing (Anwar: "Only now that I see it, I understand how horrible it was. I didn't expect that."). Third, as is suggested by psychoanalyst Mathias Hirsch in regard to another context, it can be argued that in the course of the lengthy filming and repeated re-enactments, Anwar makes contact with the parts of himself that feel victimized, which may have led him to become a perpetrator (this is to be seen against the background of state anti-communist infiltration that cast 'communists' as future aggressors). By cross-identifying and acknowledging the victim in himself, the perpetrator role cannot be further suppressed. Hirsch explains that a perpetrator-part arises in an individual "on the basis of an imitative identification [...], as a remedy against the feelings of helplessness of another, a victim-part of the self."[13]

Calling on the theories of psychoanalyst and child psychologist Anna Freud, we can label Anwar's former feelings of powerlessness deriving from his irrational fear of 'murderous communists' as anticipatory fears. Imagining him/herself as a potential victim, the fearful person adapts to this image of fear and the anticipated aggression and strength – "identifying with the dreaded external object."[14] By this defence mechanism, the painful and unwanted feeling-states are made more bearable via a "game of impersonation which children love to play."[15] Freud adds, "there are many children's games in which through the metamorphosis of the subject into a dreaded object ["pretend that you're the ghost who might meet you"] anxiety is converted into pleasurable security."[16] Parts of the anxiety object would be introjected "by impersonating the

aggressor, assuming his attributes or imitating his aggression."[17] The passively threatened person transforms himself or herself from the person threatened into the one who actively makes the threat. In "Identification with the Aggressor," Anna Freud addresses "defence mechanisms" (unconscious psychological dynamics reducing anxiety), such as repression, denial, regression, identification, introjection, projection of guilt, undoing, sublimation, and reversal into the opposite, as psychic processes that served to cope with "external objects which arouse anxiety" and to overcome mental weaknesses in as conflict-free a fashion as possible.[18]

Several of these mechanisms are relevant for an analysis of the perpetrator display in *The Act of Killing*. For example, projection, in which inner parts of the self such as social envy, feelings of hatred, and fears of death focused on 'communists' are assumed to be motivations for the perpetrators' killing intentions. After an act of violence, blame often needs to be repressed. Unfulfilled desires, such as the desire to be reconciled with the victims, can be sublimated and satisfied on an artistic level, as is made visible in *The Act of Killing*, for example in the Bollywoodesque musical episodes.

In order for perpetrators to face their irrational fear of posthumous revenge by the murdered victims, the film's re-enactments of violence are accompanied by Bollywood-like phantasmagories in which the perpetrators envision an otherworldly moment of pacification and forgiveness. Their fear of counter-violence and empowerment, carried out by the few surviving victims, their relatives, or descendants of those murdered, is transcended here by imagining a different ending of the 'story.' This comes in the shape of a miraculous reconciliation in which the victim bows to his former tormenter and expresses his thanks for being eliminated by him. Below, I argue that this can be interpreted as a bandaging[19] of the mental wounds the perpetrators have inflicted on themselves in a sort of moral self-traumatization.

In general, I will show that the portrayal of the male mass murderers of 1965–66 in the experimental film *The Act of Killing* was not only novel but also necessary in order to explore the position of perpetrators from a deeper epistemological point of view. I will demonstrate how the film on the one hand resonates with certain psychoanalytic, psycho-traumatological, and therapeutic concepts, and on the other hand corresponds with recent research on perpetrators' actions in genocidal conflicts, and thus challenges the limits of conventional forms of collective consciousness and historical reflection. In my reading, *The Act of Killing* translates critical psychography and interdisciplinary perpetrator research into film language (at times even anticipating current research outcomes). These are research approaches that argue poly-contextually,

structural-institutionally, and situational-concretely, incorporating socio-political, habitual, ideological, and economic motives of perpetration. On view are psychological experiments with perpetrators who confront their pasts as mass murderers and undergo a self-therapy in largely self-designed re-enactments. They turn from 'happy killers' who suffer from 'post-atrocity perpetrator symptoms' into individuals who are haunted and subtly troubled, or 'knocked-at,' by feelings of guilt. There is shame, self-loathing, self-knowledge, and the possibility of letting guilt from the perpetrated acts of injustice shine through. At the same time, we can see further successful repression and escape into grotesque fantasy formations.

Finally, I will summarize how *The Act of Killing* offers the possibility of considering perpetrator figures as neither "monsters" nor psychopaths. The film shows that it makes no sense to stylize perpetrators into a delinquent enigma that we should perceive with incomprehension, disrespect, contempt, hatred, or social exclusion. Nor would it be constructive to see them as incarnations of 'evil,' and thus to locate them imaginatively outside of society, in order to apotropaically ward off their potential for destruction. Rather, the knowledge the film communicates about them should be used as a starting point to reflect on the different ways in which we all, in other contexts and to some extent, consciously or unconsciously, are involved or implicated in positions of perpetration: "They are us and we are them." In a transgressive model of perpetration, both concepts, 'victims' and 'perpetrators,' are de-essentialized and deconstructed, without abolishing their contextual definability and pragmatic-political necessity in legal, sociopolitical, and moral contexts.

The perception of the Indonesian mass killings of 1965–66 as 'crimes against humanity' was suppressed until recently not only by the individual perpetrators and perpetrator groups, but also on a collective level. Certainly this was done by the Indonesian side, including efforts by the military dictatorship under General Suharto, as well as by US-American, British, and other anti-communist Western forces, which supported the mass murders in the context of the Cold War and the 'fight against communism' monetarily, technically, and logistically. The United States delivered arms and the CIA compiled death lists, and together with other supporters they then celebrated the murderers on a symbolic level.[20] In fact, in official narratives the perpetrators are still glorified across northern Sumatra as cult figures. Today, they still hold paramilitary positions of power (Image 14.2), although it is foreseeable that their power will slowly vanish because of their advancing age. The mass murderers "have never been held to account for the genocide and are celebrated as victors,"[21] and a winners' narrative dominated until the worldwide reception

Image 14.2. Happy Medan killer trio in the car, with director Oppenheimer, *The Act of Killing* (2012). Image courtesy of Joshua Oppenheimer.

of both of Oppenheimer's documentaries. *The Act of Killing* shows that even though "war crimes are defined by the winners"[22] (in the words of Anwar's friend Adi Zulkadry), the winning tale always has fissures.

At the end of the film, which depicts a ten-year journey into the convoluted rationalizations that structure the minds of mass murderers, Anwar, whose self-glorification is visibly distorted, asks Oppenheimer: "Or have I sinned? I did this to so many people, Josh. Is it all coming back to me?" (Image 14.3). The following sections explore how Anwar's question can be evaluated, and if it might be interpreted as a sign of critical self-reflection, insight, and moral transformation, even if only temporary.

Anwar Congo: From Happy Killer to Becoming a Medium of Transition

When spectators of *The Act of Killing* meet former killer Anwar Congo, a founding member of the Indonesian far-right paramilitary organization Pancasila Youth (*Pemuda Pancasila*), his statements are full of irrational stories, which degrade the 1965–66 victims ("We have thrown corpses [into the river Deli] [....] It looked pretty, like parachutes, Bam!") and tend to superstition ("Here are many ghosts!") and magical wishful

Image 14.3. Anwar asks Oppenheimer: "Or have I sinned?" in *The Act of Killing* (2012). Image courtesy of Joshua Oppenheimer.

thinking. He seems to be caught in the twilight zone between exact knowledge of his acts of violence and lack of knowledge of what exactly his wrongdoing was. It becomes clear that Anwar has constructed his ego, his subjectivity, and his persona on the basis of his murderous deeds and the sense of triumph associated with them, as well as at the expense of his independent moral integrity – denying guilt and blaming others just as thousands of other perpetrators did. His friend Adi Zulkadry, who served as the head of a death squad in 1965–66, sums up the dilemma: "Killing is the worst crime one can commit. So, you have to find a way to not feel guilty. You have to find the right argument. And one has to believe in this view." In another scene Oppenheimer, off camera, outlines Adi's arguments: "By telling yourself it was 'war,' you're not haunted like Anwar."

In the course of shooting the film, Anwar is so provoked and animated by the presence of the camera that he becomes more and more absorbed in his past as a mass murderer commissioned by the government and military. The camera becomes an instrument that helps to break up internal resistance and stimulate the perpetrator's memory (does the camera also become a personal promise for him to be able to recapture humaneness through his filmed confession?). On a fenced rooftop terrace above the former Pancasila Youth bureau, the historic killing ground where he carried out numerous executions, Anwar, now an elderly man in a green-patterned shirt, zealously demonstrates to the film crew and spectators how he accomplished the killing of a thousand people within a few months.

Image 14.4. Anwar impersonates his former self as a killer using a wire, *The Act of Killing* (2012). Image courtesy of Joshua Oppenheimer.

He tells his story vividly but from an emotional distance, explaining how he invented the most effective and creative killing techniques, ranging from beating people to death, inflicting copious bloodshed, to 'cleaner' wire strangulation. The location inspires Anwar's journey through memory, as it has physically stored this history of violence, with the concrete joints between the tiles still containing remnants of the blood of the slain, which could not be wiped away. All this happens with a smile on his face (embodying 'killing happily'), and it is followed by a light-footed cha-cha-cha dance and more bragging. Anwar casually wears the wire loop around his neck that he used in a previous camera setting to demonstrate how precisely he performed the strangling. He is assisted by a friend who tentatively acts the part of a former victim, grinning insecurely. In order to show his victim-actor-friend where to sit, while trying to reconstruct the past with accuracy, Anwar carefully placed a fresh tile next to the post where he attaches one end of the wire. After placing the noose around the victim's head at a precisely calculated angle, he steps aside and indicates how he used to tighten it in 1965–66 (Image 14.4). In the moment of the re-enacted tightening, the victim-actor looks stressed, but he tries to charmingly smile it away. The spectators can guess that he knows and now even feels that in the past Anwar did not spare anyone who found themselves in this predicament. Shortly thereafter, on the terrace, Anwar for the first time reports the serious mental symptoms that he suffered from at the time and suffers from to this day.

The legal scholar Saira Mohamed, in her 2015 study *Of Monsters and Men: Perpetrator Trauma and Mass Atrocity*, describes this as a happy killer's mentality and Anwar as a "perpetrator who embraces the murders he commits but still suffers trauma on account of those crimes."[23] Mohamed calls the investigation of such killers, whom she labels "traumatized perpetrators," a blind spot in the judicial system and international criminal law. She considers the model of a perpetrator "who performed his acts of violence willingly, and who nevertheless experiences that violence as trauma,"[24] a model that has remained largely unexplored.[25] In her comprehensive study, she supports "the idea that [...] commission of the crime itself causes a psychological injury to the perpetrator, which can result in particular adverse physical, social, or emotional consequences": "his psyche is haunted by the demons of his past."[26] Mohamed argues that the happiness and exhilaration built up during the acts of killing and in the aftermath helped the murderers, who called themselves "heroes who saved the country from a leftist coup, not murderers,"[27] to uphold the internal and external system of violence. In contrast to Mohamed, who wants to extend the trauma category to perpetrators, I would not say that *The Act of Killing* demonstrates that perpetrators can also experience their actions as psychological traumatization. Instead, in my eyes, the film exposes how violent action can lead to another form of psychological strain and moral dissolution, which must be in any case framed and identified as distinct from the concept of victim trauma, as I will argue below.

The question of where this proud and joyous display, and the bold statements of the murderer Anwar, come from leads us once again to Anna Freud's explanations in her 1936 monograph *The Ego and the Mechanisms of Defence*. The exaggerated and compulsive image that Anwar paints of himself while bragging and dancing on the roof terrace can be interpreted as an unconscious psychological defence mechanism to manipulate the cruel reality, or to deny guilt, shame, and embarrassment in the face of his actions. Demonstrating his own validity and importance obviously helps Anwar to reduce fears deriving from negative stimuli that he expects and that potentially hurt him, such as the idea of an unlikely case of arrest and punishment. To maintain his self-image of a "cool gangster," "free man" (*preman*) with a licence to kill, and "redeemer of the world from evil," who successfully killed regime-opposing 'communists,' Anwar suppresses the fear of guilt.

Framework for Violence: Signs of Moral Perversion

Anwar's attempts to fend off hidden guilt are supported by a sociopolitical and mental framework, which I will define below, that helps him preserve an idealized version of himself, a person of integrity and power. In this

upside-down world, the 1965–66 past seems to have been deeply buried by most of Indonesian society until the release of Oppenheimer's documentaries. For the perpetrators, the heroic past and its specific characteristics are highly present and relevant, while the position of the survivors and descendants of the murdered has been systematically silenced until today.

The Act of Killing shows that the anti-communist hysteria and killing activities were based on a multitude of interdependent conditions – economic, political, religious, ideological, and racist/Sinophobic – as well as a long chain of command. After the killing of the six generals in 1965, a new set of anxieties was nourished by press organs, including fear of the civilian population close to the regime of 'communists' who might overwhelm key parts of society. In the film, Ibrahim Sinik, a journalist who at that time was orchestrating mass killings and was gathering incriminating information about 'communists' during interrogations, explains: "No matter what we asked, we changed their answers to make them look bad. As a newspaper man, my job was to make sure that the public hated them ['communists']. [...] Why should I do the dirty work? Why should I kill people? I did not need that. A head movement and they were dead!" Fear of 'communists' had existed in Indonesia since the rise of the PKI in the course of the country's gaining independence from the Dutch colonial power in 1945–49. In 1965, a common image of the enemy was deployed and propagated by the army and the media to channel transpersonal anxieties resulting from collective experiences of insecurity, contingency, and upheaval, such as the fear of hyperinflation, of loss of economic status, and of even greater political influence of the PKI, before and during the regime change from Sukarno to Suharto and the latter's seizure of power. In order to be able to kill as extensively as possible, local criminals and professional gangsters, as well as other civilians, were ordered by the army to carry out the killings "in defence" (the 'us or them' myth). Indonesian government officials and foreign powers like the United States consigned responsibility to the Indonesian army, and from there to the paramilitary, the Pancasila Youth, police units and death squads, and civilian militias recruited from religious and nationalist groups. The latter were supplied with weapons by the army and acted under its command.

Local civilian perpetrators, among them Anwar and other "movie theater gangsters," had the freedom as "free men" to kill whomever they considered a 'communist' or wanted to get rid of for personal reasons. Anwar and his gang made their living out of selling movie theatre tickets for films from the West on the black market. He explains, "as the communists grew stronger – they demanded a ban on American films. [...] So, we gangsters made less money. Because there was no audience anymore." Herman Koto adds, "Or, as we say: 'the belly has missed its supper.'" Freedom of movement and a self-glorifying perspective went hand

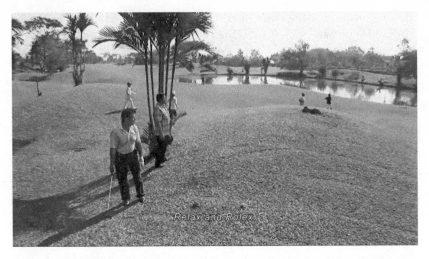

Image 14.5. Relax and Rolex!, *The Act of Killing* (2012). Image courtesy of Joshua Oppenheimer.

in hand with financial and selfish interests, for which the "gangsters" enthusiastically killed their political enemies, professional rivals, or other competitors. Today's Pancasila Youth leader Yapto Soerjosoemarno relates their former and recent motto, "Relax and Rolex!" (Image 14.5).

In 1972, the religious philosopher René Girard described the social mechanism of an act of sacrifice that redirects tensions and aggression in a society. Violence against a "'sacrificeable' victim," in this context 'communist' intellectuals and ethnic Chinese among others, would prevent society from engaging in violence "that would otherwise be vented on its own members, the people it most desires to protect."[28] "The sacrifice serves to protect the entire community," Girard writes, "from *its own* violence; it prompts the entire community to choose victims outside itself."[29] He continues: "[T]he violence directed against the surrogate victim might well be radically generative in that, by putting an end to the vicious and destructive cycle of violence, it simultaneously initiates another and constructive cycle, that of the sacrificial rite – which protects the community from that same violence and allows culture to flourish."[30] Sacrificing, Girard argued, strengthens social cohesion, and also functions as a means to constitute a community. In exactly this way, the massacres in Indonesia were instrumentalized as the founding myth of a system of sacrifice in the shape of the New Suharto regime, the so-called New Order (1966–98), whose community spirit was also based on the violence of a military dictatorship.

To hide their mainly selfish motives, Indonesian mass murderers claimed to follow ideological, *weltanschaulichen*, and ethnic motivations. Influenced by Stefan Kühl's *Ganz normale Organisationen: Zur Soziologie des Holocaust* (2014), we can speak of an anti-communist "consensus fiction,"[31] although no perpetrator really believed in the inferiority of the alleged communists, which included the marginalized Chinese minority, as *The Act of Killing* clearly states. Adi admits: "I believe it [anti-communist propaganda] is a lie. [...] Of course, that is lying. [...] So, the communists were no more cruel than we were. We were the cruel ones! What is cruel is relative." What was the driving force, then? Just like the Milgram experiment (1961) or the Stanford Prison experiment (1971)[32] concluded, Harald Welzer's investigations, in his 2002 book *Täter: Wie aus ganz normalen Menschen Massenmörder werden* (Perpetrators: How perfectly normal people become mass murderers), have shown that "most of us would probably be willing to kill – it just needs the situational, social, and dynamic conditions in order to translate potentiality into action."[33]

As discussed above, according to Anna Freud's theory of "identification with the aggressor," fear of attack by a potential aggressor is enough to provoke a vehement defensive reaction, in which the fearful person becomes the aggressor – "a reversal of the roles of attacker and the attacked."[34] In Indonesia, anticipated repressions by 'communists' were tied to the fantasy of annihilating an entire ethnic group – according to the precept "We must kill you before you kill us." Killing was an imagined antidote for the diffuse *angst* of a domestic seizure of power by the 'communists.' Killing was a protective measure against the dreaded loss of control, against the expected traumatization by the 'communist' enemy. Killing was a means of overcoming the dreaded danger and of ensuring one's own continued existence – despite the knowledge that all these were just sham arguments delivered by propaganda.

The enemy was supposedly ready to attack at any time, and this idea helped perpetrators to imagine themselves as potential victims of hyperviolent 'communist' aggression. The anxiety that resulted from this imagined threat was fueled by Suharto's later New Order, which lasted until his resignation in 1998, and that anxiety was presented in a four-hour, graphically violent propaganda film titled *The Treachery of the September 30th Movement of the Indonesian Communist Party* (1984). The film portrayed the communist-Chinese opponent as an ongoing, massively bloodthirsty, profound threat, generating and consolidating fears that reactivated an image of an enemy that had already provided a smokescreen for the killings in 1965–66. Fear of lack of differentiation, a 'mixing of peoples,' jealousy of the achievements of others, and the alleged cruelty of the 'communists' are aspects of this indoctrination narrative.

The many thousands of screenings of the propaganda film, which took place in school class after school class, functioned as a *perpetuum mobile* that legitimized the Indonesian 'genocide' again and again, depicting it retroactively as a historical necessity. Anwar said of the film: "For me, this movie is the only thing that relieves my anxiety [over apprehension and punishment for his wrongdoing]. I see the movie and feel reassured."

Profiling of the Genocide-Perpetrators

Mass killings and the attendant collapse of any universal ethical value system are preconditioned by various initiating, reinforcing, and supportive factors that can be described as concentrically shaped. In the 1965–66 Indonesian massacres, the network of supporters consisted of the United States (covert support), the domestic army, paramilitary groups, death squads, and local units of contract killers. And yet it required a transformation on an individual level to enable concrete killings. How did the mass murderer Anwar Congo in the mid-1960s suppress his ability to empathize with suffering fellow human beings?

Interpersonal compassion and a basic ability to empathize are underlined in *The Act of Killing* when Anwar very carefully teaches his two grandchildren to take care of a baby duck whose leg apparently had deliberately been injured by one of them. Not for his acts of violence in the 1960s, but in this family incident, Anwar suddenly finds words of apology that he wants the little boy to say to the hurt duck in order to unburden himself. Anwar urges him: "Say, I'm sorry, duck. [...] Now say, 'it was an accident' ... 'I was afraid of you, that's why I hit you.'" Bashfully grinning, the little one passes on to the baby duck: "I'm sorry, duck." Anwar goes on: "And pet her a little" (Image 14.6). The grandchildren's faces clearly reveal that they find their grandfather's demanded gesture of apology asks too much of them. The children do not understand that Anwar is negotiating here with his own guilt, and that they should apologize to the duck as he should apologize to those he murdered. Below, we will see how he completely inverts his dream of begging his victims for forgiveness and erects an artificial setting in which his victims absurdly ask him for forgiveness. What appears in the duck episode as a 'moral compass,' commonly constructed in childhood in the form of the superego – education-mediated social values and norms such as the prohibition of killing, corrective action, and self-criticism – became suppressed in the case of Anwar and replaced by double moral standards.

The Act of Killing reveals that receiving orders from members of the army, or from paramilitary groups such as Pancasila Youth, provided the justification for perpetrator action in the death squads, which

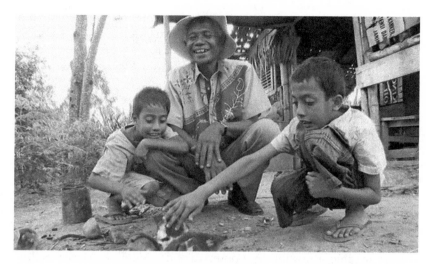

Image 14.6. Anwar as charming grandfather with baby ducks, *The Act of Killing* (2012). Image courtesy of Joshua Oppenheimer.

included members of Anwar's peer group. As a group member, the killer experienced support and backing; the members shared the same attitude, or exercised peer pressure on one another, which allowed their interests to temporarily converge. There were several larger circles of people who applauded the killings of the perpetrators, creating social recognition. In *The Act of Killing*, this social cohesion is still noticeable in different scenes: the warm greetings and mutual embracing between former group members, some of whom are still working together in politics or business. In the mid-1960s, the extreme situation of killing was experienced communally, which had an identity-building effect. This generated euphoria experienced through the elimination of opponents after their arrest, questioning, and torture. It was a precisely followed 'trinity of violence,' which served to 'prove' the victims' guilt and to prevent later doubts. In the re-enactment scenes in the 2000s, the perpetrators still tend to dissolve into irrational-propagandistic and destructive thinking, which was promoted by the group in the historical setting, as is shown in the studio/victim scene with collective perpetration, discussed below.

With Kühl's *Soziologie des Holocaust* one can ask about the specific motivations of members of the killing organizations who were ready to exterminate neighbours. Forced recruitment is not a factor here because the men were already criminals and had been collaborating with the military for a long time. Instead, other conditions that Kühl lists – obedience to authority, camaraderie, peer pressure, incentives for reward, careerism,

overcoming inhibitions to killing and brutalization through dehumanization of the victims, and legalization of state violence – can also be found in the Indonesian case.[35] In addition, in the context of eliminationist anti-communism, the responsibility for the killings seems to have been taken over by military authorities, who did not want to get their hands dirty with or risk revenge for the killings. Overwhelmed in terms of capacity, they therefore delegated the killings downwards. This allowed the latent anti-communist and anti-Chinese sentiments, which were supposed to mask the simultaneous remilitarization of the Indonesian state, to be followed by active participation in mass executions, which were packaged as patriotic acts that the army rewarded with gratitude and money. According to Kühl, in the National Socialist Third Reich the logistical trick was to let everything happen in "parcels of killing" (*"Parzellen des Tötens"*), step by step (comparable to "incremental radicalization," as described by Saul Friedländer and Ian Kershaw), which was kept as invisible as possible. Adi observes of the Indonesian case: "Killing is something you do quickly. Throw away corpses and go home"; and Anwar adds, "Because we did not want spectators." It must be said that, in 1965–66, most of the Indonesian population agreed to what they saw or heard anyway (Adi notes, "Even the neighbours knew it"). Thus, it is a matter of a relative invisibility – acting at night, packing the corpses in sacks, throwing them into the river, and so on – but the killings were visible enough to have a deterrent effect. Many knew what happened to their neighbours and remained silent, as they could easily be accused of being 'communists' themselves if they rebelled.

Another component in profiling Anwar and his friends in the historical setting is their affinity for the media. They can be considered cinephile "gangsters" who worked as ticket attendants and on the cinema ticket black market near the most famous cinema in Medan. As longtime members of organized crime, some of them or their predecessors had already terrorized the population during the colonial period under Dutch occupation. For the "movie theater gangsters," cinema not only provided concrete media models and blueprints for their killings, but also suggestions for extremely creative interrogation and killing methods. Anwar explains, "[…] cinema showed so many cool ways to kill. […] And I imitated their [the film characters'] way of killing." And in the vein of Hollywood movies, such as Elvis Presley films, they walked enthusiastically and in a prancing manner to the killings in the paramilitary bureau, which faced the cinema and was called by Anwar "office of the blood." Anwar lets the audience know, "When girls came by, we whistled. It was wonderful. We did not care what people thought. […] It was as if we killed in a good mood." It is an interesting question, one I won't

address here, to what extent the search for imaginary reinforcement by film characters – as imagined bon-vivants and accomplices of the real killing acts – may have played a role in suppressing aversion to killing.

Post-atrocity Perpetrator Symptoms

As the dramaturgical architecture of the film unfolds, it becomes apparent that Anwar is being attacked by neglected feelings of shame, which he reveals on the rooftop or when going fishing with his friend Adi Zulkadry (Image 14.7). In addition to the psychological symptoms that he describes, he is also currently suffering from paranoia and has a superstitious fear of vengeful spirits in the guise of the murdered. He fantasizes that the latter would speak with threatening voices, hate him, and laugh. How can this psychic formation be interpreted?

In contrast to Bernhard Giesen and Christoph Schneider in their book *Tätertrauma* (2004),[36] Raya Morag in *Waltzing with Bashir* (2013)[37] (see also her chapter in this anthology), or Saira Mohamed, I do not view the much-debated concept of perpetrator trauma as confirmable in principle. This is because the existential experience of shock, fear of death, and mortality of the victim in the initial traumatizing situation, that is, in the moment of being hurt, is not congruent or interchangeable with the experience of the culprit, but rather in numerous cases is diametrically opposed to it. While the victim is injured by an external power in the violent situation – the Greek word *trauma* is translated as "piercing through, penetrating, wounding" – the perpetrator may experience feelings of superiority, omnipotence and godlikeness, blood lust, and satisfaction (if not killing in a state of overwhelming panic and fear of imminent death). Certainly, he (or she or they) may have injured himself morally by the act itself, or in the aftermath experience symptoms similar to those of a surviving victim (such as nightmares, insomnia, restlessness, depression), or be haunted by feelings of remorse, shame, and guilt. However, none of this alters the asymmetry of power in place during the original scene of violence, not even if in retrospect the perpetrator perceives the violent act as wrong and recognizes his guilt due to a change of attitude.[38]

Instead of talking about 'perpetrator trauma,' borrowing the concept of traumatization for perpetrator research, and thus victimizing the perpetrator side, we can refer to the cultural anthropologist Aleida Assmann, who speaks of a future shock caused by the distressing confrontation with individual responsibility and guilt that is anticipated by perpetrators (comparable to the end of the Nazi regime). In such a case the 'genocidal' past necessarily would have to be confronted (this point

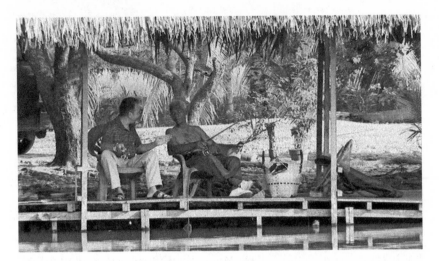

Image 14.7. Fishing in the dark killer past, *The Act of Killing* (2012). Image courtesy of Joshua Oppenheimer.

is obviously feared by Anwar and the other Indonesian mass murderers). While fishing in an artificial lake stocked with fish, Adi anticipates with great worry: "[The film] will disprove the propaganda about the communists being cruel and show that we were cruel" (see Image 14.7). Referring to Bernhard Giesen, Assmann states that the "turning point in consciousness" occurs only at the moment when a "triumphalist omnipotence fantasy abruptly reaches its limits," and could only become reality if the period that supports the killings was over.[39] Giesen explains: if Nazi perpetrators long thought themselves capable of deciding life and death, and behaved like a "self-enthroned absolute subjectivity" – similar to Anwar – they would only experience "perpetrator traumatization" when the illusion was harshly confronted with reality and exposed as a crime.[40] Only a collision with the sense of reality and a radical change in overall social values would generate a perpetrator consciousness, fueled not so much by an awakened conscience as a "dramatic shame by a total loss of face."[41] For a long time Indonesia has been far from reaching this point, but after the 2014 Oscar nomination of *The Act of Killing* and the Indonesian government's temporary acknowledgment in the same year of "human rights violations," hopefully they are getting closer to it.

Can it be said that the filming of *The Act of Killing* evokes a full awakening of Anwar's perpetrator consciousness? Since the conditions of impunity have not changed, this is hardly the case. However, Anwar and his cohort obviously are dealing with a belated identity crisis, triggered by

the constant re-enactment work while filming. With Giesen, one could say they are driven by a "post-heroic ambivalence." This does not necessarily imply a change of attitude, nor a detachment from the "triumphal-narcissistic identity"[42] or "trauma of shame." [43] Nonetheless, the filming of *The Act of Killing* has 'tugged' at their consciousness, and the warm domestic and foreign reception of the film may exert some pressure on the perpetrators, which might in turn reinforce their underlying despair or boost their repressive energies, or both.

The term 'post-atrocity perpetrator symptoms' introduced in this chapter makes it possible to see the denial of guilt in relation to acts of violence, as portrayed in *The Act of Killing*, which is connected with defence mechanisms by which the perpetrator's spirit protects itself from self-criticism or possible social sanctions. After 1965–66, the responsibility for the violence had been projected upon the victims by illegitimately stylizing them as enemies of the regime who needed to be destroyed. These mechanisms may have become chronic and pathological, adversely affecting the mental health of perpetrators. When people become perpetrators, they often violate their own moral convictions. They irreversibly cross a boundary that is ethically, socially, or religiously defined, disregarding the prohibition on killing and, in some cases, on revenge. They deliberately place themselves outside the framework of the social contract. This is also the case when the killing was ordered by rulers or allegedly serves as self-defence. If the notion of being wounded, injured, or traumatized was to be included (rhetorically mimicking the passive opposite part that actually receives the infliction), we would need to speak of a self-injury or 'self-traumatization' of the perpetrators. This is to be clearly distinguished from the passive experience of mortal agony of the victims, their feelings of powerlessness and humiliation, as well as their overpowering of perception due to fear and panic-inducing stimuli, potentially causing victim traumatization. Of course, the perpetrator's consciousness can also be impaired, as in the case of bloodlust, but this cannot be compared with the victims' experience at all. The experience of the perpetrator is fundamentally different from that of the victim, since it – as *The Act of Killing* emphasizes in various ways – is often associated with calculated killing, longing for potency, and lust for murder. Here hurting others provides relief, relaxation, satisfaction, gratification, pleasure, thrill, and ecstasy.[44]

After experiencing violence, victims often must deal with inappropriate feelings of shame, embarrassment and guilt, concealment, repression, compulsion towards repetition, and signs of a "post-traumatic stress reaction." In the case of the perpetrator, in contrast, irretrievably lost self-images of purity, shock about the violation of moral strictures,

and 'bad conscience' are dominant, which can lead to expressive 'post-atrocity perpetrator symptoms.' At the same time, as in the present case, guilt and shame are displaced. Responsibility for the deeds is denied, but simultaneously the atrocities' negative aura is repeated through bragging or re-enacting. Although some signs may resemble the trauma of victims on a performative level (insomnia, depression, heightened fright and arousal, flashbacks, nightmares, drug abuse, etc.), they have a different origin, reference point, and content. The one case involves managing the consequences of an experience of mortal fear, the other includes staving off recognition of guilt, identity crises, and a feared loss of face and reputation. *The Act of Killing* shows that the two forms of reaction – on a superficial bodily, aesthetic, symptomatological level – are parallel to each other, and both need to be taken seriously even though they belong to opposite ethical registers, political camps, and judicial norms.

Re-enactments of Violence: The Knocked-At Consciousness

How can the re-enactment scenes in *The Act of Killing*, in which the perpetrators point the camera on themselves, be described in more detail? In this essay film, planned and highly artificial re-enactment scenes in indoor and outdoor spaces are presented, which directly or indirectly refer to actual killing scenes in 1965–66. In addition, the film contains hyper-illusionary re-enactments that move beyond the realm of reality: overflowing, hyperbolic, grotesque, aesthetically exaggerated. It thus incorporates various film genres such as the Western, melodrama, thriller, and musical. According to the philosopher Robin George Collingwood in *The Idea of History* (posthumously from 1946), from a historiographical perspective a re-enactment includes "historical imagination," and it functions on various levels. Transferred to the present context, it would mean, first, the reconstruction and rebuilding of a historical event; second, acting and playing a role that creates distance from itself, while sometimes reversing past political positions (perpetrator-victim inversion); third, repeating and acting out the acts of killing; and fourth, restaging, mimicking, transforming, and merging with new elements.[45] The main difference between Collingwood's re-enactment theses and *The Act of Killing* is that, in the case of the Indonesian perpetrators, no historian retrospectively envisions and interprets the past. Instead, eyewitnesses and agents of the violent historical situation place themselves back in it (accompanied by the film team, who has another, secret agenda). In the first case it is about fidelity to the original and attention to detail but also including fantasy. In the second it is about constantly repeating the past

led by the (hidden) wish to repress it again, or to overcome it by further spinning it into elaborate cinematic fantasy settings.

The dramatic re-enactments in front of the camera and the replaying of the 'genocide' in *The Act of Killing* form a complex structure that can be described as a box model or 'télescopage of re-enactments.'[46] It consists of several elements. In the historical situation, killers like Anwar mimicked and re-enacted types of killers and killings they had seen and admired in Hollywood movies, such as strangulation with wire in mafia films. In the re-enactments in *The Act of Killing*, the historical acts of killing are, on the one hand, 'authentically' restaged, and on the other hand are enriched with today's fantasies of the perpetrators; they are thus transformed in a conceptual-aesthetic distortion. Here, the feedback element plays an essential role, consisting of film screenings on VCRs and laptops, and repeated loops that enable the correction of scenes; Oppenheimer used this technique mainly for Anwar (partly in the presence of his grandchildren or another paramilitary leader, Herman Koto). The perpetrators' long-term objective was to create an extraordinary "history film" that would consolidate their story and solidify it as a hero story. The planned film about "winners" was intended to receive recognition at the national level; at least that is the vision of Anwar and friends. They imagined being celebrated not only as local but as national heroes, which is what the mass murderers of Medan are still waiting for, as historian Benedict Anderson notes.[47] The documentary *The Act of Killing* explores these introspective journeys of the perpetrators on a meta-level by focusing on the resulting processes of critical self-questioning and, at the same time, of confirmation of their perpetrator role. In the director's cut, the elements of re-enactment are intertwined in a narrow space of time, allowing the spectator to immerse himself/herself within perpetrators' psyches and study them.

In the re-enactments, the perpetrators can pursue the urge to repeat and re-enact their deeds in an externalized form, which in the current situation is conscious, controlled, and performed under supervision (Image 14.8). In the course of this operationalized "repetition compulsion,"[48] the violent situations, whose moral impact had been repressed for decades, are played out over years and are 'digested' in the audio-visualization process (recollecting/repeating, re-enacting/restaging, acting/acting out, documenting/filming, screening/correction). The perpetrators mutually reinforce each other's potential to recollect and imagine/fantasize. It is important to point out that Oppenheimer and team did not have to ask the perpetrators to make these partly 'sincere confessions without a legal framework.' Rather, they used the perpetrators' tendency to repeat their history of violence again and again through the

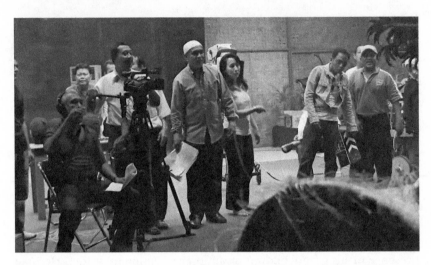

Image 14.8. Film set with perpetrators, film crew including activists, and a descendant of a former victim, *The Act of Killing* (2012). Image courtesy of Joshua Oppenheimer.

oral history tradition, which already was customary in the Indonesian perpetrator community, permanently re-enacting their killing drama. To give an example, Adi says to Anwar: "Do you still remember the 'Destroy the Chinese!' campaign in 1966? You gave me a list of Chinese communists. All along Sudirman street I killed every Chinese I met. Stabbed! I do not remember how many, but there were dozens." Enlarging and reinforcing this living tradition, Oppenheimer compresses the already existing re-enactment culture into a 'recapitulation film' (which from his side was never meant to be serious), in which the perpetrators can supposedly celebrate and, once again, justify their former acts of violence. While the greying ex-mass murderers imagine themselves in complete solidarity with the American director, Oppenheimer deceives them, and plays another game. In the various re-enactments, he sees the possibility of sending the perpetrators on a journey of self-examination. He lets them believe the common goal is a cross-genre feature film that portrays the glorious injustices of the perpetrators as 'authentic,' bloody, and as frightening as possible. He makes them think that he wants to stage them as national heroes and liberators from 'seditious elements,' as well as to consolidate their current oppressive power. In the diegesis of *The Act of Killing*, the feature film production, the announced "family film" (Anwar's words) or "glamorous heroic strip,"[49] turns out to be a film-in-the-film, whose parts are repeatedly screened in front of the

perpetrator-directors so they can think about corrections of the presentation to be realized in the next round of shooting. The result is a feature film that shows the full power and cruelty the perpetrators were capable of then and are still capable of today. The newspaper publisher Ibrahim Sinik, from whom the "gangsters" still extort protection money, jokes in Anwar's direction: "So, you are now a star! Incredible. The guy is a star!"

In Oppenheimer's *The Act of Killing*, the télescopage/re-enactments have coexisting and competing functions, which should be differentiated because remembrance takes place here amidst tensions between the repeated bragging about the killings, the perpetrators' objectification/rationalization/detaching, their self-doubts, and their processes of emotionalizing and empathizing with the victims. The documentary shows, as the filmmaker has repeatedly pointed out in audiovisual interviews, that repeated and exaggerated bragging can be the inverse of guilt, shame, and regret (for example, Anwar boasts of having knocked off heads). But before we come to this point, we need to reflect on another mechanism. Boasting is stimulated by the feeling of gratification that one has survived a dangerous situation. The writer Elias Canetti notes in his 1960 book *Crowds and Power* (*Masse und Macht*) about people at war who kill: "The lowest form of survival is killing";[50] "[w]hat they really need and what they can no longer do without [is] the continually repeated pleasure of survival."[51] In Canetti's eyes, the illusion of invulnerability, connected with a passionate search for a sense of grandeur and strength, derives for those in power from the God-like assumption of being able to decide life and death. Canetti argued in 1960, just a few years before the Indonesian massacres, that "confronting the man he has killed fills the survivor with a special kind of strength. There is nothing that can be compared with it, and there is no moment which more demands repetition." Canetti calls it the "sense of uniqueness."[52] The death of others here serves one's own survival and is therefore not mourned: "The moment of *survival* is the moment of power. Horror at the sight of death turns into satisfaction that it is someone else who is dead."[53] The constant 'theater of bragging' performed by the perpetrators in *The Act of Killing*, in front of and without a camera, can thus be interpreted as an attempt to mirror their own maintenance of power, to protect their systems of repression, and to maintain positive feelings and self-image.

By repeating and reliving the infliction of violence in multiple re-enactments, and by revisiting the scenes of killing, the former mass murderers create a constantly renewed bulwark against the intrusion of feelings of guilt and unpleasant self-criticism (against feelings of reluctance – or *Unlust* – to express it in Sigmund Freud's words), which can be provoked by external stimuli or inner drives. Anna Freud's

observation is important here, that the self-perception of one's own guilt is all the more directed against the outside world in the form of aggressions (here, projected in the re-enactment game) the less the crime one has committed is recognized as such.[54] On a superficial level, the perpetrators try to create and conserve through the chain of re-enactments a complete archive of the atrocities and suffering of their victims. Like the victims, they cannot or do not want to forget the acts of injustice, but rather seek to keep them in 'living memory' in an oral-history-like chain of repetition. By repeating, they can keep the horrors they caused in check by constantly, in a loop, reviving and repressing them for stability and self-preservation.

In Welzer's sense, this is a playful mixture of retroactive objectification, rationalization, and emotionalization. The stories circle around technical details of killing, the exact copying of killings, and depictions of everyday routine, in order to suppress emotions. The obsession with killing mechanics, automatisms, and weapons serves as self-protection and gives renewed justification, just as the 1965–66 interrogations, demoralizing, intimidation, and terrorizing of the alleged communists, as well as the meticulous recording of their self-accusations, served as first steps to justify dehumanizing the victims and to finally feel compelled to kill them.

This aspect of the re-enactment tactic may trigger an unpleasant, disorienting, or uncanny effect on the spectator. As more or less inquisitive voyeurs of the perpetrator-actors friskily reliving the joy, power, and strength of the killings, they become temporary accomplices to the crimes. Spectators witness the ex-killers' positive but also negative excitement, stimulated by the recall of the lust for killing. By retroactively becoming involved in the death game, spectators become, against their will, confidantes of a time that unfolds before their eyes and successively becomes tangible, and "takes on flesh." "Narrative models in film are not simply reflective microcosms of historical processes; they are also experiential grids or templates through which history can be written and national identity created. — [In film] time thickens, takes on flesh,"[55] Ella Shohat and Robert Stam write in a different context. Together with the perpetrators and the victims played by them, the spectators really *are* in the past – it is a time machine effect. The shared point of view might be experienced as hurtful because, until this point, spectators have already gradually come closer to the perpetrator figures. Even if a perpetrator, who is generally defined as the 'Other,' initially appears entirely alien, completely different from how one wishes to see oneself, these simple assumptions break up one by one during careful viewing of *The Act of Killing*.

The false security of repeated survival is torpedoed by the perpetrators' attempt to mimic the dormant (or passive) state of the dead, which

is realized in the re-enactments by playing the victim. So, at a deeper level, for the perpetrators the re-enactments also bring about an identification with the other side, that is, the victim being killed, by facilitating empathy and by the fact that more and more of the perpetrators' own internal characteristics of victimhood come to the surface. This is about filling the emotional vacuum, recharging emotionality, which had to be excluded or suppressed in the original situation in order to kill efficiently and mercilessly. The re-enactments revolve around wallowing in the suffering of others, combined with a gusto to kill, both of which can be turned off easily, because in the end the re-enactment situation is only a temporary game and can be abandoned at any time. As soon as victims' emotions, such as being disparaged, overpowered, or scared to death, have been adequately reconstructed, the game can be ended, and they can be ignored again. The victory of the perpetrators is thus placed on a permanent loop. But in some scenes, Anwar is mentally immersed in the past and absorbed by it to an extent that makes it hard for him to find the way back (meeting the past takes its toll), and in his old age the physically exhausting process of imitating killing seems to be more difficult for him (Image 14.9).

The cinematic dramatization of what the perpetrators did sets into motion a gradual recognition of the negative kernel of their actions. Communication studies scholar Camilla Møhring Reestorff says the killers are "troubled indexes of themselves," due to the affects the re-enactments fueled in them.[56] The spectators witness moments of self-discovery as the shell begins to crumble and the hard-boiled killer-self breaks down more and more. The perpetrators even agree with each other that they should get therapy for their mental symptoms, as is revealed by a conversation between Anwar and Adi at the fishpond:

ADI: But if you feel guilty, your defences collapse. Have you ever been to a neurologist?
ANWAR: If I went to a neurologist, it would mean, I'm crazy.
ADI: No! Psychiatrists are not for crazy people. [...] See, your nightmares are just a disturbance of the nervous system. [...] Then [the psychiatrist] gives you vitamins for the nerves.

At one point, Oppenheimer suddenly seems to abandon his maxim to not show any victims or their descendants in front of the camera (at least, this is the result, in the edited version of the film),[57] which structurally repeats their cultural silencing but at the same time makes it visible. During a studio recording, Suryono, stepson of a Chinese genocidal victim and Anwar's neighbour, who meanwhile became a member

Image 14.9. Anwar is exhausted by the re-enacted strangling, *The Act of Killing*
(2012). Image courtesy of Joshua Oppenheimer.

of the Pancasila Youth theatre group,[58] plays a victim who is interrogated
and threatened with a saber (Image 14.10). The spectators and perpetra-
tor-actors have previously learned that he was present when his beloved
stepfather's corpse was found under "an oil drum" after having been kid-
napped. Suryono and his grandfather carried the dead body away and
dug the grave: "That same morning, nobody dared to help us ... We bur-
ied him like a goat next to the main road. [...] No one helped us. I was
so small. Then, all the communist families were exiled. We were dumped
in a shanty town at the edge of the jungle. [...] Why should I hide this
from you? [...] It's only input for the film." The perpetrators, listening to
this story by a descendant of a 1965–66 victim, are surprised to hear from
Suryono what he had until this time deliberately concealed from his Pan-
casila colleagues for his own protection. While re-enacting the interroga-
tion of another victim, Suryono, who was an eleven-year-old child in the
mid-1960s, shows evidence that he is haunted by "traumatic memories"[59]
of the cruelly murdered stepfather, which threaten to overwhelm him.
He grimaces painfully, crying, slobbering, nasal mucus running down his
face. He turns into a creature who could easily be perceived as triggering
a tense state of abject disgust in the audience (Image 14.11).[60]

In this scene, the perpetrator-actors, who enjoy orchestrating the re-
enacted violence even more 'realistically' and in a manner true to the
original, are getting into a sadistic repetition loop. They repeat verbal,
psychological, and physical forms of violence, including holding the

saber directly to Suryono's neck, which visibly alarms and overburdens him. He becomes genuinely terrified and his acting skills seem to fail him, as he simultaneously attempts to suppress his memories of the execution of his stepfather, which flood his imagination. After painfully long minutes in the director's cut, in which dozens of sentences are heard, like Adi's comment: "I wanted them to accept that they were going to die," Anwar is told, "Show us how to torture" and, while the victim-actor is being gagged and blindfolded, someone throws in: "Doesn't matter if he really dies [in the re-enactment]." Suryono collapses. His mental injury and the traumatizing violence of the historical setting are present in this intrusion. The past extends into the here and now; the absent dead victim is suddenly very present. Replacing his stepfather, Suryono begs during the re-enactment game: "Have mercy on me. [...] Can you do something for my family? Or may I talk to them one last time?" As they would have probably answered his stepfather in the historical case, the perpetrator-actors reply: "By no means." The spectators can sense that Suryono now understands: having revealed his identity as a descendant of a victim, he is no longer safe among these killers. This impression is reinforced by the fact that Suryono refuses to drink a glass of water that is served to him, for fear it might be poisoned (Image 14.12). The fake modus of the re-enactment has completely vanished and provides space for the arrival of the cruel past – at least for a cinematic minute.

Temporarily Becoming the 'Other' by Cross-Identification: Anwar as Victim

As the re-enactments increase in quantity, Anwar more and more often changes sides and takes on the role of his former victims. The perpetrator-victim inversion, which retrospectively allows an imagined change of symbolic and historical positions in the re-enactment scenario, causes a change in the perpetrators' self-perception. For Anwar, the re-enactments create a connection to the 'universe of the feelings of the victims,' including his own experience of having been or felt like a victim in the past. In some game scenes, in particular the strangulation scene, he enforces the inversion until he really feels a gagging sensation and is close to unconsciousness. Suddenly, he appears apathetic, pale, exhausted, and helpless, because by impersonating the victim he has obviously come too close to their experience in the historical situation. The contact with the victim role, which causes him to fully identify, unsettles him so much that the other perpetrator-actors must care for him by touching and comforting him (Image 14.13). In another scene, Herman Koto, who as a cross-dresser[61] is playing a 'cruel female communist,' is holding a bloody animal liver to his mouth: "Look at that! Your liver! Look here! I

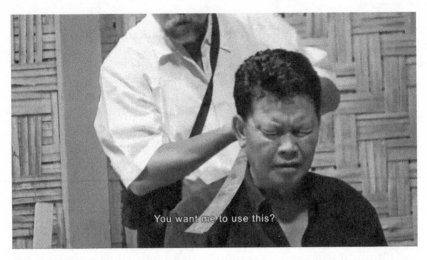

Image 14.10. Suryono is threatened by a saber, *The Act of Killing* (2012). Image courtesy of Joshua Oppenheimer.

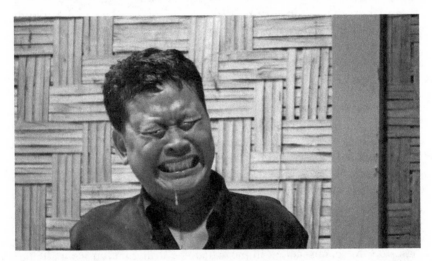

Image 14.11. Suryono in abjection-disgust mode, *The Act of Killing* (2012). Image courtesy of Joshua Oppenheimer.

eat it!" (Image 14.14). Here Herman projects his own aggression towards the 'communists' on the latter, imagining them as cruel. In the planned feature film from the pen of the perpetrators, this scene is intended to prove their potential for becoming victims and to serve as a justification for atrocities against 'communists' later in the film.

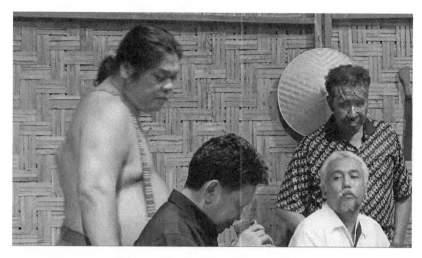

Image 14.12. Suryono's fear of poison and of the watching perpetrators, *The Act of Killing* (2012). Image courtesy of Joshua Oppenheimer.

Whether in the role of 'a potential victim of communist violence' or 'the victim of his own deeds,' Anwar develops embarrassment and admits hidden guilt feelings, or at least starts to acknowledge his real guilt. This could be a prerequisite for longer-lasting remorse or for mourning. But whether his playing-the-victim means a turning point in his 'self-re-education' and is an expression of a permanently changed perpetrator identity, or it only means a temporary masochistic enjoyment, remains unclear.

The Act of Killing offers its spectators a voyeuristic keyhole: the opportunity to watch the perpetrators' self-exploration from a position with little responsibility (namely the cinema seat). The film creates unwanted complicity with the perpetrators by a process of identification, repeating parts of the process the film director and his crew must have gone through (cf. Image 14.2). Metaphorically speaking, Oppenheimer takes on the role of obstetrician: he acts as a documentary maieutic of these tentative steps towards self-knowledge. The fact that the perpetrators are controlling the film set (Image 14.15) guarantees that they will engage in a psycho-dramatic 'self-therapy' within the logic of their planned 'glorious' feature film. The open-ended introspection of the culprits is shown as such in the documentary.

The significant difference between *The Act of Killing* and off-film psycho-dramatic therapeutic approaches, as Oppenheimer and Cynn point out in interviews,[62] is that they were not loyal to the perpetrators but 100 per cent loyal to the victims. This means that, while creating the

Image 14.13. Anwar goes pale playing a victim, *The Act of Killing* (2012). Image courtesy of Joshua Oppenheimer.

Image 14.14. Herman Koto offering the victim's liver, *The Act of Killing* (2012). Image courtesy of Joshua Oppenheimer.

gaming arena, they were relieved of the responsibility of advocacy, evaluation, and mental support of the perpetrators, because their solidarity belonged to the victims – at least as far as the film lets us know. (Oppenheimer merely accompanies the perpetrators in the role of a documentary filmmaker who protects and does not abandon them on a technical

Image 14.15. Anwar behind the re-enactment film camera, *The Act of Killing* (2012). Image courtesy of Joshua Oppenheimer.

and basic human level.) In principle, Oppenheimer sends the perpetrators on a mission without prejudging the outcome, in which they are exposed to the ghosts of their past and reveal this painful process in the film as under a glass lens, or in a cooperative laboratory experiment with unforeseeable long-term consequences.[63] Whether the perpetrators emotionally judge and savage themselves, or imagine salvation and the chance to exculpate themselves, by re-intoning the triumphalist narrative adopted by the Suharto regime, is up to them. Only once does the documentary show a judgmental intervention by Oppenheimer and the 'breaking of the fourth wall.' Here, the director's plan to film the perpetrators during their self-exposure, while they apparently believe the director is sympathetic to their political camp, is revealed. In the "Or have I sinned?" scene, in which Anwar seems temporarily close to a catharsis, it becomes clear that the filmmaker has 'duped' the perpetrators and in fact has never handed over control of the final script of the documentary. While watching a violent re-enactment in which he plays a victim on the home television screen, Anwar asks, "Did the people I tortured feel the way I do here? I can feel what those I tortured felt. Because here my dignity has been destroyed … and then fear comes right there and then … All the terror suddenly possessed my body." Oppenheimer's consequent unwillingness to enlighten his characters is partially broken when he answers frankly, betraying his undercover status:[64] "Actually, the people you tortured felt far worse – because you know, it's only a film. They knew they were being killed."

The role reversal between 'perpetrators' and 'victims' culminates in the scene where Anwar and Adi sit in the make-up studio having artificial wounds painted on their faces in order to play the part of the victims. The expressions on their faces, distorted by the make-up, not only provide an index of the multiple facial and head injuries that resulted from the historical mass killings,[65] they also announce how both are internally related to the process of accumulation of wounds and being-connected-with-the-abject, with blood, physical decay, and the like, which is in stark contrast to intact male subjectivity. The historical violence is recreated here by being facially transformed: now the perpetrators carry wounds that they have inflicted on others. Their faces do not display identity, uniqueness, and intimacy anymore, but rather the cumulative wound trophies are worn here like necrophiliac jewelry (Image 14.16). Extensive make-up becomes a medium to retrospectively identify with the victim's position, and to literally slip into the injured skin of the victims. But just as the re-enactment scenes can be interrupted at any time, when it becomes too serious or exhausting for the perpetrator-actors, the make-up can be washed off.

Although Anwar still daydreams of being officially recognized as a 'savior of the nation' who freed the Indonesian community from menacing 'communists' and heroically provided public safety, the method of re-enactment brings uncertainties, doubts, and guilt to the surface. Obviously, the documentary filming provided a (learning) environment in which Anwar was able to release blockages and open his crypt of guilt, both of which are the underside of his heroic self-image. Mathias Hirsch writes:

> [E]ven the perpetrator will have to wonder if he can stay with his self-image of power, 'borrowed' by imitating and identifying with the sadistic actions of the aggressor. By identifying with the victim, more precisely, the attempted takeover of the other, masochistic identification, he would get the chance to go through an otherwise never experienced victim identity, in order to then free himself from it. Because the mere repetition of the role of the perpetrator delegates the affects guilt, shame, fear, and pain necessary for the mourning to the new victims.[66]

In Hirsch's eyes, to admit fear, shame, and remorse is "a prerequisite for mourning work, for the detachment from the inner traumatic object, the 'frozen introject' ..., which must be thawed and experienced in the affect so to speak in order to leave behind both victim and perpetrator identity."[67] Transferring Hirsch's thoughts to the given context means that the re-enactments, together with the affects they initiate, serve as a bridge between the perpetrators and their perpetrator introjects that result from

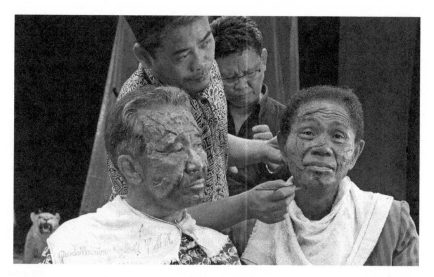

Image 14.16. Cumulative wounds as necrophiliac jewelry, *The Act of Killing* (2012). Image courtesy of Joshua Oppenheimer.

their own frozen victim parts. A precondition for healing would be that they find access to both parts of their (subconscious) persona.

Eyes Wide Open: Fear of Posthumous Revenge of Murdered Victims

In a re-enactment scene in the nocturnal forest, Anwar selects one of his recurrent nightmares and relives it in a staged manner. The nightmare revolves around a victim whom he has brutally kicked in the stomach and then decapitated with a machete, and who is staring at him posthumously. When he plays the dying victim, it seems for a moment that Anwar wants to die with him, to metamorphose into the dead, to bring all to a complete halt (cf. Image 14.1). The motif of the dead but staring eyes tells of the missed ritual of closing a dead man's eyes. Not the killing itself, but the fact he had omitted this ritual in the historical moment, persecutes Anwar and makes him feel guilty. It is an absurd diversion from the fact that about forty years ago he abducted and beheaded this person. At the same time, in retrospect, Anwar puts the blame on the victim and exculpates himself, because in his imagination those eyes stare at him to this day. They do not let him rest, and they scream for revenge, which potentially victimizes him. Irrationally, he fears a counterattack by the victim, a restoration of justice, even though, or perhaps because, he personally eradicated that person. By projection, the victim killed here is

imagined as an avenger, who returns the gaze – a gaze reversal of which the dead are not capable. This gaze follows the true perpetrator. It does not let him out of its sight. The (communication) channel between them seems to remain open. This matches Anwar's supposition that surviving 'communists' would quietly whisper their curses in the direction of the perpetrators so as not to be arrested by the men in power. Both illusions can be identified as a reaction to repeated hauntings of the perpetrator, and thus as 'post-atrocity perpetrator symptoms.'

Presumably, Anwar has the idea that the dead yet staring eyes preserved his image as the killer, the last thing the victim saw before he died, the last image on the murdered person's retina. In cultural history this is a familiar idea: as early as the nineteenth century lawyers and criminologists believed that the last image seen by a victim, the face of their murderer, could be recovered and help solve a murder.[68] For the cinematic medium as well, the human eye is a master player that has been imbued in film history with ever-varying epistemological significance. The eye is the venue of the sense most strongly stimulated in the cinema and at the same time the basic condition of everything cinematic. On a metaphorical level, film itself often functions as an eye looking into the world; the retina is analogized with the silver screen. The motif of dead but gazing eyes, which follows nineteenth-century retinal theory, is used in films such as Hitchcock's 1972 *Frenzy*.[69]

The fear of the powerful continuity of the dead victim is related to the fear that the perpetrator felt towards the victim before his death, for example in the context of the fiction of an anti-communist enemy. As a form of 'unfinished business,' Anwar cannot integrate this special victim *object*, who posthumously does not take his eyes off him and stands for hundreds of Anwar's other victims, into his intrapsychic structures. Psychoanalysts Mária Török and Nicolas Abraham have described a similar mechanism for individuals who respond to the loss of a love object by "incorporating" its intrapsychic correlate rather than mourning it.[70] The death of the loved one is denied instead of being accepted: there is an attempt to heal a real wound imaginarily.[71] The outer, actually dead object is instead relocated inside in an "endocryptic identification" and preserved in this incorporated version – a sign of failed or pathological mourning. A comparable process occurs with the *Act of Killing* perpetrator because the eliminated victim is also swallowed up as a whole and then intrapsychically does not allow any rest. Like a separate person it lives in an enclave, in the "artificial unconscious, in the middle of the ego."[72] From this position of the crypt it happens, "around the witching hour [...], that the ghost from the crypt haunts the graveyard guard [meaning the ego]" and makes strange demands – one could say, by adapting concepts by Török and Abraham to this context.

In the historic killing situation, fear of revenge from the hereafter, of those killed now coming back as revenge spirits, culminated in the widespread practice of murderers posthumously incorporating the victims' blood, which is a substitute substance of their victims. In *The Look of Silence*, we learn that some perpetrators drank the still-warm blood of their enemies immediately after killing, so as not to become "crazy." This is a custom that has a long tradition in North Sumatra and many other places, as Oppenheimer made clear in a presentation in Copenhagen in 2017.[73] Benedict Anderson refers to stories circulating in 1965–66 that said "'amateur killers' had mental breakdowns, went mad, or were […] haunted by terrifying dreams and fears of karmic retribution."[74] Likewise, Anwar, when sitting at the fishpond, expresses fear of being "crazy." On the raft, he talks about his fear that his wrongdoings could turn against him as bad karma, as a "direct punishment from God." The appropriated power of the enemy's blood was supposed to be able to prevent revenge and to immunize against attacks from the realm of the dead.

The drinking of blood was also supposed to transfer strength, which had been assigned to the victim constructed as an enemy image, to the perpetrator himself. (When Herman plays the female 'communist' and beheads a puppet representing Anwar, who imagines himself becoming the victim here, the surrounding perpetrator-actors shout out: "Drink his blood!") In addition, the phenomenon can be read as a mechanism of overkilling, in which the already lifeless body of the victim must be deprived of his last life force in order to further diminish him and to increase perpetrators' own sense of triumph.

According to *The Look of Silence*, several perpetrators left the mass-killing business because they could no longer stand the daily routine. In the view of perpetrators who continued killing, they had become "crazy," which probably meant that the psychic repression mechanism – the shutting down of empathy, the attempts at artificial justification, the whitewashing – that underpinned the killings no longer worked for them. The practice of drinking blood therefore could also stand for an attempt to make oneself spiritually invulnerable in a phantasmagoric way – precisely because of the self-perceived vulnerability and the fear of not being able to or wanting to kill any more.

Transformation Process: The Subtle Appearance of Shame and Guilt

The multitude of camera shots taken, following the perpetrators' killing scripts, over the years in which *The Act of Killing* was filmed, testify to a change in perpetrators' feelings and self-perceptions – most notably in Anwar, whose pain, according to Oppenheimer, was from the beginning

"close to the surface." Oppenheimer chose Anwar as the protagonist because he had somehow signalled that he was ready to take off the mask of a 'happy killer' and confront his pain, guilt, and shame. In *The Act of Killing*, his thoughts appear disorganized, contradictions arise, doubts knock at his conscience, and the repression-based balance seems to be in danger. In Anwar's case, the process of active repetition of the past, of being filmed, of the reassuring screenings of the recorded scenes, of the repeated revisions of the scenes in an endless loop of self-aggrandizement and self-degradation, continued for seven years. His goal was a perfect reconstruction of his glorious killer past in the planned feature film to preserve it for posterity through its fictionalizing film adaptation. But in the end, the filmic memoirs, the "film about death" in front of breath-takingly beautiful scenery, prove to be highly inglorious. On another level, however, the film-in-the-film shows that "revealing, embracing, and working with the fictions that are already operative," be they fictions about cinematic killing, political opponents, or escape fantasies of perpetrators, is extremely instructive to others and insightful for the sake of remembrance.[75]

The final scene of *The Act of Killing* proves once again how not only traumatized individuals, but in some cases also perpetrators, can be involved in senso-somatic re-experience loops and flooding mental sensations. Anwar here throws out his suppressed guilt, his self-criticism, and self-doubt in the literal sense. When he revisits a former crime scene, the above-mentioned roof terrace, and again wants to re-enact killing and disposal operations, he throws up several times. At this moment, he has no way to distance himself from his actions. Intrapsychic stimuli activate his emotionality and body memory. He feels shaken and helpless. What the ongoing acts of violence in the historical scenery could have provoked, but what Anwar systematically suppressed, is suddenly made visible. "The body keeps the score" could be said, in a modification of Bessel van der Kolk's formula.[76] It seems that Anwar's body, through the convulsive reaction, realizes faster than his mind can permanently admit what his crimes were. Anwar finally opens up: "I know it was wrong – but I had to do it. Why did I have to kill them? I had to kill ... My conscience told me they had to be killed." Although this statement acknowledges a mistake, it justifies and defends it at the same time with internalized false values that might be identified as obedience to male commands, a sense of duty, and pure patriotism – according to (his) standard notions of honour. This must be interpreted as an indication that Anwar's self-critical political consciousness has not matured by the end of the filming, as he is still affirming the dogmas and hate propaganda of 1965–66.

Bollywood Escape Fantasies – De-realization

At first glance, the phantasmatic-hypertrophic illusion of the perpetrators, in which their former victims forgive them, appears grotesque. It is not without reason that it plays in a seemingly out-of-this-world dimension. The unreal environment makes sense in relation to the intrapsychic constellation of the perpetrators, their narcissism, and their unconscious fear of political transformation. A closer look at the surreal episodes reveals that the dreamscapes, filled with psychedelic-hyperbolic images, contain clues to perpetrators' feelings of guilt and testify to the fantasy of escaping through regression into a safer world. The priestly and flamboyantly dressed perpetrators fantasize here about the unlikely event of receiving forgiveness from their victims in an act of transcendental reconciliation. In front of a fairy-tale setting with dancers and a rushing waterfall, which has a visually purifying effect, a victim killed by Anwar (played by a victim-actor) apologizes to the killer (Image 14.17). The victim gives him a gold medal to thank him for killing him and sending him off to heaven, while the title song of *Born Free* (1966, dir. Tom McGowan and James Hill), in the new adaptation of John Barry and Don Black, is playing. Through this absurd, dreamt perpetrator-victim inversion, the "gangsters" create a picture of themselves as capable even of manipulating the dead victims posthumously by forcing them to forgive their killers. Can this be read as a surreal control fantasy, or rather the yearning to rewind and reset to one's innocence? Or is this plain wishful thinking that can only be addressed in this unreal landscape?

Either way, the Bollywood fantasy suggests that it is not the perpetrators who have to change, but the world around them. It is therefore an indication of their internal resistance to admitting guilt and activating the moral system, or to understanding – a filmed derealization und undoing. At the same time, it shows an attempt to approach the victims, to erase the distance between them, even if the victim position can only be missed. Thus, the excuse scene tells of an inadmissible perpetrator-victim levelling or a fantasized 'over-forgiveness' between victims and perpetrators.[77] Imagination and illusion are used here to form a substitute for the unamenable, the painful dispute is circumnavigated, and the guilt is imaginarily removed.

Melting Ice? – On the Individual and Collective Level

The Act of Killing vehemently intervenes in the 'theater of forgetting and remembering' of the anti-communist massacres in Indonesia in the mid-1960s, challenging dominant historical narratives and activating

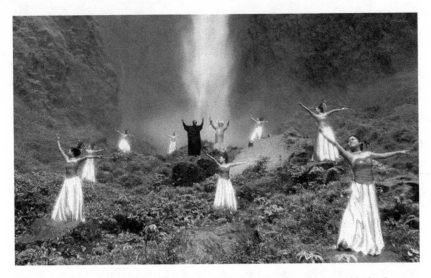

Image 14.17. Purifying waterfall of forgiveness, *The Act of Killing* (2012). Image courtesy of Joshua Oppenheimer.

processes of rewriting historiography. It portrays individual perpetrators, who have since lived unmolested, more or less 'happy,' enlightened, or almost remorseful in today's Indonesia, and who participate in criminal affairs of the state to this day. The film does not condemn them; perpetrators are not stigmatized as "evil," "devilish," "monstrous," "barbaric," or "bestial," nor does the film seek to rehabilitate them socially, for they are socially integrated based on the continuity of their power, albeit feared or shunned by descendants of victims. Rather, *The Act of Killing* focuses on their ordinariness and their humanity, their suffering, their self-doubts and weaknesses, challenging strict categorizations such as "perpetrators" and "victims."[78] It does not address the mass murderers as the only individuals responsible for the escalation in the massacres. Instead, it refers to the sociopolitical framework that promoted violence, and explores how this is related to today's repression strategies of perpetrator groups in North Sumatra.

By watching the perpetrators and their narcissistic navel-gazing as they relive their 'grand deeds' (in their distorted perception), the film provides previously taboo but instructive insight into the functioning of perpetrator mentalities. By exploring the internal view of the perpetrators, who portray themselves and their actions in a 'splendid' and multifaceted way, from a voyeuristic and scopophiliac point of view, *The Act of Killing* raises substantial questions about the causes, conditions, and

motives for extremely violent actions that affect and implicate all human beings. And this is irrespective of whether the latter perceive themselves as connoisseurs, accomplices, bystanders, or perpetrators of violence and injustice, and whether or not they are willing to acknowledge their involvement. Mid-1960s Medan is here and now; the attitudes of the perpetrators are at the same time terrible and terribly familiar, but they are by no means a distant and remote past. *The Act of Killing*, in a sense, passes on to spectators the question of when and how responsibility for the Indonesian massacres is taken or who is held accountable. This unpleasant question is addressed to all of us: how are we involved in building or indirectly nourishing conditions that allow violence on a larger or smaller scale in other contexts?

The literary scholar Michael Rothberg, in his recent book *The Implicated Subject: Beyond Victims and Perpetrators*, reflects on the implication of subjects in international scenes of violence in the past and the present, as well as from geographical and biographical distance.[79] Rothberg highlights the idea that the political responsibility of people who imagine themselves as innocent ranges from direct complicity and indirect profiteering to complex interconnections, like financial or political facilitation of acts of violence, or tolerance or approval of these acts. How are we involved in violent stories and current affairs and economies that are beyond our direct sphere of influence and personal participation? To what extent does the public participate in discursive, aesthetic, and performative creations of hierarchies and power asymmetries, in which the transition to violent and legally relevant perpetration can be fluid? How far does the focus on perpetrator characters generally serve to portray them as the 'Other,' outside a non-violent and pure society? On a metatheoretical level, one can ask with the social philosopher Pierre Bourdieu whether sub-complex models of perpetrators as a social and psychological category, through their seemingly clear demarcation, can also unilaterally assign and sanction violence, and thus render invisible symbolic violence, which, according to Bourdieu, is based on faith and magic and instructs the "perception and evaluation schemes [of social actors]."[80]

The Act of Killing pours these difficult aspects into an audiovisual staging that, like other films such as *A Mots couverts/Shades of True: Female Perpetrators of the Rwandan Genocide* (France 2014),[81] may serve intense study purposes. International spectators, who initially distance themselves from the perpetrator category, in order to secure for themselves the position of innocence, non-involvement, and reduced responsibility associated with the victim side, are awakened to the nuances of their status. And while *The Act of Killing* hits hard at one's own self-serving myths, it also helps to challenge the dominant, repressive narratives that enable

violence in the future. By not dehumanizing or demonizing the perpetrators, but instead exploring in detail the functioning of their psyches and mentalities, the film enables knowledge of perpetrator action (in the tension between perpetrator collectives and individual perpetrators) and its interrelations with victims of violence. This knowledge could be useful and valuable in informing processes of reconciliation, reparation, and compensation of victims. Since even in the (from today's perspective, unpredictable) case of a national working-through in Indonesia and an assumed responsibility by the state, it would not be expected that thousands of culprits would be imprisoned, the film could be a valuable starting point for rapprochement of victims and perpetrators.

In *The Act of Killing*, the perpetrators 'confess' their actions in nuanced and detailed killing reports. The twelve thousand hours of footage filmed by Oppenheimer and team over a decade of filming, in which the perpetrators incriminate themselves by their bragging, could be used as a reference for international criminal investigation, truth-finding, by NGOs or victim associations and, if appropriate, as an aid in prosecution. In such a case, the open-hearted narrative of the perpetrators would have acted as a boomerang that eventually will hit themselves – the material shown in the director's cut contains Adi's statement that "[i]t was not the communists who were cruel. [...] I am fully aware that we were cruel." But this is a dream of the future, which probably will not become reality in the lifetime of the perpetrators, because the film demonstrates clearly that government and power alliances are still based on the intimidating actions of paramilitary organizations and the network of "gangsters." At any rate, in the reception process, the filmed perpetrator images were transported back to the social body, the Indonesian and global collective. They enabled a partially renewed self-understanding as well as historiography, identity formation, and culture of remembrance – "challenging the legitimacy of the victor's power."[82]

Whatever the future of domestic or international conflict-processing of the Indonesian massacres of 1965–66 will look like, the film makes a powerful contribution to critical perpetrator and violence research that promotes the de-tabooing of knowledge, and thus could be transferred to other conflict zones in the Global South and elsewhere. The progressive nature of such illumination of perpetration lies in the need to reflect on one's own entanglement in psychic, physical, financial, symbolic, and social scenarios of violence. The critical knowledge communicated in the film, which revealed the humanity and 'normality' of the perpetrators as well as the conditions and choices that led to their cruelty, could help prevent future violence at an early stage. *The Act of Killing* shows that violence is often a prefabricated, albeit not necessarily foreseeable, part

of existing networks of relationships (here political elites in cooperation with the [para]military and local agents). It is involved in power relations and resulting asymmetries and dependencies, which can be deciphered (film-)analytically. The 'intimate' knowledge about single perpetrators and perpetrator alliances extracted by Oppenheimer's film-aesthetic re-enactment methods provide new and important directions for clinical and theoretical perpetrator research.

 The Act of Killing and *The Look of Silence* are decolonizing conventional perspectives in trauma studies, memory studies, and perpetrator studies[83] due to their numerous non-Western collaborators (on the level of co-workers, and cooperating/counselling organizations) as well as by providing an opportunity to more intensely perceive traumatic events that transcend European or North American geographic territory and affect the Global South. By integrating in-depth psychological knowledge about the Indonesian massacres into the global historiographic cartography, the film has made a significant contribution to bringing this 'genocide' to international attention. By supplementing knowledge of comparative genocide studies, it challenges the uniqueness, alleged incomparability, and quasi-sacred status of certain forms of genocide, such as the Holocaust/Shoah. In memory studies, the Indonesian massacres of 1965–66 need to be placed alongside the genocide in Rwanda, the Khmer Rouge mass killings in Cambodia, the Armenian genocide, and the apartheid regime in South Africa. Even more so than with some of these other scenarios, in Indonesia to date there has been absolute impunity for the perpetrators; there is no official apology in sight, no request for forgiveness from state authorities[84] for the irreparable harm inflicted on the families of victims. Despite a brief recognition of "human rights violations" by the current Indonesian government in 2014, the perpetrators continue to be powerful, even though deep down some wish to apologize on their own, as Adi points out in an ambivalent way, sitting at the fishpond: "The government should apologize, not us. It would be like medicine. It would relieve the pain. Asking for forgiveness." Anwar anxiously adds, "Would not they [the victims' supporters] curse us silently?" The scene anticipates a change: dialogue about the crimes has been sparked, and Oppenheimer's documentary film influenced the domestic media landscape in such a way that it critically addressed the mass murder shortly after the film's release, allowing perpetrator and victim perspectives to be heard, as well as debates about the difficult consequences of impunity. However, a detailed understanding of all conditions and dynamics that authorized and facilitated the killing acts is still pending – but *The Act of Killing* was an immensely important step in this direction.

The Act of Killing looks at the functioning of the 'viscera of power' linked to a neglected national memory, and it pushes the exploration of the twisted consciousness of the perpetrators to its limits, lending it malleability. The cinematographic experience provokes an epistemic vertigo, which provides insight into the intrapsychic dynamics of perpetrators, and into defence mechanisms that prevent them from recognizing their wrongdoing, facing it, and taking responsibility. Their 'post-atrocity perpetrator symptoms' become readable as a substitute for a lack of empathy and an adequate emotional repertoire. The aim of the film could be identified as a method of film therapy to liberate the perpetrators from their social masks, as well as their self-denial, and to thwart the associated historical misrepresentation (this especially coalesces in the figure of Anwar Congo). The sixty-person film crew, kept anonymous for security reasons, consisting of human rights activists, academics, and the like, enabled the perpetrators to create a filmic language of re-enactment in order to excavate the killers' human faces and gradually evoke critical self-reflection. This was about initiating a process of 'becoming someone else,' and of 'unlearning' violent perpetration. Even if this learning process comes too late for the perpetrators, it might not be too late for us.

ACKNOWLEDGMENTS

All film stills that appear in this chapter were taken from the documentary *The Act of Killing* (2012), directed by Joshua Oppenheimer, who generously gave me permission to use them as visual arguments and to illustrate my analysis. For their kind help with finalizing the manuscript regarding grammar and idiomatics, I am grateful to Jason Crouthamel, Grace E. Coolidge, Michael Huner, and Terry Teskey.

NOTES

1 *The Act of Killing/Jagal* (UK/Denmark/Norway 2012), dir. Joshua Oppenheimer, 159 min. (director's cut). The film reception (press and scientific articles), which at first partly reflected indignation, distancing, and overburdening, has meanwhile discussed the award-winning film in extensive interdisciplinary analyses. Extracts from the secondary literature are quoted in the following text.

2 The waves were visible in Indonesian groups of victims and perpetrators as well as in the world of politicians, historians, psycho-traumatologists, and violence researchers just as in transnational memory and trauma studies.

3 Michael Elm, Kobi Kabalek, and Julia B. Köhne, eds., *The Horrors of Trauma in Cinema: Violence, Void, Visualization* (Newcastle upon Tyne: Cambridge Scholars Publishing, 2014), esp. 1–29.

4 See Robert Cribb, ed., *The Indonesian Killings 1965–1966: Studies from Java and Bali* (Clayton: Centre of Southeast Asian Studies, Monash University, 1990), 1–43.

5 The film critic Georg Seeßlen employs these adjectives in characterizing the essayistic documentary; see his "Der Essayfilm als politische Geste," in *Zooming IN and OUT: Produktionen des Politischen im neueren deutschsprachigen Dokumentarfilm*, ed. Klaudija Sabo, Aylin Basaran, and Julia B. Köhne (Vienna: Mandelbaum, 2013), 97: "The essay [film] is directed in its methodical border crossing against an open or covert prohibition of thinking, perception, speaking, depicting. The essay is not only to change the prevailing discourses, but it rather tries to reach places and perspectives outside the discourses" (my translation).

6 *The Look of Silence* (Denmark/Indonesia, Finland, et al. 2014/15), dir. Joshua Oppenheimer, 99 min.

7 *The Act of Killing* focuses on male perpetrators; according to Annie E. Pohlman, there is less research on female perpetrators, profiteers, or informers who, for example, were working in security service or in the camps. An exception to this male dominance is the case of a female police officer who behaved with extreme cruelty towards an interrogated 'communist' woman with a baby; see Komnas Perempuan, *Gender-Based Crimes against Humanity: Listening to the Voices of Women Survivors of 1965* (Jakarta: Komnas Perempuan, 2007), 101. For research on female perpetrators and female victims of sexualized violence during the massacres, see Annie E. Pohlman, *Women, Sexual Violence and the Indonesian Killings of 1965–66* (Abingdon, UK: Routledge, 2015), esp. 15–20.

8 This number is debatable and varies depending on the scientific source; see, for example, Geoffrey B. Robinson's *The Killing Season: A History of the Indonesian Massacres, 1965–66* (Princeton: Princeton University Press, 2019), 3.

9 Anett Keller, "Suharto-Aufarbeitung in Indonesien: Ein monströses Verbrechen," *die tageszeitung*, 25 July 2012; Benedict Anderson, "How Did the Generals Die?" *Indonesia* 43 (April 1987): 109–134; Benedict Anderson, "Impunity," in *Killer Images: Documentary Film, Memory and the Performance of Violence*, ed. Joram Ten Brink and Joshua Oppenheimer (New York: Wallflower, 2012), 268–86.

10 See Annie E. Pohlman, "Introduction: The Massacres of 1965–1966: New Interpretations and the Current Debate in Indonesia," *Journal of Current Southeast Asian Affairs* 32, no. 3 (2013): 5, https://journals.sub.uni-hamburg.de/giga/jsaa/article/view/705/703.html.

11 Werner Bohleber, "Wege und Inhalte transgenerationeller Weitergabe: Psychoanalytische Perspektiven," in *Kinder des Weltkrieges: Transgenerationale*

Weitergabe kriegsbelasteter Kindheiten. Interdisziplinäre Studien zur Nachhaltigkeit historischer Erfahrungen in vier Generationen, ed. H. Radebold, W. Bohleber, and J.W. Zinnecker (Weinheim: Juventa, 2009), 109, my translation. The quoted words were written by Bohleber, a psychoanalyst, regarding another context: National Socialism.

12 On the problem of silencing of victims and their feelings of shame and guilt, see Christine Cynn, "Die Leute kannten nicht nur die Toten, sondern auch deren Mörder. Psychodrama-Praktiken: Der Täter als Opfer," *artechock film*, Munich, 14 November 2013, https://www.artechock.de/film/text/interview/c/cynn_2013.html.

13 Mathias Hirsch, "Täter und Opfer sexueller Gewalt in einer therapeutischen Gruppe: Über umwandelnde Gegen- und Kreuzidentifikationen," unpublished manuscript for a lecture at the conference "Tätermodelle & Transgression," Humboldt University of Berlin, 19 January 2018.

14 Anna Freud, "Identification with the Aggressor," in Freud, *The Ego and the Mechanisms of Defence* (South Hampstead: Karnac Books, 1992 [1936]), 110.

15 Ibid., 111.

16 Ibid.

17 Ibid., 113.

18 Ibid., 110.

19 See Nick Bradshaw, "Build My Gallows High: Joshua Oppenheimer on *The Act of Killing*," *Sight and Sound*, 5 June 2017. Oppenheimer explains, "[Anwar's] drawn to the pain, to the most horrifying memories and to re-enacting them, because somehow he's trying to replace the miasmic, shapeless, unspeakable horror that visits him in his nightmares with these contained, concrete scenes. It's like he's trying to build up a cinematic-psychic scar tissue over his wound"; accessed 3 March 2020, https://www.bfi.org.uk/news-opinion/sight-sound-magazine/interviews/build-my-gallows-high-joshua-oppenheimer-act-killing.

20 See Brad Simpson, "It's Our Act of Killing, Too," *The Nation*, 28 February 2014.

21 Camilla Møhring Reestorff, "Unruly Artivism and the Participatory Documentary Ecology of *The Act of Killing*," *Studies in Documentary Film* 9, no. 1 (2015): 11.

22 Adi Zulkadry continues: "I'm a winner. So I can make my own definition. I needn't follow the international definitions. And more important, not everything true is good."

23 Saira Mohamed, "Of Monsters and Men: Perpetrator Trauma and Mass Atrocity," Berkeley Law Scholarship Repository, 115 *Colum. L. Rev.* 1157 (2015), 1190 et seq.

24 Ibid., 1194.

25 Ibid., 1167.

26 Ibid., 1162f.

27 Ibid., 1192.

28 René Girard, *Violence and the Sacred*, trans. Patrick Gregory (Baltimore: Johns Hopkins University Press, 1989), 4; first published as *Das Heilige und die Gewalt*, 1972.

29 Ibid., 8, emphasis in original.

30 Ibid., 93.

31 Stefan Kühl, *Ganz normale Organisationen: Zur Soziologie des Holocaust* (Frankfurt am Main: Suhrkamp, 2014), 97–109.

32 Philip G. Zimbardo, *The Lucifer Effect: Understanding How Good People Turn Evil* (New York: Random House, 2007). The social psychologist identifies the following characteristics that are needed to turn ordinary people into killers: power, conformity, obedience and loss of personal responsibility, de-individuation, dehumanization of the victim, and apathy of the bystanders ("evil of interaction") (258, 297, 318).

33 Harald Welzer, "Wer waren die Täter? Anmerkungen zur Täterforschung aus sozialpsychologischer Sicht," in *Die Täter der Shoah: Fanatische Nationalsozialisten oder ganz normale Deutsche?*, ed. Gerhard Paul (Göttingen: Wallstein, 2002), 238, my translation.

34 Freud, "Identification with the Aggressor," 114.

35 Kühl, *Ganz normale Organisationen*.

36 Bernhard Giesen and Christoph Schneider, eds., *Tätertrauma: Nationale Erinnerungen im öffentlichen Diskurs* (Konstanz: UVK, 2004).

37 Raya Morag, *Waltzing with Bashir: Perpetrator Trauma and Cinema* (New York: Tauris, 2013).

38 Of course, there is a whole set of different acts of violence and perpetrator types that needed to be differentiated. Violence can also be the result of "traumatic restaging" ("traumatische Reinszenierung," Franziska Lamott), for example, in cases of sexualized violence and victim-perpetrator-inversion, or they happen out of self-defence, homicide, and so on.

39 Aleida Assmann, *Der lange Schatten der Vergangenheit: Erinnerungskultur und Geschichtspolitik* (Munich: C.H. Beck, 2011 [2006]), 97.

40 Bernhard Giesen, "Das Tätertrauma der Deutschen: Eine Einleitung," in *Tätertrauma: Nationale Erinnerungen im öffentlichen Diskurs*, ed. Bernhard Giesen and Christoph Schneider (Konstanz: UVK, 2004), 20–2.

41 Assmann, *Der lange Schatten der Vergangenheit*, sec. 97; Andreas Kraft, "Gespenstische Botschaften an die Nachgeborenen: 'Cultural Haunting' in der neueren deutschen Literatur," in *Rendezvous mit dem Realen: Die Spur des Traumas in den Künsten*, ed. Aleida Assmann, Karolina Jeftic, and Friederike Wappler (Bielefeld: transcript, 2014), 154.

42 Kraft, "Gespenstische Botschaften," 154.

43 Giesen, "Das Tätertrauma der Deutschen," 20–2.

44 This can be coupled with feelings of triumph, ultimate power, superiority, and control over others, as well as jubilation and self-exaltation. Statements from the ex-killers that are quoted throughout this chapter attest to these ideas and views.

45 See Julia B. Köhne, "Ästhetisierung des Unbewussten: Camillo Negros neuropathologische Kinematographie des Kriegsreenactments (1918)," in *Psychiatrie im Ersten Weltkrieg*, ed. Thomas Becker, Heiner Fangerau, Peter Fassl, and Hans-Georg Hofer (Konstanz: UVK, 2018), 67–103.

46 See the concept of "télescopage of the unconscious": Sigrid Weigel, "Télescopage im Unbewußten: Zum Verhältnis von Trauma, Geschichts-begriff und Literatur," in *Trauma: Ein Konzept zwischen Psychoanalyse und kulturellem Deutungsmuster*, ed. Elisabeth Bronfen, Birgit R. Erdle, and Sigrid Weigel (Vienna: Böhlau, 1999), 51–76.

47 Anderson, "Impunity," 282.

48 Although these psychic reactions look similar to the loops of re-experiencing of traumatized victims/survivors and could, at least to a certain extent, be described in an inversion of Sigmund Freud's categories outlined in "Remembering, Repeating and Working-Through" (1914), there is a grave difference between the two political positions.

49 Cynn, "Die Leute kannten nicht nur die Toten."

50 Elias Canetti, *Crowds and Power*, trans. Carol Stewart (New York: Continuum, 1978), 227.

51 Ibid., 230.

52 Ibid., 227.

53 Ibid., emphasis in original.

54 Freud, "Identification with the Aggressor," 118–21.

55 Ella Shohat and Robert Stam, eds., *Multiculturalism, Postcoloniality, and Transnational Media* (New Brunswick: Rutgers University Press, 2003), 10.

56 Møhring Reestorff, "Unruly Artivism," *Studies in Documentary Film* 9, no. 1 (2015): 10.

57 Joshua Oppenheimer clarified in an email (30 March 2020): "We had a rule that survivors should not participate in *The Act of Killing*. We were concerned, above all, for their safety: survivors could become easy targets of the perpetrators' anger after the film's release. We discovered later that one of the paramilitary members, Suryono, was also a survivor, in the sense that his step-father had been killed. Yet Suryono's participation was inadvertent: a second camera-person not fluent in Indonesian filmed Suryono telling his stepfather's story, and I became aware of the story only months later, while editing."

58 It seems Suryono joined the paramilitary group responsible for the death of his stepfather in order to be close to the 'political opponents' and secretly work through his trauma; or he strove by his 'conversion' to be protected by their power, in case violence against 'communists' returned.

59 For a discussion of the theoretical history of the term "traumatic memory," which addresses senso-motoric elements and sensory (intrusive) imprints that can be triggered, as dominant over 'ordinary,' conscious, cognitive, constructive, linear forms of remembrance, see Bessel A. van der Kolk, "Trauma and Memory," *Psychiatry and Clinical Neurosciences* 52 (1998), https://doi.org/10.1046/j.1440-1819.1998.0520s5S97.x.

60 Winfried Menninghaus, *Ekel: Theorie und Geschichte einer starken Empfindung* (Frankfurt am Main: Suhrkamp, 1999); Julia Kristeva, *Powers of Horror: An Essay on Abjection* (New York: Columbia University Press, 1982).

61 For thoughts on the function of cross-dressing as an outlet for stress relief in war situations, see Julia B. Köhne and Britta Lange, "Mit Geschlechterrollen spielen: Die Illusionsmaschine Damenimitation in Front- und Gefangenen-theatern des Ersten Weltkriegs," in *Mein Kamerad – Die Diva: Theaterspielen an der Front und in Gefangenenlagern des Ersten Weltkriegs*, ed. Julia B. Köhne, Britta Lange, and Anke Vetter (Munich: edition kritik, 2014), 25–41.

62 Cynn, "Die Leute kannten nicht nur die Toten."

63 In a speech in "The Lost Lectures," Christine Cynn describes this method as follows: as a filmmaker she would create "spaces or frameworks for people to explore, play with and extent their imaginary selves." https://www.youtube.com/watch?v=RMIlg91M4eQ.

64 In contrast to Oppenheimer's reticence for safety reasons, the director of the documentary film *S21 – The Khmer Rouge Killing Machine* (Cambodia/France 2003, dir. Rithy Panh) revealed his political position concerning the Khmer Rouge conflict, according to self-testimony. See Joshua Oppenheimer, "Perpetrators' Testimony and the Restoration of Humanity: *S21*, Rithy Panh," in *Killer Images*, ed. Brink and Oppenheimer, 246.

65 Julia B. Köhne, "Geister und Masken des Kriegs in Kaneto Shindōs ONIBABA (1964)," in *Geschlecht ohne Körper: Gespenster im Kontext von Gender, Kultur und Geschichte*, ed. Thomas Ballhausen, Barbara Hindinger, Esther Saletta, and Christa Tuczay (Vienna: Praesens, 2020).

66 Mathias Hirsch, "Täter und Opfer sexueller Gewalt in einer thera-peutischen Gruppe – über umwandelnde Gegen- und Kreuzidentifika-tionen," *Gruppenpsychotherapeutische Gruppendynamik* 39 (2003): 169–86, my translation.

67 Mathias Hirsch, "Psychoanalytische Therapie mit Opfern inzestuöser Gewalt," *Jahrbuch der Psychoanalyse* 31 (1993): 132–48.

68 Auguste Gabriel Maxime Vernois's (1809–77) retina thesis of 1870 states that "on the retina of corpses one can recognize the last consciously taken picture like a fixed after-image [theory of the 'optogram']." Vernois therefore had the retina of murder victims surgically removed, to read by microscopic magnification the identity of the murderers on them. The dying man, in Vernois's opinion, becomes a mechanical camera, which documents in a

final act the violence with which he is killed. See Angelica Schwab, *Serienkiller in Wirklichkeit und Film: Störenfried oder Stabilisator?* (Münster: LIT, 2001), 281.

69 Julia B. Köhne, "Auge," in *Wörterbuch kinematografischer Objekte*, ed. Marius Böttcher et al. (Berlin: August, 2014), 19–21.

70 Mária Török and Nicolas Abraham, "Trauer *oder* Melancholie: Introjizieren – inkorporieren," *Psyche* 55/6, July 2001 [1972]: 545–59.

71 Ibid., 555.

72 Mária Török and Nicolas Abraham, "Die Topik der Realität: Bemerkungen zu einer Metapsychologie des Geheimnisses," *Psyche* 55, no. 6 (July 2001 [1971]): 541.

73 See Second Annual Conference of the Memory Studies Association, 14–16 December 2017, University of Copenhagen.

74 Anderson, "Impunity," 274. Also see Christopher Browning, *Ordinary Men: Reserve Police Battalion 11 and the Final Solution in Poland* (New York: HarperCollins, 1992), esp. 55–71, dealing with a particular German killing unit sent to Poland and the Soviet Union; some of the policemen broke down in the face of routinized killing and deportation of Jews.

75 Homay King, "Born Free? Repetition and Fantasy in *The Act of Killing*," *Film Quarterly* 67, no. 2 (Winter 2013): 30.

76 On traumatic stress, its effects on victims, and fragmented traumatic memory functions, see Bessel A. van der Kolk, *The Body Keeps the Score: Mind, Brain, and Body in the Healing of Trauma* (Suffolk: Penguin, 2015).

77 Ursula Kreutzer-Haustein, "Deutsche und Israelis: Die Vergangenheit in der Gegenwart: Eine psychoanalytische Arbeitstagung in Nazareth im Juni 1994," *Forum der Psychoanalyse* 10 (1994): 364 et seq.

78 Mohamed, "Of Monsters and Men," 1169: "[T]here is value, too, to recognizing the equal humanity of the two categories [victim/perpetrator], and to recognizing the capacity for the project of international criminal law to declare the commonness, the ordinariness, the humanness of the people who commit these horrific crimes."

79 Michael Rothberg, *The Implicated Subject: Beyond Victims and Perpetrators* (Palo Alto: Stanford University Press, 2019).

80 Pierre Bourdieu, *Praktische Vernunft: Zur Theorie des Handelns* (Frankfurt am Main: Suhrkamp, 1998), 174.

81 See the documentary *A Mots couverts*, released in English as *Shades of True: Female Perpetrators of the Rwandan Genocide* (Fr. 2014), dir. Alexandre Westphal and Violaine Baraduc, 88 min., which focuses on female perpetrators of the 1994 genocide in Rwanda who are interned in a Kigali prison and, in group discussions, reflect on the preconditions of their becoming ruthless killers of Tutsi friends, neighbours, and family members.

82 Oppenheimer, cited in Tim Grierson "'The Look of Silence': How a New Doc Revisits Indonesia's Genocide," *Rolling Stone*, 17 July 2015, https://www

.rollingstone.com/movies/movie-news/the-look-of-silence-how-a-new-doc-revisits-indonesias-genocide-113990/.

83 See Michael Rothberg, "Decolonizing Trauma Studies: A Response," *Studies in the Novel* 40, no. 1/2 (2008): 224–34.

84 On apologies after human rights violations in the context of transitional justice, see Ruben Carranza, Cristián Correa, and Elena Naughton, eds., *More Than Words: Apologies as a Form of Reparation* (New York: International Center for Transitional Justice, 2015), esp. 4. See also Centre for Peace and Conflict Studies, *National Apologies: Mapping the Complexities of Validity*, accessed 3 March 2020, http://www.centrepeaceconflictstudies.org/wp-content/uploads/National_Apologies.pdf.

15 Perpetrator Trauma and Current American War Cinema

RAYA MORAG

This chapter builds on the term 'perpetrator trauma' that I introduced in 2013 as a new paradigm[1] in cinema studies to deal with national traumas, one that for the first time recognizes a shift from the victim trauma paradigm typical of the twentieth century to the perpetrator trauma paradigm typical of the twenty-first. Differentiating between the two centuries also means differentiating between modern war (e.g., the First World War), in which one army faced another, and what Mary Kaldor calls new war, in which "violence is directed against civilians not as a side effect of war but as a deliberate strategy."[2] New war, in its contemporary, multilateral, and multipolar form, has been defined by various scholars, including Michael Walzer (1977), Jean Baudrillard (2002), Chris Hables Gray (2001), Slavoj Žižek (2002), and Neta C. Crawford (2003), as typified by radical transformations.[3] In the new war, the major traditional contrasts that have been either dismantled or placed in crisis are terror–war, sovereign state–proto-state, front–home, 'us'–'them,' civilian–soldier, individual crime–organized crime, high tech–low tech, victim–perpetrator, defence–offence, beginning–end, victory–defeat, war–peace, and moral–immoral. New war indeed imposes new logic on us, demanding that we decipher it on a global scale.

Defining 'Perpetrator Trauma'

It is somehow taken for granted that canonical psychological and psychiatric trauma research from Sigmund Freud's *Aetiology of Hysteria* (1896) to the present has been carried out from the perspective of identification with the victim, preventing trauma research from developing the tools necessary to cope with the post-traumatic perpetrator. Dealing with such trauma is excluded, unimaginable, and perceived as unseemly. This interest in the victim, as well as continuous discussion surrounding the

crisis of testimony in psychoanalysis, literature, the courts, and the writing of history and trauma was widely analysed during the 1990s and the first decade of this century vis-à-vis the Holocaust, war, and domestic and state violence.[4] In other words, in the following decades as well, treatment-oriented or ideology-motivated research, duty-bound to study the major catastrophes of the twentieth century, was inherently committed to the trauma of victims and far less to that of perpetrators.

Psychiatric and psychological trauma research is not alone. Contemporary humanities-based trauma studies, whose main tenets embrace the temporality of the victims' traumatic memory (for example, Bessel van der Kolk and Onno van der Hart, Cathy Caruth, and Ruth Leys)[5] and cinema trauma research (for example, Anton Kaes, E. Ann Kaplan, and Janet Walker),[6] also largely identify with the victims and are devoted to illuminating their ordeal. The pervasiveness of this perspective has inevitably contributed to the exclusion of perpetrator trauma.

In the late 1990s, however, especially during the deliberations of the South African Truth and Reconciliation Commission (TRC), three major theoretical transformations emerged and played a significant role in human rights discourse: first, each category identified by the TRC (victim, perpetrator, bystander, beneficiary) was examined independently of the others; second, the main categories (victim and perpetrator) were considered heterogeneous rather than homogeneous (distinctions were drawn between institutional and sectoral perpetrators, individual perpetrators, victims by proxy, secondary victims, etc.);[7] and third and consequently, the binary opposition of victim-perpetrator was broken, creating the possibility of interchange between the two categories. These new theoretical insights could not have been included in the contemporary trauma discourse prevalent in the mid-1990s pioneered by Cathy Caruth, and they have yet to be adopted by new trends in cinema research, which may perceive transcending the victim-perpetrator dialectic as an inevitable act of critique in certain political situations, especially in relation to the post-9/11 war on terror[8]/new war. We should recall that conceptions of war trauma are generally derived from modern wars, since the late nineteenth century.

Despite its limitations, this short review reveals the extent to which perpetrator trauma is repressed in trauma research. The absence of such a history, the humanitarian need to defend and treat the victim, processes of societal denial and projection, and the threat post-traumatic perpetrators pose to the privileged position of victims and their social-cultural monopoly all establish that this abhorrent figure is rejected and obscure, thus making the scholar's (or the therapist's) identification with the field extremely tenuous.

Table 15.1 compares perpetrator with victim trauma. At first glance, it invokes a temptation to ignore the differences between the two post-traumatic subject positions, accentuate their similarities, and displace the ethical with the psychological register.[9] This slippery habit of addressing the perpetrator as a victim seems to be based on at least four major preconceptions: the 'victimized' point of view one is conditioned to when relating to trauma after the Holocaust, which also attests to the vast influence of Holocaust discourse on conceptualizations of the postmodern subject (as Eric Santner, for instance, claims[10]); the 'traumania' of the twentieth century;[11] the conflation between what Dominick LaCapra calls structural, transhistorical trauma and historical trauma;[12] and the aforementioned transformation of traditional\modern war to contemporary forms of new war.

I suggest that defining perpetrator trauma in the era of new war means taking into consideration the shift in the 'nature' of trauma, thus requiring a different hierarchy of the psychological, the ethical, the social, and the political.

Perpetrator trauma is an ethical, not a psychological, trauma. In order to avoid cultural slippage into habitual victim centricity or trauma envy, one should take as a point of departure the very foundation of perpetrator trauma – the ethical account. Future oriented towards the ethical imperative, this basic disparity between the ethical and the psychological registers determines all other differentiations between perpetrator and victim trauma.

The paradigm shift from victim to perpetrator trauma requires a change not only in regard to the 'nature' of trauma, but to the 'nature' of guilt. Perpetrator trauma, in contrast to victim trauma, is committed to an active acknowledgment and acceptance of guilt, a sense of guilt, and not to guilt feelings. I propose a gap between a sense of guilt (motivated by empathy for the victims and characterized by assuming responsibility and looking 'ahead') and guilt feelings (characterized by evoking identification, melancholic narcissism, self-pity, and looking 'backwards'). 'Looking ahead' includes but is not limited to halting policies that lead to atrocities, increasing the impact of international human rights norms and proper functioning of the public sphere, making reparations, encouraging domestic activism, and reviewing and revising the choice of weapons and rules of engagement. That is to say, perpetrator trauma is characterized by uncathartic guilt.

Although cinematic representations of perpetrator trauma might seem to have a psychological character similar to victim trauma's abundance of symptoms, the core of perpetrator trauma lies in the profound moral contradictions challenging the perpetrators rather than in their psychological disintegration, or disturbing and intrusive memories. The reason for this distinction lies in the character of the traumatic experience. The events perpetrators need to face are not shock and

Table 15.1. New-War Trauma

	Victim trauma	Perpetrator trauma
Character	Psychological (ethical, social, political)	Ethical (social, political)
Fundamental psychic process	Psychological disintegration	Profound moral contradictions
Nature of representation	Crisis, incoherent, unrepresentable, might be 'historically inaccurate,' based on emotional truth	Crisis, coherent, representable, historically accurate, based on ethical truth
Epistemology	Recognition	Acknowledgment
Traumatic experience	Death/survival	Perpetration of atrocities
Relation to the other	Rejection	Empathy
Relation to the event	Distanciation	Presentness
Relation to audience	Address, demand for participation, eliciting compassion	Shame, guilt, hidden demand for forgiveness
Emotional attitude	Self-involvement	Self-denouncement
Mode/format	Testimony	Confession
Time/space	Belatedness	Being there
Subject position	Given	Conditioned

Source: Raya Morag, *Waltzing with Bashir: Perpetrator Trauma and Cinema* (London: I.B. Tauris, 2013), 15.

complete surprise, overwhelming catastrophes, but events of (usually active) participation in atrocities known, even planned, in advance. Although perpetrators may suffer from recurring belated symptoms similar to those of victims, these relate to the perplexity of denying wrongdoing, or the inability to stop returning to the guilt-ridden experience, rather than to the incomprehensibility at the heart of the traumatic events. Perpetrator trauma therefore induces perpetrators to reflect on fissures in their own integrity.

In other words, acknowledgment of the deed stands in epistemological contrast to recognition of the catastrophe. Thus, unlike traumatic belatedness, which characterizes victims' psychological quest for recognition of the undecipherable 'essence' of life-shattering experiences, perpetrator trauma is more associated with being in the actual space the event took place, the site of atrocities, taking the Barthesian 'being there' literally. This conception accentuates the primacy, in an evidential sense, of the physical space over the volatility of time. The physical tangibility of the war zone is crucial for the perpetrators' acknowledgment; in many respects it is complementary to the physical traces of the atrocities themselves.

This means that victims experience the traumatic event as an occurrence in time, a *durée*; however, it is the physical space in which the event took place that haunts the perpetrators' post-traumatic subjectivity. Acknowledging their part naturally has to do with 'being in time,' but even more, with being in space, 'being there.' In contrast to the unreferential trauma of victims, the site of atrocities is a key point of reference for the perpetrators.

Unlike victims, whose position necessitates, so it seems, a distancing from and rejection of the perpetrators, empathy for the victim and openness stand at the core of perpetrators' new-war relations to 'otherness.' Moreover, the perpetrators' empathic unsettlement, to use LaCapra's vivid phrase, as a response to the victims – including the dead – might lead to mourning only if forms of self-involvement (like self-pity, guilt feelings, melancholia, and reactionary nostalgia) are replaced with self-denouncement. Undoubtedly, notwithstanding the scale of the trauma, the tension between the possibility of mourning or grievability and impaired mourning is at the core of the perpetrator's post-traumatic reaction.

In contrast to victims' testimony, perpetrators 'confess' their accounts, which I regard as the relevant mode for describing their ethical response: confession unravels the tangled relationship of memory from trauma and history. As indicated above, in current trauma research, victim testimony is marked by the absence of the traumatic event, since it fails to register in, let alone integrate into, the victim's consciousness. Moreover, in contrast to the (failed) narrativization of victims (as most scholars dealing with the subject claim), the perpetrators' confessions are 'successful' because they are inherently self-incriminating.

Central to confession as a mode, regardless of its religious roots and in contrast to its appearance in contemporary forms of entertainment, is its non-cathartic quality. This is an essential indication of both the difference between perpetrator and victim traumas and between confession and testimony. A cathartic revelation regarding the trauma of committing atrocities calls for spectator identification, and thereby blurs the boundaries between the psychological and the ethical – and through emotional reduction, between the victim and the perpetrator.

Personal conflict and structural factors demonstrate both the power of confession and the limits of its sincerity: the urge to tell versus the burden of secrecy that may last for years, the need for self-protection versus self-incrimination, the need to identify with society versus with the individual self, the desire for integration and inclusion versus exclusion, the manifest intentions versus the non-narratable and the foreignness of language itself.

The hidden demand for forgiveness that perpetrators may present during the confessional act should not override their sense of guilt and shame. Although it might seem as if they are addressing an implied

listener – in complete contrast to the victims' dependence on their testimony being heard by a supportive community – the perpetrators' confession is above all an intrasubjective process. It should adhere to its convention as a monologic genre based on introspection.

Finally, unlike the victims' subject position, that of post-traumatic perpetrators should be regarded as conditional. Its ontological status depends on the devotion of the perpetrator to a – sometimes lengthy – process of (self-imposed) acknowledgment of guilt, with all its ramifications. In this sense, victim trauma is a given, one that has happened, while the perpetrator trauma by definition is conditional and future oriented. In other words, it is defined and measured according to an idealized conception of ethical fulfilment. In fact, perpetrator trauma oscillates between being epistemologically a trauma-in-retrospect and one that is directed towards the future. Inevitably, by defining the epistemological and actual boundaries of perpetrator trauma, we reconceive the conditions that make responsibility possible and upon which moral life is based.

Perpetrator Trauma and Post-Iraq (and Afghanistan) War American Cinema

Since 9/11, research on the new 'war on terror' has been growing rapidly to an exceptional extent. Cinema research on post-Iraq (and Afghanistan) War American narrative and documentary films (2003–20), an emerging and burgeoning subgenre that by now encompasses dozens of films (as well as TV miniseries), is defined by two interrelated major subjects: new war ethics (e.g., Robert J. Lifton, 2006; Pat Aufderheide, 2007; Martin Barker, 2011; Daniel Binns, 2017)[13] and torture (e.g., Julian Lesage, 2009; Linda Williams, 2010; Jonathan Kahana, 2010; Bill Nichols, 2010).[14] Though both subjects are fundamentally connected to the issue of perpetrator trauma, post-Iraq (and post-Afghanistan) cinema research hardly engages with the mindset that this paradigm entails.

Cinema research is ideologically devoted to deciphering the uniqueness of this war in relation to the Vietnam syndrome (e.g., James R. Compton, 2006; Mark J. Barker, 2011)[15] and condemning reactionary representation of American neoliberalism/capitalism, the Bush Doctrine, law-and-order policy, and shock and awe policy in cinema. It is devoted as well to representational-ideological issues such as the visualized model of power and violence, embedded media, a host of war image platforms, reality TV–inspired techniques, and the compulsive, uncontrollable digital image of high-tech warfare embodied by spectacular hypermediation.[16] Most of these studies claim that the (mainly fiction) war films use digital multivisuality for dehistoricization and depoliticization of the war while

they simultaneously criticize the prevalent representations of the soldier (defined on a scale from 'patriotic' to 'survivor' to 'war junkie').

However, it is my claim that the research avoids framing the discussion around the films' denial of the trauma caused to the ethnic other, thus blocking a thorough ethical analysis of their major figure, the wrong-doer/perpetrator, beyond self-victimizing representations. Furthermore, cinema research lacks a comprehensive post-traumatic study that goes beyond the specific films that during these roughly twenty years won both great critical acclaim and box office success (most notably Michael Moore's *Fahrenheit 9/11*, USA 2004, Kathryn Bigelow's *The Hurt Locker*, USA 2008, and Clint Eastwood's *American Sniper*, USA 2014),[17] to promote a thorough discussion of its major ethical-psychological-political burden: the soldier-civilian clash resulting in perpetrator trauma's ethical imperative.

Instead, despite the thematic split between new war ethics and torture, and the different modes, both documentary and fiction films[18] represent a series of tensions that endow the films with irresolvable instability: culpability versus responsibility, systemic wrongdoing versus 'bad apples,' self-justification versus activism, and fetishization of soldiers' survival versus objectification of the enemy.[19] Though this series of tensions indicates an apparently incessant negotiation of ethical issues in regard to new war trauma, the framing of perpetrator trauma becomes secondary to the dynamics of patriotic victimhood (usually resulting in PTSD, or other undecipherable wounding). Building the diegetic world of the war on these tensions establishes a hierarchy of new war ethics that is devoted first and foremost to the well-being of the American soldier and not to that of the ethnic other, be it an Iraqi or an Afghani civilian. In other words, presenting atrocious images places the emphasis on expressing the American soldiers' horrific situations rather than the suffering of the civilian population and thus thwarts US acknowledgment of guilt and responsibility. As Crawford claims:

> The notion of individual responsibility of both perpetrators and commanders was developed over several centuries in both European and American treaty and domestic law and is no longer disputed. But if we consider responsibility for what happens before and after incidents of military atrocity (prospective responsibility and retrospective responsibility), the locus of moral responsibility widens beyond the individual on the battlefield.[20]

Differentiating between direct and indirect complicity (extensively defined as 'collateral damage' in these films) is misleading in terms of moral responsibility, but gains force and resilience in public discourse

as a result of being commensurable with the traumatic event, which by its very nature necessitates the duality of direct and indirect belated response on both the individual and collective levels. It is no wonder that on the collective level the differentiation itself is often displaced onto denial of the atrocious act,[21] or that the event itself becomes part of systemic atrocities that have undergone naturalization and are thus difficult to notice even as they are being produced.[22]

Five Crises of Representation

I suggest that in perpetrator trauma documentaries we can detect five prominent characteristics typical of the representation of this sort of trauma.[23] Because they involve being guilt-ridden and immanently unresolved as such, I formulate them as crises: The first is the crisis of evidence, which is indexical-iconic, and attests to the epistemological impasse in accepting the very fact that perpetration has taken place; that is, in confronting the epistemic dynamics of horror with evidence of the horror. The second is the crisis of disclosure, represented in the films by various types of concealment (e.g., of the atrocious act, of the perpetrator's identity, of the victim's identity and face). The third is gender related, ingrained both in internal masculine and feminine self-definition and in intergender power relationships. The fourth is the crisis of the audience, that is, the films' awareness that the perpetrator has no imaginary supportive community. The fifth is the crisis of narrativization, which reveals the unbridgeable gap between the narrative of pre-war identity and that of perpetration, and the gap between the victim's testimony and the perpetrator's uncathartic confession.

However, in American documentary war cinema on Iraq (and Afghanistan), these crises are transcended. The films emphasize what Zigmunt Bauman calls a "redistribution of guilt and innocence"[24] (especially in torture documentaries such as Rory Kennedy's *Ghosts of Abu Ghraib* and Errol Morris's *Standard Operating Procedure*). Furthermore, driven by finding self-redemption and confessional catharsis, the films raise the question of whether this cinematic trend indeed paves the way for Americans to assume responsibility for their deeds, or if it assists in acceptance of another stage of necropolitics.[25]

An undetected slippage from perpetrator to victim trauma characterizes most of the new war American films.[26] In the following, I analyse three prominent examples while reflecting on the perpetrator trauma paradigm and the crises of representation described above. *Poster Girl* (Sara Nesson, USA 2010), a documentary film, shows this slippage as inevitable and not fully acknowledged by the female veteran, while

particularly accentuating the crises of narrativization and gender. *The Battle for Haditha* (Nick Broomfield, UK 2007), as a hybrid film based on a true infamous event, exposes the basic new war scenario termed by the psychiatrist Robert Jay Lifton in the aftermath of this massacre an "atrocity-producing situation."[27] The crises of narrativization and evidence dominate the film. The third example, *Good Kill* (Andrew Niccol, USA 2014), is a typical narrative film that sheds light on the underlying factors of masculinity, heroism, and patriotism in the face of challenging ethical issues. The crises of gender and disclosure dominate the narrative of an ex-pilot who for twelve hours a day operates a drone that kills Iraqi by remote control.

In all three films, perpetrator trauma lurks beneath the surface of the veterans' suffering from a sense of guilt and PTSD symptoms, and although acknowledging the atrocities becomes part of the veterans' struggle to heal, their perpetrator trauma eventually nearly converges with victim trauma. That is, the veterans' own suffering, nightmares, drinking problems, desperation, physical disabilities, and other symptoms transcend the enemy's suffering and death, and US responsibility for mass killings of civilians.[28] In all three films, like in the corpus at large, because of the slippage from potential negotiation with perpetrator trauma (that is, with an ethical acknowledgment of the horrific outcomes of the soldiers' violent daily clash with the civilian population), the crisis of audience typical to perpetrator trauma is displaced into a vast proliferation of means of representation, an endless addressing of an imaginary audience. However, this proliferation of means used for representing the chaos of the new war (e.g., a public lecture based on confession, reading soldiers' letters, a semi-interview of the platoon members, video representation on an Islamic website of the violent event of a death trap that killed an American soldier, a surveillance camera's depiction of the events at the US base, etc.) does not reflect on an audience larger than the filmgoers or on US responsibility because the subject of responsibility is hardly dealt with.

The comparison of the three modes (non-fiction, hybrid, and fiction) enables a further consideration of the perpetrator trauma paradigm. Does perpetrator trauma involve only a personal ethical standing expressed by an uncathartic confession, or should we accept a 'film confession' (as in Brian De Palma's *Redacted*, USA 2007, for example[29])? The controversy that developed regarding *Redacted*'s authenticity, adherence to historical facts, and final montage of real-life photographs of Iraqi victims[30] (dubbed 'collateral damage') undoubtedly emphasizes that despite the true-stories-based films and anti-war tendency that elevates the issue of US responsibility for the enormous number of dead civilians, the purest form of perpetrator trauma is embodied in non-fiction cinema.

Poster Girl

Sara Nesson's short verité-style documentary *Poster Girl*, which follows Sgt. Robynn Murray's two-year struggle with PTSD (and the United States' dysfunctional Veterans Administration) subsequent to her service in Iraq, represents a female soldier's encounter with the violent and unpredictable militaristic, ethnic, and gendered situation of the new war. The film is exceptional among post-war documentary (as well as fiction) films in terms of representing perpetrator trauma: it is built on a long confessional act that relates to Robynn's wrongdoings and violations of human rights ("I'm recalling things that I did more and more. That are just hideous horrible, horrible actions against other humans ... When I was in Iraq, I did point my weapons at families and at children ... I stripped them of their humanity"). The major question to be asked is, what does the belated confession disclose when post-traumatic symptoms intermingle with belated memories of gender and especially ethnic conflicts during war?

The film offers an exceptional perspective on female perpetrator trauma not only because of the strife between the genders, but because in her militarized male-like involvement, the female perpetrator sheds light on both genders' involvement in new war deeds. The female soldier has to deal with participation in the oppression of the civil population in combat zones. These burdens are revealed mainly through the crises of narrativization, gender, and audience: Robynn's narrativization indicates an unbridgeable gap between her naive idealism before enlisting (exemplified by her description of her family's tradition of serving in the military and the photos in which she shows pride in her enlistment while her voice-over tells us of her strong, idealist will to help her country after 9/11) and her later shattered adjustment to, and complicity with, a reality of systemic atrocity. Gender crisis is embodied in the female encounter with a male world of routine military jobs that naturalize systemic androcentric and ethnocentric violent norms and sexual harassment. Repressed by both her brothers-in-arms and the typical new war situation, Robynn, desiring acceptance into the prevalent comradeship, underwent incessant subordination to forces that trapped her in a contradictory situation in what she wrongly believed were equal relations:

> We would have to go and assess damage to civilians' property. I went into this house ... I went in ... a man on the floor ... all blood and I can tell they were shot in their sleep. And the bodies were gone and ... there was a piece of bread ... and a piece of brain on it. And there's blood on the wall, there is blood all over ... and I had to go in and assess the damage ... and

the drama didn't even faze me. I just walked in as one of the guys ... Don't show weakness you're female, be callous, make jokes.

Because she is part of a male-dominated system, her description of how she had to adjust to appalling events perpetrated by her male comrades is represented through a comparison between her naive photo prior to her arrival to Iraq and her current, agonizing image, and an insertion of photographs of the deaths she saw interwoven with her blood-coloured hands preparing a work of art. Robynn attests to a sense of selfhood that was fundamentally enmeshed in violent circumstances by the surrounding militarily disciplined world and the gendered reality of the new war. Moreover, she talks about the unbearable lightness of mortality and her shocking encounters with ubiquitous (Iraqi and/or American) death – on the base, at patrol sites, in the streets, and so on, due to improvised explosive device (IED) incidents or standard operating procedures at checkpoints. Part of a daily routine, this new intimacy with the "utmost of abjection" (as Julia Kristeva calls it),[31] the corpse, became highly menacing and turns out to be a recurrent nightmarish image that haunts her upon returning home.

The ubiquity of death recalls Judith Butler's description of a culture of un-grievability:

Those who are unreal have, in a sense, already suffered the violence of derealization [...]. If violence is done against those who are unreal, then, from the perspective of violence, it fails to injure or negate those lives since those lives are already negated. But they have a strange way of remaining animated and so must be negated again (and again). They cannot be mourned because they are always already lost to or, rather, never 'were,' and they must be killed, since they seem to live on, stubbornly, in this state of deadness. Violence renews itself in the face of the apparent inexhaustibility of its object. The derealization of the 'Other' means that it is neither alive nor dead, but interminably spectral.[32]

Does *Poster Girl* indeed depict the new war's typical situation as being more powerful than gender differences? Robynn's confession reveals that such differences were highly influenced by the masculine order of the new war. The female soldier's place in the male-dominated military's rules of engagement, along with her so-called equality in combat jobs, not only makes it more likely she will try to fit in, but traps her in morally corrupt circumstances. Only the post-trauma of military service compels her to examine her previous norms and explore avenues for asserting possibilities of agentive selfhood. According to *Poster Girl*, as well as the other

prominent films, military service leads only to later acknowledgment of how the gendered norms of war operate when atrocities are carried out. Gender androcentric and ethnocentric violent norms leading to a war crime are represented as trapping some of the male soldiers as well. For example, in the coda of *Redacted*, Iraq war veteran McCoy (Rob Devaney), sitting with his wife and friends at a local bar at home, is asked to tell them "a war story." In tears he replies, "The killing that I did do makes me sick to my stomach ... I saw some shit there, man I just don't know how I'm gonna live with ... two men from my unit raped and killed a fifteen-year-old girl and burned her body and I did not do anything to stop it."[33]

Poster Girl's description of the crisis of audience reveals the acute influence of guilt on Robynn's ability to fully acknowledge herself first and foremost as a perpetrator of atrocities and a violator of human rights (and not as a victim of the army, the chaos of the new war, or convoluted gender relations) and her trauma as a perpetrator (and not a victim). Mostly delivered as a public speech, and not as an inner monologue, does the post-traumatic confession by Robynn indeed emerge out of an ethical stand in the so-called post-war (in fact, post-service) era?

Throughout his work, the psychiatrist, psychoanalyst, and trauma scholar Dori Laub sets forth concepts for the psychoanalytic exploration of the field of trauma. Describing the relation between witnessing trauma and restoration, Laub established the conceptualization of witnesses' relations with the listening community. Referring to the victim's trauma, he claims:

> In fact, the listener (or the interviewer) becomes the Holocaust witness before the narrator does. To a certain extent, the interviewer-listener takes on the responsibility for bearing witness that previously the narrator felt he bore alone, and therefore could not carry out. It is the encounter and the coming together between the survivor and the listener, which makes possible something like a repossession of the act of witnessing. This joint responsibility is the source of the reemerging truth.[34]

As I suggested above, following Laub and others, victim trauma depends on the testimony's being heard by a supportive community. However – in complete contrast – the perpetrator has no (real or imaginary) supportive community and his or her confession should be, in fact, an intrasubjective process. In *Poster Girl*, the ethical trouble stems from the incommensurability between Robynn's lament over her deeds and over her psychological disintegration ("trying to forget the things I've seen happen, happen"). Thus, the film is also an intriguing example of the framing of perpetrator trauma as secondary to the dynamics of

victimhood (from her desperate bursts of crying during the interviews she gives to Nesson that are intermingled within her confession, through her presenting to the camera the dozens of bottles of pills she takes against pain, anxiety, depression, and insomnia, and up to refraining from detailing the acts of wrongdoing themselves).

As the film gradually focuses on her suffering, the severely wounded, dead, and burned bodies of Iraqi civilians that she recalls (and that are incessantly presented as short flickering graphic images during her confession) become a clear source of her torment, though one that is not expressed as an ethical reflection on the Iraqi people. Finally, her lament and guilt feelings interwoven with very short expressions of a sense of guilt motivate the cathartic artwork that she does. Robynn joins a self-help group for veterans called The Combat Paper Project, a San Francisco-based organization that teaches war veterans and activists to turn military uniforms into paper and then into paper-based handmade art projects:

> We believe in this simple yet enduring premise that the plant fiber in rags can be transformed into paper. A uniform worn through military service carries with it stories and experiences that are deeply imbued in the woven threads. Creating paper and artwork from these fibers carries these same qualities.[35]

The traumatized veterans are shown producing paper out of their cut-up uniforms and other army paraphernalia and using the sheets for their artistic creations, later exhibited at the Rage Art Center. Robynn speaks to Nesson's camera (and the spectator) about the creation of her mixed-media papier-mâché busts "Indoctrination," "Baghdad," and "Healing," made from torn-up pieces of training manuals and cut-up pieces of her military uniform. When her hands, coloured with red, are making a bust, it becomes evident that the film becomes a portrayal of her journey of self-discovery and redemption. In her final talk, during the premiere of the exhibition, Robynn addresses her audience. Ethical questions are never even brought up.

The Battle for Haditha

Nick Broomfield's hybrid film *The Battle for Haditha* depicts the infamous event in which on 19 November 2005 US Marines stationed in Haditha, a Euphrates River Valley city northwest of Baghdad, killed twenty-four Iraqi civilians in their homes, including at least ten women and children, in retaliation for a deadly IED attack on their convoy. The film unfolds the story of the massacre through three perspectives (the insurgents who plant

the roadside bomb, a young Iraqi couple and their extended family later to be killed, and the US Marines of Kilo Company), which together expose the basic new-war scenario Lifton termed an "atrocity-producing situation."[36]

Analysing the mechanism at work, Lifton claims in the aftermath of the Haditha massacre:

> The alleged crimes in Iraq, like My Lai, are examples of what I call an atrocity-producing situation – one so structured, psychologically and militarily, that ordinary people, men or women no better or worse than you or I, can commit atrocities. A major factor in all of these events was the emotional state of US soldiers as they struggled with angry grief over buddies killed by invisible adversaries, with a desperate need to identify an 'enemy.'[37]

Proposing a multicausal explanation, Lifton describes the other major reasons for a predilection for war crimes:[38] strain, ideology that equates resistance with acts of terror and seeks to justify almost any action, an environment in which sanctioned brutality becomes the norm and dormant sadistic impulses are expressed, a perverse quest for meaning through the act of atrocity, and death anxiety.[39] In an interview with Caruth, he further elaborates this conception, moving from the reasons to a description of the resulting processes:

> Extreme trauma creates a second self [...]. It's a form of doubling in the traumatized person [...]. There have to be elements that are at odds in the two selves, including ethical contradictions. [...] The second self functions fully as a whole self; for this reason it is so adaptable and so dangerous. It enables a relatively ordinary person to commit evil [...]. Another function of this doubling is [...] in the case of perpetrators, the transfer of conscience. The conscience becomes associated with the group, with the sense of duty.[40]

Crawford expands Lifton's characterization, emphasizing that this situation is typical of counterinsurgency wars, the new war on terrorism, and wars of occupation. She calls attention to the pre-existing social structure:

> Military atrocity [...] may be [...] the foreseeable consequence of policies and practices that are set by collective actors [...]. These are systemic atrocities in the sense that they are produced not so much by individuals exercising their individual human agency, but by actions taken under the constraints of a larger social structure.[41]

An act at the limits of social rationality, revenge – following Lifton's and Crawford's insights – demonstrates the destructive forms of maleness. It

also demonstrates the difficulty entailed in assigning moral responsibility in cases of systemic atrocity and understanding how the moral context (and structure) within which the individuals act is shaped. However, I claim that Broomfield's film tends to embrace the "systemic atrocity" interpretation over the ethical stand entailed in a thorough presentation of perpetrator trauma, including the mechanism of doubling. As in *Poster Girl*, the film blurs victim with perpetrator trauma. Moreover, the crisis of evidence dominates *The Battle for Haditha*, motivated by the perpetrators' deliberate cover-up. At least one of the other two perspectives presented through parallel editing (that of the young Iraqi couple (Hiba [Yasmine Hanani] and Rashied [Duraid A. Ghaieb] and other members of the local population who eventually would be murdered) explicitly subverts the Marines' cover-up, and thus reflects on the crisis of evidence. In contrast to *Redacted*'s depiction of the war crime, for example, which towards its coda finally addresses the spectators through, first, the confession of the collaborator who acknowledges his ethical stand through relating to his trauma as perpetrator trauma, and, second, the last scene's shocking graphic presentation of photographs of severely wounded and dead Iraqi men, women, and children that reflects on the murder of the raped girl's family members and undermines any option of hiding the deed, the last scene of *The Battle for Haditha*, as will be analysed below, does not put forth the ethical lesson of perpetrator trauma and does not undermine the option of hiding the deed.

Based on a hybrid style that blurs non-fiction and fiction strategies, the film's beginning pre-empts its fantasmatic, non-ethical end. It begins with a series of interviews conducted with former Marines (including Corporal Ramirez [Elliot Ruiz], whose character is based on Staff Sgt. Frank D. Wuterich, who was the squad leader during the Haditha massacre). Playing the protagonists in the film and re-enacting their former selves, they express their frustration over the meaning of war, "why are we here," and the dangers they face because the civilian population, including women and children, "who are shooting at you are ... combatants." However, the editing is confusing: this interview sequence is followed by plain text on a black screen indicating the historical facts concerning the massacre in Haditha. Then the cutting to an extreme long shot of a desert invites the spectator to gaze at army vehicles, driving fast and raising sand behind them, while an action-adventure 'heroic' soundtrack emphasizes the scene's similarity to *Apocalypse Now*'s "Ride of the Valkyries" scene. Though the title "November 18th 2005, 6.30 am" that appears on the screen anchors the scene to the reality-to-happen, the soldiers' cheerful shouting during this ride and sexual-abusive gestures of 'manliness' (exposing a naked buttock through the vehicle's

window to indicate their superiority in the race between the vehicles) provide a conception of war-as-hell-as-entertainment.[42] This blurring of non-fiction and fiction strategies and confusing editing in fact subvert the role that the film, marking the dates and the hours of the happenings, takes upon itself – of chronicler and witness to the massacre.

Thus, the camera shows Ramirez (on 8 March 2006) listening with the other soldiers to the commander talking about the number of killings they are responsible for, and insisting on their obligation to defend the reputation of the Marine Corps. However, questions of responsibility, guilt, trial, and punishment are displaced: the closeup on Ramirez's face marks his fantasy presented as a recollection – the next scene shows him inside the house in the middle of the massacre (after he was shown killing many civilians in cold blood), giving his hand to a little Iraqi girl who was hiding in the bathroom while all her family members were shot at close range and are lying dead in the other room. Ramirez is seen addressing her and showing her the way out of the burning building. The last image is of the two of them standing on the threshold of this charnel house, absorbed in the dream-like light of the entrance. Simultaneously, Ramirez's voice-over is heard. Reflecting on his three tours of duty, he says: "We all saw things ... I guess after a while you just get hardened, become numb." With their silhouettes disappearing, the film ends.

Though *Haditha* is not a biographical (or autobiographical) film describing the veteran/perpetrator's perspective – in contrast to *Redacted*, which enables the truth to be heard regarding the war crime (and also reflects on its own fetishization of other forms of media coverage shown throughout) – *Haditha* betrays its best intentions. The parallel editing that allegedly enables the Marines, the victims, and the insurgents to represent themselves becomes a structure devoid of ethical implications.

The Perpetrator Complex

Putting aside the obvious differences between the Israeli and American contexts (such as compulsory service versus an all-volunteer 'poverty draft' army, confronting a civil population in occupied territories as part of a protracted conflict versus fighting in a far-away foreign country in the name of the US global war on terror, and low-tech practices and image depiction versus compulsive, uncontrollable digital images of high-tech warfare), I would like to refer through American war cinema to what I term 'the perpetrator complex' in Israeli perpetrator trauma documentaries.[43]

First, the perpetrator complex involves accepting that the perpetrator's relationship with society is inherently irresolvable. The post-traumatic perpetrator simultaneously addresses his or her guilt and society's

indirect complicitous guilt, thus defining the conflictual character of the complex. Second, in the perpetrator complex, guilt raises spectatorial identification that might serve to weaken common processes taking place on the collective level (such as denial, justification, evasion, projection, displacement, and universalism). However, an intense identification with the psychological level of the confessor blocks this necessary weakening. This instability characterizes both the perpetrator complex and the films in which it is explored. Third, in the perpetrator complex, there is an ambiguous relationship between the psychological and ethical levels of perpetrator trauma, so that by definition it includes the propensity of the latter to remain on the periphery of collective moral responsibility. This becomes more acute if we accept the view that society's responsibility "has three integral and essential components: not just the responsibility to react to an actual or apprehended human catastrophe, but the responsibility to prevent it, and the responsibility to rebuild after the event."[44]

The plot in Andrew Niccol's feature film *Good Kill* describes a Las Vegas–based fighter pilot, Tommy (Ethan Hawke), forced to become a drone pilot fighting the Taliban by remote control.[45] The film exemplifies another feature of new war, making it what Kaldor in her elaboration of the "new war thesis" calls "spectacle war":

> This virtual war is fought by the United States using superior technology, primarily air-borne technology and advanced information and communication technology. Although the wars are fought by American regular forces, the American people are only required to be spectators – they do not have to participate in any meaningful way by, for example, paying additional taxes or risking their lives.[46]

This feature, I claim, exacerbates the perpetrator complex.

I consider this film typical of the perpetrator complex. As Tommy kills civilians on a daily basis, he begins to question his mission. On one hand, in line with the films discussed above, this questioning has more to do with self-pity and his desire to be a combat pilot again than with assuming responsibility for his deeds. He is incessantly engaged in a narcissistic form of patriotic victimhood, which I regard as the subject position opposite the ethical grieving of perpetrator trauma. On the other hand, he is immersed in guilt, as his confession to his wife shows. This ambiguity is accentuated by Tommy's two acts of self-redemption as he gradually acknowledges his deeds: first, his act of rebellion against the US killings when he chooses, against orders, not to destroy an enemy vehicle and lets it escape; and, second, when he decides to shoot an Iraqi insurgent

whom he saw raping a woman. This second act displaces perpetrator's guilt (based on ethnicity) with male heroism, and apparently transcends the crisis of disclosure, exemplified by his work. It apparently transcends the immediate environment as well: *Good Kill* takes place in a US Air force compound on the outskirts of Las Vegas, a city whose simulacric 'nature' becomes the symbolic representation of virtual fighting, devoid of the corporeal sensations of war as well as the sound of the blast. In fact, this is not a 'film confession.'

This ambiguous relationship between the psychological and ethical levels of perpetrator trauma and the virtual feature by definition includes the propensity of perpetrator trauma to remain on the periphery of collective moral responsibility, which is a component of the perpetrator complex.

Furthermore, in the absence of a traditional war zone, when fighting involves "the deliberate targeting of non-combatants,"[47] an acute bodiliness characterizes new war. This implies a new ontology, one that is highly pertinent to the body's precariousness, vulnerability, and injurability. Defining perpetrator trauma in the context of new war thus expands our understanding of the relationship between this new form of traumatic experience and the ethics derived from, and implicated in, new states of emergency.

These American war (documentary, hybrid, and narrative) films illustrate that many factors need to be taken into account when defining perpetrator trauma in a specific context: the type of war being waged, the character of regime, the length of the conflict, the choice of weapons, the tactics used, the makeup of the space and security apparatus, and the structure of command. No less important are the degree of derealization of the ethnic other, the extent of dehumanization and moral indifference already at work, the scale of atrocities and human rights violations, the degree to which emergency becomes the rule, and the degree of public complicity.

Coda

As I hope this essay proves, the five crises of representation of perpetrator trauma (evidence, disclosure, gender, audience, and narrativization) should serve as a further reflection on the much-needed differentiation between victim and perpetrator traumas. The evolution of trauma theory shows us incessantly that ideological and/or therapeutical/psychoanalytical conceptualizations use trauma theory 'elasticity' for non-differentiation. Perhaps the most persistent obstacle, the question of identification with the aggressor, serves as the invisible Trojan horse within reactionary politics and psychoanalysis to undermine

twenty-first-century new war ethics and promote the convergence of these two types of trauma.

This question, we can argue, gains its prominence from its (ongoing) use in the analytic situation. For example, Jay Frankel claims:

> Exploring the early memories of his adult patients who had been abused as children, Ferenczi (1933) found evidence that children who are terrified by adults who are out of control will "subordinate themselves like automata to the will of the aggressor to divine each one of his desires and to gratify these; completely oblivious of themselves they identify themselves with the aggressor [...]. The weak and undeveloped personality reacts to sudden unpleasure not by defence, but by anxiety-ridden identification and by introjection of the menacing person or aggressor" [...]. The child "become[s] one" with the attacker.[48]

Based on the work of Sándor Ferenczi (and Anna Freud), Frankel contends that exploring identification with the aggressor as a response to traumas is "a pervasive phenomenon in human relations and in the clinical situation" because it happens when we feel overwhelmed by threat, when we have lost our sense that the world will protect us, when we are in danger with no chance of escape. What we do is make ourselves disappear. This response goes beyond dissociation from present experience: like chameleons, we blend into the world around us, into the very thing that threatens us, in order to protect ourselves. We stop being ourselves and transform ourselves into someone else's image of us. This happens automatically.[49]

Considering the political abuse of this view (as well as its legitimate tradition in psychotherapy), is there a way for current trauma theory to preserve the demarcation between these two modes of trauma? Will current trauma culture succeed, despite its own precariousness, in overcoming the influence of ill-identifications (including the long-term consequences by which victims may become aggressors themselves)?[50]

Cinema, and particularly documentary cinema, might serve as a major cultural intervention into these trends. Rupturing all sorts of dyads and slippages, its call for a new ethics opens up channels for critically confronting the hidden trail of refusing social accountability.

NOTES

1 Raya Morag, *Waltzing with Bashir: Perpetrator Trauma and Cinema* (London: I.B. Tauris, 2013).

2 Mary Kaldor, *New and Old Wars: Organized Violence in a Global Era*, 2nd ed. (Stanford: Stanford University Press, 2007).

3 This chapter declines to share in the widespread use of the term 'postmodern war' in this context both because it is a term much abused intellectually and because postmodernism assumes a-referentiality, in for example the Lyotardian tradition. Exactly the opposite is assumed in this work: contemporary war appears to be a transition stage or a clash between the wars that characterized the twentieth century up to the 1990s and those that so far have characterized the twenty-first. Apart from the variety of definitions they offer, all the authors mentioned here note that conventional/traditional/modern war has entered a new epoch. See Michael Walzer, *Just and Unjust Wars* (New York: Basic Books, 1997); Jean Baudrillard, *The Gulf War Did Not Take Place*, trans. Paul Patton (Bloomington: Indiana University Press, 1995); Chris Hables Gray, *Postmodern War: The New Politics of Conflict* (London: Guilford, 1997); Slavoj Žižek, *Welcome to the Desert of the Real: Five Essays on September 11 and Related Dates* (London: Verso, 2002); Neta C. Crawford, "Just War Theory and the U.S. Counterterror War," *Perspectives on Politics* 1, no. 1 (2003): 5–25, https://doi.org/10.1017/S1537592703000021.

4 Beginning with Judith Lewis-Herman, *Trauma and Recovery* (New York: Basic Books, 1992), through Shoshana Felman and Dori Laub, *Testimony: Crises of Witnessing in Literature, Psychoanalysis and History* (New York: Routledge, 1992) and Dominick LaCapra, *Writing History, Writing Trauma* (Baltimore: Johns Hopkins University Press, 2001), and up to Giorgio Agamben, *State of Exception*, trans. Kevin Attell (Chicago: University of Chicago Press, 2005).

5 Bessel van der Kolk and Onno van der Hart, "The Intrusive Past: The Flexibility of Memory and the Engraving of Trauma," in *Trauma Explorations in Memory*, ed. Cathy Caruth (Baltimore: Johns Hopkins University Press, 1995), 158–81; Cathy Caruth, *Unclaimed Experience: Trauma, Narrative and History* (Baltimore: Johns Hopkins University Press, 1996); Ruth Leys, *Trauma: A Genealogy* (Chicago: University of Chicago Press, 2000).

6 Janet Walker, *Trauma Cinema: Documenting Incest and the Holocaust* (Berkeley: University of California Press, 2005); E. Ann Kaplan, *Trauma Culture: The Politics of Terror and Loss in Media and Literature* (New Brunswick: Rutgers University Press, 2005); Anton Kaes, *Shell Shock: Cinema, Weimar Culture, and the Wounds of War* (Princeton: Princeton University Press, 2009).

7 See Tristan Anne Borer, "A Taxonomy of Victims and Perpetrators: Human Rights and Reconciliation in South Africa," *Human Rights Quarterly* 25, no. 4 (2003): 1116, table 1, https://doi.org/10.1353/hrq.2003.0039.

8 The term 'war on terror,' coined by US president George Bush in his address to Congress in September 2001, is problematic both in framing counterterrorist or imperialist violence as morally righteous bilateral 'warfare,' and in its association with US foreign policy. Clearly, it also describes an endless, quixotic conflict, and since March 2009, the US government has abandoned the term. It is used here to describe this particular, historical local framing of political violence rather than as an accurate description of

events. See Bruce Bennett, "Framing Terror: Cinema, Docudrama and the 'War on Terror,'" *Studies in Documentary Film* 4, no. 3 (2010): 210, https://www.tandfonline.com/doi/abs/10.1386/sdf.4.3.209_1?journalCode=rsdf20.

9 I do not refer here to post-conflict classifications like the one undertaken by South Africa's Truth and Reconciliation Committee. See Borer, "A Taxonomy," esp. 1116, on post-apartheid South Africa.

10 Eric Santner, *Stranded Objects: Mourning, Memory, and Film in Postwar Germany* (Ithaca: Cornell University Press, 1986).

11 Proliferated to the point of false traumatization, as in the well-known case of Binjamin Wilkomirski. See Wilkomirski, *Fragments: Memories of a Wartime Childhood* (New York: Schocken, 1996).

12 LaCapra, *Writing History*, 76–85.

13 Lifton, "Haditha: In an 'Atrocity-Producing Situation' – Who Is to Blame?" *War Is a Crime*, 4 June 2006, https://www.editorandpublisher.com/stories/haditha -in-an-atrocity-producing-situation-who-is-to-blame,80313?; Aufderheide, "Your Country, My Country: How Films about the Iraq War Construct Publics," *Framework* 48, no. 2 (2007): 56–65, https://digitalcommons.wayne.edu/framework /vol48/iss2/4; Barker, *A "Toxic Genre": The Iraq War Films* (London: Pluto Press, 2011); Binns, *The Hollywood War Film: Critical Observations from World War I to Iraq* (Bristol: University of Chicago Press, 2017).

14 Lesage, "Torture Documentaries," *Jump Cut* 51 (2009), accessed 27 February 2020, http://www.ejumpcut.org/archive/jc51.2009/TortureDocumentaries /index.html; Williams, "Cluster Fuck: The Forcible Frame in Errol Morris's *Standard Operating Procedure*," *Camera Obscura* 25, no. 1 (2010): 29–67. https:// read.dukeupress.edu/camera-obscura/article-abstract/25/1%20(73)/29 /58431/Cluster-Fuck-The-Forcible-Frame-in-Errol-Morris-s?redirectedFrom =fulltext; Kahana, "Speech Images: *Standard Operating Procedure* and the Staging of Interrogation," *Jump Cut* 52 (2010), accessed 27 February 2020, https://www.ejumpcut.org/archive/jc52.2010/sopkKahana/index.html; Nichols, "Feelings of Revulsion and the Limits of Academic Discourse," *Jump Cut* 52 (2010), accessed 27 February 2020, https://www.ejumpcut.org /archive/jc52.2010/sopNichols/index.html.

15 Compton, "Shocked and Awed: The Convergence of Military and Media Discourse," in *Global Politics in the Information Age*, ed. Mark J. Lacy and Peter Wilkin (Manchester: Manchester University Press, 2006); Barker, *A "Toxic Genre."*

16 Nicholas Mirzoeff, *Watching Babylon: The War in Iraq and Global Visual Culture* (New York: Routledge, 2005); Garrett Stewart, "Digital Fatigue: Imaging War in Recent American Film," *Film Quarterly* 62, no. 4 (2009): 45–55, https://doi.org/10.1525/fq.2009.62.4.45; Catelin Benson-Allott, "Undoing Violence: Politics, Genre, and Duration in Kathryn Bigelow's Cinema," *Film Quarterly* 64, no. 2 (2010): 33–43, https://doi.org/10.1525/FQ.2010.64.2.33;

Christina M. Smith, "Gaze in the Military: Authorial Agency and Cinematic Spectatorship in 'Drone Documentaries' from Iraq," *Continuum* 30, no. 1 (2016): 89–99, https://doi.org/10.1080/10304312.2015.1117571.

17 Other films, like Brian De Palma's *Redacted* (US/Canada 2007), won critical acclaim and awards (such as the Silver Lion at the Venice Film Festival) but failed at the box office. Barker's "*A Toxic Genre*" deals with the economic failure of the twenty-three fiction films made between 2005 and 2008. Focusing on production and reception, the author does not embrace trauma discourse and thus does not differentiate between victim and perpetrator trauma.

18 Such as Paul Haggis's *In the Valley of Elah* (USA 2007), Errol Morris' *Standard Operating Procedure* (USA 2008), Kathryn Bigelow's *The Hurt Locker, Brian De Palma's Redacted*, Paul Greengrass's *Green Zone* (France/USA/Spain/UK 2010), Michael Moore's *Fahrenheit 9/11*, and Dennis Danfung's *Hell and Back Again* (USA 2011).

19 Tensions are expressed through the films' hybrid style as well: deliberate authentication of fictional diegesis versus raw true-story-based diegesis; an appropriation of Vietnam War films' iconic images versus on-location vérité aesthetics; and so on.

20 Neta C. Crawford, "Individual and Collective Moral Responsibility for Systemic Military Atrocity," *Journal of Political Philosophy* 15, no. 2 (1989): 191, https://doi.org/10.1111/j.1467-9760.2007.00278.x.

21 See, for instance, Errol Morris's essay in the *New York Times*, "The Most Curious Thing," 19 May 2008, https://opinionator.blogs.nytimes.com/2008/05/19/the-most-curious-thing/.

22 Crawford, "Individual and Collective," 191.

23 See Morag, *Waltzing*, 130–1.

24 Zigmunt Bauman, *Modernity and the Holocaust*, 2nd ed. (Ithaca: Cornell University Press, 2011 [1989]).

25 For elaboration on this term, especially in the colonialist context, see Achille Mbembe, "Necropolitics," *Public Culture* 15, no. 1 (2003): 11–40, https://doi.org/10.1215/08992363-15-1-11.

26 Some of the films are entirely victim films relating to survival in the horrendous war, such as Jason Hall's *Thank You For Your Service* (USA/India 2017) and Deborah Scranton's *The War Tapes* (USA 2006), a documentary shot by National Guard soldiers, or Jon Alpert and Matthew O'Neill's *Section 60: Arlington National Cemetery* (USA 2008), which depicts families mourning at the cemetery. See note 18.

27 Lifton, "Haditha."

28 See "Iraq Body Count," accessed 27 February 2020, https://www.iraqbodycount.org/; and Statista, "Number of Documented Civilian Deaths in the Iraq War from 2003 to March 2019," accessed 27 February 2020, https://www.statista.com/statistics/269729/documented-civilian-deaths-in-iraq-war-since-2003/.

29 The film is about the gang rape, murder, and incineration of fourteen-year-old Abeer Qassim Hamza al-Janabi and the murder of her family by US soldiers in the town of Samarra in 2006.

30 For example, Paul Smith, "Atrocity Exhibitions," *Film Comment* 43, no. 6 (2007): 52–5, https://www.jstor.org/stable/43458316; Ken Provencher, "*Redacted's* Double Vision: Brian De Palma's Imaginary, 'Multi-Visual' Iraq Documentary," *Film Quarterly* 62, no. 1 (2008): 32–8, https://doi.org/10.1525/fq.2008.62.1.32.

31 Julia Kristeva, *Powers of Horror: An Essay on Abjection*, trans. Leon S. Roudiez (New York: Columbia University Press, 1984), 4.

32 Judith Butler, *Precarious Life: The Powers of Mourning and Violence* (London: Verso, 2004), 33–4.

33 McCoy tried at the time to stop the crime, but was ordered out of the house at gunpoint. He later reported it to the Criminal Investigation Division (CID). The story in the bar ends with his friends cheering him as a hero. Then the editing cuts to a series of photographs of dead Iraqis.

34 Shoshana Felman and Dori Laub, *Testimony: Crises of Witnessing in Literature, Psychoanalysis and History* (New York: Routledge), 85, Kindle.

35 The Combat Paper Project was founded in 2007 by Drew Matott and Drew Cameron. See "Combat Paper Project," accessed 27 February 2020, http://www.combatpaper.org.

36 See my analysis of what I regard as the basic Vietnam War film scenario – falling into a trap/captivity (whether real or metaphoric), a recurring scenario that "depicts masculinity as hanging between two possible subject positions: that of the Hunter, that is, a victor, one whose subjectivity is realized according to the codes of dominance; and that of the Captive, that is, the defeated, one whose subjectivity collapses, perpetuating helplessness." Raya Morag, *Defeated Masculinity: Post-Traumatic Cinema in the Aftermath of War* (New York: Peter Lang, 2009), 156.

37 Lifton, "Haditha," 2006.

38 Lifton, from as far back as 1973, analyses Nazi doctors, Vietnam War veterans, and events in My Lai and Iraq. Although he points to some differences, especially in regard to the Holocaust (i.e., level of denial, the belief system [anti-Semitism], the reintegration of the self), the structure of an atrocity-producing situation and the form of dissociation he calls "doubling" appear in all.

39 "What is perverse is that one must impose death on others in order to reassert one's own life as an individual and group. And the problem is that the meaning is real. It's *perceived* as meaning. And it's perverse in the way that in all psychological judgment there has to be ethical judgment ... We reassert our own vitality and symbolic immortality by denying them their right to live ... by designating them as victims." Quoted in Cathy Caruth, "An Interview with Robert Jay Lifton," *Trauma Explorations in Memory*, ed.

Caruth (Baltimore: Johns Hopkins University Press, 1995), 137, emphasis in original.

40 Ibid.

41 Crawford, "Individual and Collective," 188–9.

42 Thus, the cross-cutting between the insurgents who are waiting on the roof to activate the road bomb keeps the tone of previous scenes, as we are expecting (with the time indicated on the screen) for the (almost Hitchcockian) bomb to explode.

43 A new wave of Israeli perpetrator trauma documentaries that is a pioneer in world cinema emerged during the post–second intifada era. It includes films such as Tamar Yarom's *To See If I'm Smiling* (2007), Avi Mograbi's *Z32* (2008), Ari Folman's *Waltz with Bashir* (2008), and more recently, Mor Loushy's *Censored Voices* (2015) and Samuel Maoz's *Foxtrot* (2017). See Raya Morag, "Perpetrator Trauma and Current Israeli Documentary Cinema," *Camera Obscura* 27, no. 2 (80) (2012): 93–133, https://doi.org/10.1215/02705346-1597222.

44 ICISS (International Commission on Intervention and State Sovereignty), *The Responsibility to Protect* (Ottawa: International Development Research Centre, 2001).

45 See Christina M. Smith, "Gaze in the Military: Authorial Agency and Cinematic Spectatorship in 'Drone Documentaries' from Iraq," *Continuum* 30, no. 1 (2016): 89–99, https://doi.org/10.1080/10304312.2015.1117571.

46 Mary Kaldor, "Elaborating the 'New War' Thesis," in *Rethinking the Nature of War*, ed. Isabelle Duyvesteyn and Jan Angstrom (London: Frank Cass, 2005), 217.

47 Crawford, "Just War Theory," 10.

48 Jay Frankel, "Exploring Ferenczi's Concept of Identification with the Aggressor: Its Role in Trauma, Everyday Life, and the Therapeutic Relationship," *Psychoanalytic Dialogues* 12, no. 1 (2002): 103, https://doi.org/10.1080/10481881209348657.

49 Ibid., 102.

50 Anna Freud, *The Ego and the Mechanisms of Defense*, rev. ed. (New York: International Universities Press, 1936), 109–21.

Coda: Climate Trauma Reconsidered

E. ANN KAPLAN

Trauma studies in the humanities has recently been the object of considerable debate. It is by now almost de rigueur to start any writing about trauma with a critique of Western-style humanities trauma theory dating back to Cathy Caruth's research, and that of other Yale post-structuralist scholars, especially Geoffrey Hartman and Shoshana Felman.[1] The critiques run along similar lines, and include (1) objection to the Caruthian disassociation model for trauma with its claims as to trauma's unrepresentability; (2) the theory's post-structuralist, paradoxical relationship to history; (3) its favouring an avant-garde aesthetic; and, most importantly, (4) its heavy Western bias and neglect of trauma's difference across cultures and nations.[2] The critiques provided an important check on the proliferation of Caruthian-style trauma studies,[3] but the often very narrow focus of criticism on symptoms for post-traumatic stress syndrome (PTSD) left aside critique of more crucial aspects related to neglecting the long history of traumatic catastrophes in nations worldwide: this long view (which Ban Wang and I addressed in 2004)[4] gets sidelined in the presentist and individual focus on PTSD.

The best scholars (like Dominick LaCapra) have not thrown the baby out with the bathwater, as Lucy Bond and Stef Craps detail in their excellent overview of trauma studies' politics and emergence in the humanities.[5] It is clear that for certain people in specific contexts some of Caruth's, or even Bessel van der Kolk's, claims about post-traumatic stress syndrome are pertinent.[6] Few if any scholars push back against objections; however, Robert Eaglestone's critique of positivist sociologists like Wulf Kansteiner, who has been particularly hard on humanities trauma theory, suggests a fruitful direction.[7] As LaCapra notes in a useful volume, *The Future of Trauma Theory*, where trauma theory is productively critiqued, "we may have reached a point where problems can be addressed without always ringing the trauma bell."[8] He goes on

to suggest that "instead one may choose to indicate the role of trauma where suitable, but often leave its pertinence implicit."[9]

This advice makes good sense, and is largely followed by authors in this volume. Scholars recognize that it is time to move on. You can find references to what I will name the 'trauma theory debates' in some chapters, as is appropriate, but for the most part authors either (1) clarify debates by returning to the history of trauma theory and locating precedents that partly determined the humanities' 'turn' to trauma (as in Ulrich Koch, chapter 10); (2) attend to pertinent actors, like perpetrators, often deliberately avoided (as in Raya Morag, chapter 15, and Julia B. Köhne, chapter 14); (3) discuss voices referencing a trauma not usually heard (such as in chapters 1 and 3, where scholars use archival Finnish soldiers' words, or those of nurses treating the wounded); or (4) develop quite new, sometimes surprising, approaches to trauma without dragging in the theory debates, as when Adam Lowenstein (chapter 13) critiques the tendency to separate individual and collective trauma, arguing that we miss something when we do this; or, in chapter 11, when Thomas Elsaesser argues that "by the very fact of being non-integrated," trauma "potentially cuts loose from [the] past, thereby freeing energies that are directed towards a differently meaningful future." In other words, now is not the time to try to 'cure' trauma. Rather, anticipating future trauma may now be necessary to becoming active in the face, for example, of disastrous climate change.[10]

Such ideas are fitting for a volume where the goal is "to define and spearhead a 'third wave' of trauma studies, which uncovers previously unexplored languages for describing traumatic experiences, moving beyond PTSD and other medicalized frameworks for defining mental trauma."[11] As the editors further put it, the focus is on listening and hearing trauma expressed via the body or language rather than overt psychological symptoms usually associated with PTSD.[12]

I agree with the aims the editors lay down for this "third wave" in trauma studies, and rather than entering further into dialogue with essays in the volume, in the spirit of moving on I will offer my thoughts (often in tune with aims of the volume) about a specific terrain that trauma theory has recently moved into and that is not addressed here (or only peripherally), namely what I have called "climate trauma" and what others term "climate illness."[13]

Following the onslaught of petro-culture and carbon emissions made possible via capitalist policies pulling us into the devastating era of the Anthropocene, humanists have developed an enormous archive, compiled over recent years, of illuminating, informative, and varied research addressing the urgency of climate change, and demonstrating what the

humanities has to offer to the crisis.[14] Climate trauma or illness is one of the latest perspectives. I will discuss the differences between my concept of climate trauma and much of the research on climate illness, showing the importance of an approach that is oriented towards *thinking for the (dystopian) future* and the psychological problems that involves, rather than mainly being preoccupied with *either the past or the present*. From amongst the many approaches to climate illness, I will select just four: mourning nature, the ecophobia hypothesis, the "Anthropocene disorder," and pre-traumatic stress syndrome and related approaches. Each approach arguably uses new languages for approaching trauma, and some involve the kind of close listening to those mourning collective losses that is very much in line with the aims of this volume.

1. Mourning Nature

This research focuses on people's psychological suffering from severe losses of plants, trees, rivers, and lakes, to say nothing of millions of species daily becoming extinct.[15] Scholars have developed a new language for this pain, reflected in the sophisticated set of terms for the various kinds of losses. Glenn A. Albrecht's concept of "solastalgia" (that is, "the feeling of desolation or melancholia about the emplaced and lived experience of chronic deterioration of a loved home environment") in particular has been influential, along with his wide range of new language linked to losses to the biosphere.[16] While in this work there is a danger of projecting human emotions into the non-human world as the Romantics tended to do, overall the research has addressed important, if limited, aspects of climate illness.

A 2017 volume, *Mourning Nature*, co-edited by Ashlee Cunsolo and Karen Landman, offers diverse accounts of response to biosphere losses. Essays include theoretical accounts of ecological loss and grief combined with activist practices and ambitions. In her prologue to the collection, Cunsolo writes movingly of listening to the Inuit communities in Nova Scotia facing especially daunting losses related to climate change. As she puts it, "as the interviews progressed, it was increasingly clear that there was an important story to be told about the ways in which climate-related events were negatively disrupting many facets of Inuit mental and emotional health."[17] Cunsolo goes on to specify that "[p]eople shared deep feelings of loss, sadness, and despair; they expressed anxiety and fear for the future" as well as the "solastalgia" Albrecht had theorized: people interviewed can no longer gain solace from their home environment because of ways it has been desolated, destroyed. The kind of listening and attention to language these authors discuss comes close to what the

editors write in their introduction to this volume, namely that what mat-
ters "is the 'thinking through' of difficult events: the capture of ongoing
mental processes in an externalized form. While facilitators are not neces-
sary, there are also interesting instances of collaborative accounts that to
some extent speak 'on behalf of,'" very much what Cunsolo is doing here.

While Cunsolo and Landman show their indebtedness to Indigenous
philosophies of relation to the land, they also build on research by Jacques
Derrida and Judith Butler to usefully revision Sigmund Freud's original
work on mourning and melancholia. They detail ways humans need to
mourn nature, confronting losses, rather than attempting to work them
through. Mourning must be kept open as an ongoing condition.

Such an approach avoids an endless melancholy as in the Freudian
model of problematic grieving when the lost object is introjected. In this
model, the object is recognized as beyond the grieving subject. As John
Ryan puts it in a chapter in the volume, "A multispecies theory of envi-
ronmental mourning eschews the problematically individual and human
ego-focused principles of Freudian mourning."[18] Cultural trauma gains
importance in place of individual clinical symptoms.

This leads to a central theme of the volume, namely, the need for humans
to be in solidarity with the non-human world, including animals, plants,
and more generally all non-human species. Authors insist on relating to
the non-human world as linked to humans but not via humans projecting
their emotions onto that world. As Ryan argues, Freudian mourning can-
not account for "the loss of networks – interdependencies, connectivities,
relationships – between living creatures and non-living milieu."[19]

Environmental mourning has its critics, of course. Ryan, for example,
has sympathy (as I do also) with Timothy Morton's theorizing of climate
as a "hyperobject," within which we are embedded whether we know it
or not. Ryan critiques environmental mourning on the basis that we are
so deeply attached to the environment ("we *are* it") that we do not have
the perspective from which to mourn it.[20] Meanwhile, the volume raises
questions I will return to as to why losses are still on the margins of public
discourse: I'll discuss how to move beyond theory to action.

2. Ecophobia Hypothesis

Seeking ways to understand how humans arrived at the dire state we are
now experiencing, Simon Estok came up with the concept of ecopho-
bia, creating a second approach to climate illness. For Estok, ecophobia
"is a uniquely human psychological condition that prompts antipathy
toward nature."[21] While biophelia has been well studied and debated,
Estok argues that ecophobia has been largely ignored: its importance

is in explaining "why humanity continues to generate environmental crises at ever-worsening rates," with effects that "disproportionately impact women, indigenous people, developing countries, the global south, low-lying nations, queer communities and nonhuman animals."[22] He argues that such a phobic antipathy towards nature allowed humans to exploit and destroy natural resources without blinking an eye. Our alternately biophilic attitude, encouraged by the Romantics and strengthening in the twentieth century, was not enough to dampen industrial greed and corporate seizure of any land having oil, coal, or precious metals, for human gain. I am reminded of Jennifer Baichwal and Edward Burtynsky's devastating documentary *The Anthropocene: The Human Epoch* (Canada 2018), which most vividly captures the violence of multiple kinds of extraction on a vast scale worldwide, along with the equally vast mountains of waste industrialization produces. This waste ends up in China and Africa, where poverty drives people to wade in the vast muddy waste fields seeking sustenance or objects to sell.

3. Anthropocene Disorder

A third approach by Timothy Clark follows from earlier work by Timothy Morton, Tom Cohen, and others. Clark stipulates as an "Anthropocene disorder" the "sense of loss of proportion [...] a loss of proportion *tout court*, vertiginously and as yet without a conceived alternative."[23] This disorder emerges because environmental damage is happening at a scale humans are not equipped to perceive, so that it remains counter-intuitive, even invisible.[24] Following French authors B.R. Allenby and D. Sarewitz, Clark distinguishes three scalar levels of complexity, with Level III being the most important and the level least available to humans.[25] Level III effects, Clark says, "represent complex emergent properties that defy our ability to model, predict or even understand them."[26] This renders obsolete "modes of thought that are confined to Levels I and II, even if those still describe the kinds of thinking almost all people try to live by."[27]

Clark dwells on the implication of this perspective for humanities' modes of scholarship. He sees humanities' work as limited because not addressing the larger complex scale within which humans are now enmeshed, and instead continuing to use "old" categories (like psychoanalysis) that, like Morton and Cohen, Clark deems no longer viable. Such practices and thinking, especially as regards the theoretically positive influence of art once assumed to be "self-evidently adequate, progressive or merely innocuous," become, as Clark puts it, "in this emerging and counter-intuitive context, even latently destructive"[28] – a devastating critique of much humanities work.

While I appreciate and even partly agree with Clark's arguments, in the end I think we need to attend to those earlier levels within which individuals and local communities are living and trying to work through. Clark's position collapses time frames such that this period prior to total apocalyptic collapse is foreshortened. We know that the impact of collapse is uneven, with those least able to handle it (and having contributed the least to its emergence) being visited with collapse first: the poorest nations in the South, the poorest people and those most vulnerable via illness or disability, age or poverty are already experiencing devastation (e.g., the Aborigines in the Torres Straits Islands, whose land is gradually being submerged; or Fuji's vulnerable islands some of which are already drowned). But there are things that can still be done to ameliorate their conditions, if only temporarily. Attending to climate illness, and even climate trauma, and seeking to mobilize those suffering towards activism and community support are imperative as conditions worsen.

4. Pre-traumatic Stress Syndrome

It is precisely because there is currently an in-between period, where science has shown the devastation to come and yet a relative normalcy remains for many, that we need to attend to anxious anticipations of this future. Psychological distress, and the even more depleting pre-traumatic stress syndrome, lead to denial, withdrawal, even suicide, as in some fictional narratives I will briefly address.

As I have explained elsewhere,[29] climate change can activate a debilitating illness I have labelled "pre-traumatic stress syndrome" (PreTSS). This involves subjects experiencing symptoms similar to those of *post*-traumatic stress disorder (PTSD), only now instead of suffering from the triggering of *past* events, they suffer from anticipating extreme disaster from a rapidly changing climate caused by humans.

However odd it may sound, I did find *hypothetical* data of exactly such a condition in a Hollywood film, namely Jeff Nichols' *Take Shelter* (USA 2011). The film is remarkable in having a male hero who increasingly succumbs to a mental illness that unravels his life. Even more remarkable is Nichols's showing his hero, Curtis, developing a PreTSS condition. Curtis suffers symptoms familiar from PTSD, only now in relation to *what has not yet taken place*. Curtis's extreme fears and vivid, terrifying hallucinations are all in regard to a future collapse of nature that haunts him. The opening image of the film shows Curtis outside, watching unusual black clouds moving in ominous ways. Shortly, what looks at first like rain turns out to be oil pouring down on Curtis from the sky. But a quick cut takes us to Curtis having a hallucination while taking a shower.

Nichols repeats this pattern of starting with Curtis in an ordinary daily life situation that suddenly turns into ominous, and terrifying, natural events: for example, as Curtis, a construction worker, operates machines with his pal, waves of birds cloud the sky or drop dead, piling up on the road; or as he takes care of his hearing-impaired child, Hannah, storms so violent break out that they raise the house off the ground. Another time, when Curtis is driving with Hannah, the storms he imagines nature has conjured up have also produced wild zombies who try to kill him and his child. Curtis's pre-traumatic symptoms get worse as the film goes on, so that we find him having nightmares about violent storms that turn his usually friendly dog extremely aggressive to the extent of wounding Curtis's arm dangerously. In one such nightmare, to his shame, Curtis wets his bed. For days, his arm hurts, and he is haunted by the dreams, making him lose his sense of who he is. Unable to work efficiently any more, Curtis is driven to build a shelter to keep his family safe, and with this his life unravels.

The cinematic techniques used in the film brilliantly draw the viewer into the pre-traumatic stress each character experiences. Nichols shoots Curtis from behind, so that we see what he sees, suturing us to Curtis's terrifying visions. In a sense, Nichols plays with viewers in seeming to provide relief that what Curtis experiences is just hallucinations, not reality, only to apparently reverse this at the end, implicating viewers in an anticipation of planetary collapse of a devastating kind.

But exactly how viewers are affected by such dystopian visions remains an open question. Adrian Ivakhiv, for one, makes the common-sense suggestion that cinema scholars undertake empirical studies of what audiences take away from such films.[30] Heather Houser, writing from the perspective of affect theory, is, like me, against Tim Clark's pessimism about the influence of art on human thought and behavior. She argues that fiction may alter "relationships to lived environments and conceptions of agency by drawing together ecological and somatic sickness through narrative affect."[31] (This perfectly describes a probable impact of *Take Shelter* at least.) Houser goes further when she claims that fictions can break down the human-environment boundary, and that this "inseparability is the key to any possible hope."[32] I especially appreciate her argument that the stories and images that set into motion messy feelings that "can alternately direct our energies towards planetary threats and drive them away from action" can carry us "from the micro-scale of the individual to the macro-scale of institutions, nations and the planet."[33] David Opdyke's new artwork "This Land," reviewed in *The New York Times* by Lawrence Weschler with the title "Dismal Future? Do Something," has a similar aim. Opdyke is cited refuting Auden's (Clark-like) pessimism about the impact

of art, and quoting Eudora Welty's argument that *making reality real* is art's responsibility. Opdyke's aim is to make "the stakes involved in our current crisis real and tangibly visible for people."[34] One ends up hoping that art like this might propel the urgent changes in vision, one person at a time, necessary to provoke an appropriate mass response.

Conclusion

This returns me briefly to Tim Clark's critique: while indeed I approach PreTSS via the individuals struggling with it, implicitly it is understood that the symptoms individuals suffer from are a result of that larger complex scale of the undoing of systems and infrastructures humans have always relied on. The frame I take is one that, as Clark understands, I feel I can deal with.[35] But it is also one that brings the scale down to where change might still be possible if we think deeply about the future. My readings only appear to be "individualistic," since we all know that any individual is inevitably part of a much larger set of structures and systems that have partly produced the subject's symptoms and anticipatory anxieties.

In other words, once we have diagnosed PreTSS or ecosickness, the question is how to move people suffering, perhaps unconsciously, from trauma future-tense – seeing no hope for survival and living in anticipatory fear – towards some sort of what Jonathan Lear calls *radical hope.*[36]

Lear arrives at this concept by listening to Indigenous Americans speak of their trauma. By "radical hope," Lear means the ability to adapt after a catastrophe. Understanding that culture shapes, and is in turn shaped by, people living in it, Lear shows how hard it is to change. Yet once a catastrophe totally disrupts the culture that people have long lived within so that it no longer serves their new post-disaster situation, it becomes crucial to retain what can be retained while shifting into a new way of being – one appropriate for the changed conditions.

I read this as warning to people worldwide to begin to alter long-held habits and ways of being to adapt to the new conditions: these will involve scarce water, food, and other resources; no reliable sources of energy; collapse of infrastructures of all kinds, including government and civil society; random violence over resources; and people worldwide on the move for where conditions may be better.[37] It is a slim slice of hope because human nature is not flexible; the sacrifices of making needed changes to ways of living, and expectations for the future, are awesome. But having this perspective of radical hope at least offers something to start towards, as against succumbing to pre-traumatic stress syndrome and other traumatic climate illnesses. Radical hope coincides with the aims of this volume: as the editors note, "theorists have tried to open up dialogue

across disciplines to interrogate how trauma can be described, and how we can listen to narratives through which it is processed, remembered, and medialized."[38] This process suggests a way forward that is urgently needed.

E. Ann Kaplan, Stony Brook University

NOTES

1 See Cathy Caruth, ed., *Trauma: Explorations in Memory* (Baltimore: Johns Hopkins University Press, 1995); Cathy Caruth, *Unclaimed Experience: Trauma, Narrative and History* (Baltimore: Johns Hopkins University Press, 2016). See also Geoffrey Hartman, *The Longest Shadow: In the Aftermath of the Holocaust* (Bloomington: Indiana University Press, 1996), and Shoshana Felman and Dori Laub, *Testimony: Crises of Witnessing in Literature, Psychoanalysis and History* (New York: Routledge, 1992).

2 The list of scholars who have contributed to debates about humanities trauma studies is long. Critique by Ian Hacking in "Making Up People," in *Reconstructing Individualism: Autonomy, Individuality, and the Self in Western Thought*, ed. Thomas Heller, Morton Sosna, and David Wellbery (Stanford: Stanford University Press, 1986), 226–36, and Allan Young, *The Harmony of Illusions: Inventing Post-Traumatic Stress Disorder* (Princeton: Princeton University Press, 1995) started early, and was continued by Ruth Leys, *Trauma: A Genealogy* (Chicago: University of Chicago Press, 2000), and then by a host of other humanities scholars, including Susannah Radstone, *Memory and Methodology* (Oxford: Berg, 2000); E. Ann Kaplan and Ban Wang, eds., *Trauma and Cinema: Cross-Cultural Explorations* (Hong Kong: Hong Kong University Press, 2004); Stef Craps, *Postcolonial Witnessing: Trauma Out of Bounds* (Basingstoke: Palgrave Macmillan, 2013); Roger Luckhurst, *The Trauma Question* (London, 2014); Alan Gibbs, *Contemporary American Trauma Narratives* (Edinburgh: Edinburgh University Press, 2014); Gert Buelens, Sam Durrant, and Robert Eaglestone, eds., *The Future of Trauma Theory: Contemporary Literary and Cultural Criticism* (London: Routledge, 2013). Sociologists like Wulf Kansteiner, "Genealogy of a Category Mistake," *Rethinking History* 8, no. 2 (June 2004): 193–221, and Jeffrey C. Alexander, Ron Eyerman, Bernard Giesen, Neil J. Smelser, and Piotr Sztompka, *Cultural Trauma and Collective Identity* (Berkeley: University of California Press, 2004) were especially critical of humanities approaches.

3 As the authors note, Caruth herself offers expansions on her positions in her most recent research.

4 For example, in our co-edited collection *Trauma and Cinema*, Ban Wang and I frame our discussion of multi-ethnic and intergenerational trauma through

the long lens of modernity, stretching back about two hundred years. Modernity, and its shocks and disorientation to tradition, was originally a Euro-American project, expanded, via Western imperialistic striving, to other cultures, producing decimation of Indigenous Americans and the implementation of a catastrophic slavery system. The disasters that followed are well known and their horrendous traumatic legacies by now well documented.

5 See Lucy Bond and Stef Craps, *Trauma* (London: Routledge, 2020). This volume includes a detailed history of the emergence of trauma as a mental health category, and in-depth studies of each post-structuralist scholar whose trauma research shaped the field in the humanities and cultural studies. Their discussion of critiques of trauma studies and of the future and limits of trauma is one of the best yet.

6 Bessel van der Kolk and Onno van der Hart, "The Intrusive Past: The Flexibility of Memory and the Engraving of Trauma," in Cathy Caruth, ed., *Trauma: Explorations in Memory* (Baltimore: Johns Hopkins University Press, 1995), 158–82.

7 As one of the editors of the collection *The Future of Trauma Theory*, which is mainly critical of humanities trauma theory, Robert Eaglestone nevertheless comes down on the way one prolific and even hostile critic of trauma theory, Wulf Kansteiner, "Genealogy of a Category Mistake," thinks about language. In his essay "Knowledge, 'Afterwardness,' and the Future of Trauma Theory," Eaglestone argues that "Kansteiner fails to offer his view of 'the workings of language' but it seems fairly clear that he thinks of language in an unproblematic, positivist kind of way, as a vehicle to carry (presumably extra-linguistic) concepts between people"; in Gert Buelens, Sam Durrant, and Robert Eaglestone, eds., *The Future of Trauma Theory: Contemporary Literary and Cultural Criticism* (London: Routledge, 2013), 13.

8 Dominick La Capra, "Fascism and the Sacred: Sites of Inquiry After (or Along with) Trauma," in Buelens, Durrant, and Eaglestone, *The Future of Trauma Theory*, 23.

9 Ibid.

10 See E. Ann Kaplan, *Climate Trauma: Foreseeing the Future in Dystopian Film and Fiction* (New York: Routledge, 2015); Kaplan, "Is Climate-Related Pre-Traumatic Stress Syndrome a Real Condition?," *American Imago* 77, no. 1 (Spring 2020): 81–104.

11 See the editors' comments in the introduction to this volume, 7–8.

12 "Introduction," this volume, 10–11.

13 Kaplan, *Climate Trauma*; Kaplan, "Is Climate-Related Pre-Traumatic Stress Syndrome a Real Condition?"

14 There's no way to detail this vast archive here, but, for some basic and essential articles by humanists, see Ken Hiltner, *Ecocriticism: The Essential Reader* (London: Routledge, 2014).

15 A new, extensive 2019 report has updated earlier assessments of loss of biodiversity in the millions of species becoming extinct. Elizabeth Kolbert's *The Sixth Extinction* (New York: Henry Holt, 2014) already detailed the implications of losses, but the new report adds to her research with even more recent studies. See Brad Plumer, "Humans Are Speeding Extinction and Altering the Natural World at an 'Unprecedented' Pace," *New York Times*, 6 May 2019, https://www.nytimes.com/2019/05/06/climate/biodiversity -extinction-united-nations.html.

16 Glenn Albrecht, "Solastalgia and the Creation of New Ways of Living," in *Biodiversity and Culture: Rebuilding Lost Connections*, ed. J. Pretty and S. Pilgrim (London: Earthscan, 2010), 255; Albrecht, "Psychoterratic Conditions in a Scientific and Technological World," in *Ecopsychology: Science, Totems and the Technological Species*, ed. Peter H. Kahn, Jr., and Patricia H. Hasbach (Cambridge, MA: 2012), 241–64.

17 Ashlee Cunsolo and Karen Landman, eds., *Mourning Nature: Hope at the Heart of Ecological Loss and Grief* (Montreal/Kingston: McGill-Queen's University Press, 2017), xv.

18 John Charles Ryan, "Where Have All the Boronia Gone? A Posthumanist Model of Environmental Mourning," in Cunsolo and Landman, *Mourning Nature*, 121.

19 Ryan, "Where Have All the Boronia Gone?," 123.

20 Timothy Morton, *Hyperobjects: Philosophy and Ecology after the End of the World* (Minneapolis: University of Minnesota Press, 2010), 253.

21 Simon H. Estok, *Ecophobia Hypothesis* (London: Routledge, 2018).

22 Ibid., 2.

23 Timothy Clark, *Ecocriticism on the Edge: The Anthropocene as a Threshold Concept* (London: Bloomsbury Press, 2015), 23; Morton, *Hyperobjects*; Tom Cohen, "Introduction: Murmurations – 'Climate Change' and the Defacement of Theory," in *Telemorphosis: Theory in the Era of Climate Change*, vol. 1, ed. Tom Cohen (Ann Arbor: Open Humanities Press, 2012), 13–42.

24 Clark, *Ecocriticism on the Edge*, 22.

25 B.R. Allenby and D. Sarewitz, *The Techno-Human Condition* (Cambridge, MA: MIT Press, 2011).

26 Clark, *Ecocriticism on the Edge*, 8.

27 Ibid., 9.

28 Ibid., 21.

29 Kaplan, *Climate Trauma*.

30 See Adrian Ivakhiv, "Green Film Criticism and Its Futures," *Interdisciplinary Studies in Literature and the Environment* 15, no. 2 (July 2008): 1–28.

31 Heather Houser, *Ecosickness in Contemporary U.S. Fiction: Environment and Affect* (New York: Columbia University Press, 2014), 222.

32 Ibid., 223.

33 Ibid.

34 Lawrence Weschler, "Dismal Future? Do Something," *New York Times*, Arts and Leisure section, 21 January 2019, 16.

35 Clark, *Ecocriticism on the Edge*, 190–1.

36 Jonathan Lear, *Radical Hope: Ethics in the Face of Cultural Devastation* (Cambridge, MA: Harvard University Press, 2006).

37 I am editing this essay as the 2020 pandemic continues to ravage the United States. Many of us are having an experience not that different from some of the dystopian fantasies I have written about in *Climate Trauma* and that I reference here. Climate disaster and the pandemic are connected, of course, and we are already experiencing the life that climate collapse will bring.

38 See the editors' comments in "Introduction," this volume, 11.

Contributors

Jennifer Anderson Bliss received her Ph.D. in May 2014 in comparative literature from the University of Illinois Urbana-Champaign. Her research focuses on the intersections of visuality with trauma and memory studies in comics and graphic novels, and she has published articles in *Literature Interpretation Theory* and *Mosaic*.

Katrina Bugaj is a Copenhagen-based American director, performer/creator, writer, and research practitioner. She is the co-founder and artistic director of Out of Balanz, and she has written text for six of the company's original performances. Some of the recurring themes in her work are the intersection between reality and fiction, and the relationship between identity, memory, and migration. Her artistic approach is research based and interdisciplinary.

Jason Crouthamel is a professor at Grand Valley State University in Michigan. He is the author of *An Intimate History of the Front: Masculinity, Sexuality and German Soldiers in the First World War* (Palgrave Macmillan, 2014) and *The Great War and German Memory: Society, Politics and Psychological Trauma, 1914–1945* (Liverpool University Press, 2009). He co-edited, with Peter Leese, *Psychological Trauma and the Legacies of the First World War* and *Traumatic Memories of World War Two and After* (both with Palgrave Macmillan, 2016), and, with Michael Geheran, Tim Grady, and Julia B. Köhne, *Beyond Inclusion and Exclusion: Jewish Experiences of the First World War in Central Europe* (Berghahn Books, 2018). He is completing a monograph titled *Trauma, Religion and Spirituality in Germany during the First World War*.

Robert Dale is lecturer in Russian history at Newcastle University. His research focuses on the impact of the Great Patriotic War (1941–45) on states, societies, individuals, and communities, particularly in the

immediate aftermath of the war. His monograph *Demobilized Veterans in Late-Stalinist Leningrad: Soldiers to Civilians* was published by Bloomsbury Academic in 2015.

Thomas Elsaesser was professor emeritus at the Department of Media and Culture, University of Amsterdam, and since 2013 taught part time at Columbia University, New York. Among his recent books are *German Cinema – Terror and Trauma: Cultural Memory since 1945* (Routledge, 2013); with Malte Hagener, *Film Theory – An Introduction through the Senses* (Routledge, 2015); and *European Cinema and Continental Philosophy: Film as Thought Experiment* (Bloomsbury, 2018). He was also the writer-director of *The Sun Island* (2017), a documentary essay film produced for German television ZDF/3Sat (https://sunislandfilm.com/).

Maj Hasager is the program director of Critical and Pedagogical Studies (MFA) at Malmö Art Academy, Lund University. She studied photography and fine art in Denmark, Sweden, and the United Kingdom. Hasager's artistic approach is research based, dialogical, and interdisciplinary, and she works predominantly with text, sound, video, and photography.

E. Ann Kaplan is Distinguished Professor of English and Cultural Analysis and Theory at Stony Brook University. She has published articles and books in cultural studies, media, and women's studies, from diverse theoretical perspectives including psychoanalysis, feminism, postmodernism, and post-colonialism. Her work includes *Women in Film: Both Sides of the Camera* (Routledge, 1991); *Women in Film Noir* (British Film Institute, 1998); co-edited with Ban Wang, *Trauma and Cinema: Cross-Cultural Explorations* (Hong Kong University Press, 2004); *Trauma Culture: The Politics of Terror and Loss in Media and Literature* (Rutgers University Press, 2005); and *Climate Trauma: Foreseeing the Future in Dystopian Film and Fiction* (Rutgers University Press, 2015).

Bridget Keown is a lecturer in the gender, sexuality, and women's studies program at the University of Pittsburgh. She received her Ph.D. from Northeastern University in 2019, where her doctoral dissertation, titled "'She is lost to time and place': Women, War Trauma, and the First World War," focused on British and Irish women's experience of war trauma and treatment during the First World War, and the gendered construction of memory. She is a contributing writer for *Nursing Clio*.

Ville Kivimäki is a social and cultural historian of World War II and its aftermath at Tampere University, Finland. He is a research team leader at

the Finnish Centre of Excellence in the History of Experiences (HEX), where his own study is focused on the history of nation state violence. His Ph.D. thesis, "Battled Nerves" (2013), focused on Finnish soldiers' traumatic war experiences and their military psychiatric treatment during World War II. Together with Tiina Kinnunen, Kivimäki has edited a comprehensive anthology, *Finland in World War II: History, Memory, Interpretations* (Brill, 2012).

Ulrich Koch, a psychologist and a historian and philosopher of the medical sciences, is currently assistant professor of clinical research and leadership at George Washington University's School of Medicine and Health Sciences in Washington, DC. In 2014, he published his first book, *Schockeffekte: Eine historische Epistemologie des Traumas* (Shock effects: A historical epistemology of trauma; Berlin: diaphanes). He has also published articles in *Berichte zur Wissenschaftsgeschichte, History of the Human Sciences*, and *Science in Context*, and is currently working on his latest book project: a political history of methadone maintenance treatment in the United States. Besides holding academic positions, Koch has worked several years as a clinical psychologist in the field of addiction treatment.

Julia Barbara Köhne is visiting professor at the Institute for the History and Theory of Culture at Humboldt University in Berlin. Her research focus includes interrelations between visual culture, trauma (film) studies, and the history of military psychiatry. She has published the monographs *Kriegshysteriker: Strategische Bilder und mediale Techniken militärpsychiatrischen Wissens, 1914–1920* (Matthiesen, 2009; dissertation) and *Geniekult in Geisteswissenschaften und Literaturen um 1900 und seine filmischen Adaptionen* (Böhlau, 2014; habilitation), as well as several edited volumes, including *Trauma und Film: Inszenierungen eines Nicht-Repräsentierbaren* (Kadmos, 2012); with Michael Elm and Kobi Kabalek, *The Horrors of Trauma in Cinema: Violence, Void, Visualization* (Cambridge Scholars Publishing, 2014); with Jason Crouthamel, Michael Geheran, and Tim Grady, *Beyond Inclusion and Exclusion: Jewish Experiences of the First World War in Central Europe* (Berghahn Books, 2018).

Peter Leese is associate professor of history at the University of Copenhagen, Denmark. His current research interests include the cultural history of trauma in the twentieth century, and a monograph project titled *Migrant Representations: Life-Story, Investigation, Picture*. His publications include *Shell Shock: Traumatic Neurosis and the British Soldiers of the First World War* (Palgrave Macmillan, 2002) and *Britain since 1945: Aspects of Identity* (Palgrave Macmillan, 2006). He is also the co-editor, with Jason

Crouthamel, of the collected volumes *Traumatic Memories of the Second World War and After* and *Psychological Trauma and the Legacies of the First World War* (both with Palgrave Macmillan, 2016).

Adam Lowenstein is professor of English and film/media studies at the University of Pittsburgh. He is the author of *Dreaming of Cinema: Spectatorship, Surrealism, and the Age of Digital Media* (Columbia University Press, 2015) and *Shocking Representation: Historical Trauma, National Cinema, and the Modern Horror Film* (Columbia University Press, 2005). His essays have appeared in *Cinema Journal, Representations, Film Quarterly, Critical Quarterly, boundary 2, Discourse*, and numerous anthologies. He is also a board member of the George A. Romero Foundation.

Emily Mendelsohn (MFA, California Institute of the Arts) is a Brooklyn-based theatre director interested in the everyday and sublime, the social and transcendent, presence and absence. Her work has been supported by TCG Global Connections, Los Angeles Department of Cultural Affairs, Fulbright Fellowship, Network of Ensemble Theaters, and US embassies in Uganda, Rwanda, and Lithuania.

Raya Morag is associate professor of cinema studies at the Hebrew University of Jerusalem. Her research focuses on post-traumatic cinema and ethics; cinema, war, and masculinity; perpetrator cinema; documentary cinema; Israeli and Palestinian second Intifada cinema; and corporeal-feminist film critique. Her publications include *Perpetrator Trauma and Israeli Intifada Cinema* (Resling, 2017), *Waltzing with Bashir: Perpetrator Trauma and Cinema* (I.G. Tauris, 2013), and *Defeated Masculinity: Post-Traumatic Cinema in the Aftermath of War* (Peter Lang, 2009).

Dyah Pitaloka is at the Department of Indonesian Studies, School of Languages and Cultures, the University of Sydney. She specializes in health communication and social change. Her publication highlights include, with M.J. Dutta, "Embodied Memories and Spaces of Healing: Culturally-Centering Voices of the Survivors of 1965 Indonesia Mass Killings," in Mohan J. Dutta and Dazzelyn B. Zapata, eds., *Communicating for Social Change: Meaning, Power and Resistance* (Palgrave MacMillan, 2019).

Hans Pols is professor and head of school at the School of History and Philosophy of Science at the University of Sydney. He is interested in the history of medicine in the Dutch East Indies and Indonesia, and he focuses in particular on the recent history of psychiatry and mental health services as well as the relationship between political upheaval, trauma,

and the way Indonesian mental health professionals react to both. He published *Nurturing Indonesia: Medicine and Decolonisation in the Dutch East Indies* (Cambridge University Press, 2018).

Marzena Sokołowska-Paryż is associate professor at the Institute of English Studies, University of Warsaw, Poland, where she teaches courses on contemporary British and Commonwealth literature, with specific emphasis on war fiction and film in relation to history, memory, and national identity. She is the author of *Reimagining the War Memorial, Reinterpreting the Great War: The Formats of British Commemorative Fiction* (Cambridge Scholars, 2012) and *The Myth of War in British and Polish Poetry, 1939–1945* (Peter Lang, 2002). She co-edited two volumes with Martin Löschnigg, *The Great War in Post-Memory Literature and Film* (De Gruyter, 2014) and *The Enemy in Contemporary Film* (De Gruyter, 2018). She is also an associate editor for *Anglica: An International Journal for English Studies*.

Index